General Ecology

THEORY

General Ecology
The New Ecological Paradigm

EDITED BY ERICH HÖRL
WITH JAMES BURTON

Bloomsbury Academic
An imprint of Bloomsbury Publishing Plc

BLOOMSBURY
LONDON · OXFORD · NEW YORK · NEW DELHI · SYDNEY

Bloomsbury Academic

An imprint of Bloomsbury Publishing Plc

50 Bedford Square	1385 Broadway
London	New York
WC1B 3DP	NY 10018
UK	USA

www.bloomsbury.com

BLOOMSBURY and the Diana logo are trademarks of Bloomsbury Publishing Plc

First published 2017

© Erich Hörl and contributors, 2017

Erich Hörl and James Burton have asserted his right under the Copyright, Designs and Patents Act, 1988, to be identified as Editors of this work.

British Library Cataloguing-in-Publication Data
A catalogue record for this book is available from the British Library.

ISBN:	HB:	978-1-3500-1470-1
	PB:	978-1-3500-1469-5
	ePDF:	978-1-3500-1468-8
	ePub:	978-1-3500-1471-8

Library of Congress Cataloging-in-Publication Data
A catalog record for this book is available from the Library of Congress.

Series: Theory series

Cover image: Miljohn Ruperto and Ulrik Heltoft, Voynich Botanical Studies, Specimen 50r Zima, 2014. Collection of the artists and Koenig & Clinton, New York.

Typeset by Fakenham Prepress Solutions, Fakenham, Norfolk NR21 8NN
Printed and bound in Great Britain

CONTENTS

LIST OF CONTRIBUTORS

James Burton is a Lecturer in Cultural Studies and Cultural History at Goldsmiths, University of London. He has previously taught in the areas of cultural theory, the history and philosophy of art, and media and communications. From 2014–16 he was a research fellow at the ICI Berlin: Institute for Cultural Inquiry. From 2011–13, he was an Alexander von Humboldt research fellow at the Institut für Medienwissenschaft at the Ruhr University, Bochum. Working across the fields of cultural/media theory, philosophy, and literature, his current research looks at non- and posthuman approaches to error and the role of (meta)fiction in the context of modern technologized culture and ecology. He is the author of *The Philosophy of Science Fiction: Henri Bergson and the Fabulations of Philip K. Dick* (Bloomsbury, 2015), and several articles on the philosophy of memory, theories of fiction, ecology and science fiction.

Bruce Clarke is Paul Whitfield Horn Professor of Literature and Science in the Department of English at Texas Tech University. His research focuses on systems theory, narrative theory, and ecology. In 2015 he was Senior Fellow at the Erlangen Center for Literature and Natural Science (ELINAS), Friedrich Alexander University Erlangen-Nürnberg. In 2010–11 he was Senior Fellow at the International Research Institute for Cultural Technologies and Media Philosophy, Bauhaus University Weimar. Clarke edits the book series *Meaning Systems*, published by Fordham University Press. His authored books include *Neocybernetics and Narrative* (Minnesota University Press, 2014), *Posthuman Metamorphosis: Narrative and Systems* (Fordham University Press, 2008), and *Energy Forms: Allegory and Science in the Era of Classical Thermodynamics* (University of Michigan Press, 2001). His edited volumes include *Earth, Life, and System: Evolution and Ecology on a Gaian Planet* (Fordham University Press, 2015); with Manuela Rossini, *The Cambridge Companion to Literature and the Posthuman* (Cambridge 2016); and with Mark B. N. Hansen, *Emergence and Embodiment: New Essays in Second-Order Systems Theory* (Duke University Press, 2009).

Didier Debaise is a research professor at the Fonds National de la Recherche Scientifique (FNRS) and the Free University of Brussels (ULB), where he teaches contemporary philosophy. His main areas of research are

contemporary forms of speculative philosophy, theories of events, and links between American pragmatism and French contemporary philosophy. He is the director of a collection in *Presses du réel* and a member of the editorial boards of the journals *Multitudes* and *Inflexions*. He has written two books on Whitehead's philosophy—*Un empirisme spéculatif* (2006) and *Le vocabulaire de Whitehead* (2007); edited volumes on pragmatism (*Vie et experimentation* [2007]) and the history of contemporary metaphysics (*Philosophie des possessions* [2011]); and has published numerous papers on Bergson, Tarde, Souriau, Simondon, and Deleuze. His most recent book is *L'appât des possibles* (2015).

Elena Esposito is Professor of Sociology at the University Bielefeld and at the University of Modena-Reggio Emilia. Working in a systems theory framework, she studies problems of time in social systems, including memory and forgetting, fashion and transience, probability calculus, fiction, and the use of time in finance. Her current research projects focus on the possibility and forms of forgetting on the Web, on a sociology of algorithms, and on the proliferation of rankings and ratings for the management of information. Esposito's recent publications include *The Future of Futures: The Time of Money* (2011), *Die Fiktion der wahrscheinlichen Realität* (2007), *Die Verbindlichkeit des Vorübergehenden: Paradoxien der Mode* (2004), *Soziales Vergessen: Formen und Medien des Gedächtnisses der Gesellschaft* (2002), "The Structures of Uncertainty. Performativity and Unpredictability in Economic Operations," *Economy and Society*, 42 (2013), and a debate with David Stark on Observation Theory in *Sociologica*, 2 (2013).

Matthew Fuller is Professor of Cultural Studies and Head of the Centre for Cultural Studies, Goldsmiths, University of London. He has published widely on media theory, software studies, critical theory and cultural studies, and contemporary fiction, and has worked with the artist groups I/O/D, Mongrel, and YoHa, as well as independently. He is the author of *Behind the Blip: Essays on the Culture of Software* (Autonomedia, 2003), *Elephant and Castle* (Autonomedia, 2011), *Media Ecologies: Materialist Energies in Art and Technoculture* (MIT Press, 2005), and (with Andrew Goffey) *Evil Media* (MIT Press, 2012), among other titles. His edited books include *Unnatural: Techno-theory for a Contaminated Culture* (Underground, 1994) and *Software Studies: A Lexicon* (MIT Press, 2008).

Olga Goriunova is a senior lecturer at Royal Holloway, University of London. She is the author of *Art Platforms and Cultural Production on the Internet* (Routledge, 2012), editor of *Fun and Software: Exploring Pleasure, Pain and Paradox in Computing* (Bloomsbury, 2014), and co-editor, with Alexei Shulgin, of *Readme: Software Art and Cultures* (University of Aarhus Press, 2004). She is a co-founder and co-editor of *Computational Culture, A Journal of Software Studies* (computationalculture.net). She has

also worked as a curator, co-organizing, among others, *Readme*, software art festivals, 2001–05 and *Runme.org* software art repository. In 2015, she was a fellow at the University of Leuphana's Digital Cultures Research Lab. In 2014–16 she has been part of the *Posthumanities* research network and member of the Visual Social Media Lab, working on the project *Picturing the Social*. She is currently working on a monograph on digital subjects and on a co-authored book on environmental ethico-aesthetics.

Erich Hörl is Professor of Media Culture at the Institute of Culture and Aesthetics of Digital Media (ICAM) at Leuphana University of Lüneburg. His research concerns problems of a general ecology of media and technology, the critique of cyberneticization of all modes of existence, and the history of fascination with non-modernity. He publishes widely on the contemporary technological condition. He is author of *Die heiligen Kanäle: Über die archaische Illusion der Kommunikation* (Diaphanes, 2005), editor of *Die technologische Bedingung* (Suhrkamp, 2011), and co-editor, with Michael Hagner, of *Die Transformation des Humanen* (Suhrkamp, 2008). His articles include "The Technological Condition" (*Parrhesia*, 2015), "A Thousand Ecologies: The Process of Cyberneticization and General Ecology" (in *The Whole Earth: California and the Disappearance of the Outside*, Sternberg, 2013), and "Luhmann, the Non-trivial Machine and the Neocybernetic Regime of Truth" (*Theory, Culture and Society*, 2012). He was invited fellow at the IKKM, Bauhaus University Weimar (2010–11), Leuphana's Institute for Advanced Study *Media Cultures of Computer Simulation* (mecs) (2013–14) and at the Insitute for Advanced Study of the University of Konstanz (2016).

Brian Massumi teaches in the Communication Sciences Department at the Université de Montréal. His research crosses the fields of art, architecture, political and cultural theory, and philosophy. His works include *Parables for the Virtual: Movement, Affect, Sensation* (Duke University Press, 2002), *What Animals Teach Us About Politics* (Duke University Press, 2014), *Ontopower: War, Powers, and the State of Perception* (Duke University Press, 2015), *Politics of Affect* (Polity Press, 2015), and *The Power at the End of Economy* (Duke University Press, 2015). He is also the translator into English of a number of works of contemporary French philosophy, including (with Geoffrey Bennington) Lyotard's *The Postmodern Condition* and Deleuze and Guattari's *A Thousand Plateaus*.

Timothy Morton is Rita Shea Guffey Chair in English at Rice University. He gave the Wellek Lectures in Theory in 2014 and has collaborated with Björk, Haim Steinbach, and Olafur Eliasson. He is the author of *Dark Ecology: For a Logic of Future Coexistence* (Columbia, 2016), *Nothing: Three Inquiries in Buddhism* (Chicago, 2015), *Hyperobjects: Philosophy and Ecology after the End of the World* (Minnesota, 2013), *Realist Magic:*

Objects, Ontology, Causality (Open Humanities, 2013), *The Ecological Thought* (Harvard, 2010), *Ecology Without Nature* (Harvard, 2007), eight other books and 170 essays on philosophy, ecology, literature, music, art, design, and food. He blogs regularly at http://www.ecologywithoutnature. blogspot.com.

Frédéric Neyrat is Assistant Professor in Comparative Literature at University of Wisconsin-Madison. He is a French philosopher with expertise in the environmental humanities, contemporary theory, and image studies. He has been Program Director at the Collège International de Philosophie and a fellow at Cornell's Society for the Humanities. He is a member of the editorial board of the journals *Multitudes*, *Lignes*, and *Les Cahiers Philosophiques de Strasbourg*. He is the author of several books, including *Le communisme existentiel de Jean-Luc Nancy* (2013), *Atopies* (2014), and *Homo Labyrinthus* (2015), his last book, offers an analysis of dominant Anthropocene discourses (http://atoposophie.wordpress.com).

Jussi Parikka is Professor of Technological Culture and Aesthetics at the Winchester School of Art (University of Southampton) and Docent of Digital Culture Theory at the University of Turku. His publications in the fields of new media theory, media archaeology, and continental philosophy include *Insect Media: An Archaeology of Animals and Technology* (University of Minnesota Press, 2010), *The Anthrobscene* (University of Minnesota Press, 2014), and *A Geology of Media* (University of Minnesota Press, 2015). In 2015, Parikka co-edited with Joasia Krysa the collection *Writing and Unwriting (Media) Art History: Erkki Kurenniemi in 2048* (MIT Press, 2015). Together with Geoffrey Winthrop-Young and Anna Tuschling, he is co-editor of the series *Recursions: Theories of Media, Materiality, and Cultural Techniques* (Amsterdam University Press).

Luciana Parisi is Reader in Cultural Theory, Chair of the PhD program at the Centre for Cultural Studies, and co-director of the Digital Culture Unit, Goldsmiths, University of London. Her research draws on continental philosophy to investigate ontological and epistemological transformations driven by the function of technology in culture, aesthetics, and politics. Her writings address the technocapitalist investment in artificial intelligence, biotechnology, nanotechnology. She draws on cybernetics, information theory, and computation, and aims to develop a naturalistic approach to technology. Her publications include *Abstract Sex: Philosophy, Biotechnology and the Mutations of Desire* (Continuum Press, 2004) and *Contagious Architecture: Computation, Aesthetics and Space* (MIT Press, 2013). She is currently researching the history of automation and the philosophical consequences of logical thinking in machines.

Bernard Stiegler is currently Head of the Institut de recherche et d'innovation du Centre Pompidou and president of the Ars Industrialis association. He is an external tutor at the Université de technologie de Compiègne and Distinguished Professor at Nanjing University. Starting with his ground-breaking work *La technique et le temps* I–III [*Technics and Time*] (1994–2001) he has published thirty books, which have been translated into eight different languages. Among his recent works are *La Société Automatique I: L'Avenir du Travail* (Fayard, 2015), *States of Shock: Stupidity and Knowledge in the 21st Century* (John Wiley & Sons, 2014), *Symbolic Misery I: The Hyperindustrial Epoch* (John Wiley & Sons, 2014), and *What Makes Life Worth Living: On Pharmakology* (John Wiley & Sons, 2013). In 1996 he became General Director of the Institut national de l'audiovisuel (INA), and in 2001, General Director of the Institut de recherche et coordination acoustique/musique (IRCAM).

David Wills is Professor of French Studies and Comparative Literature at Brown University. His major work on the originary technicity of the human is developed in *Prosthesis* (Stanford University Press, 1995), *Dorsality: Thinking Back through Technology and Politics* (University of Minnesota Press, 2008), and *Inanimation: Theories of Inorganic Life* (University of Minnesota Press, 2016), and he is completing a book entitled *Killing Times: The Temporal Technology of the Death Penalty*. Wills has translated a number of works by Jacques Derrida into English, including *The Gift of Death* and *The Animal That Therefore I Am*. He is a member of the Derrida Seminars Translation Project and an International Fellow of the London Graduate School.

Cary Wolfe is Bruce and Elizabeth Dunlevie Professor of English at Rice University, where he is also Founding Director of 3CT: Center for Critical and Cultural Theory. His areas of research interest include animal studies, posthumanism, biopolitics / biophilosophy, American literature and culture, and eco-criticism. He is founding editor of the *Posthumanities* series at the University of Minnesota Press, which has published works by Donna Haraway, Michel Serres, Isabelle Stengers, Roberto Esposito, and Vilém Flusser, among many others. His books include *Animal Rites: American Culture, the Discourse of Species, and Posthumanist Theory* (University of Chicago Press, 2003), *What is Posthumanism?* (University of Minnesota Press, 2009) and *Before the Law: Humans and Other Animals in a Biopolitical Frame* (University of Chicago Press, 2012). He is also the editor of *The Other Emerson* (University of Minnesota Press, 2010) with Branka Arsić, *Zoontologies: The Question of the Animal* (University of Minnesota Press, 2003), and *Observing Complexity: Systems Theory and Postmodernity*, with William Rasch (University of Minnesota Press, 2000).

ACKNOWLEDGMENTS

General Ecology: The New Ecological Paradigm began as a project in January 2013, during a meeting at Beckmanns Hof at the Ruhr University, Bochum, attended by the majority of this volume's contributors. Back then, two-and-a-half intense days of presentations and discussion raised the awareness among the participants that the description of the process of ecologization must be at the core of a critical evaluation of our contemporary situation, and that this exposition is to play an important role for the future of thought. This gathering took place within the institutional frame of the Bochum Media Studies Colloquium (BKM). We thank the Alfried Krupp von Bohlen und Halbach Foundation, the Alexander von Humboldt Foundation, and Evonik Industries for making possible this get-together of outstanding thinkers. We are also grateful to Maren Mayer-Schwieger, who co-organized the event with us, and was instrumental to its conception and execution.

The present volume is the third in a series of diagnostic collections edited by Erich Hörl, starting with a first volume on the cultural history of cybernetics (*Die Transformation des Humanen: Beiträge zu einer Kulturgeschichte der Kybernetik*, Suhrkamp, 2008, co-edited with Michael Hagner) and a second on the technological condition (*Die technologische Bedingung: Beiträge zur Beschreibung der technischen Welt*, Suhrkamp, 2011). The collaboration between Erich Hörl and James Burton goes back to the period when the former hosted the latter during a two-year Alexander von Humboldt Fellowship (2011–13) at the Ruhr University. This volume is also a late descendant of this cooperation and we thank the Alexander von Humboldt Foundation for this gift of research time. James is also grateful for the support of a recent fellowship granted by the ICI Berlin, during which the latter stages of editing were completed. Erich is grateful for the inspiring milieu he found in his new working environment at Leuphana University of Lüneburg, which has offered him the opportunity for many vivid discussions about the challenges of general ecology and the stakes of the processes of ecologization and cyberneticization with his colleagues, collaborators, and students.

All contributions to this book are original, though parts of three of the papers have appeared elsewhere in different forms. The original French version of Didier Debaise's contribution has previously appeared as a chapter in his book *L'appât des possibles: Reprise de Whitehead* (Les

Presses du réel, 2015); the abbreviated version that appears here has been revised for this volume. Jussi Parikka's contribution is based on the BKM lecture that opened the Bochum meeting in 2013, and uses some material that was subsequently also discussed in *The Anthrobscene* (University of Minnesota Press, 2014). The German original of the first part of Erich Hörl's introduction has been published in abbreviated form in the *Zeitschrift für Medienwissenschaft*, 14 (2016).

We are grateful to the translators who have worked with care and diligence to provide us with original translations of three of the contributions: Michael Halewood, translator of Didier Debaise's paper; Daniel Ross, who translated Bernard Stiegler's contribution; and Nils Schott, who translated the introduction by Erich Hörl. Thanks also to Milan Stürmer for his careful proofreading of parts of the final text, and conscientious preparation of the volume's index.

We wish to thank Miljohn Ruperto and Ulrik Heltoft for permitting us to use one of the prints from their Voynich Botanical Studies for the cover of the book, and Margaret Clinton from Koenig & Clinton for providing us with the image.

We also wish to thank Liza Thompson from Bloomsbury Academic for her enthusiasm for this volume and all her efforts in ensuring its timely appearance, and Rosi Braidotti for accommodating it in the Theory Series.

Above all, Erich is deeply grateful to his wife Ksymena and his daughter Helen, who arrived somewhere in the middle of this project. This venture wouldn't have turned out well without Ksymena's patience, understanding, and support, and without the love of both that carried him through the small hours.

SERIES PREFACE

Theory is back

Critical theorists of the universal, organic or situated kind used to be defined by their ethical-political commitment to account for power relations at work in the real world, as well as in scientific practice. But their prestige waned throughout the 1990s. The "theory wars" in the U.S.A. targeted critical theory as an outdated ideological activity, dismissing the theorists as "tenured radicals." They got replaced by new "content providers," experts, and consultants, in a context of increased privatization of academic research. By the turn of the millennium, with the internet as the only true "content provider," former theorists were relocated to the market-oriented position of "ideas brokers" and, in the best cases, "ideas leaders." By now, we are all entrepreneurs of the mind. The cognitive character of contemporary capitalism and its high technological mediation paradoxically produced a "post-theory" mood and intensified attacks on radical thought and critical dissent. This negative mood also resulted in criticism of the social and scholarly value of the humanities, in a neo-liberal corporate university ruled by quantified economics and the profit motive.

And yet, the vitality of critical thinking in the world today is palpable, as is a spirit of insurgency that sustains it. Theoretical practice may have stalled in the academic world, but it exploded with renewed energy in other quarters, in media, society, the arts, and the corporate world. New generations of critical "studies" areas have grown alongside the classical radical epistemologies of the 1970s: gender, feminist, queer, race, postcolonial and subaltern studies, cultural studies, film, television, and media studies. The second generation of critical "studies" areas includes: animal studies and eco-criticism, cultural studies of science and society, religion studies, disability studies, fat studies, success studies, celebrity studies, globalization studies, and many more. New media has spawned new meta-fields: software studies, internet studies, game studies, digital postcolonial studies, and more. The end of the Cold War has generated: conflict studies and peace research; human rights studies; humanitarian management; human rights-oriented medicine; trauma, memory, and reconciliation studies; security studies; death studies; suicide studies; and the list is still growing.

These different generations of "studies" by now constitute a theoretical force to be reckoned with.

Theory is back!

This series aims to present cartographic accounts of these emerging critical theories and to reflect the vitality and inspirational force of on-going theoretical debates.

Rosi Braidotti

CHAPTER ONE

Introduction to general ecology

The ecologization of thinking

Erich Hörl

Translated by Nils F. Schott

*An ecology properly understood can be nothing other than
a technology.*

JEAN-LUC NANCY[1]

Ecology: Our new historical semantics

We are witnessing the breakthrough of a new historical semantics: the
breakthrough of ecology. There are thousands of ecologies today: ecologies
of sensation, perception, cognition, desire, attention, power, values, infor-
mation, participation, media, the mind, relations, practices, behavior,
belonging, the social, the political—to name only a selection of possible
examples. There seems to be hardly any area that cannot be considered the
object of an ecology and thus open to an ecological reformulation. This
proliferation of the ecological is accompanied by a shift in the meaning of
"ecology." The concept is increasingly denaturalized. Whereas previously
it was politically-semantically charged with nature, it now practically calls
for an "ecology without nature."[2] Thus it not only abandons any reference
to nature, but even occupies fields that are definitively unnatural. At the
same time, in losing this dimension, the concept sheds an associated and
constrictive set of immunopolitical connotations by which it was formerly
bound to dogmas of proximity and immediacy; of the familiar and of
kinship; of the healthy and the unscathed; of the proper, the house, etc. In

short, it severs its connections with dogmas of authenticity [*Eigentlichkeit*].[3]
These dogmas have haunted and reterritorialized the concept of ecology
(due to its origin in the Greek *oikos* and as its problematic logocentric
heritage) ever since its genesis in the nineteenth century.[4]

There is something remarkable about this: while, from the perspective of
the history of concepts and discourses, the concept of ecology designated
primarily the other side of technics and of mind, it has now begun to switch
sides within the nature / technics divide, undoing the sutures that bound it
to nature. And it is doing so—crucially—in parallel with or perhaps even as
a result of a fundamental unsettling of this very difference: in the twentieth
century, this difference is no longer comprehended, in the time-honored
Aristotelian way, from the side of nature. The supplementation of nature
by technics no longer seems to be inscribed in nature and its guarantee of
purposes, no longer circumscribed and regulated by nature in the manner
described in the second book of the *Physics*, which was fundamental to an
entire, long-enduring epoch of rationality. While this assigned to technics
both ends that must be given by some intentional agent and ends taken
to be always already given in advance, this technics seemed relentlessly to
obey and implement an instrumental logic of means–end relations, consti-
tuting a "structuration of ends"[5]—albeit one whose branches increasingly
multiply and intertwine; in any case, this made it both part and bearer of a
whole, determinate—that is, a teleological—rationality. Now, in what we
will shortly describe as the technoecological condition, in contrast, the very
absence of any given purpose becomes undeniable. Technics emerges as the
absolute agent of this failure, and nature begins evidently to be subordinate
to it. Finally, what emerges is nature's essential technicity: nature will hence-
forth always already have been devoid of all purposes. "Still, it is precisely
here," Jean-Luc Nancy tells us, "that technology conveys its lesson: through
technology nature itself—from which technology is descended—reveals that
nature is by itself devoid of an end [*fin*]."[6] The technological end of the
end—that is, the end in every sense, the end as "closure" that prepares an
end to the end as "aim and purpose" and thereby removes every sense of
history of the history of sense (a point discussed further below), carrying
us to an *other* sense—for Nancy constitutes "our event."[7] In accordance
with this non-Aristotelian movement of history driven by technology,
which catapults us out of the Occidental order of teleology, compelling
us to engage with the thought of another rationality and relationality,
the concept of ecology is pluralized and disseminated; it is outlined and
consolidated as the concept of non-natural ecologies; it even mutates into
technoecology.

In this consequential shift beyond teleology, which will ultimately (to
follow Nancy) either completely globalize us (leading to an uninhabitable
"un-world") or mondialize us (creating a world),[8] "ecology" becomes
a key concept and signal of the non-modern deterritorialization of the
relationship between technics and nature. Although it is finally in all its

ambivalence an effect of modernization, this radical deterritorialization is one of the salient aspects of non-modernity in general, the always already non-modern inscription of modernity. It allows us to decipher the history of the fascination with non-modernity, which is recharged by this deterritorialization. The concept of ecology finally allies itself with the new materialisms that are struggling, at the heart of this contemporary fascination, to articulate a non-modern ontology and epistemology. All of this is taking place in the wake of the theories of ecologization that have proliferated since the 1970s, and which have come to include the mind, perception, or the psycho-social, thus testifying to this transformation of the sense of ecology from an early stage.[9] In other words, it is as if the comprehensive redescription of all modes of existence,[10] which has been ongoing for a while now, were contracting around the concept of ecology, a concept that has itself begun to move. This effort, therefore, ultimately turns out to be a general ecologization of thinking and of theory, a development to which the new historical semantics of ecology testifies.

The concept of ecology thus represents the center of a great transformation of the politics of concepts and theories, but one containing elements that are extremely consequential for the history of fascination to which we are subjected. It is here, I argue, that the powerful fascination with non-modernity, which guides the elaboration of this transformation today, finds its perhaps most radical systematization and articulation. Above all, it is from here that what I call the history of the fascination with non-modernity begins to become legible as such and prepares the basis for the examination of our new sense-cultural position. As early as the end of the nineteenth century, but all the more so since 1945, the entry into the technological condition and a media-technological mobilization have bolstered the formation of first a post-, then a non-modernity. In the post-humanist present, this non-modernity is most acutely conceptualized and integrated in the denaturalized and technologized—and thereby deterritorialized and generalized—concept of ecology, which is critical of all anthropocentrism. "Ecology" has started to designate the collaboration of a multiplicity of human and nonhuman agents: it is something like the cipher of a new thinking of togetherness and of a great cooperation of entities and forces, which has begun to be significant for contemporary thought; hence it forces and drives a radically relational onto-epistemological renewal. That is the premise of this book. On the one hand it seeks to clarify the various strata and stakes of this general-ecological transformation. Yet in the course of this, it becomes, on the other hand, a matter of uncovering the possible contributions of the ecological transformation to the imaginary of our age, in particular those arising from the possible entanglement of this transformation with the cybernetic paradigms of regulation and control, within which looms something like the genesis of a non-modern rationality; and indeed ultimately the proximity of this transformation to—if not its

total derivation from—the technocapitalistic form of power, which at least runs through it, and may well have produced it in the first place.[11]

It is important to be clear on this point: semantic traditions change not only in accordance with "social development,"[12] as Niklas Luhmann emphasized in his comprehensive *Studien zu Gesellschaftsstruktur und Semantik*.[13] The emergence of a new historical semantics of ecologies is not only a reflection of society's shift towards "ecological communication"[14] as it undoubtedly takes place, Luhmann would probably have argued, in the age of the Anthropocene and with regard to the various ecological crises. Nor does ecology turn out to be merely the "absolute metaphor"[15] employed by our ecologically endangered society to name what it cannot fathom, represent, or experience; a metaphor around which our whole society might revolve, as it were—one that would reorganize our knowledge and our discourses ecologically.

Even if such interpretations, which suppose some kind of great ecological unconscious on the part of the epistemes, may seem commonsensical, they all adhere to the traditional meaning of ecology. The semantic shift at issue here, however, goes much deeper. At the very latest since Friedrich Kittler gave the question of media and technics a quasi-transcendental turn,[16] we have known that at each stage, the dominant technical-medial condition sediments, not to say is reflected—however much it may be refracted—in semantic traditions. In the end, I think, what is at issue here is the culture of sense that depends on—that is given, at least partially, in—media-technological strata. This culture is integrated into specific historical-semantic sedimentations, where it produces its particularities and finds its anchor, but where it also finds its idiosyncrasies and fixations. Historical semantics, in other words, are the expression of media-cultural, indeed, ultimately sense-cultural facts.[17] The dissemination of the concept of ecology primarily reveals—according to the thesis defended here—a shift in the culture of sense provoked by the entry into the technological condition, the shift from signifying to technoecological sense.[18] This shift, for its part—and here its deep ambivalence apparent—is traversed by power: it appears simultaneously with a new apparatus of capture which ultimately becomes manifest exactly in this movement of ecologization at the level of thought and the production of theory. This is a question of the apparatus of capture of Environmentality.[19]

The technological evolution that drives this fundamental re-ecologization of thinking and of theory as well as the readjustment of the apparatus of capture, unfolds, roughly speaking, along an axis of machine history, a line we can today decipher as the history of control, which still directly dominates the becoming of the concept of ecology. It has developed, more precisely, since the end of the nineteenth century and especially since 1950 in an ongoing process of cyberneticization, in an environmental culture of control that is radically distributed and distributive, manifest in computers migrating into the environment, in algorithmic and sensorial

environments.[20] As we will see below, this environmental culture of control undoubtedly constitutes the apex of the cybernetic imaginary of our time, the pervasive triumph of the cybernetic hypothesis of universal controllability and a corresponding ideal of regulation. It entangles us in a new technology of power that has begun to operate in a specific, ecological way and has, in any case, environmentalized itself (to follow Foucault and Massumi).[21] In this process, media-technological "infrastructures of distribution"[22] render environmental even what used to be called *Umwelt* or "environment." Thus Environmentality, which is first implemented by media technology, is the contemporary form of governmentality.[23]

At the same time, however, the neoecological determination of capacities and modes of subjectification that are offered—indeed, made possible and conceivable—by Environmentalization, takes us beyond this neocybernetic power. The technoecology of sense, as I call the formation of the culture of sense that is newly emerging in this opposition, is the central yet hardly understood event in contemporary history, more precisely in the history of sense, an event that signals a possible opening of neocybernetic power. What is at stake in elucidating the technoecology of sense is not only insight into the core of what fascinates the contemporary politics of concepts and theory. It also concerns the becoming of the project of critique in general. General ecology, as I call it, stands for the critical analysis and affirmation of this environmental turn and thereby marks the key content of a neocritical project that is no longer negativistic but characterized by a non-affirmative affirmation.[24]

Bringing back the incessantly dismissed concept of sense, carefully taking it up once more, is a programmatic move. The insistence of sense—albeit in a new guise, as we will see, sense no longer in the sense of meaning, signification, and the signifier, but an asignificative sense of sense, as developed, in particular, by Félix Guattari in his non-linguistic semiotics of collective assemblages of enunciation[25]—resolutely opposes the perfect nihilism of technological or cybernetic capitalism, in whose immediate proximity thrived, as we observe today, the various dismissals of sense and the very successful anti-hermeneutic operations of the second half of the twentieth century. What counts instead, from the point of view of a general ecology, is precisely to pass through the radical Nothing of technology, to question anew the relation between technics and sense, and to reassess this difference for the age of the technological condition.[26] I will return to this point.

If the semantic shift towards ecology does indeed, as I think it does, mark a significant change in the contemporary politics of concepts and theory, then it is important to note that alongside the crucial dimension of control, as discussed above, there is a further dimension to ecology that concerns the history of rationality. Let us go back to Luhmann once more, since he has much to offer in terms of observing this trajectory. The systems-theoretical difference between system and environment is virtually paradigmatic for the early stages of the neo-ecological awakening—and the form of rationality to

which it gives rise is itself an effect of this turn. Because it is "the ecological difference" as such, Luhmann writes, it opens up "the theoretical structure of the ecological question" and brings out "a radical change of view of the world," a "radical break with tradition";[27] in other words, a dimension that fundamentally belongs to the history of rationality. After the functional rationalization of modernity that had its condition in the printing press, Luhmann observed the advent of a new, ecological form of rationality. In Luhmann, sociological systems theory, even systems theory as such, which has always taken this precise difference between system and environment as its guide and conceptual default position and which is itself undoubtedly an offspring of cyberneticization and the history of control, goes about its business as an expression of "ecological rationality,"[28] a rationality thus endowed with definite form and made into one of its central programs. Systems theory even turns out, I would suggest, to be the first condensation of a form of rationality that has turned or is becoming ecological. In the very foundation of its conceptual and theoretical architecture, we might say, systems theory testifies above all to the general process of ecologization, a process to which it is itself subject, and which will finally exceed it; it testifies, put differently, to the transition from a modernist to a specifically non-modern ecological rationality that resolutely contravenes modernist rationality's insufficiencies, simplifications, and distortions. Once again and most persuasively, this confirms not only that "in relation to the society that employs it, a stock of ideas cannot arbitrarily be varied";[29] it also reveals, suddenly and for the first time, the entire scope of the historical movement that is at issue here. What Luhmann discovers, at least intuitively, and what throughout his oeuvre never ceases manically to spell itself out is, precisely, the core of the movement of our age: the birth of an ecological rationality and the transition to the age of ecology it operates. Whatever else it may be, systems theory is thus above all a symptom of the onto-epistemological movement of ecologization we are interested in here, an expression of the history of rationality itself. What ultimately appears in systems theory is what Dirk Baecker calls "the ecological principle."[30] And that is what counts. When Latour later sees in the opposition of modernizing and ecologizing the decisive opposition of our time, he merely reiterates the caesura in the history of rationality which Luhmann had already attested.[31]

Specifically ecological rationality is characterized by its radical revaluation of relationality. It places a premium on relations and leads to an essentially non-philosophical politics of relation. This is evident already in the dominance of concepts of relation in neo-ecological thought.[32] A focus on relationality, talk of the dawn of an age of relational thinking and of a relational culture of knowledge can be found throughout the twentieth century and has left its trace in the very foundation of its philosophical self-conception. From the beginning—since Cassirer, Whitehead, and Bachelard—it has been a question of relational epistemology, ontology, and cosmology.[33] But from today's perspective, the intensification and

establishment of the great relational switch did not take place until *after* the important elaborations of the beginning of the century. Following a longer period of latency, the transition from the paradigm of "being individual" to that of "being relational" discussed by Didier Debaise[34] began to differentiate itself ecologically. Now that, following Félix Guattari, the process of ecologization has begun to take in all the apparatuses of expression of our age, and as the new ecological paradigm has come to dominate the powers of thinking philosophically, knowing scientifically, acting politically, as well as, finally, the aesthetic power of feeling, it is no longer the site where the other of rationality or of the mind crystallizes. Even if the anti-modernism associated with a certain notion of the ecological has long held this to be the case, what is emerging here, on the contrary, is a form of rationality that rejects the previous forms as too restricted and begins to take the real's excessive wealth of relations into account.[35] Ecologization comprehends the reconceptualization of modes of existence, faculties, and forms of life in terms of relations. According to Latour, modernity means "to lose the experience of relations,"[36] to reduce the multitude of relations to a few essential relations that are moreover said to be secondary, whereas he urges, precisely in the name of ecology, a new ontological realism of relations. For Latour's relational enthusiasm, relationalism is always already non-modern. Today we have poststructuralist anthropologists' elaborations of a "relational perspective" (Tim Ingold), a "relational stance" (Alf Hornborg), a thinking of "partial connections" (Marilyn Strathern), or a perspectivist "universe that is 100 percent relational," as Viveiros de Castro has it:

> Our traditional problem in the West is how to connect and universalize: individual substances are given, while relations have to be made. The Amerindian problem is how to separate and particularize: relations are given, while substances must be defined.[37]

This, precisely, is the break in the history of rationality at issue here: ultimately, and this to me seems to be the apex of the transformation, ecologization gives rise to a new, ecological image of thought that assigns a fundamentally different value to the question of relation. Far from being simply a question, as Latour recently formulated it, of there being more or less relations to be considered, it radically reconceptualizes and transvalues relationality as such. In contrast to the enduring heritage of scholasticism, it does not turn relations into minor and derivative entities but considers them to be originary, and precisely as such to represent the central moment of a new sense. In so doing, it institutes a non-philosophical politics of relation: general ecology is a non-philosophical rethinking of relation.[38]

Yet one has to take care not to lapse into a political romanticization of relation, as so many contemporary invocations of relationality do. Even this general-ecological relationism is still inscribed, to a certain extent, within

the history of control and the corresponding rationality of power. Its point of departure, in any case, lies in a highly problematic space and should in no way be mystified politico-romantically, nor should it be mistaken for the merely emancipatory content of a new scientific spirit. For today, we find ourselves at a very specific point in the history of relationality that brings out the question and the problem of relationality much more radically than ever before: relational technologies and an algorithmic governmentality reduce, regulate, control, even capitalize relations to an enormous extent, and precisely in so doing, become essential to the form of power of Environmentality. Nigel Thrift very appropriately speaks of an "augmented relationality"[39] that makes this exploitation of relations possible. There is, in other words, a neoliberal-capitalist destruction of the relation [*Bezug*], a reduction of relations to calculable, rationalizable, exploitable ratios, in the form forcefully wielded by the mathematics of power. The general ecology of the relation [*Bezug*], and the non-philosophical politics of relations it promotes, are diametrically opposed to this mathematics of relations. Mathematics is unaware of the intensity and originary status of the relation as that which establishes the terms of a relation in the first place. It is unaware of becoming as a "movement that deterritorializes the two terms of the relation it creates, by extracting them from the relations defining them in order to link them via a new 'partical connection,'"[40] as Viveiros de Castro puts it. It only knows of extensive vectored relations between pre-given terms, terms that always precede the relation, terms that are, but do not become. The "dominance of the mathematical"[41] reterritorializes relations whereas the counter-knowledge of recent anthropological work in particular deterritorializes relations and drives the elaboration of a real relational ecologism.[42]

To give an even more precise description of the main features of control in the history of general ecologization: the new semantics of ecology reflects the cybernetic state of nature already diagnosed by Serge Moscovici.[43] After the organic, followed by the mechanic state of nature, the cybernetic state of nature rearranges "the relationships [*rapports*] between human forces and nonhuman forces" by the paradigm of control and information. An alert observer of the technological condition in the 1960s, Moscovici's reworking of the difference between technics and nature juxtaposes the common conception of a transformation of the natural world into a technical world—which, like many phantasmal figures of thought, has had a long life and continues to organize innumerable areas of philosophical politics and political ecologies to this day—with the evolution of the natural world as such.[44] This point of view not only opens up the perspective to take into account a plurality of states of nature; it also reveals every state of nature to be historically specified by a contemporaneous basic technicity. The development of the culture of control over the last one hundred years or so has differentiated the cybernetic state of nature; from microphysical areas via the spheres of the living to human societies, all are subordinated to the imperative of control. Today is the "Now of Knowability" (Walter

Benjamin) of this development, of which we are able to distinguish three major phases. Quickly sketched: the first phase includes the "control revolution"[45] around 1900 and the expansion of the control paradigm by first-order cybernetics immediately following World War II. James Beniger has provided a magisterial reconstruction of this first phase of the history of control, which equates rationalization with increased control. Faced with the "crisis of control" of advanced industrialization triggered by the proliferation of flows of commodities, energy, money, and desires, control and planning are not just logistic problems; they are problems that characterize an age. According to Beniger, the implementation of the cybernetic hypothesis as the metaphysical principle of universal regulation, the very emblem of a logic of the *Ge-stell* in which "life itself implies control"[46] and becomes a control problem, is based on this great crisis of distribution.[47] In its wake, history itself ultimately appears to be but a history of control. In conjunction with the concurrent emergence of an entire arsenal of technical media that, as Kittler already noted, marks the beginning of our present, "nothing less ... than a revolution in societal control" takes place.[48] The concepts "control," "information processing," and, finally, "communication" far exceed the horizon of engineering, and become the dominant conceptual triad. In this first phase of the history of control, to be precise, the main problem was adaptation (particularly the question of "adaptive behavior"); its characteristic and to this day iconic idea is the control circuit, the feedback loop. The second phase, implemented by second-order cybernetics (including Luhmann's thinking in systems) starting in the late 1960s / early 1970s, makes questions of manipulative behavior its priority. Learning is now the main problem; concretely, it deals with auto-control and autopoiesis. On the whole, both cybernetics have a trivial or trivializing conception of the environment as environment of a system. Yet the second cybernetics already begins to develop a more ecological mode of thinking. It even involves some first efforts to extend and transgress the sense and scope of the ecological, and attracts attention to the problem of the environment—despite its demands for the reduction of complexity or necessary trivializations of the environment. Starting around 2000, the third phase, finally, marks the neocybernetic facts of our present, which generally ought to be described in terms of an explosion of environmental agency.[49] This phase witnesses the emergence of an environmental culture of control that, thanks to the radical environmental distribution of agency by environmental media technologies, ranging from sensorial to algorithmic environments, from bio- to nano- and geotechnologies, renders environmentality visible and prioritizes it like never before. It thus ends the longstanding forgetting and denial of the environment and, moreover, raises it to the status of a new universal principle. This phase is the first to be genuinely environmental. In other words, it is only with this phase that environmentality in the widest sense becomes problematic and takes the form of a new problematics of

Environmentality as our mode of governmentality; its main problem is the capture and the control, the management, the modulation of behavior, of affects, of relations, of intensities, and of forces by means of environmental (media) technologies whose scope ultimately borders on the cosmic.[50] The "established powers"[51] Deleuze and Guattari speak of are increasingly organized eco-, even cosmo-technologically. All these phenomena and the diagram of power have now become objects of ecology—and indeed the whole contemporary apparatus of capture that begins to appear here can only be grasped in ecological terms. This is a result of the history of control, in whose third, environmental phase the cybernetic state of nature today fully comes into its own. Cyberneticization crystallizes as Environmentalization. Media, for their part, are cyberneticized and ecologized to the extent that they sustain this movement; they are no longer media of communication but turn into "machines of capture of the unsayable and unrepresentable."[52] This must be our point of departure if we seek to understand the penetrating power of ecological semantics (although its significance is by no means exhausted by its being inscribed by the history of power), a semantics that in the end—a point that bears repeating—serves to operate a fundamental critique of this movement of Environmentalization at the level of ontological and epistemological theorizing (at least in the conceptually most far-reaching and brightest moments of such theorizing).

Finally, and this is the last stratum of the historical-semantic transformation I want to outline in this first section, we have to conceive of the dissemination of the ecological, in the course of which the restricted ecology of nature transmutes into a technoecology, as a consequence of the genesis of the so-called "technological paradigm," to take up the name the geologist Peter Haff has given to the apex of the history of control. The "technosphere" this new paradigm allows us to describe supplements the previous paradigms of geological history, from the lithosphere via the atmosphere and hydrosphere to the biosphere. It appears as the most radical and comprehensive form of cybernetics, as what is likely to be the most far-reaching effect of the control revolution, as a metacybernetics that renders technology autonomous and the earth as a whole cybernetic.[53] In this transformation, technology, inversely, mutates into a geological phenomenon and thereby inaugurates a new stage of geological evolution: let's call it technogeology. This also signifies a new stage in the evolution of technicity.[54] The collaboration of all spheres might well be the most precise instance to date of what Moscovici called the cybernetic state of nature to come.

"The technosphere," Haff writes, "represents a new stage in the geologic evolution of the Earth."[55] The "technosphere" under discussion here is more than a totalization of a technical culture of objects. It is an entire formation and a global cooperation of natural and non-natural, human and nonhuman actors and forces—from all kinds of flows of energy and communication, via processes of production, to bureaucracies, states, and

human beings—in which technology becomes an autonomous entity and matrix:

> The proliferation of technology across the globe defines the techno-sphere—the set of large-scale networked technologies that underlie and make possible rapid extraction from the Earth of large quantities of free energy and subsequent power generation, long-distance, nearly instanta-neous communication, rapid long-distance energy and mass transport, the existence and operation of modern governmental and other bureau-cracies, high-intensity industrial and manufacturing operations including regional, continental and global distribution of food and other goods, and a myriad additional "artifacts" or "non-natural" processes without which modern civilization and its present 7×10^9 human constituents could not exist ... Humans have become entrained within a matrix of technology and are now borne along by a supervening dynamics from which they cannot simultaneously escape and survive ... Technology penetrates to nearly every part of the globe through a web of communi-cation and transportation.[56]

Gilbert Simondon, another great proponent of the rise of general ecology,[57] emphasizes that a mode of existence proper to technical objects cannot be posited without taking the associated technical milieu into account. Yet when he, like Canguilhem, seeks to conceive of them no longer mechanically but organically, as expressions of life, we may conclude that technology in the technosphere becomes the milieu of milieux, a kind of meta- or hypermilieu. Seen this way, the technosphere even appears, in an extension of Simondon's schema, after the elements (tools), individuals (simple, unattached machines), and the ensembles or nets (open machines), as the location of technicity.[58] Whereas, to return to Haff, their fixation on instruments or rather instrumentality made it seem perfectly obvious to human beings, all the way into the twentieth century, that the emerging technosphere was to be viewed from the inside, to be understood as a human matter, as their invention and their product, and above all as something subject to purposes, there is nothing so compelling as the consolidation of the technosphere in terms of requiring us to assume a radically critical and anti-teleological position on anthropocentrism. According to Haff, it is precisely technology that urges us to change perspectives completely, to observe from the outside, from the outside of technology:

> The technosphere is not "just" a human-created phenomenon, because, except for simple artefacts like stone tools, humans did not create technology independently, but only in the context of existing techno-logical systems. From the outside, that is, from its own vantage point, notwithstanding that its human parts are essential, technology appears

to have bootstrapped itself into its present state. This is the same process that characterizes all emergent complex systems vis-à-vis their small-scale components; that is, large-scale dynamics appears spontaneously … and define[s] an environment within which small system components must operate.[59]

At least perspectivally, the technosphere in this way even pushes beyond the long-enduring fascination with control and the cybernetic hypothesis whose manifestation it enables. This is the point at which every vision of control, which is, strictly speaking, also inherent to the entire systems-theoretical and complexity-theoretical conceptualization of the technosphere Haff himself develops, must come to an end. "The technosphere is not a giant version of a navy ship," Haff writes, alluding to the nautical and teleological background of cybernetic thought. This thought, in his view, is "purposefully designed according to engineering specifications to suppress as many undesirable degrees of freedom as humans can think of, and in the process to provide the captain with specified lines of control."[60] In contrast, the technosphere reveals the absolute beyond all purpose; it is the very emblem and, ultimately, the geological manifestation of a fundamental purposelessness and truncated teleology: "The technosphere resembles the biosphere—complex and leaderless."[61] The historical undoing of Western teleology mentioned at the beginning of this introduction, which underpins the shift in the meaning of the ecological towards a plural technoecology, results from the autonomization of the technical as it unfolded in the genesis of the technosphere and the enforcement of a technogeological paradigm of the earth. Likewise, the incantation of the unforeseeable, the uncontrollable, the ungovernable, which are deposited within the concept in Haff and have appeared ceaselessly in various other places since Heidegger and then Serres, unquestionably correspond to the contemporary rationality of power, equally characterized by the history of control. The very acknowledgment, if not the celebration of the autonomy of the technical, possibly culminating in its being assigned a unique mode of existence, may ultimately be the outcome of this form of rationality.[62]

The explosion of agencies—and nowhere is this seen more clearly than in the technosphere—disenchants what I call the Anthropocene illusion, which has assigned a fantastic monopoly on agency to human beings. The concept "Anthropocene illusion" names the central historical momentum that unsettles this phantasm: the extent to which the human being qua technics turns out to be the central agent of a new era in natural history, eventually baptized "Anthropocene," is also the extent of a proliferation and even explosion of environmental agencies [umweltlicher Handlungs- und Wirkmächte] that ends up relegating the human being as agent and demonstrates the illusionary character of what lies behind the human technological achievement, namely, the illusionary character of the monopoly on agency in general, and of the privileging of human agency in

particular. In contrast, it also discovers the irreducible variety of all possible nonhuman agents, a variety that had until now been forgotten where it was not outright denied, at least by European modernity and its conceptualization of rationality (in which relations hardly figure and are minoritized). At the intersection of the histories of control, rationality, and relationality, technoecology turns out to be the radical consequence of the collapse of the Anthropocene illusion, a consequence provoked by the entry of the technosphere onto the level of thinking and of theory. Instead of "Anthropocene" we should say "Technocene."[63] This is what the new historical semantics of ecology finally brings out.

Technhoecological sense (after Félix Guattari)

Sense too, sense especially, is subject to historicity. The difference between sense and technics, the historical transformation of its heretofore dominant aspect and thus the changes in its internal economy are central for understanding where we are today in the history of sense. In the first half of the twentieth century, Husserl warned against the dangerous shifting of sense provoked by increasing technicization and mathematization. He considered the threat and horizon of the crisis of Western science to consist in a total loss of sense, a scientifically / technically induced crisis and destruction of sense. His warning expresses a traditional philosophical politics of sense, which, in turn, belongs to a very specific formation in the history of sense that cannot be characterized solely by the opposition of sense and technics consistently instantiated by philosophical politics.[64] What is decisive, rather, is that one side of the difference is subjected to the other: technics is always subjected to sense and above all to the sense-giving subject; inversely, every shift of emphasis toward technics in the end always threatens a collapse of sense. Despite his increasing attention and sensitivity to the cultural-technical constitution of the transcendental subject, which is first of all a reading and a writing subject, to the constitution of the ego from the spirit of alphabetical writing, Husserl still operated from a moribund formation of sense that conceived of itself as counter-technical and could not but deny the technicity and mediality that are nonetheless undeniably inherent to it.[65]

Since then, this philosophical politics of sense, which Deleuze so convincingly depicted as the corollary of a dogmatic image of thought beholden to representation,[66] has increasingly lost its persuasive force. The valence expressed in the difference between sense and technics and in the subjugation of technics to sense, the valence that organized a philosophical politics of sense fixated on representation and signification, has lost its epochal self-evidence. But not because we have entered some kind of no-holds-barred nihilism of technicization that would once and for all ruin this difference as such. Instead we have, as a result of the general

cyberneticization of modes of existence and of faculties, transitioned to a different configuration in the history of sense, which in turn is characterized by a surprising revaluation of the difference between sense and technics. This revaluation runs parallel to the revaluation just described of the difference between nature and technics, which it supplements and to which it is essentially linked. It is in precisely this intrinsic link, in this twofold fact of difference politics, that the technological condition comes to the fore.

Perhaps no one is as clear on this revaluation as Jean-Luc Nancy, who writes:

> To "inhabit" technology, or to "welcome" it, would be nothing other than inhabiting and welcoming the finitude of sense ... Rather, it is a matter of getting at the *sense* of "technology" as the *sense* of existence ... The "reign of technology" disassembles and disorients the infinite feedback of a Sense.[67]

Sentences like these are almost paradigmatic indicators of the switch at issue here, which cancels out all prior philosophical politics of sense. Against the traditional notion of the infinity of sense, it is now technology itself that appears as the bearer of radical purposelessness and of a finitude of sense. Even teleological rationality, which had classically positioned technology as a means to an end, is historically dispensed with. These sentences thus have nothing of an emphatic rejection of sense about them, nothing of the short-sighted anti-hermeneutic daydreams about the end of all sense current in the second half of the twentieth century in particular. They organize practically all of Nancy's oeuvre and the revaluation of sense it operates, the revaluation that moves from sense in the sense of meaning, of referential sense, to a different sense of sense, a sense after the primacy of endowing with sense, a sense no longer to be given, no longer lost and to be restored, no longer sedimented and no longer to be discovered. The caesura this marks in the history of sense is tremendous: where we once found the anti-technical bulwark of sense we now all of a sudden see the technicity and mediality of sense.[68]

The switch in the philosophical politics of sense that takes place between Husserl and Nancy, ultimately even the transition from a philosophical to a non-philosophical politics of sense that is at least announcing itself here, marks the emergence of technoecological sense, as I would like to call this new formation in the history of sense. In this formation, the sense of technics shifts—from technics to technology—and the sense of ecology shifts—from a restricted to a general ecology that might ultimately even be called non- or anecology. What the generalization of the concept of ecology and the emergence of ecology as our new historical semantics spell out is precisely the great challenge of the politics of concepts and theory in our time: the genesis of the technoecological culture of sense.

Yet this modifies the concept of sense as a whole. The cult of the sign and of meaning that characterizes the traditional culture of sense, most often supported by a non-technical, speaking, signifying subject of sense, against this background turns out to be an essentially pre-technological illusion. To think consistently after the culture of meaning requires renouncing once and for all the primordiality of language and the despotism of the signifier.[69] Félix Guattari has mounted this great challenge to the dominance of language, which attacks the core and the evidence of an entire formation of the culture of sense. (Today, this attack is carried on in the name of "affect.") He developed it practically in parallel with Nancy, even if this simultaneity—a strange simultaneity, given how different their approaches and conceptual politics are—has so far not been understood philosophically. That is why Guattari is, alongside Nancy, one of the central theorists of the caesura in the history of sense and of the technoecological culture of sense that emerges from it, all the more so since his work leads to an ecosophy, which has remained fragmentary. Guattari's difficult difference between signifying and non-signifying semiotics, which he was struggling to develop from the late 1970s onward, if not before, and which probably constitutes the core of his reformulation of the critical project, may count at the very least as a heuristic, a guiding difference for the redescription of the culture of sense made necessary by the technoecological condition. It is wrested directly from the change in the culture of sense and serves to schematize and discover our current position in the history of power and rationality. And finally, it also gives a political-economic turn to the techno-logical condition—which is not the least of the reasons for the importance of Guattari's schema to our reading here.

While this difference between signifying and non-signifying semiotics arises from Guattari's initial focus on the question of a new machinic, meaning first of all non-linguistic, model of the unconscious (itself undoubtedly a reaction to the implementation of the technological condition and the genesis of a technological unconscious),[70] it comes to support the transversal and heterogenetic reconstellation of subjectivity in which Guattari's project culminates. This difference decenters the subject of the culture of meaning from a very precise historical perspective: it forms the basis for conceptualizing post-signifying "machines of subjectivation"[71] whose constitution was very much boosted by the development of media technologies. This is where Guattari saw the main question, the core problem but also the emancipatory potential of the technoecologically transformed present. It is the key even to what he explicitly calls his "generalized ecology" or "ecosophy."[72] Generalized ecology—and this, precisely, is what its work of generalization consists in—brings together, in an ethical and aesthetical way, the three major ecological domains Guattari outlines, environment, social relations, and human subjectivity, and thereby takes into account the genesis of a new type of rationality, namely what he calls "eco-logic."

Maurizio Lazzarato has recently given a detailed exposition of this central difference in Guattari's thought, which rearranges the relationship between technics and sense in the technological condition. He demonstrates just how valuable it is for diagnosing the contemporary situation. We no longer live in a "'logocentric' world," he writes in his brilliant study, but in a "'machine-centric' world"[73] that configures the functions of language in an entirely new way and even fundamentally reconfigures the very site of language.[74] "We are faced with an immense machinic phylum," he continues, "that in one way or another affects us and forces us beyond logocentrism."[75] This is a crucial and incisive point. One could say that Guattari's entire program arises from this machinocentric turn. Already several years before the heyday of the history of control in the first years of the twenty-first century, Guattari's program draws its conclusions with great foresight and represents the first figure of this new world:

> In the machine-centric universe, one moves from the question of the subject to that of subjectivity such that enunciation does not primarily refer to speakers and listeners—the communicational version of individualism—but to "complex assemblages of individuals, bodies, materials and social machines, semiotic, mathematical, and scientific machines, etc., which are the true sources of enunciation." The sign machines of money, economics, science, technology, art and so on, function in parallel or independency because they produce or convey meaning and in this way bypass language, significations, and representation.[76]

In Lazzarato's persuasive interpretation, Guattari's elaboration of a "general semiotics," which, precisely, comprises not just signifying speech but aesthetic, scientific-technical, biological, and social semiotic machines as well—and which can, as I would like to emphasize from the outset, reveal its relevance fully only within the framework of a general ecology— is the semiotics of the machinocentric world. It no longer works within the "semiotic triangle: 'reference, signification, representation'"[77] that dominates under the logocentric conditions of the age of meaning and characterizes the signifying semiotics at issue here. It thus reacts to the enunciatory regime of the technological culture of sense—primarily based on non-linguistic, different, asignifying semiotics such as software and programming languages, algorithms, mathematical equations, diagrams, stock market indices, etc.—and ceases to subject it to linguistic universals and human language.[78] Elsewhere, Guattari describes the move out of the house of language, which is prompted, even implemented by the total cyberneticization of forms of life and modes of existence, as the implementation of the new aesthetic paradigm (aesthetic because it appeals primarily to affects and is no longer linguistic) that in turn, as we saw above, is subject to an Environmentality now operating affectively.[79] We might say that this move practically forces the development of the kind of "semiotic theory

beyond human semiotics"[80] he finally sets out to elaborate. Guattari's efforts at developing a general semiotics no longer based on human language draw out the implications of the transition to the technological condition and the transformation in the history of sense it operates.

What is at issue here is not the diagnosis of a simple historical transition from signifying to asignifying semiotics that would reflect the switch from a logocentric to a machinocentric world. According to Guattari, there have in principle always been many modes of semiotization that integrate themselves into more or less complex assemblages of enunciation in which they variously crystallize subjectivity. This reveals them to be closely linked to modes of subjectivation and the modes of valuation these correspond to and thus, from my perspective, to be the operative key aspects of particular structural formations or types of a culture of sense. Yet there are, according to Guattari, historical changes in the configuration of various modes of semiotization vis-à-vis each other. More precisely—and this is the key insight of all of Guattari's theorizing—there is a becoming, an evolution of assemblages of enunciation that, in the second half of the twentieth century and largely thanks to the evolution of media technology, are on the verge of transitioning to a new formation of interlocking modes of semiotization, subjectivation, and valuation, modes for which Guattari himself began to provide an ecosophic model in the 1980s. Guattari's ecosophy is a perspectivation of this transition and one of the early interpretations of the technoecological culture of sense that was then only just emerging.

For Guattari, the becoming of assemblages of enunciation contains the very essence of historicity. Tasked with its description are "speculative maps" of subjectivity. Thus, according to his schema, in the first "territorialized assemblages of enunciation," precapitalist and archaic subjectivities were constituted by "diverse initiatory, social, rhetorical machines embedded in clan, religious, military, corporational, etc. institutions." Guattari conceives of them as "collective apparatuses of subjectification [*équipements collectifs de subjectivation*]."[81] In this labor of cartography, the archaic machinism appears as a foreboding, as it were, of the machinocentric world implemented by media technologies in the "age of planetary computerization."[82] Or, inversely, the entry of subjectivity into the machine, the genesis of a "machinic subjectivity of a new type"[83] that Guattari sees as instantiating itself thanks to recent media technologies in the machinized present, strangely repeats or imitates this archaic machinism. Animism and machinocentrism thus shed light each on each other, which makes rereadings of animistic systems relevant to an interpretation of today's technological condition. Between them lies the logocentric world that delimits the variety of modes of semiotization, and this world, according to Guattari, is above all the world of modernity's reterritorialized capitalist subjectivity (which is based on the age of proto-capitalist European Christianity).[84]

Essential to a precise understanding of Guattari's work on the caesura in the history of sense and crucial for an appreciation of its great diagnostic

potential is the fact that it takes place from within the spirit of a critique of capitalism that Guattari gives a semiotic turn and places in the perspective of the history of control. The radical reconceptualization of political economy thus enacted reflects the new conditions. And ultimately, this is its decisive contribution to outlining a general ecology. For Guattari, capital is a "semiotic operator at the service of specific social formations"[85] to implement control. The extent to which capitalism, in the course of its long genesis, breaks into territorialized assemblages of enunciation and deterritorializes them is the extent to which it ultimately subjects them to the general equivalent as the emblem and apex of the regime of signification.[86] This is the central operation that makes capitalism an autonomous formation and, according to Guattari, it pushes back all asignifying semiotics—until their return, with regained strength, in the machinic couplings of human and nonhuman forces in cybernetic capitalism today.[87] While it may be true, Guattari writes, that most archaic societies featured specific semiotic systems for capitalizing power—from prestige capital to the capital power embodied magically, individually, in clans or ethnic groups—a general mode of semiotization organized around the principle of general equivalence becomes autonomous only in the capitalist mode of production.[88] Guattari thus not only designates capitalism as a major agent of the age of meaning, he also suggests a fundamental redefinition of the concept of capital as a "general mode of capitalization of the semiosis of power"[89]—a definition that, as we will see shortly, already announces the crisis of the age of meaning. Hence capitalism appears as "a power operation before it [appears as] a profit operation,"[90] and in that sense, it primarily appears as a problem of control: "capitalism aims above all at controlling *the whole of society*."[91] This reading from the 1970s, that is to say, from the time of the genesis of cybernetic capitalism, is crucial to understanding this new formation. In Guattari's analysis, the capitalist machinery, thanks to miniaturized machinic techniques (but also far exceeding these), grafts itself onto the "basic functioning of the perceptive, sensorial, affective, cognitive, linguistic, etc. behaviors."[92] For Guattari, this is evidence of nothing less than a certain "'machinic direction' of history." He writes: "The *machinic phylum* inhabits and orients the *historical rhizome* of capitalism but without ever mastering its fate, which continues to be played out equally with social segmentarity and the evolution of economic modes of valorization."[93]

Enabled by its alliance with cybernetic media technologies to explicitly turn its back on the fixation on signifying semiotics (and above all human language), capitalism has greatly contributed to undermining the great ciphers of the age of meaning and once again proven its deterritorializing force.[94] Yet what about the future of the principle of general equivalence itself? Under the technological condition, is everything ultimately to be brought back once more to general equivalence, the core moment so far of capital semiotization? Is it, in spite of the richness of semiotic components, general translatability of all local modes of semiotization that will win the

day? In other words, do the possible technoecological futures end up being colonized once more by the familiar means of the logocentric world, which is grafted onto the machinocentric world? Or are there other lines of flight? That, to my mind, is the critical question of Guattari's analysis.[95]

At first sight, Guattari's forceful insistence on a semiotics, even if it is a general one geared toward rehabilitating non-signifying semiotics, might still be regarded as a survival of the age of meaning. But this is far from the case. Guattari radically reconceptualizes even the very concept of the sign in the terms of the technological condition. The key to this reconception is that signs are no longer seen primarily as representative but as *operative* entities. As Lazzarato has demonstrated, Guattari distinguishes the impotentialized signs of the semiologies of meaning, whose entire semiotic efficacy depends on their being processed by consciousness and on representation, from "power-signs" or "sign-points" that do not represent but act directly on the material fluxes.[96] "Signs 'work' things prior to representation. Signs and things combine with one another independently of the subjective 'hold' that the agents of individuated enunciation claim to have over them," Guattari writes. "With a-signifying semiotics, then, the relations of production and of reciprocal engenderment between the semiotic machine and material fluxes are radically reorganized."[97] In his *Anti-Oedipus* papers from the early 1970s, there are several longer entries on the question of "power-signs" such as: "Power capital = power signs *allied* to primitive territorial machines = power signs allied to despotic machines etc. (power signs of state monopoly capitalism, automation and computerization)."[98] The current constitution of power-signs might best be conceptualized in the terms of the digital milieus of the environmentally constituted contemporary apparatus of capture.

Guattari's interest in the regained strength of asignifying semiotics and in how they sidestep the general equivalent's signifying culture of sense, I would argue, is central for coming to grips with his ecosophic program and at the same time indicates the precise historical position of this endeavor. Ecosophy—a title he undoubtedly prefers to "ecology"[99]—is the name Guattari suggests for a fundamentally reformed way of ontological modeling on a par with the technologically shifted history of sense and, in any case, beyond the traditional schemata of the age of meaning. Down to its innermost modes of conceptualization, ecosophy is a direct (even if ultimately critical) result of the general process of cyberneticization that characterizes the twentieth century. It undertakes a process-oriented expansion of ecosystemic thinking, which in turn, viewed from the perspective of the history of knowledge and of media, may have been profoundly cybernetic and must be considered an integral moment in the rise of the ideal of control.[100] While the "ecosystemic approach of Fluxes" Guattari picks up on in *Chaosmosis* already "represents an indispensable awareness of the cybernetic interaction and feedback involved with living organisms and social structures," the ecosophic approach operates an extension by "establishing a transversalist bridge between the ensemble

of ontological strata which, each in their own way, are characterised by specific figures of chaosmosis."[101] These strata now range from "material and energetic Fluxes" via "the strata of organic life, of those of the Socius, of the mecanosphere" all the way to "the incorporeal Universes of music, of mathematical idealities, of Becomings of desire."[102] Modeling the ecosophic object includes the four ontological dimensions of fluxes, territories, universes, and machinic phyla. Against this background, being must be "conceived from a multicomponential and intensive perspective."[103] This is the ecosophic slogan that ultimately undermines every talk of Being as such and instead privileges the description of multiple modes of being and existence. Ecosophic mapping or metamodeling is a method for describing the various ontological strata and textures that only come into view in the technoecological culture of sense—that is, after the signifying culture of sense that, precisely, also included the search for the meaning of being and the general equivalent, "Being." "Being," Guattari writes, "becomes the ultimate object of a heterogenesis under the aegis of a new aesthetic paradigm."[104] To be more precise: the new ecological paradigm both goes beyond and, in the process, transforms the great ciphers of the age of meaning: Capital, the Signifier, Being. The ecosophical project—is at least if we accept that it is as such on a par with technoecological sense culture—is ontological and political at the same time. It is a radical political-ontological critique of what one might call the thinking of general equivalence—where the latter is understood as having been an integral part of the departed sense culture of meaning and having framed the hegemonic-dogmatic ontological (as well as epistemological) conceptualizations of occidental thought from the beginning—and yet one that still does not lie behind us, still insists in today's technoecological sense culture. It insists inasmuch as it dominates the manifold reterritorializations implemented by today's cybernetic capitalism. If cybernetic capitalism draws on asignifying modes of semiotization, but in the same breath also occupies the (media) technological deterritorializations of the age of meaning by bringing it ceaselessly back to the general equivalent, ecosophical practices in return have to experiment with other, therapeutic modes of de- and reterritorialization that protect us against contemporary capitalism's general-equivalent exploitation of all modes of semiotization and existence. This is ecosophy's general-ecological perspective.

Even in its general machinism, Guattari's ecosophical project—as foreshadowed in its generalized ecosystemic mode of thinking—is deeply marked conceptually by the process of cyberneticization. For only this process allows for the completely new conception of the machine beyond the "fascination with technology"[105] for which he never ceases to call. The new type of assemblage, the processual machinic assemblage, which paradigmatically supports this machinism with all its ontological and epistemological consequences, picks up explicitly on Varela's and Maturana's neocybernetic concept of autopoeisis, the concept of a self-producing and self-reproducing

machine understood as "the ensemble of interrelations and its compo-nents." Varela and Maturana, as Guattari notes, reserved this concept for living machines, conceiving of all others—from social systems to technical machines—in terms of "an *allopoiesis* in which the machine will search for its components outside of itself."[106] Guattari's general machinism, on which the conceptualization of his generalized ecology is based, opts for a combination of auto- and allopoiesis. In the late lecture "On Machines," delivered in November 1990 in Valence, this is made explicit:

> I would propose a reversal of this point of view, to the extent that the problem of technique would now only be a subsidiary part of a much wider machine problematic. Since the 'machine' is opened out towards its machinic environment and maintains all sorts of relationships with social constituents and individual subjectivities, the concept of technological machine should therefore be broadened to that of *machinic agencements*. This category encompasses everything that develops as a machine in its different registers and ontological supports. And here, rather than having an opposition between *being* and the machine or *being* and the subject, this new notion of the machine now involves *being* differentiating itself qualitatively and emerging onto an ontological plurality, which is the very extension of the creativity of machinic vectors. Rather than having a *being* as a common trait which would inhabit the whole of machinic, social, human and cosmic beings, we have, instead, a machine that develops *universes of reference*—ontological heterogeneous universes, which are marked by historic turning points, a factor of irreversibility and singularity.[107]

The machine's opening to the outside and to the machinic environment described here is one of Guattari's most far-reaching conceptual opera-tions. It appears not only as a direct inscription of the technoecological transformation in his ecosophical program, which renders the project so contemporary with ours. It also crystallizes the figure of a different kind of technicity that today we seek critically to define under the heading of general ecology.

Elements of general ecology

Together, the contributions in this volume disclose what, taking a cue from Gilles Deleuze, I would like to call the problematic of general ecology, that is, "the ensemble of the problem and its conditions."[108] Rather than provide an exhaustive description of the concept, they sketch general-ecological plateaus that remain to be elaborated and complemented in a collective effort.

Luciana Parisi's contribution marks the programmatic beginning of the collection. It describes the development of a new "ecological form of rationality" (75) that sustains the processes of ecologization and Environmentalization. At the same time, Parisi elaborates the speculative horizon of the critique of these processes, which appears as a possible new horizon of the critical project in the algorithmic age and can thus be understood to constitute an essential component of a general ecology. The paradigmatic site of the movement of ecologization she examines is the contemporary culture of design in architecture, which, as she already showed in her earlier work on the "computational turn" in the thinking of design, plays a central role in today's fundamentally transformed conception of computation.[109] The innovative and virulent force of her analysis lies in the discovery that the form of rationality as such has begun to *ecologize*. This is apparent in the profound physicalist reconception and naturalization of computation as such that takes place here: the deductive rationality of the axiomatic age, whose exception, limitation, and abyss was incomputability, has been replaced by an inductively constituted computing rationality that calculates with the indeterminate and the contingent and thereby fundamentally changes the status of the incomputable. This new rationality now follows the indeterminate potentialities, dynamics, and contingencies of physical, biological, and chemical behavior and their complex interactions. The computational qualities of nature itself are thus absorbed by the logic of computation; they are doubled, expanded, and renewed. Materiality and computation—this is the point of the development—seem always already to have been integrated. The logic of computation is thereby practically congruent with the intrinsic computation of materiality as such. After the demise of the predominance of formal logic and of a pure Symbolic, which had reigned since the late nineteenth century, computation now follows the movements of the material.[110] And materiality, in turn, is now seen to be computational through and through. The biophysical world already offers a model of computation, which is evident in swarm models. These latter, according to Parisi, merely demonstrate that "the temporal dynamics intrinsic in the biophysical environment of continuous interactions is the motor of computation" (81). Computation is thus no longer symbolic but simply material computation. Computation, in Parisi's succinct phrase, corresponds to an "eco-logical order of nature," where ecology means not merely "an (associationist) interaction of parts" but instead names "the capacities of an environment, defined in terms of a multiplicity of interlayered milieus or localities, to become generative of emergent forms and patterns" (83). This approach is as original as it is comprehensive in conceptualizing what "ecology" might mean within the framework of its general-ecological redefinition.

Yet computation's turn toward a new nature of material ecologies is also the problem to which general-ecological critique must respond. As Parisi shows, this development is, in the end, but a symptom of Environmentality, of the contemporary power formation that has only recently managed

to consolidate itself thanks to new media technologies. The becoming-environmental of computation thus also appears as a result of the becoming-environmental of power, which, according to Brian Massumi, characterizes technocapitalist naturalization in general. For if this power, under the conditions of Environmentality, is driven by its opening onto the unknown and the indeterminate, if it is interested in regulating effects, not in causality, and if it focuses on the temporal anticipation of potentialities (which is why Massumi calls this power's operative core "preemption"), then it is the occupation and colonialization of becoming thus taking place that now exposes itself as the new ecological form of rationality.[111] Ultimately, this form of rationality is the rationality of environmental power, as Parisi persuasively demonstrates. In contrast, she calls for a critical reconceptualization of computation that rejects precisely this kind of ecological rationality, which has been restrained by the history of power. The becoming-environmental of computation is to be thought as radically artificial, rejecting any attempt at biophysical naturalization (which only repeats the spirit of Environmentality). This kind of urgent refoundation of a critical theory of automatic reason can only be undertaken by a fundamentally speculative concept of reason marked by the spirit of a completely new conception of algorithmic processing.[112] Only against this background will algorithms come to be seen not merely as sets of commands processed within an environment (as they were in the axiomatic age) but as generic actions, as "an automated elaboration of data followed by an alien epistemological production" (92).

Frédéric Neyrat, too, addresses a problem that concerns ecological rationality: the excess of relation. This excess characterizes a now-dominant "ecological constructivism" that results from the theoretical-political struggle against the limitations imposed on relationality that has been waged since the nineteenth century. From the very beginning, ecology has been a knowledge of relations—a knowledge of the relations between living beings that posits relations themselves to be constitutive—and the sweeping ecologization of thinking can be conceived of as the emergence and implementation of relational ontologies, of ecologies of being-together, of attachments, of entanglements, of cooperation, and even of a new collectivism and communism of species and forces. In this process, interconnectivity, the connection of everything to everything else, has become the "principle of principles of ecology"[113] (101) that characterizes our now-ecological episteme. This historical-ontological background sheds light not only on a central dimension but also on a basic problem of the general movement of ecologization: in the immanence of the infinite web of relationships that has taken the place of a transcendentalized nature and with the total lack of gaps and spacing (*espacement*) that comes with this movement of immanentization, any capacity for discernment and any possibility of political decision-making has been lost and a technophile constructivism has come to dominate. By contrast, Neyrat, entirely

against the grain, brings separation and detachment into focus, namely as ecology's repressed. At its core, the "ecology of separation" he undertakes to outline is a critique of a relationalism that has become phantasmagoric, a relationalism that, in the wake of the resolution of modernity's "Great Divide,"[114] continues to suppress modernity's minoritarian element, the small separations.

In an earlier work, Neyrat conceptualized this relationalism that has become total in terms of "relational excesses"[115] and conceived of them simply as hypostasizing the technological condition, understood as characterized by "generalized interconnection." The antidote he suggested was an "ontology of the gap [*ontologie de l'écart*]"[116] such as we find for example in Nancy's "existential communism," according to which existence is possible only thanks to an inescapable outside that inheres in each and every being and precedes any reference.[117] This is where the programmatic principle of the ecology of separation Neyrat develops is taken up in this volume: "Every Relation is founded on a separation" (101). This criticism of the ecological fascination with relationality aims at a peculiar repositioning of nature and, in consequence, even at conceptualizing a new politics of nature that allows for bringing separation back into play. This neither substantializes nor sanctifies nature, nor does it reinstall nature as a transcendental principle. Instead, it is conceived of as a passage, as something we have to pass through again and again, as a strategic detour or corrective of thought necessary in the age of the Anthropocene. If our "exophobic epoch" (102), as Neyrat has it, has begun to shy away from all forms of negativity, distancing, and the outside, a renewed ecological theory and practice must reintroduce the gap into the bad immanence of the global technological system. This gap, which ecoconstructivism's celebration of interconnectivity had dismissed, is nature.

Neyrat's destruction goes straight to the heart of an entire phantasmagoric positioning of contemporary thought, the critique of which must generally be considered an eminent objective of a general ecology. Ultimately, the anti-constructivist ecology that takes shape here is simply the radical consequence of the inversion of the traditional relationship between nature and technics arising under the technological condition. In rethinking nature the way Neyrat suggests, as detour and separating mediation, nature takes on the role of interruptor. When nature was considered the epitome of the immediate, continual, and unmediated, this role had been reserved for technics, which in turn has now come to support a movement of immediatization: "In the era of generalized connections, of the Internet of Things or communication among machines ... geo-anthropogenic interconnections create a great, seamless tissue of 'immediations.' What if nature could appear henceforth as that which allows us to re-establish a gap within the global technological system?"; nature would then be understood as a means of "allowing us to measure the relations we produce and material limits belonging to these relations" (121). The point of reintroducing nature as

a detour is to establish a cosmotechnological perspective (an integral part of a general ecology) from which every technology appears as a cosmotechnological assemblage, that is, it produces a certain kind of world. This perspective demands that we distinguish between desired worlds and values, bring technology and the mechanisms it selects back to the world it produces, and vote, based on a politics of cooperative technologies, for or against introducing or employing it. In contrast, the current inability to separate autonomous and heteronomous, closed and open, cooperative and autistic technologies, eco-constructivism's shying away from making decisions, is symptomatic of a "unilateral taste for association, putting together, attachment" and indicates a "difficulty [with] accessing the dimension of separation, of division or opposition" (117).

Bernard Stiegler, too, is ultimately concerned with the cosmotechnological question. His chapter situates the general-ecological challenge, historically and with systematic precision, within the framework of his redescription of the technological condition. This redescription, begun under the heading of a "general organology" that takes up the work of Ernst Kapp, Jacques Lafitte, and, above all, Georges Canguilhem, is thus extended and specified by a cosmotechnological dimension. By general organology, Stiegler means the complex assemblage of three organological levels: the level of psychosomatic or endosomatic organs of the psychological individual that form a psychic system; the level of artifactual or exosomatic organs of the technical individual that form a technical system; and social organs, organizations, and institutions of all kinds that form a social system. The central task of general organology is to conceptualize the intertwined formation processes of psychical, technical, and social individuals. It describes their reciprocal processes of adaptation and dedaptation that produce concrete apparatuses of individuation operative for a given time. General organology, in other words, examines the relationships between organic organs, technical organs, and social organizations.[118] In *What Makes Life Worth Living*, Stiegler based this tripartite structure on the supposition of an essential "infidelity of the milieu,"[119] which determines Canguilhem's thinking of life as a whole. In this volume, he takes up this definition to serve as backdrop for clarifying the relationship between general organology and ecology. According to Canguilhem, life for the living being "is discussion or explanation (what Goldstein calls *Auseinandersetzung*) with an environment where there are leaks, holes, escapes and unexpected resistances," an engagement, precisely, with the infidelity of the milieu or environment that constitutes "its becoming, its history."[120] For Stiegler, technical life, in installing technical milieus, brings a whole new kind of infidelity into play. Life—and this is the point—is therefore no longer to be conceived of as organic life but as organological life. Organological life henceforth proceeds in jumps and draws on technological shocks that impose readjustments of the entire organological assemblage. It is always an "epokhal technological shock" (136) that interrupts a specific organological assemblage

and thereby demonstrates, time and again, the inescapable infidelity of the milieu. Decisively, these shocks constitute "a phase difference *that cannot be transindividuated*, that is, adopted, in the sense that it must be individuated both psychically and socially" (135). The technological shocks of infidelity that refuse psychological-collective transindividuation or adoption can only be dealt with by new conditions of fidelity that in turn can only be provided by a functioning organological assemblage. And it is they that force us to think and to continually reconstitute a certain reliability and fidelity of the milieu in the first place. This, we might say, is the organo-logical structure of care, to whose elaboration Stiegler has devoted so much attention in recent years. Mere technological becoming must first of all be converted into a (desirable) future. According to Stiegler, any understanding of being, whose historicity Heidegger pointed out, hinges on the epokhal technological shocks from which it receives its particular epokhality. And it is here, precisely, that Stiegler provides a first broad definition of general ecology: it examines the infidelities of the milieu "inasmuch as it inscribes in the cosmos the perspective of a general organology" (135). This is of fundamental importance: general ecology extends general organology on the cosmological level. General ecology, in other words, is the cosmological supplement of general organology, it superimposes, we might say, on the tripartite, organological structure the questions of the biological and of the geographical, and above all the question of cosmic systems and processes, which pervade processes of psychical, technical, and social individuation in previously unimaginable ways. It is a *general* ecology insofar as "this 'generality' is indicative of an attempt to respond to the generality (and to the planetary, and as such locally cosmic, globality) of the shock *we are given to think*" (136), and its generality perfectly corresponds to the gener-ality of general organology as well as that of general economy, as Stiegler explicitly points out.

In the end, the general-ecological extension of organology simply obeys the technological condition. Its systematic site as indicated by Stiegler only makes sense against the historical background of the thermodynamic machine. For only since then has the organological assemblage had the cosmological reach and perspective that has been debated in recent years under the heading "Anthropocene." That is why Stiegler, in the second stratum of his chapter, outlines the pharmacology of the thermodynamic machine. Stiegler conforms to the imaginary of the Anthropocene discourse, which betrays a certain fixation on the event of the Industrial Revolution and the age of combustion,[121] insofar as he considers the introduction of the thermodynamic machine, along with automatization, to be not only *the* event of modern technology and the *Ge-stell* in Heidegger's sense but even to be the trigger of a fundamental transformation of cosmology as such. Thanks to the thermodynamic machine, the question of entropy and negen-tropy at the beginning of the nineteenth century became the central problem of everyday human life, of life in general, and finally "of the universe as

a whole, which once again becomes the *kosmos* insofar as it invites, hosts and in some way houses the negentropic, that is, the living, including *noetic* life, which we therefore call the *neganthropo-logical*" (134). According to Stiegler, all thinking in terms of processes is in a sense only a consequence of the thermodynamic turn. Thus, while this cosmologic turn itself is implemented technologically, technics becomes a cosmic question thanks to this turn—and not earlier, even if the cosmic question of technics today goes far beyond any thermodynamic machinism and figures in far-reaching transformative inscriptions in the cosmos such as those implemented by nanophysics. At least in the epoch of technicity, in which we find ourselves since the emergence of thermodynamics, general organology itself, we might say, is thus inevitably always already a general ecology. Where Guattari spoke of a generalized ecology and the "three ecologies" of mind, society, and environment, Stiegler opts for a general-ecological revision of this structure in terms of three ecologies of mind, society, and technics that are traversed by cosmic processes.

Indeed, in the course of the general ecologization of thought, the cosmology of the moderns in particular has become problematic, to say the least. The movement of ecologization, as already suggested, is tied in with the history of the fascination with non-modernity that breaks out into the open here. But what exactly comes to the fore in this becoming-problematic of modern cosmology? Is there a contemporary experience of nature that contradicts the modern experience of nature and therefore compels us to undertake a far-reaching attempt at a reformulation that could be an essential moment of general ecology? What, in the first place, constitutes the modern experience of nature from which it would differ? By way of a reading of the famous phrase Alfred North Whitehead coined in his 1919 Tanner Lectures on *The Concept of Nature*, "the bifurcation of nature" (a term that names everything Whitehead's speculative project will ultimately oppose), Didier Debaise examines the origin of the modern conception of nature that, as Whitehead explains, assumes a division of nature into two heterogeneous modes of existence. While the dominant interpretations of Whitehead's phrase consider it merely to be a particularly succinct formulation of the criticism of Cartesian dualism that characterizes his oeuvre as a whole—a criticism above all of the dualism of bodies' primary and secondary qualities, and in their wake of dualisms of thought and extension, mind and body, reality and appearance in which the bifurcation is said to consist—Debaise, by contrast, shows how the concept of bifurcation names the process of differentiation as such, which precedes dualistic ontology. Far from employing "bifurcation" and "dualism" more or less synonymously, Debaise argues, bifurcation in Whitehead names the process that produces the various dualisms, which in turn constitute both the modern split experience of nature and the monisms that seek to overcome it, in the first place and anew, time and time again. On Debaise's reading, Whitehead calls bifurcation the very operation of division, an operation that he sees to

be incessantly operative thanks to the modern invention of nature. It is an operation that, and this is the point, transforms the immediate experience of nature, with which we always have to begin, into a specifically modern experience of nature in the first place. The modern invention of nature thus does not, as is often claimed, presuppose a specific ontological positing that it would then simply parse. Instead, it emerges from permanent "*local operations* of the qualification of bodies" (157), it presupposes "gestures, techniques, and operations of division" (157) that reformat immediate experience, which so to speak comes first.

The most important of these operations is the great modern abstraction that a given piece of matter can only occupy one space–time location. Debaise explicates the three premises of modern cosmology that result from the bifurcation. The ontology of the moderns, from this vantage point, turns out to be an explanation or rationalization of an operation of division permanently applied to immediate experience: "Starting with immediate experience, bifurcation operates by splitting such experience into two regimes of existence" (156), the regimes of real nature and of phenomenal nature and of everything that follows from them. It is thus no longer an ontological but an *operative* understanding of the modern conception of nature from which Whitehead's empiricist method ultimately derives—a method, Debaise tells us, concerned with a fundamental transfiguration of the experience of nature, with subrogating immediate experience once more. Finally, Debaise sketches Whitehead's "alternative thinking of nature." It conceives of nature as an event, more precisely as the "event of all events," as "evental mode of existence" that knows of only "a single plane of nature ... a single surface without dualism and without differentiation from the outset" (161). "The event takes the place of dualisms and separations," (165) as he also writes, and Whitehead's statement, "Nature is that which we observe in perception through the senses" (161), may serve as a neocosmological leitmotiv.

Against this background, we may now propose a more precise statement: while general ecology undoes the stitches that have held ecology and nature together, it does not imply a rejection or deletion of nature. One possible sense of speaking about non-natural ecology or ecology without nature lies in assuming an alternative thought of nature that is no longer based on the modern operation of division or its monistic overcoming. But can what Debaise calls "immediate experience" really serve as the starting point of such an alternative conceptualization? It would be necessary to insert an additional plateau that asks what "immediate experience of nature" could mean. For if the modern experience of nature, for its part, features media-technological reasons on which even its operation of division (i.e., all of the ontological-epistemological gestures of its instauration) is based—if, in other words, it relies on symbolic-technological mobilizations of various kinds, as Jason Moore insists in his work on the "Capitalocene"—what does this mean for the immediate experience brought to bear here? Is this

experience indeed unmediated and without cause? Or are there not precise media-technological reasons for the decay of the bifurcation of nature and for the resurgence of the immediate, so remarkable today in evocations of undivided perception and of affect? Such reasons would include, for example, twenty-first-century media technologies operating in the micro-temporal domain, what I have called the media and technology of the third cybernetics, which, precisely, drive Environmentalization. The possible presuppositions of the appeal to alternative cosmological conceptualizations must be examined, whereas leaving their technicity and mediality out of consideration usually indicates hidden fascinations.

Although general ecologization rests on a certain bracketing of nature, the question concerning the elementary-material foundations and problems of the contemporary technological condition is by no means settled. Quite the contrary. But it is now a matter of how this question, which is actually a very pressing question, can be taken up and reframed today, *after* nature. Where once we found nature—where nature once occupied, not to say obscured the question concerning the elementary and the material— we now find, almost as a counter-concept, the earth. How the earth is conceptualized in light of the general-ecological effort, or what a general-ecological conception of this earth might look like, thus takes on decisive importance.[122] Neyrat's cosmotechnological reflections are partly situated on this very challenging terrain, and Jussi Parikka, too, seeks to engage with a fundamentally important complex of problems whose concrete material details can be very unsettling indeed. Parikka's contribution puts a general ecology of twenty-first-century technological culture into perspective: it examines the "ecological materiality of technology" (169) in terms of a neomaterialist critique of media and technology. What is at stake in this endeavor is the discovery of a new "nomos of the earth" (Carl Schmitt) in which the political core moments of the present and the future might contract. The intention of the endeavor is the fundamental critique of the "anthrobscene,"[123] and Parikka's very fitting introduction of the obscene into the (overall rather dissembling) concept of the Anthropocene expresses an ethical qualification of the scientific-judicial-entrepreneurial-governmental exploitation complex on which contemporary digital media- and techno-culture in particular is based.[124]

Parikka takes up Lewis Mumford's astute emphasis on the essential significance of mining for the Industrial Revolution and the techno-capitalist evolution[125] and speaks of an "'underground turn' in modern technology" (170). Now, under the conditions of digital media technologies and despite never-ending invocations of these technologies' alleged immateriality, this evolution has reached a preliminary apex (today's computer chips contain more than sixty different chemical elements). It is only coherent, then, for Parikka to sketch a media *geology* of the anthrobscene: conceived of as a "media ecology of the non-organic" (177), it narrates the history and political economy of materials, metals, chemistry, and trash as the basis of

contemporary media technologies in particular, which he situates on the "continuum of the biological-technological-geological" (177). To this end, he takes Siegfried Zielinski's archaeological concept of the "deep time of the media" back to the original geological sense of deep time in order "to emphasize the materiality of media as part of Earth durations and Earth excavations" (170).[126]

A *political* geology of the media, as we might call it, that further amplifies the political-economic aspects of Parikka's geological take on media ecology, marks an essential moment of general ecology. It might take up, for example, the "law of Cheap Nature"[127] articulated in Jason Moore's critique of the Capitalocene. In his great investigation of the "capitalist world-ecology," Moore very succinctly shows that capitalism is centrally also a specific way of organizing nature. Capitalism is thus not only based on exploiting abstract social labor but also on appropriating abstract social nature, which necessarily supplements the accumulation of capital through commodified labor. In Moore's analysis, the value relationship that capitalism implements is a bundled relationship of human and extra-human natures. In his law of Cheap Nature, Moore distinguishes between "Four Cheaps," namely "food, labor-power, energy, and raw materials." He writes:

> Capital must not only ceaselessly accumulate and revolutionize commodity production, it must ceaselessly search for, and find ways to produce, Cheap Natures: a rising stream of low-cost food, labor-power, energy, and raw materials to the factory gates (or office doors or...). These are the Four Cheaps. The law of value in capitalism is a law of Cheap Nature.[128]

Qualitatively, Cheap Nature allows "technologies and new kinds of nature to transform extant structures of capital accumulation and world power."[129] Every great wave of accumulation comes with the discovery of a new kind of Cheap Nature. The appropriation of Cheap Nature is a creative act, as it were, based on broad symbolic-technological and scientific mobilizations, which Moore for his part describes in the case of the long sixteenth and the long nineteenth centuries. A political geology of media is a central component of an investigation—as yet lacking—into the current phase of capitalist world-ecology.

As I remarked at the very beginning of this introduction, the immunity paradigm problematically inscribes itself in ecological thought, which often moves in proximity to immunopolitical dogmatisms. All these forces seek to contain the unparalleled power of ecological thought to deterritorialize central elements of (at least) modernity's fundamental position. What stance does general ecology assume vis-à-vis these attempts at restriction? Is the basic immunopolitical operation—the ceaseless reiteration of the distinction between self and not-self and thus the execution of an ontology

of the self and a restricted economy of one's own—always a threat to general-ecological thought? And would this threat persist even if such thought took the form of an attempt at sublating the fatal dialectic of immunization into an affirmation of life as such that (phantasmatically) dedifferentiates the living, such as we find it in the affirmative biocentrism of a number of ecologisms?[130] To answer the question of the relationship between general ecology and the immunity paradigm, a question with important implications for the politics of theory, Bruce Clarke's contribution examines a very surprising scene in the history of knowledge: the conceptualization of planetary immunity in the Gaia discourse of the 1970s and 1980s demonstrates how general ecology in one of its primal scenes emerges precisely thanks to and as a radical deconstruction of the traditional immunity paradigm. General ecology is thus to be seen as a new way of thinking decisively influenced by neocybernetics, a thinking that *ecologizes* immunological thought as such. In so doing, it unhinges the core of the modern immunity paradigm, the old ontology of the self, and launches a fundamental revision of immunology by introducing the general ecological principle of symbiosis, which will end up rejecting the traditional immunity paradigm and produce an entirely different concept of immunity. Clarke thus succeeds in unearthing an archaeological key moment in the ecologization of thought, whose conceptual significance cannot be overstated.

More precisely, Clarke takes us right into the heart of the "systems counterculture" of the 1970s and 1980s, of which he is the preeminent archivist.[131] The journal *CoEvolution Quarterly,* along with *Whole Earth Catalog* which it succeeded, and William Irwin Thompson's Lindisfarne Association, which regularly brought together leading proponents of neocybernetics under the banner of a "Planetary Culture and the New Image of Man," are key sites both of the generalization of ecology and of the ecologization of thought, movements that can be traced directly from these sites to the present.[132] It is within this framework that the thoroughly cybernetic reconceptualization of the biosphere—fixated on control at first, autopoiesis later—takes place, thanks to the Gaia discourse of atmospheric chemist James Lovelock and biologist Lynn Margulis. This reconceptualization is to be a constitutive component of the new, no longer industrial but ecological way of thinking that Thompson sees emerging as the great challenge of the present. At the same time, it is in just this context that Franciso Varela and Mark Anspach undertake their revolutionary ecological reconceptualization of immunology. The previous military model of the immune system as a defense mechanism is to be abandoned in favor of a Gaia perspective: "Let us transpose the metaphor of immunobiology, and suggest that the body is like Earth, a textured environment for diverse and highly interactive populations of individuals."[133] Varela and Anspach rethink the immunological paradigm in the direction of what they call a "reenactment of Gaia inside the body," as "a microcosmic version of Gaia."[134] This is the core of their metaphorological operation. They do not

start with an already constituted biological individual constantly engaged in a defensive struggle but from coevolutionary somatic processes of individuation that take place in autonomous immuno-networks. Along with the clearly cybernetic framing of the Gaia discourse itself, their insistence, time and again, that immunological thought is tasked with repeating the shift in the cognitive sciences from (digital) computers to a distributive network perspective is yet another indication of the extent to which the ecologization of thought is prompted by the technological condition.

Yet the scene depicted by Clarke, which combines immunology and the Gaia discourse within the perspective of a planetary immunity as a central moment of general ecology, fully reveals its virulence in today's establishment of a radical symbiotic perspective, a process in which symbiosis moves from being a marginal to being an omnipresent phenomenon, and becomes, we might say with only slight exaggeration, one of the central general-ecological relations.[135] While the movement back from individuals to processes of individuation, which Varela and Anspach call for in a strange echo of Gilbert Simondon, probably already finds its most radical expression in Margulis's symbiogenesis theory, in which new forms of life emerge from the incorporation or colonization of one or more organisms into or by others,[136] it is not until today's science of symbiosis that the ecologization of both immunology and biology is completed, as Clarke persuasively shows. As we read in a key text of symbiotic thought by Gilbert, Sapp, and Tauber, quoted by Clarke: "All classical conceptions of individuality are called into question by evidence of all-pervading symbiosis."[137] Symbiosis here becomes an "ecological principle" that supports the general-ecological transformation. In the end, this important strand of general ecologization will even go beyond its neocybernetic inscriptions, as indicated by Clarke, and lead us to think not in terms of autopoiesis, but in terms of "sym-poiesis," as Donna Haraway has suggested.[138]

Cary Wolfe, too, addresses the possible immunopolitical implications of the ecological paradigm. The first part of his observations perspectivizes a general ecologization of the biopolitical paradigm in order to escape all forms of vitalism, which has dominated large swaths of the reciprocally contaminating biopolitical and ecological domains of thought. In the second part of his paper, Wolfe turns to bioart. For it is bioart, precisely, that, in the kind of self-observation of society that according to Niklas Luhmann is possible (only) through art and very much in keeping with the devitalizing ecologization of the biopolitical paradigm, renders visible the socially regulative and stabilizing contingencies with which society structures the question of "life."

Wolfe begins with a magisterial reconstruction of the two great strands of biopolitical thought still dominant today: on the one hand, thanatopolitical thought from Foucault to Derrida and Agamben, which is undoubtedly the most influential and the most intricate, but which ultimately cannot explain why a power that understands itself as precisely a power of life constantly

switches to a politics of death;[139] on the other, the thinking of an affirmative biopolitics that Roberto Esposito has developed as an objection to the thanatopolitical fixation on, not to say reduction of, the biopolitical question. While life itself must become the subject of immunity protection to prevent the more or less automatic switch from biopolitics to a politics of death and autoimmune excesses—this is the core of Esposito's affirmative biopolitics— there is a high price to be paid, as Wolfe tells us: the price of a neovitalism that substantializes "life" in all its forms and reentangles us in the kind of biocentristic dilemmas characteristic of the heyday of deep ecology in the 1970s and 1980s. Wolfe counters with a demand for an ecologizing biopolitical thought that would take us beyond vitalism's attempts at deriving ethical or political principles "from life," an ecologization that would conform to a "*denaturalized* understanding of the ecological paradigm that emphasizes form, time, and dynamic complexity" (218), and thereby renounce its own biopolitical entanglements. And in turn, it is this denaturalizing ecologism that, according to Wolfe, is to rid biopolitical thought of both its thanatopolitical fixation and all forms of vitalism; this is what, earlier in this introduction, I called, in reference to Luhmann, ecological rationality, whose genesis coincides with the cybernetic, system- and complexity-theoretical turn of thought, i.e., with the process of cyberneticization. Wolfe writes:

> what the immunological paradigm of biopolitics and the ecological paradigm have in common is that, for both, it is not a question of a biological or ecological substrate but rather of thinking the forms and processes by which the system / environment relationship is stabilized and managed by systems that find themselves in an environment of exponentially greater complexity than they themselves possess. (218)

This kind of ecologism, freely adapting Gregory Bateson (who, incidentally, was a fellow of the Lindisfarne Association, as Clarke points out, which leads us back to systems counterculture), inquires no longer into substances but into patterns; it finally demands that we think clearly the relationships that exist between an organism and its environment; and it compels us to disclose what exactly we mean when we say things like "organism *plus* environment."[140]

As for bioart, it is entirely in keeping with such a movement of ecologization accurately described by Wolfe that the living as the medium of bioart becomes the medium of a communication about the non-observability of "life" in general and as such. What bioart renders visible for the self-observation of society are the highly selective codes that are decisive for the way in which we today determine the relationship "between what we call 'Life' and its empirical instantiations in the domain of 'the living'" (230).

Albeit on a historically and systematically different terrain from Clarke and Wolfe, David Wills too engages the immunopolitical problem of

ecology. He begins by articulating blood and soil as "the two poles of every anthropo-ecological impulse and enterprise" (237) and extends the scope of this problem all the way to the question of contagion and community. The question of the difference between restricted and general ecology that comes to the fore here, and that has far-reaching theory-political implications, troubles from the very outset the concept I introduced. Wills addresses it by going back to the concept's original constellation in the theoretical and poetical works of Georges Bataille. To what extent does ecology repeat the difference between restricted and general economy, or to what extent is it already inscribed in this difference? For Wills, ecology is intricately linked to what Bataille calls the "restricted economy"[141] of life—the economy of purposes, usefulness, production, and labor, an economy of life that "restricts itself to conservation, to circulation and self-reproduction as the reproduction of meaning," as Derrida pointedly puts it.[142] Indeed, on this reading, ecology is *first of all* the figuration of this restricted economy, as a kind of second *oikos*, as an ecology of proximity and an ecology of one's own, or, in the most restricted economy, even as an ecology of home, blood, and soil. But *ultimately*, like the economy, it will find that an unstoppable movement of generalization catches up to it and realize that it is always already and inescapably confronted with a differential interruption and disruption of any and all interiority and immediacy, with a transgression of all ends and purposes. And while Wills himself in earlier writings described precisely this moment of interruption in Derridean terms as prosthetic and technological, this disruption now, in the case of ecology, appears to him as an "originary environmental rupture" (237) that his text seeks to demonstrate.[143] But what exactly does that mean? What kind of rupture is it and what kind of general-ecological would appear in it? What would the originary environmental rupture imply for conceptualizing ecology? And does it not perhaps in the end reveal the dependence of general economy on ecology, such that the inscription is the inverse of what one may have thought at the beginning? Is it possible that, already in Bataille, the general-ecological question traverses the problem of general economy, such that Bataille would have to be regarded as a pioneer of general ecology and as an ecological thinker in the strongest possible sense of the term?

Wills conceives of ecology in the original sense, which goes back to Ernst Haeckel, as a relationship between an organism and the outside world that surrounds it: "It is difficult to conceive of ecology without the idea of a relation between a living entity or organism and a more or less defined territory; indeed without the sense of an organicity of that relation, the living organism organically conforming to the territory in which it lives and moves" (237). This, Wills tells us, is one of the central preconditions of all ecology, namely "some idea of contiguity and contact" (242)—Haeckel already had spoken of a contact, a *Berührung*.[144] The traditional conception of ecology—which becomes increasingly problematic in the age of general ecologization—without, for all that, being driven out once and for all—"will

always have to wrestle with principles of proximity that are determined in turn by notions of affect. We are concerned, in ecological terms, by what affects, touches (on) something near; on the organism's organic conformity to, or harmony with its territory. Just as the first economics is home economics, so the first ecology is ... constituted by the idea of a house" (242). And this is where Wills sees Bataille intervening: Bataille undertakes a "rewriting of contact or contiguity as *contagion*" that trips up any "egoecological economy." Uncontrollable contagion is a key problem for (at least) the later Bataille, the thinker of intensive communication who excludes any possibility that beings could isolate themselves. In contagion, all autoaffection switches to heteroaffection, indeed, autoaffection turns out to be the phantasma par excellence of restricted economology that, in Bataille's wake, an entire line of thinkers from Derrida to Nancy will oppose. Heteroaffection is the differential rupture that always already destabilizes the allegedly intact and autoaffective closed circuit, shifts it and in all radicalness exposes it to the outside that was precisely supposed to remain outside, thereby, in its exteriority, introducing the "structure of prosthesis" (243). This differential rupture is what Wills calls "originary environmental rupture," without which—this is the point of his rereading of Bataille—there is no thought of the ecological. In the end, the thought of the ecological will—qua irreducible prostheticity—always be technoecological: "There is no environment without that rupture of organicity, its rewriting as prostheticity" (244).

In *Theory of Religion*, which he propounded shortly before the publication of *The Accursed Share* at the Collège philosophique in 1948 and which has to be considered within the framework of his work on general economy as well, Bataille's thinking already took a similar direction. Written against "the modern insistence that attaches to the individual and the individual's isolation,"[145] this theory of religion supposes the "immanence of an organism living in the world." This immanence of the animal or the plant, however, is no longer a very strict one and appears already to be disrupted when compared to the absolute immanence of nitrogen or water molecules that exist "without needing anything from what surrounds them,"[146] as Bataille explains:

> The immanence of a living organism in the world *is very different*: an organism seeks elements around it (or outside it) which are immanent to it and with which it must establish (relatively stabilize) relations of immanence. Already it is no longer like water in water ... the flow (the immanence) from outside to inside, from inside to outside, which is organic life, only lasts under certain conditions.[147]

There is already a first environmental rupture and differing here, even if, on Bataille's reading, they are as yet insufficiently articulated. For Bataille, the final rupture with immanence only takes place thanks to the human

being, namely through the "use of tools" that totally disrupt the continuity
of immanence and thereby introduce "exteriority"[148] in the most rigorous
sense: "In the first immanence," we are now told, "no difference is possible
before the positing of the manufactured tool."[149] Exteriority in the strict
sense is technics. Against Bataille himself, transitions have to be described
not as substantial but as gradual: what begins as environmental rupture
ends in a prosthetic-technological rupture and the promise of an impossible
immediacy and intimacy, which thereby become the subject of an entire
history of fascination. If it is true, as Wills writes, that the rupture is the
general and that it is the breaking open of the restricted economy as such
that marks generality, not, as is often believed, the moments of expenditure
and waste, then even my cursory reading of Bataille's thinking of rupture
shows that general economy is more likely to arise from general ecology
than vice versa.[150]

James Burton, too, inquires into the difference between restricted and
general ecology. He focuses on the problem of the general and of generali-
zation as such and examines what kind of generalization exactly might be
at work in the general ecologization of thought, and what the origins, the
stakes, but also the possible risks of this movement of generalization might
be. His contribution is organized by a central observation: the generali-
zation developed by general ecologization, much of whose precise meaning
remains yet to be uncovered (even beyond the possible links with Bataille's
thought of rupture, in whose proximity Burton's analysis is at least
implicitly situated), is at work in ecology as such from the outset, even in
the most restricted of contexts: "The pursuit of environmental connections
will always be expansive," Burton tells us, "always a proto-generalizing
tendency that moves any set of phenomena or system into relation with
what is beyond the initial sphere of its observation or consideration"
(263). And a couple of paragraphs later we read: "if we conceive a 'general
ecology,' it will always necessarily engender a generalizing tendency that
is already operative within ecological thinking and ecological systems"
(264). While Whitehead, in his *Adventures of Ideas* of 1933, during the
early stages, that is, of the ecologization of thought, distinguishes between
two kinds of generalization characteristic of Western thought, namely the
universalizing generalization of philosophy and the inductive generalization
of the sciences (with the latter overcoming the former), Burton considers
the generality that organizes ecological thought and already inherently
converts this thought from restricted to general ecology to be situated
right in between those two strands. If there is a historicity of generali-
zation, such an "ecological-general" might perhaps be the next step within
its framework. Burton, in any case, calls it "associative" or "relational"
generalization (263), which is characterized by an emphasis on relation-
ality and connectivity that constitutes the basic operation of ecology, as
we have already seen with Neyrat. This means that the relational-general
of ecology, a new form of the general or of generalization enters the scene

that will seize thought as such and will come to prevail in the course of the twentieth century.

The specificity of Burton's approach is that he brings together, from the outset, the question of the general in ecology with the question of metafictionality. While the term "metafiction" was coined by literary critics in the 1970s to name a self-conscious, auto-reflexive writing of fiction that highlights its own artifactuality and thereby recasts the difference between fiction and reality and ruins the representational paradigm, metafiction for Burton is no longer merely a specifically literary problem but an "aspect of (post)modern culture" (257) generally. Metafiction is inhabited by a tendency toward generalization of its own. In the transition from generic to general metafiction at issue here, Burton tells us, the emergence of metafictional texts directly expresses, acknowledges, and stages a much vaster movement that takes place during those same years: "the technological displacement of sense."[151] Metafictionality names the shift away from the categories of hermeneutics and representational thought, a shift that mirrors the technological displacement of sense. This is where it joins general-ecological thought, which is inscribed in the same historical-epistemic turn. General ecological thought may indeed be the most radical implementation of the historic-epistemic turn of the technological displacement of sense. Yet Burton takes his approach of bringing together metafictionality and general ecology even further. Undeniably, general-ecological thought bears the traits of generalized metafictionality: it is not representative, nor does its generality represent a general or universal idea, that of ecology. First and foremost, it is operative and productive, namely "productive of world(s), of ever more and newer relation among things, and of ever more 'things' emerging from the growth of relations" (266). Burton even speaks of "ecological productivity" (267). In precisely this fundamental productivity of ecology, the moment of a "general *poiesis*" (278, footnote 47) comes to the fore, which also enjoins us to think (meta) fictionalization in a generalized way as worldmaking. The "generalized idea of metafiction" (269) characterizes our age and pervades the movement of ecologization so important to this age.

The wider political horizon of Burton's approach becomes apparent—and Burton here picks up directly on Neyrat's reflections in this volume—when it comes to the choice of the "*kinds* of worlds we want" (270). The problem is readily apparent when Burton emphasizes that even capitalism's imposition of the cybernetic hypothesis in the shape of hyperconnectivity and total networking elaborates "its own general-ecological modes" (270), which above I described under the heading Environmentality: bringing metafictionality and general ecologization together allows us to see that the issue is always also one of choice and thus one of a "strategic generalization of ecology" (270) as a task of thinking. It might be useful here further to differentiate the question of "worldmaking"—e.g., in the sense of Tim Ingold's distinction between the two fundamentally different modes

of making and worldmaking, a distinction that is at the core of the peculiar general-ecological move of his anthropology of life (Ingold himself speaks of a "new" rather than a general ecology) and is based on the difference between a "building perspective" and a "dwelling perspective."[152] It would then not be the "constructive" mode, which, despite the possible multiplication, even explosion, of relations it operates misapprehends the status of relationality as such and thus appropriates it, but only the "co-optive" mode of making, which imputes an originary relational constitution of being and follows the paths of being involved in the world, in which we would have to recognize a "worlding" that we can want, as a becoming-world of the world.[153]

Elena Esposito conceptualizes the aim of general ecology from the perspective of the theory of social systems. For her, the work of generalizing the concept of ecology might start with the becoming-problematic of the environment as such, for the environment now far exceeds the kind of simple mode of givenness the traditional thinking of adaptation took it to be.[154] "Ecology deals with the environment," she writes, "but here we look to a generalization and abstraction of the concept that have been emerging more recently (since the 1950s) ... We speak of a sharper problematization of the idea of environment—not as a 'given', to which an organism or system must adapt, but as a multifaceted and flexible reference, which changes by the way it is observed and with the perspective of the observer" (285). As its mode of givenness changes, the environment loses whatever simplicity had been imputed to it. Instead, it now appears, in complete agreement with the current situation, as a complex manifold of intertwined and supplementary environments. Today, as Esposito emphasizes, there are natural, social, and psychological environments as well as environments of machines, environments made up of machines, and media environments. While it is true that work on a cybernetic ecology, which takes the becoming-problematic of the environment resulting from its twentieth-century exposition into account and pursues a rethinking of environmentality in terms of control, has well been underway since the Macy Conferences (1946–53),[155] the question remains as to the exact reasons for which this conceptual attitude, so powerful in ecological reflection, continues to be pushed in the direction of a general ecology: "What has changed since the Macy Conferences? Why do we feel the need to expand the approach to a 'general ecology'?" (287) For Esposito, the reasons for the change in the environment's mode of givenness, which necessitates a redescription, are obvious. They are found in computerization. Technological developments from the Web 2.0 via the semantic web and the social network explosion to the Internet of Things and ambient intelligence, which brings in a new kind of artificial intelligence that no longer seeks to imitate human intelligence, indicate that we have entered the new phase of an originary environmentality: "All are developments that call into question the simple distinction between the computer and its environment and between machine and user" (287). Above all, it

is the simple feedback loop, which has operationalized the environment as a problem of control since the 1950s, that just does not suffice any more when it comes to giving an account of the explosion of environmental complexity that takes place under the technological condition. If the basic problem of all ecology is the definition and observation of the distinction between system and environment in all its forms—as Esposito puts it, in accordance with an entire system-theoretical descriptive tradition, which in turn is already a conceptual reaction to a certain exposition and radicalization of environmentality in the twentieth century—the question that guides the contemporary generalization of the ecological becomes: "How can the ecological approach account for this complexity and produce a correspondingly complex concept of environment?" (288).

To outline the problem of environmentality [*Umweltlichkeit*], general ecology—and this, according to Esposito, is its key moment—no longer begins with *one* side of the difference system / environment, and especially no longer with the side of the system, as has hitherto been the case. It begins with "the distinction itself." General ecology precisely reflects "the difference system / environment and its transformations, with all their consequences" (289), Esposito writes. Whereas recent conceptual operations, faced with the explosion of environmental complexity, have taken to questioning or even simply abandoning the difference system / environment in favor of concepts like *dispositif*, socio-technical apparatuses, or hybrids, the task of general ecology as Esposito sees it lies, on the contrary, in radicalizing this difference: "I propose instead to make the opposite choice: don't blur the distinction, but radicalize it, sharpen it, so you can use it even in circular and reflective configurations" (289).[156]

From this point of view, environmentality under the technological condition, such as we witness it today in the form of intelligent environments, for example, is first and foremost a question of complex circular configurations in which entities are simultaneously subjects and objects, simultaneously inside and outside without for all that necessarily implying any kind of hybridity. According to Esposito's thesis, only extending the established cybernetic-systems-theoretical approach in the direction of an investigation of social systems and their forms can do justice to the technological transformation of environmentality. For not only are interlaced environments characteristic of social systems theory from the outset; "in the approach of social systems theory, individuals (psychic systems or consciousness) each have their own environment that also includes society, but are themselves in the environment of society" (290). Environmentality here takes the form of the so-called problem of double contingency and communication, in which communication is thought of as completely independent of human communication and meaning and conceived of as an operation of the social system that comes to terms with double contingency (which, according to Parsons, is characteristic of the basic social situation). But web-based forms of intelligence, Esposito argues,

significantly transform the traditional problem of communication: from the Web 2.0 via the Internet of Things to ambient intelligence, we find a "virtual contingency" establishing itself on the part of machines, a contingency that "'feeds' on user contributions and actively exploits them to increase its own complexity—and also the efficiency of communication" (294). Because machines, no matter how complex, do not know uncertainty but are always determinate, they derive contingency from their users alone. This exploitation of contingency, as we might call it, is paradigmatically obvious in the case of Google, and it results in a new kind of communication that, more than ever and in keeping with the good old tradition of cybernetics, demands to control and to manage the limits of systems. In the end, this will have immediate repercussions for a conception of general-ecological thought, whose difficult heritage from the history of control is very much on display when it is thematized by systems theory, for example when we read: "Complexity increases, but because differences increase, not because they are erased. The ecological issue becomes increasingly central—not as an opening to the environment, but as an understanding and management of differences" (296).

Timothy Morton undertakes to expose what he calls ecology's "spectrality." To think ecologically means opening oneself to ontological haunting and thinking an ontology of haunting, an "hauntology"[157] even, as the core of a veritable "materialism of the encounter."[158] In earlier works that made him one of the pioneers of a new ecological image of thought, Morton already inquired into the kinds of collectives that appear when we dare think "ecology without Nature," i.e., an ecology without a capitalized Nature that marks and always remains on the outside, that is the big Outside, a Nature in which "ecologocentrism" encloses and colonializes all encounters with an irreducible alterity, any radical coexistence with nonhuman beings. What, on the contrary, would a "properly materialist ecology" growing out of denaturalized collectives look like?[159] At first (and in close proximity to Derrida), Morton in his definition of an ecological materialism gives pride of place to the figure of the "strange stranger," the absolutely other who must be granted unconditional hospitality, but he limits himself in principle to living entities. Not until his more recent speculative-realist work that foregrounds so-called hyperobjects does Morton open up the problem; he radicalizes the stakes of ecological materialism and resituates the question prior not just to the difference human / nonhuman but also prior to the differences real / unreal, sentient / non-sentient, and, especially, living / non-living—let's say, prior to the cluster of correlationalist differences.[160]

In the present chapter, Morton extends his call for an ecological materialism of the encounter toward an "ecocommunism," a "communism of humans and nonhumans alike" (303), which, in his view, can only be founded on a radically de-anthropocized thought of Being-together. He asks to what image of thought this disarmament of correlationalist convictions manifest

in the bracketed differences might correspond. He begins by describing the essential spectrality of the ecological that becomes visible in the collapse of the anthropocentric regime of differences. He is concerned with uncovering the inescapable spectrality of ecological entities that all ecological thinking must take into account. Morton's work on the ecological-spectral culminates in the concept of haunting, which he turns into a key concept of ecological thought. "To encounter an ecological entity," he writes, "is to be *haunted* ... [H]aunting is a very precise term for what happens in ecological thought" (304). Ecological thought turns out to be hauntologically constituted, as a matter of an ontology marked by the logic of haunting, and hauntology itself at its core turns out to always already be an ecohauntology. And it is just this difficult ecohauntological structure that the text seeks to explicate. Morton starts with a short phenomenology of *ennui* in the vein of what he calls "the Baudelaire Moment" of modernity, the moment when the arts begin to work on questions of spectrality:

> Ennui ... is the correct ecological attunement ... With ennui I find myself surrounded, and indeed penetrated, by entities that I can't shake off ... Isn't this just the quintessence of ecological awareness, namely the abject feeling that I am surrounded and penetrated by other entities such as stomach bacteria, parasites, mitochondria—not to mention other humans, lemurs and sea foam? (306)

Ennui here serves as another name for being enveloped, surrounded by things. And, as the "abject feeling" of a generalized symbiogenetic constitution intimates, Morton ends with the spectrality of the sciences: "Science does not do away with ghosts. Rather, it multiplies them. As the human-nonhuman boundary and the life-nonlife boundary collapse, more and more specters emerge" (309). Finally, the long history of the Anthropocene turns out to be the history of an increasing spectralization, which renders the ecologocentric denial of the inescapable spectrality of Being ever more impossible and makes the deconstruction of ecologocentrism the task of thinking today. In the ecologization of thought, which takes the essential spectrality of the ecological encounter into account, "thought is confronted with its anthropocentrism" (318). And according to Morton, the ecologization of thought is probably the radical consequence of just this anthropocenic movement of history:

> When thinking becomes ecological, the beings it encounters cannot be established in advance as living or non-living, sentient or non-sentient, real or epiphenomenal. What we encounter instead are spectral beings whose ontological status is uncertain precisely to the extent that we know them in detail as never before. And our experience of these spectral beings is itself spectral, just like ennui. (309)

Even if Marx, as Derrida has shown, sees spectrality to be at work at the very base of the capitalist constitution, capitalism, according to Morton, is *"not spectral enough"* (319). It insulates, as it were, the spectrality of ecological being, of what Jason Moore, whose work was already mentioned above, calls, more harmlessly, the "web of life"; it reorganizes the manifold of relationships in a highly reductionist way; it "implies a substance ontology that sharply divides what things are, considered to be 'normal' or 'natural' fixed essences (extensional lumps without qualities), from how things appear, defanging the spectral and 'demystifying' the thing, stripping it of qualities and erasing its data, resulting in nice blank sheets or empty hard drives" (319). Nor will communism or Marxism, at least insofar as it repeats this metaphysics, be able to imagine an ecological future. That is why it will have to be spectralized in the sense of a real materialism of encounter.

At the beginning of this introduction, I pointed out that the entry into the technological condition and the revaluation of the difference between nature and technology that comes with it unsettle teleological rationality and Western teleology generally. Tightly bound up with the emergence of a fundamental purposelessness and with the ruining of the means–purpose relation generally by a technology it no longer manages to schematize, the profound problematization, rejection, or reconceptualization of finality we have since been witnessing constitutes one of the central challenges faced by general ecologization coming to the fore in this new phase of technicity. Félix Guattari's "generalized ecology," whose overall goal lies in an ecological reformulation of modes of subjectivation and valuation, draws on a deep intuition of just this non-teleological turn, which we have to discuss with respect to a dimension so far underestimated: the dimension of value. This intuition contracts into a concept when Guattari adds an "ecology of the virtual" to the three "ecologies of the visible world," the ecologies of mind, society, and environment. The ecology of the virtual raises the question of values beyond the traditional teleological fixations that always already presuppose purposes and goals that are given or to be given. The task of this virtual ecology, whose absolute urgency Guattari emphasizes, is "to reforge axes of value, the fundamental finalities of human relations and productive activity,"[161] for the one-dimensionality and the predominance of the principle of general equivalence of capitalist subjectivity has completely disoriented values. In this sense, generalized ecology "will tend to create new systems of valorisation."[162] Guattari in this context also speaks of an "incorporeal ecosystem … giving meaning and value to determinate existential Territories."[163] What is crucial here is that its "being is not guaranteed from the outside," it is not transcendentally given and warranted, but instead it "lives in symbiosis with the alterity it itself contributes to engendering."[164] What is at issue, in other words, is a fundamental modification of the way values are given—more than that, at issue is the end of their being given at all. The reorientation of values called

for here cannot simply put new values in the place of the old; it must, first of all, fundamentally reorient what value means. Only that may count as a new basis of thought in terms of values on a par with our situation in the history of sense. And here lies the full, usually overlooked challenge of Guattari's reflections on an ecology of the virtual: they challenge us to elaborate a non-teleological conceptualization of value in which value is no longer some kind of transcendental given but an immanent heterogenetic entity.

It is this kind of far-reaching reflection on a general-ecological thought in terms of values, which, where it is to be found in Guattari, remains largely implicit, that Brian Massumi incisively picks up on: "To understand what his revalued 'ecology of the virtual' might be, the very concept of value will have to be reforged, beyond the normal compass" (346). What might such a reconceptualized non-teleological theory of value look like as an essential component of a general ecology? Key aspects of the general-ecological revaluation of value itself, such as Massumi undertakes to accomplish, include articulating the concept of value outside the capitalist framework of general equivalence and without reference to transcendence, norms, or universals, and instead combining it with a becoming, a constitutively multiple singular and qualitative, with what is potential, an immanent beyond, an immanently self-transcending experience, an excess of what appears that cannot be absorbed, a "moreness" of the world, with invention, with, finally, a surplus value of life that is not the same as capitalist surplus value. Massumi sketches the outlines of such a complex, immanence-philosophical "ecology of values," as he explicitly calls it, by going back to two theorists of value that both stand for the non-teleological awakening in the twentieth century, Alfred North Whitehead and Raymond Ruyer. Massumi gives a careful reading of their impressive, non-dogmatic, axiological work. "Value," he concludes, "does not inhabit some pure moral domain. It is active in the world, alive with appetition and self-transformation" (356).

Matthew Fuller and Olga Goriunova sketch the basic traits of a general-ecological thought of devastation. Not the least of the achievements of their approach is that it accounts for the historical condition of the possibility of an ecology of values and recharts the terrain on which it takes place. The motivation for speaking in the Nietzschean tradition of a "power of devastation" rather than of "destruction" lies above all in its background in the history of sense: in the exodus from the dialectics of the negative and of contradiction and in the transition to an affirmation of difference or to difference as affirmation that Deleuze and Nancy, each from his perspective, have analyzed as the event of our history.[165] General ecology, for its part, seems to be inscribed in this broad and difficult revaluation, which quashes "the well-known complementarities between affirmation and negation, life and death, creation and destruction"[166] and instead conceives of a "nothing beyond nihilism" and begins to "snatch the existing from *final* annihilation" in order to, ultimately, "expose it to the eternal *nothing* or,

more exactly, to the nothing as eternity"[167]—to a sense without sense, goal, or purpose, which, it bears repeating, arises from the technological end of Western teleology. Following Fuller and Goriunova, it is precisely with and as the problem of devastation that general ecology affirms itself in all radicalness as the crystallization of just this revaluation and suspension: "Devastation in general ecology does not imply that there is an end to becoming or a negation of affirmation, but that there is a change to virtual becoming. Devastation seizes, eliminates or radically changes the conditions of other becomings" (325). Devastation is no longer immediately a kind of nihilating and annihilating in the sense of putting an end to something, as a thinking of destruction would have it. Given that "the conditions of the actual are grounded in the virtual, which is a differential infinitely saturated with change," as they write in reference to Deleuze, conditions in which the virtual is real but not yet actualized while simultaneously also being affected by the actual, "devastation is a kind of ontological flexure on the process of actualization and change" (325). And this, precisely, is of central importance; it raises a tremendous question whose impact we have yet to grasp. For from this perspective, "devastation can generate novelty and complexity outside diversity." Devastation, in other words, becomes productive:

> Complex devastational forms include the dynamic behaviours of new auto-immune diseases, harmful molecule compounds, cancerous growths, radiation, accumulations of carbon dioxide, which do not eliminate complexity and wholeness in favour of randomness or a flat lack of differentiation, but radically redistribute the shares of potentiality, shape planes of activity and tangle with, impersonate and swallow other processes of change. The active growth of devastation is not the individually unthinkable scope of the death of the individual or the overwhelming absences of pure nothingness, it is something to the side of such things, being devastatingly vital, active and productive. (325)

Fuller and Goriunova replace a static-mechanistic ontology that underpins the historically tenacious thinking of destruction and its fixation on negativity with a processual "ecology of non-linearity" (324) that underpins the thinking of devastation. The larger historical-ontological change that manifests itself here undoubtedly arises from the shift from a world of simple machines to the world of complex machinic assemblages under the technological condition as well.[168]

Conspicuously, devastation ultimately, and in keeping with a kind of active nihilism that clearly stands out here, turns out to be a highly active form of production: "Devastation does not simply amount to the existence of destructive qualities themselves or destruction per se. Devastation relates to changes in the conditions of becoming and can be of a form of very active production" (326). As general ecology of devastation, general

ecology comes very close to a strangely devastating productivism, which, of course, remains to be examined as to its urgency for a diagnostic reading of the present, its origins, and its difficult complicities. How exactly, we have to ask, does devastating production differ from the creative destruction Schumpeter conceives of as a core moment of the capitalist machine?[169] Is there a distinction between an active and a passive form of production, and would this distinction find its radical exposition in, precisely, the general ecology of devastation? And what paths do the transitions from a limited to a general productivism, which might run along just this difference, take? (I am thinking of the transition discussed by Deleuze and Guattari, which they eventually capture in the concept of becoming, but one might equally cite the transition inscribed in Bataille's distinction between restricted and general economy, or in Serres' parasitological conception of an initial, albeit unexpected, improbable, and rare production.)[170] Is it this turn, which we find to pervade the second half of the twentieth century at the latest, that general ecology will in the end have to account for? Is it in this turn, and precisely in the immense question of devastation, that general ecology reveals its generality?

Fuller and Goriunova call for an "ethico-aesthetic vocabulary for devastation" (324–5) capable of doing justice to the entire scale of devastating production, to a "propulsive unfolding of things, for which we have no available ethico-aesthetic figures" (327). They give some indications and hint at the richness of the problem: they discuss, for example, the devastations of oil, paradigmatic of the entire problem, but also "the commons of devastation" (330), as they put it, from the Great Pacific Garbage Patch in the North Pacific Gyre to devastated areas like Bhopal or Chernobyl, and the bodily devastation of obesity. All these cases demonstrate that, whatever else it might be, the thought of the Anthropocene will have to be a thought of devastation, from catastrophic all the way to slow, imperceptible, cumulative, variable, familiar devastation. They also raise the question of the political aspect of devastation and ask, picking up on Eyal Weizman's forensic project, how devastation can be witnessed and negotiated in the first place, what the media of devastation are, and what an epistemology might look like that acknowledges the non-linear causality of devastation rather than ignoring or obscuring it, as is usually the case. And by bringing in Catherine Malabou's conception of the "destructive plasticity"[171] of cerebral afflictions, they bring devastations of subjectivity into the purview of the fundamental problems of general ecology. Work on the ethico-aesthetic vocabulary for devastation as outlined by Fuller and Goriunova must continue. It is a significant project, one which demonstrates, perhaps like no other, the incredibly problematic nature of the space of general ecology.

Berlin, January 3, 2016

Notes

1 Jean-Luc Nancy, *The Sense of the World*, trans. Jeffrey S. Librett (Minneapolis: University of Minnesota Press, 1997), 41.

2 Timothy Morton, *The Ecological Thought* (Cambridge, MA: Harvard University Press, 2010) and "Ecologocentrism: Unworking Animals," *SubStance* 37 (117) (2008): 73–96.

3 Cf. Jacques Derrida, "Faith and Knowledge: The Two Sources of 'Religion' at the Limits of Reason Alone," trans. Samuel Weber, in *Religion*, ed. Jacques Derrida and Gianni Vattimo (Stanford: Stanford University Press, 1998). On the problem of immunopolitics see also Roberto Esposito, "The Paradigm of Immunization," in *Bíos: Biopolitics and Philosophy*, trans. Timothy Campbell (Minneapolis: University of Minnesota Press, 2008), 45–77; Frédéric Neyrat, *L'indemne: Heidegger et la destruction du monde* (Paris: Sens & Tonka, 2008).

4 It is from here, from the *oikos*, that it is possible to repeat what Bataille and Derrida have to say about general and restricted economy in ecological terms and to introduce the difference between general and restricted ecology. This peculiar repetition in fact expresses the change of the culture of sense [*Sinnkultur*] from a culture of meaning [*Sinnkultur der Bedeutung*] to a culture of technoecological sense [*technoökologische Sinnkultur*], as will be thematized below. For even if the restricted and the general economies (where Derrida already sees the latter as the transgression of the "epoch of sense") are unavoidably linked to the question of sense, it is still necessary to discover the ground of this movement in the history of sense that makes readings like Bataille's and Derrida's possible in the first place, and which prohibits us from believing in the coming to an end of sense. Yet the technoecological culture of sense, and here we have to agree with Derrida, already marks a time of sense beyond the epoch of sense. On the deconstruction of the *oikos*, see, for example, Jacques Derrida, *Of Hospitality*, trans. Rachel Bowlby (Stanford: Stanford University Press, 2000). Jason Moore's radically relational concept of the *oikeios* or nature-as-*oikeios*, which describes the bundling together of human and nonhuman agencies, likewise undermines from a Marxist perspective the restricted thinking of the house that is sedimented within the inherited concept of ecology. See Jason W. Moore, *Capitalism in the Web of Life. Ecology and the Accumulation of Capital* (London: Verso, 2015). For my notion of culture of sense [*Sinnkultur*] see Erich Hörl, "The Artificial Intelligence of Sense: The History of Sense and Technology after Jean-Luc Nancy (by way of Gilbert Simondon)," trans. Arne De Boever, *Parrhesia* 17 (2013): 11–24.

5 Jean-Luc Nancy, "Of Struction," trans. Travis Holloway and Flor Méchain, *Parrhesia* 17 (2013): 2. Simondon highlighted if not the destruction, then certainly the demystification of the idea of finality, and at least the expulsion of its "roughest and most base aspects"—"the subordination of means to end"—through cybernetics. Where previously the human was subjugated by finality, being subject to determined ends, one now finds their conscious

cybernetic organization. See Gilbert Simondon, *Du mode d'existence des objets techniques* (1958; Paris: Aubier, 1989), 103–4.

6 Nancy, "Of Struction," 3.

7 Jean-Luc Nancy, *Le sens du monde* (Paris: Galilée, 1993), 45–6.

8 Jean-Luc Nancy, *The Creation of the World, or, Globalization*, trans. François Raffoul and David Pettigrew (Albany: State University of New York Press, 2007).

9 Gregory Bateson, *Steps to an Ecology of Mind: Collected Essays in Anthropology, Psychiatry, Evolution, and Epistemology* (San Francisco: Chandler, 1972); James J. Gibson, *The Ecological Approach to Visual Perception* (Hillsdale: Earlbaum, 1986); Félix Guattari, *The Three Ecologies*, trans. Ian Pindar and Paul Sutton (London: Continuum, 2008) and "Qu'est-ce que l'écosophie?" in *Qu'est-ce que l'écosophie?* (Fécamp: Lignes, 2013).

10 My use of the concept *mode of existence* picks up on Étienne Souriau and Gilbert Simondon. Souriau coined this ultimately Spinozist term in his radical critique of hylemorphism. Associating it with what he terms the "existential incompletion of every thing," he closely links modes of existence to the question of technics. "Nothing is given to us, not even ourselves, other than in a sort of half-light, a sort of presence that is neither obvious [*ni évidente patuité*] nor a total completion nor a full existence … In the atmosphere of concrete existence, any being (of whatever kind) is never seized or experienced elsewhere than halfway on an oscillation between this minimum and maximum of its existence (to put it in Giordano Bruno's terms)," Souriau declared in a lecture before the Société française de philosophie in 1956. Every "completed existence," he continues, "demands a doing, a founding action" [*un faire, une action instauratrice*]. Every existence is "a work to be made" ("Du mode d'existence de l'oeuvre à faire," in *Les différents modes d'existence suivi de Du mode d'existence de l'oeuvre à faire* [Paris: Presses universitaires de France, 2009], 195–6). But it is Simondon who describes the technical foundations of Souriau's critique of hylemorphism and takes the concept further. In Souriau's undoubtedly aesthetic focus, "instauration" is the key concept of the redescription of the various modes of existence. In Simondon, the concept of "individuation" takes its place. For him, individuation cuts across all modes of existence, from the microphysical via the living to the psychically collective and even cosmological level of existence, finally to the mode of existence of technical objects. Simondon condenses this redescription into a radical-relational ontogenetic thinking that develops a true thinking of becoming that was nonetheless already prepared in Souriau; cf. Gilbert Simondon, *L'individuation à la lumière des notions de forme et d'information* (1964 and 1989; Grenoble: Millon, 2005).

11 For a first survey, see my article, "A Thousand Ecologies: The Process of Cyberneticization and General Ecology," trans. James Burton, Jeffrey Kirkwood, and Maria Vlotides, in *The Whole Earth: California and the Disappearance of the Outside*, ed. Diedrich Diederichsen and Anselm Franke (Berlin: Sternberg Press, 2013). On the concept of the epochal

imaginary, cf. Hans Blumenberg, *The Genesis of the Copernican World*, trans. Robert M. Wallace (Cambridge, MA: MIT Press, 1987), as well as Erich Hörl and Michael Hagner, "Überlegungen zur kybernetischen Transformation des Humanen," in *Die Transformation des Humanen: Beiträge zur Kulturgeschichte der Kybernetik*, ed. Erich Hörl and Michael Hagner, (Frankfurt: Suhrkamp, 2008).

12 Niklas Luhmann, "Gesellschaftliche Struktur und semantische Tradition," in *Gesellschaftsstruktur und Semantik: Studien zur Wissenssoziologie der modernen Gesellschaft*, vol. 1 (Frankfurt: Suhrkamp, 1993), 9.

13 Cf. Reinhart Koselleck, *Futures Past: On the Semantics of Historical Times*, trans. Keith Tribe (Cambridge, MA: MIT Press, 1985).

14 Niklas Luhmann, *Ökologische Kommunikation. Kann die moderne Gesellschaft sich auf ökologische Gefährdungen einstellen?* (1985; Wiesbaden: VS Verlag für Sozialwissenschaften, 2008). Niklas Luhmann, *Ecological Communication*, trans. John Bednarz, Jr. (Chicago: University of Chicago Press, 1989).

15 Hans Blumenberg, *Paradigms for a Metaphorology*, trans. Robert Savage (Ithaca: Cornell University Press, 2010).

16 Cf. Friedrich A. Kittler, *Gramophone, Film, Typewriter*, trans. Geoffrey Winthrop-Young and Michael Wutz (Stanford: Stanford University Press, 1999), 1–19.

17 The concept of "total sense-cultural fact," following Marcel Mauss' total social fact, refers to a fact that implies the totality of a specific sense-culture, its founding operations and relations as they are implemented through its media, technologies and institutions.

18 For a first description of this transition from signifying to technoecological sense, see my "The Technological Condition," *Parrhesia* 22 (2015): 1–22.

19 Note that where the term "Environmentality" written with a capital "E" appears in this introduction, it refers to the contemporary mode of governmentality, as used by thinkers such as Michel Foucault and Brian Massumi (a sense discussed in the following paragraph of this chapter). The term "environmentality" with a small "e", translating the German *Umweltlichkeit*, refers to a broader sense of the environmental and to the concept *Umweltlichkeit* as used by Heidegger in *Being and Time* (§§15–18), which has also been translated as "environmentality"—in both the Joan Stambaugh and the John Macquarrie and Edward Robinson translations. The concept of the apparatus of capture (*appareil de capture*) is used in the sense of Gilles Deleuze and Félix Guattari, *A Thousand Plateaus: Capitalism and Schizophrenia 2*, trans. Brian Massumi (Minneapolis and London: University of Minnesota Press, 1987), 424–73.

20 The process of cyberneticization designates much more than simply cybernetics understood as a post-Second World War military-industrial-scientific formation of knowledge, extending at least to the genesis of the cybernetic hypothesis as far back as the crisis of control in the second half of the nineteenth century. Cybernetics as a specific body of knowledge and a related epistemological project is in itself inscribed by the process

of cyberneticization. I discuss this further below. Cf. Alexander R. Galloway, "The Cybernetic Hypothesis," *Differences: A Journal of Feminist Cultural Studies* 25 (2015), 107–31. Recently Andrew Goffey argued for a reconceptualization of the history of control beyond a limited techno-scientific focus on cybernetics ("Towards a Rhizomatic Technical History of Control," *New Formations* 84/85 (2014): 58–73). According to Goffey, there is "a much greyer prior history of routinisation, bureaucratisation, calibration and technical tinkering" (65) preceding cybernetics; a grey history of engineering, management and bureaucracy; but also a greyer after history. Cf. Matthew Fuller and Andrew Goffey, *Evil Media* (Cambridge, MA: MIT Press, 2012). What I call the process of cyberneticization leading toward an environmental culture of control encompasses these greyer prior and after histories that implement and enforce the cybernetic hypothesis with its imperative of regulation and control.

21 Cf. Brian Massumi, "National Enterprise Emergency: Steps towards an Ecology of Powers," *Theory, Culture and Society*, 26 (6) (2009): 153–85; Michel Foucault, *The Birth of Biopolitics: Lectures at the Collège de France, 1978–79*, ed. Michel Senellart, trans. Graham Burchell (Basingstoke: Palgrave Macmillan, 2008), 259–60; Jennifer Gabrys, "Programming Environments: Environmentality and Citizen sensing in the Smart City," *Environment and Planning D: Society and Space*, 32 (1) (2014): 30–48. The media-technological foundations of Environmentality are discussed in detail in the third section below. The development, since the nineteenth century, of the concept of ecology as such directly follows this evolution in the history of control.

22 Florian Sprenger, "Architekturen des 'environment,'" *Zeitschrift für Medienwissenschaft* 12 (2015): 63, 67.

23 In the 1990s, Timothy W. Luke already proposed, following the biopolitical Foucault of *The History of Sexuality*, vol. 1, the concept of "Environmentality" as a means of working through the contemporary reoperationalization of governmentality. Together with the process of environmentalization, which according to Luke arose in the late nineteenth century, this concept of Environmentality focalized the development of "eco-knowledge" and "geo-power" as new power-knowledge regimes for the management of life. See "On Environmentality: Geo-Power and Eco-Knowledge in the Discourse of Contemporary Environmentalism," *Cultural Critique* 31 (1995): 57–81.

24 I use the concept of "affirmation" in connection with Gilles Deleuze (see *Difference and Repetition* [New York: Columbia University Press, 1994], 52–8.) Deleuze speaks—contra the "yes" of the ass which accepts every burden in Nietzsche's *Zarathustra*—of an originary affirmation of differing and difference itself, which precedes every negation, whereas the latter reduces the multiplicity of difference to contradiction. Rosi Braidotti has developed a critical theory of affirmation based on this, placing it explicitly within an ecophilosophical context: "Powers of Affirmation," in *Nomadic Theory: The Portable Rosi Braidotti* (New York: Columbia University Press, 2011). For a critique, see Benjamin Noys, *The Persistence of the Negative* (Edinburgh: Edinburgh University Press, 2010).

25 Cf. Maurizio Lazzarato, *Signs and Machines. Capitalism and the Production
 of Subjectivity* (Los Angeles: Semiotext(e), 2014). I develop the concept of
 the non-meaningful, asignifying sense of sense, following Félix Guattari, in
 the following section of this introduction.

26 See Erich Hörl and Marita Tatari, "Die technologische Sinnverschiebung:
 Orte des Unermesslichen," in *Orte des Unermesslichen: Theater nach der
 Geschichtsteleologie*, ed. Marita Tatari (Zurich: Diaphanes, 2014), esp.
 46–7. The deterritorialization of cybernetic capitalism consists to a large
 extent in a destruction of sense, it expresses itself as a crisis of sense, and,
 it seems to me, it goes hand in hand with the collapse of the traditional
 philosophical politics of sense. A new non-philosophical politics of sense has
 to differ from this movement of deterritorialization by its non-affirmative
 affirmation. It also has to crystallize the revaluation of the difference between
 nature and technics beyond the nihilistic technical destruction of nature.

27 Luhmann, *Ökologische Kommunikation*, 15 (footnote).

28 Ibid., 162.

29 Luhmann, "Gesellschaftliche Struktur und semantische Tradition," 17.

30 Dirk Baecker, *Studien zur nächsten Gesellschaft* (Frankfurt: Suhrkamp,
 2007), 225. While Luhmann, in his theory of the functional differentiation
 of society, describes first and foremost the modern society of print, even if
 in a certain sense this is done in the vein of the ecological rationality that
 is to follow, his pupil Dirk Baecker switches over completely to historical
 rationality and the media-technical constellation which has a central
 place in the background of the formation of systems theory: the "next
 society" of the computer. This will be, "more radically than we could
 previously have imagined," says Baecker with consistency (and here in
 an explicit connection with Jakob von Uexküll), "an ecological order; if
 ecology means that one makes it have to do with neighbouring relations
 between heterogenous orders, with which it does not have any prestabilized
 connection, any overarching order, any all-encompassing sense" (9). The
 concept of world and the concept of sense corresponding to the next society
 are, according to this principle, "radically ecologically" constituted, Baecker
 continues, in the "horizon of indeterminacy, which is not relegated to
 some place in the infinite, but is rather in the always finite, and thus in the
 supplementation-requiring character of every determination" (224).

 The history of systems theory as a whole is deeply embedded in the
 history of ecology as the history of cyberneticization, and even forms one
 of its central motors. Bruce Clarke has shown this in numerous works,
 for example, *Neocybernetics and Narrative* (Minneapolis: University of
 Minnesota Press, 2014).

31 Cf. Bruno Latour, *An Inquiry into Modes of Existence: An Anthropology of
 the Moderns*, trans. Catherine Porter (Cambridge, MA: Harvard University
 Press, 2013), 8, and "To Modernize or to Ecologize? That's the Question,"
 in *Remaking Reality: Nature at the Millenium*, ed. Noel Castree and Bruce
 Braun (London and New York: Routledge, 1998).

32 On the primacy of relationality, see Brian Massumi, *Parables for the*

Virtual: Movement, Affect, Sensation (Durham and London: Duke University Press, 2002); Alberto Toscano, *The Theatre of Production: Philosophy and Individuation Between Kant and Deleuze* (Basingstoke: Palgrave Macmillan, 2006); Erin Manning, *Relationscapes: Movement, Art, Philosophy* (Cambridge, MA: MIT Press, 2012); Erin Manning, *Always More Than One: Individuation's Dance* (Durham: Duke University Press, 2013); Didier Debaise, "What is relational thinking?," *Inflexions* 5 (2011): 1-11; Luciana Parisi, "Technoecologies of Sensation," in *Deleuze/ Guattari and Ecology*, ed. B. Herzogenrath (Basingstoke, UK: Palgrave, 2009); Luciana Parisi, *Contagious Architecture: Computation, Aesthetics, and Space* (Cambridge, MA: MIT Press, 2013); Steven Shaviro, "The Actual Volcano: Whitehead, Harman, and the Problem of Relations," in *The Speculative Turn: Continental Materialism and Realism*, ed. Levi Bryant, Nick Srnicek and Graham Harman (Melbourne: re-press, 2011); Bruno Latour, *Pandora's Hope: Essays on the Reality of Science Studies* (Cambridge, MA: Harvard University Press, 2000); Jean-Luc Nancy, *Being Singular Plural* (Stanford: Stanford University Press, 2000). It is precisely this fascination with relationality that is opposed by the speculative realists; see Graham Harman, *Tool-Being: Heidegger and the Metaphysics of Objects* (Chicago, IL: Open Court, 2002); Quentin Meillassoux, *After Finitude: An Essay on the Necessity of Contingency* (London: Bloomsbury, 2010).

33 Ernst Cassirer, *Substance and Function; and Einstein's Theory of Relativity*, trans. W. C. Swabey and M. C. Swabey (Mineola: Dover Publications, 2003); Gaston Bachelard, *The New Scientific Spirit*, trans. A. Goldhammer (Boston: Beacon Press, 1984); Alfred North Whitehead, *Process and Reality: An Essay in Cosmology* (New York: The Free Press, 1985); Didier Debaise, *Un empirisme spéculatif: Lecture de Procès et réalité de Whitehead* (Paris: Vrin, 2006).

34 Debaise, "What is relational thinking?" 2.

35 Gotthard Günther has sketched a wide-ranging speculative history of rationality based on the history of machines and triggered by the emergence of cybernetics and transclassical machines. The transclassical age marks a new way of dealing with the proliferation of relations by means of logical and calculating technics, an approach that goes beyond the classic bi-valent philosophical politics of relations. On this point, see my "Das kybernetische Bild des Denkens," in *Die Transformation des Humanen: Beiträge zur Kulturgeschichte der Kybernetik*, ed. Michael Hagner and Erich Hörl (Frankfurt: Suhrkamp, 2008). The coming formation in the history of rationality described by Günther might well be called General Ecology.

36 Latour, *Inquiry into Modes of Existence*, 256.

37 Eduardo Viveiros de Castro, "Exchanging Perspectives: The Transformation of Objects into Subjects in Amerindian Ontologies," *Common Knowledge* 10 (3) (Fall 2004): 473 and 476.

38 I have shown elsewhere that this redefinition of the sense of relation assigns a more than prominent place to one specific type of relation, namely to participation; see "Other Beginnings of Participative Sense Culture: Wild

Media, Speculative Ecologies, Transgressions of the Cybernetic Hypothesis," in *ReClaiming Participation: Technology—Mediation—Collectivity*, ed. Mathias Denecke, Anne Ganzert, Isabell Otto, and Robert Stock (Bielefeld: Transcript, 2016). The concept of participation may be very old, and may in fact be constitutive of the occidental condition. For Plato *méthèxis* means a relation of resemblance between intelligible and sensible things, whereby intelligible things—the ideas—are all that is really true, eternal and self-identical, and are the source of sensible things, which merely participate in the ideas and are therefore afflicted by an ontological loss, hence presenting participation as an asymmetric relation. The philosophical politics of relation prioritizes a static being over dynamic becoming, thereby depicting participation as being directly responsible for the devaluation and secondary status of the relation as such. But the twentieth century has seen an unprecedented reconsideration and reassessment of the traditional concept on the basis of profound epistemological, media-historical, and technological-historical changes. Especially in the works of Lucien Lévy-Bruhl and Gilbert Simondon, the term underwent a complete reversal, or rather a radicalization, towards a thinking of a primary, original, primordial participation as essential relation, which precedes the constitution of its terms, namely the participating entities. For the first time participation is considered in the strictest possible way. This revaluation of participation opens up a non-philosophical politics of relation. Another relation of great importance in this regard is the relation of symbiosis, which is reevaluated for example within the framework of Lynn Margulis's theory of symbiogenesis or subsequently Donna Haraway's thinking of sympoiesis. See Donna Haraway, "Anthropocene, Capitalocene, Plantationocene, Chthulucene: Making Kin," *Environmental Humanities* 6 (2015): 159–65; and "Anthropocene, Capitalocene, Chthulucene: Donna Haraway in Conversation with Martha Kenney," in *Art in the Anthropocene*, ed. Heather Davis and Etienne Turpin (London: Open Humanities Press, 2015), 255–70.

39 Nigel Thrift, *Non-Representational Theory: Space, Politics, Affect* (London and New York: Routledge, 2008), 165.

40 Eduardo Viveiros de Castro, *Cannibal Metaphysics: For a Post-Structuralist Anthropology* (Minneapolis: Univocal, 2014), 160.

41 On "the mathematical," see Martin Heidegger, *What is a Thing?* trans. W. B. Barton and Vera Deutsch (Chicago: Regnery, 1968), 69–75, and Dieter Mersch, *Ordo ab chao—Order from Noise* (Zurich: Diaphanes, 2013). The mathematical, however, understood as a mathematical way of thinking, as calculating thinking, does not precede the technological, as Mersch claims, following the long logocentric tradition according to which technology as merely applied science is first of all mathematics, nothing but the material implementation and incarnation of a pre-existing mathematical mode of thought. Such a perspective ultimately misreads the historicity of mathematics, as displayed for example in the contemporary and thus technologically conditioned transition from a deductive to an inductive logic of computation and in the leaving behind of the axiomatic with the entry into what is a virulently algorithmic era. The discussion of a dominance

of the mathematical corresponds at its heart to Heidegger's antimodernist conceptualization of modernity, from which we evidently cannot escape. This figure is a central component and one of the driving forces in the history of the fascination with non-modernity. Inspecting the elements of a historical fascination involved in the anti-mathematical fervor clearly does not mean an uncritical commitment to mathematization.

42 The important question of the degree to which the complexity-theoretical understanding of relationality already conceptualized in the context of the Anthropocene corresponds to the revaluation of relationality in general ecology—and the degree to which its mathematical nature might obstruct this revaluation—would require an extensive investigation, which cannot be undertaken here. In particular, this would need to include a detailed reading of Edgar Morin's "écologie généralisée (*oikos*)," which he developed in *La Vie de la Vie* (1980), the second volume of his six-volume work, *La Methode*. This is something I will be undertaking elsewhere.

43 Serge Moscovici, *Essai sur l'histoire humaine de la nature* (Paris: Flammarion, 1968), esp. 95–110. What is at stake in the historicity of states of nature as described by Moscovici is not just the historicity of concepts of nature. On the historical semantics of the concept of nature, see Niklas Luhmann, "Über Natur," in *Gesellschaftsstruktur und Semantik*, vol. 4 (Frankfurt: Suhrkamp, 1999).

44 Moscovici, *Essai*, 76, 39–40.

45 James Beniger, *The Control Revolution: Technological and Economic Origins of the Information Society* (Cambridge, MA: Harvard University Press, 1986).

46 Beniger, *Control Revolution*, vi.

47 Heidegger was already quite aware of this. He speaks of "the cybernetic way of thinking" which consists in "calculat[ing] everything, which is, as a steered process" and in considering everything that resists such planning and control to be "a disturbing factor." See Martin Heidegger, "On the Question Concerning the Determination of the Matter for Thinking," trans. Richard Capobianco and Marie Göbel, *Epoché* 14 (2) (Spring 2010): 216. Cybernetic thinking in terms of control is the apex of "orderability [*Bestellbarkeit*]," which constitutes "the last phase in the history of the transformation of presence" (218). If one follows Jason Moore, it is in this manner that the capitalist organization of nature since its beginning in the long sixteenth century with the mobilizations of symbolic technologies that grounded it, implemented a paradigm of regulation, comprising a long-lasting enforcement of the ideal of control. See Jason W. Moore, "The Capitalocene. Part II: Abstract Social Nature and the Limits to Capital," published online at http://www.jasonwmoore.com/uploads/The_Capitalocene_Part_II_June_2014.pdf (accessed January 28, 2016).

48 Beniger, *Control Revolution*, 6.

49 Cf. Mark B. N. Hansen, "System-Environment Hybrids," in *Emergence and Embodiment: New Essays on Second-Order Systems Theory*, ed. Bruce Clarke and Mark B. N. Hansen (Durham: Duke University Press, 2009).

In a series of highly innovative and inspiring papers Hansen has elaborated what he calls "our originary environmental condition" that "has been brought into the open and made accessible through recent developments in technical distribution, which is also to say, in the technical infrastructure of environment." See Mark B. N. Hansen, "Engineering Pre-individual Potentiality: Technics, Transindividuation, and 21st-Century Media," *SubStance* 129 (41) (2012): 32–59, at 33. This work culminates in Mark B. N. Hansen, *Feed-Forward: On the Future of Twenty-First-Century Media* (Chicago: University of Chicago Press, 2015).

50 Philip E. Agree, in 1994, positioned the "capture model" against the "surveillance model" and elaborated on capture as a fundamental concept of Environmentality. See "Surveillance and Capture: Two Modes of Privacy," in *The New Media Reader*, ed. Nick Montfort and Noah Wardrip-Fruin (Cambridge, MA: MIT Press, 2003). See also Till A. Heilmann, "Datenarbeit im 'Capture'-Kapitalismus. Zur Ausweitung der Verwertungszone im Zeitalter informatischer Überwachung," *Zeitschrift für Medienwissenschaft* 13 (2015): 35–47. Economist Shoshana Zuboff has christened the new hypercybernetic market form that is based on the global architecture of computer mediation and that implements "a new logic of accumulation," "surveillance capitalism." According to her this new logic of accumulation is predicated on commoditized behavior modification, in other words: on the exploitation of behavior that has become possible due to the hyperscale extraction and analysis of data turning small data into big data. Means of production turn into means of behavioral modification. See Shoshana Zuboff "Big Other: Surveillance Capitalism and the Prospects of an Information Civilization," *Journal of Information Technology* 30 (2015): 75–89. For the algorithmic basis of Environmentality see Antoinette Rouvroy "The end(s) of critique. Data behaviourism versus due process," in *Privacy, Due process and the Computational Turn. The Philosophy of Law Meets the Philosophy of Technology*, ed. Mireille Hildebrandt and Katja de Vries (Abingdon: Routledge, 2013): 143–67.

51 Deleuze and Guattari, *A Thousand Plateaus*, 376.

52 Luciana Parisi and Erich Hörl, "Was heißt Medienästhetik? Ein Gespräch über algorithmische Ästhetik, automatisches Denken und die postkybernetische Logik der Komputation," *Zeitschrift für Medienwissenschaft* 8 (2013): 39.

53 Lovelock and Margulis's conceptualization of the Gaia hypothesis in the 1970s marks the beginning of what we might call the metacybernetic imagination of the world as a control entity. But while the Gaia hypothesis as such is marked all the way down by second-order cybernetics and is even closely related to the formation of its basic concepts, such as autopoiesis, as Bruce Clarke has shown in a number of great articles, the metacybernetic concept of the technosphere corresponds to our environmental control culture. See the chapter by Bruce Clarke in this volume, as well as *Earth, Life, and System: Evolution on a Gaian Planet*, ed. Bruce Clarke (New York: Fordham University Press, 2015).

54 Following Simondon, three stages or levels of technicity may be

distinguished: element (instruments, tools), individual (machines), ensemble (networks of machines). Haff's geologically inclined autonomization thesis, which introduces a fourth level of technicity with the technosphere, directly follows Langdon Winner, *Autonomous Technology: Technics-out-of-Control as a Theme in Political Thought* (Cambridge, MA: MIT Press, 1977). The autonomy of technics was already central to Jacques Ellul's *La technique ou l'enjeu du siècle* (Paris: A. Colin, 1954), which dedicates a whole chapter to just this problem.

55 Peter K. Haff, "Humans and Technology in the Anthropocene: Six Rules," *The Anthropocene Review* 1 (2) (August 2014): 2.

56 Peter K. Haff, "Technology as a Geological Phenomenon: Implications for Human Well-Being," in *A Stratigraphical Basis for the Anthropocene*, ed. C. N. Waters, J. A. Zalasiewicz, M. Williams, M. A. Ellis, and A. M. Snelling (London: Geological Society, 2014), 301–2.

57 On this point, cf. my "Other Beginnings of Participative Sense Culture."

58 Cf. Gilbert Simondon, *L'Invention dans les techniques: Cours et conférences*, ed. Jean-Yves Chateau (Paris: Seuil, 2005), 86–101.

59 Haff, "Technology as a Geological Phenomenon," 302; cf. 306.

60 Haff, "Humans and Technology in the Anthropocene," 7.

61 Ibid. The genesis of the technosphere is to be read together with what Timothy Morton calls a "quake in being" in the last stage of the evolution of technical objects, i.e., hyperobjects. Hyperobjects are real entities whose primordial reality—"massively distributed in time and space relative to humans" (1)—radically withdraws from the human being, and whose emergence entails the necessity of a new style of thinking and a non-modern conception of the thing in particular. See Timothy Morton, *Hyperobjects: Philosophy and Ecology after the End of the World* (Minneapolis: University of Minnesota Press, 2013).

62 Alf Hornborg has critically discussed the modern fetishization of technology, which culminates in faith in its autonomy, against the background of Wallerstein's world systems theory, as a forgetting of the unequal exchange relations which form the basis of all of modern technics. He postulates a global "ecological theory of the unequal exchange" as a critique of the modern fetishizing of technology. See "Technology as Fetish: Marx, Latour and the Cultural Foundations of Capitalism," *Theory, Culture and Society*, 31 (4) (July 2014): 119–40.

63 The concept of the Technocene has been proposed by Alf Hornborg among others. See Alf Hornborg, "The Political Ecology of the Technocene. Uncovering Ecologically Unequal Exchange in the World-system," in *The Anthropocene and the Global Environment Crisis: Rethinking Modernity in a New Epoch*, ed. Clive Hamilton, François Gemenne, and Christophe Bonneuil (Abingdon: Routledge, 2015), 57–69.

64 Hans Blumenberg, "Lebenswelt und Technisierung unter Aspekten der Phänomenologie," in *Wirklichkeiten in denen wir leben* (Stuttgart: Reclam, 1981), 7–54.

65 This is why the question of media and technology marks the boundary of

phenomenology and can only ever be post-phenomenological, if and where it comes under the purview of phenomenology at all. On Husserl's politics of sense, see my "Die technologische Sinnverschiebung," in *Medien denken*, ed. Jiri Bistricky, Lorenz Engell, and Katerina Krtilova (Bielefeld: Transcript, 2010). On the question of the technical in transcendental phenomenology, see Bernard Stiegler, *Technics and Time 2: Disorientation*, trans. Stephen Barker (Stanford: Stanford University Press, 2008), as well as Jacques Derrida, *Edmund Husserl's* Origin of Geometry: *An Introduction*, trans. John P. Leavey (Lincoln, NB: University of Nebraska Press, 1989). On the project of post-phenomenology, see Mark B. N. Hansen, "Ubiquitous Sensation: Toward an Atmospheric, Collective, and Microtemporal Model of Media," in *Throughout: Art and Culture Emerging with Ubiquitous Computing*, ed. Ulrik Ekman (Cambridge, MA: MIT Press, 2013).

66 See Deleuze, *Difference and Repetition*, 129–67.

67 Jean-Luc Nancy, *A Finite Thinking*, ed. Simon Sparks (Stanford: Stanford University Press, 2003), 25–6 [translation modified].

68 See the detailed exposition in my article "The Artificial Intelligence of Sense," 11–24. Technology, undoubtedly, is the great agent and motor of the movement of the history of sense. Nancy already views the distinction between sense and technics from the other side of the caesura. From this point of view, the advent of sense already takes place through technics: the epoch of signifying sense and of endowing with meaning is the age of the subject whose labor and employment of tools and, later, simple machines mark its sovereignty in the sphere of technical culture and cultural technique. And its end, the unworking [*Entwerkung*] of signifying sense takes place through a proliferating machinism that points to the becoming of another kind of technicity. Transitioning from technical objects to assemblages and, finally, to the technosphere, this new technicity also implies a new kind of subjectivity that no longer endows with meaning and is no longer essentially non-technical. It is thus possible to distinguish between a pre-technological and technological culture of sense. Only a technological culture of sense fully acknowledges the genesis and validity of technicity, which has always had to make way for sense. While here, too, the difference between sense and technics still plays a decisive role, it is nonetheless dominated no longer by the side of sense but by the side of technics.

69 This also marks the boundary of the celebration of a purely symbolic world—a world that conceives of itself as already beyond meaning and claims to be, if not a thinking of machines and a machinism, then at least conceived in terms of machines, more precisely, cybernetic or computing machines, as is the case in Jacques Lacan or, even more so, in Friedrich Kittler. This celebration has undoubtedly accompanied the twilight of the traditional culture of sense, but it has not been able to stay on par with the next formation. The positing of a purely symbolic world as a world of the machine, the conception of everything machinic from the historical apex of a strict mathematical symbolism and formalism that manifests itself in the computer and can be implemented directly in the real thanks to the computer, still belongs to the rearguard action of the culture of meaning. In

its obvious fixation on the primacy of the signifier, it is even one of the most famous and therefore perhaps one of the most radical figures of the end of this culture—a kind of afterglow of the past culture of sense's fixation on language. See Friedrich A. Kittler, "The World of the Symbolic—A World of the Machine," trans. Stefanie Harris, in *Literature, Media, Information Systems: Essays*, ed. John Johnston (Amsterdam: GB Arts International, 1997). In *Die heiligen Kanäle: Über die archaische Illusion der Kommunikation* (Zurich: Diaphanes, 2005), I describe the historicity of this configuration in the history of sense, even if this earlier book is itself still a little fascinated by the purely symbolic. Lacan and Kittler develop their ideas in the wake of Heidegger's interpretation of computers and cybernetics from out of the spirit of a technological reformatting of language into information. According to Heidegger this formatting, in turn, is conceived of by a longstanding metaphysical interpretation of the essence of language as "giving signs" (rather than an originary "showing" and "letting appear"), which constitutes "its exposed surface [*Angriffsfläche*] and possibility." Heidegger famously opposes the total technologization of language, the "attack of technical language on what is authentic in language [*das Eigentliche der Sprache*]" and the "threat to the ownmost essence of the human being" it entails, with a different interpretation of language. Even if his hermeneutics of the world of technology operates on the extreme limits of the traditional culture of meaning and thinks a transition from out of it, it still remains within its framework. See Martin Heidegger, *Überlieferte Sprache und technische Sprache*, ed. Hermann Heidegger (St. Gallen: Erker Verlag, 1962), 23, 25.

70 Cf. for example Félix Guattari, "Escaping from Language," in *The Machinic Unconscious: Essays in Schizoanalysis,* trans. Taylor Adkins (Los Angeles: Semiotext(e), 2007). This originary focus is owed to Guattari's clinical practice in La Borde, which brought home to him the great multiplicity of non-linguistic assemblages of enunciation practically on a daily basis. Precisely this therapeutic experience formed an inexhaustible source of an unparalleled care for subjectivity which over time took on an ever more far-reaching set of political-diagnostic features. In the end Guattari came to understand the rearrangement of linguistic and non-linguistic assemblages of enunciation as the key moment in a therapeutic politics of subjectivity which, precisely because it was the offspring of his therapeutic experience, underpinned his ecosophical critiques of capitalism, media and technology. See Félix Guattari, *De Leros à La Borde* (Fécamp: Lignes, 2012).

71 Félix Guattari, *Chaosmosis: An Ethico-Aesthetic Paradigm*, trans. Paul Bains and Julian Pefanis (Bloomington: Indiana University Press, 1995), 9. Under the heading "machines of subjectivation," Guattari is explicitly concerned with discovering the "crucial" "non-human pre-personal part of subjectivity," with discovering nonhuman machines contributing to the production of subjectivity such as "the large-scale social machines of language and the mass media" (ibid.).

72 Ibid., 91. Guattari's repeated insistence, already found throughout *Anti-Oedipus*, that "[w]e need to free ourselves from a solitary reference to technological machines and expand the concept of machine so as to

situate the machine's adjacence to incorporeal Universes of reference" (31), does not contradict my reading here—quite the contrary. The concept of a technological culture of sense shows a way out of a purely technical conception and thinking of the machine that has become outmoded and redundant and instead brings out the consequences of a technicity that exceeds technical objects or, rather, objectivity as such. In other words, the expansion of the traditional concept of the machine in Guattari's machinism radically conceptualizes the technological displacement of sense towards a technoecological sense culture.

73 Lazzarato, *Signs and Machines,* 60, 92. The big question, of course, is whether there is a non-logocentric thinking of writing that could contribute to a *hermeneia* of the technological culture of sense. Following Deleuze and Guattari Lazzarato seems to reject all thinking of writing as an expression of the signifier's imperialism. Bernard Stiegler's pharmacological thinking of grammaticization, which leads to a general organology, undertakes to do just that. But does not Stiegler in turn come up against the limitations of the thinking of writing, for example where the affective is concerned, which he does not analyze convincingly but rather couches in terms of a Freudian doctrine of drives (even if, drawing on Herbert Marcuse and Donald Winnicott, he does elaborate this doctrine in the direction of a (techno) ecology of desire)? See my essay, "Prosthesis of Desire: On Bernard Stiegler's New Critique of Projection," *Parrhesia* 20 (2014): 2–14.

74 I would like to emphasize that Guattari in no way seeks to dispute the relevance of language as such; what he is concerned with is questioning its universality and its privileged status in determining modes of semiotization and assemblages of enunciation.

75 Lazzarato, *Signs and Machines,* 93.

76 Ibid., 60; Lazzarato quotes Guattari, *Machinic Unconscious,* 73.

77 Lazzarato, *Signs and Machines,* 72.

78 Cf. Lazzarato, *Signs and Machines,* 39.

79 See Félix Guattari, "The New Aesthetic Paradigm," *Chaosmosis,* 98–118.

80 Lazzarato, *Signs and Machines,* 66.

81 Félix Guattari, *Schizoanalytic Cartographies,* trans. Andrew Goffey (New York: Bloomsbury, 2012), 137, 2.

82 Guattari, *Cartographies,* 11; for a more detailed description of the (media-) technological conditions of this transformation, see ibid., 11–12.

83 Guattari, *Cartographies,* 11.

84 Cf. Angela Melitopoulos and Maurizio Lazzarato, "Machinic Animism," in *Félix Guattari in the Age of Semiocapitalism,* ed. Gary Genosko (Edinburgh: Edinburgh University Press, 2012). Let me note that this is the point at which Guattari is haunted by a fascination with non-modernity, a fascination that has become significant for contemporary thinking as a whole and, not least importantly, has left its mark in the general ecologization of thinking. Thus we read, for example: "And now it is Capital that is starting to shatter into animist and machinic polyvocity.

Would it not be a fabulous reversal if the old aboriginal African
subjectivities pre-Columbus became the ultimate recourse for the subjective
reappropriation of machinic self-reference? These same Negroes, these same
Indians, the same Oceanians many of whose ancestors chose death rather
than submission to the ideals of power, slavery and the exchangism of
Christianity and then capitalism?" (Guattari, *Cartographies*, 15). Guattari's
historical conception of assemblages of enunciation is undoubtedly one
of the sources of the current fascination with non-modernity. Yet there
is another reading that suggests itself, namely that it is less about exiting
modernity—which is essentially multilayered, despite what the anti- or
non-moderns would have us believe—than it is about exiting the regime
of the general equivalent, which for him, as we will see, constituted the
decisive vanishing point of the movement of ecologization.

85 Félix Guattari, "Capital as the Integral of Power Formations," in *Soft
 Subversions: Texts and Interviews 1977–1985*, trans. Chet Wiener and
 Emily Wittman (Los Angeles: Semiotext(e), 2009), 244. Picking up on
 Guattari's semiotization of the concept of capital, "Bifo" has outlined
 a theory of "semiocapitalism"; cf. Franco Berardi, "Schizo-Economy,"
 SubStance 36 (112) (2007): 76–85; Berardi, *The Soul at Work: From
 Alienation to Autonomy* (Los Angeles: Semiotext(e), 2009); Gary Genosko,
 "Guattari's Contributions to the Theory of Semiocapitalism," in *The
 Guattari Effect*, ed. Eric Alliez and Andrew Goffey (London and New
 York: Continuum, 2011); Gary Genosko, ed., *Félix Guattari in the Age of
 Semiocapitalism*, Deleuze Studies 6.2 (Edinburgh: Edinburgh University
 Press, 2012).

86 The question of the general equivalent returns repeatedly in Guattari.
 Capital, Being, energy, information, the signifier—all these he considers to
 be general equivalents and expressions of one and the same ethico-political
 option. They envelop, desingularize, close processes; cf., for example,
 Guattari, *Chaosmosis*, 109, 46.

87 Like the machinocentric world that follows it, capitalization in Guattari
 takes on a certain technical and medial form, from letterpress printing (and
 thus the regression of orality) via the steam engine to the manipulation of
 time by chronometric machines that erode natural rhythms and techniques
 of economic semiotization (money as credit); cf. Guattari, *Cartographies*,
 9–10. The entire first half of "The New Aesthetic Paradigm" is a bold
 sketch of the history of modes of semiotization summarized here in terms
 of a history of three types of assemblages: territorialized assemblages,
 deterritorialized capitalist assemblages, and finally processual assemblages.

88 Cf. Guattari, "Capital as the Integral of Power Formations," 244. A
 historical and systematic explication of the question of capital, modes
 of symbolization, and general equivalence within the framework of a
 theoretical numismatics can be found in Jean-Joseph Goux, *Symbolic
 Economies: After Marx and Freud*, trans. Jennifer Curtiss Gage (Ithaca:
 Cornell University Press, 1990).

89 Ibid., 255.

90 Ibid., 252.

91 Ibid., 254.

92 Ibid., 262. In *A Thousand Plateaus*, 456–8, Deleuze and Guattari schematize this grafting against the background of the difference between "machinic enslavement" and "social subjection." Accordingly, the "third age"—the age of "cybernetic and informational machines" that follows the archaic enslavement in the time of the megamachine analyzed by Mumford and social subjection in the time of technical machines—not only restores a general regime of machinic enslavement of the kind originally associated with archaic imperial constructs but integrates it with social subjection taken to the extreme in the form of contemporary subjectivity.

93 Félix Guattari and Eric Alliez, "Capitalist Systems, Structures and Processes," in *Soft Subversions* (Los Angeles: Semiotext(e), 2009), 273.

94 This view is already presented in *Anti-Oedipus: Capitalism and Schizophrenia*, trans. Mark Seem and Helen R. Lane (Minneapolis: University of Minnesota Press, 1983), 240–62.

95 Guattari himself assumed the coexistence of several capitalisms under the technological condition:

> Automatized and computerized production no longer draws its consistency from a basic human factor, but from a machinic phylum that traverses, bypasses, disperses, miniaturizes, and co-opts all human activities.
>
> These transformations do not imply that the new capitalism completely takes the place of the old one. There is rather coexistence, stratification, and hierarchalization of capitalisms at different levels, which involve:
>
> On the one hand, *traditional segmentary capitalisms*, territorialized onto Nation-States, and deriving their unity from a monetary and financial mode of semiotization.
>
> And on the other hand, *a World-Wide Integrated Capitalism*, that no longer rests on the sole mode of semiotization of financial and monetary Capital, but more fundamentally, on a whole-set of techno-scientific, macrosocial and microsocial, and mass media procedures of subjection. ("Capital as the Integral of Power Formations," 249–50)

The principles of general equivalency and "general translatability" (257) are the core of capital's semiotic operations.

96 Lazzarato, *Signs and Machines*, 84–5.

97 Félix Guattari, "The Place of the Signifier in the Institution," in *The Guattari-Reader*, ed. Gary Genosko (Oxford: Blackwell, 1996), 151.

98 Félix Guattari, *The Anti-Oedipus Papers*, ed. Stéphane Nadaud (Los Angeles: Semiotext(e), 2006), 225.

99 Félix Guattari, "Qu'est-ce que l'écosophie?"

100 On the epistemic and medial history of the concept "ecosystem," see Sharon E. Kingsland, *The Evolution of American Ecology 1890–2000* (Baltimore: Johns Hopkins University Press, 2005), 206–31. George Evelyn Hutchinson, a pioneer of research on ecosystems and one of Donna Haraway's teachers, participated in the Macy Conferences. Cf. also Bruce Clarke, "Mediations of Gaia," in *Neocybernetics and Narrative*.

101 Guattari, "The Ecosophic Project," *Chaosmosis*, 119–35, here 124.

102 Ibid., 124–5.

103 Ibid., 126.

104 Ibid., 127.

105 Félix Guattari, "On Machines," trans. Vivian Constantinopoulos, *Journal of Philosophy and the Visual Arts* 6 (1995): 8.

106 Ibid., 9, emphasis Guattari; compare Guattari, "Machinic Heterogenesis," *Chaosmosis*, 33–57, at 38.

107 Guattari, "On Machines," 9, original emphasis.

108 Deleuze, *Difference and Repetition*, 177.

109 See her work on the becoming-algorithmic of design in *Contagious Architecture: Computation, Aesthetics, and Space* (Cambridge, MA and London: MIT Press, 2013).

110 On the epistemic and media history of the primacy of symbolic machines, see Hörl, *Die heiligen Kanäle*, English translation forthcoming 2018.

111 Brian Massumi's scattered studies on Environmentality have now been collected in the volume, *Ontopower: War, Powers, and the State of Perception* (Durham: Duke University Press, 2015). "Ontopower" succeeds "biopower."

112 See Parisi, *Contagious Architecture*.

113 As early as the 1970s, Barry Commoner, in his *The Closing Circle: Nature, Man and Technology* (New York: Knopf, 1971) articulated one of his four laws of ecology as follows: "Everything is connected to everything else."

114 Bruno Latour, *We Have Never Been Modern*, trans. Catherine Porter (Cambridge, MA: Harvard University Press, 1993), 12.

115 Frédéric Neyrat, *Le communisme existentiel de Jean-Luc Nancy* (Fécamp: Lignes, 2013), 12.

116 Ibid., 55.

117 This criticism of Neyrat's thus goes in the same direction as Mark B. N. Hansen's criticism of the widespread conceptualizations of the contemporary technosphere that are fixated on hybridity: "To my mind, some conception of closure, however provisional and non-autopoietic it may turn out to be, is absolutely necessary to introduce differentiation into the undifferentiated flows of the contemporary technosphere" ("System-Environment Hybrids," 116). In her contribution to this volume, Elena Esposito, too, calls for sharpening, not blurring distinctions. For the question of the gap, spacing, and the original exposition to the outside see Jacques Derrida, *On Touching—Jean-Luc Nancy*, trans. Christine Irizarry (Stanford: Stanford University Press, 2005).

118 Cf. esp. Bernard Stiegler, "Allgemeine Organologie und positive Pharmakologie," in *Die technologische Bedingung: Beiträge zur Beschreibung der technischen Welt*, ed. Erich Hörl (Berlin: Suhrkamp, 2011), 110–46.

119 Cf. Bernard Stiegler, *What Makes Life Worth Living*, trans. Daniel Ross
 (Cambridge and Malden: Polity Press, 2013), 27–36. Canguilhem develops
 the conception of an unreliable environment in *The Normal and the
 Pathological*, trans. Carolyn R. Fawcett (New York: Zone Books, 1999),
 181–201. For my part, I develop the question of a general ecology in the
 spirit of Canguilhem's thinking of milieus in the article, "'Technisches
 Leben': Simondons Denken des Lebendigen und die allgemeine Ökologie,"
 in *Black Box Leben*, ed. Maria Muhle and Christiane Voss (Berlin: August,
 2016).

120 Canguilhem, *The Normal and the Pathological*, 198.

121 For a critique of the industrial metanarrative of the anthropocene discourse,
 see, for example, Jason W. Moore, "The Capitalocene. Part I: On the
 Nature and Origins of Our Ecological Crisis," published online at http://
 www.jasonwmoore.com/uploads/The_Capitalocene_Part_I_June_2014.pdf
 (accessed January 28, 2016), as well as his "The Capitalocene: Part II."

122 The background of the question of the Earth as it comes up here is less
 to be found in Heidegger's appeals to the earth than it is in Deleuze and
 Guattari's chaosmotic thinking of the earth as a struggle of forces, for
 example in the chapter "On the Refrain" in *A Thousand Plateaus*, 310–50.
 On this point, compare Erich Hörl, "Variations on Klee's Cosmographic
 Method," trans. Nils F. Schott, in *Grain, Vapor, Ray: Textures of the
 Anthropocene*, vol. 3, ed. Katrin Klingan, Ashkan Sepahvand, Christoph
 Rosol, and Bernd M. Scherer (Cambridge, MA and London: MIT Press,
 2014); Elisabeth Grosz, *Chaos, Territory, Art: Deleuze and the Framing of
 the Earth* (New York: Columbia University Press, 2008).

123 Jussi Parikka, *A Geology of Media* (Minneapolis: University of Minnesota
 Press, 2015), 16ff.

124 On the dissembling nature of the various anthropocene narratives, see
 the summary in Christoph Bonneuil, "The Geological Turn: Narratives of
 the Anthropocene," in *The Anthropocene and the Global Environmental
 Crisis: Rethinking Modernity in a New Epoch*, ed. Clive Hamilton, François
 Gemenne, and Christophe Bonneuil (Abingdon: Routledge, 2015).

125 Lewis Mumford, *Technics and Civilization* (London: Routledge & Kegan
 Paul, 1934), 74–7. Mumford also speaks of the birth of a "mining
 civilization" (153).

126 Even if there can be no doubt that Parikka is a pioneer of media geology, he
 is not the only one to choose this particular focus; see, e.g., Jennifer Gabrys,
 Digital Rubbish: A Natural History of Electronics (Ann Arbor: University of
 Michigan Press, 2011).

127 Moore, *Capitalism in the Web of Life*, 53.

128 Ibid.

129 Ibid.

130 See Esposito, "The Paradigm of Immunization," 45–77; compare
 Immunitas: The Protection and Negation of Life, trans. Zakiya Hanafi
 (Cambridge and Malden: Polity, 2011). Even though modernity does not
 invent the question of immunity, and all civilizations past and present have

been confronted with the problem of immunization and managed to solve it one way or another, Esposito insists on "a structural connection between modernity and immunization" ("The Paradigm of Immunization," 51). For him, it is in modernity that the logic of immunity becomes a historical force and shapes thought.

131 He has published the seminal accounts of, in particular, the genesis of the Gaia discourse we are interested here, a genesis that takes place in the context of systems counterculture. This work culminates in his chapter in the present volume. See Bruce Clarke, "Neocybernetics of Gaia: The Emergence of Second-Order Gaia Theory," in *Gaia in Turmoil: Climate Change, Biodepletion, and Earth Ethics in an Age of Crisis*, ed. Eileen Christ and H. Bruce Rinker (Cambridge, MA: MIT Press, 2009); "Steps to an Ecology of Systems: *Whole Earth* and Systemic Holism," in *Addressing Modernity: Social Systems and U.S. Cultures*, ed. Hannes Bergthaller and Christen Schink (Amsterdam and New York: Rodopi, 2011); "'Gaia is not an Organism': The Early Scientific Collaboration of Lynn Margulis and James Lovelock," in *Lynn Margulis: The Life and Legacy of a Scientific Rebel*, ed. Dorion Sagan (White River Junction: Chelsea Green, 2012); "Autopoiesis and the Planet," in *Impasses of the Post-Global: Theory in the Era of Climate Change*, vol. 2, ed. Henry Sussman (Ann Arbor: Open Humanities Press, 2012).

132 On its very cover, the first issue of *CoEvolution Quarterly* presents a counterimage to one of the foundational texts of the immunity paradigm, Thomas Hobbes' *Leviathan*.

133 Francisco Varela and Mark Anspach, "Immu-Knowledge: The Process of Somatic Individuation," in *Gaia 2: Emergence: The New Science of Becoming*, ed. William Irwin Thompson (Hudson: Lindisfarne Press, 1991), 69.

134 Ibid., 69, 81.

135 On this point, see the discussion of the history of relationality in the first part of this introduction.

136 On the question of symbiogenesis and the paradigm shift it triggered in evolutionary theory, see esp. Bruce Clarke, ed., *Earth, Life, and System: Evolution and Ecology on a Gaian Planet* (New York: Fordham University Press, 2015).

137 Scott F. Gilbert, Jan Sapp, and Alfred I. Tauber, "A Symbiotic View of Life: We Have Never Been Individuals," *The Quarterly Review of Biology* 87 (2012): 327. In this programmatic article, the symbiotic perspectivization of life serves to undermine the anatomical, embryological, physiological, immunological, genetic, and evolutionary definitions of the individual equally. Compare Erich Hörl, "'Technisches Leben.'"

138 Haraway, "Anthropocene, Capitalocene, Chthulucene," 260.

139 Compare Roberto Esposito, "The Enigma of Biopolitics," in *Bios: Biopolitics and Philosophy*, trans. Timothy Campbell (Minneapolis and London: Minnesota University Press, 2008), esp. 38–9.

140 Gregory Bateson, "Form, Substance and Difference," in *Steps to an Ecology of the Mind* (Chicago: University of Chicago Press, 2000), 455.

141 Georges Bataille, *The Accursed Share: An Essay on General Economy*, trans. Robert Hurley (New York: Verso, 1988).

142 Jacques Derrida, "From Restricted to General Economy: A Hegelianism without Reserve," in *Writing and Difference*, trans. Alan Bass (London: Routledge, 2001), 323. In note 4, I emphasized the sense-historical dimension of the constellation of Derrida's reading and the general-economic problematization of sense in general.

143 On the question of an originarily prosthetic-technological human being, see esp. David Wills, *Dorsality: Thinking Back Through Technology and Politics* (Minneapolis: University of Minnesota Press, 2008).

144 Cf. Ernst Haeckel, *Generelle Morphologie der Organismen, Bd. 2: Allgemeine Entwickelungsgeschichte der Organismen* (Berlin: Reimer, 1866), 286.

145 Georges Bataille, *Theory of Religion*, trans. Robert Hurley (New York: Zone Books, 1989), 13.

146 Ibid., 19. This is precisely where, just a few years later, Simondon's theory of individuation will come in, quash even this last possibility of strict immanence, and introduce the couple individual—milieu as a central conceptual persona of a thinking of physical individuation as well; cf. Hörl, "'Technisches Leben.'"

147 Bataille, *Theory of Religion*, 19–20, my emphasis.

148 Ibid., 27.

149 Ibid., 38.

150 Bataille's biochemical energetics, his appeal to the "general conditions of life" all the way to Vernadsky's conception of the biosphere, and the pervasive cosmoecological moments and backgrounds of general economy such as they culminate in "L'économie à la mesure de l'univers" (1946) all already suggest this archaeology of general economy.

151 See Hörl, "The Technological Condition."

152 Tim Ingold, "Building, Dwelling, Living: How Animals and People Make Themselves at Home in the World," in *The Perception of the Environment: Essays on Livelihood, Dwelling and Skill* (Abingdon and New York: Routledge, 2000).

153 Compare Nancy, *The Creation of the World*.

154 On the question of the thinking of adaptation, which has dominated the history of control since the nineteenth century and its reduction of the environmental problem, see the first part of the introduction above, as well as Hörl, "'Technisches Leben.'"

155 According to Esposito, the cybernetic conceptualization of environmentality took place largely via the three aspects that are the question of limits, the problem of control, the concept of feedback.

156 On the problems and conceptual challenges posed by the explosion in

environmental complexity, see also Bruce Clarke and Mark B. N. Hansen, eds., *Emergence and Embodiment: New Essays on Second-Order Systems Theory* (Durham: Duke University Press, 2009).

157 Jacques Derrida, *Specters of Marx: The State of Debt, the Work of Mourning and the New International*, trans. Peggy Kamuf (New York and London: Routledge, 2006), 10 and 63.

158 Louis Althusser, "The Underground Current of the Materialism of the Encounter," in *Philosophy of the Encounter: Later Writings, 1978–1987*, trans. and ed. G. M. Goshgarian (London: Verso, 2006).

159 Morton, "Ecologocentrism: Unworking Animals," 76.

160 Hyperobjects are objects that do not lend themselves to any phenomenological experience and instead envelop us, "things that are massively distributed in time and space relative to humans," they are "'hyper' in relation to some other entity, whether they are directly manufactured by humans or not" (Morton, *Hyperobjects*, 1). On the figure of the "strange stranger," see Morton, *The Ecological Thought*, where he picks up directly on Derrida's discussion of hospitality and the way it brings out the question of the stranger. Unconditional hospitality deconstructs the law and the logic of the home; it is an essential part of the general-economic and the general-ecological question equally, which demonstrates once more how much they are intertwined. Cf. Derrida, *Of Hospitality*, 24–5.

161 Guattari, *Chaosmosis*, 91, translation modified.

162 Ibid., 92

163 Ibid., 94.

164 Ibid.

165 Cf. Nancy, *The Sense of the World*, 22–6.

166 Deleuze, *Difference and Repetition*, 50–58, here 52.

167 Jean-Luc Nancy, "Nichts jenseits des Nihilismus," in *La pensée dérobée* (Paris: Galilée, 2001), 163.

168 One major impulse for grasping this transition and for the genesis of general-ecological thought came from *La Nouvelle Alliance* (Paris: Gallimard, 1979) by Ilya Prigogine and Isabelle Stengers.

169 Joseph A. Schumpeter, *Capitalism, Socialism and Democracy* (New York: Harper, 1942).

170 Eduardo Viveiros de Castro investigates the problem of production; see his *Cannibal Metaphysics*, 123–35, 159–71, as well as Michel Serres, *The Parasite*, trans. Lawrence R. Schehr (Minneapolis: University of Minnesota Press, 2007).

171 Catherine Malabou, *The Ontology of the Accident: An Essay on Destructive Plasticity*, trans. Carolyn P. T. Shread (Cambridge and Malden: Polity, 2012).

Bibliography

Agree, Philip E. "Surveillance and Capture: Two Modes of Privacy." In *The New Media Reader*, ed. Nick Montfort and Noah Wardrip-Fruin, 737–60. Cambridge, MA: MIT Press, 2003.

Althusser, Louis. "The Underground Current of the Materialism of the Encounter." In *Philosophy of the Encounter: Later Writings, 1978–1987*, trans. and ed. G. M. Goshgarian, 163–207. London: Verso, 2006.

Bachelard, Gaston. *The New Scientific Spirit*, trans. A. Goldhammer. Boston: Beacon Press, 1984.

Baecker, Dirk. *Studien zur nächsten Gesellschaft*. Frankfurt: Suhrkamp, 2007.

Bataille, Georges. *The Accursed Share: An Essay on General Economy*, trans. Robert Hurley. New York: Verso, 1988.

Bataille, Georges. *Theory of Religion*, trans. Robert Hurley. New York: Zone Books, 1989.

Bateson, Gregory. "Form, Substance and Difference." In *Steps to an Ecology of the Mind*, 454–73. Chicago: University of Chicago Press, 2000.

Bateson, Gregory. *Steps to an Ecology of Mind: Collected Essays in Anthropology, Psychiatry, Evolution, and Epistemology*. San Francisco: Chandler, 1972.

Beniger, James. *The Control Revolution: Technological and Economic Origins of the Information Society*. Cambridge, MA: Harvard University Press, 1986.

Berardi, Franco. "Schizo-Economy." *SubStance* 36 (112) (2007): 76–85.

Berardi, Franco. *The Soul at Work: From Alienation to Autonomy*. Los Angeles: Semiotext(e), 2009.

Blumenberg, Hans. "Lebenswelt und Technisierung unter Aspekten der Phänomenologie." In *Wirklichkeiten in denen wir leben*, 7–54. Stuttgart: Reclam, 1981.

Blumenberg, Hans. *Paradigms for a Metaphorology*, trans. Robert Savage. Ithaca: Cornell University Press, 2010.

Blumenberg, Hans. *The Genesis of the Copernican World*, trans. Robert M. Wallace. Cambridge, MA: MIT Press, 1987.

Bonneuil, Christoph. "The Geological Turn: Narratives of the Anthropocene." In *The Anthropocene and the Global Environmental Crisis: Rethinking Modernity in a New Epoch*, ed. Clive Hamilton, François Gemenne, and Christophe Bonneuil, 17–31. Abingdon: Routledge, 2015.

Braidotti, Rosi. "Powers of Affirmation." In *Nomadic Theory: The Portable Rosi Braidotti*, 267–298. New York: Columbia University Press, 2011.

Canguilhem, Georges. *The Normal and the Pathological*, trans. Carolyn R. Fawcett. New York: Zone Books, 1999.

Cassirer, Ernst. *Substance and Function; and Einstein's Theory of Relativity*, trans. W. C. Swabey and M. C. Swabey. Mineola: Dover Publications, 2003.

Clarke, Bruce and Mark B. N. Hansen, eds. *Emergence and Embodiment: New Essays on Second-Order Systems Theory*. Durham: Duke University Press, 2009.

Clarke, Bruce, ed. *Earth, Life, and System: Evolution and Ecology on a Gaian Planet*. New York: Fordham University Press, 2015.

Clarke, Bruce. "'Gaia is not an Organism': The Early Scientific Collaboration of Lynn Margulis and James Lovelock." In *Lynn Margulis: The Life and Legacy of a Scientific Rebel*, ed. Dorion Sagan, 32–43. White River Junction: Chelsea Green, 2012.

Clarke, Bruce. "Autopoiesis and the Planet." In *Impasses of the Post-Global: Theory in the Era of Climate Change*, vol. 2, ed. Henry Sussman, 58–75. Ann Arbor: Open Humanities Press, 2012.

Clarke, Bruce. "Neocybernetics of Gaia: The Emergence of Second-Order Gaia Theory." In *Gaia in Turmoil: Climate Change, Biodepletion, and Earth Ethics in an Age of Crisis*, ed. Eileen Christ and H. Bruce Rinker, 293–314. Cambridge, MA: MIT Press, 2009.

Clarke, Bruce. "Steps to an Ecology of Systems: Whole Earth and Systemic Holism." In *Addressing Modernity: Social Systems and U.S. Cultures*, ed. Hannes Bergthaller and Christen Schink, 260–88. Amsterdam and New York: Rodopi, 2011.

Clarke, Bruce. *Neocybernetics and Narrative*. Minneapolis: University of Minnesota Press, 2014.

Commoner, Barry. *The Closing Circle: Nature, Man and Technology*. New York: Knopf, 1971.

Debaise, Didier. "What is relational thinking?" *Inflexions* 5 (2011): 1–11.

Debaise, Didier. *Un empirisme spéculatif. Lecture de Procès et réalité de Whitehead*. Paris: Vrin, 2006.

Deleuze, Gilles and Félix Guattari. *A Thousand Plateaus: Capitalism and Schizophrenia 2.*, trans. Brian Massumi. Minneapolis and London: University of Minnesota Press, 1987.

Deleuze, Gilles and Félix Guattari. *Anti-Oedipus: Capitalism and Schizophrenia*, trans. Mark Seem and Helen R. Lane. Minneapolis: University of Minnesota Press, 1983.

Deleuze, Gilles. *Difference and Repetition*. New York: Columbia University Press, 1994.

Derrida, Jacques. "Faith and Knowledge: The Two Sources of 'Religion' at the Limits of Reason Alone," trans. Samuel Weber. In *Religion*, ed. Jacques Derrida and Gianni Vattimo, 1–78. Stanford: Stanford University Press, 1998.

Derrida, Jacques. "From Restricted to General Economy: A Hegelianism without Reserve." In *Writing and Difference*, trans. Alan Bass, 317–50. London: Routledge, 2001.

Derrida, Jacques. *Edmund Husserl's Origin of Geometry: An Introduction*, trans. John P. Leavey. Lincoln, NB: University of Nebraska Press, 1989.

Derrida, Jacques. *Of Hospitality*, trans. Rachel Bowlby. Stanford: Stanford University Press, 2000.

Derrida, Jacques. *On Touching—Jean-Luc Nancy*, trans. Christine Irizarry. Stanford: Stanford University Press, 2005.

Derrida, Jacques. *Specters of Marx: The State of Debt, the Work of Mourning and the New International*, trans. Peggy Kamuf. New York and London: Routledge, 2006.

Ellul, Jacques. *La technique ou l'enjeu du siècle*. Paris: A. Colin, 1954.

Esposito, Roberto. "The Enigma of Biopolitics." In *Bios: Biopolitics and Philosophy*, trans. Timothy Campbell, 13–44. Minneapolis and London: Minnesota University Press, 2008.

Esposito, Roberto. "The Paradigm of Immunization." In *Bios: Biopolitics and Philosophy*, trans. Timothy Campbell, 45–77. Minneapolis and London: Minnesota University Press, 2008.

Esposito, Roberto. *Immunitas: The Protection and Negation of Life*, trans. Zakiya Hanafi. Cambridge and Malden: Polity, 2011.

Foucault, Michel. *The Birth of Biopolitics: Lectures at the Collège de France, 1978–79*, ed. Michel Senellart, trans. Graham Burchell. Basingstoke: Palgrave Macmillan, 2008.

Fuller, Matthew and Andrew Goffey. *Evil Media*. Cambridge, MA and London: MIT-Press, 2012.

Gabrys, Jennifer. "Programming Environments: Environmentality and Citizen Sensing in the Smart City." *Environment and Planning D: Society and Space* 32 (1) (2014): 30–48.

Gabrys, Jennifer. *Digital Rubbish: A Natural History of Electronics*. Ann Arbor: University of Michigan Press, 2011.

Galloway, Alexander R. "The Cybernetic Hypothesis." *Differences: A Journal of Feminist Cultural Studies* 25 (2015): 107–31.

Genosko, Gary, ed. *Félix Guattari in the Age of Semiocapitalism*. Deleuze Studies 6.2. Edinburgh: Edinburgh University Press, 2012.

Genosko, Gary. "Guattari's Contributions to the Theory of Semiocapitalism." In *The Guattari Effect*, ed. Eric Alliez and Andrew Goffey, 115–33. London and New York: Continuum, 2011.

Gibson, James J. *The Ecological Approach to Visual Perception*. Hillsdale: Earlbaum, 1986.

Gilbert, Scott F., Jan Sapp, and Alfred I. Tauber. "A Symbiotic View of Life: We Have Never Been Individuals." *The Quarterly Review of Biology* 87 (2012): 325–41.

Goffey, Andrew. "Towards a Rhizomatic Technical History of Control." *New Formations* 84/85 (2014): 58–73.

Goux, Jean-Joseph. *Symbolic Economies: After Marx and Freud*, trans. Jennifer Curtiss Gage. Ithaca: Cornell University Press, 1990.

Grosz, Elisabeth. *Chaos, Territory, Art: Deleuze and the Framing of the Earth*. New York: Columbia University Press, 2008.

Guattari, Félix and Eric Alliez. "Capitalist Systems, Structures and Processes." In *Soft Subversions: Texts and Interviews 1977–1985*, trans. Chet Wiener and Emily Wittman, 265–77. Los Angeles: Semiotext(e), 2009.

Guattari, Félix. "Capital as the Integral of Power Formations." In *Soft Subversions: Texts and Interviews 1977–1985*, trans. Chet Wiener and Emily Wittman, 244–65. Los Angeles: Semiotext(e), 2009.

Guattari, Félix. "Escaping from Language." In *The Machinic Unconscious: Essays in Schizoanalysis*, trans. Taylor Adkins, 23–43. Los Angeles: Semiotext(e), 2007.

Guattari, Félix. "On Machines," trans. Vivian Constantinopoulos. *Journal of Philosophy and the Visual Arts* 6 (1995): 8–12.

Guattari, Félix. "Qu'est-ce que l'écosophie?" In *Qu'est-ce que l'écosophie?*, 71–9. Fécamp: Lignes, 2013.

Guattari, Félix. "The Place of the Signifier in the Institution." In *The Guattari-Reader*, ed. Gary Genosko, 148–57. Oxford: Blackwell, 1996.

Guattari, Félix. *Chaosmosis: An Ethico-Aesthetic Paradigm*, trans. Paul Bains and Julian Pefanis. Bloomington: Indiana University Press, 1995.

Guattari, Félix. *De Leros à La Borde*. Fécamp: Lignes, 2012.

Guattari, Félix. *Schizoanalytic Cartographies*, trans. Andrew Goffey. New York: Bloomsbury, 2012.

Guattari, Félix. *The Anti-Oedipus Papers*, transl. Kélina Gotman, ed. Stéphane Nadaud. Los Angeles: Semiotext(e), 2006.

Guattari, Félix. *The Three Ecologies*, trans. Ian Pindar and Paul Sutton. London: Continuum, 2008.

Haeckel, Ernst. *Generelle Morphologie der Organismen, Bd. 2: Allgemeine Entwickelungsgeschichte der Organismen*. Berlin: Reimer, 1866.

Haff, Peter K. "Humans and Technology in the Anthropocene: Six Rules." *The Anthropocene Review* 1 (2) (August 2014): 1–11.

Haff, Peter K. "Technology as a Geological Phenomenon: Implications for Human Well-Being." In *A Stratigraphical Basis for the Anthropocene*, ed. C. N. Waters, J. A. Zalasiewicz, M. Williams, M. A. Ellis, and A. M. Snelling, 301–9. London: Geological Society, 2014.

Hansen, Mark B. N. "System-Environment Hybrids." In *Emergence and Embodiment: New Essays on Second-Order Systems Theory*, ed. Bruce Clarke and Mark B. N. Hansen, 113–42. Durham: Duke University Press, 2009.

Hansen, Mark B. N. "Ubiquitous Sensation: Toward an Atmospheric, Collective, and Microtemporal Model of Media." In *Throughout: Art and Culture Emerging with Ubiquitous Computing*, ed. Ulrik Ekman, 63–88. Cambridge, MA: MIT Press, 2013.

Hansen, Mark B. N. "Engineering Pre-individual Potentiality: Technics, Transindividuation, and 21st-Century Media." *SubStance* 129 (41) (2012): 32–59.

Hansen, Mark B. N. *Feed-Forward: On the Future of Twenty-First-Century Media*. Chicago: The University of Chicago Press 2015.

Haraway, Donna. "Anthropocene, Capitalocene, Chthulucene. Donna Haraway in Conversation with Martha Kenney." In *Art in the Anthropocene*, ed. Heather Davis and Etienne Turpin, 255–70. London: Open Humanities Press, 2015.

Haraway, Donna. "Anthropocene, Capitalocene, Plantationocene, Chthulucene: Making Kin." *Environmental Humanities* 6 (2015): 159–65.

Harman, Graham. *Tool-Being. Heidegger and the Metaphysics of Objects*. Chicago, IL: Open Court, 2002.

Heidegger, Martin. "On the Question Concerning the Determination of the Matter for Thinking," trans. Richard Capobianco and Marie Göbel, *Epoché* 14 (2) (Spring 2010): 213–23.

Heidegger, Martin. *Überlieferte Sprache und technische Sprache*, ed. Hermann Heidegger. St. Gallen: Erker Verlag, 1962.

Heidegger, Martin. *What is a Thing?* trans. W. B. Barton and Vera Deutsch. Chicago: Regnery, 1968.

Heilmann, Till A. "Datenarbeit im 'Capture'-Kapitalismus. Zur Ausweitung der Verwertungszone im Zeitalter informatischer Überwachung," *Zeitschrift für Medienwissenschaft* 13 (2015): 35–47.

Hörl, Erich and Marita Tatari. "Die technologische Sinnverschiebung: Orte des Unermesslichen." In *Orte des Unermesslichen: Theater nach der Geschichtsteleologie*, ed. Marita Tatari, 43–63. Zurich: Diaphanes, 2014.

Hörl, Erich and Michael Hagner. "Überlegungen zur kybernetischen Transformation des Humanen." In *Die Transformation des Humanen: Beiträge*

zur Kulturgeschichte der Kybernetik, ed. Erich Hörl and Michael Hagner, 7–37. Frankfurt: Suhrkamp, 2008.

Hörl, Erich. "'Technisches Leben': Simondons Denken des Lebendigen und die allgemeine Ökologie." In *Black Box Leben*, ed. Maria Muhle and Christiane Voss, 241–68. Berlin: August, 2017.

Hörl, Erich. "A Thousand Ecologies: The Process of Cyberneticization and General Ecology," trans. James Burton, Jeffrey Kirkwood, and Maria Vlotides. In *The Whole Earth: California and the Disappearance of the Outside*, ed. Diedrich Diederichsen and Anselm Franke, 121–30. Berlin: Sternberg Press, 2013.

Hörl, Erich. "Das kybernetische Bild des Denkens." In *Die Transformation des Humanen: Beiträge zur Kulturgeschichte der Kybernetik*, ed. Michael Hagner and Erich Hörl, 163–95. Frankfurt: Suhrkamp, 2008.

Hörl, Erich. "Die technologische Sinnverschiebung." In *Medien denken*, ed. Jiri Bistricky, Lorenz Engell, and Katerina Krtilova, 17–35. Bielefeld: Transcript, 2010.

Hörl, Erich. "Other Beginnings of Participative Sense Culture: Wild Media, Speculative Ecologies, Transgressions of the Cybernetic Hypothesis." In *ReClaiming Participation: Technology—Mediation—Collectivity*, ed. Mathias Denecke, Anne Ganzert, Isabell Otto, and Robert Stock, 91–119. Bielefeld: Transcript, 2016.

Hörl, Erich. "Prosthesis of Desire: On Bernard Stiegler's New Critique of Projection." *Parrhesia* 20 (2014): 2–14.

Hörl, Erich. "The Artificial Intelligence of Sense: The History of Sense and Technology after Jean-Luc Nancy (by way of Gilbert Simondon)," trans. Arne De Boever. *Parrhesia* 17 (2013): 11–24.

Hörl, Erich. "The Technological Condition." *Parrhesia* 22 (2015): 1–22.

Hörl, Erich. "Variations on Klee's Cosmographic Method," trans. Nils F. Schott. In *Grain, Vapor, Ray. Textures of the Anthropocene*, vol. 3, ed. Katrin Klingan, Ashkan Sepahvand, Christoph Rosol, and Bernd M. Scherer, 180–92. Cambridge, MA and London: MIT Press, 2014.

Hörl, Erich. *Die heiligen Kanäle: Über die archaische Illusion der Kommunikation*. Zurich: Diaphanes, 2005.

Hornborg, Alf. "Technology as Fetish: Marx, Latour and the Cultural Foundations of Capitalism." *Theory, Culture and Society* 31 (4) (2014): 119–40.

Hornborg, Alf. "The political ecology of the technocene. Uncovering ecologically unequal exchange in the world-system." In *The Anthropocene and the Global Environment Crisis. Rethinking Modernity in a New Epoch*, ed. Clive Hamilton, François Gemenne, and Christophe Bonneuil, 57–69. Abingdon: Routledge, 2015.

Ingold, Tim. "Building, Dwelling, Living: How Animals and People Make Themselves at Home in the World." In *The Perception of the Environment: Essays on Livelihood, Dwelling and Skill*, 172–88. Abingdon and New York: Routledge, 2000.

Kingsland, Sharon E. *The Evolution of American Ecology 1890–2000*. Baltimore: Johns Hopkins University Press, 2005.

Kittler, Friedrich A. "The World of the Symbolic—A World of the Machine," trans. Stefanie Harris. In *Literature, Media, Information Systems: Essays*, ed. John Johnston, 130–46. Amsterdam: GB Arts International, 1997.

Kittler, Friedrich A. *Gramophone, Film, Typewriter*, trans. Geoffrey Winthrop-Young and Michael Wutz. Stanford: Stanford University Press, 1999.

Koselleck, Reinhart. *Futures Past: On the Semantics of Historical Times*, trans. Keith Tribe. Cambridge, MA: MIT Press, 1985.

Latour, Bruno. "To Modernize or to Ecologize? That's the Question." In *Remaking Reality: Nature at the Millenium*, ed. Noel Castree and Bruce Braun, 221–42. London and New York: Routledge, 1998.

Latour, Bruno. *An Inquiry into Modes of Existence: An Anthropology of the Moderns*, trans. Catherine Porter. Cambridge, MA: Harvard University Press, 2013.

Latour, Bruno. *Pandora's Hope. Essais on the Reality of Science Studies.* Cambridge, MA: Harvard University Press, 2000.

Latour, Bruno. *We Have Never Been Modern*, trans. Catherine Porter. Cambridge, MA: Harvard University Press, 1993.

Lazzarato, Maurizio. *Signs and Machines. Capitalism and the Production of Subjectivity.* Los Angeles: Semoitext(e), 2014.

Luhmann, Niklas. "Gesellschaftliche Struktur und semantische Tradition." In *Gesellschaftsstruktur und Semantik: Studien zur Wissenssoziologie der modernen Gesellschaft*, vol. 1, 9–71. Frankfurt: Suhrkamp, 1993.

Luhmann, Niklas. "Über Natur." In *Gesellschaftsstruktur und Semantik: Studien zur Wissenssoziologie der modernen Gesellschaft*, vol. 4, 9–30. Frankfurt: Suhrkamp, 1999.

Luhmann, Niklas. *Ecological Communication*, trans. John Bednarz, Jr. Chicago: University of Chicago Press, 1989.

Luhmann, Niklas. *Ökologische Kommunikation. Kann die moderne Gesellschaft sich auf ökologische Gefährdungen einstellen?* 1985. Wiesbaden: VS Verlag für Sozialwissenschaften, 2008.

Luke, Timothy W. "On Environmentality: Geo-Power and Eco-Knowledge in the Discourse of Contemporary Environmentalism." *Cultural Critique* 31 (1995): 57–81.

Malabou, Catherine. *The Ontology of the Accident: An Essay on Destructive Plasticity*, trans. Carolyn P. T. Shread. Cambridge and Malden: Polity, 2012.

Manning, Erin. *Always More Than One. Individuation's Dance.* Durham: Duke University Press, 2013.

Manning, Erin. *Relationscapes. Movement, Art, Philosophy.* Cambridge, MA: MIT Press, 2012.

Massumi, Brian. "National Enterprise Emergency: Steps Towards an Ecology of Powers." *Theory, Culture and Society* 26 (6) (2009): 153–85.

Massumi, Brian. *Ontopower: War, Powers, and the State of Perception.* Durham: Duke University Press, 2015.

Massumi, Brian. *Parables for the Virtual. Movement, Affect, Sensation.* Durham and London: Duke University Press, 2002.

Meillassoux, Quentin. *After Finitude: An Essay on the Necessity of Contingency.* London: Bloomsbury, 2010.

Melitopoulos, Angela and Maurizio Lazzarato. "Machinic Animism." In *Félix Guattari in the Age of Semiocapitalism*, ed. Gary Genosko, 240–49. Edinburgh: Edinburgh University Press, 2012.

Mersch, Dieter. *Ordo ab chao—Order from Noise.* Zurich: Diaphanes, 2013.

Moore, Jason W. "The Capitalocene. Part I: On the Nature and Origins of Our Ecological Crisis," Published online at http://www.jasonwmoore.com/uploads/The_Capitalocene_Part_I_June_2014.pdf (accessed January 28, 2016).

Moore, Jason W. "The Capitalocene. Part II: Abstract Social Nature and the Limits to Capital," Published online at http://www.jasonwmoore.com/uploads/The_Capitalocene_Part_II_June_2014.pdf (accessed January 28, 2016).

Moore, Jason W. *Capitalism in the Web of Life. Ecology and the Accumulation of Capital.* London and New York: Verso, 2015.

Morin, Edgar. *La méthode: Tome 2, La vie de la vie.* Paris: Points, 2014.

Morton, Timothy. "Ecologocentrism: Unworking Animals." *SubStance* 37 (117) (2008): 73–96.

Morton, Timothy. *Hyperobjects: Philosophy and Ecology after the End of the World.* Minneapolis: University of Minnesota Press, 2013.

Morton, Timothy. *The Ecological Thought.* Cambridge, MA: Harvard University Press, 2010.

Moscovici, Serge. *Essai sur l'histoire humaine de la nature.* Paris: Flammarion, 1968.

Mumford, Lewis. *Technics and Civilization.* London: Routledge & Kegan Paul, 1934.

Nancy, Jean-Luc. "Nichts jenseits des Nihilismus." In *La pensée dérobée*, 159–65. Paris: Galilée, 2001.

Nancy, Jean-Luc. "Of Struction," trans. Travis Holloway and Flor Méchain. *Parrhesia* 17 (2013): 1–10.

Nancy, Jean-Luc. *A Finite Thinking*, ed. Simon Sparks. Stanford: Stanford University Press, 2003.

Nancy, Jean-Luc. *Being Singular Plural.* Stanford: Stanford University Press, 2000.

Nancy, Jean-Luc. *Le sens du monde.* Paris: Galilée, 1993.

Nancy, Jean-Luc. *The Creation of the World, or, Globalization*, trans. François Raffoul and David Pettigrew. Albany: State University of New York Press, 2007.

Nancy, Jean-Luc. *The Sense of the World*, trans. Jeffrey S. Librett. Minneapolis: University of Minnesota Press, 1997.

Neyrat, Frédéric. *L'indemne: Heidegger et la destruction du monde.* Paris: Sens & Tonka, 2008.

Neyrat, Frédéric. *Le communisme existentiel de Jean-Luc Nancy.* Fécamp: Lignes, 2013.

Noys, Benjamin. *The Persistence of the Negative.* Edinburgh: Edinburgh University Press, 2010.

Parikka, Jussi. *A Geology of Media.* Minneapolis: University of Minnesota Press, 2015.

Parisi, Luciana and Erich Hörl. "Was heißt Medienästhetik. Ein Gespräch über algorithmische Ästhetik, automatisches Denken und die postkybernetische Logik der Komputation." *Zeitschrift für Medienwissenschaft* 8 (2013): 35–51.

Parisi, Luciana. "Technoecologies of Sensation." In *Deleuze/Guattari and Ecology*, ed. B. Herzogenrath, 182–99. Basingstoke: Palgrave, 2009.

Parisi, Luciana. *Contagious Architecture. Computation, Aesthetics, and Space.* Cambridge, MA: MIT Press, 2013.

Prigogine, Ilya and Isabelle Stengers. *La Nouvelle Alliance.* Paris: Gallimard, 1979.

Rouvroy, Antoinette. "The end(s) of critique. Data behaviourism versus due process." *In Privacy, Due Process and the Computational Turn. The Philosophy*

of Law Meets the Philosophy of Technology, ed. Mireille Hildebrandt and Katja de Vries, 142–167. Abingdon and New York: Routledge, 2013.

Schumpeter, Joseph A. *Capitalism, Socialism and Democracy*. New York: Harper, 1942.

Serres, Michel. *The Parasite*, trans. Lawrence R. Schehr. Minneapolis: University of Minnesota Press, 2007.

Shaviro, Steven. "The Actual Volcano: Whitehead, Harman, and the Problem of Relations." In *The Speculative Turn. Continental Materialism and Realism*, ed. Levi Bryant, Nick Srnicek, and Graham Harman, 279–90. Melbourne: re-press, 2011.

Simondon, Gilbert. *Du mode d'existence des objets techniques*. 1958. Paris: Aubier, 1989.

Simondon, Gilbert. *L'individuation à la lumière des notions de forme et d'information*. 1964 and 1989. Grenoble: Millon, 2005.

Simondon, Gilbert. *L'Invention dans les techniques. Cours et conferences*, ed. Jean-Yves Chateau. Paris: Seuil, 2005.

Souriau, Étienne. Du mode d'existence de l'oeuvre à faire." In *Les différents modes d'existence suivi de Du mode d'existence de l'oeuvre à faire*, 195–217. Paris: Presses universitaires de France, 2009.

Sprenger, Florian. "Architekturen des 'environment.'" *Zeitschrift für Medienwissenschaft* 12 (2015): 55–67.

Stiegler, Bernard. "Allgemeine Organologie und positive Pharmakologie," trans. Ksymena Wojtyczka. In *Die technologische Bedingung: Beiträge zur Beschreibung der technischen Welt*, ed. Erich Hörl, 110–46. Berlin: Suhrkamp, 2011.

Stiegler, Bernard. *Technics and Time 2: Disorientation*, trans. Stephen Barker. Stanford: Stanford University Press, 2008.

Stiegler, Bernard. *What Makes Life Worth Living*, trans. Daniel Ross. Cambridge and Malden: Polity Press, 2013.

Thrift, Nigel. *Non-Representational Theory: Space, Politics, Affect*. London and New York: Routledge, 2008.

Toscano, Alberto. *The Theatre of Production. Philosophy and Individuation Between Kant and Deleuze*. Basingstoke: Palgrave Macmillan, 2006.

Varela, Francisco and Mark Anspach. "Immu-Knowledge: The Process of Somatic Individuation." In *Gaia 2: Emergence: The New Science of Becoming*, ed. William Irwin Thompson, 68–85. Hudson: Lindisfarne Press, 1991.

Viveiros de Castro, Eduardo. "Exchanging Perspectives: The Transformation of Objects into Subjects in Amerindian Ontologies." *Common Knowledge* 10 (3) (Fall 2004): 463–84.

Viveiros de Castro, Eduardo. *Cannibal Metaphysics. For a Post-Structuralist Anthropology*, trans. Peter Skafish. Minneapolis: Univocal, 2014.

Whitehead, Alfred North. *Process and Reality: An Essay in Cosmology*. New York: The Free Press, 1985.

Wills, David. *Dorsality: Thinking Back Through Technology and Politics*. Minneapolis: University of Minnesota Press, 2008.

Winner, Langdon. *Autonomous Technology. Technics-out-of-Control as a Theme in Political Thought*. Cambridge, MA: MIT Press, 1977.

Zuboff, Shoshana. "Big Other: Surveillance Capitalism and the Prospects of an Information Civilization." *Journal of Information Technology* 30 (2015): 75–89.

CHAPTER TWO

Computational logic and ecological rationality

Luciana Parisi

The computational turn in architectural design has led to a new conception of nature, for which the idea of man-made structures has been surpassed by an investment in materially driven ecologies. Computational design is now concerned with the intelligence of materials, their capacity (or potentiality) to self-organize by changing over time. This attention to a bottom up *order of becoming* aims at "empowering matter in contemporary design"[1] and cannot be understood in isolation from a naturalization of logic, in which computation constitutes the ground of in-distinction between technology and matter.

Historically speaking, the development of computational design is associated with the epistemological paradigms of second-order cybernetics and interactive computation.[2] The last ten years have been characterized by a radicalization of the principles of biophysical self-organization involving a design thinking, which brings together evolutionary biology and non-standard geometry (or topology).[3] The use of digital modeling inspired by the Universal Turing Machine involved the manipulation of symbols to test results and deduce proofs for possible structures. In contrast, this neo-materialist approach, I would suggest, relies on inductive methods of reasoning, where data from the biophysical world is algorithmically reactivated to evolve spatio-temporal structures, which are, as it were, empirically derived from matter. This chapter argues that this naturalization of computation is an important instance of the ecological view of power.

Following Brian Massumi's diagnostic analysis of governance in terms of environmental order, this chapter discusses the advance of an ecological form of rationality (the naturalized logic of affective power), which feeds off its media-technological condition. The turn to computation in design is already part of an ecological rationality of governance defined by the technocapitalization of the indeterminate behavior of materials.

The increasing investment in biotechnology, nanotechnology, information technology and cognitive science points to a shift towards a dynamic rather than mechanical instrumentalization of nature. I use ecological rationality to describe the modus operandi of a logic no longer relying on deductive reason. Far from simply imitating the physical properties of matter, this rationality invests in their indeterminacy to generate conditions of affective governance. I suggest that computational materialism in design is the manifest image of a technocapitalist culture turning the mechanization of deductive reasoning into a dynamic logic of computation whose rules are established by the indeterminate potentialities of physical, biological, chemical behaviors and their complex interactions.

However, I propose that this shift implies at least two overlapping tendencies. On the one hand, environmental governance points to the end of a deductive model of rationality surpassed by an inductive—or as Massumi says an "affective" mode of governance (from the model of cognitive mapping to the activities of pre-emptive power). On the other hand, this technological form of governance involves the reduction of media to a meta-computational apparatus of data, algorithms, and programs, defining media as information systems.[4] Beneath these overlapping levels, however, this chapter argues, there is another, as yet unexplored consequence that concerns the transformation of computational logic and of a mode of reasoning involved in algorithmic processing. In what follows, I will draw on Alfred North Whitehead's notion of the speculative or metaphysical function of reason to argue that computational logic could instead pose a challenge to the totality of ecological rationality.[5]

This is an attempt to unpack the rupture between computational reason and ecological rationality. My argument about the semi-autonomy of computational reason (as part and parcel of a generic function of reason) derives from a concern with the cogent reality of data architecture and its algorithmic processing, which I argue can hardly be explained in terms of what is affectively lived, perceived, and thought. I suggest that the critique of ecological rationality embedded in the techno-computational strata cannot only be explained in terms of the affective response reflecting another naturalization of the artificial. If computational design exposes the naturalization of both computation and technomediatic governance, it also allows us to explore the historical configurations of computational logic within the larger scope of a speculative or metaphysical function of reason embedded in the actuality of algorithmic thinking.

The tendency towards the digitalization of nature is not new in design and can be traced back to the use of mathematical formulae and solutions in planning.[6] However, with the computational turn in design, the use of formulae has been replaced by the processing power of algorithms, their performative elaboration of data exceeding the a priori of axiomatic principles. The computational function of algorithms shows us that the deductive logic of truth and a priori axioms is unable to account for—and

to predict—contingent or external factors. The increasing use of large data volumes and distributive interactive systems in design has not only pointed to the limits of deductive logic (the general includes the particular) but also diffused the use of inductive methods of heuristic thinking (starting from the particular and proceeding by trial and error to arrive at the general) in which the realm of physical contingencies and not of mathematical formulae are said to be central to computation. If we read this shift to physicalism in computation as a symptom of a new logic of power, then it becomes evident that, as Massumi clearly argues, the chain of contingencies becomes the driving force for decision-making actions. Inductive reasoning is then complicit with the naturalization of computation and the emergence of an ecological rationality modeled upon the premise of indeterminacy. In particular, as evidenced in computational design, the indeterminacy of matter (and materials) to generate spatiotemporal forms has resulted in yet another idealization of physical structures, patterns, and complex behaviors.

While I suggest that inductive reasoning is central to a notion of computational nature, I also argue that ecological rationality can (and must) be questioned. The computation of matter's indeterminacy could be read as the advance of power's affective intelligence, whose actions, instead of being deduced from truths, are induced from the behavioral patterns of matter directly. This new level of equivalence between affect and reason reveals the paradoxical condition in which the technocapitalization of matter has led computational logic to become one with the physical indeterminacy of nature. This chapter is an attempt at unpacking this seamlessly paradoxical condition by arguing that the deductive limits of computation can rather be understood in terms of a transformation of the function of computational reason. I will discuss the computational mode of reason in terms of what Whitehead calls "non-sensuous" or "conceptual prehension" in so far as the algorithmic elaboration of data, I argue, partakes of a speculative, generic or metaphysical function of reason that moves through but cannot be contained by the biophysical layers of stratification central to ecological rationality. This chapter suggests that algorithmic processing is a form of reason that operates or becomes performative of a data environment through a prehensive synthesis, which mirrors neither the laws of physical nature nor the realm of mathematical order.[7] In particular, the function of rule-based processing will be discussed in terms of a speculative reason that complicates the model of both deductive and inductive processing of truths, and disentangles naturalized computation from an algorithmic mode of thought. My attempt at halving the unity of computational reason and naturalized technocapitalism is also an effort to re-address the notion of reason in terms of a generic speculative schema—constituted by rules, axioms, procedures—that are neither simply imparted nor proven by the world. Instead, as debates about the limits of the deductive model of computation in information theory suggest, rules can be bent and postulates can be revised, both according to contingencies occurring in data

processing, but also because computational processing stretches beyond given facts or data. In the history of information science, it is well known that the question of the incomputable (random or infinite strings of data) came to challenge the dominance of deductive axiomatic truths defining the universal function of finite rules according to a mechanistic view of nature. In the age of the algorithm, however, incomputables are no longer exceptions falling outside the remit of computational logic. On the contrary, the latter has surpassed its own deductive limits, and, contrary to today's claims, it cannot be explained in the biophysical terms of the material world. Instead, and this is my argument, computational reason needs to be investigated according to its internal pragmatism, its own generic performativity (or even evolution) of data through which hypotheses are generated, and initial premises are revised. If computational reason could be defined in terms of its own dynamics, it would be approached in terms of a productive instrumentalization of reason not simply espousing the project of capitalist rationality (both formal and ecological). This productive instrumentalization instead involves an engagement with the historical transformation of automated logic coinciding with the effort to theorize a generic model of artificial reason, defined by the formation of non-matching forms of intelligence—i.e., forms that cannot be naturalized into one univocal being.

This chapter suggests that divorcing computational logic from the technocapitalist naturalization of computation is a fundamental step for a speculative or metaphysical theorization of reason, that is, a generic architecture of reason that has infinite varieties of data environments and modes of abstraction. Computation, I would argue, is only one mode and the transformation of the logic of computation importantly reveals algorithmic actuality and its automated reason. This also means that computation needs to be disentangled from a totalizing notion of reason that ignores the artificiality of abstraction (or computation as a mode of abstraction) and its concrete structures of thinking. But how to engage with this mode of abstraction, which is accused of quantitatively reducing thought to a set of procedures without potentiality, chance and imagination? One way to do so may be to attempt to articulate a generic or speculative function of reason through a materialist approach that could explain the relation—and not the equivalence—between biophysical constraints and the artificiality of abstraction.

The final section of this chapter ("Speculative reason") draws on Alfred North Whitehead's brief excursus on the centrality of reason in the history of civilization, which is useful for our reconceptualization of computation because it explains that the function of reason involves the abstraction of causes from the physical chain of things. This involves counteracting the continuous process of causes and effects with a concrete abstraction of thinking. But why is a notion of speculative reason so important for counteracting the ecological rationality of technocapitalism today? Does it help us to move away from a totalizing technocapitalist naturalization

of computation in which information is said to derive from the energetic (affective) activities of matter? In short, can a speculative notion of computational reason go beyond ecological rationality?

These questions could be answered with concrete examples. However, more (or less) than offering specific cases to evaluate these points, this chapter argues that the becoming-environment of computation does not mean that computation is nature. Instead I will consider computation as an evolving mode of abstraction that reveals alien, intelligible capacities for processing incomputable data.

While, as Massumi illustrated, the neoliberal form of technocapitalist environmentalism has replaced deductive rationality with affective (nomo) logic, it is here contended that the reservoir of reason left to computation coincides neither with deductive logic nor directly with affective thought. Instead, its *alienness* remains a symptom of a non-mutual relation between ecological rationality and computational logic.

From this standpoint, this chapter suggests that it may not be sufficient to ask how and in what ways a notion of speculative reason in computation can help us to think what it may mean to live in an algorithmic environment. The alienness of automated reason rather involves the more fundamental problem of confronting the actuality of a non-sensible thought (algorithmic prehensions), amenable to neither logos (deductive rationality) nor affective thinking. The analysis of techno-mediatic computation thus requires a critical effort towards the articulation of automated reason.

What follows is an attempt to account for the function of computational reason, questioning the ontological equivalence (or mutual co-constitution) between the natural and the technical. I will discuss how computational design risks a renewed idealization of biophysical causes (and natural contingency) through the idealist conviction of an immediacy of computational logic and matter. The critique of deductive reasoning in computational design may thus risk falling into a crude materialism, in which the physical potentialities of material elements coincide with the primacy of aggregate causality (i.e., of indeterminate correlations). This view works to disqualify rather than explain the materiality of algorithms, their actual functions of extraction and abstraction of data, which are performative of a new order of finality leading to the production of rules on behalf of algorithms. Matter-oriented design seems to overlook the materiality of artificial data environments. Paradoxically, here, the acceleration of algorithmic automation has led to an anti-speculative approach to computation, in which the order of abstraction (and the intelligible processing of data) has been reduced to the fluctuating dynamics of matter.

I will now address first the use of deductive approaches in computational design, then discuss the shift to the dominant inductive designing of spatio-temporal structures.

Digital nature

The Milgo Experiment, also known as the AlgoRhythms Project, devised by architect morphologist Haresh Lalvani, exemplifies well the use of deductive logic in computational design.[8] Since 1997 Lalvani has been working with Milgo/Bufkin, a metafabrication company, to realize curved sheet-metal surfaces designed through digital programming. The development of the Morphological Genome is described as the search for a "universal code for mapping and manipulating any form, man-made or natural."[9]

The universal structures that form matter, for Lalvani, must be derived from simple genetic rules: cellular automata that specify a family of related parameters, with each parameter controlled by a single variable of form corresponding to a base in the DNA double-helix genome.[10] In other words, and in conformance with formal principles of computation, Lalvani believes that the infinity of all possible forms can be specified by a finite number of morph genes.[11] Lalvani's model of a continuously generating morphological genome embraces the deductive logic of a digital metaphysics, according to which cellular automata and discrete entities are universal codes from which it is possible to deduce, just like with DNA, an infinite variety of processes that enable the generation of new form. Lalvani's use of algorithmic architecture is not too far removed from the fundaments of so-called digital philosophy, according to which digital or discrete codes are the kernel of physical complexity: code is ontology, that is, and finite sets of algorithms are the axioms upon which it is possible to build any complex world.

According to digital philosopher Edward Fredkin, all physics can be explained through the simple architecture of cellular automata, or discrete entities that form a regular grid of cells, existing in a finite number of spatiotemporal states.[12] According to this digital view of physics, the universe is a gigantic Turing cellular automaton: a universal machine that can perform any calculation and program any reality through a finite number of steps. For Fredkin, cellular automata are the ground on which physics can be explained. The universe is digital and not continuous. Cellular automata or discrete units are the ground of nature. This digital conception of computational nature divides the Parmenidean infinitesimal continuum into finite small particles, or atoms, within which complexity is contained.

This deductive view however has been challenged by a bottom-up method in digital design. Architect Neil Leach, for instance, pointed out that the use of swarm intelligence challenged this view resting on the use of the discrete logic of fractals, L-systems, and cellular automata.[13] This meant that biophysical indeterminacy or the contingency of environmental factors had to be accounted for by computational modeling. By adapting an inductive form of reasoning in which environmental variations became a central factor in computation, digital design turned towards a

generative form of modeling, incorporating temporalities and championing the indeterminacy of biological systems.[14]

In the field of algorithmic architecture, one example of the adoption of inductive logic aiming to include contingency in digital modeling can be found in the works of architect Greg Lynn. His design takes inspiration from biophysical vector fields that involve the growth of an emerging algorithmic form.[15] Computational modeling here becomes an evolving system in constant coupling with the environment. Just as computational reason associated with cellular automata was attuned to first-order cybernetics and deductive logic, so too this view of computation involves notions of self-organization and interaction aligned to second-order cybernetics and its inductive reasoning. This shift, highlighting the centrality of interaction among agents, already constituted the germs of an ecological rationality in which computational systems are attuned to evolutionary dynamics.

Leach takes the 2008 design by Kokkugia of the Taipei Performing Arts Center as an example of swarm modeling, whereby interactive self-organizing multiagents define objects in terms of unity and the parts thereof, as being both one and many.[16] Here the parts of an object are conceived as semiautonomous agents able to evolve their own set of interactions with other objects without reproducing the same set of instructions. Similarly, changes are only dictated by the emergence of contingent solutions. This emphasis on self-organizing agents and partially interacting objects producing a whole bigger than its parts exposes second-order cybernetics' emphasis on the behavioral capacities of biophysical properties to coevolve over time. The inductive premises of computational design are thus defined by emergent and not preprogrammed properties of interactive algorithms. These premises seem to anticipate a holistic view of computation in which the multiagent swarming intelligence points to computational modeling as a variable whole. This holistic view, however, cannot help but reify the notion of a computational nature in which it is impossible to discern the continuity of biophysical complexity from the discrete character of computational abstraction. Ultimately, swarm models reveal that the temporal dynamics intrinsic in the biophysical environment of continuous interactions is the motor of computation. The next section will discuss the radicalization of this inductive form of reason in computational design.

Computational nature

The most powerful and challenging use of the computer ... is in the learning how to make a simple organization (the computer) model what is intrinsic about a more complex, infinitely entailed organization (the natural or real system).[17]

Moving away from computation as a form of symbolic representation of physical elements, the definition of so called "material computation" has radicalized the inductive method of reasoning, arguing that the biophysical world of matter already provides us with a model of computational processing.[18] From this standpoint, the elemental properties of materials and their generative rules constitute spatiotemporal structures in nature. Instead of following geometrical and mathematical patterns, this (hyper-inductive) vision of material computation aims to directly follow material processes of self-assembling that result from the interactive relations of loose elements. Physical computation corresponds to pattern formations in both living and nonliving nature driven by the analogical process of local interactions, giving rise to material self-organizing structures and behaviors.[19] Central to material computation is the question of design in nature. Against the Darwinian selection mechanisms, design is here explained in terms of physiological process and energy systems.[20] The transcendent model of natural selection based on rule-based design is replaced by an emergentist conception, whereby design is led by the inherent morphogenetic potential of material to grow and evolve into new structures. Material computation is concerned with immanent processing in which information has acquired an energetic pulse and has become itself a process *in-formation*. The scope is not simply to induce algorithmic processing by establishing a continuous feedback between programmed instructions and the biophysical environment. More radically, it involves an ontological merging of computational processing and physical process. This radicalization of inductive reasoning problematically implies a naturalization of computation, claiming that the potentialities of biophysical substrates are now central to what can be constructed, thus ultimately dissolving any binarism between thought and things, concepts and objects.

This approach in design offers us an entry point to this ontologization of computational nature. For instance, architect Achim Menges' project ICD/ITKE Research Pavillion realized at the University of Stuttgart is conceived as a "bending-active structure" in which the feedback between computational design, advanced simulation and robotic fabrication is set to explain how the material behavior of wood coincides with a complex performative structure.[21] Instead of relying on high-tech equipment that could simulate or activate material, Menges points out that the responsiveness of material is embedded in the computational capacities of the material itself.[22] This approach involves a direct manipulation of the material and "the physical programming of humidity-reactive behavior of these material systems," which leads to "a strikingly simple yet truly ecologically embedded architecture in constant feedback and interaction with its surrounding environment."[23]

These challenging bio-technical structures are understood in terms of intensive aggregation (not partes extra partes but an intrinsic self-differentiation of parts), explaining how the overall system behavior results from

the interaction of loose elements. Aggregates are thought to be able to "materially compute their overall constructional configuration and shape as spatiotemporal behavioural pattern."[24] Computation coincides here with the continuous integration between material, form and performance, in which material systems' performative capacity is, as it were, enacted again. From this standpoint, the computational qualities of nature are here doubled, expanded and regenerated. While material computation is a radical step away from formal logic and symbolic language, it involves a radical attempt at integrating computation with matter, not only because it aims to re-enact computation in nature, but because it reveals the computation of materiality itself. "Inspired by nature's strategies where form generation is driven by maximal performance with minimum resources through local material property variation," material computation proposes to "analyse model and fabricate objects, with non-binary continuously heterogeneous properties designed to correspond to multiple and continuously varied functional constraints."[25] This new level of designing matter is already instantiated by "rapid prototyping and manufacturing": one of the many attempts to use material computation to establish an economical / ecological way of minimizing energy expenditure, resources, and environmental impact.[26] The tendency of material computation therefore is not simply motivated by a reproduction of the computational processing of information found in nature. Instead, the radicalization of inductive reasoning here implies that the computation already found in biological, physical, and chemical systems explains that aggregate material properties constitute design. Differently from the crude empiricism of biomimetics, for which the natural order of design is reproduced and optimized in the development of nature-like structures, this new convergence of computation and materiality instead conceives of what is given in nature in terms of potentialities or indeterminacy. In other words, it is indeterminacy and not the already measured value of physical, biological, chemical processing of data that explain the tendency of nature to become more than what it is. This form of computation aims to explain an eco-logical order of nature. Ecology here involves not an (associationist) interaction of parts, but the capacities of the environment, defined in terms of a multiplicity of interlayered milieus or localities, to become generative of emergent forms and patterns.

Materialist computation specifically draws on the work of biologist Jakob von Uexküll, offering an ecological conception of space defined in terms of an immanent condition of subjective experience.[27] In particular, his theory of the *Umwelt* ("surrounding world" or "environment") explains natural design as intrinsic capacities of all human and nonhuman elements to feel and sense. Here the signaling processing (the transmission of information) or the interaction of perceptual and sensual signs is the condition for the activity of a selective mechanism continuously shaping and unleashing the capacities of organisms to transform and be transformed by the

environment.[28] The philosophy of Von Uexküll rejected Darwin's theory of natural selection because it excluded the inner worlds of animals and their capacity to act upon and become co-constituted with their physical environments. Here, environments uniquely afford the internal capacities to generate new functions and behaviors.[29] Von Uexküll's ethological study of the environment as a fundamental factor in the constitution of beings explains not the optimization of species but the emergence of new patterns, orders, configurations. No longer deduced from finite sets of rules, but rather hyperinduced by the potentials of local interactions, allowing for a constant transformation of energy into information, this ecological view of computation defines the primacy of ever-evolving relations over a static order of matter. While this approach is now central to computational design, I argue that it also instantiates the complex constitution of an ecological rationality in contemporary power.

Ecological rationality

Brian Massumi argues that the contemporary regime of power could be understood in terms of an *environment autonomous activity* operating through the regulation of effects rather than of causes.[30] In particular, he develops Michel Foucault's insights about the environmental qualities of power defined not by formal rationality (transcendent law), but by inductive or local responses to governability, involving the performativity (evaluation, selection, ordering) of external variations and the establishment of general codes of conduct. Following Foucault, Massumi suggests that Environmentality works through the "regulation of effects" rather than the re-establishment of causes, and must remain operationally "open to unknowns."[31] Massumi investigates the form of rationality involved in the calculation of risks and suggests that within a global mode of operative power, rationality is surpassed and replaced by an affective field.[32] The questions "What order is this? Does it still have the rationality of a system?"[33] point to the affective reconfiguration of the order of biopower.

For Massumi, this new order involves naturalization or naturing nature[34]—a concept that needs to be redefined away from any categorical opposition to the artificial because it operates in a zone of logical and ontological indistinction between nature and culture. Here the environment is not One un-adulterated given, but "indeterminacy" driven by interconnected levels of complexity, comparable to the intricate unpredictability of weather systems, for instance.[35] Massumi explains that nature now coincides with the primacy and the immanent reality of the accident—with indeterminate indeterminacy. But to understand this nuanced naturalization of power, Massumi suggests that it is necessary to develop a concept of "naturing nature coming to cultivation."[36] Here nature is at once

produced and presupposed, induced and deduced, active and passive. This concept describes the constant correlation that constitutes the environmental processing of interlayering *strata* from which an ongoing emergence of patterns is—as it were—*excarnated* from the "biosphere or noosphere." This ecological interdependency among layers involves, for Massumi, a notion of "auto-conditioning" of naturing nature moving across scales and milieus. Naturing nature can also be understood in terms of an *involutive* (non-linear) process defined not by gradual steps but by intensive temporalities.[37] Instead of the laws of nature deduced to explain the emergence of patterns, the machinic operations of a naturing nature involve a radicalization of inductive forces in which unknown effects are driving forces, a quasi-causal motor of power. Borrowing from Gilles Deleuze, one could understand this radicalization in terms of "transcendental empiricism."[38] The continuity of affects involves the temporal anticipation of potentiality, which Massumi understands in terms of *preemption*.[39] This implies not a rational logic aiming at repressing the future through the pressures of the past, but more precisely a future-oriented logic entering the achronological fullness of time, absorbed by the affective experience of duration. This temporal performativity can no longer be defined according to Jameson's critique of cognitive mapping—a critique of a deductive rationality grounded in representation or conceptual framing of matter. Instead, ecological power involves an inductive logic of effects that are generative of infinite aggregations without primary cause.

If material computation in design is an instance of this form of ecological rationality, where power does not simply instrumentalize nature, but cultivates nature and anticipates its becomings, how can a critical conception of computation—or automated mode of reason—avoid the trap of technocapital naturalization? In order to develop a notion of reason away from the technocapitalist naturalization of matter's behavior, it seems urgent to explore the computational and philosophical limits of deductive and inductive reasoning. If the deductive logic of technocapitalist naturalization involved the rational application of truth to the world through transcendent laws and rules, the technocapitalist adaptation of inductive logic rather implies that the truth becomes one with the lived world. Here reason becomes immersed in the capacities of a body to feel and make intuitive decisions rather than follow sequential, logical steps. While this ecological form of rationality explains what is at stake with technocapitalist naturalization today, it discards the historical transformation of automated logic.

As discussed in the next section, the transformation of theories of computational logic highlights the existence of blind spots within a seemingly totalizing ecological rationality. I will attempt to develop a theory of algorithmic thought in terms of a speculative notion of reason by arguing that the intelligible capacities of algorithms to transform randomness into information patterns exceed the ecological rationality of capital. Borrowing from Alfred North Whitehead's discussion of the speculative function of

reason, the next section will also address the limits of both deductive and inductive logic to account for how thinking operates. It will be suggested that beyond the tension between affective (or inductive-empirical) and rational (deductive-representational) logic, it is possible to discuss computation in terms of physical (efficient cause) and conceptual prehensions (final cause).[40] If the ecological rationality of capital exposes the univocity of nature and culture through the centrality of affective thought, then the turn to computation may offer us a way to discuss the emergence of intelligible activities that challenge the ecological self-generation of being and thought. It will be suggested that Whitehead's notion of speculative reason may be a productive starting point for a materialist approach to computation concerned not with re-enacting the computational qualities of nature, but with engaging with the intelligible tendencies of algorithms to process infinite varieties of infinite data.

Speculative reason

This final section will help clarify how and to what extent it is possible to approach computational logic without reducing its operations to technocapitalist governance. My attempt at specifically theorizing the computational function of reason wants to suggest that this is not naturalizable insofar as it has fundamentally developed through the artificial construction of data-environment, and because it involves an algorithmic order of intelligibility—an alien reason—intrinsic to the actual processing of data. Importantly, the articulation of a computational function of reason requires a theoretical engagement with the problem of the limit of computability, which has also been discussed in terms of randomness, incomputability or the famous "halting problem."[41]

While this classic question of the limit of computability has been exhaustively addressed in the history of computational theory, Gregory Chaitin's quest for Omega, or for an algorithmic pattern of randomness, seems to offer us one of the most promising views about the hypothesis that algorithmic procedures are not merely instruments of elaboration of primary data.[42] Instead, one could argue that they can also be understood in terms of their prehensive activities of recording, storing, selecting, and elaborating patternless data. Chaitin's views importantly contribute to the development of a theory of computation concerned with the transformation of automated logic. In particular, his renewed engagement with the mathematical theory of information (especially the emphasis on the ratio between meaningful patterns and noise) and the problem of entropy (the measure of chaos) in a communication system offers us the opportunity to consider the issue of the limit of computation in terms of a historical realization of the limit of logic in the first place. Chaitin's long-term study of the problem

of randomness in information theory is based on a specific notion of entropy, which he understands in terms of irreversibly increasing volumes of information generated at the input-output levels of computation.[43] Bringing together Alan Turing's question of the limit of computability with Claude Shannon's information theory, Chaitin tackles the question of indeterminacy in computation by demonstrating how randomness (noise or incompressible quantities of data) is rather central to computation.[44] For Chaitin, computation corresponds to the algorithmic processing of maximally unknowable probabilities. In every computational process, he explains, the output is always bigger than the input: something happens in the processing of data that breaks the equilibrium between input and output. Chaitin calls this phenomenon algorithmic randomness.[45]

The notion of algorithmic randomness implies that information cannot be compressed into a smaller program, insofar as between the input and the output there emerges an entropic tendency of data to increase in size (i.e., involving an increase in patternless information within the system). Chaitin explained the discovery of algorithmic randomness in terms of a rule-based processing that no longer follows the approach of deductive logic for which results are already contained in their premises. During the 1990s and 2000s, Chaitin identified this problem in terms of the limits of deductive reason. He claimed that the problem of the incomputable defining results that could not be predicted in advance by the program are to be explained in terms of "experimental axiomatics," a postulate or decision immanent to the patterns evolving in the algorithmic processing of primary data.[46] The increasing quantity of patternless information, emerging from within computational processing, points to a dynamics internal to algorithmic operations, whereby patterns are consequent to the synthetic relation between algorithms and data.

However, this dynamic is not derived from or induced by the biophysical activities of the environment, but operates within the data environment itself, according to which automated logic involves neither deductive (a priori rules) nor inductive (biophysically driven) reasoning. This is also to argue that to reject ecological rationality and its technonaturalized governance, we need to develop a new critical view of computation. One step towards the articulation of this view involves the enlargement of the question of automated logic through the theorization of a speculative function of reason, which, as will become clearer later, could account for the elaboration of generic rules from the prehensive elaboration of materially embedded data. Here the analysis of the historical transformation of computational logic as demonstrated by Chaitin's method of "experimental axiomatics" is paramount. This means that computational logic can no longer be critically rejected because of its limited formal, symbolic order of reason, syntactically working to achieve arbitrary connections between units / bits of data. Similarly, automated logic and rule-based reasoning cannot simply be jettisoned in favor of locally induced inputs. I have discussed earlier the

predominance of these two models in computational design, particularly marking the shift from the model of cellular automata to aggregate causality in material computation. This historical shift however has to be accompanied by a theoretical reconceptualization of computational logic, and, I propose, it needs to be re-examined through Whitehead's argument for a speculative function of reason (as discussed later in this section).

Similarly, one cannot overlook the increasing concreteness of data environments embedding the abstraction of social, economic, cultural, as well as physical data and constituting artificial socio-cultural environments whereby the relation among algorithms and between algorithms and data leads to the formation of socio-cultural generic patterns, rules and laws. This level of environmental artificiality cannot be explained in terms of the affective mechanisms of technocapital communication. These automated relations produce a surplus of information in which algorithms have acquired intelligible—or conceptual—functions revealing an order of decision incompatible with the effective avalanche of affective response. Instead this order reveals the establishment of algorithmic patterns of patterns elaborated through the physical and conceptual prehensions of computational data environments.

Beyond ecological rationality and the technocapitalist imaginary of a holistic enviromentality, it may be possible to argue for the "actuality" of data environments that explains the constitution of an artificial world equipped with its own notations, functions, physicality and conceptuality. This also implies the formation of a post- or neo-cybernetic phase of epistemological production in which data environments do not simply represent socio-cultural codes of conduct, but more importantly through a process of physical prehension they acquire an algorithmic order of intelligibility out of which socio-cultural rules are re-established (and re-visioned) because they are embedded in the use of techno-computational language.

As opposed to ecological rationality betting on the technocapitalization of affective thinking, data environments do not only execute instructions but also are physically and conceptually prehended to elaborate patterns at the limit of computational processing. This computational processing of data importantly points to the intelligible prehension of physical data that could create concepts or rules from a vast amount of patternless data. This process of elaboration of data into rules is what may characterize a data environment beyond the mathematical logic of deduction—establishing a formal or representational schema—and the empirical method of induction—establishing an experiential relativity of localized responses. A theory of automated reason may therefore show us the inconsistency of ecological rationality and its media-technological situation, which seems to offer us an opportunity to re-invent a critique of computation beyond the holistic history of technocapitalism. From this standpoint, computation is not equivalent to naturing nature, but involves a form of intelligibility able to use algorithmic processing to add a generic order of axioms, codes,

and instructions to what was initially programmed. Programming here corresponds to the calculation of complexity-by-complexity, exceeding programming itself.

If axioms are becoming experimental truths, able to postulate unknowns, computation too may need to be conceived in terms of experimental determinations or intelligibility prehending unknowns and contributing to a process of revising initial conditions.[47] I suggest that this experimental (i.e., a priorly improvable) processing of data can be understood in terms of Whitehead's prehension because it involves a process of elaborating data, implying a consequent finality added to what was already programmed. According to Whitehead, prehension involves the physical and conceptual modes of selecting and evaluating data and thus the registering, storing, and processing of existing data. This notion of prehension importantly implies that the function of reason is not to mentally map physical data, but to transform—in counter-intuitive manners—physically prehended data, by adding a level of finality to the physical order. Prehension, in other words, corresponds not only to the physical mechanics of registering data and using their existing functions, but more importantly it implies a process of abstraction, or a conceptual elaboration of data, unfolding another level of function able to establish or not generic rules and articulating logic. This prehensive process explains that the function of reason is not mainly to represent what is physically sensed (or even to re-potentialize sense data). More importantly, it concerns the capacity to reset and redirect the scopes of inputted data according to what can be conceptually achieved through the conjunction and disjunction of patterns, involving the construction of hypotheses that agree or not with given conditions.

From this standpoint, the centrality of randomness or the entropic tendency of information to increase in size, resulting in an output that is bigger than the input, implies that algorithmic prehension involves the activation of reasoning leading to the experimental (non-a priori) establishment of rules. The generation of a bigger output can be understood in terms of an experimental intelligibility internal to computation able to surpass the limits of its deductive premises. Alfred North Whitehead's theory of speculative reason could explain computational processing as a capacity to both surpass and bring forward deduction and induction, truth and fact as parts of its experimental axiomatics.[48] This requires addressing algorithmic intelligibility in terms of hypothesis generation in which the data environments constitute the material (non-discursive) level, which is physically and conceptually prehended by algorithms, in turn establishing an automated function of reason defined by the propensity towards the generation of rules. Algorithmic intelligibility can be explained in terms of the speculative function of reason insofar as it involves the emergence of a generic form of process or algorithmic abstraction, which is embedded in the data environment that it retrieves and through which it elaborates an order of rules beyond deductive schema.

From this standpoint, I suggest that the development of material computation in design shall not be mainly concerned with the notion of aggregate causality (efficient causality) coinciding with the complexity of physical causes, leading to the elimination of rule-based processing. More importantly, in order to disentangle the computational environment from the technocapital naturalization of computation, we may need to unpack the order of conceptual elaboration and of experimental logic within computation.

This is to say that algorithms are not simply the computational version of mathematical axioms, but are to be conceived as actualities, self-constituting composites of data, which is at once recorded and elaborated beyond its primary condition. As Whitehead explains, at a primary level of reality there are only actualities and nexuses of actuals.[49] These composite actualities are comprised of physical and conceptual data. From a chemical element to an idea, actualities are constituted by the very activity of registering, recording, selecting and evaluating data. Actualities are neither subjects nor objects but the process of nesting data is explained by the manner in which objective data acquires a subjective form involving the hypothetical tendency towards a level of finality in which actualities reach completion through what Whitehead calls "concrescence," the growing together of many levels of actualities.[50] Central to actualities therefore is not simply their material aggregation, or biophysical co-causality, but also the introduction of a conceptual level of causality, defining the aim or the subjective formation of an actuality. Actualities are thus constituted by the physical and conceptual prehension of data.

From this standpoint, instead of being merely a set of instructions to be executed in an environment, the increasing concretization of data environments rather shows that algorithms are composites of data and could be understood as actualities equipped with their own procedure for prehending data. Their actuality therefore is not defined by substance but involves data processing (sequencing, execution, elaboration), which, within information theory, has been theorized in terms of an experimental logic in which results cannot be prescribed by inputs. At the same time however, algorithms are also a form of abstraction or conceptual schema, which, following Whitehead, is inevitably embedded in actualities. From this standpoint, an aggregation of actual entities can become an abstraction in which certain actualities become dominant over others. This process of abstraction is also to be understood in terms of a speculative function and not simply in terms of representation—i.e., in terms of a generic function of reason including abstraction in every actuality and not according to pre-constituted symbols framing actualities. In particular, Whitehead explains that the speculative function of reason entails a process of abstraction aiming not at reducing but mainly at counter-articulating or repurposing registered data towards generic ends.[51] From the standpoint of computation, this process of abstraction involves the emergence of a generic order of finality or final

causality carried out by algorithms through the conceptual elaboration of physical data, a sort of algorithmic purpose that is immanent and yet not reducible to the locality of data environments. Instead, it is worth noticing that the dominance of the incomputable in interactive parallel and distributive systems today has turned these environments into uncountable quantities of search spaces, expanding rather than mainly containing the possibilities for algorithms to form generic information patterns.

The function of reason in computation importantly points to a historical transformation of mechanized logic, which in contrast to what is advocated by material computation cannot be explained in terms of the biophysical behavior of material substrates. What is needed therefore is not another technonaturalization of computation (as the approach to material computation in design risks doing) but a materialist approach to abstraction that is able to explain the evolution from physical to conceptual prehension in the formation of propositions in which an intelligible registering of data is followed by an elaboration of generic patterns or rules. Insofar as there is no actual process that is not accompanied by a conceptual prehension—or abstraction—of it, the speculative function of reason explains that the dynamics of abstraction involves a material process of elaboration and revision of rules, which emerges from and yet extends beyond the local circumstances of matter's configuration. Conceptual prehensions define a final cause that pushes the initial conditions of given facts towards newly planned actions achieved through the abstraction of prehended data entering the realm of the generic so that it can yet again enable another level of actual processing. Final cause, therefore, coincides not with pre-set aims containing their results, but with the speculative tendency of reason to become generic and re-determine truths.

Conceptual prehensions define the level of finality of any actuality because they allow the intelligible elaboration of physical data, and the capacity of the latter to transform existing concepts beyond their initial premises. In other words, speculative reason clarifies the purpose of actualities in terms of hypothesis generation or renewed determination of truths: experimental abstraction.[52]

From this standpoint, the speculative function of reason serves to explain the move from indetermination to determination defining computation as experimental axiomatic in which initial conditions—set ideas or facts—can change in the processing of data. For Whitehead, the purpose of reason is to revise its premises rather than being determined by the essence of who or what does the reasoning. In other words, and contrary to the universal principle of sufficient reason, any actuality has its own immediate finality driven by its own mode of reason determined by its own discretization of data, making infinities partially intelligible and thus extending the limits of reason towards incomputables. This is an instance of immanent finality, which rejects both vitalist (empirical induction) and mechanicist (or idealistic deduction) purposes of reason. It explains the autonomy of

any actuality that above all serves itself, rather than being an instrument for (and of) something else. It suggests that the computational function of reason is not a totalizing, sufficient model of reasoning.

A denaturalized conception of computational reason instead starts from the premise that prehensions involve non-conscious but nonetheless intelligible operations of gathering and selecting data. Algorithmic prehensions imply no direct bodily sensing and no sense of self-awareness. Nevertheless, they are not simply the reproduction of existing data seamlessly reprocessing over and over again. Instead of a mechanical unconscious, which could be understood in terms of the affective qualities of feeling (and thinking) before cognition (and rational decision), the notion of algorithmic prehension here aspires to define an intelligible function of automation able to re-finalize gathered, selected, and evaluated data. Unlike the consciousness attributed to rational choice and to the analytic operations subtending decision, algorithmic prehensions do not achieve sophisticated levels of self-reflection (or critical view) and are thus instances neither of cognitive functions nor of the unconscious power of affective thought. How then to articulate these unfelt—unintuitive—and yet non-conscious automatisms? This is a challenging question and one that can be addressed if we entertain the possibility that automation also performs an intelligible function, and, to some extent, achieves a conceptual determination of incomputables. From this standpoint, the computational environment cannot simply be an instance of ecological rationality. Instead, the automatic functions of algorithmic prehension involve non-conscious[53] yet intelligible elaborations of physically prehended data, showing a contradiction internal to techno-capital, which is unable to mend its own schizophrenic constitution.

The computational function of reason thus coincides with the discretization, selection, evaluation of increasingly random data (both external and internal to the computational environment itself), which importantly points to the generation of alien inferences advancing in the processing of data and algorithms (data, metadata, big data). Here a materialist approach to computation cannot be mainly concerned with the potentialities of computation already existing in nature, but needs to address the artificiality of an automated elaboration of data followed by an alien epistemological production. Against the technocapitalist naturalization of computation which appears to be an extension (or smooth continuation) of the potentialities of nature, the computational environment of algorithms defines the development of a semi-autonomous mode of reason involving a level of abstraction of socio-cultural, economic, and political data: an artificial environment generating its own rules through conceptual prehensions. The adaptation of this speculative conception of reason to explain the transformation of automated logic however is here primarily intended to argue against the holistic view of capital and technology, questioning the dominant critique of instrumentalization of matter. Whether or not capital is deemed to be one with computation, the articulation of the speculative

function of reason could enable us both to interrogate this equivalence and to theorize algorithmic actions as partaking of (and not representing) the historical transformation of the generic function of reason today.

Notes

1 See Achim Menges and S. Ahlquist, eds, *Computational Design Thinking* (London: John Wiley, 2011); Achim Menges, "Material Computation— Higher Integration in Morphogenetic Design," *Architectural Design* 82 (2) (2012). Lisa Iwamoto, *Digital Fabrications: Architectural and Material Techniques* (Architecture Briefs) (New York: Princeton Architectural Press, 2009). Michael Weinstock, *The Architecture of Emergence: The Evolution of Form in Nature and Civilisation* (London: John Wiley, 2010); Michael Hensel, Achim Menges, Michael Weinstock, eds, *Emergence: Morphogenetic Design Strategies* (London: John Wiley, 2004); Neill Spiller and Rachel Armstrong, "Protocell Architecture," *Architectural Design* 81 (2011).

2 On the paradigmatic constitution of second-order cybernetics, see Katherine N. Hayles, *How We Became Posthuman* (Chicago: University of Chicago Press, 1999).

3 See Michael Hensel and Achim Menges, *Morpho-Ecologies: Towards Heterogeneous Space In Architecture Design* (London: AA Publications, 2007); Menges, "Material Computation."

4 See Lev Manovich, *Software Takes Command* (London: Bloomsbury 2013); Friedrich Kittler, *Literature, Media, Information Systems,* trans. John Johnston (New York: Routledge, 2013).

5 See Alfred North Whitehead, *The Function of Reason* (Boston: Beacon Press, 1929).

6 See Mario Carpo, *The Alphabet and the Algorithm* (Cambridge, MA: MIT Press, 2011).

7 It has been argued that "algorithms are mathematical and thus abstract structures, but should not be mistaken for algebraic formulae, since assignments or instructions operated by algorithms are non-reversible." See Shintaro Miyazaki, "Algorithmics: understanding micro-temporalities in computational cultures," *Computational Culture. A Journal of Software Studies* 2 (2012). Available online: http://computationalculture.net/article/ algorhythmics-understanding-micro-temporality-in-computational-cultures (accessed April 2015).

8 See Kostas Terzidis, *Algorithmic Architecture* (Oxford: Architectural Press, 2006). Michael Meredith, Tomoto Sakamoto, and Albert Ferre, eds, *From Control to Design: Parametric/Algorithmic Architecture* (Barcelona: Actar, 2008).

9 See John Lobell, "The Milgo Experiment: An Interview with Haresh Lalvani," *Architectural Design* 76 (4) (2006): 57.

10 Ibid., 58.

11 Ibid.

12 See Edward Fredkin, "Finite Nature," *Proceedings of the XXVIIth Rencontre de Moriond* (1992). Available at the website "Digital Philosophy" http://www.digitalphilosophy.org/Home/Papers/FiniteNature/tabid/106/Default.aspx (accessed April 2015).

13 See Neil Leach, "Swarm Urbanism," *Architectural Design* 79 (4) (2009).

14 For a historical overview, see Hayles, *How We Became Posthuman*, Ch. 6; N. Katherine Hayles, *My Mother Was a Computer: Digital Subjects and Literary Texts* (Chicago: University of Chicago Press, 2005); Andrew Pickering, *The Cybernetic Brain: Sketches of Another Future* (Chicago: University of Chicago Press, 2010).

15 Greg Lynn, *Folding in Architecture* (London: John Wiley-Academy, 2004); Greg Lynn, *Animate Form* (New York: Princeton Architectural Press, 2011).

16 Leach, "Swarm Urbanism," 58.

17 Sanford Kwinter, quoted in Menges, "Material Computation," 16.

18 Menges, "Material Computation."

19 Menges specifically refers to Philip Ball, *Nature's Patterns: A Tapestry in Three Parts* (2009). Menges, "Material Computation," 17.

20 Menges refers to J. Scott Turner, *The Extended Organism* (2000) and *The Thinker Accomplice* (2007) in which Claude Bernard's homeostatic machine, centered on physiological and energy-oriented evolution of material (bones for instance), is opposed to Darwin's selective mechanisms. Menges, "Material Computation," 17.

21 Ibid.

22 Ibid.

23 Ibid.

24 Ibid., 20.

25 Ibid., 17.

26 Ibid., 20.

27 From this standpoint, it is symptomatic that Jakob von Uexküll's work has a special place in the neo-materialist approach to computational space. In particular, his concept of the *Umwelt* (environment), also central to the development of system theory and cybernetics, explains that while environments are shared, the experienced *Umwelt* is unique to the organism's sensory and affective configuration. This means not that there is one environment differently adapted to specific organisms, but that the singular arrangement of affects and percepts of any organism is directly generated by environmental configurations. See Jakob von Uexküll, "An Introduction to Umwelt", in *Space Reader. Heterogeneous Space in Architecture*, ed. M. Hensel, M. Hight, and A. Menges (London: Wiley, 2009), 145–8.

28 See Dorion Sagan, "Umwelt After Uexküll," in Jakob von Uexküll, *A Foray Into the Worlds of Animals and Humans: With a Theory of Meaning*, trans. Joseph D. O'Neil (Minneapolis: University of Minnesota Press, 2010).

29 It would be interesting to explore this theory of *Umwelt* in relation to J. J. Gibson's theory of embedded perception based on environmental affordances, due to certain strong intellectual affinities between these milieu-centered perspectives on the evolution of human or animal perceptual cognition. James J. Gibson, *The Ecological Approach to Visual Perception* (Boston: Houghton Mifflin, 1979).

30 According to Massumi, power can be now defined in terms of the operative functions of both neoconservatism and neoliberalism. He points to a symbiotic relationship between neoliberalism and neoconservatism, which remains however a counterpoint between an investment in life productivity and the technical determination of any incipient productive force of life. For Massumi, they are both part of the "proto-territory of life": a primordial yet advanced plane that has no bounds. See Brian Massumi, "National Enterprise Emergency: Steps Toward an Ecology of Powers," *Theory, Culture and Society* 26 (6) (2009): 175.

31 Massumi is referring specifically to Michel Foucault, *The Birth of Biopolitics: Lectures at the Collège de France, 1978–1979*, trans. Graham Burchell (New York: Palgrave Macmillan, 2008), 261; in Massumi, "National Enterprise," 155.

32 Ibid., 4.

33 Ibid., 6.

34 Massumi's notion of naturing nature is inspired by Baruch Spinoza's conception of nature defined in terms of a substance in a process of changing itself by extending within modes, which are modalities, modifications of substance itself. There is no a priori axiomatics that guarantees a return to unchanging truths. Instead, as Deleuze's reading of Spinoza radically claims, the manners or modalities of nature coincide with the operations of change, the nurturing that constitutes nature in terms of becoming. Similarly, Massumi explains that naturing nature involves a "reiterative playing out its formative forcing" which itself generates "conditions for a plurality of extensive distinctions and their iterative regeneration. See Massumi, "National Enterprise," 34.

35 This nature–culture continuum in which the rules of natural systems correspond to the rules of war is explored at length by Manuel DeLanda, *War in the Age of Intelligent Machines* (New York: Zone Books, 1992).

36 As Massumi clarifies "The emphasis on natured natures' operative reality and effective givenness distinguishes this concept from social constructivism's notion of naturalization ... as presupposed as it is produced, given for the making and made a given." Massumi, "National Enterprise," 34.

37 Massumi is directly referring to Deleuze and Guattari's concept of Mechanosphere. Massumi, "National Enterprise," 34. See also Gilles Deleuze and Félix Guattari, *A Thousand Plateaus, Capitalism and Schizophrenia* (London: The Athlone Press, 1987), 69.

38 The notion of "transcendental empiricism" was first developed by Gilles Deleuze, *Empiricism and Subjectivity*, trans. Constantin Boundas (New York: Columbia University Press, 1991).

39 Massumi developed this concept in several writings. See Brian Massumi, "Potential Politics and the Primacy of Preemption," *Theory and Event* 10 (2) (2007); Brian Massumi, "The Future Birth of the Affective Fact," in *The Affect Reader*, ed. Greg Seigworth and Melissa Gregg (Durham, NC: Duke University Press, 2010). See also "National Enterprise," 27–9.

40 My understanding of algorithmic reason in terms of prehension is indebted to Whitehead's argument against perception understood in terms of mental representation and image impression, but also away from being pure sensori-motor receptor. Prehensions are between the physical registering of data and conceptual elaborations. Prehensions are also constitutive of the concrescence of actual occasions insofar as to prehend involves not only continuity but also discontinuity of being. To prehend implies stability of organization but also necessary transformation. Prehension is an activity of selection and evaluation of data that operates through a physical and mental pole, and ultimately constitutes the subjective form of what is prehended.

41 Alan M. Turing, "On Computable Numbers, with an Application to the Entscheidungsproblem," *Proceedings of the London Mathematical Society*, 42 (2nd series: 1936): 230–65.

42 See Gregory Chaitin, *Meta Math! The Quest for Omega* (New York: Pantheon, 2005).

43 Gregory Chaitin's notion of an incomputable limit is influenced by the nineteenth-century physicist Ludwig Boltzmann, who defined entropy as a measurement of the degree of disorder, chaos, and randomness in any physical system. See Chaitin, *Meta Math!,* 169–70.

44 Andrey Kolmogorov's complexity theory is considered to have pioneered the field of algorithmic information theory. See Ming Li and Paul Vitanyi, eds, *An Introduction to Kolmogorov Complexity and Its Applications*, Third Edition (New York: Springer Verlag, 2008). Gregory J. Chaitin, "Randomness and Mathematical Proof," *Scientific American* 232 (5) (1975).

45 See Christian S. Calude and Gregory Chaitin, "Randomness Everywhere," *Nature* 400 (1999). Gregory J. Chaitin, *Exploring Randomness* (London: Springer Verlag, 2001), 22; Chaitin, *Meta Math!*

46 Gregory J. Chaitin, "The Limits of Reason," *Scientific American* 294 (3) (2006).

47 As opposed to cognitive theories of computation, according to which to compute is to cognize and thus to produce a mental map of the data gathered by the senses, and computational theories of cognition, for which to think is a binary affair determined by pre-set sequences of logical steps, I draw on Whitehead's notion of prehension. According to Whitehead, prehensions are first of all mental and physical modalities of relations by which objects take up and respond to one another. Alfred North Whitehead, *Process and Reality: An Essay in Cosmology* (New York: Free Press, 1978), 23–6.

48 Alfred North Whitehead, *The Function of Reason* (Boston: Beacon Press, 1929).

49 Whitehead, *Process and Reality*, 230.

50 The process of concrescence of an actual entity is therefore defined by a
 subjective aim driving the entity to become a unity, to reach satisfaction and
 then to perish (i.e., the actual entity then becomes objective data that can be
 prehended by another entity). Whitehead, *Process and Reality*, 22, 104.

51 See Whitehead, *Process and Reality*; on efficient cause, 237–8; on final
 cause, 241; on the transition from efficient to final cause, 210.

52 It may be possible to explain this process in more detail by borrowing
 Charles Sanders Peirce's notion of abduction, referring to a particular kind
 of non-deductive inference that involves the generation and evaluation
 of explanatory hypotheses. For a recent elaboration of Peirce's notion
 of abduction in the context of computation see Lorenzo Magnani,
 *Abductive Cognition. The Epistemological and Eco-cognitive Dimensions
 of Hypothetical Reasoning* (Berlin: Springer Verlag, 2009), 1–41.
 Material computation, mainly relying on the inductive logic of physical
 interconnections, problematically omits the abstractions carried out by
 conceptual prehension for which there can be no direct observation,
 intuition or immediate experience. Whitehead, *The Function of Reason*, 25.

53 On non-conscious cognition in digital media see, Katherine N. Hayles
 "Cognition Everywhere: The Rise of the Cognitive Nonconscious and the
 Costs of Consciousness," *New Literary History* 45 (2) (2014).

Bibliography

Calude, Christian S. and Gregory Chaitin. "Randomness Everywhere." *Nature*
 400 (1999): 319–20.
Carpo, Mario. *The Alphabet and the Algorithm*. Cambridge, MA: MIT Press,
 2011.
Chaitin, Gregory. "The Limits of Reason." *Scientific American* 294 (3) (2006):
 74–81.
Chaitin, Gregory. "Randomness and Mathematical Proof." *Scientific American*,
 232 (5) (1975): 47–52.
Chaitin, Gregory. *Exploring Randomness*. London: Springer Verlag, 2001.
Chaitin, Gregory. *Meta Math! The Quest for Omega*. New York: Pantheon,
 2005.
DeLanda, Manuel. *War in the Age of Intelligent Machines*. New York: Zone
 Books, 1992.
Deleuze, Gilles and Félix Guattari. *A Thousand Plateaus, Capitalism and
 Schizophrenia*. London: The Athlone Press, 1987.
Deleuze, Gilles. *Empiricism and Subjectivity*, trans. Constantin Boundas. New
 York: Columbia University Press, 1991.
Foucault, Michel. *The Birth of Biopolitics: Lectures at the Collège de France,
 1978–1979*, trans. Graham Burchell. New York: Palgrave Macmillan, 2008.
Fredkin, Edward. "Finite Nature." *Proceedings of the XXVIIth Rencontre de
 Moriond* (1992).
Gibson, James J. *The Ecological Approach to Visual Perception*. Boston:
 Houghton Mifflin, 1979.

Hayles, N. Katherine. "Cognition Everywhere: The Rise of the Cognitive Nonconscious and the Costs of Consciousness." *New Literary History* 45 (2) (2014).

Hayles, N. Katherine. *How We Became Posthuman*. Chicago: University of Chicago Press, 1999.

Hayles, N. Katherine. *My Mother Was a Computer: Digital Subjects and Literary Texts*. Chicago: University of Chicago Press, 2005.

Hensel, Michael and Achim Menges. *Morpho-Ecologies: Towards Heterogeneous Space In Architecture Design*. London: AA Publications, 2007.

Hensel, Michael, Achim Menges, and Michael Weinstock, eds. *Emergence: Morphogenetic Design Strategies*. London: John Wiley & Sons, 2004.

Iwamoto, Lisa. *Digital Fabrications: Architectural and Material Techniques* (Architecture Briefs). New York: Princeton Architectural Press, 2009.

Kittler, Friedrich. *Literature, Media, Information Systems*, trans. John Johnston. New York: Routledge, 2013.

Leach, Neil. "Swarm Urbanism." *Architectural Design*, 79 (4) (2009): 50–6.

Li, Ming and Paul Vitanyi, eds. *An Introduction to Kolmogorov Complexity and Its Applications*. Third Edition. New York: Springer Verlag, 2008.

Lobell, John. "The Milgo Experiment: An Interview with Haresh Lalvani." *Architectural Design* 76 (4) (2006): 52–61.

Lynn, Greg. *Animate Form*. Princeton: Princeton Architectural Press, 2011.

Lynn, Greg. *Folding in Architecture*. London: John Wiley-Academy, 2004.

Magnani, Lorenzo. *Abductive Cognition. The Epistemological and Eco-cognitive Dimensions of Hypothetical Reasoning*. Berlin: Springer Verlag, 2009.

Manovich, Lev. *Software Takes Command*. London: Bloomsbury, 2013.

Massumi, Brian. "National Enterprise Emergency: Steps Toward an Ecology of Powers." *Theory, Culture and Society* 26 (6) (2009): 153–85.

Massumi, Brian. "Potential Politics and the Primacy of Preemption." *Theory and Event* 10 (2) (2007).

Massumi, Brian. "The Future Birth of the Affective Fact." In *The Affect Reader*, ed. Greg Seigworth and Melissa Gregg. Durham, NC: Duke University Press, 2010.

Menges, Achim and S. Ahlquist, eds. *Computational Design Thinking*. London: John Wiley, 2011.

Menges, Achim. "Material Computation—Higher Integration in Morphogenetic Design." *Architectural Design* 82 (2) (2012): 14–21.

Meredith, Michael, Tomoto Sakamoto, and Albert Ferre, eds. *From Control to Design: Parametric/Algorithmic Architecture*. Barcelona: Actar, 2008.

Miyazaki, Shintaro. "Algorithmics: understanding micro-temporalities in computational cultures." *Computational Culture. A Journal of Software Studies*, no. 2 (2012). Available online: http://computationalculture.net/article/algorhythmics-understanding-micro-temporality-in-computational-cultures (accessed April 2015).

Pickering, Andrew. *The Cybernetic Brain: Sketches of Another Future*. Chicago: University of Chicago Press, 2010.

Sagan, Dorion. "Umwelt After Uexküll." In *A Foray Into the Worlds of Animals and Humans: With a Theory of Meaning*, Jakob von Uexküll, trans. Joseph D. O'Neil, 1–34. Minnesota: University of Minnesota Press, 2010.

Spiller, Neill and Rachel Armstrong. "Protocell Architecture," *Architectural Design* 81 (2011).

Terzidis, Kostas. *Algorithmic Architecture*. Oxford: Architectural Press, 2006.

Turing, Alan M. "On Computable Numbers, with an Application to the Entscheidungsproblem." *Proceedings of the London Mathematical Society* 42 (2nd series 1936): 230–65.

Uexküll, Jakob von. "An Introduction to Umwelt." In *Space Reader: Heterogeneous Space in Architecture,* ed. M. Hensel, M. Hight, and A. Menges, 145–8. London: Wiley, 2009.

Weinstock, Michael. *The Architecture of Emergence: The Evolution of Form in Nature and Civilisation*. London: John Wiley, 2010.

Whitehead, Alfred N. *Process and Reality: An Essay in Cosmology*. New York: Free Press, 1978.

Whitehead, Alfred N. *The Function of Reason*. Boston: Beacon Press, 1929.

CHAPTER THREE

Elements for an ecology of separation

Beyond ecological constructivism

Frédéric Neyrat

Translated by James Burton

Everything is interconnected: such is the *principle of principles* of ecology. The objective of an *ecology of separation* is to contest this principle, not in order to refute it entirely, but to show that every relation is founded on a separation. In other words, it is concerned with causing the repressed content of ecology, and of the thinking which inspires it, to resurface. This repressed element is the following: interconnection must leave room for separation and must metabolize, symbolize, recognize it, if it is to avoid falling into the confusion resulting from the abolition of differences. For a confusion is not a relation, but its opposite—an indistinct jumble.

This confusion is not only harmful to theory, that is to say, to our capacity to distinguish [*faire la part*] forms of existence, but also to the political. Without separation, that is, without the capacity to produce a distance within the interior of a socio-economic situation, no real political decision is possible, no technological choice is truly conceivable, no resilience—understood in the first instance as the capacity to draw back—can be expected.[1] In a universe of pure continuity, with no faults, no outside, automated reactions replace decisions, and each new technology that appears in the saturated market of anthropogenic environments presents itself as an ineluctable destiny. For we no longer know how to tell apart [*faire la part*], we no longer know how to maintain a distance, how to separate ourselves. We are fascinated by the accumulation of forecasted ecological catastrophes, *and* we continue to adore a divine Technology that

we expect to save us from ourselves; every year we award a prize to the Hollywoodian scenario of the end of the world that we find most probable, *and* we admire the proposed atmospheric shield that geo-engineers promise will protect us from climate change.[2] The imagination does not help us to contest this world: it does not offer us an alternative image, a counter-model to what we are; nor does it constitute the romantic reserve of lost voices of modernity, but participates in the production of the global network in which the living and the machinic, humans and nonhumans blend together. We are thoroughly interlinked, and we dream of being even more so.

The ecology of separation, this apparent paradox, does not refuse relations, zones of continuity and contiguity, the marvellous ambiguities in which differences change places and lose themselves; it is not in any sense about restoring pure ontological identities, sealed boundaries or any kind of symbolic order![3] The ecology of separation maintains simply this: to be truly political, to take into consideration the dangers which may threaten us, to *distinguish* between that which humans may construct and that which *cannot* or *should not* be constructed, to know in what ways it is still possible to use the words "nature" and "environment," to enable the ecosystems to be resilient and to endure the disasters of the Anthropocene, ecology must *leave space* for separation. This will not be possible without attacking that which is clogging up this space, which we may call "ecological constructivism." Upheld by declared constructivists (Bruno Latour), advocates of a "pragmatic ecology" (Emilie Hache), sociologists of "risk" (Ulrich Beck) and by the "post-environmentalists" (Ted Nordhaus and Michael Shellenberger), ecological constructivism may be recognized by certain recurrent traits: (1) the idea, repeated like a mantra, that everything is interconnected; (2) the taking into consideration of "uncertainty" as a new *deus absconditus*; (3) an unshakeable faith in modernity—"reflexive" (Ulrich Beck) or not—and in technological progress, a progress that has already become sensitive to the "risks" and "unforeseen consequences" that always arise in an "uncertain world"; (4) a refusal of every idea of nature and environment, leading to the idea that everything is "process" and that as a consequence, *everything is constructible*. It is from this constructivism that ecological theory and practice need to separate themselves.

The reader will notice the strongly "critical" dimension of this chapter— and perhaps find it disappointing: shouldn't one be positive? Isn't critique borne by resentment, by envy, maybe even by evil—in every case, arising from the inability to create new ideas? It is true that our exophobic epoch recoils from the negative just as it does from keeping-at-a-distance and from the recognition of the infinity of the outsides.[4] Nevertheless, I maintain that no new approach to ecology will be possible without a critical understanding of the hegemonic structure that now constitutes ecological constructivism, both in theory and in industry. This hegemony extends far beyond professed constructivists: in speaking of an "ecology against nature" or "without nature"; in supposing (some forty years late,

as though that which Donald Worster terms the "ecology of chaos" had not profoundly transformed the environmentalist paradigm) that ecologists today still think of nature as a "well-balanced order" and a beautiful "homeostatic" totality; in recalling that nature is nothing other than a "second nature," Žižek inscribes himself clearly within an ontologically constructivist perspective.[5, 6] This is not, of course, intended to reduce the thought of Žižek to constructivism, and we all know his radical *political* positions; however we must be able to discern, in his philosophy as in the hegemonic discourse relating to ecology, the *ontological constructivist traits* which orient the contemporary debates and the economic and technological choices with which they are associated.

At the heart of the hegemonic structure of ecological constructivism lies what Bruno Latour calls "political ecology." The latter's influence is felt in numerous theoretical fields, some of which rightly consider him one of the major thinkers of our time. Latour has ceaselessly contested the "great divides"; it is thus with him in particular that we may affirm the confusions that ensue *when every kind of separation is rejected.* His theory of "attachments" and of the actor as "what is *made to* act"[7] leads us straight away to the political impasses of our time: the incapacity to really choose the world we want. Against these attachments, we must propose a *detachment*, which is not to say, as in Latour's caricature, a manner of retiring from the world into some imaginary citadel, but rather *a distance within the world* without which no politics are possible—other than, of course, the automatic politics of unlimited development and of what we can call *the democracy of the economy* (that is to say the subjection of politics to the sphere of economics). This distance alone may allow us to say—if necessary—"no," precisely where ecological constructivism is incapable of doing so because it considers every possibility of a limit to be the effect of superstitious terror and ignorance. For *material* limits—as opposed to moral ones—are nothing but *the other side of the relations* which living beings maintain with the ecosphere. Against the dismissal of every idea of nature, an anti-constructivist ecology must be capable of thinking nature neither as fixed substance, nor as indefinite process, but as *separating mediation,* as the gap between ourselves and that which we wish to produce; in other words, a necessary *detour.*

The principle of principles of ecology and ecological constructivism

A critique of ecological constructivism is obliged to understand from the outset that the *principle of principles* of ecology—the axiom of interconnection—has both a history and a powerful justification. In the scientific and political form it has taken since at least the nineteenth century, ecological

theory has always consisted in a struggle against a *denial of the relation*: between so-called man and his "environment," between the industrial revolution and the destruction of the conditions of possibility of the living, between humans and nonhumans, technologies and "risks" (Ulrich Beck), etc. But I maintain that ultimately this battle was waged against the wrong target. For the "humanist" denial of the relation, which grants to man a *dignitas* which he refuses other forms of life (animals), or the "Cartesian" denial of the relation, which excepts human consciousness from a matter that is mathematizable and controllable, is not—contrary to what we might believe—a *separation* which recognizes differences, but a *split [clivage]* which denies the existence of that which it opposes. *Where separation articulates differences, the split juxtaposes identities without relations.* In other words, *the denial of the relation is founded on the split, and not on separation.*

In light of this, let us briefly explore the history of ecological theory, that is, of the thinking informed by environmentalism. It has been perfectly justified in its struggle against the denial of relations. From the invention of the concept of ecology by Ernst Haeckel in 1866, to the "Gaia hypothesis" defended by James Lovelock and Lynn Margulis and recently reformulated by Isabelle Stengers, via the romanticism of John Muir, the ecosystem of Arthur Tansley, or Aldo Leopold's land ethic, from the fierce oppositions to the deforestations taking place at the beginning of the nineteenth century, all the way to the struggles against genetically modified organisms (GMOs) and the "growth objectors" of the twenty-first century, ecological theory and environmental activism have shown the extent to which the world is a tissue of "entanglements" [*enchevêtrements*] (Isabelle Stengers) or "attachments" (Bruno Latour). In both theory and practice, it is endlessly confirmed that ecology is the "science of the relations between living beings."[8] In order to oppose the domineering paradigm of a mechanistic science responsible for the "death of nature," ecological theory raised once again the torch of organicism, and reaffirmed the need to take into consideration the relation between the whole and its parts.[9] In order to avoid closing in on itself, it had to extend the science of fundamental interconnections proper to "natural" environments, to environments considered "anthropogenic". Supported by atmospheric chemists, it proposes today, with the concept of the Anthropocene, to consider the human being as a "major geological force"[10] interlaced with the earth.

But what this model history leaves in shadow is the current impasse of ecological theory. In constantly raising the stakes of the necessity of calling into question the "great divides"—between culture and nature, the built and the natural environment, and above all between humans and the earth—ecological theory is becoming less and less capable of making distinctions. Maintaining that nature does not exist, or that it is of the order of pure faith, ecological theory is delivered, bound hand and foot, to the constructivist viewpoint, which, often going well beyond that of declared ecological

constructivists, concerns every approach that is based on the following idea: since nature doesn't exist, since there is no preconditional common world, everything makes itself over and over again, endlessly constituting and reconstituting itself, ceaselessly becoming. Ecological constructivism pushes the rich thinking of flux and becoming—of a Serres, a Deleuze, a Whitehead—into a limitless artificialism, as if Lucretius had replaced his atoms and his void with tools and capital—as if *De rerum natura* had given way to *De rerum factura*. This lack of distinction unavoidably translates into two major symptoms:

1 A *fantasy of fusion*. Contrary to received wisdom, this is not the
 fantasy of radical ecologists or deep ecologists, because most of
 them live in the pain and sorrow of the *lack* of separation, and
 of the *unrestrained* intrusion of humans into nonhuman spaces.
 Ecological constructivism has not eroded the great divides; its
 action has not consisted—as some wrongly suggest, and as
 reactionaries complain—in eliminating frontiers, but in *colonizing
 the minority element of the great divides*: thus the human has
 colonized the nonhuman, and technologies have colonized the
 domain which used to be called nature. Whence the illusion of
 the "end" of the great divides, which is ultimately nothing but the
 reinforcement of the movement initiated by the techno-humanistic
 colonization of modern times. Ecological constructivism must be
 analyzed as a narcissistic thinking, quasi-incestuous, loving itself
 among the nonhumans, without noticing that they are the products
 of its own industrious operations.

2 An *unquestioning faith in technology* [*un suivisme technologique*],
 which acquires its condition of possibility from a blind technophilia.
 Resolutely modern, the ecological constructivist swears by the most
 recent technology, the latest industrial innovation. It will extol the
 virtues of the sequestration of carbon for mastering climate change,
 right up until the approach finally proves to be impracticable;
 no matter—another possibility will present itself, one which will
 seem just as wonderful in the eyes of the ecological constructivist:
 marveling before the promises of climate geo-engineering, the
 ecological constructivist in fact becomes a *geo-constructivist*.[11]

In summary, the fantasy of fusion and the unquestioning faith in technology delineate the hegemonic psycho-political landscape—stretching well beyond those constructivists who are recognized as such—from Žižek to Crutzen.[12] The difficulty is in knowing whether it is possible to propose a different landscape; an alternative topography.

The future of post-environmentalism

"Post-environmentalism" is a perfect illustration of ecological construc-tivism. Edited in 2011 by Ted Nordhaus and Michael Shellenberger, *Love Your Monsters: Postenvironmentalism and the Anthropocene* lays out clearly what is theoretically and practically at stake in this approach: getting rid of a form of environmentalism judged by the two editors to be outmoded. How, they ask, can we reduce the ecological footprint of the human being in a world of seven billion individuals all "seeking to live energy-rich modern lives"?[13] It is thus necessary to embrace from now on "human power, technology, and the larger process of modernization" (57). Fundamentally, Ted Nordhaus and Michael Shellenberger claim, there exists no natural limit, neither for the human being, nor for the rest of what is known as nature. For human beings have always lived in a relationship with a technological universe, which has fashioned them in turn. Instead of stupidly rejecting technologies, we must find in them the means of "saving" ourselves.

Saving the earth does not mean protecting it from all contact with man—in fact, such a preservation would be impossible: (a) how does one determine the natural state of nature? This point is fair: a natural state cannot be a state determined in the past, since ecosystems are changing all the time; (b) likewise, how should one determine a state of nature protected from human activity, given that humans have modified the ecosphere from top to bottom and that they have become, as Paul Crutzen maintains, a "major geological force"? To save the earth can thus mean only one thing, and this is the leitmotif of ecological constructivism and of all post-environmentalism: *intervening even more*, that is, "creating and recreating [the earth] again and again" (111–12). We need not be afraid of this further intervention in the least; quite to the contrary, it is fear that we need to get rid of, along with all the "apocalyptic fears of ecological collapse" which have turned environmentalism into an "ecotheology" (162). Against this archaic religion, it is necessary to oppose the "theology of modernization" which envisages technology as something "*humane and sacred*" (208).

What problems does this analysis pose? Doesn't it seem like common sense? Shouldn't we accept the idea that technologies, even while dangerous, are the only means humans have at their disposal with which to save themselves? Going beyond this understanding of technologies as means, should we not recognize that, in every aspect, the notion of humanity itself is unthinkable without technologies? This, let us recall, was the lesson of *2001: A Space Odyssey*: without the black monolith, and without the bone which becomes a weapon, there is no passage from the pre-human to the human ... However, a doubt assails us. Ted Nordhaus and Michael Shellenberger tell us that, from the Neolithic era until the present, the manner in which human beings have shaped "nonhuman nature" has not

changed in "kind," but in "scope" and in "scale" (131–3). Is this really the case? Is the Anthropocene merely a change of scale? Or is it the sign of a movement of much greater amplitude, an "event"?[14] On this account, is it really stupid to experience certain fears regarding the future? What if the stupidity, in the sense of the stupefaction which prevents one from thinking correctly, were on the side of those who make modernization into a religion, and make this religion into the comfort of a future of unrestrained development?

Let us slow down, and reconsider whether it may not be a little too soon to be *post*-environmentalist. To test this, we must turn to the foundations of the thought of Ted Nordhaus and Michael Shellenberger: one will notice that the title of their collection, *Love Your Monsters*, is also that of the article bearing Latour's name in the same volume. Such a choice cannot be by chance. It signals the importance, for these two authors, of Latour's thought in their sustained attempt to show that environmentalism is "outmoded."[15] In the following sections, we will try to show the intertwining of post-environmentalism and the "political ecology" of Bruno Latour.

Monstrous ecology

Entitled "Love your Monsters: Why we must Care for our Technologies as we do our Children,"[16] Latour's essay begins with a rereading of *Frankenstein* by Mary Shelley. This rereading had already been developed ten years earlier in *Aramis, or The Love of Technology* (1992). In this book, as in the article, Latour asserts that the crime of Dr. Frankenstein was not his hubris, his transgressive creation, but the abandonment of his creature. The latter became monstrous because of this abandonment, and not as a result of his unusual genesis. *Frankenstein* should thus be seen as paradigmatic of our inadequate relationship with that which we produce: in referring to foodstuffs as "frankenfood" or "frankenfish," Latour tells us, we are constantly reproducing the gesture and the error of Dr. Frankenstein. Rather than taking care of our productions, we reject them. And it is this rejection itself that should be considered the ultimate cause of our troubles.[17]

This rejection would be anchored in the manner in which we consider ourselves modern. Following up in this article on the analyses carried out in *We Have Never Been Modern* (1993), Latour claims that the perception we have of ourselves rests on a misunderstanding: *we believe we have clearly separated the domains of science and politics*, we believe that modernity consists precisely in this separation; but in fact we have spent our time constructing our world on the basis of an unending series of hybridizations.[18] In reality the science referred to as modern has intertwined science and politics, humans and nonhumans, it has produced with all its strength

what Latour names "attachments": connections between nature and scientific production (GMOs), links which could never have been possible without robotics (Latour takes the example of robots sent to Mars), climate change, etc. To believe ourselves modern is to believe that science has "emancipated" us from "nature," where in fact it has produced ever more "imbroglios" and "entanglements" (289). For this reason, Mary Shelley's novel, romantic as it is, will wholly remain prisoner to the belief that modernity has built around itself. And so we will always remain prisoners too: even as the dissonance, Latour tells us, between what we believe we are and what we truly are comes to light, even as everything proves to be interconnected and as attachments become more and more evident, we continue to refuse that it is so, we refuse this generous ecology that attaches humans to nonhumans—to GMOs, to bacteria, to the earth. Why?

Because modern belief, as erroneous as it is, has not been without effect: in believing that science has emancipated nature, we have believed in the existence of a Great Divide between ourselves and the rest of the world. There is all that we have made, our technologies, progress; and, alas, the collateral damage of progress—pollution, the hole in the ozone layer, Chernobyl. Yet the idea itself of collateral damage is an effect of the Great Divide. In the same way, claims Latour, ecological disasters are the analogues of Frankenstein's creature because our representations rest upon a Great Divide: culture–technology–humans versus nature–nonhumans. But everything changes, or would change, if we came to grasp that *everything is attached*. Everything will change if we understand that science has never stopped connecting nature and culture, to the point where it produces what Latour calls "natures–cultures" (106–7). In fact, if everything is connected, then collateral damage, or at least the "unwanted consequences" of progress are nothing more nor less than inevitable: a new technology will necessarily, whether one wishes it to or not, have an impact upon us and on what is known as "environment."[19]

Like Michel Serres and Ulrich Beck, Bruno Latour declares the expiration of the concept of environment. The latter is in fact built upon the division—fallacious, but with real consequences—between humans (at the center) and their (surrounding) environment.[20] In other words, claims Latour, we have begun to speak of the environment at the same moment that we come to understand that there is no environment! This idea is at the heart of the conceptual strategy of Ted Nordhaus and Michael Shellenberger: they reproach the environmentalists for believing in the environment, that is, as a "separate 'thing'" from humans—from humans who see themselves as "separate" from and "superior" to the "'natural world.'"[21] But with the conceptual and real disappearance of the environment, as if by magic, the monsters disappear as well: *the monstrous turns out to be normal!* Instead of being surprised by some unfortunate "unwanted consequence" of a new technology launched onto the global market, we should on the contrary take specific and constant care of that which we produce, tracing

and tracking the consequences of our productions. Far from abstaining from creation, far from "retreat[ing]—as the English did on the beaches of Dunkirk in the 1940s"[22] and leaving so-called nature alone entirely, Latour invites us to "intervene even more" (348). In this sense, "the environment is exactly what should be even more managed," supervised, "integrated and internalized in the very fabric of the polity" (344). We need to be, increasingly, "master and possessor of nature," to recall Descartes' famous statement, provided one fully grasps that this "mastery" must be understood as an increasingly strong "attachment" between "things and people" (383–400). More attachments, more mastery, more interventions: here is where someone like Paul Crutzen would be in agreement.[23]

A first lesson imposes itself here: the opposition between Hans Jonas and Bruno Latour could not be greater. Where the former, in *The Imperative of Responsibility,* deals with a "Prometheus permanently unbound" and insists, like the majority of ecologists, on worrying about limits,[24] the latter, on the contrary, develops the idea of a Prometheanism without soul-searching, free of complexes; a kind of *hyper-Prometheanism.* Where we moderns (who believe ourselves to be modern), the Jonases and all those who want to "withdraw" into themselves, are taken, in a caricature of a religion from another era, to be saying, "Thou shall not transgress," Latour and his friends Nordhaus and Shellenberger say: "we shall overcome."[25] According to this view, we must go beyond our timorous natures to intervene technologically, surpass our constant fear in order to become the Prometheus that we cannot not be—we, technologically assisted beings, the Terraformers of our own planet.

Having always been modern, or: Long live development

One point however seems to distinguish Latour from Nordhaus and Shellenberger: where Latour critiques the false consciousness of the first modernity, the modernity that is not "reflexive" and has not accepted its inevitable share of "risks" (Beck), Nordhaus and Shellenberger place their faith solely in an immediate and unilateral "theology of modernization." However, Latour and the post-environmentalists have precisely the same target: those who refuse development; or in other words, those who want to move "from hubris to asceticism," as Latour writes in the long version of "Love your Monsters," which bears the eloquent title, "It's Development, Stupid!"[26] In a footnote, Latour explains for North American readers: "'Décroissance' is the term used by some French groups" to describe this asceticism.[27] Of course, for Latour, those who wish to "withdraw" are after all resolutely ensconced within the faith of modernity, in that they too think that there is a Great Divide between humans and nonhumans.

In *Politics of Nature*, in 1999, ecologists were attacked for their "nature-centrism," which maintains unchanged the modern faith in a nature that it is considered necessary to preserve intact.[28] As an extreme example of this position, deep ecologists were considered to be simply outside of ecological politics (43); in 2011, it is not deep ecology but the idea of *décroissance* (degrowth) that is attacked. According to Latour, *décroissants* are those who are too "stupid" to understand the necessity of development. Certainly, all those who believe in the Great Divide are stupid for Latour; but the greater, more dangerous imbeciles are those who not only believe in this divide, but through their "asceticism" do nothing but confirm and reinforce it. They are dangerous in that they do not understand at what point it is necessary, in order to address environmental problems, to engage in further techno-logical intervention. Like Nordhaus and Shellenberger, Latour maintains that it is necessary to have done with "the limits of the notion of limits"[29] and that the time has come to "develop *more,* not *less*" (3): "the goal of political ecology," Latour writes, "must not be to stop innovating, inventing, creating, and intervening."[30] Like Nordhaus and Shellenberger, Latour has an iron-clad belief that salvation comes about through techno-logical development. In this sense—and this is the point we need to grasp—like Nordhaus and Shellenberger, *Latour is resolutely modern*—without hesitation, without distance. To be sure, Latour maintains that he is not modern and that "between modernizing and ecologizing, we have to choose."[31] Yet in believing that science, or rather techno-science, will save us from climate change, Latour expresses the essence of modernity! He thus adopts the position perfectly summarized by von Neumann in 1955:

> Prohibition of technology ... is contrary to the whole ethos of the indus-trial age ... It is hard to imagine such a restraint successfully imposed in our civilization. Only if those disasters that we fear had already occurred, only if humanity were already completely disillusioned about technological civilization, could such a step be taken. But not even the disasters of recent wars have produced that degree of disillusionment, as is proved by the phenomenal resiliency with which the industrial way of life recovered even—or particularly—in the worst-hit areas.[32]

The example of Fukushima perfectly validates this statement. It seems in fact that the calling into question of technology is the prohibition before which *all* moderns recoil—Latour included. In this sense, "It's Development, Stupid!" is the modern enunciation par excellence. *The moderns are those who believe in the sacrosanct holiness of technological development.* Being modern means having faith in the technological surmounting of the impos-sible, as Latour affirms: the moderns "want the impossible, and they are right"; but, he adds, we must change the impossible.[33] The impossible that is to be abandoned is impossible emancipation with regard to nature; this should not require of us too great an effort, since this emancipation (this

detachment) has, for Latour, never really existed! In fact, as we have seen, Latour claims that the moderns have spent their time, without realizing it, in hybridizing humans and nonhumans. That is, emancipation in relation to nature is for Latour truly impossible. In turn, the impossible to be promoted, according to Latour, is that which consists in having done with "the limit of limits": wanting there to be no limits any longer, it is to this that Latour addresses his prayers (12). But isn't finishing with "the limit of limits" the modern project par excellence? Consider Bacon:

> The end of our foundation is the knowledge of causes and the secret motion of things; and the enlarging of the bounds of the human empire, to the effecting of all things possible.[34]

Contrary to what Latour claims, for the thinkers of modern science, the problem is not emancipation with regard to nature (such is already theoretically accomplished by the transformation of nature into a mathematical object) but the future technological realization of all possible things. It is from this impossible that Latour, as a good modern, is not detached. It is this *attachment* which leads him to the declaration that concludes the article: "We want to develop, not withdraw."[35] Here we are faced with an infernal pair of alternatives: on the one hand the proposition of the endlessly developmental ecology of Latour and his post-environmentalist comrades; on the other a form of withdrawal which would consist in the refusal of all technology.

That we are constrained to these alternatives will come as a bit of a surprise, for Latour appears to be a shrewd modern who knows perfectly well that progress is indissociable from "unwanted consequences"—but which consequences does he draw from this constant necessity of relating to consequences? What does it mean, for Latour, to take care of our creations *in their consequences*? Describing the principle of precaution, as it was introduced into the current French Constitution, Latour seeks to show that the principle's opponents and its supporters fundamentally agree. The first group refuses this principle on the pretext that it necessitates anticipating risks to the point where one is no longer able to innovate, while the second—those who Latour designates the "modernist environmentalists"—celebrate a law which dictates "no action, no new technology, no intervention unless it could be proven with certainty that no harm would result."[36] Latour simultaneously refuses to give in to paralyzing anticipations and to "withdrawal," but demands—what, in the end?—a *following* [*un suivisme*]. Whence comes the metaphor of love for our monsters, of which Nordhaus, Shellenberger and Latour are all equally fond. To love our technological creations means accompanying them in their effects, neither leaving them to grow in isolation, nor believing there will be no consequences; it is certain that there will be, for our creations are attached to us, to everything, to the world, on account of the generalized interconnection which relates every part of the world to every other part.

Of course, it is fairly obvious that we do not leave the nuclear power plant to run on its own, the door slamming shut behind us as we head off to the pub, just as we make sure to install automatic alarm systems capable of reacting to "unforeseen" accidents. But Latour seems to have forgotten that what was at stake in the principle of precaution was precisely the putting in place of systems of constraint able to incorporate uncertainty! To say that we do not know what consequences will follow the introduction of a new technology into the world is absolutely right, but these are the central stakes of our relations with technologies: this should generate that which Hans Jonas called a *concern,* and not a fear, as some wrongly suggest (Jonas uses the word *Sorge,* "care," "concern"). But this concern consists precisely in thinking *in advance* that a certain uncertainty must lead us *not* to promote certain technologies. Dispensing with such an "in advance," such an anticipation amounts to no more nor less than the dismissal of the foundation of the principle of precaution, and venturing forth without direction; like a good modern. If there is something to be criticized in the principle of precaution, it is not that it has paralyzed action, but that it has wrongly considered risks to be calculable (in the form, for example, of risks of risks). To this *precaution,* we must oppose—following the work of Günther Anders and Jean-Pierre Dupuy—a *prevention,* that is, a preventive action which accepts *its inability to calculate risks.*[37] This is to say that the problem does not really lie in knowing that *there will be* unwanted consequences (this is obvious), but in knowing that one can *not want* some of these unwanted consequences, at any cost.

But *Latourian theory does not allow us to not want.* This is one of the traits common to the ecological constructivism of Latour and the post-environmentalism of Nordhaus and Shellenberger, whereby they claim that "each new act of salvation will result in new unintended consequences, positive and negative, which will in turn require new acts of salvation" (110–11): with them, Prometheus, whose name signifies "the one with forethought," fuses with his brother Epimetheus, "the one who reflects after the fact." In *Technics and Time 1: The Fault of Epimetheus,* Bernard Stiegler insists on the difference between Epimetheus, who because he foresees nothing leaves the human being destitute [*démuni*], without qualities, and Prometheus, the one who, because of his foresight, takes care of the human being by compensating for the fault of Epimetheus with the gift of technics.[38] With this dangerous fusion of Prometheus and Epimetheus, it is no longer a question of care [*soin*] and anticipation: henceforth, Prometheus will be able to make use of his (nuclear) fire and his weapons, *but will do so freed of any necessity of foreseeing anything.* Epiprometheus is this new monster—must we love him? Must we be bound to him? Let us hesitate for a moment before replying; later, it will doubtless be too late.

Making Dr. Frankenstein hesitate

Let's hesitate; and return with precaution to the analysis of Mary Shelley's book proposed by Latour. It is quite true that Victor Frankenstein's creature suffers from a lack of love from his creator. When the two of them meet in the Alps, Victor Frankenstein uses every name he can to abuse his creature—"devil," "vile insect," "abhorred monster," etc.[39] And the poor creature informs him of his solitude, reproaching his creator for failing to "perform thy part, the which thou owest me" (68). We will thus grant Latour an acknowledgment that the attitude of Victor Frankenstein lacks the most elementary care—it lacks responsibility. All very well—but the question is, what caused Victor Frankenstein to become this way?

Contrary to what Latour would have us believe, the doctor is not exactly a modern: in his early youth, he was influenced by "natural philosophy," Cornelius Agrippa and Paracelsus—in other words, by conceptions of science legitimizing magic and alchemy, the quest for the philosopher's stone and the elixir of eternal life. It is from this context that Victor Frankenstein draws his fundamental desire: to manufacture life—to become "capable of bestowing animation upon lifeless matter" (32), "render[ing] man invulnerable to any but a lifeless death!" (23). But during his studies, Dr. Frankenstein encountered modern science, and the manner in which it took over from what had preceded it. This is what Professor Waldman says in Mary Shelley's novel: the previous professors "promised impossibilities" while "the modern masters promise very little"; they seek neither the philosopher's stone nor the elixir of life, but "dabble in dirt" and "pour over the microscope" (28). In so doing, they have accomplished miracles:

> They penetrate into the recesses of nature, and shew how she works in her hiding places. They ascend into the heavens; they have discovered how the blood circulates, and the nature of the air we breathe. They have acquired new and almost unlimited powers; they can command the thunders of heaven, mimic the earthquake, and even mock the invisible world with its own shadows. (28)

A humble approach, and a change of method in comparison to the alchemists, certainly—but with results that are so much more marvelous! Modern science appears here as *the pursuit of magic and its fantasies by other means*. And Victor Frankenstein stands precisely at the junction of this monstrous fusion of the modern with an enduring magical thinking. And we ourselves, just how far have we really moved beyond the search for the elixir of life …? In a famous passage of the *Discourse on the Method*, Descartes argued that modern science, specifically physics, will allow us to attain that "primary good" that is "the preservation of health";[40] today, we are less concerned by health, which presupposes a state to be attained,

than by *fitness*, which knows no upper limit—as Zygmunt Bauman writes: "However fit your body is—*you could make it fitter.*"[41] One should certainly not confuse the elixir of life, preservation of health, and fitness; just as—on another plane—one should not confuse the omnipotence of God with the sovereignty of the State; secularization (of religion and of magical thinking) is never a simple reproduction of identity. But just as certain states imagine themselves to be all-powerful because they possess nuclear weapons, one might say that, on a scientific plane, a certain imaginary of eternal life has found a new embodiment through the will to mastery and possession which Descartes formulated in the middle of the seventeenth century. This hypothesis may allow us to understand that what leads to the belief in the all-powerful nature of development and technologies is *a belief in modern science under-girded by a pre-modern fantasy.*[42] Isn't it this belief and this fantasy that the constructivists and the post-environmentalists perpetuate? If they are modern, in the end it is not only because they want more technologies (this is merely a symptom), but because they do not question the manner in which modernity has metabolized—integrated, reprised and modified—pre-modern science and its libidinal investment in technologies. It is this belief which animates geo-engineering, that is, the project—approved by Paul Crutzen—which consists in mastering climate change through the technological "optimization" of the climate. And it is this belief which ecological theory must today do away with.

It becomes therefore very problematic to generalize Latour's proposition that we should love *all* our monsters. In fact, Victor Frankenstein bears some resemblance to our monstrous Epiprometheus, who acts first and thinks later. We can certainly understand that there should be cases where, once a creation has taken place, it becomes necessary to take care of it. One might think here of the fiction—which is becoming less and less absurd—of human clones: once they have been created, regardless of what the law might say, it will be untenable not to take care of them. Yet what the position of Nordhaus, Shellenberger, and Latour renders impossible is preventive action, that is, the possibility of *not realizing* a technology. We said above that a fundamental prohibition weighs down upon us: the prohibition on calling technology into question. To call into question [*remettre en cause*] should mean, theoretically, to *return to its cause* [*ramener à sa cause*], to interrogate causes and thus to get away from the "pragmatic ecology" proposed by Emilie Hache, who speaks in favor of a "pragmatic philosophy" understood as an "*art of* consequences which is interested in the *effects* which its propositions induce."[43] The ecological theory that we are seeking to promote is anti-pragmatic for reasons that are very ... pragmatic: to take an interest in effects, is to take an interest too late; it is on causes that we need to reflect, ahead of actions. Only a return to causes, to aims, to principles, to what we desire, may allow us to *make the distinction* between the technologies that we want and those we do not want. This distinction must be made before, not after the event.

Dividing technologies: Cosmotechnologies and selected mechanisms

To make this distinction, it is first of all necessary to think technologies as such, in other words to stop confounding—as Latour does—the education of children and the production of technologies, the love we devote to the former and the attachment we sometimes feel towards the latter. A robot is not, after all, the same as a child! Thereafter, it becomes possible to restrain oneself, and to abstain. It is this abstention which is impossible for Latour, for the principle of precaution is "not a principle of abstention, but a change in the way *any action* is considered," that is, a profound change relative to the connection between science and politics: thanks to this principle, "unexpected consequences are *attached* to their initiators and have to be followed through all the way."[44] The problem of the post-environmentalist is that he always arrives after the party: the new technologies have been launched onto the market, and the post-environmentalist asks us to love them, to observe them closely and tirelessly. Ecological constructivism is a kind of caricatural pragmatism: the causes (the principles, the ontological foundation of technologies) don't matter; but let's pay attention to the consequences. This is why the ecological constructivist says yes to every technology—to GMOs, to fracking, to nuclear technology and climate engineering.

Post-environmentalism, like every ecological constructivism, is prisoner to a scheme of thought which obscures ecological theory and reduces everything to two possibilities: either the hatred of technology, or the love of it. Either one rejects everything, absolutely, or one accepts all technologies. Either one refuses all development, or deems "stupid" those who reject it. Our problem is not that of finding some kind of median position, but on the contrary, of precisely establishing a political position whose goal would be differentiating what we want from what we don't. Such is the first meaning of the expression "ecology of separation": learning to distinguish between what is harmful and what is not. But this entails knowing how to work on *causes* before being able to act on their consequences. What are the criteria that might allow us to evaluate and separate technologies? In *The Domestication of Being*, Peter Sloterdijk distinguishes between:

(1) on the one hand, "allotechnologies," which name a violation of the earth, and lead to the "destruction of primary materials." The allotechnologies are applied from the outside, they are exercized by a subject (a master) who applies his power to an object (a subordinate).[45] As some thinkers of resilience have understood, merely trying to "control," from the outside, a supposedly "predictable" nature, makes ecosystems vulnerable and "contribute[s] to the erosion of [their] resilience";[46]

(2) on the other hand, "homeotechnologies": developed based on the paradigm of information, the "thought of complexity" and "ecology," these technologies entail a strategy of "cooperation," of "dialogue" with nature. Homeotechnologies, Sloterdijk writes, "cannot at all desire to differ totally from that which 'things themselves' are for themselves or may become for themselves."[47]

André Gorz, one of the most important ecological thinkers France has known, takes up these distinctions at the end of one of his works, *L'immatériel*.[48] Drawing on the works of Ivan Illich, Gorz distinguishes between "technologies of confinement" [*technologies verrou*], which lead to the domination of nature, "dispossess[ing] people of their living environment," and "open technologies," which "favour communication, cooperation, interaction, such as the telephone, or nowadays, networks and open source software."[49] What Sloterdijk and Gorz ultimately stress is the opposition between *cooperative technologies* and *self-enclosed technologies*, the latter leading on from what Illich called the "radical monopoly," which replaces the "empowerment [*pouvoir-faire*] of the individual."[50] This radical monopoly is today simply that which makes possible the democracy of the economy, in other words, the possibility of a capitalism without restraint.

Still, we can see the problem posed by the ecology of separation: how to mark the difference between good and bad technologies, without presupposing a predetermination of technologies that would fail to take into consideration the manner of their use? Aren't uses varied and unforeseeable? Doesn't the critique of the end of the Great Divides lead to a new essentialism? In fact, it is necessary to think together technologies and the world whose production (or destruction) they tend towards: *every technology is a cosmotechnology*. If, for example, nuclear technology is an "allotechnology," a "technology of confinement," it is because the nuclear *requires* the secret (that of the routing of nuclear waste), *requires* an army to defend it, *requires* a simultaneously economic and policing mechanism to allow this self-enclosed technology to exist. It is not that there is an essence of the nuclear plant, but that there are *mechanisms selected* by this technology. A selected mechanism is not inscribed in the essence of a technology, but forms the complement without which its use would be impossible, or suicidal (for example: publicly informing potential terrorists or anti-nuclear activists of the routes of the trains that carry nuclear waste ...). In this sense, a technology and its selected mechanisms produce a certain type of *world* (of society, of individual relation to energy and its consumption, etc.) To believe that nuclear power could vary according to its uses—to believe for example that it is possible to have nuclear technology without an army—is to believe in a dangerously idealist fiction: the constructivist fiction of worlds without limits which one can form at will.

In the end, it is only by envisaging problems from a cosmotechnological perspective that we will be able (1) to *distinguish* desired values, desired

worlds; (2) to know, through *attentiveness to causes*, which are the *mechanisms selected* by such and such a technology, and which *world* is necessarily associated with these mechanisms; and (3) to decide upon a politics which legitimizes *cooperative* technologies—here again, it is separation (*parting*) which presides over the relation (*cooperation*).

Uncertain collectives

This inability to separate technologies is to be understood as one of the symptoms of constructivism as such: its unilateral taste for association, putting together, attachment, means it has difficulty accessing the dimension of separation, of division or opposition. Remember that for Latour, human beings do not form a society of subjects cut out of the world of objects, but rather a constantly growing collective of humans recognizing the existence of nonhumans aspiring to find their place in this collective. The collective is a set of procedures whose function is "*collecting* associations of humans and nonhumans."[51] One can always call into question the collection, accept or refuse new entrants, propose their "*candidacy* for common existence" after "consultations" of these new "propositions" (104). The collection has no end, its edges are not fixed except in a temporary manner. We may add that this collection is not the effect of a sovereign decision made by humans: for Latour, there is nothing more false than the "concept of a *human* actor who would be *fully* in *command*."[52] Human creators and constructors must accept that they "share their *agency* with a sea of actants over which they have neither control nor mastery": in place of a fantastical human mastery, reigns "uncertainty" (32). The latter presides over all construction, all collective "composition," knowing that the goal of the "political process" is to create a "common world": "the unified world is a thing of the future, not of the past. In the meantime, we are all in what James calls the 'pluriverse'" (37–9). The goal of this common world is to guarantee that "humans and nonhumans are engaged in a history which should render their separation impossible" (39).

That there should be concern for nonhumans is one thing; that all separation should be impossible is another. Proposing the common, non-separation, unification, as a *political* objective, highlights a crucial point: the *ultimate* objective of Latour is not to let the multiplicity of actants exist, but to *produce the One*. Although the unified world is a "thing of the future," such an idea obliges us to reconsider this statement that Latour made in *Politics of Nature*: "The term 'collective' does not mean 'one'; rather ... it means 'all, but not two'" (94). We can take from this the following lesson: *the (ontological and political) rejection of the two leads inevitably to the One*, "future" though it may be. Certainly, the One is deferred, since Latour's collective is uncertain, always "*on the path of*

expansion," capable of being ceaselessly amended, reformed, always able to recognize the existence of new entrants. But while separation and the two have no place, everything tends towards intermixing, and becoming indistinct: *the Latourian collective places all beings on the same plane*—prions, primates, and humans, in the same way that, as we have seen, technological production is placed on the same plane as human generation. Some will find this very amusing, and proclaim the delights of *object-oriented ontology* with its endless lists.[53] But the problem is that the conditions of such a collective make it impossible to discern politically between what is important and what is not, placing the knowledge or disappearance of prions on the same level as the knowledge or disappearance of the great apes. As Alain Caillé writes in an article on Latour:

> It is hard to understand which people is likely to live on, or more generally, which human subject will be capable of surviving in the long term, given that they have been placed in principle on the same plane as any electron, amoeba, virus or adjustable spanner. The only moral which seems to survive the process of Latourian (de)construction is that of permanent openness to the infinity of the thinkable and the feasible. To translate: everything that can be done, technically, should be done. Nothing will know how to oppose, nor should oppose the indefinite expansion of biotechnologies ... It is against this absence of limits, this *hubris*, that the ecologists are battling ... Is there not something paradoxical in calling for a political ecology which in the end develops a tendency to substantiate objectives which are situated at the other end of the spectrum from those clearly manifested by ecologists?[54]

"Nothing in the proposition of Latour," Caillé adds, "permits opposition of any kind to GMOs, to the hegemony of biotechnologies or to the unlimited modification of the genome, for example," but "everything encourages them" (113). And this is for a very simple reason: the political, for Latour, can never mean *conflict* (which would require, at least, that there be two!), but always means *process* and production—this being the manner in which the multiple converges towards the One. His problem is knowing "how to bring the sciences into democracy"—this is the subtitle of *Politics of Nature*—rather than how to get democracy into the sciences![55] It is a matter of building, building well, building better—"how can [the world] be built *better*?"[56]—but by no means of opposing that which might end up being produced badly. To do so would be to oppose *the imperative of absolute realization,* this Baconian superego which consists in the *inevitable* technological realization of everything it is possible to realize. Latour's unbounded collectives are the effects of this imperative: everything is uncertain, except the certainty of producing everything.

Thus we grasp the problem: uncertainty, which does seem to describe adequately an ontological state of matter in its quantic state, is employed

in an expansive manner to justify the fact that the manner in which humans must relate themselves to nonhumans is uncontrollable. Yet whence comes the uncertainty in the case of Fukushima? From the tremendous *agency* of plankton and shrimp? From some mystical and improbable reaction on their part to the equally mysterious components of the reactors? No. A plant installed on a seismic rift, documents of inspection falsified by Tepco, a lack of respect for the WHO and other global regulators of nuclear and environmental safety,[57] the destruction of the cliff that formed a natural protective barrier,[58] and so on: Fukushima was not an accident, the unintended consequence resulting from uncertainty and our lack of ontological mastery; Fukushima was a *programmed accident*. We know, we could have known. Talking here of uncertainty or of "unexpected" conse-quences, is either ignorance or the sinister justification of disasters and their causes. Behind the uncertain collectives of Latour lies the certainty of the pluriverse aspiring to the One; against this, an ecology of separation must measure up to the task of reintroducing the power (*puissance*) of the two, of the separation without which every association becomes vague, of the opposition without which producing and developing become meaningless.[59]

Nature as detour

If everything is uncertain, if everything shapes and reshapes itself endlessly, if everything is process and everything is constructible, in the end this coheres with the constructivist and post-environmentalist declaration: there is no nature. For Latour and his friends, for Žižek as for Crutzen, the end of nature is great news! "Thank God, nature is going to die. Yes, the great Pan is dead! After the death of God and the death of man, nature, too, had to give up the ghost."[60] What is dead is nature as a term that "*makes it possible to recapitulate the hierarchy of beings in a single ordered series*" (25), nature as order, law, right, "inflexible causality," "imprescriptible laws" (28). What are the advantages and the drawbacks of such a position? This is what we will seek to grasp in concluding this chapter.

The goal of an ecology of separation does not consist in the restoration of nature as order, substance or transcendental scheme, as the basis for identifying and ordering distinct cultures. Every ecological theory worthy of the name has had to integrate the contributions of what Donald Worster has called "the ecology of chaos," formed, in the 1970s, on the wreckage of those ecologies based on the idea of a well-balanced nature.[61] Nevertheless, the idea that everything is process has *also* served to accompany the ontological requirements of industry under the capitalist condition and its penchant for unlimited development. To adhere *without reservation* to the ontological thesis that "all is process" risks leading irreversibly to the blind political *following* [*suivisme*] analyzed above, that is, to the state in

which one says yes to *all* the latest industrial innovations. In other words, is it not the phobia of everything that could resemble, from near or far, a limit placed upon the joys of uncertain collectives, which has driven the post-environmentalists and constructivists, and indeed a large portion of contemporary thought, to declare nature dead?

It is certain that ecological theory and practice have succeeded in replacing the term "nature" with terms like "ecosystem" and "ecosphere," and have insisted on the fact that, as Barry Commoner proposed in 1971, "everything is connected to everything else."[62] The problem is the rapid manner in which this theory, based on cybernetics, has been denaturalized: interconnections are used less and less to describe the internal relations of ecosystems, and more and more to describe *that which human beings put into contact*. Once *entangled* with constructed ecosystems, those ecosystems referred to as natural have become, little by little, simple elements *integrated* within anthropogenic super-ecosystems. The principle of principles of ecological theory has become the principle of anthropogenic interconnections, and henceforth, in the era of the Anthropocene, the *principle of geo-anthropogenic interconnections*. The paradox is the following: the more, in theory, we affirm that the struggle against anthropocentrism consists in recognizing the uncertainty that inhabits our projects and the *agency* proper to nonhumans, the more, in practice, that is to say in industry, we allow the so-called "end of the Great Divides" to fulfill itself, to the benefit of humans and their total colonization of the world. In other words, the more the post-environmentalists affirm that there is no nature, no limit, no separation between humans and their environment, the less *agency* nonhumans will have ...

What, then, is the proposition of an ecology of separation with regard to nature?

1 First of all, we recall that every relation implies a limit that is not
 moral and religious, but material. The relation maintained with
 this or that source of energy or water includes the possibility
 that that source might run out. After all, this is what ecological
 discourse has been saying since its beginning! A limit is nothing
 but *the immanent and material underside of every relation*. One
 may say: that's obvious! But post-environmental constructivism has
 rendered this obvious truth inaudible, by incessantly hammering
 away at the point that to speak of limits is necessarily to adopt the
 frightened discourse of those who fear to "transgress" ... Thinking
 the connections between material limit, relation and technology,
 means thinking in cosmotechnological terms; it means measuring
 the risk of selected mechanisms that do not favor democracy, care
 for environments and their possible resilience; it means reinserting
 technologies into the context of a desirable world and of the
 oppositions which this desire will never fail to provoke—the
 political power of the two is unassailable.

2 But how can we become capable of considering both the relation
and the limit, in other words, the interconnection *and* that which
could shatter it, in a world which increasingly presents itself as
immanent, lacking an outside, continuous? Instead of considering
nature as a fixed substance or an element folded into a permanent
process of transformation, an ecology of separation might take on
the thinking of *nature as detour*, that is, as a mediation allowing us
to separate ourselves, even if only temporarily, from what we are
doing. This would be the inversion of a paradigm that considers
nature as something immediate (continuous, enveloping, perhaps
even maternal), precisely where technologies (of information,
communication) are supposed, in complete contrast, to allow the
creation of mediations among beings. But, in the era of generalized
connections, of the Internet of Things or communication among
machines, it is the opposite which is true: geo-anthropogenic
interconnections create a great, seamless tissue of "immediations."
What if nature could appear henceforth as that which allows
us to re-establish a gap within the global technological system?
Rather than being a totality, nature should be understood locally,
as a means of allowing the creation of a temporal procedure
of mediation, as detour—spatial and temporal—allowing us to
measure the relations we produce and the material limits belonging
to these relations.

On the basis of such a hypothesis, let us reread the famous 23rd letter of *La
Nouvelle Héloïse* by Jean-Jacques Rousseau: in the end, that supernatural
aspect of nature which Saint-Preux feels in the high mountains is simply
a way of considering nature not as substance or transcendental principle,
but as the *detour,* the *mediation,* the *transient outside* which permits him
to engage in a radical critique of a society, and to call for its political
transformation.

Notes

1 One of the main etymological meanings of *resilire* is "'to draw back,
distance oneself from an undertaking' or 'recoil in repugnance'": "we
appreciate that the populist notion of resilience as 'bounce-back' includes
disgust at the way things are, a necessary *self-distancing* from the
normative." Stephanie LeMenager and Stephanie Foote, "Editors' Column,"
Resilience: A Journal of the Environmental Humanities 1 (1) (2014).
Available online: http://www.jstor.org/stable/10.5250/resilience.1.1.00
(accessed December 22, 2015). Without such a distance, it is impossible to
be resilient in the common sense of the term, that is, to adjust to unforeseen
shocks.

2 On this subject, see Clive Hamilton, *Earthmasters: The Dawn of the Age of Climate Engineering* (New Haven: Yale University Press, 2013).

3 On this question, see my essay "Une hégémonie d'extrême-droite: Etude sur le syndrome identitaire français," *Lignes* 45 (3) (2014).

4 On this point, see my book *Jean-Luc Nancy et le communisme existentiel* (Paris: Lignes, 2013), as well as *Atopies: Manifeste pour la philosophie* (Caen: Éditions Nous, 2014).

5 Slavoj Žižek, *In Defense of Lost Causes* (London: Verso, 2008), 433, 442. In *Looking Awry* (Cambridge, MA: MIT Press, 1992), Žižek claims that the fantasy "constructs" desire as such, because the latter is not "given in advance" (6). This is the standard poststructuralist position: there is no natural desire because there is no nature in general. It is this that leads Žižek to a *constructivism of the signifier* (or, a constructivism of the symbolic operation).

6 On the "ecology of chaos" and the works of William Drury and Ian Nisbet, see Donald Worster, *The Wealth of Nature: Environmental History and the Ecological Imagination* (Oxford: Oxford University Press, 1993), 162–7.

7 Bruno Latour, *Re-assembling the Social: An Introduction to Actor-Network-Theory* (Oxford: Oxford University Press, 2005), 46.

8 Jean-Paul Deléage, *Une histoire de l'écologie* (Paris: La Découverte, 1991), 79.

9 Carolyn Merchant, *The Death of Nature* (San Francisco: Harper & Row, 1980).

10 Paul Crutzen and Eugene Stoermer, "The 'Anthropocene,'" *Global Change Newsletter* 41 (2000): 18.

11 On this term, see my article, "Critique du géo-constructivisme. Anthropocène et géo-ingénierie," *Multitudes* 56 (1) (2014).

12 For Paul Crutzen and Christian Schwägerl, "the long-held barriers between nature and culture are breaking down. It's no longer us against 'Nature.' Instead, it's we who decide what nature is and what it will be" ("Living in the Anthropocene: Toward a New Global Ethos," *Yale Environment 360* (2011). Available online: http://e360.yale.edu/feature/living_in_the_anthropocene_toward_a_new_global_ethos_/2363 (accessed December 22, 2015). We can see very clearly that the so-called end of the great divides always benefits "us," human beings. This uneven dividing up of the effects of the end of the great divides is one of the blind spots typical of ecological constructivist discourse.

13 Michael Shellenberger and Ted Nordhaus, eds. *Love Your Monsters: Postenvironmentalism and the Anthropocene* (Oakland: Breakthrough Institute, 2011), Kindle edition, Kindle Location 54.

14 Such is the thesis upheld by Christophe Bonneuil and Jean-Baptiste Fressoz in *L'événement Anthropocène* (Paris: Seuil, 2013). The *Homo Sapiens* hypothesis (which takes as its point of departure the transformations occasioned by fire and hunting 200,000 years ago), the "early anthropogenic hypothesis" of paleoclimatologist William Ruddiman (who

insists on the role of the dawn of agriculture 7,000 years ago) and the hypothesis of acceleration (which sees everything as beginning after the Second World War), all have the effect of nullifying the upheaval brought about by the industrial revolution (which Crutzen locates as the temporal and economic origin of the Anthropocene)—and thus of confirming the techno-developmentalist enthusiasm of ecological constructivism.

15 Ted Nordhaus and Michael Shellenberger, *The Death of Environmentalism* (Oakland: Breakthrough Institute, 2004), 8. Available online: http://www. thebreakthrough.org/images/Death_of_Environmentalism.pdf (accessed December 22, 2015).

16 Bruno Latour, "Love your Monsters: Why we must Care for our Technologies as we do our Children," in *Love Your Monsters: Postenvironmentalism and the Anthropocene,* ed. Ted Nordhaus and Michael Shellenberger (Oakland: Breakthrough Institute, 2011). This article can also be found here: http://thebreakthrough.org/index.php/journal/ past-issues/issue-2/love-your-monsters/

17 Cf. Bruno Latour, *Aramis, or The Love of Technology* (Cambridge, MA: Harvard University Press, 1996), 83, 227, 248–9, 280.

18 Bruno Latour, *We Have Never Been Modern* (Cambridge, MA: Harvard University Press, 1993).

19 Latour, "Love your Monsters," 339.

20 On this point, cf. Michel Serres, *The Natural Contract* (Ann Arbor: University of Michigan Press, 1995), 33, and Ulrich Beck, *Risk Society* (London: Sage, 1992), 80–2.

21 Nordhaus and Shellenberger, "The Death of Environmentalism," 12.

22 Latour, "Love your Monsters," 308.

23 Cf. Crutzen and Schwägerl, "Living in the Anthropocene," and my footnote 12 above.

24 The original German phrase is "der endgültig entfesselte Prometheus"; Hans Jonas, *Das Prinzip Verantwortung. Versuch einer Ethik für die technologische Zivilisation* (Frankfurt: Suhrkamp, 2003), 7.

25 Latour, "Love your Monsters," 320–1.

26 Bruno Latour, "'It's Development, Stupid!' or: How to Modernize Modernization," 10. This long, as yet unpublished version of "Love your Monsters," can be found here: http://www.bruno-latour.fr/sites/default/ files/107-NORDHAUS&SHELLENBERGER-GB.pdf

27 [*Trans.*] *Décroissance* literally means a decrease or decline; here it carries the more active sense of both withdrawal and the restricting of growth.

28 Bruno Latour, *Politics of Nature: How to bring the Sciences into Democracy*, trans. Catherine Porter (Cambridge, MA: Harvard University Press, 2004), 26.

29 Latour, "It's Development," 2.

30 Latour, "Love your Monsters," 3.

31 Bruno Latour, *Enquête sur les modes d'existence. Une anthropologie des Modernes* (Paris: La Découverte, 2012), 20.

32 John von Neumann, "Can we survive technology?" in *The Fabulous Future. America in 1980* (New York: E. P. Dutton & Co., 1955), 44.

33 Latour, "It's Development," 12.

34 Francis Bacon, "New Atlantis," in *Ideal Commonwealths* (1629; New York: Dedalus/Hippocrene, 1988), 129.

35 Latour, "It's Development," 13.

36 Latour, "Love your Monsters," 380–1.

37 On all these points, see Günther Anders, *Le temps de la fin*, quoted by Déborah Danowski and Eduardo Viveiros de Castro, "L'arrêt de monde" in *De l'univers clos au monde infini* (Paris: Éditions Dehors, 2014), 298, and Jean-Pierre Dupuy, *Pour un catastrophisme éclairé: Quand l'impossible est certain* (Paris: Seuil, 2002).

38 Bernard Stiegler, *La technique et le temps 1: La faute d'Epiméthée* (Paris: Galilée, 1994), 191–210.

39 Mary Shelley, *Frankenstein* (New York: W. W. Norton & Co., 2012), 67–8.

40 René Descartes, *Discourse on Method and Meditations* (New York: Dover Publications, 2003), 42. See also: "The Conservation of Health Has Always Been the Principal End of My Studies," René Descartes, *The Philosophical Writings of Descartes* Vol. III (Cambridge: Cambridge University Press), 275.

41 Zygmunt Bauman, *Liquid Life* (Cambridge: Polity, 2005), 93.

42 My intention is not in any way to challenge the "legitimacy of the modern age" (Blumenberg), but to show how modernity constitutes itself, strangely, by prolonging certain pre-modern traits—somewhat as if the pre-modern were the unconscious of modernity, its active repressed part. More precisely: it is a matter of saying neither that there was an absolute rupture, nor a flawless continuity, between scientific pre-modernity and scientific modernity, but that there was *a rupture in method* and *the continuity of an unconscious wish*. Only an *ecoanalysis* would allow us to avoid foreseeable catastrophes of a climate engineering that perpetuates and strengthens this unconscious wish. This is what will allow us to make it clear that it is not climate engineering as such that is dangerous, but this technology to the extent that it is guided by a pre-modern fantasy.

43 Emilie Hache, *Ce à quoi nous tenons: Propositions pour une écologie pragmatique* (Paris: La Découverte, 2011), 12. See also: "If a gap exists between moral principles and the world with which we are experimenting, it is our principles that lack morality, not the world" (ibid., 55). Against this statement, I argue that to get rid of the gap is the problem, not the solution.

44 Latour, "Love your Monsters," 380–4.

45 Peter Sloterdijk, *La domestication de l'être* (Paris: Mille et une nuits, 2000), 91.

46 Carl Folke, Steve Carpenter, Thomas Elmqvist, Lance Gunderson, C. S.

Holling, and Brian Walker, "Resilience and Sustainable Development: Building Adaptive Capacity in a World of Transformations," *AMBIO: A Journal of the Human Environment* 31 (5) (2002): 438–9.

47 Peter Sloterdijk, *La domestication de l'être*, 91.

48 André Gorz, *L'immatériel* (Paris: Galilée, 2003).

49 André Gorz, *Ecologica*, trans. Chris Turner (Paris: Galilée, 2008), 16.

50 There is "a radical monopoly" when the "domination of the domination of the tool establishes obligatory consumption and hence restrains the autonomy of the person. In this we have a particular type of social control, reinforced by the obligatory consumption of a mass production that only the major industries can provide." Ivan Illich, *La convivialité* (Paris: Seuil, Points-Essais, 2003), 81–2.

51 Bruno Latour, *Politics of Nature: How to bring the Sciences into Democracy*, trans. Catherine Porter (Cambridge, MA: Harvard University Press, 2004), 238.

52 Bruno Latour, "The Promises of Constructivism," in *Chasing Technoscience: Matrix for Materiality*, ed. D. Ihde and E. Selinger (Bloomington: Indiana University Press, 2003), 31.

53 See, for example: "humans, dogs, oak trees, and tobacco are on precisely the same footing as glass bottles, pitchforks, windmills, comets, ice cubes, magnets, and atoms." Graham Harman, *Tool-Being: Heidegger and the Metaphysics of Objects* (Chicago: Carus Publishing Co., 2002), 2.

54 Alain Caillé, *Revue du MAUSS* 17 (Paris: La Découverte, 2001), 111.

55 Such would be the goal, rather, of Isabelle Stengers.

56 Bruno Latour, "The Promises of Constructivism," 42.

57 "The present catastrophe was the result of human carelessness," interview with Eisaku Sato, the former Governor of Fukushima, *Le Monde*, March 28, 2011.

58 "Pour construire la centrale, Tepco avait raboté la falaise," *Le Monde*, July 12, 2011.

59 (1) *An Enquiry into Modes of Existence* changes nothing with regard to the analyses carried out here: there Latour renews the fundamentals of ecological constructivism (no difference between nature and society, etc.) and engages in a "regional ONTOLOGY" (31, French edition) capable of accounting for "modes of existence" (fiction, technique, right, habit, etc., fourteen in all), manifesting an "ontological pluralism" (150). This uncertain pluralism (always in negotiation, always ready to be modified, work in progress capable of integrating all critiques in order to dissolve them, once again leaves no place for *internal division* (2); I confess that I do not understand why Latour employs the term "existence" (it is rather the "mode" that interests him).

60 Latour, *Politics of Nature*, 25–6.

61 Donald Worster, *The Wealth of Nature*, 162.

62 Barry Commoner, *The Closing Circle* (New York: Knopf, 1971), 29.

Bibliography

Bacon, Francis. "New Atlantis." In *Ideal Commonwealths*. 1629. New York: Dedalus/Hippocrene, 1988.

Barry Commoner. *The Closing Circle*. New York: Knopf, 1971.

Bauman, Zygmunt. *Liquid Life*. Cambridge: Polity, 2005.

Beck, Ulrich. *Risk Society*. London: Sage, 1992.

Bonneuil, Christophe and Jean-Baptiste Fressoz. *L'événement Anthropocène*. Paris: Seuil, 2013.

Caillé, Alain. *Revue du MAUSS* no 17. Paris: La Découverte, 2001.

Crutzen, Paul and Christian Schwägerl. "Living in the Anthropocene: Toward a New Global Ethos." *Yale Environment 360* (2011). Available online: http://e360.yale.edu/feature/living_in_the_anthropocene_toward_a_new_global_ethos_/2363 (accessed December 22, 2015).

Crutzen, Paul and Eugene Stoermer. "The 'Anthropocene.'" *Global Change Newsletter* 41 (2000): 17–8.

Danowski, Déborah and Eduardo Viveiros de Castro. "L'arrêt de monde." In *De l'univers clos au monde infini*. Paris: Éditions Dehors, 2014.

Deléage, Jean-Paul. *Une histoire de l'écologie*. Paris: La Découverte, 1991.

Descartes, René. *Discourse on Method and Meditations*. New York: Dover Publications, 2003.

Descartes, René. *The Philosophical Writings of Descartes*. Volume III. Cambridge: Cambridge University Press.

Dupuy, Jean-Pierre. *Pour un catastrophisme éclairé. Quand l'impossible est certain*. Paris: Seuil, 2002.

Folke, Carl, Steve Carpenter, Thomas Elmqvist, Lance Gunderson, CS Holling and Brian Walker. "Resilience and Sustainable Development: Building Adaptive Capacity in a World of Transformations." *AMBIO: A Journal of the Human Environment* 31 (5) (2002).

Gorz, André. *Ecologica*, trans. Chris Turner. Paris: Galilée, 2008.

Gorz, André. *L'immatériel*. Paris: Galilée, 2003.

Hache, Emilie. *Ce à quoi nous tenons: Propositions pour une écologie pragmatique*. Paris: La Découverte, 2011.

Hamilton, Clive. *Earthmasters: The Dawn of the Age of Climate Engineering*. New Haven: Yale University Press, 2013.

Harman, Graham. *Tool-Being: Heidegger and the Metaphysics of Objects*. Chicago: Carus Publishing Company, 2002.

Illich, Ivan. *La convivialité*. Paris: Seuil, Points-Essais, 2003.

Jonas, Hans. *Das Prinzip Verantwortung: Versuch einer Ethik für die technologische Zivilisation*. Frankfurt: Suhrkamp, 2003.

Latour, Bruno. "Love your Monsters: Why we must Care for our Technologies as we do our Children." In *Love Your Monsters: Postenvironmentalism and the Anthropocene,* ed. Ted Nordhaus and Michael Shellenberger. Oakland: Breakthrough Institute, 2011.

Latour, Bruno. "The Promises of Constructivism." In *Chasing Technoscience: Matrix for Materiality*, ed. D. Ihde and E. Selinger. Bloomington: Indiana University Press, 2003.

Latour, Bruno. *Aramis or The Love of Technology*. Cambridge, MA: Harvard University Press, 1996.

Latour, Bruno. *Enquête sur les modes d'existence: Une anthropologie des Modernes*. Paris: La Découverte, 2012.

Latour, Bruno. *Politics of Nature: How to Bring the Sciences into Democracy*, trans. Catherine Porter. Cambridge, MA: Harvard University Press, 2004.

Latour, Bruno. *Re-assembling the Social. An Introduction to Actor-Network-Theory*. Oxford: Oxford University Press, 2005.

Latour, Bruno. *We Have Never Been Modern*. Cambridge, MA: Harvard University Press, 1993.

Le Monde. "Interview with Eisaku Sato, the former Governor of Fukushima." March 28, 2011.

Le Monde. "Pour construire la centrale, Tepco avait raboté la falaise." July 12, 2011.

LeMenager, Stephanie and Stephanie Foote. "Editors' Column." *Resilience: A Journal of the Environmental Humanities* 1 (1) (2014). Available online: http://www.jstor.org/stable/10.5250/resilience.1.1.00 (accessed December 22, 2015).

Merchant, Carolyn. *The Death of Nature*. San Francisco: Harper & Row, 1980.

Neumann, John von. *"Can we survive technology?"* In *The Fabulous Future. America in 1980*. New York: E. P. Dutton & Co., 1955.

Neyrat, Frédéric. " Une hégémonie d'extrême-droite. Etude sur le syndrome identitaire Français." *Lignes* 45 (3) (2014): 19–31.

Neyrat, Frédéric. "Critique du géo-constructivisme. Anthropocène et géo-ingénierie." *Multitudes* 56 (1) (2014): 37–47.

Neyrat, Frédéric. *Atopies. Manifeste pour la philosophie*. Caen: Éditions Nous, 2014.

Neyrat, Frédéric. *Jean-Luc Nancy et le communisme existential*. Paris: Lignes, 2013.

Nordhaus, Ted and Michael Shellenberger. *The Death of Environmentalism*. Oakland: Breakthrough Institute, 2004. Available online: http://www.thebreakthrough.org/images/Death_of_Environmentalism.pdf (accessed December 22, 2015).

Serres, Michel. *The Natural Contract*. Ann Arbor: University of Michigan Press, 1995.

Shellenberger, Michael and Ted Nordhaus, eds. *Love Your Monsters: Postenvironmentalism and the Anthropocene*. Oakland: Breakthrough Institute, 2011. Kindle edition.

Shelley, Mary. *Frankenstein*. New York: W. W. Norton & Co., 2012.

Sloterdijk, Peter. *La domestication de l'être*. Paris: Mille et une nuits, 2000.

Stiegler, Bernard. *La technique et le temps 1. La faute d'Epiméthée*. Paris: Galilée, 1994.

Worster, Donald. *The Wealth of Nature. Environmental History and the Ecological Imagination*. Oxford: Oxford University Press, 1993.

Žižek, Slavoj. *In Defense of Lost Causes*. London: Verso, 2008.

Žižek, Slavoj. *Looking Awry*. Cambridge, MA: MIT Press, 1992.

CHAPTER FOUR

General ecology, economy, and organology

Bernard Stiegler

Translated by Daniel Ross

Ecology, organology, cosmology

In "A Thousand Ecologies: The Process of Cybernetization and General Ecology," Erich Hörl takes up a proposition wherein Michel Deguy makes ecology the "task of thinking."[1] And he points out that a phrase such as the "task of thinking" owes something to Martin Heidegger. On the basis of this remark, he explains why Heidegger could not himself assume such a(n) "ecological") task *in our epoch*, that is, inasmuch as it posits that *humanity's ecological dimension is what, above all, today reveals its primordially artificial constitution*—and its "artifacticity."[2]

Furthermore, Erich Hörl himself refers to Gilbert Simondon to show that, in addition to the fertility of the terms and analyses proposed by this thinker of the relation, ecology, insofar as it is above all a relational form of thinking, must be conceived starting from cybernetics and from Simondon's critique thereof (in the Kantian sense of "critique"), and by taking up this program on new bases (other than those of Norbert Wiener). This is what leads Hörl to conceive of a general ecology capable of assuming the task of thinking on the basis of a techno-logical perspective in which cybernetics, which was for Heidegger, too, the science characteristic of "modern technics" (see *Zeit und Sein*), constitutes the new conceptual framework that opens the way for a new "encyclopedism" in Simondon's sense—that is, forming the new horizon of the transindividual (which in Simondon constitutes meaning) insofar as it bears the promise of a reconciliation between "culture" and technics.

I have myself argued for ten years that cybernetics must be understood as the most recent stage of a process of grammatization that can be

thought only through the perspective that I have called, on the basis of a
critique of Simondon (again, in the Kantian sense of "critique"), a "general
organology," which I believe to be a more apt way of approaching these
questions than through what Simondon himself called a "mechanology"
(although he did occasionally use the term "organology").[3]

Before giving a recap of what I call general organology, let me explain
how I use the concepts of Bertrand Gille, such as the concept of technical
system and of social systems. General organology is a method of thinking,
at one and the same time technical, social, and psychic becoming, where
technical becoming must be thought via the concept of the technical system,
as it adjusts and is adjusted to social systems, themselves constituted by
psychic apparatuses.

There is no human society that is not constituted by a technical system.
A technical system is traversed by evolutionary tendencies that, when they
concretely express themselves, induce a change in the technical system.
Such a change necessitates adjustments with the other systems constituting
society—those systems that Bertrand Gille called social systems, in a sense
that should be specified in confrontation with Niklas Luhmann.

These adjustments constitute a suspension and a re-elaboration of the
socio-ethnic programs or socio-political programs that form the unity
of the social body. This re-elaboration is a selection among possibilities,
effected across what I call retentional systems, themselves constituted by
mnemo-techniques or mnemo-technologies that I call hypomnesic tertiary
retentions, the becoming of which is tied to that of the technical system,
and the appropriation of which permits the elaboration of selection criteria
constituting a motive, that is, a characteristic stage of psychic and collective
individuation.

Hypomnesic tertiary retentions are fruits of a process of grammatization,
wherein all the fluxes or flows through which symbolic and existential acts
are linked can be discretized, formalized, and reproduced. The most well-
known of these processes is written language. And digital tertiary retention
is the most recent of these processes.

Let's now remind ourselves about the meaning of what I call "general
organology": general organology defines the rules for analyzing, thinking,
and prescribing human facts at three parallel but indissociable levels: the
psychosomatic, which is the endosomatic level, the artifactual, which is
the exosomatic level, and the social, which is the organizational level. It is
an analysis of the relations between organic organs, technical organs, and
social organizations.

As it is always possible for the arrangements between these psychoso-
matic and artifactual organs to become toxic and destructive for the organic
organs, general organology is a pharmacology. In the analysis that I will
present here, I would like to project these perspectives into what I believe
to be a broader, more encompassing, more clearly urgent and "relevant"
(as one says in English) consideration of what for the last fifteen years has

been referred to as the Anthropocene, which I would like to consider from the point of view of what I provisionally call, with regard to Alfred North Whitehead, a "speculative cosmology."

The speculativity of such a cosmology, which would also be performative, leads to the theoretical and practical prospect and program of a passage from the Anthropocene to what I propose naming the Neganthropocene—all these issues being placed in the context of the cosmological stakes of thermodynamics, with the notion of entropy that is its second law, and of the analysis of life *and technics* as negentropic inversions and bifurcations that nevertheless do not oppose entropy but divert it, *by deferring it*, in a process resembling what Derrida called *"différance,"* with an "a."

This diversion is, in the case of technics (that is, organology), a pharmacology, and it constitutes a *future*, an *avenir*, within the irreversible law of entropic becoming, *devenir*—a becoming that, insofar as it is inherently entropic, then becomes the law of what had hitherto and without major objection been referred to as "being": that is, until 1924, the year of the discovery by Edwin Hubble of the expansion of the universe, opening the era of what Ilya Prigogine calls the evolutionary perspective in physics.

Generality, metaphysics, cosmology

What does the adjective "general" mean in the expressions *general ecology* used by Erich Hörl and *general organology* as I try to think it? Is it the same as what Georges Bataille was referring to in his thought of *general economy*?[4] Does this "generality" inevitably lead us back to a *metaphysica generalis*—or to a *metaphysica speculativa*?

These questions must be explored in dialogue with Whitehead and Simondon, that is, with, respectively, *concrescence* as that process which is the subject of Whitehead's *Process and Reality*, and the *process of concretization*,[5] which is one of the main concepts of Simondon's *Du mode d'existence des objets techniques*—by raising the question of the generality of the point of view of *process*, and as passage from abstraction to concretion, or to concrescence, *the abstract and the concrete* being conceived here, therefore, from a fundamentally and primordially processual point of view.

In addition, these questions lead us back to that *cosmology* which passes through Simondon and Whitehead—beyond the rational cosmology of Kant, who could not, precisely, take into account the *organological* question (any more than could philosophy in general, with the exception of Marx). The ideas of a rational cosmology are in Kant those of reason (see "The Transcendental Dialectic," Chapter 2, "The Antinomy of Pure Reason"), and we shall see that Whitehead sees himself in some respects from a similar perspective. Nevertheless, it is impossible to think with this

apparatus alone the thermodynamic question such as it was constituted with Sadi Carnot as the *theory of the steam engine.*

Kantianism, in fact, is constituted by a denial of the organological conditions of the formation of reason as well as of understanding. This does not allow for any thought of entropy such as Carnot understands it on the basis of the artifact that is the steam engine as closed thermodynamic system. Nor does it allow for consideration, therefore, of those regimes of negative entropy that were uncovered by Erwin Schrödinger, preceded by Henri Bergson,[6] then by Claude Shannon, Léon Brillouin, and Nicholas Georgescu-Roegen, who, unlike his predecessors, insisted on the issue of exosomatic organs.

I tried to show, in *Technics and Time, 3,* why the Kantian schematism, fruit of the transcendental imagination, did not allow him to think the organological (that is, tertiary retention) and its consequences for any idea of reason (including the idea of rational cosmology).[7] From the organological perspective I defend here, the schematism originally comes from technical exteriorization and the artifactualization of the world as the condition of the constitution of the world, that is, as condition of the projection in the world of concepts *constituting* the given data of intuition of this world such as it is *ordered* in the *cosmos*—and it is the consideration of the cosmos itself (and not just of the world) that hence finds itself affected: we access the cosmos as cosmos on the basis of hypomnesic tertiary retentions in all their forms, from the shaman's instruments to Herschel's telescope.

Since the time of ancient philosophy, the *kosmos,* as an arrangement [*disposition*] of *physis,* through which it lets itself be seen and thus *appear* (phenomenalize itself) as this very arrangement, and as an *order,*[8] has been conceived in terms of spheres and cycles closed in upon themselves as a fundamental and absolute equilibrium. In Aristotle's *Metaphysics,* which localizes the sublunary world in the fixed sphere, technics, which constitutes the organological condition, is in relation to the sublunary as the region of contingency and of "what can be otherwise than it is" (*to endekhomenon allos ekhein*), whereas the *eide,* conceived in relation to cosmic fixities, opposes to this facticity the necessity of *to on.* This division will be maintained in Kant, and this is particularly clear in "Theory and Practice."[9]

Combustion

The advent of the thermodynamic *machine,* which Heidegger does not take into account, nevertheless constitutes, with the automation of machines, what Heidegger refers to as the *Ereignis* of "modern technology" (that is, of the industrial revolution) and its *Gestell*—and this is also the advent (*"Ereignis"*) of what today we refer to as the Anthropocene, but not as an

Er-Eignis, that is, a co-propriation, as the French translators of Heidegger wrongly claimed, but rather as an ex-propriation, wherein the human world appears to constitute a *fundamental disruption* of the cosmos, and of its local (planetary) equilibriums.

The thermodynamic *machine* is, however, *also* what introduces the question of an irreducible processuality of the cosmos itself, of the irreversibility of becoming, and, if not the instability, then at least the processuality in which this becoming consists, and it introduces all this at the heart of physics itself. This question seems, however, to have remained hidden in Heidegger due to his fixation on cybernetics (which seems equally to mask the question of marketing—in Heidegger as well as in Hans Jonas—such as Deleuze attempted to think it as that knowledge characteristic of societies of control).[10]

The thermodynamic machine—which in *physics* raises the specific and new problem of the dissipation of energy and, more generally, of the irreversibility of the "arrow of time" oriented towards disorder, that is, the irreversible increase of entropy—is also an industrial technical object that, arranged with the first automatisms and establishing *proletarianization* (that is, loss of knowledge) as the *fundamental principle of productivity*, fundamentally disrupts *social* organizations, and at the same time radically alters "the understanding that Dasein has of its being."

If proletarianization radically disrupts social organization, the thermodynamic machine also transforms the scientific point of view. Consisting essentially in a *combustion*, this technical object—an element of which, the flyball governor, will prove critical for conceiving cybernetics—introduced, on both the physical plane and the ecological plane, *the question of human fire and of its pharmacology*, which is thereby inscribed at the heart of the thought of the cosmos *as cosmos* (both from the perspective of physics and from that of anthropological ecology), the play between them being both cosmic and mundane: this is what the Promethean myth of fire means in Greek tragedy.

The notion of the Anthropocene can appear as such only from the moment when the question of the cosmos reveals itself to be that of combustion, accomplishing the transformation of cosmology into an astrophysics of combustion, and as emerging from the thermodynamic question opened and posed by the steam engine—that is, by the techno-logical conquest of fire. Only within this perspective can there occur the kenosis of the "death of God."

As a problem of physics, the techno-logical conquest of fire (which is the *Ereignis* of *Gestell* on the basis of which proletarianization arises as *Bestand*) placed *anthropogenesis at the heart of concrescence*, that is, *organological organogenesis* (what Georgescu-Roegen therefore calls the exosomatic), and as the *local technicization of the cosmos*—local and therefore *relative*. But this leads to a *complete rethinking* of the cosmos from an astrophysical perspective, *starting from this position and from*

this local opening of the question of fire, and as a *pharmakon* of which we must *take care*, which we must tend, and such that the question of the *energy* it harbors constitutes the *matrix of the thought of life as well as of information as the play of entropy and negentropy.*[11] The cosmos certainly becomes the universe well before this, with Nicolas of Cusa and Giordano Bruno. But it is only with thermodynamics that it becomes the astrophysical "consumption" of becoming.

The notion of entropy natively presupposes the *experience* of *anthropic fire*, so to speak, as the entropy of physical combustion, then as the negentropy of vital combustion, if we can put it this way, through which the living finds its place, its locality and its *ethos* in the universe that is carried along in the dissipative movement of its disorder. Here the living, insofar as it is not immortal, nor therefore divine, *always returns* to cosmic entropy—including as the production of methane by animals, which can lead to the disequilibrium of the biosphere in relation to the ozone layer and so on, that is, even before they return to inertia.

Organology of the question

It is doubtful whether the full dimension of the question of entropy and negentropy among human beings, as a *question*, has ever truly been grasped.[12] We could show, for example, that the works dedicated to entropy by Henri Atlan and Edgar Morin take no account whatsoever of the specificity of organological (exosomatic) negentropy, nor obviously of the equally specific entropy that it generates—in particular since the advent of the Anthropocene. And we could show that this also fundamentally weakens the theory of information conceived as a regime to entropy and negentropy (Simondon included).[13]

At the beginning of the nineteenth century, technics establishes, scientifically but also socially (as standardization and proletarianization), the *question* of entropy and negentropy as *the* crucial *problem* of the everyday life of human beings and of life in general, and, ultimately, of the universe as a whole, which once again becomes the *kosmos* insofar as it invites, hosts and in some way houses the negentropic, that is, the living, including *noetic* life, which we therefore ought to call the *neganthropo-logical*.

As such, that is, as the organogenesis of this *anthropos* that is not self-sufficient, technics—which is also anthropic in the sense that it extends and accelerates the entropy of anthropization in the Anthropocene—constitutes the matrix of all thought of the *oikos*, of habitat and of its law as *ecology* as well as *economy*, which is also to say, as *oikonomia* (which can here be "general" only in George Bataille's a-theological sense).

This is also what was going on with what was at one time conceived as hermeneutic knowledge of the mind. This eventually became, with the

utilization by cognitivism of the concept of information—as it was thought by information theory and computationalist cybernetics—a new "science of the mind" (and of *spirit* and *Geist*), in which mind and spirit find themselves folded back into "cognition."

In this new metaphysics that is cognitivism, the organological question that *makes possible* such a perspective (where the computer assumed to be a "Turing machine" becomes the model of the mind) is never posed. "Organological" means here: that which causes the living to pass from the organic stage to the organological stage, which requires radically new terms with which to think the organization of that of which this new organogenesis is the condition.

Technics—as the advent and event of what Ernst Kapp and then Friedrich Engels called "projection" or "organic extension," but which more precisely is an *organological* extension, an extension that is *not* organic—is the pursuit of life by means other than life. And this is also the opening of what Heidegger believed should still be called the "question of being" as the advent of *Dasein*, that is, of the "being who questions." Contrary to this Heideggerian perspective, we posit that if Dasein questions, it can only be insofar as *technics challenges it, puts it into question*—and does so starting from the fact that it is necessary to *formulate* this challenge, that is, to exteriorize it, which is very often (if it is indeed a question and not a fantasy or chatter) the starting point for a new technical exteriorization and a new putting in question, a new challenge, and so on.

As this organogenesis that is at once anthropic and neganthropic, technics is the *post-Darwinian* evolution of life that has become *essentially technical and organological*, and not just organic. This technical form of life poses in completely new terms the problem of what Canguilhem called the infidelity of the milieu, which confronts living things in general each time their milieu changes, but which, in the case of *technical* life, constitutes a *technical milieu* that introduces a new type of infidelity, in which it is organological and not just organic life that ceaselessly disrupts its milieu, and does so structurally and ever more rapidly: structurally to the extent that this disruption is vital to it, but tragically to the extent that it is always also toxic—insofar as it constitutes a phase difference *that cannot be transindividuated*, that is, adopted, in the sense that it must be individuated both psychically and socially (this is what Niklas Luhmann, it seems to me, does not see).

In other words, this organological milieu poses in completely unprecedented terms the question of the relations between what Claude Bernard called the interior milieu and the exterior milieu. *New conditions of fidelity are required in order to overcome the shocks of infidelity*, so to speak, that are provoked by what I call the *epokhally double redoubling*. This study of milieus and infidelities constitutes the field of what we can refer to as a general ecology inasmuch as it inscribes in the cosmos the perspectives of a general organology. It is also the pathway to a new understanding of the dynamics and statics of religion.

The quasi-causal economy of infidelity

When life becomes organological, and not just organic, and when the "external" technical milieu conditions and in so doing constitutes the interior milieu of collective individuation and of the social systems in which it consists, as well as of psychic individuation (which results, as we now know, in an organological reorganization of the organic organization in which the cerebral organ primarily consists, and through the psycho-synaptic internalization of the exosomatic and the social relations which it weaves, as the work of Maryanne Wolf shows), organological and pharma-cological beings encounter the infidelity of the technical milieu, which *as such* constitutes them as *noetic* beings, for whom noesis is always both the repercussion [*contre-coup*] and the aftershock [*après-coup*] of an *epokhal technological shock*.

Technological shock is epochal in as much as it makes an epoch, that is, it is a suspension, an interruption, a disruption, and as such *stupe-faction*. Epochal technological shock (such as the thermodynamic machine in partnership with discretization and the reproduction of the gestures of work by mechanical and automatic tertiary retention) is stupefying (and generates stupidity in a thousand ways) in that it disrupts the organo-logical arrangements established by a prior and metastabilized stage of transindividuation—forming what Heidegger called "the understanding that there-being has of its being."

Such an "understanding" is trans-individuated between the psychoso-matic organs, technical organs, and social organizations (that Gille and Luhmann both call, but in two very different senses, "social systems"), and engenders a new "understanding that there-being has of its being" formed by the new circuits of transindividuation that form between the initial technological shock and a second moment that amounts to a noetic fulfilment (that is, a circuit of transindividuation) through which stupor becomes surprise and ultimately eventuates in an understanding.

General ecology, general economy and general organology are attempts to form such circuits in our epoch. This "generality" is indicative of an attempt to respond to the generality (and to the planetary, and as such locally cosmic, globality) of the shock *we are given to think*, and this requires us to trans-form this thinking into action—that is, into *decision*, a decision that *slices into* becoming, that carves *into* it in order to carve *out* a future, that is, a protention that is *desirable* and that would not be reducible to becoming: becoming, *devenir*, is entropic, whereas the future, *avenir*, is negentropic. Such a program is necessarily also a neganthropology.

Stupefaction, which is the condition of noesis (just as stupidity is the condition of thinking, as say Nietzsche and Deleuze), is that of which one always finds an echo, more or less near or distant, in what I call surprise, a sur-prised ap-prehension, a *sur-prehension* [*surpréhension*], which would

be irreducible to under-standing [*compréhension*], and where this relates to reason, to that reason which Kant distinguished from understanding.

It is as *reconstitution of a fidelity to the milieu, and, in this milieu, to psychic individuals, technical individuals, and social individuals* (via social systems), that a *libidinal economy* is established that would also be a *general* economy and a general *ecology*. In this libidinal and as such general economy, psychic, technical, and social individuals take care of one another through *transductive* relations, relations in which one side (for example, psychic individuals) cannot exist without the others (for example, technical individuals or social individuals), even though technical and social individuals *pre-cede* psychic individuals, and do so as the condition of formation of their *preindividual* funds, funds that were previously constituted as circuits of transindividuation for those who are now dead.

In principle, and because reason is rooted in what Kant called transcendental apperception as the *spontaneous coming together that occurs between the noetic order and the cosmic order*, care, insofar as it is inherently negentropic, and as such derives from a neganthropology, is also that care taken of ecology insofar as the cosmic milieu is locally neganthropic and must be protected from anthropic disequilibriums.

To what extent and in what economic conditions the coming together, the agreement, that founds Kantian transcendental apperception is possible in the Anthropocene epoch is the entire issue at stake in bringing together general ecology, general organology and general economy—that is, libidinal economy as the possibility of moving beyond the drive-based stage of consumerist capitalism and as constituting an economic system founded on the valorization of negentropy translated into neganthropology.

The precedence of technological shock constitutes what Simondon described as a *phase difference*, and it finds its point of departure in the *originary default of origin*. In this regard, the allegory of Prometheus and Epimetheus is the mythical formulation of what the archaeology of André Leroi-Gourhan describes as a process of exteriorization, after it was thought by Canguilhem as technical life, and which I myself call the pursuit of life—that is, of *negentropogenesis*—by means other than life.

This shock through which life mortifies itself by secreting what I have described as an epiphylogenetic memory that constitutes the possibility of what we today call culture, and which is the unthought ground of what Dilthey called the science of spirit, is also what constitutes libidinal economy insofar as, as artifact, it constitutes the fetish and hence the organological body as object of desire. In this way the instinct becomes the drive, that is, the capacity for detachable fixations, which is also to say, for perversion, and ultimately desire, via the binding of these drives through what Freud described as identification, idealization and sublimation—which is always a neganthropic process.

Such a libidinal economy implements, through various *causal chains arising from the cosmos and the biosphere*, a *positive quasi-causality*. And

as such it inverts the arche-event or *Ereignis* of organological facticity into a therapeutic necessity, and does so to the benefit not only of psychic, technical, and social individuals, but also vital, terrestrial and cosmic individuals: to take care of psychic and collective individuation, that is, of the organological biosphere (that we currently call the Anthropocene) is *also* to take care of what constitutes the general ecological condition.

Selection and decision

Here it is absolutely essential to read and critique *The German Ideology*, and then to re-read the *Grundrisse* on the basis of this re-reading of *The German Ideology*. I have tried to open up this work in *States of Shock* and in *Pharmacologie du Front National*. Only on the basis of such a critique of what in Marx and Engels amounts to the first philosophical formulation of the organological question (engendering and pre-ceding as it does the question of class struggle) is it possible and necessary to constitute general ecology on the basis of a general economy, that is, a libidinal economy, itself conceived on the basis of a general organology, and to do so as a new political thinking founded on a critical reinterpretation of Marx.

But this in turn is possible only on the basis of a conjoined re-reading of Marx, Freud, Husserl, Canguilhem, Leroi-Gourhan, Derrida, Deleuze, Lyotard and many others, through an investigation of the fundamental question of the difference between the organic and the organological, which is also their mutual *différance(s)*, and thereby opens a new age of that *différance* that is noesis (by tracing new circuits of transindividuation) in relation to the *différance* that is life.

Such an investigation, such an instruction, is itself possible only by adopting a method that will coordinate the diverse knowledge that constitutes a theory of general organology, but that will also, and as organological practice, invent negentropic instruments at the service of all forms of knowledge—*savoir faire, savoir vivre, savoir théoriser* (knowledge of how to do, live and think): it is *in relation to these two dimensions* that, with IRI, Ars Industrialis, pharmakon.fr and the digital studies network, I understand the program that Deleuze formulated in his call to "look for new weapons."

In this context, Ars Industrialis problematizes digital shock in the social field as in the psychic field; IRI elaborates prototypes that are instrumental alternatives derived from what we call practical organology; pharmakon. fr engages in theoretical practices with these instruments; and the digital studies network understands these problematics from a transdisciplinary perspective that takes the digital as its object insofar as it is conceivable only on the condition of rethinking all forms of knowledge starting from the organogenesis of artifacts, societies and psychic individuals that has been occurring since the origin of hominization.

As I imagine it, the general ecology invoked by Erich Hörl is both a scientific and a political ecology, and it must as such tightly articulate the questions of *selection* and of *decision*—in the epoch of the digital trace and its algorithmic treatment, as well as in debate with Nietzsche. It is, in other words, a fundamental critique that poses the question of the *criteria* of selection, formed in such a way that they become criteria *of decision*, that is, *critical categories*, rather than merely biological, psychic or technical automatisms (and I will return to this question from the perspective of a philosophy of automaticity).

The *passage* from *psycho-biological automatic selection* to its *dis-automatization* as *decision* is possible only when *organic* organs combine with, and form a *system* with, the organological organs *that are tertiary retentions*, that is, with the epiphyologenetic supports of collective memory, opening up an *interpretive play* (a *différance*) through which criteria of selection become criteria of decision, that is, of *psychosocial individuation*, and not just vital individuation.

The outcome of this interpretive play is the production of circuits of transindividuation, that is, the continuous formation of new knowledge arising from the unfurling of organogenesis, generating new *pharmaka* from the circuits of transindividuation deriving from constituted knowledge, in turn requiring new forms of knowledge—placing into crisis those from which they stem, and provoking more or less stupefaction as this stunning and astounding in which the *pharmakon* always consists.

Hence is produced the transformation of techno-epochal shock into a surprise, a sur-prehension that eventually becomes a com-prehension— which is less the understanding that there-being has of its being than that through which psychosocial individuation takes care of its organological and pharmacological condition, by trans-forming *technical becoming* by the same token into a *noetic future*, that is, into the *desire to live in quasi-causality*, and therefore *by default*, and as a fault *that is necessary*—and on the basis of which, and because it has become banal, can arise a new and always surprising pharmacology.

Neganthropy of "torpor"—if not stupor, if not stupidity

It is in the context of this normativity that we must interpret Canguilhem when he posits that knowledge of life is the specific form of life capable of caring for itself, treating itself—and in the same way we must understand ecology as this same form of life caring for itself through the knowledge of the milieus, systems and processes of individuation through which the concrescence of the cosmos generates processes of individuation such that entropic and negentropic tendencies play out in different ways in each of the different forms of infidelity of these milieus.

The questions about life and negentropy that arise with Darwin and with thermodynamics must in this sense be reinterpreted in the organological context, given that natural selection gives way to artificial selection, and that the passage from the organic to the organological displaces the play of entropy and negentropy.[14] Thought in this way, technics is an *accentuation of negentropy*, since it is a factor of *increased differentiation*, but it is *also an acceleration of entropy*—not just because it is a process of combustion and of the dissipation of energy, but because *industrial standardization* seems today to lead to the destruction of life as the burgeoning and proliferation of differences: biodiversity, cultural diversity, and the singularity of psychic individuations as well as collective individuations.

Only from this perspective do the questions of *Bestand, Gestell,* and *Ereignis* makes sense for us—that is, for those in the Anthropocene who question the epokhal singularity in which this time, which is a period that presents itself as the probability of the end of time, fails to consist, so to speak. But if so, *Bestand, Gestell,* and *Ereignis* take on a meaning that is in a way the epoch of the default of epoch, which is possible only according to a twist of meaning that is incompatible with Heideggerian thought—even less so given that the epochal dimension of thermodynamics is in no way taken into account in the writings of the *Kehre*.

In addition, the *perspective and the prospect* (that is, the future) that I propose here (as the epoch still to come) in terms of general organology with respect to a Neganthropocene calls upon a neganthropological conception of noetic life, that is, of life that studies and knows life in order to care for it (as biology, ecology, economy, organology, and everything that this entails—namely, every form of knowledge understood in terms of its cosmic tenor). This would furthermore be a life that would be functionally and primordially that of a libidinal economy, and of such an economy rethought in organological terms and as general economy in Georges Bataille's sense, which requires a complete redefinition of phenomenology in general and the existential analytic in particular.

Such a redefinition passes through the inscription of Freudian shock within an organological perspective, thereby going beyond Freud himself. It means asking the organological question of tertiary retention as that which constitutes the possibility of the dis-automatization of instinct—in a vein not foreign to the questions raised by Arnold Gehlen, who must be read here with John Bowlby and Donald Winnicott. The dis-automatization of instinct comes at the cost of the formation of other automatisms, artificial—that is, psychic, technical, and social—automatisms that as a general rule require an economy: that which sets the rules in any society and does so through various forms of regulation (rituals, education, law, institutions), governing the processes of exchange resulting from the dis-automatization of the instincts insofar as this makes possible and necessary the detachability of artificial organs, which become objects of exchange, as well as the detachability of the drives, which, precisely

insofar as they themselves become detachable, must be bound together so as not to become entropic.

General economy, general ecology, and general organology are a salvage effort with respect to the conditions of a libidinal economy today ruined, which it is a matter of rethinking from the perspective of neganthropology starting from the fetish, the transitional object, and the artifact as condition of all consistence—and in the sense where Whitehead inscribes this dimension of consistence at the heart of concrescence.

General economy, ecology, and organology thus conceived with Georges Bataille, together call for Vladimir Vernadsky's concept of "biosphere," later replaced with that of "ecosystem," and reactivated in France by René Passet, a concept with which we can explore the *paradox of technology*, which is another name for what Ivan Illich called *counterproductivity*. When, *as a system*, the growth of technology reaches a certain point, its *effects are inverted*—and as such it becomes paradoxical, which Passet described as a "passage to limits." We must relate this concept of counterproductivity to the *pharmakon* in general, and the diverse counterproductive effects of the prevailing organological condition should be seen as entropic and negentropic pharmacological effects.

The automotive *pharmakon*, the car, created to augment mobility, engenders urban congestion. The computerized *pharmakon*, created to *assist with decision-making*, engenders cognitive overflow syndrome and paralysis (confounded with stupefaction and consolidated with the systemic and functional stupidity wrought by drive-based capitalism, to which is added, in France, the institutional stupidity generated by the *Ecole nationale d'administration*, an institution responsible for training, for example, François Hollande and most of his advisers: hence France hurtles towards its current fate, one in which stupidity reaches extreme levels). This paradox can also be seen with *medicines* that, if poorly prescribed (not just in the wrong doses), poison the patient, or may even produce what in pharmaceutical science is called a "paradoxical reaction," that is, where the medicine acts in such a way that it causes the very thing against which it is intended to fight.

The pharmacological paradox equally afflicts the social organizations that are institutions and corporations insofar as they always make use of political technologies, governmentality, and management, in the sense in which Foucault placed these political technologies at the heart of his thought of power in general under the umbrella of biopower (which should be related back to Weber, and read alongside Polanyi), an issue that should also be explored with Gille and Luhmann with respect to the concept of social system, all of these things constituting specific cases of the pharmacology that conditions and limits any organology and therefore any human ecology.

Limits

We must, then, also examine more closely the general conditions of emergence of these paradoxical effects, and we must do so alongside a reading of Passet's *L'Économique et le Vivant*, in which the problem of sustainable development is examined from the perspective of systems theory, in terms of passages to limits in various domains, domains that are understood as systems or elements of systems:

> Sustainable development is not a question like others, or just one among others. This question reveals a passage to limits through which it is the interplay of economic laws that is transformed.[15]

These limits raise the question of new equilibriums and disequilibriums, establishing new general conditions of *intersystemic metastability*:

> Beginning in the eighties, in fact, with the issue of global damage to the biosphere ... it is no longer specific resources or environments that are threatened, but the regulatory mechanisms of the planet itself.[16]

The biosphere is defined here, following Vladimir Vernadsky, as a complex

> and self-regulating system, in the adjustments and evolutions of which life—and thus the human species—plays a fundamental role. Two logics confront each other here: that which presides over the development of economic systems and that which ensures the dynamic reproduction of natural environments.[17]

The question raised here is that of the Anthropocene—more than twenty years before its more or less official recognition—at the level of *natural milieus*. But this question also arises today, and perhaps especially, and certainly *firstly*, at the level of *organological milieus themselves*, and of *social systems and social environments*—that is, *mental environments*.

For if it is true that the question is care, its organization, its culture, one might even say its worship [*culte*]—care as the formation of attention through circuits of transindividuation that cultivate reason through reasons to live and to take care of life in quasi-causality—*then the question of mental ecology precedes the question of environmental economy*—even though mental ecology is conditioned by organology and pharmacology, so that from Plato to Marx and up until ourselves, it presents itself as the question of *stupor*, or of *torpor*: I employ this latter term that Adam Smith used in his analysis of the extremes of the industrial division of labor— "torpor" was used by Smith to describe the effects of mechanization on the minds of those who were in the course of becoming proletarian.

And such torpor becomes, in our time, a stupor—and our stupefaction in the face of the state of shock provoked by digital technology leads not only to functional stupidity, but to a catastrophic and dis-astrous (losing the light of the stars, the stars that in French are "asters," and losing them for lack of a *therapeutic of computation* based on a new cosmology), destruction of *noesis* itself by automatic proletarianization.

As for development, in Passet's terms, this involves growth that is both complexifying and multi-dimensional:

- this growth is complexifying through a dual movement of diversification and integration, allowing the system to grow by reorganizing itself yet without losing its coherence;

- it is multi-dimensional to the extent that, beyond the economic in the strict sense, it takes into account the quality of the relations established between human beings within the human sphere, and their relations with the natural environment.[18]

This duality is a source of conflict because

while nature maximizes its stocks (biomass) on the basis of a given flow (solar radiation), the economy maximizes market flow by depleting natural (non-market) stocks, the decrease of which is noted in no economic records and produces no corrective action.[19]

Hence there arises a question of nature and culture. I would have liked to show that to address Passet's question we must overcome this opposition, but I will be able to do no more than give an outline of this in my concluding remarks.

Be that as it may, this conflict has today reached a threshold that amounts, precisely, to a passage to limits. Now, in reaching its limits,

any system in 'phase transition' undergoes changes in the way it functions:
- the limit of the saturation of needs ...
- the limit of the reproducibility of a natural resource ...
- the limit of rhythms of assimilation or self-purification ...[20]

Such a passage to limits is a sudden return to entropy. At stake is therefore the power to provoke bifurcations in this entropic becoming, reopening unknown pathways to come, to the future—and I argue (in agreement, I think, with the perspective of Erich Hörl) that such pathways are organo-logical, and must above all consider the still unknown possibility of the most recent stage of grammatization, that is, of digital tertiary retention inasmuch as it makes possible new and unprecedented neganthropic works.[21]

The calculation industry, quantum organization of the inorganic, and decision

Let us conclude by turning to Whitehead. When he introduces the concept of process, he at the same time establishes that the *opposition* between natural phenomena and cultural phenomena has become outdated. This obviously does not mean that the *distinction* between nature and culture would be outdated. In this way, a general economy is outlined that is not yet a general organology, but that calls for the latter and requires it.

In Whitehead, with regard to cosmology, it is no longer a question of spheres, but of process, that is, more precisely, of dynamic interlocked spirals materialized by regimes of speed—and where there is such a thing as *infinite speed*, which is that of thought: the power to *disrupt* and to *dis-automatize*, that is, *to change the rules*—a power that is knowledge, which Whitehead, in his "Introductory Summary" to *The Function of Reason*, also called history, and which *is par excellence* the *function* of reason (Whitehead here inherits something from the Kantian framework that I recalled at the beginning of my remarks):

> History discloses two main tendencies in the course of events. One tendency is exemplified in the slow decay of physical nature. With stealthy inevitableness, there is degradation of energy. The sources of activity sink downward and downward. Their very matter wastes. The other tendency is exemplified by the yearly renewal of nature in the spring, and by the upward course of biological evolution. In these pages I consider Reason in its relation to these contrasted aspects of history. Reason is the self-discipline of the originative element in history. Apart from the operations of Reason, this element is anarchic.[22]

This discipline that is reason, the privilege of noetic beings in Aristotle's sense, is obviously a specific negentropic capacity to "realize" an order in struggling against this "anarchic element." I myself argue that such a faculty is neganthropological and constitutes the *neganthropos* that we strive to be in actuality.

More often, however, we are entropic, in particular since the advent of consumer capitalism: this capacity to change the rules that is neganthropological reason brings with it a danger of intersystemic conflict (highlighted by von Bertalanffy in the introduction to his *General System Theory*, and as this theory's justification[23]). The pharmacological question is in this way inscribed at the heart of cosmology and as the "anthropotechnical," bio-spherical and local consequence that follows from the initial combustion and its universal thermodynamic law.

To change the rules is the power to move faster than the speed of light, insofar as the latter has become, as the speed of digital automata,

the horizon of the calculation and computing industry: it is to move *infinitely* fast—to escape established circuits regardless of their speed, and to introduce a bifurcation—at the speed of desire, that is, of *idealization, through which neganthropy passes onto the plane of consistence*, making the noetic economy of desire the line of flight of any neganthropology that can be realized only organologically, that is, pharmacologically, and this is the stake of what Whitehead called the function of reason:

The function of Reason is to promote the art of life.[24]

The higher forms of life are actively engaged in modifying their environment. In the case of mankind this active attack on the environment is the most prominent fact in his existence.[25]

The primary function of Reason is the direction of the attack on the environment.[26]

Such a power, however, presupposes knowledge, knowledge that is always the knowledge of powerlessness (and of a "non-knowledge"). The question then arises of the laws of the universe conceived as constituting the field of what we call physics, a body of rules for a game that we cannot change—but that we can localize and, through this localization, which is also an augmentation, interpret. That is, we can *organize* this inorganic, entropic, and sidereal play or game, and this is what we do with nanophysics and quantum technology, at the risk of bringing about, in return, dis-organizations, such as for instance via that new toxicity imposed on organisms by the nanometric infidelity of new milieus of life. And this is so only because the universe is incomplete, unfinished.

Given that technics consists above all in the *organization of inorganic matter*, leading in turn to the *organological reorganization of cerebral organic matter*, which modifies the play of every somatic organ, and thus gives rise to a new form of life (that is, a new form of negentropy) that is nevertheless also, as technical, an accelerator of entropy on all cosmic planes (and it is this two-sidedness that characterizes the *pharmakon*), there remains a cosmic question of technics: that is, of a technical epoch of a cosmos within which nanophysics amounts to a transformational inscription (in Jean-Pierre Dupuy's sense when he refers to transformational technologies), at the quantum level, of re-organization, one that operates via the intermediary of the scanning tunneling microscope.

The scanning tunneling microscope is itself a computer capable of simulating, that is, of schematizing. This arrangement between the cerebral organ and the quantum scale of hyper-matter is a stage of concrescence that is also a process of concretization in the broader Simondonian sense—in that it operates on all planes of the cosmos at the same time: sidereal, vital and psychosocial, that is, technical. This localization can act retroactively

on the play of the whole biosphere, into which it can in a way spread itself generally (through a process of amplification[27]), and this has now engendered that specific stage of concrescence that we refer to in our epoch as the Anthropocene.

Technics obviously respects the laws of physics, since otherwise it would not function. But technics, as "matter that functions" organologically (and constituting as such what I propose calling hyper-matter), locally trans-forms the cosmic order in ways that are not predictable. Hence the concretization of the technical individual as a mode of existence, the functioning of which cannot be dissolved into the laws of physics, tends to gives rise to associated techno-geographical milieus. It was for this reason that Simondon claimed the need for a mechanology that I prefer to understand as an organology—given that mechanology does not enable us to think pharmacologically, or to think the links between psychic, technical, and collective individuation.

Processes, concrescence, disruptions, infidelities of milieus, and metastable equilibriums (and thus disequilibriums) all form what, in our epoch, presents itself to us as what we are causing *within* ourselves, *around* us, and *between* us, as projections of a becoming that we are no longer able to trans-form into a future on the basis of our organological and pharmacological condition, that is, as the play between the processes of psychic, technical, and collective (that is, social) individuation, processes through which and in which we always find ourselves tied to these three dimensions by their mutual organological condition.

It seems today that this play and this game is turning into a massacre, wherein psychic and collective individuation are being killed off by a technical individuation that is slave to a self-destructive economy—because it is destructive of the social milieus without which no technical milieu is possible that does not at the same time destroy the physical milieus of the biosphere.

The *general ecological* question poses and imposes on this tripartite division the question of biological, geographical, and cosmic systems and processes, such that they thoroughly infuse, constantly, locally, and in conditions of locality that remain totally to be thought, the processes of psychic, technical, and social individuation. In addition to analyzing the condition of transindividuation through co-individuation of the processes of psychic, technical, and social individuation, general organology studies the conditions of returning to vital biological sources, and of doing so in the cosmic, entropic, and sidereal conditions of negentropy, insofar as these are made possible by scientific and noetic instruments.

Through this dual approach, general organology investigates the conditions of possibility of a political and noetic *decision*, a decision that is made possible by grammatization. And at the same time it investigates the specific regime of the *pharmakon* that is established by grammatization, which is haunted by the question of proletarianization. The realities of the

latter, in terms of subsistence and existence, must be studied for each epoch of the "history of the supplement," given that, failing the development of therapies and therapeutics, proletarianization has the effect of eliminating the possibility of decision, that is, of neganthropogenesis.

Notes

1 Erich Hörl, "A Thousand Ecologies: The Process of Cyberneticization and General Ecology," in *The Whole Earth: California and the Disappearance of the Outside*, ed. Diedrich Diederichsen and Anselm Franke (Berlin: Sternberg Press, 2013).

2 Ibid., 122: "Contrary to all of the ecological preconceptions that bind ecology and nature together, ecology is increasingly proving to epitomize the un- or non-natural configuration that has been established over more than half a century by the extensive cyberneticization and computerization of life. The radical technological mediation that has been implemented since 1950 through the process of cyberneticization—and which today operates within the sensory and intelligent environments that exist in microtemporal realms, in pervasive media and ubiquitous computing— causes the problem of mediation as such to come fully into focus, exposing it with a radicality never seen before. As such, it is both a problem and question of constitutive relationality; or, more precisely—to paraphrase Gilbert Simondon—the problem of an original relationship between the individual and its milieu, with which it has always already been coupled and which would not simply constitute a readymade, prior 'natural' environment to which it would have had to adapt, but which must rather be conceived as the site of its originary and inescapable artifacticity, with which it is conjoined…"

3 For example, in Gilbert Simondon, *Communication et information: Cours et conférences* (Chatou: Éditions de la transparence, 2010), 167.

4 The question of the generality of Bataille's general economy, which will be explored in depth in Bernard Stiegler, *La Société automatique 2: L'avenir du savoir* (forthcoming), was introduced in Bernard Stiegler, *Automatic Society, Volume 1: The Future of Work*, trans. Daniel Ross (Cambridge: Polity Press, 2016) in order to counter the point of view developed by Claude Lévi-Strauss at the end of *Tristes Tropiques*, trans. John and Doreen Weightman (Harmondsworth: Penguin, 1976), where he likens anthropology to an "entropology," which I oppose by passing through Bataille and in terms of the question of a neganthropology that would also be an organology and a pharmacology.

5 But also with the concept of grammatization, that is, discretization, which is also to say, with respect to the question of categorization as *condition of concretization*—this reference to categorization pointing here towards a hypothesis formulated by IRI in relation to the web: we posit that the web must see its general architecture evolve in the direction of the constitution

of a hermeneutic web, itself founded on a graphic language of contributory annotation, a platform for sharing notes and a hermeneutic social network.

6 As Nicholas Georgescu-Roegen recalls in "De la science économique à la bioéconomie," *Revue d'économie politique* 3 (88) (1978), 337–82. Cf. Henri Bergson, *L'évolution créatrice* (Paris: F. Alcan, 1907), Ch. 3.

7 For in fact, if what reason produces is not concepts but rather ideas, that extend the pure concepts of understanding beyond their regime of legality, which is experience given by intuition, and if these concepts are themselves conditioned by schemas conditioned by hypomnesic tertiary retention, as I argue in *Technics and Time, 3: Cinematic Time and the Question of Malaise*, trans. Stephen Barker (Stanford: Stanford University Press, 2010), then the ideas of reason are themselves also conditioned by tertiary retention.

8 This order is that of the "parure" that is the kosmos as *that which appears*, according to a translation by Jean Beaufret, *Dialogue avec Heidegger. Greek Philosophy*, trans. Mark Sinclair (Bloomington and Indianapolis: Indiana University Press, 2006), 7.

9 Immanuel Kant, "On the Common Saying: 'This May be True in Theory, but it does not Apply in Practice'", *Political Writings* (Cambridge: Cambridge University Press, 1991), 61–92.

10 Gilles Deleuze, *Negotiations* trans. Martin Joughin (New York: Columbia University Press, 1995).

11 I have elsewhere argued, in *Automatic Society, Volume 1,* that these conceptual mutations of physics and of cosmology-become-astrophysics also involve a mutation of the notion of work, which becomes force measured in Watts (force being what Aristotelian metaphysics conceived as *dunamis*), and no longer conceived as *energeia*, that is, as *noetic act*, that is, as *individuation*. It is this transformation that also makes possible that proletarianization that occurs when the steam engine combines with the automatisms made possible by the mechanical tertiary retention characteristic of industrial mechanization.

12 In the sense that I attempted to redefine this as a question, as *creating* a question, in *What Makes Life Worth Living: On Pharmacology*, trans. Daniel Ross (Cambridge: Polity Press, 2013).

13 On this subject, see my *Beyond the Anthropocene*, trans. Daniel Ross (New York: Columbia Univeristy Press, forthcoming).

14 Which cannot but radically affect ecological science, and not just political ecology. But it does so by inscribing the political event into the very heart of the science of the living in its negotiation with the organized non-living and the organizations in which it results.

15 René Passet, *L'Économique et le Vivant* (Paris: Economica, 1996), x–xii.

16 Ibid.

17 Ibid.

18 Ibid.

19 Ibid.

20 Ibid.

21 The latter pass through a fundamental economico-political change, which takes account of automation and its ruinous effects on employment, and installs a new mechanism to redistribute productivity gains, in the wake of the analyses of Oskar Negt and André Gorz, in the form of time allocated for the development of individual and collective capabilities (in Amartya Sen's sense): it is for this reason that Ars industrialis advocates the creation of a contributory revenue, modeled on the law of the "intermittents" of the entertainment industry in France, and IRI is developing contributing research platforms with a view to designing a new architecture of the world wide web at the service of an economy that values negentropy and fights entropy at the same time. These perspectives are developed in Stiegler, *Automatic Society, Volume 1.*

22 Alfred North Whitehead, *The Function of Reason* (Princeton: Princeton University Press, 1929), "Introductory Summary," n.p.

23 Ludwig von Bertalanffy, *General System Theory* (New York: George Braziller, 1968), 3–29.

24 Whitehead, *The Function of Reason*, 2.

25 Ibid., 5.

26 Ibid.

27 See Simondon, *Communication et information.*

Bibliography

Beaufret, Jean. *Dialogue with Heidegger: Greek Philosphy*, trans. Mark Sinclair. Bloomington and Indianapolis: Indiana University Press, 2006.

Bergson, Henri. *L'évolution créatrice*. Paris: F. Alcan, 1907.

Bertalanffy, Ludwig von. *General System Theory*. New York: George Braziller, 1968.

Deleuze, Gilles. *Negotiations*, trans. Martin Joughin. New York: Columbia University Press, 1995.

Georgescu-Roegen, Nicholas. "De la science écnomique à la bioéconolie." *Revue d'économie politique* 3 (88) (1978): 337–82.

Hörl, Erich. "A Thousand Ecologies: The Process of Cyberneticization and General Ecology." In *The Whole Earth: California and the Disappearance of the Outside*, ed. Diedrich Diederichsen and Anselm Franke, 121–30. Berlin: Sternberg Press, 2013.

Passet, René. *L'Économique et le Vivant*. Paris: Economica, 1996.

Kant, Immanuel. *Political Writings*, trans. H. B. Nisbet. Cambridge: Cambridge University Press, 1991.

Lévi-Strauss, Claude. *Tristes Tropiques*, trans. John and Doreen Weightman. Harmondsworth, Penguin, 1979.

Simondon, Gilbert. *Communication et information. Cours et conferences*. Chatou: Éditions de la transparence, 2010.

Stiegler, Bernard. *Automatic Society, Volume 1: The Future of Work*, trans. Daniel Ross. Cambridge: Polity Press, 2016.

Stiegler, Bernard. *La Société automatique 2. L'avenir du savoir* (forthcoming).
Stiegler, Bernard. *Beyond the Anthropocene*, trans. Daniel Ross. New York: Columbia University Press, (forthcoming).
Stiegler, Bernard. *Technics and Time, 3: Cinematic Time and the Question of Malaise*, trans. Stephen Barker. Stanford: Stanford University Press, 2010.
Stiegler, Bernard. *What Makes Life Worth Living: On Pharmacology*, trans. Daniel Ross. Cambridge: Polity Press, 2013.
Whitehead, Alfred North. *The Function of Reason*. Princeton: Princeton University Press, 1929.

CHAPTER FIVE

The modern invention of nature[1]

Didier Debaise

Translated by Michael Halewood,
with James Burton

A growing tension has set its seal on our experience of nature. There is, on the one hand, the modern conception of nature which we have inherited and which permeates each of our thoughts and, on the other, the contemporary ecological transformations with which we are faced. It seems that this tension has, today, reached a point of no return. The concepts we deploy, the abstractions we construct, our very modes of thought, are no longer able to deepen and develop our experience of nature; they only obscure its meaning. My ambition, then, is twofold: first, to show that the modern conception of nature does not express any true ontology (dualist or monist), but that it is essentially *operative*; and that if we want to understand how a certain representation of nature has imposed itself, it is the status of these operations that we must elucidate and interrogate. The center of this operation, the constitutive gesture which characterizes it, is the division of nature into two heterogeneous modes of existence; its paradigmatic expression is the difference between "primary" and "secondary" qualities. The whole distribution of beings, all the oppositions between their attributes and their appearances, derive from this: existence and value, the real and the apparent, fact and interpretation. Hence I propose, secondly, to follow the proposition of an evental conception of nature, according to which the sense of value, of importance and finality—which in the modern experience of nature are classified as "psychic additions," human projections on to a nature that would otherwise be destitute—can be found everywhere, from the most primary, microorganic forms of life, to reflective consciousness.

The gesture of bifurcation

My primary aim is to take up, while also trying to update, Whitehead's protest against what he calls "the bifurcation of nature." Although this phrase is, at first sight, somewhat puzzling, it designates the collection of experiential, epistemological and political operations which were present at the origin of the modern conception of nature, a concept whose effects can still be felt today. In the very first pages of *Concept of Nature*, Whitehead provides a definition, in the form of a protest:

> What I am essentially protesting against is the bifurcation of nature into two systems of reality, which, in so far as they are real, are real in different senses. One reality would be the entities such as electrons which are the study of speculative physics. This would be the reality which is there for knowledge; although on this theory it is never known. For what is known is the other sort of reality, which is the byplay of the mind.[2]

This passage has been the subject of a series of misreadings and misunderstandings with regard to how bifurcation should be understood. It is necessary to take this passage at face value, in order to develop a better grasp of what is at stake in the challenge that it makes. The first impression is that, in one way or another, bifurcation returns us to *dualism*. The terminology and the oppositions used certainly seem similar. Does the difference between a "reality which is there for knowledge" and a reality established by "the byplay of the mind" or, equally, between "causal nature" and "apparent nature," not return us to the distinction between extension and thought, between matter and spirit? If this were the case, would bifurcation not simply be a new way of thinking about dualism and, furthermore, a new approach to developing a critique of dualist philosophy, principally that of Descartes, and its influence on the modern epoch? If Whitehead's philosophy is read in this way, it might certainly gain from a juxtaposition with other critiques of dualism, but it would lose its originality. Yet it is this reading of bifurcation as offering a new critique of dualism, which has predominated. It can be found in the lectures that Merleau-Ponty[3] gave on Whitehead's philosophy, in the work of Jean Wahl,[4] but it is Félix Cesselin who makes the point most starkly: "I think that it is only possible to fully grasp Whitehead's thought by starting with a reading of what he understands by the rejection of the 'bifurcation' of nature. The bifurcation of nature is dualism. In particular, it is Cartesian dualism."[5] This interpretation is far from being an isolated case. It expresses most clearly and succinctly that which the majority of readers of Whitehead believe they have found in bifurcation.

I would like to suggest a different way of inheriting this concept by affirming *a radical difference between bifurcation and dualism*. This is

not to claim that previous readings of bifurcation are false, but they have reduced its importance. If bifurcation is to be given its true force, another approach needs to be taken. In order to substantiate this hypothesis, three elements will be introduced. Firstly, although Whitehead often refers to dualism in his writings, notably Cartesian dualism, he also talks of bifurcation, its constituent elements, and its influence in the experience of modernity, without invoking any relationship to dualism. If bifurcation really were just another name for dualism, if Whitehead had tried show its constitutive role in the constitution of modern science, then why did he not take the time to link them in some way? The most plausible inter-pretation is that the two problems seemed so different to Whitehead that he did not think it necessary to comment on the distinction. It seemed, to Whitehead, that the obvious difference between the two requires no expla-nation. As a result, according to Whitehead the only possible relation is one of an inversion. One of the rare occasions on which Whitehead does link bifurcation and dualism can be found in *Science and the Modern World*, when he writes: "the revival of philosophy in the hands of Descartes and his successors was entirely coloured in its development by the acceptance of the scientific cosmology [the bifurcation of nature] at its face value."[6] This is a particularly important remark which merits a careful reading. Far from identifying bifurcation with dualism, Whitehead is clear that both Cartesian dualism, and dualism more generally, are dependent upon the question of bifurcation. It is Cartesian philosophy which accepts "at its face value" the cosmology of the bifurcation of nature. This rare allusion to the relation between bifurcation and Cartesian philosophy makes Whitehead's position absolutely clear, although he does not draw out its implications. The reading of this passage offered here entails that the notion of bifur-cation outlines a concept which is broader and more fundamental than that of dualism which, ultimately, is only one of its manifestations. Taken in the most direct, literal, sense, these two notions designate fundamentally different realities. The notion of bifurcation manifests the idea of process, a movement of differentiation. It is the trajectory through which nature is divided into two distinct branches. The phrase says nothing about how this division occurred, and even less about that which produced it, but it already points to a primary and important difference to dualism. If dualism is understood in terms of a duality of substances, regardless of how these are characterized, bifurcation indicates something very different, namely, how a single reality, nature, came to be viewed as divided into two distinct realms.

I will use the terms "gesture"[7] and "operation" to account for the division of nature, as they seem to capture most accurately the particular character of bifurcation. The fundamental question is not that of knowing whether nature is genuinely, in itself, composed of two realms, each with distinct attributes. Rather, it is a question of the means by which the differ-entiation of these attributes was established. It is the *modus operandi* of

the division, the gesture of the constitution of this division, which needs to be addressed, not its consequences, as expressed in a dual vision of nature.

As such, the origin of bifurcation should be sought not in the relations between thought and extension, mind and body, the real and the apparent, but in the characteristics of bodies themselves. Bifurcation gains its sense at the intersection of a range of questions: what is a natural body? What are its qualities and how do we experience it? Can we identify characteristics which are common to the multiplicity of physical and biological bodies, and what would these be? These are the same questions as those posed by the distinction between the primary and secondary qualities of bodies that lies at the origin of the modern conception of nature, of which we are still the heirs.

One of the classic texts in which the difference between the qualities of bodies is most clearly stated, and which provides the basis for Whitehead's development of his critique of bifurcation, is Locke's *An Essay Concerning Human Understanding*. Of course, Locke's *Essay* cannot claim to be the origin of the problem. For example, Boyle's book *The Origin of Forms and Qualities According to the Corpuscular Philosophy*, published in 1666, undoubtedly influenced Locke's thought, and this text contains the essentials of the difference between the qualities of bodies. However, it is not an outline of the history of bifurcation, as such, which is important here. Rather, the task at hand is to trace its dispersed invention and how it was consolidated within both experimental practice and certain texts which provided it with its conceptual expression.

> first such as are *Primary qualities* utterly inseparable from the body ... These I call original or primary qualities of body, which I think we may observe to produce simple ideas in us, viz. solidity, extension, figure, motion or rest, and number. Secondly, such qualities which in truth are nothing in the objects themselves but power to produce various sensations in us by their primary qualities, i.e. by the bulk, figure, texture, and motion of their insensible parts, as colours, sounds, tastes, etc. These I call secondary qualities.[8]

In this passage, Locke assigns the qualities of bodies to two different realms. Firstly, there are *primary qualities* which are "inseparable from the body." The term "primary" should be taken in its strong sense, as it indicates that these qualities are fundamental to the body and characterize its deepest reality. Primary qualities express the purified state of the body, unadorned by any variations to which it could be subjected. The qualities which Locke lists in this passage all refer to a physico-mathematical order: solidity, extension, figure [number], motion, and rest. As such, it is now possible to give a first response to the question: what is a natural body? It is a particular articulation between physico-mathematical qualities. Locke gives an example which has become well-known: "take a grain of wheat, divide it into two parts; each part has still *solidity, extension, figure,* and *mobility*: divide it again, and it retains

still the same qualities and so divide it on, till the parts become insensible; they must retain still each of them all those qualities."[9] The phenomenal variations, such as the color of the grain, its particular texture, the sensations that we have of it, in no way undermine the status of the primary qualities with which they are associated. Even when division renders a body imperceptible, so that it falls short of producing an empirical experience, as these qualities are of a specific kind and refer to what might be called a non-subjective aspect of nature, they must still be constitutive of all experiences of bodies. This is why it is necessary to insist that without these primary qualities, nature would be "soundless, scentless, colourless; merely the hurrying of material, endlessly, meaninglessly."[10] It would be wrong to think that this is an outdated conceptual approach; its legacy can still be found in contemporary science.

> There persists, however, throughout the whole period the fixed scientific cosmology which presupposes the ultimate fact of an irreducible brute matter, or material, spread throughout space in a flux of configurations. In itself such a material is senseless, valueless, purposeless. It just does what it does do, following a fixed routine imposed by external relations which do not spring from the nature of its being. It is this assumption that I call "scientific materialism." Also it is an assumption which I shall challenge as being entirely unsuited to the scientific situation at which we have now arrived.[11]

Having set out this primary realm of bodies, it is now possible to turn to that which Locke calls "secondary." In the passage cited above, he gives some examples: colors, sounds, taste, etc. It is important to note a subtle point here. Secondary qualities are not described as simple projections by the mind onto bodies, as if the perceiving subject projects forms or impressions which are completely external or unrelated to the bodies which are experienced. This is the difficulty presented at the end of the quotation taken from Locke's *Essay*. Here he writes that secondary qualities are nothing other than the "power to produce various sensations in us by their primary qualities."[12] Locke is invoking a complex relation of dependence and difference. The mind is clearly involved, since it is in the activity of perception that primary qualities are altered, forming the different aspects by which we experience them, but the mind's capacity is intimately linked to the *power* of primary qualities to affect. In short, although secondary qualities are radically distinct from primary qualities, they are derived from them, as they are an aspect of them. Secondary qualities constitute what might be called the domain of "psychic additions." It is through such an addition that materialism is able to give a place to subjective experience:

> we perceive the red billiard ball at its proper time, in its proper place, with its proper motion, with its proper hardness, and with its proper

inertia. But its redness and its warmth, and the sound of the click as a cannon is made off it are psychic additions, namely, secondary qualities which are only the mind's way of perceiving nature.[13]

In the context of bifurcation, the theory of psychic additions enables a link to be established between primary and secondary qualities. This theory appears to give a place to the phenomenal experience of bodies by inscribing the latter in an order of non-phenomenal qualities. In our immediate experience, we only encounter hybrid qualities, ones derived from the power of bodies, but altered by the mind. In this sense, and in more contemporary terms, it is possible to re-read the previous examples and state:

> What is given in perception is the green grass. This is an object which we know as an ingredient in nature. The theory of psychic additions would treat the greenness as a psychic addition furnished by the perceiving mind, and would leave to nature merely the molecules and the radiant energy which influence the mind towards that perception.[14]

What is fundamental is that the distinction between primary and secondary qualities starts from an empirical base—the perception of a grain of wheat, the red billiard ball, the green grass, the law court—in order to then differentiate between non-perceptual qualities and those subjective qualities which are supposedly derived from the former, while also expressing them. This is the center of the operation of bifurcation. It is here that the moment of bifurcation is located. Starting with immediate experience, bifurcation operates by splitting such experience into two regimes of existence. In doing so, it takes that which makes up the primary experience of nature and places it in a derivate, phenomenal realm. Once this bifurcation is established, once the two regimes are stabilized and subjective experience is rendered as epiphenomenal, it is possible to state that even if a fundamental knowledge of primary qualities is permanently postponed, *in fact*, it is possible, *by right*, bypassing both secondary qualities and the need for an exploration of the perceptions of such bodies. On this basis, it is possible to define the process of which is at the root of all epistemologies that are derived from the operation of bifurcation, an operation which makes any correlation between secondary qualities, simple appearances, and primary qualities, purely conjectural.

> Another way of phrasing this theory which I am arguing against is to bifurcate nature into two divisions, namely into the nature apprehended in awareness and the nature which is the cause of awareness. The nature which is the fact apprehended in awareness holds within it the greenness of the trees, the song of the birds, the warmth of the sun, the hardness of the chairs, and the feel of the velvet. The nature which is the cause of

awareness is the conjectured system of molecules and electrons which so affects the mind as to produce the awareness of apparent nature. The meeting point of these two natures is the mind, the causal nature being influent and the apparent nature being effluent.[15]

The conclusion which can be drawn is that the modern invention of nature does not come from an ontological position, either dualist or monist, but from the *local operations* of the qualification of bodies. The ontology of the moderns is the manner in which it tries to explain, while masking, the gesture of the permanent repetition of a division between bodies and their qualities. In short, this ontology presupposes the gestures, techniques, and operations of division.

The localization of matter

Bifurcation leaves a murky zone in its wake, one produced by its own operations. Since all modern experience of nature inhabits this bifurcation and points towards the primary qualities of bodies, which are both constitutive of experience and yet inaccessible to it, a more detailed investigation into these natural bodies in themselves is necessary. The question of quite what these primary qualities are in themselves is put center-stage, dramatized, intensified to the maximum, by this murky zone. But bifurcation leaves open the question of knowing how to characterize bodies when they are extricated from their phenomenal dimension. The operation of bifurcation only repeats, permanently, the separation of the qualities of bodies into various registers—that of physics, the biological, and social. But this separation continually leads back to a series of questions which receive no adequate response: what *is* a body which is separated from its secondary qualities? How can we make sense of such a body, since we only have access to secondary qualities? What kind of knowledge would allow us to penetrate into the interior of these non-observable qualities? According to the interpretation provided above, the inability provide a characterization of primary qualities is not a weakness of the modern conception of nature, it is where it draws its strength. It is the dramatization of this difficulty which constitutes this modern conception. It was necessary to push this point to the extreme, in order to give due weight to the second operation [procedure] which is constitutive of modern cosmology. Whitehead grants it a new name: "the simple location of matter." It is this which will provide the abstractions which are required to deal with natural bodies. I will cite the long passage in which Whitehead describes this:

> To say that a bit of matter has simple location means that, in expressing its spatio-temporal relations, it is adequate to state that it is where it

is, in a definite finite region of space, and throughout a definite finite duration of time, apart from any essential reference of the relations of that bit of matter to other regions of space and to other durations of time. Again, this concept of simple location is independent of the controversy between the absolutist, and the relativist views of space or of time. So long as any theory of space, or of time, can give a meaning, either absolute or relative, to the idea of a definite region of space, and of a definite duration of time, the idea of simple location has a perfectly definite meaning.[16]

Whitehead seems to state that, in the modern conception of nature, the possibility of having a simple location is a quality of matter. It is important not to misunderstand his point. Whitehead's proposition is much more fundamental and it is possible to derive a general definition of matter from it; in any case, it represents the crucial element of this passage. With regard to the question—"what is matter in modern experience?" I would offer the response—"a *localizable* point." It is a minimal definition, but it has a radical effect. For, questions about the origin, form and nature of matter are replaced by a question of a quite different order—where is it situated? Thus, it is as if the body, detached from "psychic additions," is no more than an element which is localizable in space–time. It is only possible to understand "scientific materialism" if we take into account the circularity of its definition of matter and of space–time which leads to the reduction of matter to a localizable element. "The characteristic common both to space and time is that material can be said to be here in space and here in time, or here in space–time, in a perfectly definite sense which does not require for its explanation any reference to other regions of space–time."[17]

There is a multiplicity of here-and-nows which precisely delimit zones of matter and the boundaries that separate other areas of the universe. According to this perspective, one space–time is sufficient, in itself, and does not need to make any reference to other space–times. Consequently, the response to the question "what is the world made of" that emerged in the seventeenth century was as follows: "the world is a succession of instantaneous configurations of matter, or of material, if you wish to include stuff more subtle than ordinary matter, the ether for example."[18] Whitehead sees Newtonian physics as one of the most important examples of this cosmological outlook:

Newtonian physics is based upon the independent individuality of each bit of matter. Each stone is conceived as fully describable apart from any reference to any other portion of matter. It might be alone in the Universe, the sole occupant of uniform space. But it would still be that stone which it is. Also the stone could be adequately described without any reference to past or future. It is to be conceived fully and adequately as wholly constituted within the present moment.[19]

Whitehead's critique of the notion of "simple location" can be developed by delineating three premises which are fundamental to modernity's cosmology and which need to be analysed further. The first premise is: *Matter can only occupy one space–time*. The reason for this is clearly that this premise is based on the idea of *simple* location. This simplicity must be taken literally. It describes the mode of localization, a quality which has a profound place in modern thought. Schematically, it is possible to say that matter is placed *here* in space and, even more so, *now* in time; it is not only a question of the spatial and temporal framework, but of nature itself. Nature is envisaged as a multiplicity of localizable material points which form the bodies and locales of all existence. Thus, Whitehead rejects the first premise of localization and states that the simple existence of matter is a myth or, more precisely, an abstraction which has had disastrous consequences.

While the division of space and time into points and instants is useful in many cases, it is made possible by the work of an abstraction and becomes the center of innumerable difficulties and false problems when it is generalized and posited as a principle of matter itself. The questioning of this first premise will lead Whitehead to develop a relativistic theory of time and space.

Second premise: *Other modes of existence of matter are exclusively phenomenal*. It is in this premise that simple location most clearly displays its relation to the bifurcation of nature. Indeed, the same gesture of differentiation between two orders of reality can be found here, but now situated in a more technical framework. On one side, these points of localizable points constitute matter; on the other, are all the derivative forms such as duration, persistence of matter, the variations and intensifications of existence. This is bifurcation redeployed at another level, with its psychic and phenomenal additions, yet always reducible to the material, brute, existence of simple location. This construction "is beautifully simple. But it entirely leaves out of accout the interconnections between real things. Each substantial reality is thus conceived as complete in itself, without any reference to any other substantial reality."[20]

Third premise: *matter is that which is more concrete*. This is the paradox of scientific materialism. Material points, the ultimate existents of matter, which are called upon to occupy a central and primary place in any explanation of nature in general, are unthinkable without a formalization of space–time. Yet, how is it possible to locate a point and establish an instant without positing, either beforehand or simultaneously, a space and a time within which these can be established? This premise demonstrates one of the aspects of the relation between materialism and formalism.

> Matter (in the scientific sense) is already in space and time. Thus matter represents the refusal to think away spatial and temporal characteristics and to arrive at the bare concept of an individual entity. It is this refusal which has caused the muddle of importing the mere procedure

of thought into the fact of nature. The entity, bared of all characteristics except those of space and time, has acquired a physical status as the ultimate texture of nature; so that the course of nature is conceived as being merely the fortunes of matter in its adventure through space.[21]

According to the interpretation given above, bifurcation entails, necessarily, the localization which will complete it and provide it with its formal tools. The three premises that I have tried to outline form the axes from which this relation between bifurcation and localization draws it efficacy. Whitehead's position is unambiguous: "I shall argue that among the primary elements of nature as apprehended in our immediate experience, there is no element whatever which possesses this character of simple location."[22]

A whole tranche of modern philosophy has strayed into bifurcation and localization, losing itself in their effects, notably that of dualism, without ever returning to the source of the operations which they claim to have gone beyond. Whitehead paints a picture which is undoubtedly incomplete but gives the general image of the kind of thought which was founded on bifurcation: "There are the dualists, who accept matter and mind as on an equal basis, and the two varieties of monists, those who put mind inside matter, and those who put matter inside mind."[23] The range of positions is apparent, for they all share the same space, a common problem; one which accepts the primary existence of bifurcation but tries to reduce its effects while still confirming its importance. Thus, "the enormous success of the scientific abstractions, yielding on the one hand matter with its simple location in space and time, on the other hand mind, perceiving, suffering, reasoning, but not interfering, has foisted onto philosophy the task of accepting them as the most concrete rendering of fact."[24] Therefore, we do not have to choose between these alternatives, as they all confirm the gestures at the origin of this image of thought. Simply opposing modern ontology does not make sense as the operations from which they are derived remain implicit, finding their efficacy in their effacement. The modern experience of nature has consisted in trying to connect conjecture (real nature) to a dream (phenomenal nature).

Nature as event

The bifurcation must be surpassed. But in what direction should we look for the conditions of such a surpassing? Everything seems blocked. We are at the crossroads of different possibilities, but the Whiteheadian diagnostic of the emergence of the concept of nature in modernity renders every position suspect at the least. Have we not said that the alternatives can only be apparent, that the ontologies which are presented as so many propositions, in seeking to replace the bifurcation, too often conceal the operations

and the gestures which they have just confirmed? We have tried to separate the concepts of bifurcation and localization in order to reveal the higher interests at work in this construction of the concept of nature. It is a question of interests which are essentially operational, practical, deriving from gestures of differentiation whose function is to allow possible actions and formalizations with regard to nature. Everything has been inverted: operation has taken the place of ontology, abstraction has replaced the concreteness of things and the possibilities of the knowledge of existence itself.

And what if we replaced everything in nature? What if, instead of distinguishing a phenomenal order and a real order, an order of secondary qualities and one of primary qualities, an aesthetic order and an ontological order, we began with a profoundly hybrid experience of nature, articulated according to axes that would be subject to variation at each moment, where the aesthetic immediately became an ontological problem, where perception and its qualities were commingled at the heart of being? Doesn't the contemporary experience of nature oblige us to link together that which the cosmology of the moderns has conscientiously attempted to separate? Let us therefore restore everything to a single plane of nature, a single surface, without dualism and without differentiation from the outset! Whitehead gives the formula for this in a central passage of *The Concept of Nature*, which I would like to make the leitmotif of this alternative thinking of nature: "Nature is that which we observe in perception through the senses."[25] Here, in the form of a simple proposition, Whitehead makes a radical decision. It entails the restoration to immediate experience of all its rights: "All we know of nature is in the same boat, to sink or swim together."[26] This is an opportunity to deploy a true method. There is in these propositions a method which *The Concept of Nature* follows as strictly as possible, and which, transformed, deployed in the most radical possible form, will become the method particular to speculative thought. I would claim without hesitation that the evolution of Whitehead's thought, leading him towards a speculative approach, is connected to this method, which he never wished to renounce: nothing is to be removed from experience. In his final work, *Modes of Thought*, he reprised this notion and identified it with an exigency which would be proper to philosophy, notably in contrast to the sciences: "philosophy can exclude nothing."[27]

How, in *The Concept of Nature*, does this method transfigure the experience of nature? Let us take up the starting point to which the empiricist method appeals. How can it be directly given to us in perception, given that we subtract nothing and add no external elements? Whitehead's response to this question is disconcerting to say the least, since it opens up perception to a hitherto unknown level: "the immediate fact for awareness is the whole occurrence of nature. It is nature as an event present for sense-awareness, and essentially passing."[28] This last part of the phrase is particularly important, since it raises the question of the "essence of

nature," describing this essence as "passing." It is from this quality of "passage" attributed to nature that everything else in the experience of nature derives, as multiple instances or actualizations. Whitehead specifies the meaning of this in returning once again to the philosophy of Bergson: "I am in full accord with Bergson, though he uses 'time' for the fundamental fact which I call the 'passage of nature.'"[29] Whitehead wants to take up this Bergsonian notion of passage anew, and give it as broad a sense as possible. It is to indicate not only a temporal transition, an evolution or a becoming, but also a spatial change, a shifting of place or a movement. There is no reason to attribute primacy to one or the other of these dimensions. All passage is directly—immediately, we should say—temporal and spatial.

How, starting from this notion of event, this conception of nature as event of all events, can Whitehead truly reconstruct a concept of nature which would free itself from the bifurcation? I will address this on the basis of three enunciations, each of which expresses an evental mode of existence in nature.

1 "Yesterday a man was run over on the Chelsea Embankment."[30]
 The idea of an accident or a singular occurrence is the most
 common characteristic of an event: something has happened. An
 accident, the unexpected collapsing of a situation, the emergence
 of a reality that seems to break with the causal chain to which we
 may retrospectively connect it, a more or less radical rupture in
 the continuity of experience—all these are contained within the
 idea of the event as an occurrence within nature. There is nothing
 surprising in this. Whitehead does nothing more than take up the
 commonsense conception of the event in gathering these disparate
 expressions under the term "occurrence." Nevertheless, if we go a
 little deeper, we find in them a base of presuppositions which the
 "Chelsea" example particularly brings out. Where exactly should
 we situate this idea of an "occurrence"? Is it in the subject to which
 something happens, and which therefore pre-existed that event?
 In this sense, would the evental dimension of what happened be
 merely an attribute? Let us be more precise: in our statement, is
 the event situated in the man who is run over, or does it have,
 rather, a more diffuse reality, connecting the witnesses, the victim,
 the driver, and perhaps the histories which populate the Chelsea
 Embankment? There has certainly been an occurrence, but it seems,
 when we explore it more deeply, to divorce itself from any support,
 any subject to which it could be attributed or from which it might
 emanate. The decision of Whitehead, who does nothing but take up
 the method that is imposed upon him, is that we have no reason to
 reduce the event to anything other than itself, to that which is given
 to us in immediate consciousness. This is a change of perspective
 which gives everything its proper place: the event as such *is* this

occurrence, and it is this which becomes the genuine *substantiality* whose attributes will then be the man, the witnesses, the Chelsea Embankment, and the narrator. Let us go further. The occurrence "a man was run over" unfurls itself in a multiplicity of spatial relations which become clear as we try to express their meaning. It is adjacent to "a passing barge in the river and the traffic in the Strand."[31] But it is also very much a temporal occurrence, which inserts itself within an infinite multiplicity of other past or concomitant experiences. Hence, "the man was run over between your tea and your dinner"[32] expresses this temporal localization of the occurrence, within a constellation of others. This spatio-temporal relation of the occurrence, which situates it at the center of a collection of other events, is not an exterior context, as if time and space were merely forms, receptacles or axes within which events took place. Whitehead makes the relation among events the center, from which time and space draw their consistency.

2 "Cleopatra's Needle is on the Charing Cross Embankment."[33] Attributing the status of event to Cleopatra's Needle is a decision which at first seems to run counter to common sense. We find in it nothing in terms of those notions of occurrence, passage, temporal transition, that can easily be attributed to events belonging to the first category. What remains here of those accidents, those causal ruptures, those irruptions which formed the substance of the first type of event? If we look a little closer, however, the difference is perhaps not so marked as it first appears. We can find the same dimensions here, but transposed onto a new scale. In order to show this, Whitehead appeals to an experience of thought, an imaginative change of experience: "If an angel had made the remark some hundreds of millions of years ago, the earth was not in existence, twenty millions of years ago there was no Thames, eighty years ago there was no Thames Embankment, and when I was a small boy Cleopatra's Needle was not there."[34] Everything depends on the temporal perspective in which we are invested. If we insert ourselves within a particularly long time, the persistence of the Needle becomes more ephemeral than our initial impression of it. We may add that if, from a point of view with sufficient scope, it is true that the Needle seems unchanging, when we observe it in more precise detail, when we insert ourselves into its internal existence, when we analyze its parts, we see that beneath its apparent simplicity there unfolds a multiplicity of modifications, variations and exchanges with its surroundings. Thus a "physicist who looks on that part of the life of nature as a dance of electrons, will tell you that daily it has lost some molecules and gained others."[35] If we were to decide to view it within a much larger timescale, or if we inserted ourselves

within the micro-variations which are imperceptibly transforming it, the observation would be similar: the continuity of the Needle's existence is an event which is not so different, in its principles, from any occurrence in nature. However, this has an important implication. If we agree with Whitehead, then all the "objects" of our experience—material objects, physical, technical, biological objects—are indeed events displaying similar principles of passage and temporal transition. An evental occasion, an accident or an occurrence, does not directly display the idea of a persistence, even if it presupposes one. In the case of my first example, the persistence of the driver, the victim, the witnesses, and Charing Cross, are required in order for the accident as irruption, as the bifurcation of a situation, to have any reality at all. The accident realizes itself on the basis of multiple persistences in relation to which it produces a difference. But what is persistence, exactly, for Whitehead? It relates to notions of duration, of maintained existence, of an extended being. As I said above, if we were to insert ourselves into these persistences, to sink ourselves into their interior, we would find there the multiplicity of little accidents, little changes and little metamorphoses which, beneath the level of apparent stability and invariance of the "needle," are transforming it at every moment of its existence. We may identify the following general consequence of this: persistence presupposes occurrence.[36] The sustained existence of the Needle is nothing but the repetition, the recurrence of what Whitehead would later call the "historical route"; that is, of a series of occurrences, of little events, that are wholly ephemeral within the perspective of the scale of its existence.

3 "There are dark lines in the Solar Spectrum."[37] This enunciation seems at first glance to converge with and confirm the first two. One would be tempted to see in this a fresh insistence on expressing either the idea of occurrence—the fact that a dark line can make an irruption within the solar spectrum—or the persistence of the spectrum, whose existence involves the presence of dark lines. However, it is actually a new component of the notion of event which Whitehead wants to highlight on the basis of this enunciation. What is at stake is neither the question of how to speak properly of the existence of "dark lines," nor of the "solar spectrum," but the putting of these two events into a relation. In a certain manner, as I have already said, every event is essentially relational, whence the impression that this enunciation does nothing more than affirm the other two. How then does the putting into relation of these two events in fact differentiate itself from the relational existence of other events? The singularity of this enunciation must be positioned in the *operation* of this relating, in

the introduction of a new dimension added to the events which are the "solar spectrum" and "dark lines." Whitehead does not make this qualification directly. I propose to call it *objective correlation.* The question which this enunciation poses is the following: given two events, what correlation may be established? This activity is at the heart of the theories, and primarily the scientific theories, whose specificity Whitehead wants to reveal based on the solar spectrum example. One may say that "if any event has the character of being an exhibition of the solar spectrum under certain assigned circumstances, it will also have the character of exhibiting dark lines in that spectrum."[38] This is the whole theoretical dimension, abstract and operational, that Whitehead means to locate in the theory of events. This decision is loaded with consequences. First of all, it shatters the initial distinction between the events of nature and the ways of representing them, in order to place them directly on the same level, on the same plane. Everything is positioned horizontally on this plane of nature. The ways in which we connect events form parts of experience itself; they are factors of existence just as real as the persistence of the Needle. Recall the importance, for Whitehead, that encompasses the method from which he proceeds, and which must accept no exception. Theories are immediate data of consciousness just as much as the Chelsea accident or the persistence of the Needle. Subsequently, in affirming that correlations are events as such, Whitehead induces the idea that they should have been treated like every other event in nature. The question of the consequences of this relation between theories and events remains in suspension at the time of *The Concept of Nature.* Scientific theories are events, marked by the same characteristics of occurrence, persistence, historical trajectory, mobile relation. Thus, the eventual meaning of this third enunciation is that the event "solar spectrum" is connected to another event, "dark line," by the intermediary of a third type of event, that of correlation. It is an entirely different space of events which establishes itself, with the function of associating and articulating other events. What I call the *objective correlation* thus becomes a new mode of existence of events, which adds itself to *occurrence* and *persistence.* The method which Whitehead implicitly follows, let us say again, consists in placing within experience what is, for sensory consciousness, the immediate fact of the passage of nature. At this level, it is the interlacing of these components which forms the primary matrix of the plane of nature: the accident, Cleopatra's Needle and the dark lines correlated with the solar spectrum, are immediate fact.

It is on the basis of this that a new composition of nature becomes possible. The event takes the place of dualisms and separations. All the operations

are displaced, now forming the general qualities of the events of nature. If we follow this logic of events directly, it is no longer necessary to oppose ethics to ontology, perception to being, appearance to reality, fact to value, epistemology to axiology. The immediate fact is the great plane of nature, surface with neither height nor depth, site of the constant entanglement of the events which form the substance of beings.

Notes

1 This chapter is modified version of a chapter of my book *L'appât des possibles* (Dijon: Presses du réel, 2015).

2 Alfred North Whitehead, *The Concept of Nature,* (Cambridge: Cambridge University Press, 1920), 30.

3 Maurice Merleau-Ponty, *La nature: Notes, cours du Collège de France* (Paris: Seuil, 1995).

4 See, for example, Jean Wahl, *Vers le concret: Etudes d'histoire de la philosophie contemporaine, William James, Whitehead, Gabriel Marcel* (Paris: J. Vrin, 2010) and *Les philosophies pluralistes d'Angleterre et d'Amérique* (Paris: Empêcheurs de penser en rond, 2005).

5 Félix Cesselin, *La philosophie organique de Whitehead* (Paris: Presses universitaires de France, 1950), 21.

6 Alfred North Whitehead, *Science and the Modern World* (Cambridge: Cambridge University Press, 1953), 22.

7 I have taken this term from the work of Gilles Châtelet, particularly *Les enjeux du mobile: Mathématique, physique, philosophie* (Paris: Seuil, 1993).

8 John Locke, *An Essay Concerning Human Understanding* (1690; London: Penguin Books, 1997), 135 (Book 2, Ch. VIII).

9 Locke, *An Essay Concerning Human Understanding,* 135.

10 Whitehead, *Science and the Modern World,* 69.

11 Ibid., 22.

12 Locke, *An Essay Concerning Humand Understanding,* Book 2, Ch. VIII, §10.

13 Whitehead, *Concept of Nature*, 42.

14 Ibid., 29–30.

15 Ibid., 31.

16 Whitehead, *Science and the Modern World,* 62.

17 Ibid., 54.

18 Ibid., 51.

19 Alfred North Whitehead, *Adventures of Ideas* (Cambridge: Cambridge University Press, 1933), 200–1.

20 Ibid., 132–3.

21 Whitehead, *Concept of Nature*, 20.

22 Whitehead, *Science and the Modern World*, 58–9.

23 Ibid., 57.

24 Ibid.

25 Whitehead, *Concept of Nature*, 3.

26 Ibid., 148.

27 Alfred North Whitehead, *Modes of Thought* (New York: Macmillan), 2.

28 Whitehead, *Concept of Nature*, 14–15.

29 Ibid., 54.

30 Ibid., 165.

31 Ibid., 166.

32 Ibid.

33 Ibid.

34 Ibid.

35 Ibid., 167.

36 We can locate a Whiteheadian heritage in Bruno Latour's *Enquête sur les modes d'existence*, in the definition of persistence as a trajectory of *reprises*. Cf. Bruno Latour, *Enquête sur les modes d'existence: Une anthropologie des Modernes* (Paris: La Découverte, 2012), particularly Ch. 3 and Ch. 4.

37 Whitehead, *Concept of Nature*, 165.

38 Ibid., 167.

Bibliography

Cesselin, Félix. *La philosophie organique de Whitehead*. Paris: Presses universitaires de France, 1950.

Chatelet, Gilles. *Les enjeux du mobile: Mathématique, physique, philosophie*. Paris: Seuil, 1993.

Debaise, Didier. *L'appât des possibles*. Dijon: Presses du réel, 2015.

Latour, Bruno. *Enquête sur les modes d'existence: Une anthropologie des Modernes*. Paris: La Découverte, 2012.

Locke, John. *An Essay Concerning Human Understanding*. 1690. London: Penguin Books, 1997.

Merleau-Ponty, Maurice. *La nature: Notes, cours du Collège de France*. Paris: Seuil, 1995.

Wahl, Jean. *Les philosophies pluralistes d'Angleterre et d'Amérique*. Paris: Empêcheurs de penser en rond, 2005.

Wahl, Jean. *Vers le concret: Etudes d'histoire de la philosophie contemporaine, William James, Whitehead, Gabriel Marcel*. Paris: J. Vrin, 2010.

Whitehead, Alfred North. *Adventures of Ideas*. Cambridge: Cambridge University Press, 1933.

Whitehead, Alfred North. *Modes of Thought*. New York: Macmillan, 1938.

Whitehead, Alfred North. *The Concept of Nature.* Cambridge: Cambridge University Press, 1920.

Whitehead, Alfred North. *Science and the Modern World.* New York: Macmillan, 1925.

CHAPTER SIX

Deep times and media mines

A descent into the ecological materiality of technology

Jussi Parikka

The classic curse of Midas became perhaps the dominant characteristic of the modern machine: whatever it touched was turned to gold and iron, and the machine was permitted to exist only where gold and iron could serve as foundation.

LEWIS MUMFORD, *TECHNICS AND CIVILIZATION*, 1934

Introduction

In Lewis Mumford's influential take on technology, one aspect stands out as well as literally escapes the eye. For Mumford, the underworld of excavations and mines is a crystallization of modern technology. It is devoid of nature, an artificial environment, which transposes the city into a place underground. It is mobilized and itself accelerates the emergence of capitalism[1] while at the same time creating a new sort of a media-ecological environment, the non-organic habitat. Rosalind Williams does an excellent job of elaborating Mumford's historical philosophy of technology as an analysis of the contemporary technological moment. Mumford's argument that the underground constitutes one essential part of technological development becomes clear through his mapping of the mining culture producing coal and other mining products as a paleotechnical industry and his account

of mining as a wider metaphor for technology: the artificial, constructed environment, carefully managed, burrowing into the earth and displacing the natural with the constructed, the non-organic. The geological identification of earth history, Cuvier's work on fossils as indicators of different spatio-temporal strata of the earth, the emergence of mining cultures but also the urban life of the underground—transport, sewage, building projects, infrastructure—were together responsible for the birth of the technological imaginary of the underground.[2] Mumford stands as one early theorists of this "underground turn" in modern technology but we can more broadly ask, what are the media-ecological stakes in the depths of the earth and the geophysical?

The underground and the geological persist as part of the discourse and practices of technology. Williams is equally apt in her argument that the depth and method of excavation were transposed into quests for truth: the political economy, the discovery of the undergrounds of the mind in psychoanalysis and other forms of hermeneutics of depth, were indicative of the rise of the modern idea of surface-depth-dialectics as part of epistemology. For our contemporary media culture, this idea of depth has carried over some of its earlier meanings. Our discourse of data mining drives the enthusiasm-fuelled big data-discourse and business practices; besides depth, massive building projects have not disappeared and characterize the contemporary geoengineering in the midst of the Anthropocene: plans for Canal Istanbul connecting the Black Sea and Marmara Sea, the Kingdom Tower in Jeddah, Saudi Arabia that has had to lower its ambitions from the original plan of 1.6 kilometers to 1 kilometer, the earlier speculations of China's ambition to build a railroad of 1.3 kilometers to connect Russia, China, and the U.S., and many more. The architectural imaginary in connection with the ecological focus is a way to understand the contemporary media cultural moment and is penetrated by the geophysical forces that are closely entangled with technology. Besides the architectural angle, media technologies are, in short, ways of making sense of the earth (surveying, visualizing, informationalizing, quantifying, modeling, simulating) as well as being enabled by it—from electromagnetic communications to the minerals we extract to make cars and computers work.

This chapter is a short take on this notion of the underground and more specifically the deep time of the media. The term was already used by the media theorist Siegfried Zielinski, but I will take it in an alternative direction, using it to emphasize the materiality of media as part of earth durations and earth excavations: the mineral and metal basis of digital media ecology. In Mumford's take, the materiality of the elements, places, and practices—wood, coal, mines, mining, etc.—stand out in discussions of technology and allow us to realize, again, the influence of such elemental conditions of media-technological relations to the earth. One can connect this to Guattari's ecological thought, but in ways that expand from three ecologies to the multiple overlapping stratifications of the informational

across the earth. Benjamin Bratton speaks of the stack as the leading concept for this planetary condition, which reorganizes some of the political coordinates of the geographical becoming geopolitical becoming geophysical. Bratton's analysis includes six layers of *"Earth, Cloud, City, Address, Interface,* and *User,"* demonstrating a rich ecology of interactions vertically and horizontally.[3] The stack defines interdependent layers that seem to be partly technological, partly natural, partly social, but the best way to understand them is as political geographies, and what Bratton, drawing on Carl Schmitt, calls the new *nomos* defining the design of the contemporary political moment.

Furthermore, in terms of extensions of the Guattarian ecological, Gary Genosko has recently spoken of the four elements of the contemporary political moment. "Earth–air–fire–water" are mobilized by Genosko from fragments of Empedocles into the beginning of an ecological ontology of the contemporary in terms of the earth and the recircuited political economy of appropriation:

> Wrapped around these elements is the planetary phylum, a great tellurian cable bunch with its own products: EARTH: electronics; WATER: liquidities like bottled water, which throws forward diagrammatic intensities in the explosion of plastic debris; AIR: gases (greenhouse); and FIRE: artificial plasmas and lasers. However, as we have seen, the new elements combine both in existing direct—blood mixed with dust in the extraction of conflict minerals and oil fields, or methane, a flammable unnaturally mingled with the water supply, and which contributes to the greenhouse gas effect—and extra-rotational manners, by means of especially communicative matters, like microscopic fragments of plastics that perfuse the oceans and get into the food chain, and constitute fine dusts that affect respiration, settling among the fogs, gases and lethal clouds.[4]

As one of the elemental media conditions, deep time resources of the earth sustain technological processes—the machine that needs "gold and iron" as its foundation—but also a wider range of other metals, minerals and energy. The emergence of geology as a discipline since the eighteenth and nineteenth centuries, as well as the techniques of mining developed since then, are essential for media-technological culture. Institutions such as the US Geological Survey have transformed into institutions central to the contemporary geological and geographical condition; they are sites of epistemological transformation where the earth becomes an object of systematized knowledge. This knowledge, including knowledge concerning material resources, becomes mobilized towards technological production, governmental geopolitics and increasingly a global survey of the minerals of the earth.

Land artist Robert Smithson referred to "abstract geology": the idea suggests that tectonics and geophysics pertain not only to the earth but

also to the mind. Thinking and conceptual work become embedded in a wider material condition. Abstract geology is a field where a geological perspective is distributed across the organic and non-organic division. Its reference to the "abstract" might attract those with a Deleuzian inclination and resonate with the concept of "abstract machines." However, Smithson's interest was in the materiality of the art practice, reintroducing metals (and hence geology) back into the studio. What's more, Smithson was ready to mobilize his notion, which emerged in the artistic discourse of land art in the 1960s, towards a conceptualization of technology that we can say was nothing less than anti-McLuhanian: instead of seeing technology as extensions of Man, here technology is aggregated and "made of the raw materials of the earth."[5] From our twenty-first-century perspective, approximately fifty years later, it starts an imaginary alternative media-theoretical lineage that does not include necessarily McLuhan, Kittler and the like, but instead tells a story of materials, metals, chemistry, and waste. These materials articulate the high-technical and low-paid culture of digitality. They also provide an alternative ecological paradigm for the geophysical media age—the persistence of the deep elements, remixed.

And the earth screamed, alive

So here is a suggestion that differs from the usual narrative of digital economy: What if your guide to the world of media were not one of the usual suspects—an entrepreneur or evangelista from Silicon Valley, or from a management school, aspiring to catch up with the smooth crowd-sourced clouding of the network sphere? What if your guide were Professor Challenger, the Arthur Conan Doyle character from the 1928 short story "When the World Screamed"? The text appeared in the *Liberty* magazine and offered an odd insight into a mad scientist's world, with a hint of what we would nowadays call "speculative realism." Professor Challenger, whose dubious and slightly mad reputation preceded him, raised a prospect later taken up by the philosophers Deleuze and Guattari: that the earth is alive, and its crust is tingling with life, exhibiting the work of non-organic life, as Manuel DeLanda argued. The idea of the living earth has a long cultural history: from Antiquity it persists as the idea of *terra mater*, and in the emerging mining cultures of the eighteenth and nineteenth centuries becomes embedded within Romantic philosophy; later, in the twentieth century, the emergence of Gaia theories brings a different connotation to the holistic life of the planet.

The narrative of strata and geology starts with a letter: an undated letter addressed to Mr. Peerless Jones, an expert in Artesian drilling. The letter is a request for assistance. The nature of what is required is not specified, but the reputation of the mad scientist, the slightly volatile personality of

Professor Challenger, promises that it will not be a normal operation. Mr. Jones has to put his specialist knowledge in drilling to good use. In Sussex, U.K., at Hengist Down, Professor Challenger is engaged in a rather secret operation, although it remains for a long period unclear what sort of a job the special drills are needed for. Even the sort of material to be penetrated is only later revealed to be different from what is usually expected when we speak of mining operations: it is not primarily chalk or clay that are to be drilled, or the usual geological strata, but some kind of jelly-like substance that demands the attention of the specialist.

The operation itself did not start with the undated letter. The Professor had already for a long time been drilling deeper and deeper into the earth's crust, until finally he had reached a layer that pulsated like a living animal. The earth is alive, and to prove this vitality with experimental means was actually the true objective of Challenger's mission. Instead of drilling and mining for petroleum, coal, copper, iron ore and other valuables for which men usually dig holes in the ground, Challenger's mission is driven by a desire to prove a new speculative position that concerns the living depths of the earth: beyond the strata of "sallow lower chalk, the coffee-coloured Hastings beds, the lighter Ashburnham beds, the dark carboniferous clays, and … gleaming in the electric light, band after band of jet-black, sparkling coal alternating with the rings of clay,"[6] one finds unusual layers, which do not adhere to the classical geological theories of Hutton or Lyell. It seems suddenly as if undeniable that even non-organic matter is alive: "The throbs were not direct, but gave the impression of a gentle ripple or rhythm, which ran across the surface."[7] Mr. Jones describes the deep surface they found: "The surface was not entirely homogenous but beneath it, seen as through ground glass, there were dim whitish patches or vacuoles, which varied constantly in shape and size" (11). The whole layers, the core and the strata throbbed, pulsated, animated. Hence it is not even necessary to go to such lengths as Professor Challenger, in one of the most bizarre rape-like scenes in literature, when he penetrates that jellyesque layer just to make the earth scream. This scientific sadism echoes in the ears of the audience and much further afield. It is the sound of "a thousand of sirens in one, paralysing all the great multitude with its fierce insistence, and floating away through the still summer air until it went echoing along the whole South Coast and even reached our French neighbours across the Channel."[8] All this was observed and witnessed by an audience called by the Professor—peers and interested international crowd, by invitation only.

Professor Challenger was predated by nineteenth-century fiction characters, like Heinrich in Novalis' "Heinrich von Ofterdingen" (1800/02), asking "Is it possible that beneath our feet a world of its own is stirring in a great life?"[9] The poetics of the earth was paralleled by the increasing demand for new resources of energy and non-fuel minerals. Earth metals and minerals were tightly linked to the emergence of modern engineering, science and technical media. Metals such as copper were a crucial material

feature of technical media culture from the nineteenth century onwards. A lot of the early copper mines were however exhausted by the start of the twentieth century, leading to new demands both in terms of international reach and in terms of depth: new drills were needed for deeper mining, which was necessary in order to provide the materials for an increasing international need exacerbated by its systematic—yet environmentally wasteful—use in wires and network culture. In addition the increasing demand and international reach resulted in the cartelization of the copper business from mining to smelting.[10] Indeed, besides such historical contexts of mining, in which Challenger's madness starts to make sense, one is tempted to think of the imaginary of horrors of the underground from Lovecraft to Fritz Leiber. Leiber preempts a much more recent writer of the biopolitics of petroleum, Reza Negarestani, both of them highlighting the same theme: petroleum as a living, subterranean life form.[11] One should neither ignore the earth-screams caused by hydraulic fracturing—fracking—which besides the promise that it might change the geopolitical balance of energy production, also points towards what is often neglected in the discourse of geopolitics, that is, the *geo*, the earth, the soil and depth of the crust that leads to bowels of the earth. By pumping pressurized water and chemicals underground the procedure forces gas out from between rocks, forcing the earth to become an extended resource. Rocks fracture, benzene and formaldehyde creep in, and the earth is primed to such a condition to expose itself. Fracking is in the words of Brett Neilson perfectly tuned to the capitalist hyperbole of expansion across limits: "Whether it derives from the natural commons of earth, fire, air, and water or the networked commons of human cooperation, fracking creates an excess that can be tapped."[12]

The metallic reality of the earth finds its way to consumer technologies, infrastructures and also media technologies. Besides the speculative stance, one can turn back to empirical material. According to 2008 statistics, media materiality is actually very metallic: "36 percent of all tin, 25 percent of cobalt, 15 percent of palladium, 15 percent of silver, 9 percent of gold, 2 percent of copper, and 1 percent of aluminum"[13] goes annually to media technologies. We have shifted from being a society that until the mid-twentieth century was based on a very restricted list of materials ("wood, brick, iron, copper, gold, silver, and a few plastics"[14]) to one reliant on a computer chip that is composed of "60 different elements."[15] Such lists of metals and materials of technology include critical materials such as rare earth minerals that are increasingly at the center of both global political controversies of tariffs and export restrictions from China. They are also related to the debates concerning the environmental damage caused by extensive open pit mining, which is massively reliant on chemical processes. Indeed, given that the actual rock mined is likely to contain less than one percent copper,[16] the pressure is on the chemical processes to tease out the Cu for further refined use in our technological devices.

The figures concerning the metals of media seem astounding, yet testify to another materiality of technology that can be linked to Conan Doyle, but also to the contemporary media arts discourse of the deep time of the earth. There is an interest in the living matter of geology that continues from poetics and narratives to the mobilization of resources that animate (digital) media culture. Thus, I will move on from Professor Challenger to Siegfried Zielinski, and his conceptualization of deep times of media art histories. In short, and as I shall elaborate in more detail soon, the figure of deep time is for Zielinski a sort of a media-archaeological gesture that, while borrowing from paleontology, actually turns out to be a riff used to understand the longer-term durations of artistic and scientific collaboration in Western and non-Western contexts.

An ecology of deep time

Zielinski's notion of *Tiefenzeit*, deep time, is itself an attempt to pick up on the idea of geological time as a way of guiding how we think of the humanities-focused topics of media arts and digital culture. Deep time carries a lot of conceptual gravity and is employed as a way to investigate the "Deep Time of Technical Means of Hearing and Seeing." Zielinski's approach kicks off as a critique of a teleological notion of media evolution which assumes a natural progress embedded in the narratives of the devices—a sort of a parasitical attachment, or insistence on the rationality of the machines and digital culture, that of course has received its fair share of critique over the past few decades of media and cultural studies.

For Zielinski, earth times and geological durations become a theoretical strategy of resistance against the myths of progress that impose a limited context as the basis for understanding technological change. It relates in parallel to the early modern discussions concerning the religious temporal order vis-a-vis the growing "evidence of immense qualitative geological changes"[17] which articulated the rift between some thousands of years of biblical time and the millions of years of earth history.

This deep temporality combined the spatial and temporal. Indeed, in James Hutton's *Theory of the Earth*, from 1778, depth means time: under the layers of granite you find further strata of slate signaling the existence of deep temporalities. Hutton proposes the radical immensity of time, although this comes without a promise of change; all is predetermined as part of a bigger cycle of erosion and growth.[18] Indeed, it becomes necessary for Zielinski to rely on Stephen Jay Gould's more nuanced contemporary theories of the punctuated equilibrium and variation at the core of geological time—and find in them an indication of how to think media artistic / cultural times as well.

For Zielinski, this makes possible a way to understand media archaeology as related to a notion of the deep times of the ways in which we modify, manipulate, create and recreate means of hearing and seeing. Zielinski introduces inspirational deep times of apparata, ideas and solutions for mediatic desires which take inventors as the center of gravity. He himself admits that this approach is romantic and focused paradoxically on human heroes. It includes figures such as Empedocles (of "the four elements" fame), Athananius Kircher, and for instance Joseph Chudy, with his operatic dreams and his early audiovisual telegraph system dating from the late eighteenth century (he composed a one-act opera on the topic, *The Telegraph or the Tele-Typewriter*). They also include the opium-fuelled media desires of the slightly masochistically inclined Jan Evangelista Purkyne, a Czech from the early nineteenth century, who was in the habit of using his own body for various drug- and electricity-based experiments geared towards understanding how the body itself is a creative medium. What we encounter are variations that define an alternative deep time strata of our media culture outside the mainstream. The approach offers the anarchaeology of surprises and differences, of the uneven in media cultural past revealing a different aspect of a possible future. Zielinski's project is parallel to imaginations of "archaeologies of the future"[19] that push us to actively invent other futures.

In any case, while Zielinski's use of the deep time of media as a metaphor is fascinating, I want to focus on the rather more materially animated version of media geology. With a theoretical hard hat on, I wonder if there is actually more to be found in this use of the notion of deep time both as temporality and geological materiality. Perhaps this renewed use may offer a variation that attaches the concepts back to discussions concerning media materialism as well as the political geology of contemporary media culture, with its reliance on the metals and minerals of the earth. The earth time gradually systematized by Hutton and other geotheorists of his period sustains the media time we are interested in. In other words, the heat engine cosmology of earth times that Hutton provides as a starting point for a media art historical theory of later times is one that also implicitly contains other aspects we need to reemphasize in the context of the contemporary Anthropocene and its obscenities: the machine of the earth is one that lives off its energy sources, in a manner similar to the way our media devices and political economy of digital culture are dependent on energy (cloud computing is still to a large extent powered by carbon emission-heavy energy production[20]) and materials (metals, minerals, and a long list of refined and synthetic components). The earth is a machine of variation, and media can live off variation—but both are machines that need energy and are tied together in their dynamic feedback loop. Electronic waste is one of the examples of the way in which media feeds back into the earth's history and the future fossil strata of a deep time to come.

The main question that Zielinski's argument raises is this: besides the media-variantological account concerning the design of apparatuses, users,

desires, expressions, and different ways of processing the social order and means of seeing and hearing, there is this other deep time too. This kind of alternative is more literal in the sense of returning to the geological stratifications and a Professor Challenger-type excavation deeper into the living ground. The interest in geology from the eighteenth and nineteenth centuries onwards produced what was later coined "deep time," but we need to understand that the new mapping of geology and the earth's resources was the political economic function of this emerging epistemology. Indeed, the knowledge of the earth through geological specimens (demonstrated for instance in Diderot and D'Alembert's "Mineral Loads or Veins and their Bearings" in volume 6 of *Encyclopédie* in 1768) and its newly understood history meant a new relation between aesthetics and the sciences. This link is also beneficial for new ways of extracting value: "As a result of eighteenth-century archaeological and antiquarian activities, the earth acquired a new perceptual depth, facilitating the conceptualization of the natural as immanent history, and of the earth's materials as resources that could be extracted just like archaeological artifacts."[21]

The media-theoretical deep time divides in two related directions:

1 Geology refers to the affordances that enable digital media to exist as a materially complex and political-economically mediated realm of production and process: a metallic materiality that links the earth to the media-technological.

2 Temporalities such as deep time are understood in this alternative account as concretely linked to the non-human earth times of decay and renewal but also to the current Anthropocene and the obscenities of the ecocrisis.

Deep temporalities[22] expand to media ecology: such ideas and practices force media theory outside the usual scope of media studies in order to look at the wider milieu in which media materially and politically become media in the first place. This relates to John Durham Peters' speculative question about cosmology, science and media, which develops into a short historical mapping of how astronomy and geology are susceptible to being understood as media disciplines of a sort.[23] Continuing Peters' idea we can further elaborate geophysics as the degree zero of media-technological culture. It allows media to take place, and has to carry their environmental load. Hence this "geology of media" perspective expands to the earth and its resources. It summons a media ecology of the non-organic, and it picks up from Matthew Fuller's notes on "media ecology as a cascade of parasites"[24] as well as an "affordance," but one that itself is supported by a range of processes and techniques that involve the continuum of the biological-technological-geological.

A media history of matter: From scrap metal to zombie media

One aspect of any general ecology of twenty-first-century capitalist techno-logical culture is its relation to specific environmental themes. Electronic waste and planned obsolescence are indexes of this context and another aspect relates to energy and power.[25] Indeed, what I want to map as the alternative deep time relates to geology in the fundamental sense of the Anthropocene. Crutzen's original pitch presented it as a transversal map across various domains: from nitrogen fertilizers in the soil to nitric oxide in the air; carbon dioxide to the condition of the oceans; photochemical smog to global warming. (Is photochemical smog the true new visual media form of post-Second World War, technological, polluted culture?) Already Crutzen had initiated the expansive way of understanding the Anthropocene to be about more than geology. In Crutzen's initiating defini-tions it became a concept investigating the radical transformations in the living conditions of the planet.

The Anthropocene can be said to be—as Erich Hörl suggests in reference to Deleuze—a concept that maps the scope of a transdisciplinary problem. So what is the problem? Hörl's suggestion is important.[26] He elaborates the Anthropocene as a concept that responds to specific questions posed by the technological situation. It concerns environmental aspects but is completely tied to the technological: this concept as well as its object are enframed by technological conditions into which we should be able to develop further insight with the tools and conceptual arsenal of the humanities. Indeed, this is where a geology of media can offer the necessary support as a conceptual bridge between materials of chemical and metallic kinds and the political economy and cultural impact of media technologies as parts of the ongoing discourses of the global digital economy.

The concept of the Anthropocene becomes environmental. This is not meant purely as a reference to "nature" but to an environmentality under-stood and defined by the "technological condition."[27] The environmental expands from a focus on the natural ecology to an entanglement with technological questions, notions of subjectivity and agency (as a critique of the human-centered worldview) and a critique of accounts of rationality that are unable to talk about nonhumans as constitutive of social relations. The Anthropocene is a way to demonstrate that geology does not refer exclusively to the ground under our feet. It is constitutive of social and technological relations, as well as environmental and ecological realities. Geology is deterritorialized in the concrete ways that metal and minerals become themselves mobile, and enable technological mobility: Benjamin Bratton's words could not be any more apt, when he writes how we carry small pieces of Africa in our pockets, referring to the role of, for instance, coltan in digital media technologies; visual artist Paglen makes a similar

point in seeing the geo-orbital layers of satellite debris as outer reaches of earth's geology and the Anthropocene (The Last Pictures project).[28]

Mammolith, an architectural research and design platform, describes technological artifacts such as iPhones as "geological extracts," drawing earth resources across the globe and supported by a multiplicity of infrastructures. The bits of earth you carry around are not restricted to small samples of Africa but include the material from Red Dog pit mine in Alaska, from where zinc ores are mined, before they are refined into indium in Trail, Canada. That's only one example. Such sites where minerals and mining transform into technology are "scattered across the globe in the aforementioned countries, as well as South Korea, Belgium, Russia, and Peru."[29]

More concretely, let's focus for a while on China and its role in the global chains of production and discarding of media technologies. This geopolitical China is not solely about the international politics of trade and labor, though these are not to be neglected either. In a sense, we can focus on the material production of what later ends up as the massive set of consumer gadgets, and the future fossil record for a robot media archaeologist, but also as discarded waste: both electronic waste and scrap metals in general are necessary for the booming urban building projects and industrial growth. So much of this is driven by the entrepreneurial attitude of optimism; of seeing the world in terms of material and immaterial malleability, which in the case of media technologies has recently been realized also to include hardware in new ways. Indeed, in the midst of the wider enthusiasm for a global digital economy of software, some business correspondents like Jay Goldberg have realized that hardware is dirt cheap and even "dead."[30] His claim is less related to the Bruce Sterling-initiated proposal for a Handbook of Dead Media, "A naturalist's field guide for the communications palaeontologist,"[31] and has more to do with observing a business opportunity.

Goldberg's dead media business sense is focusing on the world of super-cheap tablet computers he first encountered in China, then in the U.S., for forty dollars. In this particular story, it triggers a specific realization regarding business models and hardware: the latter becomes discardable, opening a whole new world of opportunities.

> When I show this tablet to people in the industry, they have universally shared my shock. And then they always ask "Who made it?" My stock answer is "Who cares?" But the truth of it is that I do not know. There was no brand on the box or on the device. I have combed some of the internal documentation and cannot find an answer. This is how far the Shenzhen electronics complex has evolved. The hardware maker literally does not matter. Contract manufacturers can download a reference design from the chip maker and build to suit customer orders. If I had 20,000 friends and an easy way to import these into the U.S., I

would put my own name on it and hand them out as business cards or Chanukah gifts.[32]

The reduced price of the tablets means widespread availability even for specified niche uses: from waitresses to mechanics, elderly people to kids, tablets could become the necessary accessory in such visions that would amaze investors. The visceral reaction by Goldberg is followed by rational calculations of what it might mean in the context of digital economy business models:

> Once my heart started beating again, the first thing I thought was, "I thought the screen alone would cost more than $45." My next thought was, "This is really bad news for anyone who makes computing hardware ..."
> No one can make money selling hardware anymore. The only way to make money with hardware is to sell something else and get consumers to pay for the whole device and experience.[33]

Even hardware gets drawn into the discourse of experience economy with its connotations of immateriality. Hardware softens, becomes immaterialized; its materiality seems to change before our eyes. What Goldberg misses is that hardware does *not* die, not even in the Sterling sense of the unused dead media that become a sedimented layer of fossils left for quirky media archaeologists to excavate. Instead, it is abandoned, forgotten, stashed away, and yet retains a toxic materiality that surpasses the usual time scales we are used to in media studies. Such abandoned media devices are less about the time of use, or practices of users, than the time and practices of disuse. It would actually be interesting to write a history of cultural techniques of technological disuse. Besides such ideas, I want to remind us of the chemical durations of metal materiality. Think of this idea as the media-technological equivalent of the half-life of nuclear material, calculated in hundreds and thousands of years of hazard; in media-technological contexts, it refers to the dangerous materials inside screen and computing technologies that are a risk to scrap workers as well as to nature, for instance through the contamination of soil.

Next, look at the case from a different perspective. Adam Minter's journalistic report *Junkyard Planet* offers a different story of hard metals and work, and looks at the issue from the perspective of the geology of scrap metals.[34] China is one of the key destinations not only for electronic waste but scrap metals in general, a fact which offers a different insight to the circulation of what we could call geology of technologies. China's demand for materials is huge. Integral to its still continuing major building projects, from buildings to subways to airports, was the need to be able to produce—or reprocess—more metals: scrap copper, aluminium, steel, etc.:

On the other side of the mall, in all directions, are dozens of new high-rises—all under construction—that weren't visible from the subway and my walk. Those new towers reach 20 and 30 stories, and they're covered in windows that require aluminum frames, filled with bathrooms accessorized with brass and zinc fixtures, stocked with stainless steel appliances, and—for the tech- savvy households—outfitted with iPhones and iPads assembled with aluminum backs. No surprise, China leads the world in the consumption of steel, copper, aluminum, lead, stainless steel, gold, silver, palladium, zinc, platinum, rare earth compounds, and pretty much anything else labeled "metal." But China is desperately short of metal resources of its own. For example, in 2012 China produced 5.6 million tons of copper, of which 2.75 million tons was made from scrap. Of that scrap copper, 70 percent was imported, with most coming from the United States. In other words, just under half of China's copper supply is imported as scrap metal. That's not a trivial matter: copper, more than any other metal, is essential to modern life. It is the means by which we transmit power and information.

The big picture of technological culture is not restricted to worried comments about the rare earth minerals essential to iPhones. Instead it is necessary to realize the link between design and the residual of technology; the abandoned e-waste and other sorts of issues not always considered as part of the consumer cycle. The material history of media—for instance telecommunications—extends to the copper extracted from wires, through the removal of the outer covers to uncover this mini-mine of valuable media materials. The history of copper mining with its environmentally dangerous effects is extended to the re-mining from wires for use in a variety of novel ways of repurposing. One could say, following Minter's narrative, that such a technological history of materials and material history of media as matter does not really follow the logic of a trajectory from life of use to death of disuse, but in places such as Foshan's Nanhai District, technologies and media materials never die: they are the places where scrap metal gets processed.[35]

In *Zombie Media*, Garnet Hertz and I address the wider context and impact of the refusal of "dead media" to disappear from their planetary existence.[36] Building on Sterling's work, we argue that there is a need to account for the undead nature of obsolete media technologies and devices in at least two ways: in order to be able to remember that media never die, but remain as toxic waste residue, and in order to be able to repurpose and reuse components in new ways, as for instance circuit-bending and hardware-hacking practices imply. The zombie media angle builds on two contexts not specific to digital media but present in such accounts as Goldberg's and the wider micropolitical stance that ties consumer desires to design practices. Planned obsolescence is one such design feature that has been focused on in the critical literature. It is also something that other

art and hacking projects, such as Benjamin Gaulon's Recyclism, address as a persistent part of the design and production of technological objects and systems. Similarly, such approaches take into account the current issue of abandoned hardware, which even in functional devices amounts to hundreds of millions of screens, mobiles, electronic and computing devices that are still not properly dealt with after their use. U.S. Environmental Protection Agency (EPA) statistics from 2009 indicate that there are 2.37 million tons of electronics ready for their afterlife management, representing "an increase of more than 120% compared to 1999."[37] The primary category is related to screen technologies but we can safely assume that the rise of mobile technologies will soon constitute a rather big share of this dead media pile, of which only 25 percent was collected for any sort of actual management and recycling in 2009. The quantity of operational electronics discarded annually is one kind of geologically significant pile that entangles first, second, and third nature:[38] the communicational vectors of advanced digital technologies have a rather direct link to and impact upon first natures, reminding us that the contemporary reliance on swift communicational transactions is also reliant on this aspect of hardware. Those communicational events are sustained by the broader sphere of geology of media: technologies abandoned and consisting of hazardous material: lead, cadmium, mercury, barium, etc.

National, supranational, and NGO bodies are increasingly forced to think the future of media and information technologies as something "below the turf." This means both a focus on the policies and practices of e-waste as one of the crucial areas of concern and planning for raw material extraction and logistics to ensure supply. As illustrated by the brief mention of scrap metal in China, the usual practices of mining are not considered the only possible route for the future geology of media. The future geo(physical)politics of media circulate around China, Russia, Brazil, Congo and for instance South Africa as key producers of raw materials. The materiality of information technology starts from the soil and the under-ground. Miles of crust opened up by sophisticated drills. This depth marks the passage from the mediasphere to the lithosphere. An increasing amount of critical material is found only by going down deeper into the crust or otherwise difficult-to-reach areas. Offshore oil drilling is an example of this—in some cases in rather peculiar circumstances and at unusual depths: the Tupi deposits of oil off the shore of Brazil, "beneath 1.5 miles of water and another 2.5 miles of compressed salt, sand and rock";[39] new methods of penetrating rocks, by fracturing them or through steam-assisted cavity drainage; deep sea mining by countries such as China; the list could be extended. Corporations and mines compete for the depth record of mining for fuel and materials such as gold. Imagining the passage tens of thousands of feet under the ground and the ocean floor, suddenly an image comes to mind, one familiar from an earlier part of this essay: Professor Challenger's quest of digging deeper and deeper inside the living crust.

Depth becomes not only an index of time but also a resource in the fundamental sense of Martin Heidegger's standing-reserve: technology reveals nature in ways that can turn it into a resource. For Heidegger, the writer of trees, rivers, and forest paths, the river Rhein turns from Hölderlin's poetic object into a technological construct effected in the assemblage of the new hydroelectric plant. The question of energy becomes a way of defining the river, and in Heideggerian terms, transforming it:

> The revealing that rules throughout modern technology has the character of a setting-upon, in the sense of a challenging-forth. That challenging happens in that the energy concealed in nature is unlocked, what is unlocked is transformed, what is transformed is stored up, what is stored up is, in turn, distributed, and what is distributed is switched about ever anew. Unlocking, transforming, storing, distributing, and switching about are ways of revealing.[40]

This notion of transformation becomes a central way to understand the technological assemblages in which metals and minerals are mobilized as part of technological and media contexts. Technology constructs such new pragmatic and epistemological realms, where geology turns into a media resource. And similarly, geology itself transforms into a contested technologically conditioned object of research and a concept that we are able to use to understand the widespread mobilization of nature. It also transforms question of deep times from a merely temporal question of pasts to one of futures of extinction, pollution, and resource depletion, triggering a huge chain of events and interlinked questions: the future landscape of media technological fossils.

This transformation of geology of media, and media of geology / metals, works in a couple of directions. Theorists, policy makers, and even politicians are increasingly aware of the necessity of cobalt, gallium, indium, tantalum and other metals and minerals for media technological ends, from end-user devices like mobiles and game consoles to, more generally, capacitors, displays, batteries and so forth. The geophysics of media consists of examples such as:

Cobalt—(used for) lithium-ion batteries, synthetic fuels
Gallium—thin layer photovoltaics, IC, WLED
Indium—displays, thin layer photovoltaics
Tantalum—micro-capacitors, medical technology
Antimony—ATO, micro-capacitors
Platinum—fuel cells, catalysts
Palladium—catalysts, seawater desalination
Niobium—micro-capacitors, ferroalloys
Neodymium—permanent magnets, laser technology
Germanium—fibre optic cables, IR optical technologies[41]

Moments of deep time are exposed in such instances as Clemens Winkler's 1885/86 discovery of Germanium (named of course after his home country) when he was able to distinguish it from antimony.[42] Winkler's discovery in Freiberg has its place in the history of chemistry and elements for sure, but it also relates to computing culture and the necessary materials for semiconducting: Germanium alloy was the competing material to what we now consider a naturalized part of computers: silicon. But the deep times are also telling a story of the underground which is not to be confused with the discourse of underground art and activism, to which we so often revert in media-art-historical discourse. This new definition of media deep time is more in tune with mining and transportation of raw materials, logistics, and the processing and refining of metals and minerals.

To reiterate the argument: the extensively long historical durations of deep time in the manner introduced to media art discussions by Zielinski take place in Antiquity, with medieval alchemists and in nineteenth century science-art collaborations, as exemplary events of deep time media-artistic techniques and ideas. But what if we need to account for an alternative deep time, which extends deeper towards a geophysics of media culture? This is a possibility not to be missed: an alternative media history of matter. Such a project extends the historical interest in alchemists to contemporary mining practices, minerals and the consequent materialities.

The geology of media that nods towards Zielinski but wants to extend deep times towards chemical and metal durations includes a wide range of examples of refined minerals, metals, and chemicals that are essential for media technologies to operate in the audiovisual and often miniaturized mobile form that we have grown to expect as end-users of content. A usual focus on Understanding Media is complemented with the consideration of the duration of materials as significant for media temporality.[43] Gold and iron might refer to alchemy of transformation, but nowadays this transformation concerns the scientific and technological forces that are producing multiple ecologies, recircuiting the earth.

Notes

1 Lewis Mumford, *Technics and Civilization* (London: Routledge & Kegan Paul Ltd, 1934), 74–7.

2 Rosalind Williams, *Notes on the Undergound. An Essay on Technology, Society, and the Imagination*, 2nd edn (Cambridge, MA: MIT Press, 2008), 4–5, 22–32.

3 Benjamin Bratton, "The Black Stack," *E-Flux* 3 (2014). Available online: http://www.e-flux.com/journal/the-black-stack/ accessed March 21, 2014.

4 Gary Genosko, "The New Fundamental Elements of a Contested Planet," talk at the "Earth, Air, Water: Matter and Meaning in Rituals" conference, Victoria College, University of Toronto, June 2013.

5 Robert Smithson, "A Sedimentation of the Mind: Earth Projects," in *Robert Smithson: The Collected Writings*, 1968, ed. Jack Flam (University of California Press, 1996), 101. Of course, the resonances with Gregory Bateson's ideas from the 1960s and 1970s are explicit and thus a link to Guattari would also be interesting to map. See Gregory Bateson, *Steps to an Ecology of Mind* (St. Albans: Paladin, 1973).

6 Arthur Conan Doyle, "When the World Screamed," *Classic Literature Library* (1928). Available online: http://www.classic-literature.co.uk/scottish-authors/arthur-conan-doyle/when-the-world-screamed/ebook-page-10.asp (accessed October 9, 2013).

7 Ibid. Available online: http://www.classic-literature.co.uk/scottish-authors/arthur-conan-doyle/when-the-world-screamed/ebook-page-11.asp (accessed October 9, 2013).

8 Ibid. Available online: http://www.classic-literature.co.uk/scottish-authors/arthur-conan-doyle/when-the-world-screamed/ebook-page-14.asp (accessed October 9, 2013). The allusion to rape is even more obvious if considered in light of the long-term mythological articulation of the earth with the female. The female interior of the earth is one of valuable riches. Steven Connor, *Dumbstruck: A Cultural History of Ventriloquism* (Oxford: Oxford University Press, 2000), 52.

9 Novalis, quoted in Theodore Ziolkowski, *German Romanticism and its Institutions* (New Jersey: Princeton University Press, 1990), 31.

10 Richard Maxwell and Toby Miller, *Greening the Media* (Oxford: Oxford University Press, 2012), 55.

11 Fritz Leiber, "The Black Gondolier," in *The Black Gondolier and Other Stories* (E-Reads, 2002). Reza Negarestani, *Cyclonopedia. Complicity with Anonymous Materials* (Melbourne: re.press, 2008). Eugene Thacker, "Black Infinity, or, Oil Discovers Humans," in *Leper Creativity: Cyclonopedia Symposium*, ed. Ed Keller, Nicola Masciandaro, and Eugene Thacker (New York: Punctum, 2012).

12 Brett Neilson, "Fracking," in *Depletion Design*, ed. Carolin Wiedemann and Soenke Zehle (Amsterdam: Institute of Network Cultures and xm:lab, 2012), 85.

13 Maxwell and Miller, *Greening the Media*, 93.

14 T. E. Graedel, E. M. Harper, N. T. Nassar, and Barbara K. Reck, "On the Materials Basis of Modern Society," *PNAS* Early Edition (October 2013): 1.

15 Ibid. See also Akshat Raksi, "The metals in your smartphone may be irreplaceable," *Ars Technica* (December 5, 2013). Available online: http://arstechnica.com/science/2013/12/the-metals-in-your-smartphone-may-be-irreplaceable/ (accessed December 9, 2013).

16 Brett Milligan, "Space–Time Vertigo," in *Making the Geologic Now*,

Responses to the Material Conditions of Contemporary Life, ed. Elizabeth Ellsworth and Jamie Kruse (New York: Punctum, 2013), 124.

17 Siegfried Zielinski, *Deep Time of the Media: Toward an Archaeology of Hearing and Seeing by Technical Means*, trans. Gloria Custance (Cambridge, MA: MIT Press, 2006), 3.

18 Stephen Jay Gould, *Time's Arrow, Time's Cycle: Myth and Metaphor in the Discovery of Geological Time* (Cambridge, MA: Harvard University Press, 1987), 86–91.

19 Fredric Jameson, *Archaeologies of the Future* (London: Verso, 2005).

20 The figures as to exactly how much network computing and data centers consume vary a lot, as well as those concerning the dependence on carbon emission-heavy energy. Peter W. Huber, "Dig More Coal, the PCs Are Coming," *Forbes*, May 31, 1999. Duncan Clark and Mike Berners-Lee, "What's the Carbon Footprint of … The Internet?" *Guardian,* August 12, 2010. Available online: http://www.theguardian.com/ (accessed January 24, 2014). Seán O'Halloran, "The Internet Power Drain," *Business Spectator,* September 6, 2012. Available online: http://www.businessspectator.com. au/article/2012/9/6/technology/internet-power-drain (accessed January 24, 2014).

21 Amy Catania Kulper, "Architecture's Lapidarium," in *Architecture in the Anthropocene. Encounters Among Design, Deep Time, Science and Philosophy*, ed. Etienne Turpin (Ann Arbor: Open Humanities Press, 2013), 100.

22 Recent media and cultural theory has in most interesting ways picked up the notion of temporality again. In media archaeology it has emerged in the form of non-narrative and nonhuman-based understandings of temporalities—for instance microtemporality (Wolfgang Ernst). For Ernst, microtemporalities define the ontological basis of how media as reality production work at speeds to which the human senses have limited access. Hence Ernst has also written about "tempo*realities.*" See Wolfgang Ernst, *Chronopoetik. Zeitweisen und Zeitgaben technischer Medien* (Berlin: Kadmos, 2013). See also Wolfgang Ernst, "From Media History to Zeitkritik," trans. Guido Schenkel, *Theory, Culture and Society* 30 (6) (2013). In a slightly similar fashion Mark Hansen's recent work has flagged up the need to embed media theoretical vocabulary in a different regime of sensation than that of conscious perception. In Hansen's Whitehead-inspired perspective, the limitations of phenomenology are worked through so as to address the current ubiquitous digital media culture and the speeds at which it unfolds as part of the human, without being accessible through human senses. See Mark B. N. Hansen, *Feed Forward: On the Future of the 21st Century Media* (Chicago: University of Chicago Press, 2014). At the other end of the scale, the duration of climatic and geological timescales has to be addressed. See also for instance Claire Colebrook on Extinction and the weird temporalities of nature and knowledge of nature. Claire Colebrook, "Framing the End of Species," in *Extinction: Living Books About Life* (Open Humanities Press, 2011). Available online: http://www.livingbooksaboutlife.org/books/Extinction/Introduction

(accessed December 4, 2013). See also Jussi Parikka, *A Geology of Media* (Minneapolis: University of Minnesota Press, 2015) for an extended discussion of the themes of this chapter.

23 John Durham Peters, "Space, Time and Communication Theory," *Canadian Journal of Communication* 28 (4) (2003). Available online: http://www. cjc-online.ca/index.php/journal/article/view/1389/1467 (accessed February 12, 2014).

24 Matthew Fuller, *Media Ecologies. Materialist Energies in Art and Technoculture* (Cambridge, MA: MIT Press, 2005), 174.

25 Sean Cubitt, Robert Hassan, and Ingrid Volkmer, "Does Cloud Computing Have a Silver Lining?" *Media, Culture and Society* 33 (2011).

26 Paul Feigelfeld, "From the Anthropocene to the Neo-Cybernetic Underground: A conversation with Erich Hörl," *Modern Weekly* (Fall/ Winter 2013). Available online (English version): http://www.60pages.com/ from-the-anthropocene-to-the-neo-cybernetic-underground-a-conversation- with-erich-horl-2/ (accessed December 6, 2013).

27 Ibid.

28 Benjamin Bratton, *The Stack* (Cambridge, MA: MIT Press, 2015). Michael Nest, *Coltan* (Cambridge: Polity, 2011). On Trevor Paglen's The Last Pictures, see "The Last Pictures" project website at *Creative Time*. Available online: http://creativetime.org/projects/the-last-pictures/ (accessed September 8, 2015).

29 Rob Holmes, "A preliminary atlas of gizmo landscapes," *Mammolith*, April 1, 2010. Available online: http://m.ammoth.us/blog/2010/04/a-preliminary- atlas-of-gizmo-landscapes/ (accessed February 10, 2014).

30 Jay Goldberg, "Hardware is Dead," *Venturebeat*, September 15, 2012. Available online: http://venturebeat.com/2012/09/15/hardware-is-dead/ (accessed November 11, 2013).

31 Bruce Sterling, "The Dead Media Project. A Modest Proposal and a Public Appeal," *The Dead Media Project*. Available online: http://www.deadmedia. org/modest-proposal.html (accessed November 11, 2013).

32 Goldberg, "Hardware is Dead."

33 Ibid.

34 For a specific focus on scrap metals, technology and China, see Adam Minter, "How China Profits From Our Junk," *The Atlantic*, November 1, 2013. Available online: http://www.theatlantic.com/china/archive/2013/11/ how-china-profits-from-our-junk/281044/ (accessed November 12, 2013). On the life cycle of metals as part of technological society, see Graedel, "On the Materials Basis of Modern Society," 1–6.

35 Ibid.

36 Garnet Hertz and Jussi Parikka, "Zombie Media: Circuit Bending Media Archaeology into an Art Method," *Leonardo* 45 (5) (2012).

37 U.S. Environmental Protection Agency, "Statistics on the Management of Used and End-of-Life Electronics", *EPA* (2009). Available online: http://

www.epa.gov/osw/conserve/materials/ecycling/manage.htm (accessed
November 11, 2013).

38 McKenzie Wark, "Escape from the Dual Empire," *Rhizomes* 6 (Spring
 2003). Available online: http://www.rhizomes.net/issue6/wark.htm (accessed
 December 17, 2013).

39 Michael T. Klare, *The Race for What's Left. The Global Scramble for the
 World's Last Resources* (New York: Metropolitan Books, 2012), 12.

40 Martin Heidegger, *The Question Concerning Technology and Other Essays*,
 trans. William Lovitt (New York: Garland Publishing, 1977), 16.

41 European Union Critical Raw Materials Analysis, by the European
 Commission Raw Materials Supply Group, 30 July 2010, executive
 summary by Swiss Metal Assets, October 1, 2011. Available online: www.
 swissmetalassets.com (accessed July 24, 2012).

42 Clemens Winkler, "Germanium, Ge, ein neues, nichtmetallisches Element,"
 Berichte der deutschen chemischen Gesellschaft 19 (1886).

43 Jonathan Sterne has also flagged up the need for a deep time perspective,
 without using those terms: "if the span of media history in human history
 amounts to approximately 40,000 years, we have yet to really seriously
 reconsider the first 39,400 years." Jonathan Sterne, "The Times of
 Communication History," (presented at "Connections: The Future of Media
 Studies," University of Virginia, April 4, 2009).

Bibliography

Bateson, Gregory. *Steps to An Ecology of Mind*. St. Albans: Paladin, 1973.
Bratton, Benjamin. "The Black Stack." *E-Flux* 3 (2014). Available online:
 http://www.e-flux.com/journal/the-black-stack/ (accessed March 21,
 2014).
Bratton, Benjamin. *The Stack*. Cambridge, MA: MIT Press, 2015.
Chevron Corporation. "Chevron Announces Discovery in the Deepest Well Drilled
 in the U.S. Gulf of Mexico." Chevron press release, December 20, 2005.
 Available online: http://investor.chevron.com/phoenix.zhtml?c=130102&p=irol-
 newsArticle_Print&ID=800411 (accessed December 6, 2013).
Clark, Duncan and Mike Berners-Lee. "What's the Carbon Footprint of …
 The Internet?" *Guardian*, August 12, 2010. Available online: http://www.
 theguardian.com/ (accessed January 24, 2014).
Colebrook, Claire. "Framing the End of Species." In *Extinction: Living Books
 About Life*. Open Humanities Press, 2011. Available online: http://www.
 livingbooksaboutlife.org/books/Extinction/Introduction (accessed December 4,
 2013).
Connor, Steven. *Dumbstruck: A Cultural History of Ventriloquism*. Oxford:
 Oxford University Press, 2000.
Cubitt, Sean, Robert Hassan and Ingrid Volkmer "Does Cloud Computing Have a
 Silver Lining?" *Media, Culture and Society* 33 (2011): 149–58.
Doyle, Arthur Conan. "When the World Screamed." *Classic Literature Library*

(1928). Available online: http://www.classic-literature.co.uk/scottish-authors/arthur-conan-doyle/when-the-world-screamed (accessed October 9, 2013).

Ernst, Wolfgang. "From Media History to Zeitkritik," trans. Guido Schenkel. *Theory, Culture and Society* 30 (6) (2013): 132–46.

Ernst, Wolfgang. *Chronopoetik: Zeitweisen und Zeitgaben technischer Medien.* Berlin: Kadmos, 2013.

Feigelfeld, Paul. "From the Anthropocene to the Neo-Cybernetic Underground: A conversation with Erich Hörl." *Modern Weekly* (Fall/Winter 2013). Available online (English version): http://www.60pages.com/from-the-anthropocene-to-the-neo-cybernetic-underground-a-conversation-with-erich-horl-2/ (accessed December 6, 2013).

Fuller, Matthew. *Media Ecologies: Materialist Energies in Art and Technoculture.* Cambridge, MA: MIT Press, 2005.

Genosko, Gary. "The New Fundamental Elements of a Contested Planet." Talk at the "Earth, Air, Water: Matter and Meaning in Rituals" conference, Victoria College, University of Toronto, June 2013.

Goldberg, Jay. "Hardware is Dead." *Venturebeat*, September 15, 2012. Available online: http://venturebeat.com/2012/09/15/hardware-is-dead/ (accessed November 11, 2013).

Gould, Stephen Jay. *Time's Arrow, Time's Cycle: Myth and Metaphor in the Discovery of Geological Time.* Cambridge, MA: Harvard University Press, 1987.

Graedel, T. E., E. M. Harper, N. T. Nassar, and Barbara K. Reck. "On the Materials Basis of Modern Society." *PNAS* Early Edition (October 2013): 1–6.

Hansen, Mark B. N. *Feed Forward: On the Future of the 21st Century Media.* Chicago: University of Chicago Press, 2014.

Heidegger, Martin. *The Question Concerning Technology and Other Essays,* trans. William Lovitt. New York: Garland Publishing, 1977.

Hertz, Garnet and Jussi Parikka. "Zombie Media: Circuit Bending Media Archaeology into an Art Method." *Leonardo* 45 (5) (2012): 424–30.

Holmes, Rob. "A preliminary atlas of gizmo landscapes." *Mammolith,* April 1, 2010. Available online: http://m.ammoth.us/blog/2010/04/a-preliminary-atlas-of-gizmo-landscapes/ (accessed February 10, 2014).

Huber, Peter W. "Dig More Coal, the PCs Are Coming." *Forbes,* May 31, 1999.

Ippolita and Tiziana Mancinelli. "The Facebook Aquarium: Freedom in a Profile." In *Unlike Us Reader: Social Media Monopolies and Their Alternatives,* ed. Geert Lovink and Miriam Rasch. Amsterdam: Institute of Network Cultures, 2013.

Jameson, Fredric. *Archaeologies of the Future.* London: Verso, 2005.

Klare, Michael T. *The Race for What's Left: The Global Scramble for the World's Last Resources.* New York: Metropolitan Books, 2012.

Kulper, Amy Catania. "Architecture's Lapidarium." In *Architecture in the Anthropocene: Encounters Among Design, Deep Time, Science and Philosophy,* ed. Etienne Turpin. Ann Arbor: Open Humanities Press, 2013.

Leiber, Fritz. "The Black Gondolier." In *The Black Gondolier and Other Stories.* E-Reads, 2002.

Maxwell, Richard and Toby Miller. *Greening the Media.* Oxford: Oxford University Press, 2012.

Milligan, Brett. "Space–Time Vertigo." In *Making the Geologic Now: Responses to the Material Conditions of Contemporary Life*, ed. Elizabeth Ellsworth and Jamie Kruse. New York: Punctum, 2013.

Minter, Adam. "How China Profits From Our Junk." *The Atlantic*, November 1, 2013. Available online: http://www.theatlantic.com/china/archive/2013/11/how-china-profits-from-our-junk/281044/ (accessed November 12, 2013).

Mumford, Lewis. *Technics and Civilization*. London: Routledge & Kegan Paul Ltd, 1934.

Negarestani, Reza. *Cyclonopedia: Complicity with Anonymous Materials*. Melbourne: re.press, 2008.

Neilson, Brett. "Fracking." In *Depletion Design*, ed. Carolin Wiedemann and Soenke Zehle. Amsterdam: Institute of Network Cultures and xm:lab, 2012.

Nest, Michael. *Coltan*. Cambridge: Polity, 2011.

O'Halloran, Seán. "The internet power drain." *Business Spectator*, September 6, 2012. Available online: http://www.businessspectator.com.au/article/2012/9/6/technology/internet-power-drain (accessed January 24, 2014).

Parikka, Jussi. *A Geology of Media*. Minneapolis: University of Minnesota Press, 2015.

Peters, John Durham. "Space, Time and Communication Theory." *Canadian Journal of Communication* 28 (4) (2003). Available online: http://www.cjc-online.ca/index.php/journal/article/view/1389/1467 (accessed February 12, 2014).

Raksi, Akshat. "The metals in your smartphone may be irreplaceable." *Ars Technica* (December 5, 2013). Available online: http://arstechnica.com/science/2013/12/the-metals-in-your-smartphone-may-be-irreplaceable/ (accessed December 9, 2013).

Smithson, Robert. "A Sedimentation of the Mind: Earth Projects." In *Robert Smithson: The Collected Writings*. 1968, ed. Jack Flam. University of California Press, 1996.

Sterling, Bruce. "The Dead Media Project: A Modest Proposal and a Public Appeal." *The Dead Media Project*. Available online: http://www.deadmedia.org/modest-proposal.html (accessed November 11, 2013).

Sterne, Jonathan. "The Times of Communication History." Presented at "Connections: The Future of Media Studies," University of Virginia, April 4, 2009.

Thacker, Eugene. "Black Infinity, or, Oil Discovers Humans." In *Leper Creativity: Cyclonopedia Symposium*, ed. Ed Keller, Nicola Masciandaro and Eugene Thacker, 173–80. New York: Punctum, 2012.

U.S. Environmental Protection Agency. "Statistics on the Management of Used and End-of-Life Electronics", *EPA* (2009). Available online: http://www.epa.gov/osw/conserve/materials/ecycling/manage.htm (accessed November 11, 2013).

Wark, McKenzie. "Escape from the Dual Empire." *Rhizomes* 6 (Spring 2003). Available online: http://www.rhizomes.net/issue6/wark.htm (accessed December 17, 2013).

Williams, Rosalind. *Notes on the Undergound: An Essay on Technology, Society, and the Imagination*. 2nd ed. Cambridge, MA: MIT Press, 2008.

Winkler, Clemens. "Germanium, Ge, ein neues, nichtmetallisches Element." *Berichte der deutschen chemischen Gesellschaft* 19 (1886): 210–11.

Zielinski, Siegfried. *Deep Time of the Media: Toward an Archaeology of Hearing and Seeing by Technical Means*, trans. Gloria Custance. Cambridge, MA: MIT Press, 2006.

Ziolkowski, Theodore. *German Romanticism and its Institutions*. New Jersey: Princeton University Press, 1990.

CHAPTER SEVEN

Planetary immunity

Biopolitics, Gaia theory, the holobiont, and the systems counterculture

Bruce Clarke

Biopolitics and the immunitary paradigm

Biopolitics concerns the thinking together of issues of sovereignty and governmentality with the matter of life, predominantly but not exclusively human life. Standard biopolitical topics include the eugenics movement of the earlier twentieth century, especially as it brought about laws for racial hygiene; also, the dire outcome of eugenic initiatives in the Nazi death camps; and, in contrast to such "thanatopolitical" events, the post-war normalization of the welfare state in advanced industrial nations. In this sampling, the political themes are clear enough, but the bio- of biopolitics leaves nonhuman life largely out of the equation. In his introduction to a French edition of Italian philosopher Roberto Esposito's work on biopolitics, Frédéric Neyrat writes: "Of course, life protects itself, 'by nature'; but modern sovereignty must be thought of as a second, 'meta-immunitary' 'dispositif' that, coming from life itself, separates itself from it, and forms a transcendent instance that bears down on life to the extent that it destroys it."[1] However, what appear to be Neyrat's assumptions about "life" and its "nature" leap over a number of biological and ecological issues of great import to the aim of Esposito's project as Neyrat describes it, "to make impossible any transcendent normativity, which will always have as its effect to prescribe a dreadful distinction between a good life on the one hand, and on the other hand a life that deserves only death or abandonment" (36).

This chapter also seeks to question notions of immunopolitical transcendence, with an inquiry into the possibility of thinking Gaia theory and biopolitics together, of thinking the form of a Gaian biopolitics.

Francisco Varela's second-order systems-theoretical characterization of the theory provides a succinct synopsis of the strand of Gaia discourse on which I will stake my argument:

> We all are used to thinking that the biosphere is constrained by and adapted to its terrestrial environment. But the Gaia hypothesis proposes that there is a circularity here: this terrestrial environment is itself the result of what the biosphere did to it. As Lovelock puts it metaphorically: we live in the breath and bones of our ancestors. As a result the entire biosphere/Earth "Gaia" has an identity as a whole, an adaptable and plastic unity, acquired through time in this dynamic partnership between life and its terrestrial environment.[2]

To make a start, then, on the construction of a Gaian biopolitics, Cary Wolfe's *Before the Law: Humans and Other Animals in a Biopolitical Frame*, given its concern to extend biopolitical discussion beyond humans alone, offers this enquiry a posthumanist if not altogether planetary orientation.[3] *Before the Law* sets about deconstructing some key pairs of distinctions endemic to standard biopolitical thought, such as proper / improper and inside / outside, while pressing them toward the immunitary form of these dialectics, in Wolfe's words, "the 'immunitary' (and, with Derrida, 'autoimmunitary') logic of the biopolitical."[4] His note to this remark cites Esposito's *Immunitas: The Protection and Negation of Life*.[5] While Esposito's text does not take nonhuman animals and their possible standing "before the law" into its purview, it too drives beyond standard biopolitical discussion by delving deeply into some key histories of modern biology and physiology. *Immunitas* draws out the multivalent development of the notion of immunity from its classical roots as a political concept of individual exemption from communal demands to a modern biomedical concept of organic exemption from the harm borne by environmental pathogens: "But if the notion of immunity only takes form against the backdrop of meaning created by community," Esposito remarks, "how are we to characterize their relationship? Is it a relation of simple opposition, or is it a more complex dialectic in which neither term is limited to negating the other but instead implicates the other, in subterranean ways, as its necessary presupposition?" (5).

Immunitas unfolds in great detail what turns out to be an exceedingly complex dialectic between the concepts of immunity and community. However, once the issue of immunity in relation to community is posed in its biological provenance, where is one to stop? Could one not reconfigure one's view of the community of the living, whatever the vagaries and variations of its immunitary situations, in order to extend it to Gaia's planetary horizon? Esposito appears to gesture in that direction at the end of his work *Bios: Biopolitics and Philosophy*, in particular, through a reflection on a remarkable, proto-ecological passage from Spinoza's *Ethics*:

So if something in Nature appears to us as ridiculous, absurd, or evil, this is due to the fact that our knowledge is only partial, that we are for the most part ignorant of the order and coherence of Nature as a whole, and that we want all things to be directed as our reason prescribes. Yet that which our reason declares to be evil is not evil in respect of the order and laws of universal Nature, but only in respect of our own particular nature.[6]

However, according to Wolfe, Esposito draws from Spinoza's defense of Nature's right to exist on its own terms the contemporary imperative that "a turn away from the thanatological and autoimmunitary logic of biopolitics can only take place if life as such—not just human (vs animal) life ... becomes the subject of immunitary protection," which absolute imperative amounts to a form of "biologistic continuism."[7] Some of the issues here may be stated like this: does such "immunitary protection" refer to political and legal or to biological and ecological matters? Can such protections be applied to both at once? And in either case, can such protections really be referred to "life as such" as opposed to some forms of life rather than others? Wolfe comments: "Where Esposito is wrong is in his insistence on 'the principle of unlimited equivalence for every single form of life'"; for this leads him dangerously close to "a sort of neovitalism that ends up radically dedifferentiating the field of 'the living' into a molecular wash of singularities that all equally manifest 'life.'"[8]

Wolfe counters Esposito's Deleuzian route to an affirmative biopolitics with an alternative model that develops the operational isomorphism between immunitary and autopoietic systems, and so insists instead on the necessity to observe biological and social differentiations in the midst of their integration into higher-order ensembles.[9] We will come back to this in the context of biologist and evolutionary theorist Lynn Margulis's formulation of the Gaian system as an autopoietic system in its own right. But for the moment let us return to Esposito's *Immunitas*. This is a crucial text precisely for its author's candor in declaring how the more recent immune-system theorizing available to him around the year 2000 disorients the dialectical approach he has brought to the topic. As we will see, it is this more recent immune discourse, significantly inflected by the work of Francisco Varela and Humberto Maturana, that can be effectively marshalled for something like a Gaian ecopolitics of planetary immunity.[10] Encountering this constructivist school of immunological thought, Esposito's own dialectical inquiry into the self / non-self distinction reaches the limits of its paradigm. Let us look quickly at how Esposito presents this instructive impasse in his introduction to *Immunitas*.

Given how the full text of his study will detail the manifold conceptual cul-de-sacs, the dismaying hypertrophies of militaristic metaphors, and other negativities, contradictions, and self-destructive dynamics of the immunitary paradigm, it makes good sense for Esposito to preview the shift in tone to come at the end of this book. He asks: "Is there a point at which

the dialectical circuit between the protection and negation of life can be interrupted, or at least problematized? Can life be preserved in some other form than that of its negative protection?" (16). Must biopolitics always devolve into a thanatopolitics where the lives of some are protected by the putting to death of others, or could there be an affirmative biopolitics that might avert the sorts of murderous episodes commonplace in the twentieth century? The biological turn in Esposito's philosophy is driven by this quest for a non-facile form of biotic affirmation: "I have sought the answer to the question with which I began at the very heart of the protective mechanism that has progressively extended itself to all the languages of life—namely, on the biological plane, in the immune system that ensures the safeguarding of life in the body of each individual" (16). However, upon lengthy examination of the modern discourse of the immune system, affirmation is not easy to come by. Indeed, according to biomedical and immunological discourse from the time of Pasteur to the time of AIDS, vertebrate immune systems succeed in protecting their possessors against the onslaughts of the viruses, the bacteria, and the killer fungi only by placing their beneficiaries on uncertain hair-triggers against autoimmune fiascos. Life is war, pathogenicity is everywhere, and your best friend could be your worst enemy.

It is against this dismal immunitary vista that Esposito locates incipient glimmers of an alternative view:

> However, more recent study of the structure and functioning of the immune system seems to suggest another interpretive possibility, one that traces out a different philosophy of immunity ... This new interpretation situates immunity in a nonexcluding relation with its common opposite. The essential point of departure ... is a conception of individual identity that is distinctly different from the closed, monolithic one we described earlier ... Rather than an immutable and definitive given, the body is understood as a functioning construct that is open to continuous exchange with its surrounding environment. (17)

Indeed, he concludes, "once its negative power has been removed, the immune is not the enemy of the common, but rather something more complex that implicates and stimulates the common" (18). Admirably, however, he confesses that "the full significance of this necessity, but also its possibility, still eludes us" (18). I will venture to suggest that in this remark Esposito sees clearly enough that the old dialectical machinery of self and non-self no longer provides an adequate description of immune functions, but also, that he cannot yet see how to fit these newer observations into some other comprehensive scheme. But in the subsequent development of immunological theory, that alternative scheme and its significance have taken on sharper outlines. A key element of these newer conceptions of the immune system concerns its ecological extension beyond the "immune self." This revision to the immunitary paradigm is amenable to a Gaian

description of biological community coordinated with ecological environments, a view that lifts the immunitary paradigm up to a planetary horizon.

Gaia and the systems counterculture

A set of planetary discourses published several decades ago already indicated how to expand the immunitary paradigm beyond the old ontologies of the self. Current biopolitical thought provides an apt occasion to consolidate some of these abiding theoretical leads. They originated with the architects of Gaia theory, Lynn Margulis in particular, in the milieu of a larger systems counterculture including William Irwin Thompson and Francisco Varela. If the power of their combined vision has since lain semi-dormant in a state of relative obscurity, or submerged under insipid or bastardized versions of their insights, I hope to extract the actual detail of that conceptual vision from such neglect for renewed appreciation. Some narration and commentary from a 1986 NOVA documentary will give us a preview of our destination:

> Narrator: Geologists use changes in fossils to date the history of the world. And the record shows that mass extinctions have happened repeatedly. Is this a failure of Gaia? Or has life been under attack from the outside, and survived? The answer may lie in the large craters scattered around the earth's surface. One popular though controversial theory holds that they were caused by asteroids or comets hitting the earth. The effect of an impact great enough to cause such craters would be devastating. It's calculated that the shock would be a thousand times that of all of the world's nuclear weapons going off in one place. The effect would be to throw up a blanket of dirt and debris, which would circulate around the world, blocking out the sun, freezing the continental areas, killing most plants and animals. How could the Gaian system have survived such a devastating blow?

> Lynn Margulis: Gaia is run by the sum of the biota, and therefore you can lose enormous numbers and great diversity with mass extinctions, but you never come anywhere near losing everything, and you certainly don't lose the major groups of bacteria, ever. They've been in continuous existence, and we think it's the major groups of bacteria that actually are running the Gaian system. So in a sense these—whether they're caused by impact or whatever they're caused by—these great extinctions are tests of Gaia, and the system bounces back.[11]

Several intellectual venues helped to cultivate the Gaia concept such that its immunitary implications would eventually take on a specifically biopolitical inflection. The first of these venues is the *Whole Earth Catalog*, with

its persistent foregrounding of "whole systems." Such "wholeness" was not precisely a medical, psychological, or spiritual ideal, although those connotations are always available. In the beginning, the "whole Earth" named a desire to see a photograph taken from space of the full earth, like the full moon, unobscured by shadow.[12] But once that technical image did arrive in 1967, the wholeness in question was explicitly *synergetic* in the sense popularized by the original intellectual hero of the *Catalog*, Buckminster Fuller, synergy being the "unique behavior of whole systems, unpredicted by the behavior of their respective subsystems' events."[13] As filled out by its regular opening section, "Understanding Whole Systems," the *Catalog*'s vision of wholeness is broadly cybernetic, systems-theoretical: it is the operational wholeness of a systemic process bounded with a closed organizational loop while driven by a material-energetic flux. The outside back cover of the *Catalog*'s second major iteration in Spring 1969 figured this initial orientation toward far-from-equilibrium thermodynamic systems by placing the following statement next to an image of Earthrise: "*the flow of energy through a system acts to organize that system.*"[14] The self-organizing system in question is clearly the whole earth in solar context.

Among the many wider repercussions of the *Whole Earth Catalog* as it expanded in size and mutated in form over the next two decades was its availability to a conceptual gathering I call the systems counterculture. In the late sixties, the systems thinkers favored by the *Catalog* featured, preeminently, Buckminster Fuller, as well as the inventor of the term *cybernetics*, Norbert Wiener, and also, less famously but more importantly for future developments, cyberneticist Heinz von Foerster, who provided the *Catalog*'s editor, Stewart Brand, with a seminal review of George Spencer-Brown's calculus for constructivism, *Laws of Form*.[15] After the prematurely named *Last Whole Earth Catalog* of 1971, it was three years before the *Catalog* project reappeared in new forms. One of these was the *Whole Earth Epilog*, released in September 1974. For our narrative the key development here is the arrival of Gregory Bateson in the wake of his signature collection of 1972, *Steps to an Ecology of Mind*. The influence of Bateson now eclipsed that of Fuller, leading Brand during the 1970s to prefer whole systems thinking purveyed through less technological, more anthropological and ecological varieties of cybernetics.[16] This development is epitomized by the major mutation of the occasional *Catalog* into a quarterly journal that began operation in the spring of 1974—the *CoEvolution Quarterly* (*CQ*).

The cover of the first *CQ* wonderfully captures this ecological shift. We observe coevolution as a human face figured from a profusion of myriad coevolutionary relationships gathering together insects and flowers, sea creatures and oceans, microbes and galaxies, an image Gaian in spirit if not in letter. Meanwhile, with Bateson as its primary standard bearer, the systems counterculture began to gather within the pages of *CQ*. An early number included an announcement for a voluntary community formed in 1972 by a scholarly prodigy and lapsed Yeats expert turned poet and cultural

historian, William Irwin Thompson. Thompson had already published two widely distributed trade books, *At the Edge of History: Speculations on the Transformation of Culture* in 1971 and *Passages About Earth: An Exploration of the New Planetary Culture* in 1974. During that period he founded the Lindisfarne Association as an esoteric community with a contemplative orientation toward an intellectual agenda taking up the cultivation of a "Planetary Culture and the New Image of Man." We will come back shortly to Bill Thompson and his place within the systems counterculture.

Lynn Margulis and James Lovelock arrive in *CQ*'s Summer 1975 issue, making it the first non-specialist journal to publish on Gaia, with what was still a distinctly specialized treatment.[17] Their headnote begins: "We would like to discuss the Earth's atmosphere from a new point of view—that it is an integral, regulated, and necessary part of the biosphere," and in the article proper they restate the main point: "The purpose of this paper is simply to present our reasons for believing the atmosphere is actively controlled" (30, 32). The discussion regarding "regulation" and "control" is in a distinct idiom of engineering cybernetics. And the object of discussion is still relatively modest: it is not precisely the whole earth or the biosphere in its entirety but a specific component thereof, the atmosphere as systemically coupled to the biota. Early Gaia discourse reconceived the evolution and composition of the contemporary atmosphere not as the abiotic lucky happenstance of traditional geology but as a system regulated by and integrated with the biota, and as a necessary outcome of living, largely microbial processes. This construction was heretical then, but settled science now: the air we aerobic organisms breathe to stay alive is itself biogenic. In overwhelming proportions it comes from life and forms the earthly repository—both sink and source—wherein the gaseous wastes of living metabolisms circulate in and out of organic capture and use. Lovelock and Margulis's atmosphere hypothesis was also cybernetic to the core: the peculiarly far-from-equilibrium and biologically viable composition of the atmosphere is the emergent outcome of a closed loop of biogeochemical cycles at the planetary level, held in homeostasis, that is, feedback-regulated, throughout geological time "by and for" the biota.[18]

Another member of the systems counterculture arrives in the Summer 1976 issue of *CQ*. Francisco Varela is the subject of a fine interview that lays out some of the original conceptuality of second-order cybernetics.[19] Carl Sagan, Margulis's ex-husband, had recommended her to Brand, but how does an unknown émigré Chilean neurobiologist make such a dramatic debut in the pages of *CQ*? In fact, his mentor, Humberto Maturana's good friend and colleague, Heinz von Foerster, had put Varela forward, who thereby quickly came to the notice of the California systems intelligentsia. That same summer, Varela attended the "Mind / Body Dualism Conference" organized by Brand and Bateson and attended by von Foerster and others, and that fall, *CQ* published his conference contribution, "Not One, Not Two," which material he would incorporate into his first book, *Principles*

of Biological Autonomy, published three years later.[20] "Not One, Not Two" formulates the post-dialectical epistemology of second-order systems theory, for which "dualities are adequately represented" neither by negation nor polarity but, rather, "by *imbrication* of levels, where one term of the pair *emerges* from the other."[21] I call this logical modality *double positivity*, as in the mutually supplementary relation of systems and their environments. Gaian applications would be to observe, first, that the Gaian system emerged from the dynamical coupling of the primeval biota *to* the planetary surface to form a geobiosphere, and next, that from that moment on, all earthly environments within the Gaian sphere have co-emerged from or in structural relation to the operations of living systems in the same measure that living beings have had their terms of existence in correlation with the contingencies, affordances and limitations, of their enabling environments.

In *CQ* for Winter 1978 we come upon another encounter with William Irwin Thompson.[22] What one would not have been able to learn from the pages of *CQ* is that for several years now his Lindisfarne Association had run a Fellow-in-Residence program. The first Lindisfarne residential fellow was Gregory Bateson in 1976, while he was working on his final book, *Mind and Nature: A Necessary Unity*, followed by Varela in 1977 and 1978, during which time he completed *Principles of Biological Autonomy*. While the residential component of Lindisfarne gradually waned, its major activity continued in the form of annual symposia, which Thompson approached as a master intellectual impresario with an intensive rigor manifest in organization, strategic invitation, and discursive preparation. Gathered from several Lindisfarne events in the 1980s, but based in particular on the 1981 meeting, in 1987 Thompson published the collection *Gaia—A Way of Knowing: Political Implications of the New Biology*.[23] With some significant anticipations on the part of Stewart Brand's operations at *CQ*, and adding in a dash of continental flavor with the inclusion of the French theoretical biologist Henri Atlan, *Gaia—A Way of Knowing* assembles in one prime location the top tier of the systems counterculture.

This impression is only strengthened by the fact that, although he is not present in the volume, von Foerster also spoke at the 1981 Lindisfarne meeting that forms the core of the volume. Moreover, in assembling the "new biology" for political interrogation, Thompson places the Gaia concept in direct relation to his vision of a planetary culture. With the general ecological theorist Bateson participating in absentia and the key theorist of second-order cybernetics von Foerster present but off-stage, *Gaia—A Way of Knowing* seizes and synthesizes the epistemological suggestions implicit in all of the countercultural systems biologies on hand. These have now emerged full-blown in Lovelock's first-order cybernetic Gaia hypothesis crossed with Margulis's signature discourse of microbial symbiosis, placed alongside Maturana and Varela's inspired application of second-order cybernetics, defining biological self-reference, operational autonomy, and cognitive capacity through the concept of autopoiesis.

Working out a planetary cultural synthesis of the new systems biologies, Thompson develops that discourse in terms that are distinctly at home in second-order systems theory: "what I am offering in this book is not so much a description of some scientific theories but an unfoldment in which *the observer of the scientific observer changes the science of the scientist.* The literary writer, the poet, becomes possessed by science, and in reflecting the work back to the scientist, the scientist sees his image transformed."[24] Thompson's second-order observation acts not as a mere reception and sorting operation but as a new construction in its own right, specifically as a determination of cultural values proper to the artist's role. And with hindsight it is rather stunning that his terms, as in the phrase below, "politics of life," leap out to us now as precisely *biopolitical.* Thompson gets all the way there by adding the element of mindfulness in the discourse of autopoietic cognition to the feedback circuit between Gaia and the biota. His preface to the *Gaia* volume concludes:

The Gaia hypothesis alone would not be enough to express the way of knowing or the politics of life. With the atmospheric chemistry of Lovelock, we have the macrocosm; with the bacteriology of Margulis we have the microcosm, but moving between the macrocosm of the planet and the microcosm of the cell is the mesocosm of the mind. It is here in the cognitive biology of Maturana and Varela that knowing truly becomes the organization of the living that brings forth a world. (10)

Drawn from his introductory remarks at the 1981 Lindisfarne meeting, the introduction following Thompson's preface to the *Gaia* volume begins by noting Bateson's absence—he would die within a month—while explicitly addressing the wider cybernetic transformations in which he was a crucial participant as one of the key thinkers "responsible for opening up new paths in cybernetics, epistemology, and self-organizing systems biology."[25] Toward the conclusion of a set of detailed remarks drawing out and linking up the conceptual interconnections of the systems counterculture into an overarching view, Thompson speculated that "if food-sharing is the fountainhead and source of our original humanity, then we most truly perform that humanity when we share food and see with Lewis Thomas in his *Lives of a Cell* that the whole earth is a single cell and that we are simply symbiotic organelles involved with one another. There can be no 'us' and 'them.' The global politics that issues forth from this vision is truly a *bios* and a *logos*" (25–6). In what he calls elsewhere *Gaia politique,* Thompson indicates again the biopolitical substance of his intervention. Importantly, he notes that our symbiotic coupling with the rest of life in a "single" Gaian "cell" is not universal merger but dynamic differentiation leading to higher coevolutionary complexity:

The fundamental principle that I see coming out of this new mode of thought is that living systems express a dynamic in which opposites are

basic and opposition essential. One cannot say that the ocean is right
and the continent is wrong in a Gaian view of planetary process. What
this means for me is that the movement from archaic industrial modes
of thought into a new planetary culture is characterized by a movement
from ideology to an ecology of consciousness. (27)

Let us skip ahead one more time. The May 1988 Lindisfarne Fellows
meeting in Perugia, Italy, became the basis for a subsequent Gaia collection,
Gaia 2—Emergence: The New Science of Becoming. Once again the core
group is Lovelock, Margulis, and Varela. From its contents I single out for
quick summary just one article, which will close the circle for now on our
recovery of a discourse of planetary immunity from within the systems
counterculture. Co-written with Mark Anspach, Varela's contribution
to *Gaia 2* is "Immu-knowledge: The Process of Somatic Individuation."
Finalized around 1990, this article reviews the newer immunology being
developed throughout the 1980s, including the network theory of Niels
Jerne and the work on immune system autonomy and cognition in Varela's
collaborations with Nelson Vaz, Antonio Coutinho, and others. It is this
work and its continuation throughout the 1990s that enters Roberto
Esposito's narrative at the end of *Immunitas*. The following passage, from
which I cited an excerpt early in this chapter, sketches the main argument:

> The alternative view we are suggesting can be likened to the notion of
> Gaia claims that the atmosphere and earth crust cannot be explained in
> their current configurations (gas composition, sea chemistry, mountain
> shapes, and so on) without their direct partnership with life on Earth. We
> all are used to thinking that the biosphere is constrained by and adapted
> to its terrestrial environment. But the Gaia hypothesis proposes that
> there is a circularity here: this terrestrial environment is itself the result of
> what the biosphere did to it. As Lovelock puts it metaphorically: we live
> in the breath and bones of our ancestors. As a result the entire biosphere/
> Earth "Gaia" has an identity as a whole, an adaptable and plastic unity,
> acquired through time in this dynamic partnership between life and its
> terrestrial environment ... Let us transpose the metaphor to immunobi-
> ology, and suggest that the body is like Earth, a textured environment for
> diverse and highly interactive populations of individuals. The individuals
> in this case are the white blood cells or lymphocytes which constitute the
> immune system. (69)

Varela and Anspach go on to write that one must "drop the notion of the
immune system as a defensive device built to address external events," and,
instead, "conceive it in terms of self-assertion, establishing a molecular
identity by the maintenance of circulation levels of molecules through the
entire distributed network [...] This idea is strictly parallel to the species
network giving an ecosystem an identity within an environment" (78–9).

Exit the individual, enter the holobiont

In comparing the immune system to an ecosystem, and ultimately, to Gaia altogether, Varela anticipated by two decades some of the most exciting contemporary work on the symbiotic nature of immunological regimes. This work has been based in recent years on the arrival of genome-sequencing technology capable of unraveling the molecular detail of symbioses among host organisms and their microbiomes.[26] And while no one person gets full credit for the current shift in the view of symbiosis from a marginal to a pervasive phenomenon, the systems counterculture's evolutionary biologist Lynn Margulis deserves a major portion of it.[27] Indeed, after the full run of Margulis's scientific career, symbiosis is no longer just a biological issue, and biology is no longer a self-contained object of knowledge. In a symbiotic view, biology is always also ecological and geobiological, or, in a word, Gaian.

Precisely defined, symbiosis is the temporary or permanent living-together of two or more different organisms in bodily contact. Close relations between, say, a human and a domestic animal may be termed companionate, but they are not symbiotic in this strong sense. The permanent mutualistic relation of fungal nodules—mycorrhizae—growing on and into plant roots: this is symbiosis. Yet symbiosis was once a doubtful, even derided topic in biology, because its emphasis on ensembles and collectives of living beings ran counter to the larger discipline's inheritance of Western and modern valorizations of individuality. Proper biology was to be concerned with individual organisms, or individual species, or individual populations of the same species, all caught up in a struggle for life with the survival of the fittest individuals, and so forth, and so on. Indeed, "the Darwinian view of life regarded aggregates of individuals of common ancestry as identifiable units in competition with one another."[28] And in its fixation on molecular biology, neo-Darwinism—the gene-centered synthesis of Darwinian evolution through natural selection with molecular genetics—drove this philosophical commitment to unitary units and singular causes down to the genetic bone, with what Gilbert et al. state as the "one-genome / one-organism doctrine of classical genetics" (330), declaring that one specific genome alone must account for all the distinct traits of each individual of each species.

The second edition of Margulis's major scientific text, *Symbiosis in Cell Evolution: Microbial Communities in the Archean and Proterozoic Eons*, presents the mature version of her most famous scientific contribution, serial endosymbiosis theory, or SET. Here symbiosis is accorded a central role in the early evolution of life's quantum jumps in complexity. The term Margulis uses for this particular symbiotic dynamic is *symbiogenesis*—the development of new life forms by the incorporation or colonization of one or more organisms into or by one another. As restated through Carl

Woese's three-domain idiom, over life's first three billion years, symbio-genesis names the step-by-step evolutionary assembly of the eukaryotic or nucleated cell, and thus, of the domain Eukaryota—all life forms composed of eukaryotic cells—out of a viable symbiotic / symbiogenetic microbial consortium coupling the two evolutionarily prior domains, as an Archean host accepts a series of Eubacterial partners.[29]

Symbiosis in Cell Evolution also discusses in passing some non-microbial manifestations of symbiosis, and in the process, Margulis provides terms that have gained a new currency. For instance, the lichen exhibits the fecundity of symbiotic possibilities. In all of their varieties, lichens arise from the opportunistic but non-obligatory integration of a fungus with either an alga or a bacterium: "The integrated symbionts (holobionts) become new organisms with a greater level of complexity."[30] Lichens are emergent cross-kingdom holobionts with their own peculiar properties, organisms wholly built out of dissociable symbiotic partnerships. More commonly, however, symbioses evolve toward obligate status, such as those endosymbioses that have locked together the previously independent components of the eukar-yotic cell. Mutualistic symbionts joined in a holobiont typically arrive at permanent and obligatory accommodations, and the newer understanding is that virtually all plants and animals have never been free-standing or pure individuals but, instead, from the evolutionary get-go, host partners to a holobiont containing an indispensable complement of microbial symbionts.

Traditional accounts of evolution have been strongly zoocentric, treating the microbial relations of animals as either peripheral or pathological. Being animals ourselves, we identify with their seeming discreteness as separate, individuated organisms. However, the recent literature of symbiosis has paid particular attention to the cross-domain relations between animals and bacteria in the evolutionary formation and distributed functions of holobionts that encompass both domains. Evolving from the largely microbial world of the pre-Cambrian seas prior to fungi or plants, animals emerged out of and within a biospheric matrix of microbes, a microcosm within which they have always been ecologically integrated and from which they can never viably depart.[31] With such developments, the newer sciences of symbiosis are in the process of *ecologizing* immunology and biology altogether.[32] McFall-Ngai et al. write:

> Viewing bacterial colonization of animals as an ecological phenomenon adds clarity to an understanding of the mechanisms and routes by which phylogenetically rich and functionally diverse microbial communities become established and evolve on and within animal hosts. An ecological perspective influences not only our understanding of animal-microbiome interactions but also their greater role in biology. The ecosystem that is an individual animal and its many microbial communities (i.e., the holobiont) does not occur in isolation but is nested within communities of other organisms that, in turn, coexist in and influence successively

larger neighborhoods comprising ever more complex assemblages of microbes, fungi, plants, and animals. (3233–4)

Moreover, the microbial-animal holobiont possesses multiple and specific organ-system niches for particular activities and select populations of the diverse symbionts they support. These include the gut or digestive system, the circulatory system, and the central nervous system. Gilbert, Sapp, and Tauber's "Symbiotic View of Life" draws out the systemic foundations of symbiotic relations: "Only with the emergence of ecology in the second half of the 19th century did organic *systems*—comprised of individuals in cooperative and competitive relationships—complement the individual-based conceptions of the life sciences." They note how the prior Darwinian fixation on biological individuals no longer fits the new evidence: "Symbiosis is becoming a core principle of contemporary biology, and it is replacing an essentialist conception of 'individuality' with a conception congruent with the larger systems approach now pushing the life sciences in diverse directions" (326).

What had traditionally been taken to be the nature of individuality has now been shown to be an inadequate construction. Every "individual" animal is always already a multi-systemic, multi-genomic holobiont host. Gilbert et al. mount a sustained attack on the residual ideology of biological individualism, revealing its roots in pre-scientific philosophical ideas. In contemporary symbiotic science, then, the concept of individuality is having its "natural" credentials revoked, revealing instead that concept's deep participation in Western idealism's metaphysics of essence. Their essay deconstructs the modes of biological individuality piece by piece. For instance, for traditional anatomy, "the individual animal is regarded as a structured whole"; but now, "the term 'holobiont' has been introduced as the anatomical term that describes the integrated organism comprised of both host elements and persistent populations of symbionts" (327–8). In due course these authors also dismantle the embryological, physiological, and genetic rationales for the thesis of biological individuality.

For instance, in the case of the genetic rationale: "The one-genome / one-organism doctrine of classical genetics has been eclipsed by studies of hereditary symbiosis. Microbial symbionts form a second type of genetic inheritance" (330). Moreover, the neo-Darwinist fixation on allelic variation in nuclear genomes (alleles are subdivisions of the genome that encode specific traits of the phenotype), must yield its grip, because "there is also allelic variation in the human microbiome. The genes of *Bacteroides plebeius* differ in different human populations. The Japanese strain contains at least two genes (horizontally transferred from a marine relative) that enable the bacteria to metabolize complex sugars, such as those found in seaweeds."[33] In this example of epigenetic symbiosis, the gut microbiome of certain Japanese people possesses a microbial symbiont that has incorporated the genetic machinery to digest seaweed by horizontal transfer from

a marine bacterium that presumably entered the gut microbiome along
with the seaweed. The marine relative of the gut symbiont did not itself
colonize the gut, did not itself become a part of the Japanese holobiont.
But by the lateral transfer of some of its genetic complement, it shared its
seaweed-digesting metabolic capacity with its gut-dwelling cousin. Now
the Japanese seaweed-eater gets more nutrition from it than a non-native
person, or, has coevolved to be more fit than strangers are to exploit their
indigenous environment. And shooting down dogmatic neo-Darwinist
rejections of "group selection," it turns out that "the entire group—the
holobiont—is the selectable entity rather than either host or symbiont
alone" (330). The combined genetic make-up of the holobiont has been
termed the "hologenome" and has already been elaborated in a "holog-
enome theory of evolution."[34] And so down goes, too, the evolutionary
rationale for biological individuality.

The recent literature on symbiosis handles another prime topic—the
immune system. Once again the genome-sequencing evidence runs counter
to the traditional notion that "portrays the immune system as a defensive
network against a hostile exterior world," that the "immune individual
rejects anything that is not 'self' ... In a fascinating inversion of this view
of life, however, recent studies have shown that an individual's immune
system is in part created by the resident microbiome" (330). And if that is
so, then what is "self" or "not-self" is not a dialectical discriminating of
singular or individual essence but a collective negotiation carried out by the
committee comprising the holobiont. Gilbert et al. extend the biopolitical
analogs of the situation: "associates in a symbiotic relationship are under
the social control of the whole, the holobiont ... If the immune system
serves as the critical gendarmerie keeping the animal and microbial cells
together, then to obey the immune system is to become a citizen of the
holobiont" (332). The prior immunitary paradigm has been stood on its
head: the immune system's primary concern is not to seek out and destroy
any and all microbial elements of "not-self," it is instead to hold together
the many selves of the holobiotic ecosystem, comprised of the animal host
coupled to its own microbiome, by identifying, tolerating, and recruiting
beneficial microbial symbionts. Only the occasional bad microbial actors
are targeted for removal.

Echoing Gilbert et al.'s "fascinating inversion" of the individual /
symbiont relation, another recent essay strikes the same note of conceptual
reversal: "Bacteria also must be seen as an essential part of the vertebrate
immune system. The paradigm that the adaptive immune system has
evolved to control microbes has been modified to include the concept that
the immune system is in fact controlled by microorganisms."[35] In this new
immunitary scenario, the traditional location of control with the *host*—
the supposedly controlling metazoan individual providing the protected
"environment" of the microbial inhabitants and invaders—is reversed:
control is relocated with the encompassed population. The distribution and

reciprocation of agency within the holobiont and the displacement of the biological individual in favor of the holobiont's symbiotic ecology makes it a contemporary avatar of a prior ecological scenario—the inversion of "control" as initially propounded by the Gaia hypothesis.

At first, Lovelock and Margulis framed the Gaia hypothesis as a provocative reversal of the normal scientific axiom that states that life is controlled by and so must adapt itself to its geological host, the abiotic environment. In its upstart period during the 1970s, in a sheer reversal of prior biological common sense, the Gaia hypothesis stated to the contrary that life controls the abiotic environment. In this extreme form it was hooted down by its mainstream critics. However, as their science developed beyond its first decade, Gaia's theoreticians saw that, once systemic self-regulation emerges from the synergy of the entire ensemble, the inherited distinction between life and its environment is no more absolute than that between any of the partners of a holobiotic consortium. The science of Gaia graduates from hypothesis to theory with the recognition—aptly expressed in Varela's formulation cited earlier—that neither life nor its planetary medium is so fundamental that either can be said to control the other. Rather, after four billion years of coevolution, living processes, symbiotic organizations, and the sum of their global niches are all relative to ongoing reformulation by evolving eons of matter, life, and sun. Geobiological history has thoroughly churned them all together into a planetary holobiont that maintains, defends, but also surpasses its parts. Just as symbiosis is no longer just a biological matter but must now be seen as an ecological principle, an all-pervasive geobiological dynamic—so, too, "Gaia is symbiosis seen from space."[36]

The system bounces back

Consequently, and in full vindication of Margulis's predictions about the fundamental role of symbiosis for the biosphere altogether, the old, static "immune self" has been jettisoned in favor of the holobiont—the ecologically distributed and environmentally dynamic and conserved consortium of a fungal, plant, or animal host and its microbial symbionts. And, as we have seen, when Varela addressed his close colleagues Margulis, Lovelock, and Thompson at the 1988 Lindisfarne meeting, his treatment of "immu-knowledge" expressed a remarkable, explicitly Gaian turn, pushing the ecosystem metaphor all the way to the planetary horizon. It is not only, as explicitly articulated by Thompson in his introduction to *Gaia 2*, that "Gaia, in essence, is the immune system of our planet."[37] It is also, as explicitly articulated by Varela and Anspach, that the immune system itself may be taken as operating "like a microcosmic version of Gaia" (69). In the new immunitary paradigm already under construction in Varela's bioscience, the

defensive function is subordinated to an "individual molecular identity," that is, a *systemic* coherence of which Gaia is the molar outcome. The counterpart to the protection of life is not the negation of that which threatens it but the affirmation of its dynamic continuity. Like Gaia or the biosphere, any given immune system has "stability and plasticity":

> The point is not to deny that defense is possible, but to see it as a limiting case of something more fundamental: individual molecular identity ... Defensive responses, the center of attention in medical immunology, are secondary acquisitions ... Or in the Gaian metaphor, certainly the stability and plasticity of the eco/biosphere has been remarkably successful in coping with, say, large meteoric impacts. But such events were rare, and it seems odd to say that ecosystems evolved because of those events. (81–2)

The point is also this: if, after a serious planetary infection such as that produced by the evolution of the cyanobacteria, which precipitated the "oxygen holocaust" that forever changed the early biosphere, or if, after a traumatic planetary injury such as the meteoric impact that theoretically extinguished the last of the dinosaurs, in Margulis's phrase, "the system bounces back," it does so because life's own predilection for community has systematized itself at the planetary level. What bounces back is neither some atomized assortment of random living beings nor some mystic whole but the Gaian system itself, that is, a distributed but bounded planetary network whose systemic resilience rises above the particular fates of its living components. The Gaian perspective foregrounds, first of all, the autopoietic systematicity of living organization. Restated in immunitary terms, from the moment of life's first appearance some 3.5 thousand million years ago, every living being in its minimal and bounded quasi-autonomy has needed protection from the sheer physical flux of elements and energies. So prior to any evolutionary development whatsoever, and prior to any gain of safety in collective numbers, in their very origin and emergence from prebiotic conditions, living systems may be thought of as self-immunizing. Stated in a neocybernetic idiom, in their very self-constitution and self-maintenance as membrane-bounded, autopoietic unities, living systems operate to maintain the integrity of their "somatic individuation," in Varela's phrase, from the wider abiotic matrixes out of which they emerge. From the primordial cell on, to be alive is to be exempted as much as may be possible from entropic dispersion back into a relatively non-differentiated physical environment. To be alive grants temporary immunity from an eventual return of the living system's material elements to non-living conditions of non-operation—in short, immunity from being dead.

And finally, the Gaian perspective foregrounds the dynamic coupling of biotic and abiotic organizations. Following upon the arrival of the microbial world as a microcosm distributed across the surface of the earth, the Gaian

system arose as a second-order development. Restated in the idiom of the biopolitical theory with which we began, Gaia theory suggests that in the early evolution of primordial life and its expansion into an operationally coupled symbiotic planetary phenomenon, the global interactions of living beings eventually fell into the systemic form of an immunitary consortium. Microbial life in its integration with the earth, to form and maintain a geobiological system, evolved Gaia as the communal immune system of the biosphere. Subsequent to her encounters with Maturana and Varela, Margulis would go on to suggest that the Gaian system is autopoietic in its own right.[38] And if that is so, then just as the membrane self-produced by a living cell operates to immunize that system as much as possible from incursions from or dispersions into its circumambient environment, so too Gaia's own operational closure as a system, like that of its living elements, forms an immunitary boundary around the biosphere as a whole, a membrane whose upper surface is the atmosphere. Gaia operates to provide life on earth temporary immunity from cosmic extinction. Keeping that vigil going, walking that beat for three billion years, has been no paltry accomplishment. The symbiotic tolerance of planetary immunity might be a place to begin a new reflection on human political organization in relation to a planetary ecology we are still only beginning to discover in the wider range of its cooperational diversities.

Notes

1 Frédéric Neyrat, "The Birth of Immunopolitics," trans. Arne de Boever, *Parrhesia: A Journal of Critical Philosophy* 10 (2010): 32. Available online: http://www.parrhesiajournal.org/parrhesia10/parrhesia10_neyrat.pdf (accessed November 27, 2015).

2 Francisco J. Varela and Mark Anspach, "Immu-knowledge: The Process of Somatic Individuation," in *Gaia 2—Emergence: The New Science of Becoming*, ed. William Irwin Thompson (Hudson, NY: Lindisfarne Press, 1991), 69.

3 Cary Wolfe, *Before the Law: Humans and Other Animals in a Biopolitical Frame* (Chicago: University of Chicago Press, 2013).

4 Wolfe, *Before the Law*, 6. See Jacques Derrida, "Autoimmunity: Real and Symbolic Suicides," in *Philosophy in a Time of Terror: Dialogues with Jürgen Habermas and Jacques Derrida*, ed. Giavanna Borradori (Chicago: University of Chicago Press, 2003).

5 Roberto Esposito, *Immunitas: The Protection and Negation of Life,* trans. Zakiya Hanafi (Malden, MA: Polity Press, 2011).

6 Cited in Roberto Esposito, *Bios: Biopolitics and Philosophy*, trans. Timothy Campbell (Minnesota: University of Minnesota Press, 2008), 186.

7 Wolfe, *Before the Law*, 55, 7.

8 Ibid., 56, 59; Esposito cited from *Bios*, 186.

9 Cary Wolfe, "Life, (Auto)Immunity, Social Theory, and Control" (plenary address at the European Society for Literature, Science, and the Arts (SLSA-EU) conference "Life, in Theory," Turin, Italy, June 2014). Wolfe's interventions on behalf of a systems-theoretical redescription of the immunitary paradigm are crucial for correcting misapprehensions such as that transmitted by Neyrat in remarking how "Esposito criticizes theories of auto-organization, of *autopoiesis* and auto-regulation, namely because they end up 'questioning the idea of exteriority itself'" (Neyrat, "Birth of Biopolitics," 36). Questioning the idea of exteriority is exactly what systems theory, properly understood, does *not* do. Luhmann could not be clearer on this point: "self-referential closure is possible only in an environment, only under ecological conditions." Niklas Luhmann, *Social Systems*, trans. John Bednarz with Dirk Baecker (Stanford: Stanford University Press, 1995), 9.

10 This work goes back to seminal publications of Varela, such as Nelson Vaz and Francisco Varela, "Self and Non-Sense: An Organism-Centered Approach to Immunology," *Medical Hypothesis* 4 (1978), and Francisco J. Varela, Antonio Coutinho, Bruno Dupire, and Nelson M. Vaz, "Cognitive Networks: Immune, Neural, and Otherwise," in *Theoretical Immunology*, Part 2, ed. A. S. Perelson (Boston: Addison-Wesley, 1988). For an application of Maturana's thought to immunological theory, see Nelson M. Vaz, "The Specificity of Immunologic Observations," *Constructivist Foundations* 6 (3) (2011). See also Alfred I. Tauber, "Immunology's Theories of Cognition," *History and Philosophy of the Life Sciences* 35 (2013); and "The Cognitivist Paradigm 20 Years Later: Commentary on Nelson Vaz," *Constructivist Foundations*, 6 (3) (2011); and Nelson Vaz, "The Enactive Paradigm 33 Years Later: Response to Alfred Tauber," *Constructivist Foundations* 6 (3) (2011).

11 *Gaia: Goddess of the Earth* [TV program], a NOVA documentary (PBS, January 28, 1986).

12 Stewart Brand, "The First Whole Earth Photograph," in *Earth's Answer: Explorations of Planetary Culture at the Lindisfarne Conferences*, ed. Michael Katz, William P. Marsh, and Gail Gordon Thompson (New York: Harper and Row, 1977), 186. See also Bruce Clarke, "Steps to an Ecology of Systems: Whole Earth and Systemic Holism," in *Addressing Modernity: Social Systems Theory and U.S. Cultures*, ed. Hannes Bergthaller and Carsten Schinko (Amsterdam: Rodopi, 2011).

13 "The insights of Buckminster Fuller initiated this Catalog." Stewart Brand, "Buckminster Fuller," *Whole Earth Catalog*, ed. Stewart Brand (Spring 1969), 3, which article also cites Fuller's definition of synergy.

14 See Harold J. Morowitz, *Energy Flow in Biology: Biological Organization as a Problem in Thermal Physics* (New York: Academic Press, 1968), 3.

15 Heinz von Foerster, "Laws of Form," *Whole Earth Catalog*, ed. Stewart Brand (Spring 1970), 14.

16 "Where the insights of Buckminster Fuller initiated the *Whole Earth Catalog*, Gregory Bateson's insights lurk behind most of what's going on in

this *Epilog.*" Stewart Brand, "Steps to an Ecology of Mind," *Whole Earth Epilog*, ed. Stewart Brand (September 1974): 453.

17 Lynn Margulis and James E. Lovelock, "The Atmosphere as Circulatory System of the Biosphere: The Gaia Hypothesis," *CoEvolution Quarterly*, 6 (1975). Earlier that year Margulis wrote to Lovelock to report a series of hopeful if still tentative arrangements she had just worked out to publish one of their co-authored Gaia articles in both a mainstream highbrow science magazine, *Natural History*, and slightly sooner, in the *CoEvolution Quarterly*. Margulis wrote that Brand "is claiming that his journal is responsible and responsive, refuses to compartmentalize science and that my accusation that he's into food fadism and astrology is totally unfounded ... & since after reading CoQ I find myself sympathetic to his goals, I would hope you will agree to this plan." Lynn Margulis to James Lovelock, April 29, 1975, Lynn Margulis papers, University of Massachusetts Amherst.

18 These points were driven home by the *CQ* article's inclusion of an excerpt from an even more technical, co-written Gaia article, lead-authored by Lovelock, "Atmospheric Homeostasis by and for the Biosphere: The Gaia Hypothesis," *Tellus* XXVI (1–2) (1974).

19 For instance, he introduces the important matter of operational closure: "the closure, the self-referential-ness, seems to be the hinges upon which the emergent properties of a system turn." Francisco J. Varela, "On Observing Natural Systems," *CoEvolution Quarterly* 10 (Summer 1976): 27.

20 Francisco J. Varela, "Not One, Not Two: Position Paper for the Mind–Body Conference," *CoEvolution Quarterly* 11 (Fall 1976); *Principles of Biological Autonomy* (New York: North Holland, 1979).

21 Ibid.

22 A year earlier, under his Lindisfarne Books imprint, Thompson had edited the essay collection *Earth's Answer: Explorations of Planetary Culture at the Lindisfarne Conferences* (see note 12 above), including contributions by Stewart Brand, Gregory Bateson, Jonas Salk, E. F. Schumacher, Paolo Soleri, and Lewis Thomas.

23 William Irwin Thompson, ed., *Gaia—A Way of Knowing: Political Implications of the New Biology* (Great Barrington, MA: Lindisfarne Press, 1987).

24 William Irwin Thompson, "Preface," in *Gaia—A Way of Knowing: Political Implications of the New Biology*, ed. William Irwin Thompson (Great Barrington, MA: Lindisfarne Press, 1987), 9; my emphasis. The observation of observation is a central theme of second-order cybernetics, or again, in von Foerster's phrase, "the cybernetics of cybernetics."

25 William Irwin Thompson, "Introduction: The Cultural Implications of the New Biology," in *Gaia—A Way of Knowing: Political Implications of the New Biology*, ed. William Irwin Thompson (Great Barrington, MA: Lindisfarne Press, 1987), 11–12.

26 Margaret McFall-Ngai et al., "Animals in a Bacterial World, a New Imperative for the Life Sciences," *PNAS* 110 (9) (February 26, 2013). Available online: http://web.stanford.edu/~fukamit/mcfall-ngai-et-al-2013.

pdf (accessed November 28, 2015). "Carl Woese and George Fox opened a new research frontier by producing sequence-based measures of phylogenic relationships, revealing the deep evolutionary history shared by all living organisms. This game-changing advance catalyzed a rapid development and application of molecular sequencing technologies, which allowed biologists for the first time to recognize the true diversity, ubiquity, and functional capacity of microorganisms" (3229).

27 Margulis's "strong influence has been critical for development in three major arenas: the prevalence of symbiosis as a driving force in evolution of eukaryotes, the central role of the microbial world in the dynamics of the past and present biosphere, and the recognition that the earth is a self-regulating system, that is, the Gaia hypothesis." Margaret McFall-Ngai, "Truth Straight On: Reflections on the Vision and Spirit of Lynn Margulis," *The Biological Bulletin* 223 (August 2012): 1. Available online: http://www. biolbull.org/content/223/1/1.full.pdf (accessed November 28, 2015).

28 Scott F. Gilbert, Jan Sapp, and Alfred I. Tauber, "A Symbiotic View of Life: We Have Never Been Individuals," *The Quarterly Review of Biology* 87 (4) (December 2012): 326. Available online: http://blogs. bu.edu/ait/files/2012/12/SymbioticViewQRB.pdf (accessed November 28, 2015).

29 See Norman R. Pace, Jan Sapp, and Nigel Goldenfeld, "Phylogeny and Beyond: Scientific, Historical, and Conceptual Significance of the First Tree of Life," *PNAS* 109 (4) (January 24, 2012). Available online: http://www. pnas.org/content/early/2012/01/13/1109716109.full.pdf+html (accessed November 28, 2015).

30 Lynn Margulis, *Symbiosis in Cell Evolution: Microbial Communities in the Archean and Proterozoic Eons*, 2nd edn (New York: W. H. Freeman, 1993), 7. Margulis's credit for coining the term "holobiont" is affirmed in Seth R. Bordenstein and Kevin R. Theis, "Host Biology in Light of the Microbiome: Ten Principles of Holobionts and Hologenomes," *PLoS Biology* 13 (8) (August 18, 2015).

31 "Animals diverged from their protistan ancestors 700-800 Mya, some 3 billion years after bacterial life originated and as much as 1 billion years after the first appearance of eukaryotic cells. Thus, the current-day relationships of protists"—microbial eukaryotes—"with bacteria, from predation to obligate and beneficial symbiosis, were likely already operating when animals first appeared." McFall-Ngai et al., "Animals in a Bacterial World," 3230.

32 Alfred Tauber notes that "an ecological orientation … already assumes a subordination of the individual to a collective picture of biological function, and in place of differentiation, integration and coordination serve as organizing principles." See Alfred I. Tauber, "The Immune System and Its Ecology," *Philosophy of Science* 75 (April 2008): 228. Available online: http://blogs.bu.edu/ait/files/2012/08/The-Immune-System-and-Its-Ecology-AIT.pdf (accessed November 28, 2015).

33 Gilbert, Sapp, and Tauber, "Symbiotic View," 330. See also McFall-Ngai et al., "Animals in a Bacterial World," 3231.

34 See Ilana Zilber-Rosenberg and Eugene Rosenberg, "Role of Microorganisms in the Evolution of Animals and Plants: The Hologenome Theory of Evolution," *FEMS Microbiology Review* 32 (2008). Available online: http://onlinelibrary.wiley.com/doi/10.1111/j.1574-6976.2008.00123.x/pdf (accessed November 28, 2015).

35 Thomas C. G. Bosch and Marilyn J. McFall-Ngai, "Metaorganisms as the New Frontier," *Zoology* 114 (2011): 187–8. Available online: http://labs.medmicro.wisc.edu/mcfall-ngai/papers/11bosch.pdf (accessed November 28, 2015).

36 Lynn Margulis and Dorion Sagan, *What is Life?* (Berkeley: University of California Press, 2000), 189.

37 William Irwin Thompson, "The Imagination of a New Science and the Emergence of a Planetary Culture," in *Gaia 2—Emergence: The New Science of Becoming*, ed. William Irwin Thompson (Hudson, NY: Lindisfarne Press, 1991), 24.

38 See Bruce Clarke, "Neocybernetics of Gaia: The Emergence of Second-Order Gaia Theory," in *Gaia in Turmoil: Climate Change, Biodepletion, and Earth Ethics in an Age of Crisis*, ed. Eileen Crist and H. Bruce Rinker (Cambridge, MA: MIT Press, 2009), 293–314, and "Autopoiesis and the Planet," in *Impasses of the Post-Global: Theory in the Era of Climate Change*, vol. 2, ed. Henry Sussman (Ann Arbor: Open Humanities Press, 2012). Available online: http://quod.lib.umich.edu/o/ohp/10803281.0001.00 1/1:4?rgn=div1;view=fulltext (accessed November 28, 2015).

Bibliography

Bordenstein, Seth R. and Kevin R. Theis. "Host Biology in Light of the Microbiome: Ten Principles of Holobionts and Hologenomes." *PLoS Biology* 13 (8) (August 18, 2015): e1002226. doi:10.1371/journal.pbio.1002226.

Bosch, Thomas C. G. and Marilyn J. McFall-Ngai. "Metaorganisms as the New Frontier." *Zoology* 114 (2011): 185–90. Available online: http://labs.medmicro.wisc.edu/mcfall-ngai/papers/11bosch.pdf (accessed November 28, 2015).

Brand, Stewart. "Buckminster Fuller." *Whole Earth Catalog*, ed. Stewart Brand (Spring 1969).

Brand, Stewart. "Steps to an Ecology of Mind." *Whole Earth Epilog*, ed. Stewart Brand (September 1974).

Brand, Stewart. "The First Whole Earth Photograph." In *Earth's Answer: Explorations of Planetary Culture at the Lindisfarne Conferences,* ed. Michael Katz, William P. Marsh, and Gail Gordon Thompson, 184–8. New York: Harper and Row, 1977.

Clarke, Bruce. "Autopoiesis and the Planet." In *Impasses of the Post-Global: Theory in the Era of Climate Change*, vol. 2, ed. Henry Sussman. Ann Arbor: Open Humanities Press, 2012. Available online: http://quod.lib.umich.edu/o/ohp/10803281.0001.001/1:4?rgn=div1;view=fulltext (accessed November 28, 2015).

Clarke, Bruce. "Neocybernetics of Gaia: The Emergence of Second-Order Gaia

Theory." In *Gaia in Turmoil: Climate Change, Biodepletion, and Earth Ethics in an Age of Crisis*, ed. Eileen Crist and H. Bruce Rinker, 293–314. Cambridge, MA: MIT Press, 2009.

Clarke, Bruce. "Steps to an Ecology of Systems: Whole Earth and Systemic Holism." In *Addressing Modernity: Social Systems Theory and U.S. Cultures*, ed. Hannes Bergthaller and Carsten Schinko, 259–88. Amsterdam: Rodopi, 2011.

Derrida, Jacques. "Autoimmunity: Real and Symbolic Suicides." In *Philosophy in a Time of Terror: Dialogues with Jürgen Habermas and Jacques Derrida*, ed. Giavanna Borradori, 85–136. Chicago: University of Chicago Press, 2003.

Esposito, Roberto. *Bios: Biopolitics and Philosophy*, trans. Timothy Campbell. Minnesota: University of Minnesota Press, 2008.

Esposito, Roberto. *Immunitas: The Protection and Negation of Life*, trans. Zakiya Hanafi. Malden, MA: Polity Press, 2011.

Foerster, Heinz von. "Laws of Form." *Whole Earth Catalog*, ed. Stewart Brand (Spring 1970).

Gaia: Goddess of the Earth [TV program]. A NOVA documentary. PBS, January 28, 1986.

Gilbert, Scott F., Jan Sapp, and Alfred I. Tauber. "A Symbiotic View of Life: We Have Never Been Individuals." *The Quarterly Review of Biology* 87 (4) (December 2012): 325–41. Available online: http://blogs.bu.edu/ait/files/2012/12/SymbioticViewQRB.pdf (accessed November 28, 2015).

Lovelock, James E. and Lynn Margulis. "Atmospheric Homeostasis by and for the Biosphere: The Gaia Hypothesis." *Tellus* XXVI (1–2) (1974): 1–10.

Luhmann, Niklas. *Social Systems*, trans. John Bednarz with Dirk Baecker. Stanford: Stanford University Press, 1995.

Margulis, Lynn and Dorion Sagan. *What is Life?* Berkeley: University of California Press, 2000.

Margulis, Lynn and James E. Lovelock. "The Atmosphere as Circulatory System of the Biosphere: The Gaia Hypothesis." *CoEvolution Quarterly* 6 (1975): 31–40.

Margulis, Lynn. *Symbiosis in Cell Evolution: Microbial Communities in the Archean and Proterozoic Eons*. 2nd edn New York: W. H. Freeman, 1993.

McFall-Ngai, M. "Truth Straight On: Reflections on the Vision and Spirit of Lynn Margulis." *The Biological Bulletin* 223 (August 2012): 1–2. Available online: http://www.biolbull.org/content/223/1/1.full.pdf (accessed November 28, 2015).

McFall-Ngai, M., M. G. Hadfield, T. C. Bosch, H. V. Carey, T. Domazet-Lošo, A. E. Douglas, N. Dubilier, G. Eberl, T. Fukami, S. F. Gilbert, U. Hentschel, N. King, S. Kjelleberg, A. H. Knoll, N. Kremer, S. K. Mazmanian, J. L. Metcalf, K. Nealson, N. E. Pierce, J. F. Rawls, A. Reid, E. G. Ruby, M. Rumpho, J. G. Sanders, D. Tautz, and J. J. Wernegreen. "Animals in a Bacterial World, a New Imperative for the Life Sciences." *PNAS* 110 (9) (February 26, 2013): 3229–36. Available online: http://web.stanford.edu/~fukamit/mcfall-ngai-et-al-2013.pdf (accessed November 28, 2015).

Morowitz, Harold J. *Energy Flow in Biology: Biological Organization as a Problem in Thermal Physics*. New York: Academic Press, 1968.

Neyrat, Frédéric. "The Birth of Immunopolitics," trans. Arne de Boever. *Parrhesia: A Journal of Critical Philosophy* 10 (2010): 31–8. Available online: http://

www.parrhesiajournal.org/parrhesia10/parrhesia10_neyrat.pdf (accessed November 27, 2015).

Pace, Norman R., Jan Sapp, and Nigel Goldenfeld. "Phylogeny and Beyond: Scientific, Historical, and Conceptual Significance of the First Tree of Life." *PNAS* 109 (4) (January 24, 2012): 1011–8. Available online: http://www.pnas. org/content/early/2012/01/13/1109716109.full.pdf+html (accessed November 28, 2015).

Tauber, Alfred I. "Immunology's Theories of Cognition." *History and Philosophy of the Life Sciences* 35 (2013): 239–64.

Tauber, Alfred I. "The Cognitivist Paradigm 20 Years Later: Commentary on Nelson Vaz." *Constructivist Foundations* 6 (3) (2011): 342–4.

Tauber, Alfred I. "The Immune System and Its Ecology." *Philosophy of Science*, 75 (April 2008): 224–45. Available online: http://blogs.bu.edu/ait/files/2012/08/ The-Immune-System-and-Its-Ecology-AIT.pdf (accessed November 28, 2015).

Thompson, William Irwin, ed. *Gaia—A Way of Knowing: Political Implications of the New Biology*. Great Barrington, MA: Lindisfarne Press, 1987.

Thompson, William Irwin. "The Imagination of a New Science and the Emergence of a Planetary Culture." In *Gaia 2—Emergence: The New Science of Becoming*, ed. William Irwin Thompson, 11–29. Hudson, NY: Lindisfarne Press, 1991.

Varela, Francisco J. "Not One, Not Two: Position Paper for the Mind–Body Conference." *CoEvolution Quarterly* 11 (Fall 1976): 62–7.

Varela, Francisco J. "On Observing Natural Systems." *CoEvolution Quarterly* 10 (Summer 1976): 26–31.

Varela, Francisco J. and Mark Anspach. "Immu-knowledge: The Process of Somatic Individuation." In *Gaia 2—Emergence: The New Science of Becoming*, ed. William Irwin Thompson, 68–85. Hudson, NY: Lindisfarne Press, 1991.

Varela, Francisco J. *Principles of Biological Autonomy*. New York: North Holland, 1979.

Varela, Francisco J., Antonio Coutinho, Bruno Dupire, and Nelson M. Vaz. "Cognitive Networks: Immune, Neural, and Otherwise." In *Theoretical Immunology*, Part 2, ed. A. S. Perelson, 359–75. Boston: Addison-Wesley, 1988.

Vaz, Nelson and Francisco J. Varela. "Self and Non-Sense: An Organism-Centered Approach to Immunology." *Medical Hypothesis* 4 (1978): 231–67.

Vaz, Nelson. "The Specificity of Immunologic Observations." *Constructivist Foundations* 6 (3) (2011): 334–42.

Vaz, Nelson. "The Enactive Paradigm 33 Years Later: Response to Alfred Tauber." *Constructivist Foundations* 6 (3) (2011): 345–51.

Wolfe, Cary. "Life, (Auto)Immunity, Social Theory, and Control." Plenary address at the European Society for Literature, Science, and the Arts (SLSA-EU) conference "Life, in Theory," Turin, Italy, June 2014.

Wolfe, Cary. *Before the Law: Humans and Other Animals in a Biopolitical Frame*. Chicago: University of Chicago Press, 2013.

Zilber-Rosenberg, Ilana and Eugene Rosenberg. "Role of Microorganisms in the Evolution of Animals and Plants: The Hologenome Theory of Evolution." *FEMS Microbiology Review* 32 (2008): 723–35. Available online: http:// onlinelibrary.wiley.com/doi/10.1111/j.1574-6976.2008.00123.x/pdf (accessed November 28, 2015).

CHAPTER EIGHT

Ecologizing biopolitics, or, What is the "bio-" of bioart?

Cary Wolfe

Introduction

In this brief chapter I want to put two problematics side by side and examine the extent to which they illuminate each other: biopolitical thought and bioart. The reason I find this a worthwhile endeavor is simple: if we believe that biopolitics is a new and / or dominant mode of the political in modern society, a mode whose distinctive characteristic is that *life itself* in its barest form becomes the direct object of political power, then the question of the socially and politically representative character of bioart takes on a new and pressing relevance, simply because what distinguishes bioart (or so the story goes) is that life itself becomes the medium of the artwork—versus say gouache, or cor-ten steel, or the digital image.

I want to begin to frame this question of the socially representative character of bioart by providing a bit of background on two fundamental and divergent strands in biopolitical thought centered around the work of Agamben and Foucault, and then move to Roberto Esposito's attempt to split the difference, if you will, in what he calls his attempt to think an "affirmative biopolitics." While I admire Esposito's work, I want to suggest that his retort contains a particular danger for biopolitical thought—namely, a kind of neo-vitalism—and it is a danger that is even *more* dangerous for thinking about bioart, simply because a persistent temptation with bioart (for all the obvious reasons) is to think that the meaning or politics of the artwork can somehow be anchored in or indexed to the particular and peculiar character of its medium, its material substrate. What I will want to argue, however, is that the meaning and politics of bioart cannot be understood in this way, and that a different and more pragmatically effective grasp of the biopolitical meaning of bioart will diverge from such an understanding

along two different axes of biopolitical thought: either what we might call a "restricted" sense of the political (and of art, as it turns out) that might be associated with the work of Niklas Luhmann, or a more generalized and diffuse understanding of the complex relationship between the political and "politicization" that is focused not on the problem of sovereignty (as it is in Agamben or Schmitt) but on material dispositifs and apparatuses that constitute political effectivity, a line of thought associated most of all in biopolitics with the work of Michel Foucault.

What is needed, to put it another way, is what we might call an "ecologization" of the biopolitical paradigm: an ecologization that drives us toward not a vitalism that wants to derive ethical or political imperatives from "life" (in the form, let's say, of the "biocentrism" familiar to us from the moment of "Deep Ecology," or a *prima facie* valuing of biodiversity in certain versions of environmental ethics) but rather a *denaturalized* understanding of the ecological paradigm that emphasizes form, time, and dynamic complexity (in the case at hand, social complexity as that bears upon the forms taken by "life") as the key constituents for thinking how biopolitics and bioart operate and signify. This "ecological" or "evolutionary" or "metabiological" emphasis on social complexity, as Hans-Georg Moeller puts it, "starts from the 'for itself' of organic life and goes behind it" to "the cybernetically described, basic phenomenon of the self-maintenance of self-relating systems in the face of hyercomplex environments."[1] A certain (and, I would argue, dominant) understanding of ecology would share with biopolitical vitalism the desire to ground what Esposito calls an "affirmative" biopolitics in the material substrate of life itself as a given good. But the understanding of "ecology" that I am promoting here would emphasize that what the immunological paradigm of biopolitics and the ecological paradigm have in common is that, for both, it is not a question of a biological or ecological substrate but rather of thinking the *forms* and processes by which the system / environment relationship is stabilized and managed by systems that find themselves in an environment of exponentially greater complexity than they themselves possess—all of which reaches back to perhaps *the* most important thinker in the ecological paradigm, Gregory Bateson, who long go reminded us that, in ecological thinking, you don't ask "what it's made of—earth, fire, water, etc.," you ask "what is its *pattern*?" To put it another way, the immunitary mechanism,[2] like Derrida's *pharmakon*, can't be about a grounding in a material substrate simply because the effect and indeed meaning of a given substance—toxic or therapeutic—depends on the real-time, dynamic state of the system (and this includes legal and political systems, not just biological systems, as we will see).[3]

* * *

Let me begin with a brief survey of the biopolitical literature, its main lines of fracture and divergence, and how the problem of neo-vitalism makes

itself manifest in Esposito, before moving to a more specific discussion of bioart in its biopoltical dimension. As any number of commentators have observed, the general drift of contemporary thought on the biopolitical—whether under the influence of Giorgio Agamben's large body of work on the Nazi death camps, or Jacques Derrida's analysis of the autoimmunitary logic of modern democratic politics—has been overwhelmingly thanatopolitical: that is, oriented toward the domination of life and the increasing power over the life / death interval at a capillary level heretofore unknown. As is well known, Michel Foucault argues in *The History of Sexuality* that "for millennia, man remained what he was for Aristotle: a living animal with the additional capacity for a political existence; modern man is an animal whose politics places his existence as a living being in question."[4] Moreover, as Foucault famously defines biopolitics, it "is the power to make live. Sovereignty took life and let live. And now we have the emergence of a power that I would call the power of regularization, and it, in contrast, consists in making live and letting die."[5]

In the three-volume sequence of which *Bios* is the third installment, Esposito sets himself two main tasks: trying to understand the extent to which biopolitics is a specifically modern phenomenon, and exploring the extent to which biopolitics is *necessarily* thanatopolitical, with the eventual aim, as he puts it, of framing an "affirmative" biopolitics that runs counter (most conspicuously) to the work of Agamben.[6] The possibility of an affirmative biopolitics hinges for Esposito on a reconceptualization of the "subject" of politics (in both senses), one that can be traced to Foucault's later work. As we know, Foucault argues in *Society Must Be Defended* that

> an important phenomenon occurred in the seventeenth and eighteenth centuries: the appearance—one should say the invention—of a new mechanism of power which had very specific procedures, completely new instruments, and very different equipment. It was, I believe, absolutely incompatible with relations of sovereignty. This new mechanism of power applies primarily to bodies and what they do rather to the land and what it produces ... It was a type of power that presupposed a closely meshed grid of material coercions rather than the physical existence of a sovereign.[7]

Most importantly for our purposes, he argues that this shift from sovereignty to biopower involves a new concept of the subject, one who is endowed with fundamental interests that cannot be limited to or contained by the simple *legal* category of subjectivity.

What Maurizio Lazzarato calls Foucault's radical "displacement" of the problem of sovereignty "does not neglect the analysis of sovereignty," but merely points out that "the grounding force will not be found on the side of power, since power is `blind and weak'" (as Foucault puts it)—hence, its growing need, in an increasingly complex and differentiated field, for the

various techniques of management, surveillance, and so on that it deploys.[8] What we are dealing with here is not, as Esposito puts it, "some kind of withdrawal or contraction of the field that is subjected to the law," but rather how the law for its force gradually shifts "from the transcendental level of codes and sanctions that essentially have to do with subjects of will to the immanent level of rules and norms that are addressed instead to bodies."[9]

As Lazzarato argues, three important points follow from this: first, "biopolitics is the form of government taken by a *new dynamic of forces* that, in conjunction, express power relations that the classical world could not have known";[10] second, "the fundamental political problem of modernity is not that of a *single* source of sovereign power, but that of a *multitude of forces* ... If power, in keeping with this description, is constituted from below, then we need an ascending analysis of the constitution of power *dispositifs*"; and third, "Biopower coordinates and targets a power that does not properly belong to it, that comes from the 'outside.' *Biopower is always born of something other than itself.*"[11]

Here, then—with Foucault's emphasis on bodies "before" and "outside" the law—we find a potentially creative, "aleatory" element (to use Foucault's term) that inheres in the very gambit of biopower, an element that is not wholly subject to the thanatological drift of a biopolitics subordinated to the paradigm of sovereignty. In Foucault's words, "where there is power, there is resistance, and yet, or rather consequently, this resistance is never in a position of exteriority in relation to power."[12] Indeed, the political payoff of Foucault's analyses of the mechanisms of disciplinarity, governmentality, and so on resides in no small part in their anatomy of how the machinery of power races to maintain control over the forces it has brought into its orbit— forces that derive in no small part from animal bodies (both human and nonhuman) that are not always already abjected, as in Agamben. Quite the contrary, those bodies are enfolded via biopower in struggle and resistance. And because those forces of resistance are thereby produced in a specifically articulated form, through particular *dispositifs*, there is a chance—and this marks in no small part Foucault's debt to Nietzsche (as Esposito points out)—for life to burst through power's systematic operation in ways that are more and more difficult to anticipate. Thus, as Lazzarato notes, "Without the introduction of the 'freedom' and the resistance of forces," he concludes, "the *dispositifs* of modern power remain incomprehensible."[13]

But as Esposito observes, all of this leaves us with "a decisive question: if life is stronger than the power that besieges it, if its resistance doesn't allow it to bow to the pressure of power, then how do we account for the outcome obtained in modernity of the mass production of death?" In short, "Why does biopolitics continually threaten to be reversed into thanatopolitics?"[14] Are the Nazi death camps, to use Agamben's words, not "a historical fact and an anomaly belonging to the past," but rather "the hidden matrix and *nomos* of the political space in which we are still living"?[15] It is this impasse,

Esposito argues, that Foucault never really overcomes because he does not fully develop the "immunitary" logic of the biopolitical that he identifies in his later work (a paradigm also explored in this connection by Donna Haraway, Jacques Derrida, and Niklas Luhmann). Foucault recognizes in his lectures from 1976 that "the very fact that you let more die will allow you to live more,"[16] but he is unable to see that the affirmative and thanatological dimensions of biopolitics—either "a politics *of* life or a politics *over* life," as Esposito puts it—are joined in a single mechanism.[17] "Rather than being superimposed or juxtaposed in an external form that subjects one to the domination of the other," Esposito writes, "in the immunitary paradigm, *bios* and *nomos*, life and politics, emerge as the two constituent elements of a single, indivisible whole that assumes meaning from their interrelation."[18] So if the fundamental logic of biopolitics is immunitary, then the problem becomes how to keep the immunitary from more or less automatically turning into the *autoimmunitary* along the lines described by Derrida in the interview "Autoimmunity: Real and Symbolic Suicides" where, following the earlier logic of the pharmakon, the very mechanism designed to cordon off and protect the body politic instead makes it all the more vulnerable, attacking it from the inside by a logic of runaway hyper-purification according to some identity principle.[19]

For his part, Esposito insists that a turn away from the thanatological and autoimmunitary logic of biopolitics and toward an affirmative biopolitics can only take place if life as such—not just human (vs animal) life, not just Aryan (vs Jewish) life, not just Christian (vs Islamic) life—becomes the subject of immunitary protection. Esposito writes:

> we can say that the subject, be it a subject of knowledge, will, or action as modern philosophy commonly understands it, is never separated from the living roots from which it originates in the form of a splitting between the somatic and psychic levels in which the first is never decided [*risolve*] in favor of the second ... This means that between man and animal—but also, in a sense, between the animal and the vegetal and between the vegetal and the natural object—the transition is rather more fluid than was imagined.[20]

And this is so, he argues, because "there is never a moment in which the individual can be enclosed in himself or be blocked in a closed system, and so removed from the movement that binds him to his own biological matrix."[21] And this leads, in turn, to Esposito's retrofitting of Spinoza's concept of natural right to make "the norm the principle of unlimited equivalence for every single form of life."[22] The general idea here is that this new norm will operate as a sort of homeostatic mechanism balancing the creative flourishing of various life forms. As Esposito characterizes it, "the juridical order as a whole is the product of this plurality of norms and provisional result of their mutual equilibrium."[23]

But there are a few fundamental problems here. First—if we are indeed talking about actual political and legal norms—there are serious pragmatic limitations to this view. For one thing, it replays all of quandries around "biocentrism" brought to light during the 1970s and 80s in North America during the heyday of the "Deep Ecology" movement—debates that Esposito (or for that matter his fellow Italian political philosophers) would have little reason, perhaps, to know about. As Tim Luke notes, if *all* forms of life are given equal value, and if no form of life can be favored over another with regard to ethical and legal norms, then we face questions such as the following: "Will we allow anthrax or cholera microbes to attain self-realization in wiping out sheep herds or human kindergartens? Will we continue to deny salmonella or botulism micro-organisms their equal rights when we process the dead carcasses of animals and plants that we eat?"[24] There are perhaps those who would respond to Luke's questions in the affirmative—who would argue that, yes, all forms of life should be equally allowed to take their course, even if it means a massive die-off of the species *homo sapiens*. But biopolitically speaking, that hardly solves the problem (or even achieves the stated aim) because when we ask what the demographic distribution of such an event would likely be, we realize that the brunt would be absorbed by largely black and brown poor populations who live south of the "rich North Atlantic democracies" (to use Richard Rorty's phrase), which would protect themselves by whatever means possible.[25]

Secondly (and more theoretically, as it were), if all forms of life are taken to be equal, then (as Eugene Thacker has pointed out) it can only be because they, as "the living," all equally embody and express a positive, substantive principle of "Life" not contained in any one of them. "The problem," he argues, "is that once one considers something like life-in-itself"—whether in the form of a "life-principle" or some other "inaccessible first principle"—then "one must also effectively dissociate Life from the living."[26] To put this slightly otherwise, what Esposito is unable to articulate is that what "binds him to his own biological matrix" is nothing "living," but neither is it "Life." Instead, as Martin Hägglund has argued, it is the trace-structure and "spacing" that is "the condition for anything that is subject to succession, whether animate or inanimate, ideal or material."[27] Such a structure (or more precisely, such a system) is, strictly speaking "dead"; it is a "*machinalité*" (to use Derrida's term) that allows the concatenation of material processes that may (but only may) eventuate in forms of life.[28] Far from metaphysical, however, such a system is perfectly compatible with a materialist and naturalistic account of how life evolves out of non-living matter, how even the most sophisticated forms of intentionality or sensibility arise out of the inorganic systematicity of repetition and recursivity, retention and protention.[29] In this way, the arche-materiality of the structure of succession, of what Derrida calls "living-on," allows, as Hägglund puts it "for a conceptual distinction between life and matter that takes into account the Darwinian explanation of how the living evolved out

of the non-living, while asserting a distinguishing characteristic of life that does not make any concessions to vitalism."[30]

This is an important point, I think, for making sense of the biopolitics of contemporary bioart. It brings into focus the manifold problems with equating the norm with "the principle of unlimited equivalence" of "life" pure and simple in the same way that prominent developments in contemporary biology such as in vitro meat or synthetic biology do. After all, is in vitro meat "real" meat? Is it "life"? Or does it simply underscore what was always already true of "life" to begin with—that forms of life depend upon a recursive ongoing interaction between the "who" (biological wetware) and the "what" (environment, weather, shared social and semiotic archives and repertoires, "fixed" or "instinctive" stimulus–response mechanisms, tool use and tool making, and the like). Precisely here, it seems to me, it is useful to remember Derrida's discussion of cloning in his late book *Rogues*. As he summarizes it, those who oppose cloning object to it "in the name of ethics, human rights ... the dignity of human life ... and the *nonrepetitive* unicity of the human person ... a unique, irreplaceable, free, and thus nonprogrammable living being."[31] But what is overlooked here, he argues, is that

> So-called identificatory repetition, the duplication, that one claims to reject with horrified indignation, is already, and fortunately, present and at work everywhere it is a question of reproduction and of heritage, in culture, knowledge, language, education, and so on ... so many dimensions that are irreducible, even for "identical" twins, to this supposedly simply, genetic naturalness. What is the consequence of all of this? That, in the end, this so-called ethical or humanist axiomatic actually shares with the axiomatic it claims to oppose a certain geneticism or biologism, indeed a deep zoologism, a fundamental but unacknowledged reductionism.[32]

Derrida's commentary here—and the example of synthetic biology in general—enables us to see how the biopolitical frame makes possible the thinking of a more nuanced and differentiated set of ethical and political relations with regard to "forms of life," but only if we do not succumb to the sort of neo-vitalism that, at the end of *Bios*, seems to leave us with a stark choice: either "life" as "unique, irreplaceable, free, and thus nonprogrammable" and the biocentrism that results from it on the one hand, or the autoimmune disorder which, Esposito suggests, is bound to eventuate if the continuum of life is broken, on the other.

* * *

What all the foregoing draws our attention to is the intensely *non-generic* and "transversal" (to use Deleuze's term) character of the "bio" of biopolitics

in its Foucauldian articulation, how it is essentially a strategic problem and object for political power, one that is conjugated and reconjugated anew under very specific coordinates and conditions, which may be ontological (in the sense of specific forms of embodiment and articulation with the environment) or sociological and historical, or both. What I now want to ask is what *art* adds, exactly, to that understanding. What does bioart make available to us that we can't get elsewhere—in an essay on synthetic biology and capital, say, or a lecture on genetic engineering, patents and law? It would be easy enough to begin by saying that bioart dramatizes what is always already true of the "bio" of biopolitics in general: that it is always a matter of the enfolding and coimplication of the living, the "wet," and that which is radically *not* living and nonorganic—technicity and *machinalité* in the broadest sense—whether that takes the form of the tool and the semiotic, the archive, the "*gramme*" of the instinctive program (so-called) or, most conspicuously in art, the frame and the *parergon* which is linked, via Heidegger's famous essay on technology, to the entire genealogy of bipolitical thought. But I want to try and be a little more specific about how bioart may be seen to be socially or politically representative, *as art,* in a biopolitical context, in ways that might seem a little unexpected while at the same time nevertheless extending the Foucauldian idea of the political itself.

Here, I want to return to Niklas Luhmann's work in *Art as a Social System,* which I used in *What Is Posthumanism?* to make sense of certain trends in contemporary architecture's relationship to what we used to call "nature" and "landscape." As Luhmann tells it, once the patronage system collapses, art is faced with the problem of justifying, and securing, its own autonomy, which can no longer be explained by reference to how it serves the church, the Medicis, and so on. In this new situation of modernity understood as a phenomenon of functional differentiation, the social system of art obeys the same formal dynamics that all social systems do. In brief, the art system, like all social systems, faces the dilemma of having to reproduce itself and maintain its autopoiesis under conditions of overwhelming environmental complexity—an asymmetry between system and environment that is axiomatic for systems theory. Like all social systems, it does so by using a highly selective code to reduce environmental complexity. For the education system, the code is knowledge / ignorance; for economics, credit / debit; for politics, power / opposition.[33] For art as a social system, Luhmann sometimes says that the code is beautiful / ugly, but clearly this can't be right. It makes more sense to say instead, as he puts it, that art under functional differentiation exists to constantly raise the question that it itself also answers—if only for a fleeting moment—necessitating the production of more art: namely, the question "what is art?" and "is *this* particular thing a work of art?"[34] But all such distinctions that organize the autopoiesis of social systems are built around a constitutive "blind spot," as Luhmann puts it, because of their tautological self-reference. To wit, in the legal system, the two sides of its organizing distinction legal / illegal are

in fact a *product* of only one side of the distinction, namely the legal. But the legal system cannot acknowledge the fundamental, tautological identity of both sides of the distinction *and* at the same time use it to organize and carry out its first-order operations. Only *another* observer, a second-order observer, using *another* code or distinction, can do that—can undertake what Luhmann calls "the observation of observation"—but of course the second-order observer will be bound by the same formal dynamics of blindness and self-reference.[35]

Here, however, Luhmann's theory of art introduces a wrinkle that is important for our purposes. For Luhmann, "the paradox unique to art, which art creates and resolves, resides in the observability of the unobservable"—and this is because art alone is able, uniquely, to re-enter the difference between consciousness (or perception, as he sometimes puts it) and communication into its *own* systematic communication.[36] For all other social systems, the autopoiesis of communication takes place *in spite of* perception, consciousness, psychic activity, and so on. For art, however, communication takes place *through* perception and consciousness—or more precisely, by means of the artwork's modulation of the difference between perception and meaning, consciousness and communication, against the background of the art system as a whole and formal selections that are meaningful in that context. (For as Luhmann points out, perception and communication operate in mutually exclusive, operationally closed autopoietic systems—the neurophysiological wetware of the brain and body vs the externality of social systems of communication and their media—though those systems may be structurally coupled through symbolic media such as language.) This difference—between perception and communication, and especially between their different speeds and qualitative aspects (perception is fast and "all at once" while communication is linear and sequential, for example, operating by means of delays and deferrals-) is used by art to call attention to the contingency of communication or, to put it another way, to simply raise the question of meaning: namely, is the thing we are looking at or experiencing *art,* and how does this particular artwork mean in the larger context of art as a social system and its function? And so, as Luhmann puts it, "The function of art would then consist in integrating what is in principle incommunicable—namely, perception—into the communication network of society," thus giving society another way—indeed a unique way—to observe itself.[37]

Following Luhmann, we might put it this way: if art, because of its unique use of the difference between perception and communication, has a privileged relationship to the invisible or ineffable (namely, making it visible) then it *also* makes more visible than other social systems the fact that when one thing is made visible (or formally selected) another is made invisible (because of the "blind spot" of observation and its contingent self-reference). And if we rewrite *that* point about the visible versus the invisible in terms of Thacker's reading of the difference between "the living" and

"Life," then my larger point about bioart comes into view: that the old adage "art imitates life" remains true (and is intensified by bioart) only in the sense that the "the living" makes "Life" invisible—that is to say, art imitates life only by *not* imitating Life. Or as Luhmann puts it, "art can no longer be understood as an imitation of something that presumably exists along with and outside of art"; rather, "to the extent that imitation is still possible, it now imitates the world's invisibility, a nature that can no longer be apprehended as a whole."[38]

What this means is that "the living" as the medium of bioart is actually able to become a medium for art's communication about the unobservability of "Life" in general and as such. The self-reference of bioart thus communicates how "Life" is never apprehended "as a whole" or "as such" but always takes *specific* forms, which are themselves riven by contingency, difference, and "blindness." That is simply to say those forms (of "the living") are *selective*. Thus, what Luhmann says about "the world" in the following quote could as well be said about "Life" with regard to bioart's use of "the living": "The world displays all the qualities that Nicholas of Cusa ascribed to God: it is neither small nor large, neither unity nor diversity, it neither has a beginning nor is it without beginning—and this is why the world needs forms."[39] Or as he puts it later in *Art as a Social System*:

> the function of art is to make the world appear within the world—with an eye toward the ambivalent situation that every time something is made available for observation, something else withdraws, that, in other words, the activity of distinguishing and indicating that goes on in the world conceals the world ... *Yet a work of art is capable of symbolizing the reentry of the world into the world because it appears—just like the world—incapable of emendation.*[40]

And this is true even of works—one might actually say *especially* of works—such as *Genesis* or *GFP Bunny* by bioartist Eduardo Kac, in which changes in the work (in either its medium or its component parts) inevitably become part of the meaning of the work itself, its ongoing recursive build up of its own self-reference: a process that starts, for the artwork, in a decision, a mark, an indication that is absolutely contingent and moves from there, through self-reference, to demarcate itself from everything else in the universe, as *this object and not some other*.[41] In *Genesis*, for example, Kac takes a passage from the King James Bible that reads "Let man have dominion over the fish of the sea, and over the fowl of the air, and over every living thing that moves upon the earth," then translates that first into Morse code, and then into *genetic* code by making the dashes equal thymine, the dots, cytosine, the spaces between words, adenine, and the spaces between letters, guanine. This "translation" is then used to create the genetic sequence for a unique "artist's gene," which

is then incorporated into bacteria displayed in the gallery space. Online participants can remotely activate ultraviolet light in the gallery to cause mutations in the bacteria, and the resulting changes are then translated back from the genetic code to the biblical passage, altering its meaning and in some cases rendering particular words gibberish, so that the resulting *non*-communicative verbal elements are incorporated into the artwork's specific communication. *GFP Bunny* takes a different tack, which consists not only of the green fluorescent rabbit named Alba that Kac created with the help of genetic engineers, but also the public dialogue and drama that unfolded around the project when the director of the lab in which she was born in France refused to release her to return home with Kac to Chicago— to which Kac responded, in turn, by staging various means of protest, such as placing "Free Alba" posters in various parts of Paris and mounting an exhibition of the same name which "reappropriated and recontextualized this vast coverage, exhibiting the productive tension that is generated when contemporary art enters the realm of daily news."[42]

Such strategies are not rare; in fact, they are part of the stock in trade of many practicing bioartists, as attorney Lori Andrews points out in her essay "Art as a Public Policy Medium." She gives several examples of how bioartists integrate into their work various legal disputes, edicts handed down by university committees regulating the use of biological material, and so on. *Banks in Pink and Blue*, created by artist Inigo Manglano-Ovalle for the University of Washington's Henry Art Gallery, for example, consisted of two sperm bank tanks, each containing sperm more likely to produce boys or girls. When the university's Institutional Biosafety Committee requested that he destroy the samples when the show ended, he hired lawyers to challenge the order and then used the contracts with the sperm providers, the university, and himself as part of the installation.[43] Andrews argues that bioart can thus help society "confront the social implications of its biological choices, understand the limitations of the much hyped biotechnologies, develop policies for dealing with biotechnologies, and confront larger issues of the role of science and the role of art in our society."[44]

There is little to argue with here, of course, but when it comes to political theory, the devil is in the details, as they say. Here again, it seems to me the systems theory perspective can be of use for thinking about the complexities and actual channels of real political effectivity in the context of biopolitics. Andrews argues that "by pointing out the gaps in regulation, the risks of these technologies, the inequities in access, and the way in which application of certain technologies may harm important social and cultural values, artists can encourage the social discussion that is necessary to adopt social public policies for biotechnologies."[45] But the question, of course, is what *is* the nature of this "social discussion" and what are the processes by which public policies are adopted? On this question, Andrews' problem is not unlike that of Bruno Latour's "political ecology,"

which pays insufficient attention to the autopoiesis of the law—and, more broadly, the phenomenon of functional differentiation as the very motor of modernity. As legal theorist Gunther Teubner puts it, Latour imagines a "great unified collective" where professions make their contributions to the decision-making process in a single conversation, but in fact there is little evidence to suggest that "an overarching societal discourse" called "political ecology" will emerge. Indeed, the phenomenon of functional differentiation and the specialization and self-reference of the various professions involved in these conversations (not least of all, of course, the specialization and differentiation of the various branches of the law itself) suggests quite otherwise; and thus, the sites on which Latour's political ecology plays out are fragmented, "dispersed over different social institutions."[46] As Teubner points out, each social subsystem operates "under sharply defined conditions" for attributing actions, responsibilities, rights, duties, and so on.[47] "Using their specific models of rationality," he writes, "each institution produces a different actor, even where concretely it is the same, human or non-human, that is involved."[48] This doesn't mean that the question of nonhuman actants doesn't affect the operations of the law or of other social subsystems; it means, rather, that they affect them in quite specific ways (and not others). And it also means that these new social actors—nonhuman animals, electronic technologies, biological materials, and so on—thus "lead a highly fragmented existence in society," appearing "in very different guises in politics, in the economy, in the law, and in other social contexts."[49] What art can do, then—as part of the larger environment in which the legal system operates—is perturb and stimulate the law to respond to changes taking place in the world around it, but that response will take place in and through the law's own autopoiesis. And so, we end up with a picture of the legal system as both open *and* closed: open to its environment, but responding to changes in it in terms of the autopoietic closure of its own self-reference, what the legal code makes possible or forecloses.

Indeed, Andrews' essay ends with the story of a case that bears out this fact quite clearly. When British artist Anthony Noel-Kelly convinced Richard Heald of the Royal College of Surgeons to grant him access to cadavers so that he could sketch them (a practice in keeping with longstanding artistic tradition, of course) all seemed well. But soon, Noel-Kelly began smuggling cadavers and body parts out to take them to his studio where he could make casts of the bodies and body parts, burying them in the grounds of his family's estate when he was done. When a police officer realized at one of Noel-Kelly's exhibitions that the statues must have been cast from dead bodies, the artist was charged with theft, but he defended himself by arguing that the body parts had been "abandoned" (the same argument that protects doctors and scientists who do research on human tissues). And he pointed out that even if he were in violation of the law, so too was the Royal College of surgeons, which kept the body parts

even longer without burying them "in a timely manner." His primary legal argument, however, was a very simple but very broad one: that he could not be charged with theft because for centuries judges had made it clear that the human body could not be property. (This is why turn-of-the-century body snatchers were charged not with theft but with violating public decency.) The prosecutor in the case countered that this legal tradition was the result of an erroneous reading of a case from 1614 where defendants had stolen corpses to take their burial clothes—and the error had been perpetuated since by centuries of legal precedent.[50]

The judge in the case, Geoffrey Rivlin, conceded that it was indeed strange that body-snatching in its heyday was not declared a felony, even though during the same period other offenses, from shooting rabbits to appearing in disguise on a public road, could be punished by the death penalty. Rivlin finally concluded that the reason body-snatching was not declared a felony was that "Parliament, if not exactly turning a blind eye to it ... winked at it in the interest of medical science." And while he agreed that body parts were not, after all, property—seemingly letting the artist off the hook for the charge of theft—he then cited a 1908 Australian case which established that *altering* body parts (as the Royal College had done by putting them in formaldehyde) transformed them into the alterer's property. And so Noel-Kelly was convicted of stealing human remains in April of 1998.[51]

The final twist in the story is this: as part of the litigation, Noel-Kelly's sculptures were ordered to be given to the Royal College of Surgeons to display in their museum, underscoring the fact, as Andrews puts it, "that medical institutions are allowed to do things with body parts that other individuals and institutions are not." At the same time, however, she notes that in the United States, artists are in some ways more favored by laws pursuant to the Constitutional emphasis on "the progress of science and useful arts." For while a scientific researcher receives a twenty-year monopoly on his or her invention under patent law, the copyright of an artist is good for life plus seventy years after the author's death. Moreover, it is unconstitutional under the First Amendment right of free speech to adopt a law prohibiting art about a particular subject matter (a ban on paintings that parody a president is Andrews' example), but researchers are routinely blocked from undertaking various kinds of research (on human fetuses, for example) without that constituting a violation of the researcher's first amendment rights.[52]

Another way to put it, then—to return to my opening question—is to say that if bioart is socially representative, what it is socially representative *of* is the inability of any particular social system to steer or determine the autopoiesis of how *other* social systems relate to or "code" the question of "Life" (and the difference between "Life" and "the living") in terms of their own self-reference. It is always a matter of "transversal" relations, you might say—a fact which Luhmann emphasizes and intensifies by rethinking

"objects" as "eigen values" (to use Heinz von Foerster's terminology). From this vantage point, as Luhmann puts it, "giving up the notion of the subject"—which biopolitical thought, like systems theory, *already* does (a point that receives particular emphasis in Esposito's work)—"requires reconstructing the object, which loses its opposite."[53] In this light, objects appear not as givens but "as repeated indications, which, rather than having a *specific* opposite, are demarcated against 'everything else'"; they appear as "eigen-behaviors of recursive calculations."[54] But even more important for our purposes—and here we extend but also refine the Foucauldian line of biopolitical analysis—is that "the stabilization of objects (identification, recognizability, and so on) is more likely to contribute to stabilizing social relationships than the famous social contract," so that "objects that emerge from the recursive self-application of communication [as eigen behaviors] contribute more than any other kinds of norms and sanctions to supplying the social system with necessary redundancies."[55] And even *more* significant is that "this may be even more true of objects that have been invented for the sake of this specific function, such as kings or soccer balls"—or, works of art, which are "quasi-objects" (to use Michel Serres' term) in exactly this sense. It is precisely because such quasi-objects dramatize what is already true of *all* objects—that they are not given but rather produced by recursive social communications and behaviors—that, in the quasi-object,"the socially regulative reveals itself."[56] And in my view, such a process is political *precisely because* it is contingent and ontologically ungrounded, always a matter, as Foucault reminds us, of highly specific configurations, overdeterminations, histories, *dispositifs,* and so on. To put it this way is to give a different cast to what is often seen as the "apolitical" character of Luhmann's social systems theory. It allows us to understand how the point is not that art is "political" in the usual sense of having a linear or representational relationship to some political ground that is external to it and that determines or motivates its features or themes. Rather, art's relationship to the political is *non*-representational in making visible for society's self-observation the "socially regulative" and "stabilizing" contingencies that structure the field of objects and observations in which we make art and communicate, the highly selective overdeterminations that bear upon how—in the contemporary context of the "right to life," the sixth great extinction event in the history of the planet, the increasing pervasiveness of synthetic biology and genetic engineering, and much else besides in the domain of the "bio-"—we conjugate the relationship between what we call "Life" and its empirical instantiations in the domain of "the living."

Notes

1 Hans-Georg Moeller, *The Radical Luhmann* (New York: Columbia University Press, 2012), 23.

2 In fact, as Moeller points out, "that a system is in an environment means that it functions while other systems function simultaneously. A more appropriate example than the fish in the water is the immune system. We can well say that the immune system is within the body, but this does not mean that it has any principal seat in the body. The immune system can only exist within the complex environment of the body—it cannot work without blood circulation, digestive processes, and respiratory activity all functioning simultaneously. There is, however, no pineal or other gland that serves as the nexus between the immune system and its bodily environment. The very concept of nexus is what the system / environment distinction is no longer in need of," opting instead for "a highly complex pluralism of simultaneously operating systems" (63). Opting, that is to say, for ecological thinking.

3 As Leonard Lawlor characterizes the pharmakon, "always in Derrida, the concern is with the logic of the limit—say, between evil and good—that is not oppositional, a logic in which the two poles are not external to one another" (8). "Indeed," he writes later, "Derrida says that the pharmakon is the *milieu* prior to any possible dissociation of opposites, even the opposites of form and content or form and matter" (35)—all of which is to say (and the point is nailed down by remembering the links between *milieu*, "medium," and environment that so many thinkers have underscored) that the pharmakon is ecological or environmental; it names the (non)place where environmental complexity gets "re-entered," as Luhmann will say, on the system side of the system / environment relation, and in terms of the system's own self-reference, thus creating what Lawlor, like Luhmann calls the "blind spot" that "amounts to the only way ... to twist free of Platonism" (35). Leonard Lawlor, *This Is Not Sufficient: An Essay on Animality and Human Nature in Derrida* (New York: Columbia University Press, 2007). For Esposito's own conjugatioin of the immunitary mechanism and the pharmakon, see his *Immunitas: The Protection and Negation of Life,* trans. Zakiya Hanafi (London: Polity, 2011), 127.

4 Quoted in Esposito, *Bios: Biopolitics and Philosophy*, trans. and intro. Timothy Campbell (Minneapolis: University of Minnesota Press, 2008), 33.

5 Michel Foucault, *"Society Must Be Defended"*: Lectures at the Collège de France, 1975–76, trans. David Macey, ed. Mauro Bertani and Alessandro Fontana (New York: Picador, 2003), 247.

6 Esposito, *Bios,* 7.

7 Foucault, *"Society Must Be Defended,"* 35–6.

8 Maurizio Lazzarato, "From Biopower to Biopolitics," *Pli* 12 (2002): 104.

9 Esposito, *Bios,* 28.

10 Lazzarato, "From Biopower to Biopolitics," 101.

11 Ibid., 103.

12 Quoted in Esposito, *Bios,* 38.

13 Lazzarato, 104.

14 Esposito, *Bios,* 39.

15 Giorgio Agamben, *Homo Sacer: Sovereign Power and Bare Life*, trans. Daniel Heller-Roazen (Stanford: Stanford University Press, 1998), 166.

16 Foucault, *"Society Must Be Defended,"* 255.

17 Esposito, *Bios,* 32, emphasis added.

18 Ibid., 45.

19 Giovanna Borradori, ed., *Philosophy in a Time of Terror: Dialogues with Jürgen Habermas and Jacques Derrida* (Chicago: University of Chicago Press, 2004).

20 Esposito, *Bios,* 180.

21 Ibid., 188.

22 Ibid., 186.

23 Ibid., 187.

24 Tim Luke, "The Dreams of Deep Ecology," *Telos* 76 (Summer 1988): 51.

25 Richard Rorty, "Postmodern Bourgeois Liberalism," in *Objectivity, Relativism, and Truth: Philosophical Papers, Vol. 1* (Cambridge: Cambridge University Press, 1991), 198. For a discussion of these questions in relation to biocentrism and Deep Ecology, see Murray Bookchin and Dave Foreman, *Defending the Earth: A Dialogue Between Murray Bookchin and Dave Foreman*, ed. and intro. Steve Chase, foreword David Levine (Boston: South End Press, 1991), 123–7.

26 Eugene Thacker, *After Life* (Chicago: University of Chicago Press, 2010), 234.

27 Martin Hägglund, "The Arche-Materiality of Time: Deconstruction, Evolution and Speculative Materialism," in *Theory After Theory*, ed. Jane Elliott and Derek Attridge (London: Routledge, 2011), 265.

28 Jacques Derrida, *Without Alibi*, trans. and ed. Peggy Kamuf (Stanford: Stanford University Press, 2002), 136.

29 Hägglund, "The Arche-Materiality of Time," 272–3. "Far from metaphysical" for the following reason: "the deconstructive notion of the trace is logical rather than ontological. Accordingly, my argument does not assume the form of an unconditional assertion ('being is spacing, hence arche-materiality') but rather the form of a conditional claim ('if your discourse commits you to a notion of succession, then you are committed to a notion of spacing and hence arche-materiality'). The discourse in question can then be ontological, epistemological, phenomenological, or scientific—in all these cases the logic of the trace will have expressive power insofar as there is an implicit or explicit commitment to a notion of succession" (270).

30 Ibid., 275.

31 Jacques Derrida, *Rogues: Two Essays on Reason*, trans. and ed. Michael

Naas and Pascal-Anne Brault (Stanford: Stanford University Press, 2005), 146–7.

32 Ibid., 147.

33 See my *What Is Posthumanism?* (Minneapolis: University of Minnesota Press, 2010), 203–38.

34 Niklas Luhmann, *Art as a Social System*, trans. Eva Knodt (Stanford: Stanford University Press, 2000), 69.

35 See Wolfe, *What Is Posthumanism?*, 15–16.

36 Luhmann, *Art as a Social System*, 149.

37 Ibid., 141.

38 Ibid., 92.

39 Ibid., 15.

40 Ibid., 149, emphasis added.

41 For a much longer version of this discussion of Kac's work, see Wolfe, *What Is Posthumanism?*, 158–67.

42 Eduardo Kac, ed., *Signs of Life* (Cambridge, MA: MIT Press, 2009), 170.

43 Lori B. Andrews, "Art as a Public Policy Medium," in Kac, *Signs of Life*, 139.

44 Ibid., 126.

45 Ibid., 142.

46 Gunther Teubner, "Rights of Non-humans? Electronic Agents and Animals as New Actors in Politics and Law," *Journal of Law and Society* 33 (4) (December 2006): 518.

47 Ibid., 518.

48 Ibid., 519.

49 Ibid.

50 Andrews, "Art as a Public Policy Medium," 140.

51 Ibid., 141.

52 Ibid.

53 Luhmann, *Art as a Social System*, 46.

54 Ibid., 46–7.

55 Ibid., 47.

56 Ibid.

Bibliography

Agamben, Giorgio. *Homo Sacer: Sovereign Power and Bare Life*, trans. Daniel Heller-Roazen. Stanford: Stanford University Press, 1998.

Andrews, Lori B. "Art as a Public Policy Medium." In *Signs of Life*, ed. Eduardo Kac. Cambridge, MA: MIT Press, 2009.

Bookchin, Murray and Dave Foreman. *Defending the Earth: A Dialogue Between Murray Bookchin and Dave Foreman*, ed. and intro. Steve Chase, fwd David Levine. Boston: South End Press, 1991.

Borradori, Giovanna, ed. *Philosophy in a Time of Terror: Dialogues with Jürgen Habermas and Jacques Derrida*. Chicago: University of Chicago Press, 2004.

Derrida, Jacques. *Rogues: Two Essays on Reason*, trans. and ed. Michael Naas and Pascal-Anne Brault. Stanford: Stanford University Press, 2005.

Derrida, Jacques. *Without Alibi*, trans. and ed. Peggy Kamuf. Stanford: Stanford University Press, 2002.

Esposito, Roberto. *Bios: Biopolitics and Philosophy*, trans. and intro. Timothy Campbell. Minneapolis: University of Minnesota Press, 2008.

Esposito, Roberto. *Immunitas: The Protection and Negation of Life*, trans. Zakiya Hanafi. London: Polity, 2011.

Foucault, Michel. *"Society Must Be Defended": Lectures at the Collège de France, 1975–76*, trans. David Macey, ed. Mauro Bertani and Alessandro Fontana. New York: Picador, 2003.

Hägglund, Martin. "The Arche-Materiality of Time: Deconstruction, Evolution and Speculative Materialism." In *Theory After Theory*, ed. Jane Elliott and Derek Attridge. London: Routledge, 2011.

Kac, Eduardo, ed. *Signs of Life*. Cambridge, MA: MIT Press, 2009.

Lawlor, Leonard. *This Is Not Sufficient: An Essay on Animality and Human Nature in Derrida*. New York: Columbia University Press, 2007.

Lazzarato, Maurizio. "From Biopower to Biopolitics." *Pli* 12 (2002).

Luhmann, Niklas. *Art as a Social System*, trans. Eva Knodt. Stanford: Stanford University Press, 2000.

Luke, Tim. "The Dreams of Deep Ecology." *Telos* 76 (Summer 1988).

Moeller, Hans-Georg. *The Radical Luhmann*. New York: Columbia University Press, 2012.

Rorty, Richard. "Postmodern Bourgeois Liberalism." In *Objectivity, Relativism, and Truth: Philosophical Papers, Vol. 1*. Cambridge: Cambridge University Press, 1991.

Teubner, Gunther. "Rights of Non-humans? Electronic Agents and Animals as New Actors in Politics and Law." *Journal of Law and Society* 33 (4) (December 2006).

Thacker, Eugene. *After Life*. Chicago: University of Chicago Press, 2010.

Wolfe, Cary. *What Is Posthumanism?* Minneapolis: University of Minnesota Press, 2010.

CHAPTER NINE

Ecologies of communion, contagion, &c, especially Bataille

David Wills

So this is where it all ends, or perhaps begins. I'll quote from the original to save myself some embarrassment:

> Hâtivement, nous fîmes, hors du chemin, dans la terre labourée, les dix pas que font les amants. Nous étions toujours au-dessus des tombes. Dorothéa s'ouvrit, je la dénudai jusqu'au sexe. Elle-même, elle me dénuda. Nous sommes tombés sur le sol meuble et je m'enfonçai dans son corps humide comme une charrue bien manœuvrée s'enfonce dans la terre. La terre, sous ce corps, était ouverte comme une tombe, son ventre nu s'ouvrit à moi comme une tombe fraîche. Nous étions frappés de stupeur, faisant l'amour au-dessus d'un cimetière étoilé. Chacune des lumières annonçait un squelette dans une tombe, elles formaient ainsi un ciel vacillant, aussi trouble que les mouvements de nos corps mêlés. Il faisait froid, mes mains s'enfonçaient dans la terre : je dégrafai Dorothéa, je souillais son linge et sa poitrine de la terre fraîche qui s'était collée à mes doigts …
>
> Je dus, comme je pouvais, tirer mon pantalon. Je m'étais mis debout. Dirty restait le derrière nu, à même le sol. Elle se leva péniblement, elle attrapa une de mes mains. Elle embrassa mon ventre nu: la terre s'était collée à mes jambes velues: elle la gratta pour m'en débarrasser. Elle s'accrochait à moi. Elle jouait avec des mouvements sournois, avec des mouvements d'une folle indécence. Elle me fit d'abord tomber. Je me relevai difficilement, je l'aidais à remettre ses vêtements, mais c'était difficile, nos corps et nos vêtements devenus terreux. Nous n'étions pas moins excités par la terre que par la nudité de la chair.[1]

That is Georges Bataille down and dirty, his female fictional character nicknamed as such (Dirty), both of them in the dirt, covered in it, in the climactic scene of *Blue of Noon*. It is also Georges Bataille down to his most ecological, if by that we mean—something no one is conceding here—an intimate relation with an elemental nature: naked bodies in soft bare soil, sexual intercourse like ploughing a field, fellatio impeded by grit on hairy legs, carnal excitement competing with humicolous arousal. This is a sex that returns to the earth, composts itself almost, shares the same space as the tomb, and gives itself over to the teeming life of the soil.

Something perverse keeps bringing me back to this scene: in books, in classes, in provoking a close colleague and friend happy to participate in a panel on Bataille "as long as you don't ask me to talk about the fiction." But in coming back to it I am also of course economizing, using a renewable resource, avoiding archival overload, reducing my or our intellectual and neuronal footprint, even keeping things down to earth. Or else capitalizing, exploiting it for all it's worth, trading it in the marketplace of rarified super-structural exchange, fetishizing it beyond any authentic use value, even automatizing it in some uncanny and grotesque repetition.

It is where it all ends, or perhaps begins, because the scene is set in that most *economicological* of cities, Trier, perhaps Germany's oldest town but specifically Marx's birthplace, and its timing is calculated to be All Saints' Day, 1934. Offstage, as far as the novel is concerned, Gustav Simon, the *Gauleiter* (Nazi party regional leader) appointed by Hitler, is making the city a Brown Shirt stronghold and showcase. It is eight months since Heidegger resigned as Freiburg Rector, four months since the Night of the Long Knives, and a couple of months since Carl Schmitt published his defense of the Führer's upholding the law. It is also during this time frame that Bataille has entered a period of intense erotic disarray centered on the person of Colette "Laure" Peignot, without doubt the most important woman in his life, who will accompany him through what he will later call—referring specifically to 1934—"a serious moral crisis," and with whom he will remain, into the Acéphale adventure, until her death in November 1938.[2] An additional time frame: when Bataille publishes *La Part maudite* [*The Accursed Share*] in 1949 he refers to it as a work eighteen years in the making, which takes its beginning back to the early 1930s, and he will not publish *Blue of Noon* itself, dated May 1935 but whose "Introduction" was drafted in 1928, until 1957. That makes the beginning of *Blue of Noon*, where Troppmann the narrator and Dirty / Dorothea are first found wallowing in alcohol, tears, vomit, perfume, body odor, blood, urine, and shit, the first thing Bataille will have written, and turns the novel into a work that spans most of his active life as a writer.[3]

The earth that is made so explicitly and elementally present in Troppmann's Trier tryst—in which he overcomes his impotence—with Dorothea is of course not the only thing to be emphasized in this scene. Equally, if not more important, is its necrophilic bias; not just the fact of

the festival of the dead in the cemetery and the thematics of the skeletal, but the whole apocalyptic approach of war presaging dead children, a legless Dorothea, and finally the whole "rising tide of murder" of the book's final paragraph, "far more corrosive than life (because blood is more luminous in death than in life)."[4] For whereas Bataille's necro-erotics is, as we know and as I shall shortly develop, a multi-layered question, it begins as a relation to blood that is more vital for being shed, more highly charged when it overflows its bodily limits, more incandescent in its awful visibility. Thus although in this scene the blood does not explicitly flow— perhaps a few scratches when they take a tumble, the threat of much more had they "fallen into the night,"[5] the hallucinated killings and mutilations of war foretold—it remains the implicit undercurrent of, and thematic counterpoint to the earth and soil that becomes the lovers' bed. After all, blood and soil are the two poles of every anthropo-ecological impulse and enterprise, the two *oikoi* or (home-)bases upon which rest both the private and public versions of *environmentalization* in general, both the personal and political self-constitutions of the human. In each case what takes place in the first place—and these are precisely events of "taking place as first place"—is an economy of interiorization: immediate environment, ideally no environment, conceived of as self-enclosed interiority. Blood is that interior life in the body, pumping from heart to extremity without for all that breaching the confines of the body; soil is the blood of the nation, the very substance that defines and circumscribes native territory from its center or capital to its borders (and in whose interest and for whose safeguarding blood must periodically be shed).[6]

Some version of ecology in that most literal sense might therefore have to be conceded here, since it is the very literalization of the stable (house) vis-à-vis the mutable or less defined (environment), even if we resist reducing it to an intimate relation with an elemental nature. It is difficult to conceive of ecology without the idea of a relation between a living entity or organism and a more or less defined territory; indeed, without the sense of an organicity of that relation, the living organism organically conforming to the territory in which it lives and moves; and that is figured through *Blue of Noon* as blood relating to soil. Hence my interest here is in the buttresses that ecology relies on, and the stresses to which it is exposed once the concept is required to confront Bataille's thinking concerning *communion* and *contagion*; and further, once it is called upon to deal with what I'll call an originary environmental rupture, prosthetization and technologization.

The tension between blood and soil is a major problematic posed in Bataille's *Blue of Noon*, and the cemetery scene in Trier, followed by what happens the following day, represents such a problematic in all its ambivalence. In 1934 in Germany the restricted economy of both a metaphorical and metonymical transfer between blood and soil (the authentic lifeblood of the *Volk* pumping up the *Vaterland*; the blood, already being shed, whose present and future effusion will cleanse the Aryan earth) is well on the way

to being fully mobilized. In the novel, Hitler youth are encountered by the protagonists en route to their funereal tryst, an SA officer is on the train the next day, and in the square in front of the Frankfurt station the narrator is drawn to a concert by Nazi boys in uniform, playing a "violent music, a sound of unbearable bitterness" as though "possessed by some cataclysmic exultation." It is a music whose marching rhythm mimics, supposedly, the beating of the heart, but that, in the event, is so inflexible that it takes the narrator's breath away [*un rythme si cassant que j'étais devant eux le souffle coupé*], like a machinic heart that stops the heart: "Each peal of music in the night was an incantatory summons to war and murder. The drum rolls were raised to their paroxysm in the expectation of an ultimate resolution in bloody salvos of artillery."[7] As is made patently clear in those words, so extraordinarily prescient that it is hard to imagine Bataille never revised them between 1935 and 1957, and as is made equally clear by means of the martial music they describe, the ideology of exultation that marked that part of the twentieth century was expressed as a fever-pitched stridency of nationalist fusion accompanying an orgy of holocaustic violence and cruelty. And its ideology was wedded to the earth, rooted in a specific soil, functioning within the most restricted economy of home and land, the strictest law of belonging, requiring increasingly bloody expurgation.

In opposition to that, the sexualized soil, the besmirched coupling of Bataille's fictional protagonists promises only slim resistance, and reveals itself as the ineffectual indulgence that tradition accuses it of being. Yet that promise is precisely what is wagered, according to a straightforward reading, by means of the narrative conceit of the novel: Troppmann, plagued by sexual impotence and lacking respect for any woman who does not desire the same level of debauchery as Dirty, and beset by a parallel bad faith regarding his own lack of political commitment, either to a more or less doctrinaire Marxism or to the revolutionary anarchism that he witnesses taking shape in Barcelona, finally finds himself, or satisfaction, albeit melancholically, in the Trier scene. According to that interpretation, Bataille is positing in this early fiction the double wager of a general economy, capable of expending itself by means of the hecatombs of war (wanton dissipation of the national body) as well as in the grimy excesses of sexual dissolution (wanton dissipation of lovers' bodies). Such a double economy comes to be articulated through the writer's two grand projects that are *Inner Experience* (1954) and *The Accursed Share* (1949); or within the larger version of *The Accursed Share* between the political economy of the first volume, and the works on eroticism and sovereignty that followed; or within that first volume, in the alternative that emerges at the end between a third World War and the Marshall Plan. And fundamental to Bataille's understanding of economy, as is laid out superbly by Allan Stoekl in his *Bataille's Peak*, what makes that economy an ecology in the most everyday sense, and what makes Bataille a thinker for the current age and a thinker of ecology, is the question

of sustainable energy. According to Stoekl, Bataille puts "energy at the forefront of his thinking of society: we are energy, our very being consists of the expenditure of quantities of energy."[8] In doing that Bataille follows Giordano Bruno's idea that movement, or "what a later age might call energy is ... the driving force of all matter" (5); and Sade, for whom "the greatest energy ... entails a radical selfishness that finally is not even selfish: it is a kind of impersonal power that concentrates its effects in order to heighten the effect of energy itself, intensifying and hastening the process of destruction" (14–15).

Erotic life provides the clearest context for energy spent for its own sake, outside of any utility, or in forms that greatly exceed reproductive necessity. Indeed, the useless excess of pleasure is inextricably woven within the very the act—to the extent of diverting or perverting it—by which the species performs its most important and utilitarian function, namely procreation. A profound asociality operates inside the means by which the social entity guarantees its continuation:

> It is always by means of conduct dedicated to growth that we affirm ourselves on the social level. But in the moment of sexual fever we conduct ourselves in a contrary fashion: we deplete our forces without keeping account, and we expend considerable amounts of energy without measure or profit. Sexual pleasure [*volupté*] seems so much like ruination that we have named the moment of its paroxysm "a little death."[9]

The expenditure of energy in Bataille thus involves an irreducible principle of destruction that is epitomized by death. As Stoekl reads Sade, and as Bataille's work on eroticism will make abundantly clear, "nature needs the death of her creatures; death is not definitive but a point of transition in a larger movement of life."[10] Hence the principle of energy will not automatically give rise to questions of conservation. On the contrary, conservation is at the outside conceptually incompatible with an energy that is determined by excess; or rather, conservation has somehow to be conceived of within an economy whose principle is excessive expenditure, a "prodigality" as Bataille states in *Eroticism*, that is extended to the point of "intolerable anguish."[11] Thus, for Stoekl:

> Bataille's energy is a transgression of the limit; it is what is left over in excess of what can be used within a fundamentally limited human field ... It is the energy that by definition does not do work, that is insubordinate, that plays now rather than contributing to some effort that may mean something at some later date and that is devoted to some transcendent goal or principle. It is, as Bataille reminds us a number of times, the energy of the universe, that energy of stars and "celestial bodies" that do no work, whose fire contributes to nothing.[12]

The energy of the universe comes to the earth naturally and automatically, and effectively limitlessly, by means of the sun. At bottom, Bataille writes in "L'économie à la mesure de l'univers," "we are only an effect of the sun."[13] The blue of noon is the sovereign moment of solar recognition or reconciliation, described in the novel of the same name as an "insolence" bestowed on the narrator, elating him "with a happiness affirmed against all reason."[14] The "triumph" of that insolence is described at the end of Part 1 of *Blue of Noon*, an italicized dreamlike sequence that barely extends onto a second page, but which, formally speaking, has the same weight as the rest of the book (Part 2 amounts to ninety pages in the *Oeuvres complètes*). The narrator explains how that insolence persists, then bursts upon him, following a confrontation with the law or with God in the person of the Commendatore.[15] From there and throughout Part 2, leading up to the delirium of the series of Barcelona chapters that are entitled "Blue of Noon," it is as if he were working to regain such a sovereign indifference, through scenes that alternate between night and day (or open and closed eyes), between starlight and sunlight, and between his past childhood and the present:

> There were stars, an infinity of stars ... I was eager for daybreak and sunrise ... When I was a child, I loved the sun; I used to shut my eyes and let it shine, red through my lids. The sun was terrible—it evoked dreams of explosion ... Now, in this opaque night, I'd made myself drunk with light ... My eyes were no longer lost among the stars that were shining above me in reality, but in the blue of the noon sky. I shut them, so as to lose myself in that brilliant blueness ... I opened my eyes. The stars were still covering my head, but I was mad with sunlight.[16]

That solar elation allows him to emancipate himself from a childhood in which he stabbed himself with a pen, and a new "happy insolence" now sustains him, making him capable of nothing less than "turn[ing] the world, quite ineluctably, upside down" (ibid.). But some pages later, following nightclub and beach scenes, he realizes that he has not escaped from, but instead reconstructed the life he was trying to flee by leaving Paris. Out in the sun once more, he encounters a beggar who stares at him fixedly and insolently, but that insolence, which Troppmann envies, now seems beyond his reach: "In the sunshine, there was an insolent look about him, a solar look [*un aspect solaire*] ... I would have liked to have that dreadful look, that solar look of his, instead of acting like a little boy who never knows what he wants."[17] In a sense, then, that alternation between elation and morbidity pursues the narrator right up to the end of the novel. Trier, after Barcelona, will be all grey, autumnal, and lunar, meager candlepower and deep foreboding. Following Dorothea's departure in another direction, and the final episode of martial music, Troppmann will take the train to an uncertain destination and future.

So the question is: what sort of energy is this, both solar and lunar, insolent and morbid, potent yet useless, inexhaustible yet dissipated? How can a species such as the human make sense of, resist, harness, or conform to such a force of nature? How does one choose between a rationalization of energy expenditure and abandonment to its implacable burn-off? Those irreconcilable questions appear to be as susceptible to a Hegelian treatment as to a mystical explanation, and Bataille's work of course explores both, on its way to understanding how—especially by means of religious or quasi-religious rites—societies of all stages of development deal with the inassimilable elements of their systems of self-organization, and periodically reconcile with the boundless energy of matter. But if we follow Stoekl's cogent analysis, the terms of those questions ultimately posit a politics and ethics of "generosity" that he also calls one of "postsustainability." Such a politics "would entail not a cult of resource conservation and austere selfhood, but, instead, a sacrificial practice of exalted expenditure and irresistible glory."[18] The self would be precisely what was sacrificed through such expenditure, as when, in Sade, "extreme pleasure is pushed to the limit [and] the sheer energy of destructiveness threatens the stability of all selfish subjectivity" (27).

The provocation or perversity of Bataille's general economy therefore renders him less than an ideal poster boy for the ecological paradigm, hardly a paragon of ecological virtue. At the global level—and beyond—his generosity has nothing to do with sacrifice understood as making do with less, for it is based on a principle of pure waste such as motivates the offering up of an animal or human to some divinity, even though that practice be rationalized as a form of thanks, repayment of a debt, or down payment on future security. It would refuse an understanding of energy that turned on the depletion of fossil fuels, as well as an understanding of resource depletion related solely to the sustainability of a restricted economy of middle-class comfort. To the extent that such an economy increasingly includes notions of respect for natural resources, postsustainability would require that such respect be understood within the ecological indifference of the universe, which values a particular animal species no more than it does forms of vegetation. But within that "cruelty" such as it would be felt by a depleting species in the same way that it befalls the victims of cruelty in Sade, there can again be found the space of generosity: "The post-sustainable economy is a general economy; beyond the desires and needs of the human 'particle,' it entails the affirmation of resources conserved and energy spent on a completely different scale ... the world offers itself as sacred victim" (144). This is not to revel in the destructive force of the sun as a pretext for turning a blind eye to the perils of global warming, or for ignoring the perversion of inattention to human destruction of the ecosphere, which is, in any case, systematically employed in the cause of the restricted economic practices of the first world. It is rather to recognize that no economy, and no ecology, can ignore its own heterogeneous complexity.

And, in any case, in a situation where human waste—from household refuse to spent nuclear fuel rods, to marine archipelagos of plastic garbage, and orbiting satellite wreckage—already haunts the entire ecospheric landscape, the species seems to be suffocating, stretched to the limit on the altar or rack of meager creature comfort, when it could otherwise be celebrating its fulgurant consumption in the universal ocean or firmament of excess.

* * *

Ecology as relation of organism to environment presupposes some idea of contiguity and contact. As traditionally conceived, it will always have to wrestle with principles of proximity that are determined in turn by notions of affect. We are concerned, in ecological terms, by what affects, touches (on) something near; on the organism's organic conformity to, or harmony with its territory. Just as the first economics is home economics, so the first ecology is, as I have already suggested, constituted by the idea of a house. One could cite examples as diverse as the hermit crab in competition with the mollusk, celebrated by Francis Ponge:

> The mollusk is endowed with powerful energy to close itself in. To tell the truth, it is simply a muscle, a hinge, a door latch and its door.

> A latch that secreted the door. Two slightly concave doors constitute its entire abode.

> First and last abode. It resides there till after its death.

> There's no way to get it out alive.

> Every last cell in a human body clings in the same way, and with the same vigor, to words—reciprocally.

> But at times some other creature comes along and violates this tomb, when it's well made, and settles there in place of its late builder.

> Take the hermit crab for instance.[19]

Or, alternatively, one could cite Levinas's sense of exteriority—and interiority—as developed in the "Interior and Economy" section of *Totality and Infinity*, an articulation that relies entirely upon a certain undecidability of the house. Man, writes Levinas, "plunges into the elemental from the domicile ... He is *within* what he possesses, such that we shall be able to say that the domicile ... renders the inner life possible"; and later: "Simultaneously without and within, he goes forth outside from an inwardness [*intimité*]. Yet this intimacy opens up in a house, which

is situated in that outside"; and again, "Interiority [is] concretely *accomplished* by the house."[20]

Those examples, extending from a simple marine symbiosis to an ethics based on an encounter that is rooted in a more or less enclosed space, determine ecology as contact with what is contiguous. Ponge's mollusk is all house, a latch that secretes a door, and its energy is all devoted to self-enclosure for the duration of its life, at which point the house becomes its tomb. Its mode of being is attachment: glued to the shell, which is glued shut. The hermit crab will appropriate the house as its own form of being-in-attachment, albeit different from that of the mollusk. Levinas's man self-constitutes as interiority thanks to his contiguous existence within a house that is exterior interiority; it is from the house that he learns and adopts the exterior limits that give him interiority, according to a mode of being-in-attachment that borrows aspects of both the mollusk (he must first close the door in order to constitute himself) and the hermit crab (he is thereafter mobile enough to desert the house).

A third example could be provided by an ecology of sound.[21] In *De Anima* Aristotle found that among the senses "touch alone perceives by immediate contact," but that hearing nevertheless relies on a single and continuous mass of air "from the impinging body up to the organ of hearing [which is thus] physically united with air."[22] Hearing would therefore function as a form of touching, which gives hearing oneself speak all the auto-affective force that Derrida has analyzed and deconstructed. It appears to take place within a single organic otolaryngological circuit, in a perfect egoecological economy whereby one simultaneously hears the sound waves that one feels issuing from the throat, as though nothing had escaped outside of the body. Speaking (or singing, or otherwise uttering) thus creates for the self a house of sound. But, in fact, any seeming closed circuit is "radically contradicted" by difference—beginning with time—in which "is rooted the possibility of everything we think we can exclude from auto-affection: space, the outside, the world, the body, etc."[23] The presumed organicity of contact produced by soundwaves emerging from the body to re-enter the ear comes therefore to be broken. Every auto-affection is in that way a hetero-affection: touching oneself means being touched—which always means being touched from the outside, as Nancy has emphasized[24]—and hearing oneself is a matter of being heard, from the outside. Furthermore, as Derrida emphasizes, for example in *On Touching*, the differential rupture that takes place within the supposed intact and closed auto-affective circuit introduces not only a displacement but also the structure of prosthesis, leading him to ask "whether there is any pure auto-affection of touching or touched, and therefore any pure, immediate experience of the purely proper body, the body proper that is living, purely living. Or if, on the contrary, this experience is at least not already *haunted*, but *constitutively* haunted by some hetero-affection related to spacing." Presuming that is the case, such a spacing would have to include "the outside itself, the other, the inanimate,

'material nature,' as well as death, the nonliving, the nonpsychical in general, language, rhetoric, technics, and so forth."[25]

Thus the contiguity of the house, the very fact of its making contact with its inhabitant, determines it as prosthetic to its supposed organic interior. There is no environment without that rupture of organicity, its rewriting as prostheticity. So how does ecology deal with that originary environmental rupture, not just that of the human / animal divide, or that between living and non-living, but the fundamental rupture within *physis* of the technological, the denaturing of nature and ecosystem alike? In Bataille's terms it would be the rupture of the general within the restricted economy, the heterogeneous within the homogeneous, and his response would entail in the first instance a rewriting of contact or contiguity as *contagion*. The word "contagion," which is of course an emblematic term in Bataille, is used in his earliest text, *Story of the Eye*, to refer already to a contact whose terms are not determined by normal social or societal relations, a contact whose model would be infection. It might be understood in the first instance as something as innocent as infectious laughter ("she couldn't ... stop laughing, so that, partly by contagion, partly because of the intense light, I began laughing as hard as she, and so did Sir Edmund"[26]), but the transfer that takes place by means of laughter stands for any such form of effervescence up to and including the orgiastic. That sense of contagion can begin in the context of a highly codified societal ritual that actually requires touching, or ingesting (such as handling taboo objects, or the Eucharist).[27] But there is nothing to prevent such a codified usage from intensifying to the point where the codes no longer hold, and indeed such usages themselves are often designed to play with their own limits, or open themselves to perversion such that the contagion spreads beyond any controlled contact. Hence contagion will also refer to something as indiscriminate as the transfer of feelings, such as the sexual, through which the limits of corporeal substantiality come to be unsettled ("this renewed desire was unsettling me ... and the state of malaise was such that it was communicated by contagion to Sir Edmund"[28]). Bataille's contagion is, if you wish, a type of animal or microbial contact, but it might more accurately be described as viral, for it is able to mutate out of the strict physical materiality that the word suggests, becoming in *Story of the Eye*, for instance, the figure of an uncontrolled drift—in excess of any clear semantic or rhetorical logic—that connects eyes, eggs, testicles, milk, sperm and milky way in an orgy of signification. From another point of view it can be understood as an organic relation that unites participants in a given system while at the same time producing a rupture within that system, introducing heterogeneous elements or provoking an eruptive overflow of it, destroying its organic coherence. As Bataille writes in *Le coupable*, "*contagion* (the intimate compenetration of two beings) *is contagious* (giving rise to an indefinite repercussion)."[29] Thus, the operation of *contagion* within an ecology that presumes a contextual environment defined by *contact*, necessarily has a

delocalizing and destabilizing effect. But that is, after all, how nature works, rendering the concept of an ecosphere or ecosystem highly problematic: because such systems overflow, a presumed protected environment or habitat is destabilized by intrusions, and ecological balance becomes an issue.

By the time of *Inner Experience* contagion will thus have become Bataille's key word for the more or less indiscriminate manner by which energy is communicated throughout, and in excess of an organic entity:

> What you are derives from the activity that links the innumerable elements that compose you to the intense communication among those elements. These are contagions of energy, movement, heat, or transfers of elements that internally constitute the life of your organic being. Life is never situated in a particular point: it rapidly passes from one point to another ... like a sort of electric stream [*ruissellement*] ... Living signifies for you not only the flows and fleeting play of light that combine in you, but the passing of heat and light from one being to another.[30]

In that passage the operation is described in increasingly fluid terms, to the point of becoming decidedly oceanic, as life is said to be transformed "from its empty and sad solidity to the happy contagion of heat and light as communicated by water and air," and each existence opens to "the contagion of a wave and its repercussions," whose unity is "as indefinite, as precarious as that of the agitation of the waters."[31]

Bataille is there again referring to the contagion of laughter, and by extension to the fusional experiences that for him constitute communication, or rather *communion* within a community. "Words, books, monuments, symbols, laughter are only so many paths to that contagion" in which "individual beings count for little and encompass unavowable points of view once one considers what gets animated, transferring from one to the other in love, tragic spectacles, moments of fervor."[32] But as we know from history, the precise history that was being written as Bataille was composing *Inner Experience* (1943), already presaged in *Blue of Noon*, communal fusion risks not just the dissolution of the community's individual members but their (re)coalescence as a homogeneous, monolithic and fascistic singularity. Bataille's own "Psychological Structure of Fascism" (1933) attempted to analyze that singularization in terms of a type of sublation by society of its inassimilable heterogeneous elements in the person of a dictator who is himself heterogeneous ("in opposition to democratic politicians, who represent in their respective countries the inherent platitude of homogeneous society, Mussolini and Hitler immediately stand out as wholly other"), without for all that showing any way out of that totemic attraction and the more or less morbid fascination that it entails.[33] The greatest politico-ecological threat resides precisely in an effervescence that preserves *contact* in a *communosphere* without *contagion*;

more precisely still in the absolute anthropocentrism of such homogeneous contiguity. For the pure congealed humanism of Nazism was precisely what allowed it to purge heterogeneous members of its communities by calling them sub- or nonhuman; and the dream of a distillation-in-effervescence rather than dissolution-in-excess was what tethered it to the homeostatic ideals of blood and soil. Bataille's community, on the other hand, is in the first instance a community of an-anthropomorphic "particles": among them "there is *some* this that forms here or there, each time in the form of a unity, but that unity doesn't persevere as such … it is riven by its profound internal division, it remains imperfectly closed and, at certain points, can be attacked from the outside."[34] Thus, even though he did not himself theorize the radical *inorganicity* of that outside, as we saw earlier following Derrida, it necessarily generalizes to include "the other, the inanimate, 'material nature,' as well as death, the nonliving, the nonpsychical in general, language, rhetoric, technics, and so forth."[35]

<center>* * *</center>

This discussion has turned around a paradigmatic ecological moment constituted by a "return to the earth." It can mean the fusional terrestrial appropriation that we have just seen, whose uniformed representatives move ominously from background to foreground in the closing episodes of *Blue of Noon*. But it can also return us to the terms of Dirty's and Troppmann's cemetery tryst, precisely the metonymy of their sex and the buried dead. The return to the earth of the dead by means of burial is generally assumed to be a particularly human approach to death, an assumption to which Derrida, for instance, declines to subscribe in *The Animal That Therefore I Am*.[36] But it would make sense, à la Bataille, to read in the burial of the soon-to-rot, soon-to-be-maggot-ridden corpse the heterological disavowal of life-in-decay that nevertheless also operates as a type of primary or even primal ecology. Death is where the house that is the body is seen most spectacularly and most repulsively to exceed its limits, being violated from outside, oozing and exploding from inside, given over to the unstoppable energy of teeming life. Of all that, sex can be only a pale simulacrum, try as we might to render it in its own way repulsive or spectacular.

But there is, in the messy aftermath of such a big death, a broad if not deep ecology, precisely in the sense of attending to what state of the ecosphere we leave behind. Each practice of disposal of the dead, from proverbial Inuit ice floe to Parsi towers of silence, to cremation and inhumation, necessarily amounts to an ecological ethics of the treatment of remains, understood as what returns to the earth, and as a concern for the state in which we leave the earth behind us. Bataille would want to interpret that within the perspective of his version of solar vitalism, which is what mobilizes the necro-eroticism that we have been tracing from the beginning: what returns most ethically to the earth, or the means by

which an ethical return to the earth is enacted, is determined by a practice of remains that somehow celebrates death as expenditure. The forms of festivity or reaffirmation of life that customarily accompany funerals—at least in the West—may or may not fall within such an ethics since they likely signify a return to, and triumph of the restricted economy whose safe circuits of exchange the affirmation of life all the way to death (by means of sex, laughter, other ecstasies, death itself) precisely wished to break open. The ecologico-ethical treatment of remains would, for Bataille, presumably involve some form of orgiastic contagion and communion that does not conform to the variety of taboos that codify and enforce the handling of a corpse. For at the very moment following death, the moment at which solar energy is about to take over and recycle a cadaver, to defile it with the pure force of nature, the dead body is socially homogenized more than ever, more than ever treated as intact and inviolable. In shocking contrast to that we can read Simone's sacrilege involving the eye of the murdered priest at the end of *Story of the Eye*; an orgy of desecration beyond the pale. If I am tempted to cite that indigestible scene in conclusion, as the inassimilable counterpoint to the Trier passage from *Blue of Noon* with which we began—never fear, I'll save us all the embarrassment, preserve us all from Bataille's extreme heteronomy[37]—it is in order to make this point: the ecology of death returns the corpse not just to the earth and to the sun. It turns it over to the other in the most general sense, beginning with its being handed over to the inanimate. In order for nature and the sun to turn it back into animating energy it must first be treated as a thing to be disposed of. That is what Derrida emphasizes in his long discussion of inhumation versus cremation, and the fear and fact of being buried alive, in *The Beast and the Sovereign*:

> Being dead, before meaning something quite different, means, for me, to be delivered over ... with no possible defense, after being totally disarmed, to the other, to others. And however little I know about what the alterity of the other or the others means, I have to have presupposed that the other, the others, are precisely those who might die after me, survive me, and have at their disposal what remains of me, my remains ... the other is what always might, one day, do something with me and my remains, *make me into a thing, his or her thing*.[38]

Being dead means not just being reanimated by the energetic forces of the universe in Bataille's sense; it also means being *deanimated*, reduced to an inanimate thing. A necessary ethical element of the treatment of our dead, along with respect for the human and respect for the earth, is a respect for the thing, recognition of the body's rupture into thingness. But that does not, of course, begin with death itself, no more than does becoming-a-thing-for-the-other. The little death of eroticism stages a similar passive objectification, even *inanimation*, as part of the general economy that we

sign on to when we invite the other to disrespect us in one form or another even as we presume that disrespect will stay within certain bounds. The necro-erotics of *Blue of Noon*'s cemetery scene includes important elements of such objectification: beyond the obvious metonymy of prostrate bodies and corpses, as well as the crass comparison between penetration and plowing the earth, lovemaking is initially described as a ten-step technical program [*les dix pas que font les amants*].[39] Similarly in *Story of the Eye*, Simone's nether-regional antics with the priest's eye, manifestly out of bounds, are nevertheless "permitted" to function within the structure of a general erotic economy, as Bataille realized. But any such excess—and there is no eroticism without excess—from plowed body to an eye as sex toy, functions as a prosthetization or technologization that is the general structure of the body's articulation with supposed external otherness, which necessarily includes the inanimate, the nonliving, the technological: technologizing and prosthetizing the very body that resorts to inanimate aids to living or to loving. As long as the human body's relation to its earthly environment remains the basis for ecology, then such an ecology will have to be understood to be fractured, within itself, by originary technicity. There is no return to the earth without that rupture of organicity, which renders the earth both teeming with animality to wallow in, and the scaffold life mounts over its own abyss.

Notes

1 Georges Bataille, "Le Bleu du ciel," in *Oeuvres complètes Vol. III* (Paris: Gallimard, 1971), 481, 482. Unless otherwise stated, translations from the *Oeuvres complètes* are mine. Citations from *Blue of Noon* adhere loosely to the Harry Mathews translation, but I have often modified it or transliterated to emphasize my point. Hence here:

> "Hastily, leaving the path for the plowed earth, we went through the ten steps that lovers take. We still had the graves below us. Dorothea opened wide, I bared her to the loins. She in turn bared me. We fell on the loose soil and I thrust myself into her wet body like a well steered plough thrusts into the earth. The earth under her body lay open like a tomb; her naked crotch lay open to me like a freshly dug grave. We were stunned, making love over a starry cemetery. Each of the lights stood for a skeleton in its tomb, and they formed thus a shimmering sky, as unsteady as the motions of our mingled bodies. It was cold. My hands sunk into the earth. I unbuttoned Dorothea, smearing on her underclothes and breasts the soft earth that stuck to me fingers ...
> I had to pull up my pants as best I could. I was standing up. Dirty stayed bare-assed on the dirt. She got up with difficulty, grasping one of my hands. She kissed my bare groin: dirt was sticking to my hairy legs, she scratched at it to remove it. She clung to me. She played between sly movements and grossly indecent ones. At first she made me fall

down. I had a hard time getting back up. I helped her to her feet. I helped her put her clothes back on, but it was difficult, our bodies and clothing covered in soil. We were no less excited by the earth than by the nakedness of our flesh." (Georges Bataille, *Blue of Noon*, trans. Harry Mathews [New York: Urizen Books, 1978], 144, 145).

Further references to *Le Bleu du ciel / Blue of Noon* will be indicated in footnotes, with the respective abbreviations *OC III* and *BN*.

2 Cf. Georges Bataille, "Note autobiographique": "The Democratic Communist Circle [directed by Boris Souvarine, Peignot's companion] ceased to exist in 1934. In that year Bataille experienced, following several months of illness, a serious moral crisis. He separated from his wife [Sylvia Maklès, who would take up with Lacan]. He then wrote *Blue of Noon*, which is in no way the story of that crisis but which is, without too much exaggeration, a reflection of it" (*Oeuvres complètes Vol. VII* [Paris: Gallimard, 1976], 461). Regarding Laure see Bataille, "Vie de Laure": "From the first day I felt there was complete transparency between her and me" (*Oeuvres complètes Vol. VI* [Paris: Gallimard, 1973], 278).

3 See the "Foreword" to *La Part maudite* in *Oeuvres complètes VII*, 23; and Notes to *Le Bleu du ciel* in *OC III*, 560. The latter Notes explain that the "Introduction" to *Le Bleu du ciel*, published separately in 1945, was taken from the lost manuscript W.-C., mentioned by Bataille in his posthumous *Le Petit* as the Preface to *Histoire de l'oeil* [*Story of the Eye*], his first published work (1928, under the pseudonym Lord Auch). W.-C. was written a year earlier, under the pseudonym Troppmann (see *OC III* 57–60).

4 *OC III* 487; *BN* 151.

5 *OC III* 482; *BN* 145.

6 These ideas receive extensive treatment in my *Dorsality* (Minneapolis: University of Minnesota Press, 2008), 102–29, and in *Inanimation: Theories of Inorganic Life* (Minneapolis: University of Minnesota Press, 2016).

7 *OC III* 486–7; *BN* 150–1.

8 Allan Stoekl, *Bataille's Peak: Energy, Religion, and Postsustainability* (Minneapolis: University of Minnesota Press, 2007), xiii. The arguments I am advancing here are greatly indebted to the logic of Stoekl's excellent book.

9 Georges Bataille, *L'Histoire de l'érotisme*, in *Oeuvres complètes Vol. VIII* (Paris: Gallimard, 1976), 152. Cf. Georges Bataille, *The Accursed Share Vols. II & III*, trans. Robert Hurley (New York: Zone Books, 1993), 177.

10 Stoekl, *Bataille's Peak*, 11. See Bataille's opening sentence to *L'Érotisme* (1957): "Of eroticism it is possible to say that it is the approbation of life all the way into death"; and later: "for us discontinuous beings, death has the sense of the continuity of being: reproduction leads to the discontinuity of beings, but it puts into play their continuity, which is to say that it is intimately linked to death"; "the horror of death is not only tied to the annihilation of a being, but to the decay that exposes dead flesh to the general ferment of life"; "A great deal of strength is required to perceive the link between the promise of life, which is the sense of eroticism, and

the luxurious aspect of death … Blindfolded as we are, we refuse to see that death alone ceaselessly assures the resurgence without which life would decline" (*Oeuvres complètes Vol. X* [Paris: Gallimard, 1987], 17, 19, 58–9, 62); cf. Georges Bataille, *Erotism*, trans. Mary Dalwood (San Francisco: City Lights Books, 1986), 11, 13, 55–6, 59.

11 "If one envisages human life on a global scale it aspires to prodigality to the point of anguish, *to the point of anguish, to the limit where that anguish is no longer tolerable.*" (Bataille, *Oeuvres complètes Vol. X, 63*; cf. Bataille, *Erotism, 60*)

12 Stoekl, *Bataille's Peak*, xvi.

13 Georges Bataille, "L'économie à la mesure de l'univers," *Oeuvres complètes Vol. VII*, 10.

14 *OC III* 395–6; *BN* 24.

15 Another version of the episode is found, in the context of explicit reference to Mozart's *Don Giovanni*, in *Inner Experience* (George Bataille, *Oeuvres complètes Vol. V* [Paris, Gallimard, 1973], 92–5; cf. *Inner Experience*, trans. Leslie Ann Boldt [Albany: State University of New York Press, 1988], 77–80).

16 *OC III* 454–5; *BN* 10–18.

17 *OC III* 468; *BN* 126.

18 Stoekl, *Bataille's Peak,* 142.

19 Francis Ponge, "The Mollusk," in *The Nature of Things*, trans. Lee Fahnestock (New York: Red Dust, 2011), 26; (cf. "Le mollusque" in *Le parti pris des choses* suivi de *Prôemes* [Paris: Gallimard, 1948], 50).

20 Emmanuel Levinas, *Totality and Infinity: An Essay on Exteriority*, trans. Alphonso Lingis (Pittsburgh: Duquesne University Press, 1969), 131–2, 152, 154, trans. modified (cf. *Totalité et infini* [Paris: Livre de poche, 1971], 139, 162, 164). That house is in turn defined as a feminine intimacy, and emerges as the basis of the ethics of the face-to-face. See my extended discussion in *Dorsality*, 53–61.

21 The ecology of sound was the topic of my paper at the Ecological Paradigm conference at Ruhr-Universität Bochum in January 2013. A version of that paper appears as "Positive Feedback: Listening behind Hearing," in *Thresholds of Listening*, ed. Sander van Maas (New York: Fordham University Press, 2015).

22 Aristotle, "De Anima," in *The Basic Works of Aristotle*, ed. Richard McKeon (New York: Random House, 1941), 602, 571.

23 Jacques Derrida, *Speech and Phenomena and Other Essays on Husserl's Theory of Signs*, trans. David B. Allison (Evanston, IL: Northwestern University Press, 1973), 82.

24 Cf. Jean-Luc Nancy, *Corpus*, trans. Richard Rand (New York: Fordham University Press, 2008), 128–9.

25 Jacques Derrida, *On Touching—Jean-Luc Nancy*, trans. Christine Irizarry (Stanford: Stanford University Press, 2005), 179, 180.

26 Georges Bataille, *Histoire de l'oeil*, in *Oeuvres complètes Vol. I* (Paris,

Gallimard, 1970), 58. Cf. *Story of the Eye*, trans. Joachim Neugroschel (San Francisco: City Lights, 1987), 68.

27 Stoekl refers specifically to the "contagious power, analogous to an electrically charged piece of metal that can transfer its energy—with a spark and a shock" of a taboo object in Durkheim and Mauss (*Bataille's Peak*, 18).

28 Bataille, *Oeuvres complètes Vol. I*, 55; *Story of the Eye*, 62.

29 Georges Bataille, *Le coupable*, in *Oeuvres complètes Vol. V* (Paris, Gallimard, 1973), 391.

30 Georges Bataille, *L'expérience intérieure*, in *Oeuvres complètes Vol. V*, 111; cf. *Inner Experience*, 94.

31 Ibid., 112–13; *Inner Experience* 95–6.

32 Ibid., 111; *Inner Experience* 94.

33 Georges Bataille, "La structure psychologique du fascisme," in *Oeuvres complètes Vol. I*, 348; cf. "The Psychological Structure of Fascism," in *Visions of Excess*, ed. Allan Stoekl (Minneapolis: University of Minnesota Press, 1985), 143. For further discussion of community in Bataille, and its relation to fascism, see Maurice Blanchot, *The Unavowable Community*, trans. Pierre Joris (Barrytown, NY: Station Hill Books, 2006), and Jean-Luc Nancy, *The Inoperative Community*, ed. Peter Connor (Minneapolis: University of Minnesota Press, 1991).

34 Bataille, *L'expérience intérieure*, in *Oeuvres complètes V*, 110–1; cf. *Inner Experience* 93–4.

35 Derrida, *On Touching*, 180.

36 Cf. Jacques Derrida, *The Animal That Therefore I Am*, trans. David Wills (New York: Fordham University Press, 2008), 5, 135.

37 Cf. Bataille, *Oeuvres complètes Vol. I*, 67–9; *Story of the Eye*, 83–4.

38 Jacques Derrida, *The Beast and the Sovereign*, Vol. II, trans. Geoffrey Bennington (Chicago: University of Chicago Press, 2011), 126–7, my italics. I discuss this question at length in Chapter 3 of *Inanimation*.

39 *Les dix pas que font les amants* suggests both a step-by-step program, and, as a play on *faire les cent pas*, which means to pace up and down distractedly or nervously, a type of automation.

Bibliography

Aristotle. "De Anima." In *The Basic Works of Aristotle*, ed. Richard McKeon. New York: Random House, 1941.

Bataille, Georges. *Blue of Noon*, trans. Harry Mathews. New York: Urizen Books, 1978.

Bataille, Georges. *Oeuvres complètes Vol. I*. Paris: Gallimard, 1970.

Bataille, Georges. *Oeuvres complètes Vol. III*. Paris: Gallimard, 1971.

Bataille, Georges. *Oeuvres complètes Vol. V*. Paris: Gallimard, 1973a.

Bataille, Georges. *Oeuvres complètes Vol. VI*. Paris: Gallimard, 1973b.

Bataille, Georges. *Oeuvres complètes Vol. VII*. Paris: Gallimard, 1976a.

Bataille, Georges. *Oeuvres complètes Vol. VIII*. Paris: Gallimard, 1976b.

Bataille, Georges. *Erotism*, trans. Mary Dalwood. San Francisco: City Lights Books, 1986.

Bataille, Georges. *Oeuvres complètes Vol. X*. Paris: Gallimard, 1987.

Bataille, Georges. *Story of the Eye*, trans. Joachim Neugroschel. San Francisco: City Lights, 1987.

Bataille, Georges. "The Psychological Structure of Fascism." In *Visions of Excess*, ed. Allan Stoekl. Minneapolis: University of Minnesota Press, 1985.

Bataille, Georges. *Inner Experience*, trans. Leslie Ann Boldt. Albany: State University of New York Press, 1988.

Bataille, Georges. *The Accursed Share Vols. II & III*, trans. Robert Hurley. New York: Zone Books, 1993.

Blanchot, Maurice. *The Unavowable Community*, trans. Pierre Joris. Barrytown, NY: Station Hill Books, 2006.

Derrida, Jacques. *On Touching—Jean-Luc Nancy*, trans. Christine Irizarry. Stanford: Stanford University Press, 2005.

Derrida, Jacques. *Speech and Phenomena and Other Essays on Husserl's Theory of Signs*, trans. David B. Allison. Evanston, IL: Northwestern University Press, 1973.

Derrida, Jacques. *The Animal That Therefore I Am*, trans. David Wills. New York: Fordham University Press, 2008.

Derrida, Jacques. *The Beast and the Sovereign, Vol. II*, trans. Geoffrey Bennington. Chicago: University of Chicago Press, 2011.

Levinas, Emmanuel. *Totalité et infini*. Paris: Livre de poche, 1971.

Levinas, Emmanuel. *Totality and Infinity: An Essay on Exteriority*, trans. Alphonso Lingis. Pittsburgh: Duquesne University Press, 1969.

Nancy, Jean-Luc. *Corpus*, trans. Richard Rand. New York: Fordham University Press, 2008.

Nancy, Jean-Luc. *The Inoperative Community*, ed. Peter Connor. Minneapolis: University of Minnesota Press, 1991.

Ponge, Francis. "Le mollusque." In *Le parti pris des choses* suivi de *Prôemes*. Paris: Gallimard, 1948.

Ponge, Francis. "The Mollusk." In *The Nature of Things*, trans. Lee Fahnestock. New York: Red Dust, 2011.

Stoekl, Allan. *Bataille's Peak: Energy, Religion, and Postsustainability*. Minneapolis: University of Minnesota Press, 2007.

Wills, David. "Positive Feedback: Listening behind Hearing." In *Thresholds of Listening*, ed. Sander van Maas, 70–88. New York: Fordham University Press, 2015.

Wills, David. *Dorsality: Thinking Back Through Technology and Politics*. Minneapolis: University of Minnesota Press, 2008.

Wills, David. *Inanimation: Theories of Inorganic Life*. Minneapolis: University of Minnesota Press, 2016.

CHAPTER TEN

Metafiction and general ecology

Making worlds with worlds

James Burton

We cannot produce that final adjustment of well-defined generalities which constitutes a complete metaphysics. But we can produce a variety of partial systems of limited generality. The concordance of ideas within any one such system shows the scope and virility of the basic notions of that scheme of thought. Also the discordance of system with system, and success of each system as a partial mode of illumination, warns us of the limitations within which our intuitions are hedged.

—ALFRED NORTH WHITEHEAD[1]

Herein lies the charm and the terror of ecology—that the ideas of this science are irreversibly becoming a part of our own ecosocial system.

—GREGORY BATESON[2]

Introduction

This paper attempts to think the relation between ecology and metafiction, not, primarily at least, in order to continue the task of resituating literature within the new media ecology, effectively pioneered—in quite different

ways—by Friedrich Kittler and Marshall McLuhan, and since taken up in a variety of projects, but rather in order to consider the more direct role of metafiction as a non-literary dimension of ecological thinking, specifically in terms of what may be called, with some qualification, their shared generalizing tendencies. Treating metafiction as ultimately a process or phenomenon that is not essentially literary does not mean, here at least, ignoring its emergence as a concept, critical tool and putative literary category or subgenre within the field of literary criticism; given the extent to which the imbrication of the general and the particular is at stake here, it would seem unwise to neglect a major local context of the emergence and study of metafictional processes. There is however no scope here for engaging in sustained readings of literary works: instead, I begin with a telescoped look at the literary-critical study of metafiction, in order to highlight both the broad cultural and theoretical potential it finds in the concept and its objects of study, *and* the way such study restricts this potential through the maintenance of a set of disciplinary, humanist, and critical boundaries.

Most crucially, these restrictions may be said to have given rise to a failure to think metafictively about metafiction. One of the central tasks of the thinking of general ecology, it seems to me, is, in parallel with the challenge of metafiction, to think ecologically about ecology (or the ways the study of ecology fosters ecological thinking), and to attend to the implications of this, both obvious and obscure. Thus I want to point here to some of the ways the thinking of general ecology might seek to avoid the traps encountered in the literary study of metafiction—which should, arguably, have given rise to a general engagement with fictionalizing and metafictionalizing but instead largely restricted itself to an account of the way this challenge was posed by certain literary works; and beyond this, to consider some of the ways ecological thinking, both in restricted and general(ized) contexts, must always already be considered metafictional—albeit in a sense which, as we will see, converges with a notion of reality-building or worldmaking—and what this may imply for its ongoing study and application.

It is worth noting at the outset, however, that the relationship between metafiction and general ecology is not just a parallel to be constructed or developed here: rather, it can be argued that these two phenomena are to a large extent conditioned by and participate in a shared set of historical-cultural and epistemological developments. Crucial among these would be the historical growth of the process of cyberneticization (which, as Erich Hörl notes in the introduction to this volume, precedes the emergence of cybernetics as a post-war research field, and is traceable back as far as the nineteenth century), and what Hörl, as discussed below, refers to as the "technological shifting of sense." Partly as a result of these trends, and partly informed in its various cultural sites of emergence by diverse local factors and concerns, we may point to a wide-ranging epistemological shift

across the twentieth century, manifest in different forms in different fields, away from the focus on an individual, system or object, towards a consideration of its relationship to its environment or context. One could trace an entire, interdisciplinary history of this shift towards more "environmental" perspectives from the mid-nineteenth century onwards, encompassing, variously: the emergence of ecological ideas in biological research and theory, following the impact of Darwinian theory and Ernst von Haeckel's introduction of the term *Oecologie*;[3] the shift away from the hermeneutics and analysis (or "practical criticism") of individual texts, artworks and other cultural products in favor of attending to their socio-cultural and historical contexts—and later, their technical / mediatic conditions; the numerous ways in which both governmental politics and political theory have been forced to expand any restricted focus on the internal situations of given nations or groups and approach their objects of interest from international and global perspectives; the general trend in psychology and psychoanalysis away from individual psyches to psycho-social processes; the various moves in philosophy beyond paradigms privileging subjects and objects as pre-given, stable entities, traceable in the emergence of process philosophy and vitalism at the turn of the twentieth century, and the explosion of relational ontologies at its end; and of course, the various strands of political-social environmentalism—the "ecological" movements in the most everyday sense—themselves.

One of the interesting features to arise from such a historical overview would be the overlaps in the ways that, in such areas and others, the movement towards a more environmental or ecological perspective seems to give rise to elements of self-reference and (self-)generalization, whereby, as the perspective is widened to encompass the environments, contexts, milieus or sets of relations surrounding and partially constituting particular objects or phenomena, the study itself along with its cognizing observers or thinkers are also recognized as part of those environments or milieus. Thus—again, to give some indicative, if cursory examples: philosophy must attempt to take into account its own conditions of (im)possibility, the effects and limitations arising from the human mind or being's own implication within its objects of study—whether in the sense of the Heideggerian *Destruktion* of ontology,[4] Derridean deconstruction, or any number of critical projects from François Laruelle's "nonphilosophy" to the variety of approaches recently dubbed "speculative realism";[5] biology, at least in certain areas, attempts to take into account the fact that biologists (their brains, organisms, the cognitive behavior through which the study is conducted) are also part of its object;[6] different branches of physics (not just quantum mechanics) attempt to understand and operate in light of the so-called observer effect, in which the observer (human or otherwise— e.g., in the form of a measuring instrument) has a nontrivial effect on the phenomenon under observation; critical and cultural studies, in a wide variety of areas (e.g., critical ethnography, postcolonial studies, feminism,

post-Marxist theories of power) attempt to negotiate the power relations and hierarchies implicit within their own academic and social relationships to the phenomena and subjects they discuss.

Within the sphere of literature, the appearance of metafiction would be one of the sites of this seeming tendency (if, indeed, it may be considered legitimate to see a tendency or pattern across such diverse areas of thought; such generalization is itself part of the task but also the risk of thinking in general ecological terms—as Bateson puts it in the above citation, both "the charm and the terror of ecology"). Yet at the same time, a consideration of the notion of metafiction as a process particularly illuminated within, but ultimately going far beyond certain literary and narratological domains, offers an opportunity to explore the ways in which this tendency towards self-reference and self-generalization that is bound up with environmental-izing shifts in perspective in various manifestations, is always already in some sense metafictionalizing. This is why this essay takes up metafiction as an object of potential significance to the thinking of general ecology.

Perhaps the most "general" of the many attempts that have been made to incorporate the observer / researcher / perceiving-producing agent into the systems and phenomena being observed / researched / engaged is the sphere of second-order cybernetics and systems thinking. As discussed by Hörl, again in this volume's introduction, systems theory (at least in its Luhmannian form, but under the influence of Humberto Maturana and Francisco Varela, and arguably other second-order thinkers such as Gregory Bateson)[7] can be understood as one of the early legible forms of an "ecological rationality," and thus a key strand of the burgeoning general ecological thinking. In his contribution to this volume, Bruce Clarke elaborates the importance of such thinking to the rise of the ecological movement, as a constitutive part of what he terms the "systems counter-culture." It would thus be both viable and productive to highlight the parallels and the convergences between metafiction and general-ecological thinking by using second-order systems theory, with its attentiveness to the blind spots that are necessarily built in to any self-referential observing system, as well as the essential role of constructivism that this entails. It would make perfect sense to use key terms in the lexicon of second-order systems thinking, such as the feedback of feedback and levels of (self-)observation, to (re)describe metafiction as "second-order fiction," fiction(alizing) about fiction(alizing). Indeed, there are now several works applying the implications of second-order systems thinking to literature, especially in terms of self-reference and autopoiesis;[8] and in works such as *Postmodern Metamorphosis* (2008) and *Neocybernetics and Narrative* (2014), Clarke has made major contributions to such a task, while tracing various of its wider implications for both cultural reality and interdisci-plinary thinking. As he writes elsewhere, metafiction's "foregrounding of paradox by narrative embedding, metalepsis, and *mise-en-abyme* are to postmodern narrative aesthetics ... what self-referential recursion and

system differentiation—the emergence of systems within systems—are to second-order systems theory."[9]

Though the possibility of such a redescription is both an implication of and an implicit influence on the account I give here, my choice not to follow this line explicitly in this particular chapter has two bases. First, especially given the context of this volume, in focusing on (self-)generalization, I hope to contribute to an understanding of the sense and role of the "general" in "general ecology"; and at the same time, to suggest that, if it can be argued that a (self-)generalizing tendency is endemic to ecological thinking, then the potential emergence of general-ecological thinking is always already germinal or incipient within it—and indeed subject to certain necessary constraints by virtue of this very fact. Second, as noted above, I want to point to the ways in which metafictionalizing may be considered a general mode of contemporary cultural thought, expression, practice, and one that is at least in some sense integral to (the thinking of) general ecology. Nevertheless, this role of the (meta)fictional, especially given the extent to which, as I argue below, it tends towards a coincidence with "world-making" or poiesis, means that it too may ultimately be fed back into a second-order systems discourse, in which autopoiesis plays a central role.

From generic to general metafiction

To link literature to ecology is no longer anything new: the rise of informational and media-sensitized paradigms and approaches to literary narratives, under the influence of such diverse figures as Marshall McLuhan, Michel Serres, and Friedrich Kittler, has led to the widespread recasting of literature within a contemporary media ecology (or multiplicity of such ecologies).[10] To an extent this approach—literature as information, as mediatically in-formed—has superseded and swallowed up the paradigm of metafiction, which was at its most prominent in literary criticism and theory in the late 1980s and 1990s. Though some of the insights and implications arising from analyses conducted through the lens of metafiction have now been taken up or reformulated in subsequent work, it is worth taking at least a brief look back at the metafictional approach in this period, for the potential it uncovered, but arguably failed to develop, regarding the wider, more general understanding of metafiction as an aspect of (post)modern culture, rather than a literary sub-genre or trend.

The term "metafiction" came into usage in the early 1970s, in reference to literary writing displaying certain characteristics—in particular, heightened degrees of self-consciousness and self-reference (in various senses), a foregrounding within the work of its status as fictional invention, the thematizing of and playing with the unstable boundary between fiction and reality, and the erosion of the distinction between literature / fiction

and criticism. Coinage of the term is generally attributed to William Gass,[11] though its adoption by Robert Scholes seems to have been equally important to its dissemination.[12] Other terms used before and since, such as "self-conscious fiction," "surfiction," "anti-fiction," overlap with the term's supposed meaning and have been applied to the same examples.[13] In French literary academia, the term *metatextualité* has been used in closely related contexts, in association with writing employing *mise en abyme*, the *nouveau roman* and other literary output sharing many of the convention-challenging strategies and themes which tend to be taken as typical of metafiction in Anglophone contexts.[14]

One of the most influential Anglophone texts in the field is Patricia Waugh's *Metafiction*.[15] Though rightly still regarded as a useful primer for the study of literary metafiction, Waugh's book epitomizes two broad limiting tendencies found in various critical engagements with metafiction: first, a tendency to focus on describing the workings and key features of supposedly metafictional writing, at the expense of inquiring into the possible historical and cultural reasons for its emergence; second, a tendency to restrict the scope and application of the term to written fiction—i.e., either to "literature," or to manifestations of a late twentieth-century mutation of / reaction against the literary tradition which would still be defined by their relationship to it—as Jonathan Culler puts it, to "works which, falling outside of established genres, would be treated as ... 'residual' literature."[16] Waugh posits a "sliding scale" of metafictionality, finding a "minimal form of metafiction" in novels which draw attention to the ways their characters "play roles," citing as examples Muriel Spark's *The Prime of Miss Jean Brodie* (1961) and John Barth's *The End of the Road* (1958), in which a character engages in "compulsive roleplaying" as a form of "mytho-therapy."[17] A stage up from this are novels in which characters seem to be aware that they are following a script pre-determined by someone else, and thus "implicitly draw attention to the fictional creation / description paradox" (120). Then there are categories of what Waugh sees as more radical metafiction—employing "forms of radical decontextualisation," rebuffing attempts to read them through naturalizing interpretation, and refusing to maintain any "stable tension" between fiction / illusion and reality / truth (136). Such categories are characterized by various forms of self-contradiction, paradox and the increasing incapacity of the reader to establish any stable frame of reference (e.g., ontological, epistemological, hermeneutic) for making sense of what they are reading, tending towards "total anarchy" through "intellectual overkill" at the extreme end of the scale (146).

Thus while Waugh considers a range of varieties of metafiction—from novels which "still implicitly invoke the context of the everyday world" to those which continually make radical shifts of context (115)—she never-theless confines its application to "fictional writing which self-consciously and systematically draws attention to its status as an artefact in order to

pose questions about the relationship between fiction and reality" (2). Her text remains predominantly a survey and description of a literary (or counter-literary) phenomenon. In this, it reflects the convergent interests of several literary studies scholars in the 1970s and 1980s, and, along with Linda Hutcheon's accounts of "historiographical metafiction," paves the way for a number of subsequent studies employing metafiction as a paradigm for reading (post)modern experimental writing.[18] Such accounts do not lose sight of the potential social functions of metafiction—indeed, critical readings carried out in their wake frequently emphasize the ethical implications and political effects of the works they study.[19] Yet even so, in such cases the focus remains, in the tradition of critical reading, primarily on how the writing achieves its effects—with an emphasis on critical description at the level of the individual writer or text, just as Waugh and Hutcheon offer critical descriptions of the field of metafiction at a more generic level.[20] In short, it is really poetics or literature, rather than the much broader category of fiction, which is at stake in such contexts.

Even where metafiction *is* recognized as a widespread contemporary phenomenon—one whose "ubiquity makes it impossible to see metafictional self-consciousness as an isolated and introspective obsession within literature"[21]—critical discussions have continued to focus on the literary manifestations of this phenomenon. Where metafiction is seen as revealing the instability between literature and criticism, literary narrative and history, language and reality, it is nevertheless usually the techniques and devices by which metafictive writing is able to bring about such revelations—rather than their implications—that are of primary concern.

Though these tendencies may be considered reasonable given the disciplinary contexts in which the discourses around metafiction emerged, they have the unfortunate effect of restricting the critical potential of the concept by confining it to the context of literature.[22] Effectively, they treat metafiction as shifting the terms and frameworks of interpretation, meaning, representation which are conventionally used to seek to understand a literary text, or indeed any phenomenon, textual, physical, social or otherwise—yet continue to approach their objects as though these frames remained intact, i.e., in a relatively traditional (albeit modern) form of hermeneutic literary criticism. In Erich Hörl's sense, many of the (anti-)literary texts considered metafictional may themselves be said to acknowledge and enact a "technological shifting of sense" (or of meaning) [*technologische Sinnverschiebung*].[23] Sometimes this may entail a thematic attentiveness to modern informational and technological processes and systems, seeming to filter through, as in Thomas Pynchon's *The Crying of Lot 49* (1966) or *Gravity's Rainbow* (1973), to the levels of narrative construction and content, displacing conventions of meaning and sense. Elsewhere, equivalent effects are produced through disrupting the conventional techniques and technologies of literary production, authorship, reading: John Barth's now classic *Lost in the Funhouse. Fiction for Print,*

Tape, Live Voice (1968) provides a wealth of examples, from "Menelaid"'s use of multiple quotation marks to indicate concentric narratological layers within layers, to "Life-Story"'s frequent invitations / demands that the reader "fill in the blanks" where information is omitted, to "Frame-Tale"'s transformation of the "codex" structure of the leafed book into the substrate-medium for an infinite, virtually content-less code, in the historically ancient (but perhaps also contemporary) sense highlighted by Kittler, according to which code itself literally means "displacement."[24] As Bruce Clarke writes, "framed narratives suggest the embedding of worlds within worlds," and stories within stories even more so, such that whatever sense they might make cannot be considered "independent of the medium."[25] Yet literary-critical accounts of metafiction, while acknowledging this shift away from hermeneutic and representational categories as necessitated by such works, seem to a large extent to have ignored its further implications in the modes by which they approach them: that is, their appreciation of the above-mentioned "creation / description paradox" does not extend to the level of their own criticism, which proceeds as though its objects could still reasonably be subjected to analysis within relatively conventional critical frameworks of representation, classification, and description. Even if for understandable, practical, and professional reasons, such approaches treat metafiction as though it could remain contained within a cage of "literature" whose extreme fragility it has already exposed.

It is here that we may identify a key aspect of the relationship between metafiction and general ecology. For what I have discussed so far as recognized traits of metafiction may be considered to amount, as I will shortly elaborate, to a tendency to generalize certain characteristics and modes inherent to fiction, that is, to expand its scope beyond the confines of "literature" or indeed any other frame or context in which it is operative. Such a tendency, I will argue, can be said to characterize ecology as both mode of being and mode of thought. But if the literary criticism of metafiction has been marked by a tendency (inadvertent or not) to curtail this generalization, the concept and thought of general ecology initially avoids making an analogous restriction, in seeking to outline an ecology of ecologies, ecology as a general, contemporary mode of thought and being, rather than as a descriptor for certain specific phenomena and localized fields of study. Yet at the same time, the task of thinking general ecology, of thinking ecology ecologically, faces what is in a sense an inverted version of the challenge and danger faced by literary studies of metafiction: for while it acknowledges as a starting-point the general-ecological character of our time, as something beyond any given discursive or epistemological account of a particular ecology, it may risk losing something of its own critical and creative potential if it loses sight of the way the generalizing tendencies it seeks to grasp, think and develop, are already immanent within those restricted ecological contexts which it seems to situate itself beyond. For as every restricted ecology possesses the potential for its own

generalization, so every image of general ecology necessarily retains its own particularities.

Generalization

In order to develop the above claim and set of concerns, it is worth first considering a little more carefully what kinds of "generality" and "generalization" are at stake here. I suggested above that, to a large extent, metafiction may be understood as characterized by a generalizing (or auto-generalizing) tendency. In the works of Borges and Pynchon, of Raymond Federman and Donald Barthelme, among many others, we observe what might be characterized as an aspiration, often seemingly belonging to the text or narrative itself, to enter or rejoin "the world at large," the world beyond literature and beyond fiction (narrowly proscribed)—not in the sense of providing an accurate representation of some dimension of "objective" social or political reality (in the sense of the realist novel) or an adequate onto-cosmological reflection of the world (as embodied in what Deleuze and Guattari named the "root-book")[26]—but in the sense of recognizing themselves as always-already part of that world, responding to, affected by, and shaping it, as part of it, whether in minor or major ways. Or, as Clarke puts it, "narratives connect to worldly systems not in their putative representational verisimilitude—especially if the narrative is fantastic, speculative, or science-fictional—but in the ways that, at their deepest levels of abstraction, they allow the construction of functional homologies to real processes of life, mind, and society."[27] Sometimes this entails characters and / or narrators becoming aware of their fictionalized status, as in Borges' "The Circular Ruins," where the protagonist's desire "to dream a man ... with minute integrity and insert him into reality" ends with the recognition that "he too was a mere appearance, dreamt by another."[28] Elsewhere, the book or characters seemingly attempt to interact with the narrator / author, as in Flann O'Brien's *At Swim-Two-Birds* (1939); or the story-text itself attempts to incorporate the reader within it, as in Willam H. Gass's *Willie Masters' Lonely Wife* and Italo Calvino's *If on a winter's night a traveller* (1979); or characters come to perceive the fictionalized nature of their world and attempt to cross the diegetic boundary to reach that of the reader, as in Philip K. Dick's *The Man in the High Castle* (1962).

This may be considered a generalizing tendency in that it constitutes, in various forms, an attempt to move beyond a particular perception of reality (e.g., that which is implicit in the construction of a narrative's diegesis) to a more general perspective that would encompass that local perception, along with a multiplicity of others. In other words, they seek to make their environment part of themselves, giving rise to new, larger system-environment couplings. As such, it is a tendency whose generalization may

theoretically be continued indefinitely: the terrible realization (though also relief) of Borges' wizard is one which his readers, as well as he as author, must supposedly countenance in relation to their own perceptions of reality, in which "The Circular Ruin" is "only" a short piece of fictional writing; and we may posit that any putatively godlike being for whom all of human life would have the equivalent ontological status and significance of a historical novel, a program running on a computer, or a cell culture in a laboratory Petri dish, might be subject to an equivalent subjective self-doubt, especially if prompted by observing it in her human subjects. Generalization is in this sense a means by which the diminished, the *minor,* is able to reach back up to, and affect, the augmented, the major—a means by which the insignificant makes itself significant. A narrative which observes or draws attention to the technological, psychological, social, ontological conditions of its own construction, almost inevitably invites consideration of the effects of such conditions on any perception of reality. By using the narrative's literal role in constructing the reality experienced by its character as a vehicle connecting different levels (intra- and extra-diegetic), a metafictional work generalizes the character's specific set of experiences, and at the same time renders them contiguous with the real—no longer considered as the world beyond the fiction, but as the world which constitutes and is partially constituted by that fiction.[29]

This characteristic can be said to approach what Clarke describes as "the contextual or holistic impetus in the best cybernetic thinking," whereby explanation is always sought by moving upwards through (in Bateson's phrase) the "hierarchy of contexts within contexts."[30] This proximity to (second-order) cybernetics should already alert us to the possibility that the same (not only analogous, but homologous) generalizing process may be found in the study and thought of ecology. In *Adventures of Ideas*, Whitehead suggests a distinction between two types of generalization belonging to science and philosophy respectively: whereas science, broadly conceived, draws "inductive generalizations" from "observation of particular occurrences," giving rise to ways of classifying things according to their functioning, philosophy places emphasis on the intuition of generalizations that aspire to "universal application."[31] Yet the kind of generalization involved in the thinking of general ecology, it seems, would need to be situated between these two, borrowing something from each: at first glance, it seems to arise through an intuitive effort, and is conceivably applicable (or connectible) to an infinite range of aspects of existence (though without going so far as to regard this as an aspiration to what Anglophone analytic philosophy terms "absolute generality," i.e., of the variety producing statements that are supposed to apply to "absolutely everything there is"[32]); yet at the same time, it seems unlikely that it could have become thinkable without the emergence of a wide range of particular, local, "restricted" ecologies. We might think of the generalization that characterizes its relation to these other ecologies, rather than as inductive

or universalizing, as "associative" or "relational." That is, the intuitions that give rise to something like the generalization of ecology seem often to appear in passing, alongside and *in connection with*, rather than as a logical consequence of, the study of particular ecological phenomena or contexts, or indeed in connection with projects belonging to seemingly different epistemological spheres entirely. In this, we might already recognize the specifically recursive nature of the generalization that is at work in ecological thinking—in that it is characterized by the modes of relationality and connectivity which it studies.

In contrast to the general ideas Whitehead identifies, which are firmly situated within the history of culture and thought—for example, slavery as a dominant and determining idea for classical Mediterranean culture, or freedom as having a thorough-going and determining influence on his own[33]—we would have to recognize that in the case of ecology, we are dealing with an idea that already in itself incorporates or implies something like a generalizing process, even, if not most vividly, in its most "restricted" contexts. The history of biological or zoological ecology is the history of the study and theorizing of the processes connecting an individual or organism to its wider environment. Though we might more often refer to such processes using terms such as extension, connectivity, environmentalization, they nevertheless entail an appreciation of the ways one localized situation is connected to and affected by a larger, more general sphere that contains it alongside and connects it with multiple other such localized situations. If, as Frédéric Neyrat suggests, the "principle of principles"— the "metaprinciple," we might say—of ecological thinking is "everything is interconnected,"[34] the pursuit of environmental connections will always be expansive, always a proto-generalizing tendency that moves any set of phenomena or system into relation with what is beyond the initial sphere of its observation or consideration.

Hence whenever one examines an account of such expansive, at least nominally generalizing tendencies at work in the phenomena observed within a particular sphere of restricted ecology, it is possible to observe these same tendencies effectively at work in the thinking that examines them. For example, Jakob von Uexküll's *Umweltforschung* thinks the individual organism in relation to the environment it innately constructs or selects from all physical possibilities, made up of those elements that are significant to it: "As the spider spins its threads, every subject spins his relations to certain characters of the things around him, and weaves them into a firm web which carries his existence."[35] In attributing to each type of creature its own world, Uexküll's schema seemingly restricts the environment to a local set of relations with a given individual, which he figures as a "soap bubble" in order to depict how "the spherical *Umwelt* circles around and contains the limits of each specific organism's life"[36]—yet situates the uncountable complex of connected soap bubbles as "a harmony composed of different melodic and symphonic parts" in which, through

their *Umwelten,* "organisms express themselves outwardly in the form of interlacing and contrapuntal relationships."[37] As Agamben puts it in *The Open,* from the postulation of an "environment as a closed unity in itself," and the "reciprocal blindness" among individual organisms or actors with their own closed environments, emerges a "paradoxical coincidence," among worlds that are at the perceptual level "absolutely uncommunicating" yet nevertheless "so perfectly in tune."[38] Uexküll's schema already implies a movement in the direction of a general ecology, in its recognition, for example, of the "highly contradictory" roles played by nature for the astronomer, the marine biologist, the chemist, the nuclear physicist compared to the student of air waves and the musician, the behaviorist compared to the psychologist: "Should one attempt to combine [nature's] objective qualities, chaos would ensue. And yet all these diverse *Umwelten* are harbored and borne by the One that remains forever barred to all *Umwelten.*"[39] The generalizing tendency continues today, as, following though by no means in direct lineage with the varying influences of Uexküll's thought on a range of later thinkers (including Heidegger, Merleau-Ponty, Deleuze, Agamben), the apparent closure of this broader harmonious system of nature as a whole is being broken down in turn and opened up to myriad other ecologies, not least among them ecologies of technology and media.

Thus from the starting-point of considering one restricted environment, we are invited to consider one that would have to be considered more general—with respect to the first, a kind of meta-ecology, though also simply an ecology in its own right. The thinking of ecology gives rise to ecological thinking, as the thought of any given environment leads to the thinking of others that go beyond and include it without being identical with it (including that thought itself). We could trace such a tendency in various more recent examples of ecological thinking—such as, to name just three of the more prominent, Gregory Bateson's ecology of mind or ideas, with its diverse application to "the bilateral symmetry of an animal, the patterned arrangement of leaves in a plant, the escalation of an armaments race, the processes of courtship, the nature of play, the grammar of a sentence, the mystery of biological evolution, and the contemporary crises in man's relationship to his environment";[40] Félix Guattari's "ecosophical" account of the interpenetration of social ecology, mental ecology and environmental ecology, which he refers to as a "generalized ecology";[41] or Lynn Margulis and James Lovelock's Gaia theory, which draws on insights from thermodynamics, cybernetics, and information theory in producing an account of the earth's atmosphere as regulated by life itself, and later by the whole earth system.[42]

Thus if we can conceive a "general ecology," it will always necessarily engender a generalizing tendency that is already operative within ecological thinking and ecological systems. Hörl's coinage of the term recalls Georges Bataille's opposition between a restricted and a general economy: at its simplest, the notion of general ecology thus indicates a thinking and

approach to ecology that would be beyond the concerns of the particular biological and environmentalist discourses and projects from which the term first acquired its scientific, political, and popular currency. Yet the implications of this are anything but simple, entailing nothing less than "a momentous redefinition of our entire objective condition and the place that we as subjects occupy therein ... a fundamental ecological reorientation of the mode of cognition and being, whose contours we are only just beginning to recognize."[43] If this theoretical or conceptual project first and foremost reflects (and invites us to recognize) an already ongoing, wide-ranging set of transformations of contemporary existence, under the effect of what Hörl calls our "technological condition" [*technologische Bedingung*]—transformations of the relations between humans and nonhumans, technology and culture, each and every identifiable system and its environment, every subject and object—then these changing conditions are no less significant for the task of thinking such transformations than they are for the transformations in themselves.[44] Thus in relation to general ecology, as in relation to metafiction, it seems we are dealing with a *particular* kind of generality, in that it must bear within it a recursive relation between the particular and the general.

For the same reason, if the notion of general ecology dispenses with the biological-environmentalist binding of ecology to a certain understanding or image of nature, it still does so to a large extent on the basis of this prior binding, whose salient features are not left behind in this move, but reincorporated, reconstituted and indeed reimagined: what a restricted ecology attempts to highlight in terms of the predetermining relation between organism and environment, humanity and the so-called natural world, or between biosphere, geosphere and atmosphere, general ecology attempts to highlight in terms of any and all such predetermining relations—indeed, in terms of the predetermining nature of relationality as such.[45] Thus if it implies a radically different notion of ecology from those in which ecology remains tied to a particular conception of nature, it also does so as a kind of extension of those restricted modes it seems to leave behind, paradoxically continuing their immanent tendencies towards their own outsides.

The poiesis of ecological thinking

One of the implications of this recursive generality is that, in Bateson's sense, and in the sense of Maturana and Varela,[46] no essential separation or discontinuity can be maintained between the thinking and the things thought (be they phenomena, processes, relations, systems, objects, organisms, environments, and so on). Furthermore, if in the case of ecology what is thought consists at least partially (and crucially) in the ongoing formation of new connections or relations, then the implications of this

for the thought of ecology ought to be taken into account, by a general ecology most of all. That is, if general ecology is to remain attentive to the "creation / description paradox" acknowledged and yet curtailed in studies of literary metafiction—here recognized as pertaining to any relation to reality or world, including and especially the general-ecological relation—it must grasp the productive, creative dimension of ecological thought, both in restricted or particular contexts, and in its own operations.

In order to better expose what is at stake in this challenge—and at the same time, to further develop the convergence of ecology and metafiction—it will be helpful to reflect on the ways such descriptive-productive processes must already be considered, at least in some sense, fictionalizing—though in the sense in which metafiction reveals all fictionalizing to be, to varying extents, worldmaking.[47] In their hyper-connected (ecosytemic) and hyper-connective (environmentalizing, rhizomatic) tendencies, both ecologies and the ecological thinking that seemingly borrows such characteristics from them, must be considered productive of world(s), of ever more and newer relations among things, and of ever more "things" emerging from the growth of relations. To separate such productivity into physical and perceptual (or material and ideal, real and fictional, concrete and imaginary) categories is only possible within older, representational paradigms which (general-)ecological thinking—in parallel with the general thinking of metafiction, and in the wake of a host of twentieth-century developments, from cybernetics to poststructuralism, from process philosophy to posthumanism, from hermeneutic to posthermeneutic literary, cultural, and media studies—necessarily attempts to move beyond.

There are numerous recent and contemporary thinkers to whom we might turn in order to support and develop the notion that fictionalizing is a constituent aspect of any consideration of or belief in reality—that any perception or notion of, or indeed, relation with anything that might be termed "world" should be considered something that is produced in that process—fictionalized not in the conventional sense (implying illusory, false, purely imagined, unreal), but in the metafictive sense which effectively erodes any form of fiction / reality distinction.[48] Nelson Goodman's *Ways of Worldmaking* concisely elaborates this process as immanent to (at least human) existence, without requiring either a return to purely idealist paradigms of philosophy, or having recourse to any of the various contemporary forms of social constructivism.[49]

By taking it as "hardly debatable" that there are many different, and somehow co-existent world-versions—and taking the question of "worlds-in-themselves" as "virtually empty" (4)—Goodman sets out to consider not "an ambivalent or neutral *something* beneath these versions but ... an overall organization embracing them" (5). He considers a number of ways in which we engage in worldmaking processes—such as taking-apart and putting-together existing perceived elements of worlds, "weighting" this or that element over others, or applying various modes of "ordering."[50] Salient

for us here in Goodman's argument is that these ways of worldmaking all involve making use of, or constructing from, aspects of existing worlds (those that we have already "built" or come to accept):

> The many stuffs—matter, energy, waves, phenomena—that worlds are made of are made along with the worlds. But made from what? Not from nothing, after all; but *from other worlds*. Worldmaking as we know it always starts from worlds already on hand; the making is a remaking. (6)

In this sense, worldmaking as what we might otherwise call fictionalizing—in everyday contexts the choice of the latter term generally connotes merely that a particular made world has not (yet) come to be habitually treated as real, a point I will expand on below—is already akin to metafiction. Our "worlds"—realities as we perceive them—are produced through a kind of poiesis—but one which is always working with the "many stuffs" on hand taken "from other worlds." This may also be viewed as a form of ecological productivity (it bears more than a little resemblance to the framework developed by Uexküll, whose argument regarding the constitution of *Umwelten* could be considered a "ways of worldmaking" oriented towards the animal as opposed to human organism, the harmonious arrangement of "soap bubbles" paralleling Goodman's "overall organization" relating multiple co-existent worlds). But if so, we would have to consider it characteristic of the ways not only "we" build worlds, but, in an era in which nonhuman, individuating and individuated constellations of all shapes and hues are recognized as active, productive, even creative forces, of the ways ecologies of various kinds themselves build new systems, new ecologies, out of existing ones. This may be exemplified in the media-ecolial operations of artistic production, intensified and heightened in the information era, as identified and explored by Matthew Fuller, among others.[51] But we could consider the ways all sorts of systems or collections of processes and phenomena we identify as ecological may display this property—continually re-making themselves through connections with other ecologies, which may seem to produce stasis much of the time (the stable ecosystem) but which may also allow new ecologies to form—even if they will only be recognized / observed to the extent that they are considered relevant / significant.

Goodman's framework has the virtue of allowing us to emphasize how worldmaking (effectively always in some sense a meta-worldmaking, in its constant employment of the "many stuffs" of other worlds to hand) coincides with (meta)fictionalizing, which is relieved of its conventional opposition to the real in the same degree (in fact, at the same stroke) as "world" is relieved of its association with the absolutely concrete or real. This means that fictionalized worlds, including those framed in narrative terms, or fleshed out in a particular medium, are worlds like any other—the only difference being our habitual tendencies to treat some worlds

or world-versions as more real than others: "for reality in a world, like realism in a picture, is largely a matter of habit."[52] This reference to habit might suggest (if only by a certain philosophical habituation) that in fact we needed to turn to no one more recent than David Hume in order to find a strong justification for such a position—though the Hume-version or Hume-world that would be most suited to this task is perhaps made more perceptible through the lens of Deleuze's reading.

The significance of Hume's *Treatise of Human Nature,* at least for Deleuze, lies in his highlighting of the roles of belief, affect and habit—but also, of the imagination—in the nature of reality as we perceive and understand it: every relation of cause and effect is fictionalized in the sense and to the extent that it is believed in and affects those beings which perceive it, despite having no absolute necessity which pure reason can access. The perception that the existence of one thing (e.g., an effect) depends on another (e.g., its putative cause) can be affirmed only through belief, which is accrued "by custom or a principle of association."[53] Or, as Deleuze puts it, "causality is *felt*. It is a perception of the mind and not a conclusion of the understanding."[54] But in addition to highlighting how Hume raises the question of the roles of relations, affect and belief as key elements of our existence, Deleuze also highlights, if seemingly in passing, a further aspect of importance for us here: the notion of a general idea—and specifically, the recursive form of generality that is at stake in such (perhaps all) non-rationalist thinking.

At the end of the first part of the *Treatise* (following his first treatments of relations, modes and substances) Hume provides an argument in support of Berkeley's position according to which "all general ideas are nothing but particular ideas annexed to a certain term, which gives them a more extensive signification, and makes them recall upon occasion other individuals, which are similar to them."[55] In Deleuze's account of Hume's "associationism," it is the easy passage among ideas, brought about by relations (one idea introduces another), substance and mode (several simple ideas combine to form a more complex one) and the general idea, which produce the mind (or "human nature") as a set of tendencies. But if, as Hume argues, any particular idea may take on the role of the general, and no idea is by itself intrinsically general, then every general idea must be considered as an instance of the recursive generality discussed above. More crucially for us, since relations are necessarily beyond the grasp of reason alone, and yet are perceived, they must in some sense be imagined: "Hume, in fact, observes that general ideas must be represented, but only in the *fancy,* under the form of a particular idea having a determined quantity and quality."[56]

If we apply this reasoning to the thinking of general ecology, the implication is that any image of the general ecology we construct will ultimately fall short of full generality by virtue of its own particularity. On the one hand, this may indicate that the general idea (of ecology) can never fully

dispense with the particular ideas from which it has arisen. On the other hand, to the extent that, through these processes, the thought of a general ecology *does* present something other than, beyond, or in excess of every restricted ecology, we would still have to recognize that every presentation of this thought will have its own particularity, will give rise to a particular image. No two presentations of this idea will be exactly alike, any more than two metafictions (or even two accounts of metafiction as a general idea, category or genre) will, as emphasized by the differences between Cervantes' and Pierre Menard's *Don Quixotes*.[57]

This should not be considered a flaw or impasse for the thinking of general ecology, however. For if the image or *representation* of a general idea has a particular form in the imagination, the *operation* of a general-ecological mode of thinking may consist in a constant or reiterative liberating of the generalizing potential in every such quasi-stable form. If every particular or restricted idea of ecology has a tendency towards (or at least, an immanent potential for) its own generalization—and if this generalization tends towards something which can only be thought, in some sense, through imagination—then the thinking of general ecology may, perhaps paradoxically, rediscover the generalizing tendency it seeks to grasp in the process of approaching, describing, producing, using each particular image of ecology—not only those of existing examples of (restricted) ecological thought, but in the particularity of its own general images.

Ecological metafictions

The thought of general ecology may thus be considered a metafictional mode of thinking in the sense that it retools a generalizing, worldmaking potential operative in any local ecology or its study (as literary metafiction rediscovers and illuminates the strange, boundary-crossing capacities of fiction per se), and extends this potential in the course of its own world-making activity.

Metafiction—understood now in terms of processes operative well beyond the sphere of literature, perhaps even central to our psychological and material existence—is not invoked here as the basis for a mode of relativist constructivism: in particular, the products of fictionalizing are seldom neutral. My concern with a generalized idea of metafiction, while seeking to move it beyond the restricted / restricting scope of literary criticism, is no less particular than any image of a general ecology (or of any "general" idea). While the idea of metafiction could be used to support a perspective aspiring to neutrality, whereby its main purpose would be to show that—and to help describe how—all reality is (all worlds are) produced through the fictionalizing (worldmaking) use of elements of existing fictions (worlds), for me at least, such a perspective

is only worth developing in connection with a consideration of the *kinds* of worlds we want. As Goodman puts it, "recognition of multiple alternative world-versions betokens no policy of laissez-faire. Standards distinguishing right from wrong versions become, if anything, more rather than less important."[58] Recognizing the ongoing, productive role of fictionalizing in any world is a first step towards actively engaging in worldmaking processes, and is arguably crucial in our dealings with the ecological.

We cannot embrace everything—every set of connections and relations, every putative emergent ecology—any more than we can track or observe it: nor should we want to, if we want to retain any political agency, as Neyrat's call for an "ecology of separation" in Chapter 3 of this volume makes clear; or as Steven Shaviro suggests, in parallel manner, in light of the contemporary tendency to see everything (computers, rainforests, intelligence, the capitalist economy) as a network, and under constant pressure to integrate oneself ever more fully in the network society, "the problem is not how to get onto the network, but how to get off."[59] To recognize that there is critical and political value in disconnection, separation, restriction in this context, it is enough to acknowledge that capitalism has its own general-ecological modes, as do the control society (e.g., as elaborated in Tiqqun's "cybernetic hypothesis"[60]), the network(ed) society, or the late modern global form of domination named "Empire" by Hardt and Negri.[61] Their ecological character is perhaps most discernible in their tendencies to connect with and encompass one another, even as they extend their reach ever further into the psychological, material, biological, and social structures of existence, whether we figure this in terms of Guattari's "integrated world capitalism"[62] or Foucault's biopower. The residual and recurrent particularism of every image or thought of general ecology, coupled with a grasping of its metafictional potential as a collection of worldmaking processes—grasping not simply in the sense of understanding, but of taking-hold, making ready-for-use—may well be crucial to its capacity to curb these other general-ecological proliferations, both "in the fancy" (at the level of its critical-epistemological engagement with them) and, by contiguous passage, in concrete, material existence and experience.

Examples from apparently restricted, nature-bound contexts of ecological thinking may reveal how metafiction has already played key roles in the strategic generalization of ecology in response not only to the threat of environmental disaster, but in light of numerous ongoing and long-established forms of political and social violence which operate ecologically, both through steering hyper-connective proliferation in particular directions, and by their imbrication with the processes of environmental change. For environmentalism can no longer be considered "purely" a question of nature, or even politics, in an era in which, as Michel Serres suggests, pollution (including pollution through noise and images, as well as in physical forms of waste and excrement) becomes a

means of activating "perfectly conscious and organized plans by owners for waging open war to invade the world and occupy space";[63] and in which, as Adrian Lahoud puts it, the struggle over an issue such as global carbon capacity becomes "in very real terms a war, but a war whose agents, weapons, and theater of operations bear little resemblance to the conflicts of the past."[64]

To take a concrete example, the *Whole Earth Catalog* of the late 1960s and 1970s can be understood as a metafictional enterprise aiming to counter a certain dominant image of a future global society rationally organized and efficiently managed through the application of technology and underpinned by faith in scientific progress. The *Catalog*'s famous cover image of the "Earthrise" photograph of the earth seen from space—for most people offering a radically new perspective—brought the planet as a fragile, interconnected, shared system into popular consciousness: yet this perspectival shift should be seen as a key element in the literal construction of a new fiction or world (following Goodman) through the reappropriation of central elements in the pre-existing fiction or grand narrative of scientific and technological progress—including space travel, military technology, and Cold War capitalist ideology. In discussing their recent exhibition on the influence of the *Catalog*, Diedrich Diederichsen and Anselm Franke highlight the ways this thinking, and the image, emerge from effectively the same paradoxical situation in which metafiction arises (i.e., that of being simultaneously inside and outside of a world or system, fostering aporetic modes of self-reference):

> DD: The image of a planet, just like a system, is something you watch from the outside. But at the same time you're also inside it. And this is the aporia of the system, because the system always tells us: you can't look at a system when you're part of it. But you're *always* part of it.
> [...]
> AF: ... whenever you look at or talk about this image, you are actually surfing a sort of schizo-meridian, a borderline between being part of it and being on the outside of it.[65]

The almost intrinsically metafictional situation of a particular ecological perspective—in this case, the human subject's self-observation as both within and outside the planetary ecology—gives rise to further metafictionalizing (or worldmaking) strategies. This is seen in the wealth of information, advertising and imagery contained in the *Catalog*, which continues the re-appropriation of the dominant elements of technocapitalism by offering the reader (or user) access to knowledge and tools, both practical and educational, that may allow her to participate in and foster an agriculturally attuned, self-sustaining way of life, "to conduct [her] own education, find [her] own inspiration, shape [her] own environment, and share [her] adventure."[66] In short, environmentalist concerns are already

imbricated here within questions of social and mental ecology in ways that anticipate Guattari's "ecosophy."

Instances of what may be considered strategic metafictionalizing in various (restricted—but generalizing) ecological contexts, even if not directly identified as such, are discussed in a number of essays collected in the recent volume *Forensis,* many of which attend to the complex interrelations between natural, technological and material environments in contexts of political and social violence.[67] For example, the metaphor of the "hole" in the ozone layer, as Eyal Weizman writes, though the product of meterological and geophysical observation and analysis, was "constructed as a concept and an image in order to call for action," and subsequently mobilized in debates against climate change skeptics' denial of the gradual depletion of ozone levels in the stratosphere.[68] Meanwhile, Paulo Tavares discusses the complex ecological, political, historical and legal circumstances surrounding the recognition, in Ecuador's new constitution of 2008, of the rights of nature.[69] The legal theory behind this development has its roots in Christopher Stone's argument, originally put forward in 1972, that, in light of the numerous "inanimate rights-holders: trusts, corporations, joint ventures, municipalities" which are recognized through the convention of "legal fictions" as "persons" or "citizens" for various "statutory and constitutional purposes,"[70] we should "give legal rights to forests, oceans, rivers and other so-called 'natural objects' in the environment—indeed, to the natural environment as a whole."[71] Following Ecuador, Bolivia's passing of the Law of the Rights of Mother Earth in 2010 actualizes this suggestion, combining the much older, mythologically inflected apostrophization of Nature with the modern legal technique of assigning personhood, in upholding the rights of Mother Earth as "a living, dynamic system composed of the indivisible community of all systems of life and living beings, interrelated, interdependent and complementary, that share a common destiny."[72]

Such examples may seem a far cry from the (residually) literary metafictions with which we began. One might argue that they constitute a rhetorical deployment of metaphor and imagery in ecological discourse that is closer to Hayden White's account of the narratalogical character of historical writing than to the strange, paradox-embracing, frame-shifting constructions of Borges, Pynchon, or Barth.[73] Yet they arise from and perpetuate the same deconstruction of fiction / reality, truth / illusion boundaries: the ozone layer and Mother Earth are *both* fictional and real phenomena, components of worlds which we are *both* inside and without. Furthermore, their acknowledgment of the complex, nonlinear relations which characterize ecological systems gives rise in post-Humean fashion not only to an appreciation of the roles of affect, belief, habit, imagination in the perception of (especially causal) relations, but to attempts to engage these roles in the mobilization of alternative world-versions against those habitually dominant in everyday perception or promoted by the grand

narratives of modernity.[74] If such complexities require relatively simplistic fictions in order to be rendered more conceivable and communicable, these are nevertheless underpinned by the deeper level of invested fictionality underpinning all perception of relations, which the thinking of general ecology both grasps and mobilizes in its own recurrent particular forms.

The generalization operating in the notion of general ecology moves it even further beyond the associations with nature which continue to characterize most of the ecological examples I have discussed here—which could be said to be "residually" natural in the way Culler, as noted above, described certain metafictional texts as residual literature. Yet among the present and future tasks of thinking the general ecology, it seems to me, is the challenge of recognizing these characteristics across ecological thinking, to produce a generalization of generalizations, a metafiction of metafictions—and at the same time to recognize that this in turn will never attain to absolute generality, to universality, but will always bring with it new blind spots, such that every image or thought of general ecology will have its own particularities, at various levels, from the historicity of its terminology and vocabulary, to the political and institutional contexts of its production, to its visualizations of possible current and future realities—its ways of worldmaking. The challenge is to activate this residual particularity as a worldmaking property—which is to say, reality-building, creative, metafictionalizing capacity—as opportunity rather than limit: to combine the recognition of the shapelessness enabling every shape, the processes and relations prior to every form, with the ongoing capacity to make shapes and forms, a capacity that is also an ineluctable necessity.

For if the idea of a general ecology, at least to some degree, shares the particularity of the restricted ecologies it considers, even as it seeks to move beyond them, extending their immanent potential for moving beyond their own epistemological and ontological milieus, and, further, acquires its own particularity in each image or reflection, this residual and recurrent particularity may ultimately form a valuable means of restricting—in a different sense—of reshaping and affecting, even if in minor ways, the forms of general ecology that are already exercising their worldmaking capacity upon us.

Notes

1 Alfred North Whitehead, *Adventures of Ideas* (1933; Harmondsworth: Penguin, 1972), 172.

2 Gregory Bateson, *Steps to an Ecology of Mind* (Northvale, NJ: Jason Aronson, 1972), 510.

3 See Ernst von Haeckel, *Generelle Morphologie der Organismen, Zweiter Band: Allgemeine Entwicklungsgeschichte der Organismen* (Berlin: Reimer,

1866), 286–9 ("Oecologie und Chorologie," Book 5, Ch. 19, XI). Haeckel defines *Oecologie* as the study of the relations of an organism to the surrounding exterior world [*umgebenden Aussenwelt*], taking account of its conditions of existence [*Existenz-Bedingungen*] in the widest sense (286).

4 Thus for Heidegger, "the destructuring [*Destruktion*] of the history of ontology essentially belongs to the formulation of the question of being" and "the problem of Greek ontology must, like that of any ontology, take its guideline from Dasein itself … that is, the being of human being." Martin Heidegger, *Being and Time*, trans. Joan Stambaugh (Albany: State University of New York Press, 1996 [1953]), 20, 22.

5 Indicative examples of these approaches and a diverse range of critical discussions of them can be found in Levi Bryant, Nick Srnicek, and Graham Harman, eds, *The Speculative Turn: Continental Materialism and Realism* (Prahran, Victoria: re.press, 2011).

6 Cf. Humberto Maturana and Francisco Varela, *The Tree of Knowledge: The Biological Roots of Human Understanding* (Boston: Shambala, 1998).

7 Piyush Mathur has argued, despite the paucity of direct references, for the influence of Bateson on Luhmann (which would in any case be traceable indirectly through their associations with Francisco Varela). See Piyush Mathur, "Gregory Bateson, Niklas Luhmann, and Ecological Communication," *The Communication Review* 11 (2008): 151–75, doi: 10.1080/10714420802068391.

8 See, for example, Joseph Tabbi, *Cognitive Fictions* (Minneapolis: University of Minnesota Press, 2002); Ira Livingstone, *Between Science and Literature: An Introduction to Autopoetics* (Chicago: University of Illinois Press, 2006); David Roberts, "Self-Reference in Literature," in *Problems of Form*, ed. Dirk Baecker, trans. Michael Irmscher with Leah Edwards (Stanford: Stanford University Press, 1999).

9 Bruce Clarke, "Systems Theory," in *The Routledge Companion to Literature and Science*, ed. Bruce Clarke and Manuela Rossini (Abingdon: Routledge, 2011), 221.

10 The essays collected in Joseph Tabbi and Michael Wutz, eds, *Reading Matters. Narratives in the New Media Ecology* (Ithaca, NY: Cornell University Press, 1997) offer a variety of examples of this broad approach, particularly as informed by influential works by Friedrich Kittler such as *Discourse Networks, 1800/1900*, trans. Michael Meteer with Chris Cullens (Stanford: Stanford University Press, 1992), and *Gramophone, Film, Typewriter*, trans. Geoffrey Winthrop-Young and Michael Wutz (Stanford: Stanford University Press, 1999). Marshall McLuhan has arguably had the most general and widespread influence in terms of the displacement of literary and related traditional humanities paradigms by categories pertaining to a wider media ecology (e.g., oral and print culture, electronic media, a range of technological modes of communication), in texts such as *The Gutenberg Galaxy: The Making of Typographic Man* (Toronto: University of Toronto Press, 1962) and *Understanding Media* (New York: McGraw Hill, 1964). Michel Serres' various engagements with literature in the five *Hermès* books, and subsequent works such as *Feux et signaux*

de brume: Zola (Paris: Grasset, 1975) and *Le Parasite* (Paris: Grasset, 1980) have been influential for the interdisciplinary study of literature and / as information, taken up, for example, by William Paulson in *The Noise of Culture: Literary Texts in a World of Information* (Ithaca: Cornell University Press, 1988) and *Literary Culture in a World Transformed: A Future for the Humanities* (Ithaca: Cornell University Press, 2001).

11 William H. Gass, *Fiction and the Figures of Life* (New York: Knopf, 1970). In an example of the combination of randomness and unexpected ordering that characterizes the multi-layered undermining of fiction / reality distinctions which this term denotes, and indeed their seemingly inherent tendency to multiply beyond the contexts of their initial deployment, we might note that Gass was born in the small North Dakota town of Fargo, whose name was borrowed by the Coen brothers for the title of their metafictional film *Fargo* (1996), which begins with the statement "THIS IS A TRUE STORY" and ends with the standard disclaimer that all its characters are completely fictional. None of the film was shot in Fargo, despite occasional incidental references in the narrative that suggest that this is where its events take place.

12 Robert Scholes, "Metafiction," *Iowa Review*, 1 (Fall 1970).

13 See Raymond Federmann, *Surfiction: Fiction Today and Tomorrow* (Athens, OH: Swallow Press, 1973); Robert Alter, *Partial Magic: The Novel as a Self-Conscious Genre* (Berkeley: University of California Press, 1975); Bruce Kawin, *The Mind of the Novel: Reflexive Fiction and the Ineffable* (Princeton: Princeton University Press, 1982).

14 Centre de recherche inter-langues angevin (CRILA), *Métatextualité et métafiction: Théorie et analyses* (Rennes: Presses Universitaires de Rennes, 2002).

15 Patricia Waugh, *Metafiction. The Theory and Practice of Self-Conscious Fiction* (London: Routledge, 1984).

16 Jonathan Culler, "Towards a Theory of Non-Genre Literature," in *Theory of the Novel: A Historical Approach*, ed. Michael McKeon (Baltimore: Johns Hopkins University Press, 1975), 52.

17 Waugh, *Metafiction,* 117.

18 See Linda Hutcheon, *A Poetics of Postmodernism: History, Theory, Fiction* (London: Routledge, 1988), 105–23. I would not want to give the impression that such critical and theoretical writing lacks interdisciplinary awareness: Hutcheon in particular applies a broad range of contemporary cultural theory and shows sensitivity to political and social issues in situating metafiction, among other facets of modern literary writing, within the context of postmodernism. My point is that, for whatever reasons, fiction, and with it metafiction, remain effectively reduced to literature in such discourses, rather than constituting a much larger set of processes that becomes particularly legible in literary contexts.

19 See, for examples, Bernd Engler and Kurt Müller, eds, *Historiographic Metafiction in Modern American and Canadian Literature* (Paderborn: Schöningh, 1994); Ulf Cronquist, *Erotographic Metafiction: Aesthetic*

Strategies and Ethical Statements in John Hawkes's 'Sex Trilogy' (Göteborg: Acta Universitatis Gothoburgensis, 2000); Christina Kotte, *Ethical Dimensions in British Historiographic Metafiction: Julian Barnes, Graham Swift, Penelope Lively* (Trier: WVT, 2001).

20 Hayden White's paradigm of "metahistory," influential for Hutcheon, may seem to offer the prospect of an extension of the implications of metafictionality into realms beyond literature as traditionally conceived, namely historical consciousness and narrative. However, I would suggest (though there is not the scope to develop such an argument in detail here) that while such an extension is to a degree implicit in his undermining of conventional separations of fact from fiction, reality and representation (in parallel with various structuralist and poststructuralist thinkers), his development of a "poetics of history" is ultimately more focused on the application of traditional categories of literary criticism to historical narrative than with the role of specifically metafictional thinking as something which, though arising within literature, implies and fosters the breaking down of such literary-critical categories and approaches. His is another, parallel and related particular or restricted conception of metafiction, though even in this it offers further indications of its potential generalization.

21 Mark Currie, ed., *Metafiction* (London: Longman, 1995), 2.

22 This combination of wider potential and disciplinary restriction may be considered parallel to, if not overlapping with the state of affairs identified by Bruce Clarke in narratological theory, which he sees as "well en route" to a more general systems theory, but held back by "a common stock of humanist tropes." Bruce Clarke, *Posthuman Metamorphoses: Narrative and Systems* (New York: Fordham University Press, 2008), 33.

23 Erich Hörl, "Die technologische Bedingung. Zur Einführung," in *Die technologische Bedingung: Beiträge zur Beschreibung der technischen Welt*, ed. Erich Hörl (Berlin: Suhrkamp, 2011), 11. The dilemma faced by the Anglophone reader, in deciding whether to treat the German *Sinn* as "meaning" or "sense," is effectively reflected in this shift itself, which sees the former dominance of hermeneutic paradigms giving way to a post-hermeneutic emphasis on the sensory and perceptual modes and effects of communication.

24 Friedrich Kittler, "Code, or, How You Can Write Something Differently," in *Software Studies: A Lexicon,* ed. Matthew Fuller (Cambridge, MA: MIT Press, 2008), 45.

25 Clarke, *Posthuman Metamorphoses*, 114.

26 Gilles Deleuze and Félix Guattari, *A Thousand Plateaus: Capitalism and Schizophrenia*, trans. Brian Massumi (Minneapolis: University of Minnesota Press, 1987), 5.

27 Clarke, *Posthuman Metamorphoses*, 35.

28 Jorge Luis Borges, "The Circular Ruins," trans. James E. Irby, in *Labyrinths: Selected Stories and Other Writings* (New York: New Directions, 1964).

29 Thus in its seeming transcendence of its own conventional limitations, this generalizing tendency of (literary) metafiction engenders a kind of radical immanence. Numerous parallel gestures might be identified in modern philosophical thought—perhaps the most stringent and committed in the non-philosophy of François Laruelle, which, under a certain, if largely and strategically negated, poststructuralist influence, attempts to reject every philosophical "decision" as the establishment or reinforcing of philosophy's privileged separation from the Real, recognizing itself as nothing more nor less than an immanent aspect of reality. See François Laruelle, *Principles of Non-Philosophy,* trans. Anthony Paul Smith and Nicola Rubczak (London: Bloomsbury, 2013); John Mullarkey and Anthony Paul Smith, "Introduction: The Non-Philosophical Inversion: Laruelle's Knowledge Without Domination," in *Non-Philosophy: An Introduction,* ed. John Mullarkey and Anthony Paul Smith (Edinburgh: Edinburgh University Press, 2012).

30 Bruce Clarke, *Neocybernetics and Narrative* (Minneapolis: University of Minnesota Press, 2014), 55. Clarke cites Bateson, *Steps,* 402 ("Cybernetic Explanation").

31 Whitehead, *Adventures of Ideas,* 169–70.

32 Agustin Rayo and Gabriel Uzquiano, "Introduction," in *Absolute Generality*, ed. Agustin Rayo and Gabriel Uzquiano (Oxford: Oxford University Press, 2006), 1.

33 The shift in dominance from the first to the second can be said to be the basis for the emergence of what Lyotard identifies as a determining metanarrative of modernity, "humanity as the hero of liberty." See Jean-François Lyotard, *The Postmodern Condition: A Report on Knowledge,* trans. Geoffrey Bennington and Brian Massumi (Manchester: Manchester University Press, 1984), 31.

34 Frédéric Neyrat, "Elements for an Ecology of Separation," Ch. 3 this volume, 101.

35 Jakob von Uexküll, "A Stroll Through the Worlds of Animals and Men: A Picture Book of Invisible Worlds," in *Instinctive Behavior: The Development of a Modern Concept,* trans. and ed. Claire Schiller (New York: International Universities Press, 1957), 14.

36 Brett Buchanan, *Onto-Ethologies: The Animal Environments of Uexküll, Heidegger, Merleau-Ponty, and Deleuze* (Albany: State University of New York Press, 2008), 23.

37 Ibid., 25–6.

38 Giorgio Agamben, *The Open: Man and Animal,* trans. Kevin Attell (Stanford: Stanford University Press, 2003), 41–2.

39 Uexküll, "A Stroll Through the Worlds," 76–80.

40 Bateson, *Steps,* 1.

41 Félix Guattari, *The Three Ecologies,* trans. Ian Pindar and Paul Sutton (London: Athlone, 2000), 41, 52.

42 James Lovelock and Lynn Margulis, "Atmospheric Homeostasis by and for the Biosphere: The Gaia Hypothesis," *Tellus* XXVI (1–2) (1974).

43 Erich Hörl, "The Technological Condition," trans. Anthony Enns, *Parrhesia* 22 (2015): 1–15, at 7.

44 Cf. Erich Hörl, "A Thousand Ecologies: The Process of Cyberneticization and General Ecology," in *The Whole Earth: California and the Disappearance of the Outside,* ed. Diedrich Diederichsen and Anselm Franke (Berlin: Sternberg Press, 2013), 127: "these unnatural ecologies … have begun not only to bring about the far-reaching ecologization of sense-culture, but are also furthering the ecologization of the critical theory which accounts for them, and necessitating a general ecologization of thought."

45 "If one thing has become clear, it is that the new sense of sense … involves a radically different experience and therefore a renegotiation of the meaning of relation and reference as such." Erich Hörl, "Other Beginnings of Participative Sense Culture: Wild Media, Speculative Ecologies, Transgressions of the Cybernetic Hypothesis," trans. Anne Ganzert and James Burton, in Mathias Denecke, Anne Ganzert, Isabelle Otto, and Robert Stock, eds, *ReClaiming Participation* (Bielefeld: Transcript, 2016), 114.

46 Maturana and Varela, *The Tree of Knowledge.*

47 The apparent circularity of this statement (worldmaking processes are fictionalizing processes because fictionalizing processes are worldmaking processes) is not intended to obfuscate, but ultimately to point to a single underlying type of process, in a sense a general *poiesis,* which manifests in various forms of imaginary and concrete, technical and psychical production, these being distinguished largely according to intellectual habit and cultural convention.

48 We might think of this as a placing of "fiction" and its terminological variants under erasure, or a returning of fiction to its etymological roots in the Latin *fingere,* meaning to form, mould, construct.

49 Nelson Goodman, *Ways of Worldmaking* (Indianapolis: Hackett, 1978).

50 See ibid., 7–17 for this account in full.

51 Matthew Fuller, *Media Ecologies: Materialist Energies in Art and Technoculture* (Cambridge, MA: MIT Press, 2007).

52 Goodman, *Ways of Worldmaking,* 20.

53 David Hume, *A Treatise of Human Nature* (1738; Oxford: Clarendon, 1896).

54 Gilles Deleuze, *Empiricism and Subjectivity: An Essay on Hume's Theory of Human Nature,* trans. Constantin V. Boundas (New York: Columbia University Press, 2001), 26.

55 Hume, *Treatise of Human Nature,* 17. Cf. Deleuze, *Empiricism and Subjectivity,* 25: sometimes an idea "becomes capable of representing all these ideas with which, through resemblance, it is associated (general idea)."

56 Deleuze, *Empiricism and Subjectivity,* 25.

57 See Jorge Luis Borges, "Pierre Menard, Author of the *Quixote,*" in *Labyrinths: Selected Stories and Other Writings* (New York: New Directions, 1964).

58 Goodman, *Ways of Worldmaking*, 107.

59 Steven Shaviro, *Connected, or What it Means to Live in the Network Society* (Minneapolis: University of Minnesota Press, 2003), 3–5.

60 Tiqqun, "The Cybernetic Hypothesis." Available online: http://cybernet. jottit.com (accessed May 18, 2014).

61 Michael Hardt and Antonio Negri, *Empire* (Cambridge, MA: Harvard, 2000).

62 Guattari, *Three Ecologies*, 47 and *passim*.

63 Michel Serres, *Malfeasance*, trans. Anne-Marie Feenberg-Dibon (Stanford: Stanford University Press, 2011), 60.

64 Adrian Lahoud, "Floating Bodies," in *Forensic. The Architecture of Public Truth*, ed. Forensic Architecture (Berlin: Sternberg/Forensic Architecture, 2014), 496–7.

65 Ana Teixeiro Pinto, "The Whole Earth: In Conversation with Diedrich Diederichsen and Anselm Franke," *e-flux* 45 (May 2013).

66 Stewart Brand, ed., *Whole Earth Catalog* (Fall 1968), 2.

67 Forensic Architecture, ed., *Forensic. The Architecture of Public Truth*. (Berlin: Sternberg/Forensic Architecture, 2014).

68 Eyal Weizman, "Matter after Memory," in *Forensis*, ed. Forensic Architecture, 367. Seth Denizen, "Three Holes: In the Geological Present," in *Architecture in the Anthropocene. Encounters Among Design, Deep Time, Science and Philosophy*, ed. Etienne Turpin (Ann Arbor: Open Humanities Press, 2013).

69 Paulo Tavares, "Nonhuman Rights," in *Forensis*, ed. Forensic Architecture.

70 Christopher Stone, *Should Trees Have Standing? Law, Morality, and the Environment*, 3rd edn (Oxford: Oxford University Press, 2010), 1–2.

71 Ibid., 3.

72 *Ley Corta de Derechos de la Madre Tierra*, Bolivian Plurinational Legislative Assembly Law 071, Article 3 ("Madre Tierra").

73 Hayden White, *Metahistory: The Historical Imagination in Nineteenth-Century Europe* (Baltimore: Johns Hopkins University Press, 1975). Cf. my note 20 above.

74 If the language here is reminiscent of Lyotard's *petits récits* in contrast to the metanarratives of modernity, which each have their own metafictionalizing (worldmaking) structures, this should perhaps serve as a further indicator of the precarious path the thinking of general ecology must take, and of the importance of its cultivation of residual forms of particularity (and by implication, difference, dissensus). See Lyotard, *Postmodern Condition*. If there is an easy slippage from a minor generalizing tendency to a major, absolute or general universalizing category, it is perhaps reflected in the proximity of the senses of *meta-* in metafiction (reflexive, about, "working upon") and metanarrative (overarching, dominating).

Bibliography

Agamben, Giorgio. *The Open: Man and Animal*, trans. Kevin Attell. Stanford: Stanford University Press, 2003.

Alter, Robert. *Partial Magic: The Novel as a Self-Conscious Genre*. Berkeley: University of California Press, 1975.

Bateson, Gregory. *Steps to an Ecology of Mind*. Northvale, NJ: Jason Aronson, 1972.

Borges, Jorge Luis. "Pierre Menard, Author of the Quixote." In *Labyrinths: Selected Stories and Other Writings*, 36–44. New York: New Directions, 1964.

Borges, Jorge Luis. "The Circular Ruins," trans. James E. Irby. In *Labyrinths: Selected Stories and Other Writings*, 45–50. New York: New Directions, 1964.

Brand, Stewart, ed. *Whole Earth Catalog* (Fall 1968).

Bryant, Levi, Nick Srnicek, and Graham Harman, eds. *The Speculative Turn: Continental Materialism and Realism*. Prahran, Victoria: Re.press, 2011.

Buchanan, Brett. *Onto-Ethologies: The Animal Environments of Uexküll, Heidegger, Merleau-Ponty, and Deleuze*. Albany: State University of New York Press, 2008.

Centre de recherche inter-langues angevin (CRILA). *Métatextualité et métafiction: Théorie et analyses*. Rennes: Presses Universitaires de Rennes, 2002.

Clarke, Bruce. *Posthuman Metamorphoses: Narrative and Systems*. New York: Fordham University Press, 2008.

Clarke, Bruce. "Systems Theory." In *The Routledge Companion to Literature and Science,* ed. Bruce Clarke and Manuela Rossini, 214–25. Abingdon, Routledge, 2011.

Clarke, Bruce. *Neocybernetics and Narrative*. Minneapolis: University of Minnesota Press, 2014.

Cronquist, Ulf. *Erotographic Metafiction: Aesthetic Strategies and Ethical Statements in John Hawkes's 'Sex Trilogy'*. Göteborg: Acta Universitatis Gothoburgensis, 2000.

Culler, Jonathan. "Towards a Theory of Non-Genre Literature." In *Theory of the Novel: A Historical Approach*, ed. Michael McKeon, 51–6. Baltimore: Johns Hopkins University Press, 1975.

Currie, Mark, ed. *Metafiction*. London: Longman, 1995.

Deleuze, Gilles and Félix Guattari. *A Thousand Plateaus: Capitalism and Schizophrenia*, trans. Brian Massumi. Minneapolis: University of Minnesota Press, 1987.

Deleuze, Gilles. *Empiricism and Subjectivity: An Essay on Hume's Theory of Human Nature*, trans. Constantin V. Boundas. New York: Columbia University Press, 2001.

Denizen, Seth. "Three Holes: In the Geological Present." In *Architecture in the Anthropocene: Encounters Among Design, Deep Time, Science and Philosophy*, ed. Etienne Turpin, 29–46. Ann Arbor: Open Humanities Press, 2013.

Engler, Bernd and Kurt Müller, eds. *Historiographic Metafiction in Modern American and Canadian Literature*. Paderborn: Schöningh, 1994.

Fargo [Film]. Dir. Joel Coen and Ethan Coen. United States: Polygram Filmed Entertainment, 1996.

Federmann, Raymond. *Surfiction: Fiction Today and Tomorrow*. Athens, OH: Swallow Press, 1973.

Forensic Architecture, ed. *Forensis: The Architecture of Public Truth*. Berlin: Sternberg/Forensic Architecture, 2014.

Fuller, Matthew. *Media Ecologies: Materialist Energies in Art and Technoculture*. Cambridge, MA: MIT Press, 2007.

Gass, William H. *Fiction and the Figures of Life*. New York: Knopf, 1970.

Goodman, Nelson. *Ways of Worldmaking*. Indianapolis: Hackett, 1978.

Guattari, Félix. *The Three Ecologies*, trans. Ian Pindar and Paul Sutton. London: Athlone, 2000.

Hardt, Michael and Antonio Negri. *Empire*. Cambridge, MA: Harvard, 2000.

Heidegger, Martin. *Being and Time*, trans. Joan Stambaugh. Albany: State University of New York Press, 1996 [1953].

Hörl, Erich. "A Thousand Ecologies: The Process of Cyberneticization and General Ecology." In *The Whole Earth: California and the Disappearance of the Outside*, ed. Diedrich Diederichsen and Anselm Franke, 121–30. Berlin: Sternberg Press, 2013.

Hörl, Erich. "Die technologische Bedingung: Zur Einführung." In *Die technologische Bedingung: Beiträge zur Beschreibung der technischen Welt*, ed. Erich Hörl, 7–53. Berlin: Suhrkamp, 2011.

Hörl, Erich. "The Technological Condition," trans. Anthony Enns. *Parrhesia* 22 (2015): 1–15.

Hörl, Erich. "Other Beginnings of Participative Sense Culture: Wild Media, Speculative Ecologies, Transgressions of the Cybernetic Hypothesis," trans. Anne Ganzert and James Burton. In *ReClaiming Participation,* ed. Mathias Denecke, Anne Ganzert, Isabelle Otto, and Robert Stock, 91–119. Bielefeld: Transcript, 2016.

Hume, David. *A Treatise of Human Nature,* 1738. Oxford: Clarendon, 1896.

Hutcheon, Linda. *A Poetics of Postmodernism: History, Theory, Fiction*. London: Routledge, 1988.

Kawin, Bruce. *The Mind of the Novel: Reflexive Fiction and the Ineffable*. Princeton: Princeton University Press, 1982.

Kittler, Friedrich. "Code, or, How You Can Write Something Differently." In *Software Studies. A Lexicon*, ed. Matthew Fuller, 40–7. Cambridge, MA: MIT Press, 2008.

Kittler, Friedrich. *Discourse Networks, 1800/1900*, trans. Michael Meteer with Chris Cullens. Stanford: Stanford University Press, 1992.

Kittler, Friedrich. *Gramophone, Film, Typewriter*, trans. Geoffrey Winthrop-Young and Michael Wutz. Stanford: Stanford University Press, 1999.

Kotte, Christina. *Ethical Dimensions in British Historiographic Metafiction: Julian Barnes, Graham Swift, Penelope Lively*. Trier: WVT, 2001.

Lahoud, Adrian. "Floating Bodies." In *Forensis: The Architecture of Public Truth*, ed. Forensic Architecture, 495–518. Berlin: Sternberg/Forensic Architecture, 2014.

Laruelle, François. *Principles of Non-Philosophy*, trans. Anthony Paul Smith and Nicola Rubczak. London: Bloomsbury, 2013.

Livingstone, Ira. *Between Science and Literature: An Introduction to Autopoetics*. Chicago: University of Illinois Press, 2006.

Lovelock, James E. and Lynn Margulis. "Atmospheric Homeostasis by and for the Biosphere: The Gaia Hypothesis." *Tellus* XXVI (1–2) (1974): 1–10.

Lyotard, Jean-François. *The Postmodern Condition: A Report on Knowledge*, trans. Geoffrey Bennington and Brian Massumi. Manchester: Manchester University Press, 1984.

Maturana, Humberto and Francisco Varela. *The Tree of Knowledge: The Biological Roots of Human Understanding*. Boston: Shambala, 1998.

McLuhan, Marshall. *The Gutenberg Galaxy: The Making of Typographic Man*. Toronto: University of Toronto Press, 1962.

McLuhan, Marshall. *Understanding Media*. New York: McGraw Hill, 1964.

Mullarkey, John and Anthony Paul Smith. "Introduction: The Non-Philosophical Inversion: Laruelle's Knowledge Without Domination." In *Non-Philosophy: An Introduction*, ed. John Mullarkey and Anthony Paul Smith, 1–18. Edinburgh: Edinburgh University Press, 2012.

Paulson, William. *Literary Culture in a World Transformed: A Future for the Humanities*. Ithaca: Cornell University Press, 2001.

Paulson, William. *The Noise of Culture: Literary Texts in a World of Information*. Ithaca: Cornell University Press, 1988.

Pinto, Ana Teixeiro. "The Whole Earth: In Conversation with Diedrich Diederichsen and Anselm Franke." *e-flux* 45 (May 2013).

Rayo, Agustin and Gabriel Uzquiano. "Introduction." In *Absolute Generality*, ed. Agustin Rayo and Gabriel Uzquiano, 1–19. Oxford: Oxford University Press, 2006.

Roberts, David. "Self-Reference in Literature." In *Problems of Form,* ed. Dirk Baecker, trans. Michael Irmscher with Leah Edwards. Stanford: Stanford University Press, 1999), 27–45.

Scholes, Robert. "Metafiction." *Iowa Review* 1 (Fall 1970): 100–15.

Serres, Michel. *Feux et signaux de brume: Zola*. Paris: Grasset, 1975.

Serres, Michel. *Le Parasite*. Paris: Grasset, 1980.

Serres, Michel. *Malfeasance*, trans. Anne-Marie Feenberg-Dibon. Stanford: Stanford University Press, 2011.

Shaviro, Steven. *Connected, or What it Means to Live in the Network Society*. Minneapolis: University of Minnesota Press, 2003.

Stone, Christopher. *Should Trees Have Standing? Law, Morality, and the Environment*. 3rd edition. Oxford: Oxford University Press, 2010.

Tabbi, Joseph. *Cognitive Fictions*. Minneapolis: University of Minnesota Press, 2002.

Tabbi, Joseph and Michael Wutz, eds. *Reading Matters: Narratives in the New Media Ecology*. Ithaca, NY: Cornell University Press, 1997.

Tavares, Paulo. "Nonhuman Rights." In *Forensis: The Architecture of Public Truth*, ed. Forensic Architecture, 554–72. Berlin: Sternberg/Forensic Architecture, 2014.

Tiqqun. "The Cybernetic Hypothesis." Available online: http://cybernet.jottit.com (accessed May 18, 2014).

Uexküll, Jakob von. "A Stroll Through the Worlds of Animals and Men: A Picture Book of Invisible Worlds." In *Instinctive Behavior: The Development of a Modern Concept*, trans. and ed. Claire Schiller, 5–80. New York: International Universities Press, 1957.

Waugh, Patricia. *Metafiction: The Theory and Practice of Self-Conscious Fiction.* London: Routledge, 1984.

Weizman, Eyal. "Matter after Memory." In *Forensis: The Architecture of Public Truth*, ed. Forensic Architecture, 361–80. Berlin: Sternberg/Forensic Architecture, 2014.

White, Hayden. *Metahistory: The Historical Imagination in Nineteenth-Century Europe.* Baltimore: Johns Hopkins University Press, 1975.

Whitehead, Alfred North. *Adventures of Ideas.* 1933. Harmondsworth: Penguin, 1972.

CHAPTER ELEVEN

An ecology of differences

Communication, the Web, and the question of borders

Elena Esposito

Environments of systems

The debate about ecology, as we understand it here, has a specific history that separates it from the rather organicist discourse concerning the relationship of living beings with their environments (since the second half of the nineteenth century). Ecology deals with the environment, but here we look to a generalization and an abstraction of the concept that have been emerging more recently (since the 1950s). We speak of general ecology. And we look for a sharper problematization of the idea of environment—not as a "given," to which an organism or system must adapt, but as a multi-faceted and flexible reference, which changes with the way it is observed and with the perspective of the observer.

In this sense, the environment is not an assumption, it is a problem. It is not the environment in itself (a notion which doesn't make much sense), but the environment of someone or something. There are many environments, and one has to specify to which one is referring. In our discourse on general ecology the environment is a multiplicity of environments that are intertwined and complement each other, where you look for reliable (although presumably neither final nor stable) references—not only the natural environment, but also the social environment, the psychological environment (or the billions of environments of the different minds), the environment of machines and the machines in the environment, the media environment, and so on. Which environment includes all these environments, and from what vantage point can we observe it?

A reference model is often found in Gregory Bateson's reflections on Mind and its relationship with Western epistemology, developed within systems theory and cybernetics.[1] It is not by chance that these reflections were developed in the very creative context of the Macy Conferences and of the seemingly disparate issues addressed there: from feedback mechanisms to perception, from neural networks to memory, to learning, to communication and many other topics.[2] In fact all these problems and the ways they are dealt with, even in their diversity, rely on some common underlying issues, which formed the background of all discussions during the Conferences. These issues continue to qualify reflection on ecology, and it will be useful to briefly recall them.

First the question of *borders*, which has always been the crucial issue of systems theory. The concept of system itself was intended to identify specific objects able to dynamically interact with the environment—systems that produce a continuous exchange of materials and energy with the outside world (inputs and outputs).[3] This exchange, however, presupposes a distinction: what becomes open? Input and output from what? How can you detect the identity of a system under or through such continuous processes of exchange? To study openness you first have to find a way to indicate what it is that is open (this being the system that the theory is named after)[4]—or more specifically the boundary that determines what's in and what's out. As indicated by the controversial debate on autopoiesis since the 1980s, the issue is far from trivial.[5]

The second question of the ecological approach is the problem of *control*: how is the relationship between inside and outside regulated, how do exchanges proceed? Is it possible to indicate, in a non-arbitrary way, how the processes constituting the system and its environment operate? As we know, these questions gave rise to cybernetics, founded explicitly as the science of control in all possible areas (in animals and machines, according to Wiener's original formulation in 1948)—an understanding of control that quickly formulates it as an issue of communication. How can internal processes influence external ones and vice versa? What kind of contacts can exist between the two sides of the border?

The fascinating (and extremely fruitful) response of the time was the concept of *feedback*, which retains the whole complexity of the problems but provides operational indications. The ingenuity of feedback is that the boundary is assumed in order to be neutralized—the separation serves to indicate the forms in which the operations of the system make it fluid and allow for a constant, reciprocal influence between inside and outside. But the separation must exist, otherwise there could be no influence and everything would get lost in indeterminacy. Think of the thermostat, the classic example of feedback, which works very well to keep the room temperature adjusted and presupposes the distinction between the machine, with its programming, and the environment, with its temperature. It starts with a separation. But it's not a univocal relationship: is it the thermostat that

controls the room or the room that controls the thermostat?[6] Does the thermostat, which gives indications, result in the temperature of the room, or is it the room that triggers the thermostat (which is activated when the room temperature drops below a certain threshold)? The question remains open, and with it appears the indeterminacy of the ecological approach: the separation between system and environment is needed in order to study their interrelations, not to neutralize them.

In cybernetics, control does not have the purpose of canceling differences (making the aim coincide with the end)[7] but of multiplying them.[8] The linearity of the traditional interpretation of causality folds into a complex series of circular relationships, and it was exactly these which interested the heterogeneous participants in the Macy Conferences, and from which the ecological approach begins.

The double loop of cybernetic objects

Let us return to our primary topic. What has changed since the Macy Conferences? Why do we feel the need to expand the approach to a "general ecology"? Beyond the origin of the concept, when today in daily communication we speak of cybernetics we do not refer primarily to control or to the Greek *kybernētēs*—rather, we first think of computers. This is not really a distortion, not only because computer science is an indirect result of the same context, but also because the architecture of computer systems is itself an application of the concept of feedback in complex hierarchies of intertwined loops.[9] In this sense, however, the situation is more complicated, and requires a revision of the basic concepts, including the issue of borders.

Over the past few decades, but more clearly in recent years, the focus has shifted from the single computer to the connection, from the isolated machine to the web. We had the transition to the Web 2.0 and maybe to the semantic web, the explosion of social networks, the spread of cloud, of smartphones and tablets, of the Internet of Things and of smart environments: all are developments that call into question the simple distinctions between the computer and its environment and between machine and user. The consumer of media content, as we know, is at the same time the producer of content (prosumer), while the information processed by the machine is often produced by the network itself. With complex procedures of data mining and profiling, the "intelligence" elaborated by the system seems to be distributed outside and inside its borders, in the system and in its environment.

In this transformation, the classic loop of feedback circuits becomes a double loop—and as such, much more complex and difficult to deal with. The observer observes a system facing its environment, and discovers himself to be involved in the object he observes: the web user gets

information from the network, which also depends on the user's own search for information and has a corresponding form—a different user would get different information, and in general all available information depends on the fact that there are people looking for information (we will return to this circularity later). The observation of feedback between the environment and the system produces a second feedback circuit between the observer and his object. The interaction with the web imposes in practice the model of *second-order cybernetics*,[10] in which an observer observes a world that not only operates circularly, but to which he himself belongs, and he knows it. How can the ecological approach account for this complexity and produce a correspondingly complex concept of environment?

It is not surprising that the spread of the web and of various complicated forms of mediated communication increased the level of interest in a series of concepts (or quasi-concepts) that try to reflect this condition: that is, a confrontation with quasi-objects that are at the same time inside and outside, natural and human, technical and social, presupposed and constructed. For example, the term "dispositif": a heterogeneous ensemble made of material objects, philosophical and moral discourses and social institutions.[11] Or consider Callon's socio-technical devices and Latour's "hybrids": human and nonhuman agencies beyond the opposition between nature and society, revealing a technological reality that is at the same time as immediate as nature and as constructed as society and language.[12] Keeping in mind the question of environment, we could say that there is an increasing interest in concepts that seem to consider this new condition of reflection and exchange between the environment and the system, where the system can be found in the environment and the environment seems to penetrate to the interior of the system.

Although not always explicitly declared, all these examples deal with the problem of defining and observing the distinction system / environment and its forms (which is in my understanding the basic problem of every ecology).

Usually one starts by questioning the idea of system, maybe replacing it with concepts that seem more flexible, like network. The borders are opened to allow it to include entities that previously seemed to belong to the environment: typically nonhuman entities like machines, artifacts, bodies, but also animals or institutions. Inside the network what is considered an actor is what works as an actor: persons and social groups, devices and technological objects. "Actors are network effects."[13] Actor and network are mutually constitutive: the network exists in its elements and its elements cannot act outside it.[14] This is why the human or nonhuman nature of the elements (actors) makes no difference, because there is no reference to any external instance: neither the subject, nor society, neither nature nor God—everything is reconstructed a posteriori.[15]

The same step, however, could be taken in a symmetrical fashion in reference to the environment, which also loses its "distinctness" and is

permeated by the system. The Internet of Things indicates a new mode of ambient intelligence, which appropriates a typical feature of systems (specifically of consciousnesses). In becoming agents, animated or inanimate objects alter their nature and enter into a different relationship with the system (or network) that defines them—the environment itself becomes part system, the objects become part subjects. Hence one could thus also start by questioning the concept of environment.

Maybe, however, one should take a different approach, and this could be the real reason for the recent interest in ecology and in the complex debates of the 1940s and 1950s, with their attention to borders and their consequences: to start not from one of the sides of the distinction (system or environment) but from the distinction itself. Here general ecology comes into play, which I understand as reflection on the difference system / environment and its transformations, with all their consequences—for example the issues of second-order cybernetics with its double feedback. Is this reflectivity in the environment or in the system (in nature or in society, in the network or outside it)?

Hybridization and double contingency

This decision, which I will elucidate in the following pages, has very precise consequences. For example, it requires a strategy opposite to the popular approach of actor-network theory (ANT),[16] which, faced with new forms of circularity in the relation between system and environment, chooses to blur the distinction and start from mediators (hybrids) in order to reconstruct the way in which the two poles (natural and social) are the result of a typical modern "purification."[17] This blurring would be the starting point, not the evolution of the distinction. I propose instead to make the opposite choice: don't blur the distinction but radicalize it, sharpen it, so you can use it even in circular and reflective configurations. Only if you are able to indicate clearly what's in and what's out, what belongs to the system and what is part of its environment, will you also be able to study the complex forms produced when the inside reflects the outside and vice versa.

One then has to deal with forms of re-entry in the sense of Spencer Brown,[18] which show the ability of a distinction to admit even the distinction inside itself, without losing its determination. This entails a situation in which a system has such a strong identity and distinctness from the environment that it can also reflect upon its distinction from the environment without getting confused. In this case the environment re-enters the system as observed object, but the system knows that what re-enters is only its own reference to the environment, not the environment per se (even and precisely when it deals with it as something autonomous and independent).

This ability allows for the study of complex circular configurations (like the current medial landscape) considering the subjective side of objects and vice versa (the intelligence of the environment or the materiality of the system)—but not because they are hybrid entities that are at the same time subjects and objects, internal and external. On the contrary: it can deal with them precisely because it's so clear what is inside and what is outside that you can also consider how the two sides affect and reflect each other.

In order to do this, however, the approach of cybernetics and systems theory needs to be extended to the study of society and its forms. Only in reference to society, as we will see, does the issue of the openness / closure of a system's borders acquire a clear operative reference. It is not individuals that are inside and outside society at a given time. Society is not made of individuals and can therefore accomplish its specific form of closure.

This step, together with the theoretical developments of recent decades, needs to clarify some points that were already present in Bateson and in the debate of the 1950s, in particular the distinction between different levels of system. Bateson proposed an articulation in terms of individuals, societies, and ecosystems, each with their own homeostatic cycles and all gathered together in the higher cybernetic system originating the ecological issue: the Mind or the overall comprehensive system (or ambience).[19] The relationships between the various levels would be governed by a hierarchy of logical types modeled on Russell and Whitehead's type theory.[20]

We know now that the double feedback of second-order cybernetics inevitably leads to an entangling of the hierarchy of logical types, producing paradoxes and undecidability. But the underlying problem is a different one. Bateson's model provides for a sort of encapsulation of various types of systems (and environments): individuals are combined into societies that give rise to ecosystems, in an overall ordering that goes all the way up to an all-encompassing system that collects them all. The sociological approach requires much sharper attention to the differences and to the necessary separation between levels: by empirical observation it is not realistic to think that individuals are part of society, or even that their relationships could be collected in a supreme order. This is Luhmann's sharp and much disputed decision, which also has great importance for our ecological problems.[21]

In the approach of social systems theory, individuals (psychic systems or consciousnesses) each have their own environment that also includes society, but are themselves in the environment of society: the relationship between the two levels is not one of inclusion but of mutual exclusion. There is no broader environment including the smallest environments: the environments are all different and strictly speaking incompatible. Society is not made of individuals: individuals are outside society, and due to this separation are indispensable for its operations. Society is made of communications that do not coincide with the thoughts of the participating individuals, although they require that there are individuals thinking about what is communicated (said, read, broadcast).[22]

The meaning of communication is not what people think, which remains their exclusive and incommunicable property (made by their history, their experience, their unique and unrepeatable perspective on the world)—it is something different, allowing each participant to interpret communication in his own way, getting information which the speaker did not have in mind and which differs from that of any other participant (including when communication is successful). The separation between individual systems and between different types of system is very clear, and this (rather than an alleged confusion of boundaries) explains the evolution of increasingly complex and unlikely forms of organization.

The key concept for explaining the emergence of communication from a nebula of thoughts that remain separate and directly inaccessible is *double contingency*, initially formulated by Talcott Parsons.[23] Double contingency describes the encounter between two black boxes (individuals) that remain opaque to one another, but depend on each other and know it (each also knowing that the other party knows it).[24] Ego and Alter are both contingent, meaning that they are free to decide their own behavior (they can do or not do something, or do something else), but double contingency occurs because the contingency of the one reflects the contingency of the other and conditions it. Double contingency does not mean here simple contingency multiplied for the number of systems involved, but the circular condition in which the possibilities of each one depend on the possibilities of the other one, who is in the same condition—contingency duplicated inside itself. So a condition of indeterminacy arises because nobody has the information necessary to decide: "I do what you want, if you do what I want"—and of course nobody does anything.[25] A typical paradoxical condition arises, in which one side of a distinction refers to the other one and vice versa, in an oscillation which makes decision and action impossible.

Actually, however, pure double contingency is never experienced. The only possible transparency, and the starting point for putting in motion a social dynamic, is generated not because everyone knows what the other thinks and wants (an unrealistic and even disturbing perspective), but because each knows that the other, like them, decides what to do depending on the behavior of its counterpart. It starts from dependency. That something happens (a greeting, a communication, a gesture) is enough to create an engagement both can refer to, initiating a dynamic of mutual influence. An order arises in which the selections of a partner circularly depend on the selections of the counterpart; that is, each acts in referring to the other, without a need to know what the other thinks or wants.

Communication is the operation which practically (not conceptually) solves double contingency, giving rise to a new dynamic whereby each communication is followed by a further communication which in turn generates other communications. Luhmann explains in this way the emergence of a new level of system (a social system made of communications) from the mutual intransparency of partners—from the inaccessibility

of their thoughts and from the incomparability of the reciprocal environments. The system of communications will have its own environment, which in turn will be different from that of the participants and incomparable with it (as shown by the fact that communication can go on with minimal participation, even if the individuals do not express many of their thoughts and feelings).

Like ANT, this approach allows the possibility of nonhuman agencies. Indeed, it relies on an even more radical anti-humanism,[26] because independence from human meaning is not the exception but the rule. The reference to the "human" aspect (the sense intended by individuals) never explains the sense of communication, which processes its own information and produces its own sense, the latter being open to being understood by others in ways completely different from the initial meaning intended by the issuer. This makes possible all kinds of nonhuman agencies, if and insofar as they contribute to the production of a communicative sense circulating through the operations of the system and producing further communications. If in ancient societies natural phenomena like lightning or the burning of a bush were seen as divine communication, the corresponding objects actually acted as agents in the circuit of communication: one could communicate with bushes or through the flight of birds. Today our society (the system of communications) normally does not contemplate the possibility of communicating with God through natural objects—but deals with hybrids and socio-technical devices. As ANT maintains, it is communication that decides who and what acts as an agent, depending on their ability to activate a condition of double contingency.

Communicating with machines

The question that remains open is how this approach can be used with reference to the issues we face today: does the concept of communication based on double contingency allow us to usefully explain today's forms of internet-mediated intelligence? Does it facilitate explanations of the production of information by agencies relating to machines or other technological constructs? And does it help to clarify our ecological problems? Does it require a blurring of the boundary between society (made of communication) and (smart) objects in its environment?

What happens when, in communication, there is a computer, which by its nature is and must be a machine that does not know randomness, uncertainty, and contingency? The computational and operational advantages of computers are connected directly to the fact that they are machines processing a particular kind of object (data), but operating as machines, hence not on the basis of meaning but on the basis of algorithms—no matter how complex, flexible and capable of a specific form of learning.

From neural networks and genetic algorithms to the semantic web, computers have also simulated their own mode of evolution, changing programs depending on the sequence of operations and apparently incorporating unpredictability and uncertainty.[27]

But the latter is still a "domesticated" version of uncertainty—an unpredictability predicted and anticipated by programmers, even if they don't know in detail the form it can take at any given time. It is a kind of extrinsic uncertainty, applicable for an observer who cannot anticipate the changing behavior of a machine over time, but not for the machine, which always decides in a completely determined way. Its unpredictability has been envisaged in its initial set-up. As von Foerster already noted, a historical machine can be absolutely unpredictable, but is no less determined.[28] Computers do not know uncertainty, and can therefore perform calculations and computations with a speed and efficiency that were unthinkable for a consciousness, which is always burdened by contingency, by possibilities and by meaning—but also capable of operating in ways inaccessible to a machine that remains determinate (albeit in a very complex way).

What kind of communication can be realized with a machine of this kind, which develops and produces complex and structured information, but only knows data? Can computers really communicate? It is clear that communication with a computer can be enormously informative for the user, who can even develop an emotional and affective relationship with digital devices. Sherry Turkle looked at the kind of attachment that children and elderly people appear to display toward "robotic pets" such as Furby or Aibo, which respond appropriately to external stimuli, need care, and develop their relationship with the user depending on how they are treated.[29] The user clearly communicates with the device—much more doubtful is whether the device communicates with the user.

What we can observe is an unprecedented unilateral communication, which produces its own form of contingency, sufficient to evolve the relationship but devoid of the circularity of double contingency. The contingency of Ego duplicates in communication, but not because Alter (the device) is authentically contingent, rather because it has learned to absorb, reflect and elaborate the contingency projected by the user. The digital object "feeds" on the contingency of the user and returns it (to him or to others) in an elaborate, unrecognizable, and always surprising form. In this version of contingency the behavior of the counterpart will be endlessly unpredictable, because it absorbs the inexhaustible unpredictability and variety of the behavior and perspective of the users.

What the user is interacting with through digital technology is his own reflected and revised contingency. In a sense the user communicates with himself in an unrecognizable and surprising form—but he does not face the complexity of authentic double contingency, with its paradoxes and its openness. We can talk of a form of *virtual contingency* that like virtual reality is not simply a fake reality (and the computer is not a fake

consciousness).[30] It produces a true alternative reality, but needs an original reality projected in it (just as the reflection in a mirror, the first example of virtuality, needs objects to reflect).[31] The computer acts as an alternative partner only if genuine partners (communication participants) provide their contingency and allow the machine to process it in its unpredictable forms.

This applies at the individual level (Turkle's robotic toys), but also and especially at the communicative level, where it produces the huge variety and specific forms of web intelligence. Indeed, one could say that the authentic novelty of the Web 2.0 (and presumably of 3.0) is not so much personalization, but rather the inclusion and use of virtual contingency, which "feeds" on user contributions and actively exploits them to increase its own complexity—and also the efficiency of communication. In the Internet of Things and in ambient intelligence the network becomes enormously clever, and in this sense it is plausible to see it as the outcome of decades of Artificial Intelligence projects, starting with the Dartmouth Conference and the prophetic visions of Vannevar Bush,[32] but precisely because it gives up, consciously or not, the idea of building a machine that is itself intelligent.[33]

Artificial intelligence on the net does not imitate human intelligence: it doesn't understand but calculates, doesn't interpret but reflects, doesn't remember but records. It is able to take advantage of the computing capability of machines to multiply contingency, acquiring its own structures—and thus an unprecedented form of intelligence, based on the fact that machines work in a different rather than similar way to humans. According to its inventor, the world wide web makes human improvization (contingency) coexist with the operations of machines (computation).[34]

More concretely: where does virtual contingency operate in the Web 2.0? Can we observe specific examples of this form of complexity processing? We find them first in the practices of "googlization":[35] tools that solve in a seemingly counter-intuitive way the classic problem of "information overload" generated by the contrast between the (limited) human forms of information processing and (virtually unlimited) availability of data. Google's amazing effectiveness relies on its ability to transform the classic problem of information overload into an advantage, exploiting virtual contingency: when the amount of data grows, the engine works better, not worse. The PageRank algorithm notoriously bases the classification of sites on the number and relevance of links made by the users: Google "feeds" on the past selections of users in order to orient present selections.[36] The more selections there are, the more the classification is refined—a quantitative and computational mechanism that is radically different from the human modes of selection of information, which nevertheless allows human users to sort information. Basically the search engine does not select anything (it does not have its own intelligence), but combines and multiplies the selections made by users, obtaining a kind of logic that it applies to the network as a whole.

But there is not only Google. Filters have such a central role in the web that some observers consider them its defining feature: according to Anderson we are leaving the "Information Age" to enter the "Recommendation Age," whose central issue is not the ability to get information (always available and always in excess) but to know how to select it.[37] These filters are all of a cooperative and collaborative type—that is, they are based on the user's behavior, which is reflected and elaborated in order to selectively orient the subsequent behavior of the user.[38] The mechanism can be voluntary (as when users spontaneously produce evaluations and reviews, e.g., on Amazon or on TripAdvisor), but in most cases is automated: a communication is derived from users' choices, yet the users did not mean to communicate anything. Google works this way, but so do Amazon's algorithms, suggesting books based on the similar choices of other readers, who never meant to make recommendations, and especially the wide variety of sources of the Internet of Things (mobile phones, GPS navigators, supermarket loyalty cards and many more). The "machine learning" used in the techniques of profiling (for commercial, legal or other purposes) is based mainly on "ex-post" models in order to establish patterns of correlation in data:[39] it acquires from the web the schemes that are used to scour the web. The most effective filters are "post-filters" that were not designed by anyone and do not try to predict users' behavior, but direct it by registering past behavior, reflecting it and amplifying it.[40] They direct contingency without knowing it, reflecting the contingency of users.

Reflexive environment

These are complex and fascinating issues. But we must return to our topic: what are the consequences for ecology and its generalization? How can the study of the relationship between system and environment adequately take account of these developments?

In this dynamic of mutual reflection between double contingency and virtual contingency, a form of communication (or quasi-communication) is realized, one which doesn't imply any hybridization: subjects increasingly operate as subjects and objects as objects, and this radicalization of the difference produces a specific form of intelligence. Not only do programs explicitly give up on the idea of reproducing the human form of information processing, but subjects need less and less to understand how the machine works (this is the increasing opacity of technology already observed by Husserl). They conform less and less to operations in the environment. There is no risk of confusion between communication and its environment, even and especially when the users can communicate with robots without even realizing it: it is the system that processes these operations, and manages to do it very effectively—either one communicates or one does not

communicate. The problems are diverse: difficulties in the management of memory,[41] which can no longer resort to the "structural amnesia" of earlier forms of communication;[42] privacy issues, including the risk of flattening of the future onto the past reflected in virtual contingency;[43] problems with the management of explicitness and with the hypertrophy of the present, as it occurs in social networks—but in all cases problems that depend on an increasing capacity of communication to include more and more different forms, not on a weakening of the differences.

As in Bateson's days, we are dealing with ecological problems—problems of control and of management of the borders of the system, but in the form of double feedback (or autology). Observing the others (its environment), communication finds itself and its operations (that is, once again, the system) in the reflected and elaborated form of the machine. Facing its environment the system finds itself in a different way. Complexity increases, but because differences increase, not because they are erased.[44] The ecological issue becomes increasingly central—not as an opening to the environment, but as an understanding and management of differences.

Notes

1 Gregory Bateson, *Steps to an Ecology of Mind: Collected Essays in Anthropology, Psychiatry, Evolution and Epistemology* (Chicago: University of Chicago Press, 1972).

2 See "Summary: The Macy Conferences" (*History of Cybernetics,* Ch. 2, "The Coalescence of Cybernetics"), American Society for Cybernetics. Available online: http://www.asc-cybernetics.org/foundations/history/MacySummary.htm (accessed January, 2014).

3 Classic texts dealing with these questions are Ludwig von Bertalanffy, *General System Theory: Foundations, Development, Applications* (New York: Braziller, 1968) and Walter Buckley, *Sociology and Modern Systems Theory* (Englewood Cliffs, NJ: Prentice-Hall, 1967).

4 As Francisco Varela will say later, the condition for opening is some form of closure (distinct from closedness, which does not acknowledge the relationship with the environment). Francisco J. Varela, *Principles of Biological Autonomy* (New York: North Holland, 1979).

5 See Humberto R. Maturana and Francisco J. Varela, *Autopoiesis and Cognition* (Dordrecht: Reidel, 1980); Niklas Luhmann, 'The Autopoiesis of Social Systems', in *Sociocybernetic Paradoxes: Observation, Control and Evolution of Self-Steering Systems*, ed. Felix Geyer and Johannes van der Zouwen (London: Sage, 1986).

6 Ranulph Glanville, *Objekte* (Berlin: Merve, 1988).

7 Norbert Wiener, *Cybernetics, or Control and Communication in the Animal and the Machine* (1948; Cambridge, MA: MIT Press, 1961), 6.

8 Niklas Luhmann, "Kommunikationsweisen und Gesellschaft," in *Computer, Medien, Gesellschaft*, ed. Werner Rammert (Frankfurt a.M.: Campus, 1989).

9 Terry Winograd and Francisco Flores, *Understanding Computers and Cognition* (1986; Reading, MA: Addison-Wesley, 1988).

10 Alternatively, the theory of observation of observers: cf. Heinz von Foerster, *Observing Systems* (Seaside, CA: Intersystems Publications, 1981). It is not surprising that this theory also originated in the context of the Macy Conferences. The idea of double feedback can already be found in Bateson, *Steps to an Ecology of Mind*, 279–308.

11 Michel Foucault, "The Confession of the Flesh," in *Power/Knowledge: Selected Interviews and Other Writings 1972–1977*, ed. Colin Gordon (New York: Pantheon, 1980). Michel Foucault, *Security, Territory, Population* (New York: Palgrave Macmillan, 2007). See also Giorgio Agamben, "What is an Apparatus?," in *What is an Apparatus? And Other Essays* (Stanford: Stanford University Press, 2009).

12 Michel Callon, ed., *The Laws of the Markets* (Oxford: Blackwell, 1998); Bruno Latour, *We Have Never Been Modern* (Cambridge, MA: Harvard University Press, 1993). In many of these cases the reference is the notion of "actant" developed by Greimas as part of a semiological interpretation of Propp's narratology and used to indicate the bearers of roles within a narrative (hero, villain, sender or helper), largely independent of the specific subject impersonating them. See Algirdas Julien Greimas, *Sémantique structurale: Recherche de methode* (Paris: Larousse, 1966).

13 John Law, "After ANT: complexity, naming and topology," in *Actor Network Theory and After*, ed. J. Law and J. Hassard (Oxford: Blackwell, 1999), 5.

14 The premise is the "principle of generalized symmetry": the explanation starts from the intermediate point at which you can simultaneously follow the attribution of human and nonhuman properties.

15 Bruno Latour, "On recalling ANT," in *Actor Network Theory and After*, ed. J. Law and J. Hassard (Oxford: Blackwell, 1999), 22.

16 For a discussion see J. Law and J. Hassard, eds, *Actor Network Theory and After* (Oxford: Blackwell, 1999).

17 Latour, *We Have Never Been Modern*.

18 George Spencer-Brown, *Laws of Form* (New York: Julian Press, 1972).

19 Bateson, *Steps to an Ecology of Mind*.

20 Bertrand Russell and Alfred North Whitehead, *Principia Mathematica* (Cambridge: Cambridge University Press, 1913).

21 Niklas Luhmann, *Die Gesellschaft der Gesellschaft* (Frankfurt a.M.: Suhrkamp, 1997), § I.VI.

22 Niklas Luhmann, "Wie ist Bewußtsein an Kommunikation beteiligt?" in *Materialität der Kommunikation*, ed. H. U. Gumbrecht and K-L. Pfeiffer (Frankfurt a.M.: Suhrkamp, 1988).

23 Talcott Parsons, "Interaction: Social Interaction," *International Encyclopedia of the Social Sciences*, vol. 7 (New York: Macmillan, 1968).

24 Niklas Luhmann, *Soziale Systeme: Grundriß einer allgemeinen Theorie* (Frankfurt a.M.: Suhrkamp, 1984).

25 Ibid., 166.

26 Elena Esposito, "Do we need an 'open man'? The anthropology of *agencements*," manuscript for the Workshop "Agencing Markets," Institut d'Études Scientifiques de Cargèse (IESC), September 17–20, 2013.

27 They also seem to understand meanings, because they recognize contexts and circumstances and behave differently depending on the situation (the much anticipated Web 3.0 is notoriously supposed to be a "semantic web"; Tim Berners-Lee, James Hendler, and Ora Lassila, "The Semantic Web: A new form of Web content that is meaningful to computers will unleash a revolution of new possibilities," *Scientific American Magazine*, May 17, 2001).

28 Heinz von Foerster, "Für Niklas Luhmann: Wie rekursiv ist Kommunikation?" *Teoria sociologica* I (2) (1993): 61–88.

29 Sherry Turkle, *Alone Together: Why We Expect More from Technology and Less from Each Other* (New York: Basic Books, 2011).

30 Elena Esposito, "Zwischen Personalisierung und Cloud: Medialität im Web," in *Körper des Denkens: Neue Positionen der Medienphilosophie*, ed. Lorenz Engell, Frank Hartmann, and Christiane Voss (München: Fink, 2013).

31 Elena Esposito, "Fiktion und Virtualität," in *Medien-Computer-Realität,* ed. Sybille Krämer (Frankfurt a.M.: Suhrkamp, 1998).

32 Nigel Shadbolt, Wendy Hall, and Tim Berners-Lee, "The Semantic Web Revisited," *IEEE Intelligent Systems* (2006): 96–101; Nicholas Carr, *The Big Switch: Rewiring the World, from Edison to Google* (New York: Norton, 2008), 211–30.

33 The airplane can be considered the outcome of an equivalent step, as highlighted in the much-cited example of Hans Blumenberg: humans learned to fly when they gave up the idea to imitate the flight of birds and to build a machine that beats its wings. See Hans Blumenberg, *Wirklichkeiten, in denen wir leben* (Stuttgart: Reclam, 1981), 55–103.

34 Tim Berners-Lee, *Weaving the Web: The Original Design and Ultimate Destiny of the World Wide Web by Its Inventor* (New York: Harper 1999), 140.

35 Richard Rogers, *Digital Methods* (Cambridge, MA: MIT Press, 2013).

36 Carr, *The Big Switch*, 153; John Battelle, *The Search: How Google and its Rivals Rewrote the Rules of Business and Transformed our Culture* (London: Portfolio, 2005).

37 Chris Anderson, *The Long Tail: How Endless Choice is Creating Unlimited Demand* (London: Random House, 2006), 107.

38 Yochai Benkler, *The Wealth of Networks: How Social Production Transforms Markets and Freedom* (New Haven: Yale University Press,

2006); Eli Pariser, *The Filter Bubble: What the Internet Is Hiding from You* (London: Viking, 2011), 28.

39 Martijn van Otterlo, "A Machine Learning View on Profiling," in *Privacy, Due Process and the Computional Turn: The Philosophy of Law Meets the Philosophy of Technology*, ed. Mireille Hildebrandt and Katja de Vries (New York: Routledge, 2013), 41–63.

40 Anderson, *The Long Tail*, 123.

41 Viktor Mayer-Schönberger, *Delete: The Virtue of Forgetting in the Digital Age* (Princeton: Princeton University Press, 2009).

42 Jack Goody and Jan Watt, "The Consequences of Literacy," in *Language and Social Context*, ed. P. Giglioli (London: Penguin, 1972), 311–57.

43 Elena Esposito, "Digital Prophecies and Web Intelligence," in *Privacy, Due Process and the Computional Turn: The Philosophy of Law Meets the Philosophy of Technology*, ed. Mireille Hildebrandt and Katja de Vries (New York: Routledge, 2013), 121–42.

44 Already at the time of the Macy Conferences there was talk of the need for polyvalent logics in order to formalize (not to compute) this kind of situation. See Gotthard Günther, *Beiträge zur Grundlegung einer operationsfähigen Dialektik*, 3 vols (Hamburg: Meiner, 1976; 1979; 1980).

Bibliography

Agamben, Giorgio. "What is an Apparatus?" In *What is an Apparatus? And Other Essays*, 1–24. Stanford: Stanford University Press, 2009.

Anderson, Chris. *The Long Tail: How Endless Choice is Creating Unlimited Demand*. London: Random House, 2006.

Bateson, Gregory. *Steps to an Ecology of Mind: Collected Essays in Anthropology, Psychiatry, Evolution and Epistemology*. Chicago: University of Chicago Press, 1972.

Battelle, John. *The Search: How Google and its Rivals Rewrote the Rules of Business and Transformed our Culture*. London: Portfolio, 2005.

Benkler, Yochai. *The Wealth of Networks: How Social Production Transforms Markets and Freedom*. New Haven: Yale University Press, 2006.

Berners-Lee, Tim, James Hendler, and Ora Lassila. "The Semantic Web: A new form of Web content that is meaningful to computers will unleash a revolution of new possibilities." *Scientific American Magazine*, May 17, 2001.

Berners-Lee, Tim. *Weaving the Web: The Original Design and Ultimate Destiny of the World Wide Web by Its Inventor*. New York: Harper 1999.

Bertalanffy, Ludwig von. *General System Theory: Foundations, Development, Applications*. New York: Braziller, 1968.

Blumenberg, Hans. *Wirklichkeiten, in denen wir leben*. Stuttgart: Reclam, 1981.

Buckley, Walter. *Sociology and Modern Systems Theory*. Englewood Cliffs, NJ: Prentice-Hall, 1967.

Callon, Michel, ed. *The Laws of the Markets*. Oxford: Blackwell, 1998.

Carr, Nicholas. *The Big Switch: Rewiring the World, from Edison to Google*. New York: Norton, 2008.

Esposito, Elena. "Digital Prophecies and Web Intelligence." In *Privacy, Due Process and the Computional Turn: The Philosophy of Law Meets the Philosophy of Technology*, ed. Mireille Hildebrandt and Katja de Vries, 121–42. New York: Routledge, 2013.

Esposito, Elena. "Do we need an 'open man'? The anthropology of agencements." Manuscript for the Workshop "Agencing Markets." Institut d'Études Scientifiques de Cargèse (IESC), September 17–20.

Esposito, Elena. "Fiktion und Virtualität." In *Medien-Computer-Realität*, ed. Sybille Krämer, 269–96. Frankfurt a.M.: Suhrkamp, 1998.

Esposito, Elena. "Zwischen Personalisierung und Cloud: Medialität im Web." In *Körper des Denkens: Neue Positionen der Medienphilosophie*, ed. Lorenz Engell, Frank Hartmann, and Christiane Voss, 231–53. München: Fink, 2013.

Foerster, Heinz von. "Für Niklas Luhmann: Wie rekursiv ist Kommunikation?" *Teoria sociologica* I (2) (1993): 61–88.

Foerster, Heinz von. *Observing Systems*. Seaside, CA: Intersystems Publications, 1981.

Foucault, Michel. "The Confession of the Flesh." In *Power/Knowledge: Selected Interviews and Other Writings 1972–1977*, ed. Colin Gordon, 194–228. New York: Pantheon, 1980.

Foucault, Michel. *Security, Territory, Population*. New York: Palgrave Macmillan, 2007.

Glanville, Ranulph. *Objekte*. Berlin: Merve, 1988.

Goody, Jack and Jan Watt. "The Consequences of Literacy." In *Language and Social Context*, ed. P. Giglioli, 311–57. London: Penguin, 1972.

Greimas, Algirdas Julien. *Sémantique structurale: Recherche de method*. Paris: Larousse, 1966.

Günther, Gotthard. *Beiträge zur Grundlegung einer operationsfähigen Dialektik*, 3 vols. Hamburg: Meiner, 1976; 1979; 1980.

Latour, Bruno. "On recalling ANT." In *Actor Network Theory and After*, ed. J. Law and J. Hassard, 15–25. Oxford: Blackwell, 1999.

Latour, Bruno. *We Have Never Been Modern*. Cambridge, MA: Harvard University Press, 1993.

Law, J. and J. Hassard, eds. *Actor Network Theory and After*. Oxford: Blackwell, 1999.

Law, John. "After ANT: Complexity, Naming and Topology." In *Actor Network Theory and After*, ed. J. Law and J. Hassard, 1–14. Oxford: Blackwell, 1999.

Luhmann, Niklas. "Kommunikationsweisen und Gesellschaft." In *Computer, Medien, Gesellschaft*, ed. Werner Rammert, 11–18. Frankfurt a.M.: Campus, 1989.

Luhmann, Niklas. "The Autopoiesis of Social Systems." In *Sociocybernetic Paradoxes: Observation, Control and Evolution of Self-Steering Systems*, ed. Felix Geyer and Johannes van der Zouwen, 172–92. London: Sage, 1986.

Luhmann, Niklas. "Wie ist Bewußtsein an Kommunikation beteiligt?" In *Materialität der Kommunikation*, ed. H. U. Gumbrecht and K-L. Pfeiffer, 884–905. Frankfurt a.M.: Suhrkamp, 1988.

Luhmann, Niklas. *Die Gesellschaft der Gesellschaft*. Frankfurt a.M.: Suhrkamp, 1997.

Luhmann, Niklas. *Soziale Systeme: Grundriß einer allgemeinen Theorie.* Frankfurt a.M.: Suhrkamp, 1984.

Maturana, Humberto R., and Francisco J. Varela. *Autopoiesis and Cognition.* Dordrecht: Reidel, 1980.

Mayer-Schönberger, Viktor. *Delete: The Virtue of Forgetting in the Digital Age.* Princeton: Princeton University Press, 2009.

Otterlo, Martijn van. "A Machine Learning View on Profiling." In *Privacy, Due Process and the Computional Turn: The Philosophy of Law Meets the Philosophy of Technology,* ed. Mireille Hildebrandt and Katja de Vries, 41–63. New York: Routledge, 2013.

Pariser, Eli. *The Filter Bubble: What the Internet Is Hiding from You.* London: Viking, 2011.

Parsons, Talcott. "Interaction: Social Interaction." *International Encyclopedia of the Social Sciences,* vol. 7, 429–41. New York: Macmillan, 1968.

Rogers, Richard. *Digital Methods.* Cambridge, MA: MIT Press, 2013.

Russell, Bertrand and Alfred North Whitehead. *Principia Mathematica.* Cambridge: Cambridge University Press, 1913.

Shadbolt, Nigel, Wendy Hall, and Tim Berners-Lee. "The Semantic Web Revisited." *IEEE Intelligent Systems* (2006): 96–101.

Spencer-Brown, George. *Laws of Form.* New York: Julian Press, 1972.

Turkle, Sherry. *Alone Together: Why We Expect More from Technology and Less from Each Other.* New York: Basic Books, 2011.

Varela, Francisco J. *Principles of Biological Autonomy.* New York: North Holland, 1979.

Wiener, Norbert. *Cybernetics, or Control and Communication in the Animal and the Machine.* 1948. Cambridge, MA: MIT Press, 1961.

Winograd, Terry and Francisco Flores. *Understanding Computers and Cognition.* 1986. Reading, MA: Addison-Wesley, 1988.

CHAPTER TWELVE

Specters of ecology

Timothy Morton

*They talk to me about civilization, I talk about proletarianization
and mystification.*

—AIMÉ CÉSAIRE[1]

Specter: a word that itself is spectral, by its own definition, since it wavers
between appearance and being. It could mean *apparition*, but it could
also mean *horrifying object*, or it could mean *illusion*, or it could mean
the shadow of a thing.[2] *Specter* floats around, like a specter. This chapter
summons them, because as it will show, such a convocation of specters will
aid us in imagining something like an ecocommunism, a communism of
humans and nonhumans alike.

A specter is haunting the specter of communism: the ghostly presence
of beings not yet formatted according to the kind of "nature" that Marx
is talking about: the human economic metabolism of things. Things in
themselves haunt data: this is possibly the shortest way of describing the
continental philosophical tradition since Kant. Marx's version of it is that
use value is already on the human metabolic side of the equation: the spoon
exists insofar as it becomes part of how I organize my enjoyment, which is
just what economics is, when we take the capitalist theological blinkers off.

Perhaps communism is *only* fully thinkable as a coexisting of humans and
nonhumans—and as we will see, this does strange things to the thought of
communism. Because what is required is to think a radical being-with that
is now de-anthropocentrized. This coexistence drastically lacks something
that we hear in the fifteenth chapter of the first volume of *Capital*, with its
imaginative architects and mechanical bees, namely the sharp distinction
between human being and everything else that Marx inherits from Kant,
and in which Kant is still haunted by the specter of Descartes and his
substance ontology of purely extensional lumps connected mechanically.

Such an inclusive communist thought would also need to correct the lopsided (though at least half true) correlationism (also from Kant) in which a (human) decider, in Marx's case human economic relations, makes reality "real," "'realizes' it" as one might realize a script in the form of a movie.

The more we think ecological beings—a human, a tree, an ecosystem, a cloud—the more we find ourselves obliged to think them not as alive or dead, but as spectral. The more we think them, moreover, the more we discover that such beings are not solidly "real" nor completely "unreal"— in this sense, too, ecological beings are spectral. In particular, ecological beings provide insights into the weird way in which entities are riven from within between what they are and how they appear. Another way of putting this is that beings, as a possibility condition for their existing at all, are specters.

So many specters, so little time. In this chapter I shall outline a way of proceeding into a thinking of ecological beings as necessarily spectral. In order to do this, we need to consider what it is to encounter an ecological being. The encounter as such is a moment at which I encounter something that is not me, in a decisive way, such that even if this being is obviously part of me—say, my brain—I do not experience it as part of the supposed whole that makes up "me." Ecological thought is Adorno's ideal of thinking as the encounter with non-identity.[3] When it is not simply a cartoon of itself, pushing preformatted pieces around, thought meets specters, which is to say, beings whose ontological status is profoundly ambiguous, and perhaps irreducibly ambiguous—and how can we even tell?

Given the precedent of Derrida's *Specters of Marx* so clearly evoked in its title, one should perhaps not be surprised that this is the eventual conclusion of this chapter. For if communism is a specter that is haunting Europe, then ecological awareness—not to mention theory and political praxis—is a specter in many kinds of sense that most definitely haunts communism. Either communism is big enough, or can grow big enough, to accommodate it; or communism is now up against an internal limit easy to identify in an era of global warming and mass extinction. Simply put, communism may have a space for nonhumans—or not. Ecological awareness is a specter that haunts communist theory with the possibility either of its undoing, or of its expansion. And given the uncertainty between undoing and shifting change, the choice itself is spectral.

Furthermore—and this is the most general concluding point—if ecology names relations between beings, then these relations are spectral. And since I hold that relationality just is what we call causality, stripped of its metaphysical, pre-Humean junk, we had better accommodate ourselves to the fact that causality is spectral, or better, what we call the spectral is in fact the causal, whether we like it or not.

To encounter an ecological entity, then, is to be *haunted*. And although I must use this term metaphorically for now, it will become clear that haunting is a very precise term for what happens in ecological thought.

For now we can try for some kind of detail, nevertheless. Something is already there, before I think it. When we talk about haunting, then, what we are talking about is what phenomenology calls givenness. Givenness is the condition of possibility for data (the Latin for *what is given*). There is already a light in the refrigerator before I open the door to see whether or not the light is on. The light's givenness—it's a light, not an octopus—is not something I have planned, predicted, or formatted. I cannot reduce this givenness to something expected, predictable, planned, without omitting some vital element of givenness as such. Givenness is therefore always surprising, and surprising in surprising ways: *surprisingly surprising*, we might say. Yet in haunting, the phenomenon of the disturbing, surprising given, whose surprise cannot be reduced, also repeats itself.

Each time givenness repeats, according to the logic I have sketched out here, there is no lessening of surprise, which is perhaps why givenness is surprisingly surprising. Repetition does not lead to boredom, but rather to an uncanny sense of refreshment. It is as if I am tasting something familiar yet slightly disgusting, as if I were to find, upon putting it to my lips, that my favorite drink had a layer of mold growing on its surface. I am as it were stimulated by the very repetition itself: stimulated by boredom. Another term for this—one made familiar by Charles Baudelaire—is *ennui*. Ennui is the sine qua non of the consumerist experience: I am stimulated by the boredom of being constantly stimulated. In ennui, then, I heighten the Kantian window-shopping of the Bohemian or Romantic consumer.

The experience of vicarious experience—wondering what it would be like to be the kind of person who wears *that* shirt—itself becomes too familiar, slightly disgusting, distasteful. I cannot enjoy it "properly," to wit, I am unable to achieve the familiar aesthetic distance from which to appreciate it as beautiful (or not). Disgust is the flip side of good taste in this respect: good taste is the ability to be appropriately disgusted by things that are in bad taste. I have had too many vicarious thrills, and now I find them slightly disgusting—but not disgusting enough to turn away from them altogether. I enjoy, a little bit, this disgust. This is ennui.

Since in an ecological age there is no appropriate scale on which to judge things (human? microbe? biosphere? DNA?), there can be no pure, unadulterated, totally tasteful beauty. Beauty is always a little bit weird, a little bit disgusting. Beauty always has a slightly nauseous taste of the kitsch about it, kitsch being the slightly (or very) disgusting enjoyment-object of the other, disgusting precisely because it is the other's enjoyment-thing, and thus inexplicable to me. Moreover, since beauty is already a kind of enjoyment that isn't to do with my ego, and is thus a kind of not-me, beauty is always haunted by its disgusting, spectral double, the kitsch. The kitsch precisely is the other's enjoyment object: how can anyone in their right mind want to buy this snow globe of the Mona Lisa? Yet there they are, hundreds of them, in this tourist shop.

Since beauty involves me in organizing enjoyment, it is (as Derrida would again have argued, slightly differently) a profoundly *economic* phenomenon. And in the interesting sense that its use value has not yet been determined. Beauty, in other words, strangely gives us a way to think economics that crosses over the correlationist boundary a little bit, the boundary between things and data, between what things are and how things appear. Beauty, in that case, provides a channel through which the nonhuman specters haunting the specter of communism can enter. They do not have to be left out in the prefabricated "nature" of bourgeois ideology, with its unquestioned metaphysical assumptions. Ecology, in other words, does not have to be excluded in advance from the New Left project as "a hippie thing" unlike race and gender (actual statement by actual *New Left Review* contributor).

Beauty is the nonhuman footprint of a nonhuman. And ennui is when we allow beauty to begin to lose its anthropocentric equalization. Now in ennui I am not totally turning my back on this sickening world—where would I turn to anyway, since the ecological world is the whole world, 360 degrees of it? Rather, ennui is, and this is as it were the Hegelian speculative judgment of this chapter (though I am far from a Hegelian), the correct ecological attunement!

The very consumerism that haunts environmentalism—the consumerism that environmentalism explicitly opposes and indeed finds disgusting—provides the model for how ecological awareness should proceed. Moreover, this model is not dependent on the "right" or "proper" ecological being, and thus not dependent on a necessarily metaphysical (and thus illegal in our age) pseudo-fact (or set of facts). Consumerism is the specter of ecology. When thought fully, ecological awareness includes the essence of consumerism, rather than shunning it. Ecological awareness must embrace its specter.

With ennui, I find myself surrounded, and indeed penetrated, by entities that I can't shake off. When I try to shake one off, another one attaches itself, or I find that another one is already attached, or I find that the very attempt to shake it off makes it tighten the grip of its suckers more strongly. Isn't this just the quintessence of ecological awareness, namely the abject feeling that I am surrounded and penetrated by other entities such as stomach bacteria, parasites, mitochondria—not to mention other humans, lemurs, and sea foam? I find it slightly disgusting and yet fascinating. I am "bored" by it in the sense that I find it provocative to include all the beings that I try to ignore in my awareness all the time. Who hasn't become "bored" in this way by ecological discourse? Who really wants to know where their toilet waste goes all the time? And who really wants to know that in a world where we know exactly where it goes, there is no "away" to flush it to absolutely, so that our toilet waste phenomenologically sticks to us, even when we have flushed it?

Consider the infamous "Spleen" poems of Charles Baudelaire,

poet-consumerist par excellence, bohemian inventor of the *flâneur*, or rather, the one who christened this quintessential, "Kantian" mode of consumption; and furthermore the poet who originated the notion of ennui. I quote the poems in their entirety for various reasons. First because I am not so much interested in analyzing particular poems as I am in tracing a more general structure of feeling across the poems. Second, because the provocative titling—exactly the same ("Spleen") for four poems in sequence in *The Flowers of Evil*—compels us to read them together, as if the same affect were collapsing, or going to sleep, then queasily restarting each time. Third, because the very form of the poems as such—as individual poems, without doubt, but also as a sequence, as the point about restarting is beginning to make—suggests being haunted, in the sense of being frequented, of an event occurring more than once. We all know how repetition is intrinsically uncanny: in other words, how there would be no such thing as the uncanny without the notion of repetition. Freud's essay on the uncanny, for this very reason, is a startling exegesis of the puzzle of repetition.

Here in sequence are the four "Spleen" poems of Baudelaire:

The month of drizzle, the whole town annoying, a dark cold pours from its urn in torrents on the pale inhabitants of the adjoining cemetery and over the mortals in foggy suburbs.

My cat, looking for a tile to sleep on, fidgets restlessly his thin mangy body; the soul of some old poet trundles down the rainspout with the sad voice of a chilly phantom.

A bumblebee moans, the smoking log backs up in falsetto the congested clock; meanwhile in a game reeking with sordid perfumes—

Mortal descent from an old dropsical dame—the handsome jack of hearts and the queen of spades make sinister small talk about their defunct loves.[4]

I've more memories than if I were a thousand years old.

A big chest of drawers, cluttered with bank statements, poems, love letters, lawsuits, romances, thick locks of hair rolled up in receipts, contains fewer secrets than my sad brain, a pyramid, an immense vault holding more corpses than a paupers' boneyard.—I am a cemetery the moon abhors where, like remorse, long worms crawl across my favorite dead. I am an old boudoir full of faded roses, strewn with a jumble of outmoded fashion, where only plaintive pastels and pale Bouchers breathe the odor of an unstoppered flask.

Nothing's as long as the limping days when, under thick flakes of snowy years, ennui—fruit of bleak incuriosity—takes on immortal proportions.—From now on, O stuff of life, you are mere granite wrapped in vague terror, drowsing in the depth of a fog-hidden Sahara; an old sphinx unknown to a heedless world, forgotten from the map, whose savage mood harmonizes only with the sun's rays setting. (76)

I am like the king of a rainy country, rich but powerless, young and yet very old, who having tutors contemptuous of curvets suffers ennui with his hounds, as with other beasts. Nothing can cheer him, not game, not falcon, not his people perishing under his balcony. A grotesque ballade from his favorite fool no longer relaxes the brow of this cruel invalid; his lilied bed becomes a grave and his ladies-in-waiting, for whom every prince is a beauty, can no longer dress indecently enough to draw a smile from this young skeleton. The mage who makes gold for him has never managed to expunge the corrupt element in his makeup, and in those baths of blood that come to us from Rome and which the powerful bring to mind in their final days, he cannot rekindle that dazed cadaver which runs, not with blood, but with the green waters of Lethe. (77)

When the sky, low and heavy, weighs like a lid on the groaning spirit, prey to long ennui; when from the full encircling horizon it sheds on us a dark day, sadder than our nights;

when earth is changed into a damp cell, where Hope, like a bat, beats timid wings against the walls and bumps its head against a rotten ceiling;

when the rain's immense spouts imitate prison bars and a mute population of vile spiders constructs webs at the base of our brains,

bells burst out suddenly in fury and hurl skyward a frightful howl, like homeless wandering spirits raising a stubborn whine.

—And long hearses, without drum, without music, file off slowly within my soul. Hope, conquered, weeps, and atrocious Anguish, despot, upon my bowed head plants his black flag. (78)

This is Keats left in the refrigerator too long and accumulating mold. Everything slips into the uncanny valley, even the difference between consumerism and ecological awareness. The breakdown of well-ordered poetry into something like prose is the deliquescence of lineation, writing as plowing. The narrator tells of being surrounded, permeated, by other beings, "natural" and "unnatural" and "supernatural," willy-nilly. The narrator is an abject ecosystem. The Sphinx, that monstrous hybrid, returns from death. Living and dead things become confused and weigh

on the narrator, depressing him. Isn't ecological awareness fundamentally depressing in precisely this way, insofar as it halts my anthropocentric mania to think myself otherwise than this body and its phenomenological being surrounded and permeated with other beings, not to mention made up of them?

Which is to say, isn't ecological awareness a kind of spectrality that consists of awareness of specters? One is unsure whether a specter is material or illusory, visible or invisible. What weighs on Baudelaire is the specter of his bohemian, Romantic consumerism, his Kantian floating, enjoyment tinged with disgust tinged with enjoyment. The specter is called ennui, badly translated merely as *boredom*. It is being enveloped in things, like a mist. Being surrounded by the spectral presence of evacuated enjoyment.

Ecological awareness is not unlike the attitude of the narrator of Baudelaire's "Spleen" poems. When thinking becomes ecological, the beings it encounters cannot be established in advance as living or non-living, sentient or non-sentient, real or epiphenomenal. What we encounter instead are spectral beings whose ontological status is uncertain precisely to the extent that we know them in detail as never before. And our experience of these spectral beings is itself spectral, just like ennui. Starting the engine of one's car isn't what it used to be, since one knows one is releasing greenhouse gases. Eating a fish means eating mercury and depleting a fragile ecosystem. Not eating a fish means eating vegetables, which may have relied on pesticides and other harmful agricultural logistics. Because of interconnectedness, it always feels as if there is a piece missing. Something just doesn't add up, in a disturbing way. We can't get compassion exactly right. Being nice to bunny rabbits means not being nice to bunny rabbit parasites. Giving up in sophisticated boredom is also an oppressive option.

Science does not do away with ghosts. Rather, it multiplies them. As the human–nonhuman boundary and the life–nonlife boundary collapse, more and more specters emerge.

Art since 1800—since the inception of the Anthropocene—has been about allowing specters in. With whom or with what are we coexisting? How can we prove that a *who* isn't in fact a *what*? Photography's emergence in the nineteenth century gave rise quite rapidly to a fascination with *photographing ghosts*. The desire arose to see, in the flesh, rather than in the mind's eye, some kind of material ghost, imagined as an ectoplasmic, anamorphic being. *Anamorphic* means not simply *distorted*, but "unshaped." Not exactly without a shape altogether, but in a process of liquefaction, such that any discernible, obvious shape is collapsing. Why this fascination with the anamorphic specter? It is significant to say the least that the ability to imprint paper with photons reflected from actual things immediately suggests the possibility of seeing the unseeable, as if one could glimpse oneself from beside oneself. But isn't this the basic drive of science—to see what cannot (or indeed should not) be seen?

The emergence of specters becomes very vivid in the transition from Romantic to Expressionist and other forms of atonal music. *Strukturklang* is the serialist composer Anton Webern's term for the sound of the whole structure of a musical work. Yet if we think about it, this "sound" is an impossible, inaudible sound, or rather it is not a sound at all if by *sound* we mean *musical note*. What if, in some bizarre and disturbing way, we were to hear this inaudible yet pervasive sound? It would be a disturbing dissonant ambience that haunts the entire work, heard, for instance, in the vast reverberation of the piano at the end of The Beatles' "A Day in the Life."[5] *Strukturklang*, far from being an abstract pattern, is nothing other than the resonance of the actually existing physical entities in collaboration with which humans make music: pianos, sitars, gongs, voices.

The traditional term is *timbre*. Its etymology has to do with drums, but the sound evokes "timber" and hence the Greek *hyle*, which means *matter* and also *wood*. The history of European and American music since the start of the Anthropocene has been the story of the gradual liberation of these physical entities from their slavish role in telling human-flavored stories about human-flavored emotions. Instruments have become non-instrumental, insofar as they are left to vibrate, twang or otherwise "express" their physicality without an obvious human story. Atonalism liberated the notes while serialism in turn liberated musical form in which the notes were played. Students of Schoenberg liberated the instruments themselves, from Cage with his prepared piano to his student La Monte Young and his use of whole number tunings (Just Intonation), tunings that allow for maximum harmonic depth and lucidity and minimum storytelling. Human stories disappear, and the timbre of the instrument manifests, because modulating between keys to symbolize emotion is impossible unless you bind the instrument to Equal Temperament, slightly fudging the ratios between the notes to make them shallower and blunter, as if one were seeing an old sepia photograph. Young domesticates this sound within the conceptual apparatus of Hindu devotion and its arts of the drone. Without this conceptual frame, what is heard is a spectral resonance, precisely the fullest possible *spectrum* of an instrument's timbre.

The encounter with this strange reverberation is, once again, spectral, insofar as it's an encounter with something already present (givenness) that was nevertheless suppressed in European and American music: the physicality of things and the necessary (and therefore ecological) collaborations between humans and nonhumans such as flutes, silicon chips, and valves.

But the inception of the spectral in modern art surely occurs at a moment we could call the Baudelaire Moment. In the decades of the nineteenth century before this moment, there had occurred a mapping of almost every move within the possibility space of consumerism. In particular, the top level of consumerism had become the subject of art itself. This is "bohemian" or Romantic consumerism, a Kantian version in which one doesn't consume anything, per se: what one consumes is the pure possibility

of consuming, without purpose or purchase.[6] This is reflected in the activity of the flâneur, later the window shopper, later still the surfer.

Romantic consumerism takes an already reflexive mode—the *ism* of consumerism gives this away—and bends that reflexivity back on itself: the reflexivity of reflexivity.

Part Two

In the hall of mirrors of Romantic consumerism—the reflexivity of reflexivity—a very strange thing happens. It is not simply the case that there is a dizzying spiral of pure ideality, or idealism, with its physical flip side, an "I can do anything to anything" sadistic joy. For in this hall of mirrors, the mirrors themselves become appreciable as entities in their own right. And this in turn allows for the appreciation of other entities in their own right.

Of all people, it was Darwin who opened the gate to the spectral world. Reason, jumping to a dimension at which emergent forces such as evolution could be discerned, was the force that opened it. When one collapses the life–nonlife boundary and relaxes the human–nonhuman boundary, all kinds of spectral creatures start to be seen, nightmarish beings that scuttle about. They are not categorizable. Yet they exist. They look like nightmare beings because of the extreme pressure they exert on existing frames of reference, existing categorial boxes.

But when the boxes dissolve, are these beings intrinsically horrifying? Is the Gothic view of these beings the only view, for the rest of time, or is it a temporary effect of the pressure that such beings place on categories such as life and nonlife? The spectral realm is an uncanny valley into which more and more beings begin to slide. Here I am using a concept in robotics that explains why people have negative reactions to lifelike robots, and more pleasant reactions to less human-looking ones such as R2D2. The more lifelike the robot, the more it approaches the condition of a zombie, an animated human corpse, that is to say, a being exactly like us, yet not alive—a being that suggests that we ourselves might also be some kind of zombie.

But what happens when everything is in the uncanny valley? In other words, when the valley is no longer a valley, but has transmogrified itself into a gigantic charnel ground with no center and no edge?

The valley is uncanny because it is familiar and strange, and strangely familiar—and familiarly strange—all at the same time. Beings we recognize—a human, a fruit fly—start to flit around outside the categorial boxes of human versus nonhuman, and of life versus nonlife.

The uncanny valley is precisely not a void. One of the things under pressure in the modern period is precisely the empty container, the void,

in which things sit. Such empty spaces fill us with dread (Pascal), they are the objective correlative of Cartesian reason, and are inferred by Newtonian laws. This kind of void is objectively present. To put it in its most paradoxical form, this kind of void lacks nothingness. It is not void enough, in a sense.

A feature of beings in the uncanny valley is nothingness. We should draw a strong distinction between nothingness and void. This distinction emerged in the long history of the assimilation of Kant, that fragmentary distorted echo of the start of the Anthropocene. Kant opened up the Pandora's box of nothingness, by discerning an irreducible gap between a thing and its phenomena.

Is horror truly the most adequate attunement to the discoveries of the Anthropocene? The Pascalian dread of the infinite void is perhaps, we might surmise, only a temporary reaction to the discovery of spectral beings and the uncanny valley. If we replace the void with nothingness, we may need to replace horror. Nothingness is not intrinsically horrible. It is intrinsically *weird*.

H. P. Lovecraft's insane otopoid god Cthulhu is evoked many times to describe the putative "horror" of speculative realist philosophy. Why is horror the compulsory philosophical affect with which thought confronts reality, which is to say the spectral? The horror of the story of Cthulhu is an attempt to *contain* the nothingness. Cthulhu dwells in a non-Euclidean city under the ocean. This is the precise inverse of the universe according to relativity theory. In this universe, Euclidean spaces are small-enough (human scaled) regions of spacetime that appear to lack the general, mollusk-like ripples and twists in the universal fabric. Yet they only appear to do so. It is more accurate to say that human space occupies a small region of Cthulhu's universe.

If the initial reaction to this fact is horror, then it is only because one's habitual conceptual frame has been pointed out in its narrowness and arbitrariness. Horror is the feeling of void giving way to nothingness—of premodernity giving way to modernity. But what happens after modernity?

If we act to reduce carbon emissions, we will never know whether global warming science was totally accurate or not. Unverifiability is built into the theory of global warming. There is a weird dance between science and mystery, which we are not expecting. We were expecting science to demystify. But reason itself finds itself driven slightly mad.

What seems trivially the case—the Muppets and Michael Jackson and Olympic opening ceremonies remind me daily—the fact that I am human; is this fact not actually *the most phenomenologically distant thing* in the known universe, more distant than the supermassive black hole at the center of the Milky Way? And isn't it precisely this thing, the fact that I am human, that I must reckon with if I am to understand my role as a geophysical force on a planetary scale? Yet to think my human being is the task of ecological awareness.

The category *human* is, like all other modern categories, spectral. The human inhabits the uncanny valley. When one thinks the human, the category collapses into all kinds of entities. Humans are made of nonhumans—gut bacteria, mitochondria, "Left over parts from the apes."[7] They also derive from nonhumans—as Richard Dawkins is fond of saying, one's million times great grandfather was a fish. And closer to the arrival of humans, there are all kinds of hominids and hominins. Then there are other species of human, such as the Neanderthals. As we approach the human, these entities become more and more obviously uncanny.

Let us return to the idea that spectral beings emerge when the life–nonlife boundary collapses, along with the human–nonhuman boundary—behind which is lurking the (human) subject–object boundary. The long history of the Anthropocene so far has been the history of the emergence of these specters, which can also be said this way: the uncanny valley into which beings slip begins to cover a wider and wider range, so that it ceases to be a valley.

Miljohn Ruperto's 2014 exhibition at the Whitney in New York exemplifies how the spectral is an intrinsic part of thinking ecology. In *Voynich Botanical Studies*, pages from the weird, indecipherable (but is it?) Voynich Manuscript (composed in fifteenth-century Italy) depict nonexistent (or are they?) plants. We might call them *ghost plants*. Ruperto reworks these illustrations into three-dimensional, black-and-white renderings that almost look like photographs. Again, recall that within the first few decades after the beginnings of photography, photographers became fascinated with capturing ghosts on film. Modernity is not about disillusionment, despite what it keeps telling itself.

Nietzsche's Zarathustra says that man is somewhere between a plant and a ghost. *Between a plant and a ghost*: Nietzsche means that a human flickers between what she is and how she appears. Doesn't the idea also suggest a kind of scale in which you could be 30 percent plant, 70 percent ghost, or 40 percent plant, 60 percent ghost, and so on? Doesn't this in turn suggest the possibility that a plant could be a ghost?

And also—there is something not human about being human. When you look at a human, you are looking at a gap between things or within a thing.

The ghostly images of plants on the right-hand sides of the Voynich Manuscript bring out something that is intrinsic to being a plant. A plant's DNA exploits its appearance to attract pollinating insects. A plant's appearance is not a plant, but a plant-appearance for some other being, such as a bee. A plant emits a sort of ghost of itself, an uncanny double.

What is called Nature is a forgetting of this ghostliness, this necessary doubling, the way in which a plant is haunted by its appearance, or the way in which a physical system such as DNA is also a semiotic one, and that there is a strange disconnection between these levels.

Digital images of plants, made with electrons and silicon: mineral monsters. Monsters that are metaphors for humans, wavering between

plant and ghost. In an era in which nonhumans press on our glass windows ever more insistently, get stuck in our machines, caught in our webs of fate—in this ecological age, such a strange peeling apart of the human into its ghostly nonhuman components is necessary.

Another work of Ruperto's at the exhibition is called *Elemental Aspirations*. Different minerals are molded to the shape of a gold nugget. *Elemental Aspirations* is about the conversation that takes place within a thing between the past and the future, or to put it another way, between phenomenon and thing. The form of a thing is what happened to it. The form of a thing is the past. The essence of a thing is what is not-yet fully revealed. The essence of a thing is the future. This not-yet is irreducible, such that there is a fundamental, wavering unpredictability about being a thing.

A thing is a sort of train station in which past and future slide against one another, not touching. This sliding has sometimes been called nothingness. Nothingness is not absolutely nothing at all, but rather a flickering, sparkling play of presence and absence, hiding and revealing. A thing is a platform where ghosts glide past.

The gold nugget's form is the past: it provides the cast for the liquid metals, the alchemical beings we call lead, iron, copper, tin, silver, mercury. But what are these strange forms, these twists of metal? Every answer we give will not be them. If they could speak, what they would say would not be them. They haunt us like ghosts, ghosts of minerals future.

They are not just lumps, these little spools of metal. They look like candies in twisted wrappers. They look like drills. They look like heads. Or ducks. Or rabbits. They aspire: they are breathing, as if exhaling simulacra of themselves, into the realm of appearance.

Elemental Aspirations is a conversation between Aristotle and post-Humean science; that is, the way science is done is in the light of Hume. *Mineral Monsters* talks about how the aesthetic has been sidelined in contemporary theories of physical things such as plants, rocks and ducks or rabbits. Yet I'm going to argue here that post-Humean (that is to say, contemporary) science might *also* be aesthetic in a strange and surprising way: a way that is not acknowledged by scientism, which is a tactic to prevent just this thought. By illegally reducing the world to bland substances or bland extension, scientism covers over the anxiety lit up by Hume and the continuing conflagration called Kant, who explained the deep reason why Humean skepticism works: there is an irreducible gap between a thing and how it appears. This means that for Hume and his successors—the scientists in their white coats—we live in a world of phenomena, of data, without direct access to things in themselves. We live in a world not unlike the world of art, where things appear mysterious and withdrawn, where we are confused and bedeviled with the octopus ink of appearance.

To re-enchant the world—to discover its necessarily aesthetic comportment, which I can't peel away from the world without damage: this

is Miljohn Ruperto's project. How do you re-enchant the world without just saying anything, without resorting to the kinds of statements that just ignore science? And without recourse to primitivism or to Nature?

When you reintroduce Aristotle, it seems as if you are regressing. But Aristotle is in front of contemporary materialism, which illegally reduces the world to sheer stuff, sheer extension, despite the impeccable constraints placed by Hume and Kant on doing just that.

How can you know, after Hume and Kant, a thing in itself? You can't. You know data. You know statistical correlations, not causes and effects. You know ghosts, impressions of things: a pattern in a cloud diffusion chamber; a map of weather changes in a high-dimensional phase space; hundreds of monkeys who react the same way over and over again to some stimulus. And yet, and yet … this doesn't mean that *there is nothing*. This doesn't mean that *there are only atoms*. This doesn't mean that *only the subject decides on reality*. All these trusty positions are reactions against the explosiveness of the founding assertion, that when I try to find out whether the light is on in the refrigerator, I have to open the fridge, and thus change the fridge. There is no way to get at a thing in itself. But we don't just have appearances. We don't just have stuff plus illusory appearances. We don't just have the subject's decision as to what counts (or history's, or economics', or whatever kind of Decider you want, George Bush included).

Materialism is a way to avoid the panic that ensues when the gap between what a thing is and how it appears becomes clear. Materialism comes in two basic flavors: regular, and new. The regular flavor is inhabited by rather square minds; the new flavor is decidedly groovy. It's strange, this new materialism, this new solution to our modern anxieties. Aristotle had already refuted reductionism to sheer matter, over two thousand years ago. Aristotle understood that things could not be reduced to sheer matter. Aristotle understood that to be a thing is to have a certain specific and unique form (Greek, *morphē*). But for Aristotle a thing is substantially, constantly "there." Hume shows us that there is no way to assert this, because all we have are data, not things themselves. We have sparkling rocks, we have twists of metal, we have the evidence of eyes and ears and measuring devices of all kinds. Yet this is precisely evidence of just this nugget of stone. It's not a popsicle. It isn't just any old thing. New materialism likes to think there is an underlying substance, something fluid rather than something solid, as if being fluid were the solution to all our problems.

What is seen in modernity is not matter. It is specters.

The solution to our problems is to realize that there is no solution to the intrinsic weirdness of a thing. In what does this weirdness consist?

Yet another part of Ruperto's exhibition is an animation of a duck morphing into a rabbit, a time-lapse version of the duck–rabbit illusion. As an old, cryptic joke puts it: *What is the difference between a duck? One of its legs is both the same.* The duck–rabbit is dying, but not dead. Yet not

fully alive, whatever that means. A spectral duck–rabbit with a strangely startled expression, weirded out by its own uncanniness.

To be alive just is to be a duck–rabbit. To maintain one's existence is to maintain a necessary rift between what one is and how one appears. In this respect, death is the reduction of a thing to consistency. To be alive, without imposing a concept of life rigidly opposed to death, is to be undead. To be a specter. This is already the afterlife, in the sense that what wriggles around here cannot be categorized according to the long tradition of concepts of life.[8]

Death is the end of spectrality. When I die I become my appearances. There are some notes in a wastebasket, some memories in your mind, a corpse. The difference between me and these appearances has evaporated.

Life is inconsistency. Existing is inconsistency. Being a thing is inconsistency. There is a fundamental, irreducible gap between being me and appearing to be me. I am a duck–rabbit.

Which means that I am a sort of weird, true lie. It is perfectly logical to allow some things to tell the truth and lie at the same time. You can tell it's logical, because if you try to eliminate true lies, you get worse true lies.

Consider the sentence *This sentence is false*, which is both true and a lie at the very same time. It is true that it's a lie, so it's telling the truth, which means that it's false. And so on. A spectral sentence.

Imagine you can make a rule that goes *"This sentence is false" is not a sentence*. But someone can make a new sentence that blows up your rule: *This is not a sentence*. How come they can do this? Because it is okay for some sentences to be contradictory. Because things are contradictory. To be a thing is to be a duck–rabbit. Trying to exorcise the specters that haunt logic only results in more specters. There is a simple conclusion: something about reality is spectral, so that something about the structure of logic is spectral, incapable of being categorized as true or false.

A certain kind of person (not to mention a certain kind of social structure, a certain kind of ideology) wants to contain these double-truthed things, these dialetheias. This would be someone anxious about the spectral nothingness opened up by Hume and Kant, the flickering nothingness we call modernity. Someone like that wants to draw a line, to say, for instance that there are can be no mineral monsters. To draw a line between the living and the nonliving, like Georges Canguilhem, for instance. But there is nothing in the data to prove that this thing, palpitating before me, is alive, or sentient, or conscious, or a person. Even when that thing is my own reflection.

The default condition of being a person is being paranoid that one might not be a person: to be a puppet, a thing manipulated by some external, demonic force. You can stave off the anxiety of this thought by concluding that being a person is a pure illusion—there is only matter, or there are only relationships between systems, or what have you. This is scientism.

Miljohn Ruperto's conversation with medieval minerals and alchemy is a way to talk to scientism, not to regress from modernity to an older, safer

age where things meant what they said they meant, but rather to channel something from the future. A future in which we have somewhat made friends with the anxiety that things are, and are not, as they appear. To bring back Aristotle and Ptolemy in this light is not to block one's ears to the modern, but to try to open them a little bit wider.

A tiny, tiny piece of metal breathes. When you isolate it by cooling it close to absolute zero in a vacuum, you can see it vibrating and not vibrating at the same time. This tiny, tiny piece of metal is ever so much bigger than an electron or a photon or other things that we often associate with quantum theoretical effects.[9]

What does this mean? It means that quantum effects (such as vibrating and not vibrating at the same time) are possible because to be a thing at all is like that. To be a thing is to be a breathing duck–rabbit, living–dying, moving–still.

Modernity has allowed us to open to the possibility of connecting to the nonhuman without a conceptual framework. Can I prove a plant is not sentient? Can I prove that there can be no mineral monsters? Isn't monstrosity installed at the mineral level, since to be a monster is to be on display (Latin, *monstrare*)?

In other words, to be a mineral is to have an appearance that floats weirdly in front of a thing, lying and telling the truth at the same time. There can be mineral monsters, and the same modernity that generates the phobic reaction to its most strange discovery is also capable of thinking this thought.

Thus to be a monster is to be a distortion that is also true. The distorted metal nuggets, the ghostly plants, the dying duck–rabbit, all proclaim this distortion. To be is to be monstrous.

This is why the experience of beauty is also an experience of something slightly disconcerting, to say the least, and monstrous, when its contours become more explicit. Beauty tells me that a thing cannot be grasped in its essence. A thing exceeds my capacity to grasp it. There is an inevitable gap between how it appears and what it is. A thing is not smooth. This was true in the Kantian age, but it is more explicit in an ecological one. There is no authority that orders me to like this and not that. I have to look for the rule in my inner space, but when I look there, I encounter this spectral not-me, something about which I am uncertain. Furthermore, since there is no accounting for taste for Kant, the idea of a single recognizable standard seems spurious from the start, and Kant's attempts to police what he means by beauty are symptoms of that. In an ecological age, that there is no one scale on which to judge anything becomes ominously clear. Which scale should we use? Microbe? Human? Biosphere? Planetary? In the absence of an authoritative scale, all art sinks into the uncanny valley called kitsch: the slightly (or hugely) disgusting enjoyment-objects of the other, who for some bizarre reason like this particular ceramic horse. Disgusting because of the other.

Thus a specter haunts the specter of communism: the specter of the nonhuman, or we might now even say, with Derrida, the specter of spectrality as such—and I hope I've shown how this is indeed the same thing as the nonhuman.[10] No longer able to exclude them with a straight face, thought is confronted with its anthropocentrism. It simply cannot be proved, as Marx wants to, that the best of bees is never as good as the worst of (human) architects, because the human uses imagination and the bee simply executes an algorithm.[11] Prove that I'm not executing an algorithm when I seem to be planning something. Prove that asserting that humans don't blindly follow algorithms is not the effect of some blind algorithm. The most we can say is that human architects pass our Turing Test for now, but that is no reason to say that they are better than bees. It is instead to assert that we can't prove whether humans are executions of algorithms or not, casting doubt on our certainty that bees really do execute algorithms blindly, since that certainty is only based on a metaphysical assertion about humans, and is thus caught in fruitless circularity.

Bees and architects are important, because for Marx, in the lineage of Kant, there is a Decider that makes things real. For Marx, the Decider is human economic relations. But ecological relations without doubt subtend human relations of all kinds (let alone economic); and ecological relations extend beyond them throughout the biosphere. Human economic relations are simply general ecological relations with arbitrary pieces missing—huge numbers of them. Either Marxism can be thought in a way that includes this irreversible knowledge, or it can't. If it can, then communism must involve greater and better relations with nonhumans. As Marx says in the chapter on machines in *Capital*, capitalism produces the misery of the worker and the depletion of the soil.[12] And soil is decomposing lifeforms and the bacteria whose extended phenotype these lifeforms are.[13] In short Marx implicitly includes nonhumans, while explicitly erasing them.

What is called Nature is also a way to blind and deafen oneself to this strangeness. Ecological awareness, now occurring for everyone on earth, is a way to take one's hands away from one's ears, to hear a message that was transmitted loud and clear in the later eighteenth century, a message that not even its messengers wanted entirely to hear.

Kant blocked his own ears, limiting the gap he had discovered to the gap between human beings and everything else. It is time to release the copyright control on this gap. The name of this release is ecological awareness. Ecological awareness is coexisting, in thought and in practice, with the ghostly host of nonhumans. Thinking itself is one modality of the convocation of specters we summoned at the beginning of this chapter. To this extent, one's "inner space" is a test tube for imagining a being-with that our metaphysical rigidity refuses to imagine, like a quaking peasant with a string of garlic, warding off the vampires. Like Adorno, we need to brave the encounter with non-identity.

This doesn't have to be considered as a bizarre stretch. Recall that commodity fetishism means that a table, a piece of fruit, a cloud of carbon dioxide begin to operate like computer programs, chattering with one another about their exchange values, and that this is *far stranger* than if we accepted that they could act in a paranormal way, which is to say, a "magical" way outside of normative modernity, by dancing around. That is precisely what Marx says about commodity fetishism:

> A commodity appears at first sight an extremely obvious, trivial thing. But its analysis brings out that it is a very strange thing, abounding in metaphysical subtleties and theological niceties. So far as it is a use-value, there is nothing mysterious about it, whether we consider it from the point of view that by its properties it satisfies human needs, or that it first takes on these properties as the product of human labour. It is absolutely clear that, by his activity, man changes the forms of the materials of nature in such a way as to make them useful to him. The form of wood, for instance, is altered if a table is made out of it. Nevertheless the table continues to be wood, an ordinary sensuous thing. But as soon as it emerges as a commodity, it changes into a thing which transcends sensuousness. It not only stands with its feet on the ground, but, in relation to all other commodities, it stands on its head, and evolves out of its wooden brain grotesque ideas, far more wonderful than if it were to begin dancing of its own free will.[14]

The future thought that Marx can't quite articulate himself is right there, not exactly in the argument, but in the imagery. This future thought is quite easy to decipher. In commodity fetishism, spoons and chickens don't have agency: they become the hardware platform for capitalist software. It is far *easier* to allow in to thinking the host of dancing daffodils that Wordsworth talks about, the dancing tables of Marx, let alone dancing chimpanzees. Allowing this spectral, paranormal supplement of modernity to enter the thought of communism, does not mean that capitalism flirts with the spectral, but that *capitalism is not spectral enough*. And in not being spectral enough, capitalism implies a substance ontology that sharply divides what things are, considered to be "normal" or "natural" fixed essences (extensional lumps without qualities), from how things appear, defanging the spectral and "demystifying" the thing, stripping it of qualities and erasing its data, resulting in nice blank sheets or empty hard drives. The extent to which any given form of Marxism retweets this metaphysics is the extent to which it cannot imagine an ecological future. But this requires accepting that some forms of mystery are not so bad.[15]

Notes

1 Aimé Césaire, "Discourse on Colonialism," in *Postcolonial Criticism*, ed. Bart Moore-Gilbert, Gareth Stanton and Willy Maley (New York: Routledge, 1997), 82.

2 *Oxford English Dictionary*, "spectre," *n.* Available online: http://www.oed.com (accessed August 7, 2014).

3 Theodor W. Adorno, *Negative Dialectics*, trans. E. B. Ashton (New York: Continuum, 1973), 5 ("Dialectics is the consistent sense of nonidentity"), 147–8, 149–50.

4 Charles Baudelaire, "Spleen," in *Les Fleurs du Mal*, trans. Richard Howard (Brighton: Harvester, 1982), 75.

5 The Beatles, "A Day in the Life," *Sgt. Pepper's Lonely Hearts Club Band* (Parlophone, 1967).

6 Timothy Morton, *The Poetics of Spice: Romantic Consumerism and the Exotic* (Cambridge: Cambridge University Press, 2000), 6.

7 Crash Test Dummies, "In the Days of the Caveman," *God Shuffled His Feet* (Arista, 1993).

8 Eugene Thacker, *After Life* (Chicago: University of Chicago Press, 2010).

9 Aaron D. O' Connell, M. Hofheinz, M. Ansmann, Radoslaw C. Bialczak, M. Lenander, Erik Lucero, M. Neeley, D. Sank, H. Wang, M. Weides, J. Wenner, John M. Martinis, and A. N. Cleland, "Quantum Ground State and Single Phonon Control of a Mechanical Ground Resonator," *Nature*, 464 (2010).

10 Jacques Derrida, *Specters of Marx: The State of the Debt, the Work of Mourning, and the New International*, trans. Peggy Kamuf (London: Routledge, 1994).

11 Karl Marx, *Capital* 1, trans. Ben Fowkes (Harmondsworth: Penguin, 1990), 283–4 (Ch. 7).

12 Marx, *Capital* 1, 638 (Ch. 15).

13 Richard Dawkins, *The Extended Phenotype: The Long Reach of the Gene* (Oxford: Oxford University Press, 1999).

14 Marx, *Capital* 1, 163.

15 This thought is strangely akin to what Aimé Césaire (as cited at the beginning of this chapter) argues about the colonized person—she or he needs to be remystified: "They talk to me about civilization, I talk about proletarianization and mystification" (*Discourse*, 82).

Bibliography

Adorno, Theodor W. *Negative Dialectics*, trans. E. B. Ashton. New York: Continuum, 1973.

Baudelaire, Charles. "Spleen." In *Les Fleurs du Mal*, trans. Richard Howard. Brighton: Harvester, 1982.

Beatles, The. "A Day in the Life." *Sgt. Pepper's Lonely Hearts Club Band*. Parlophone, 1967.

Césaire, Aimé. "Discourse on Colonialism." In *Postcolonial Criticism*, ed. Bart Moore-Gilbert, Gareth Stanton and Willy Maley. New York: Routledge, 1997.

Crash Test Dummies. "In the Days of the Caveman." *God Shuffled His Feet*. Arista, 1993.

Dawkins, Richard. *The Extended Phenotype: The Long Reach of the Gene*. Oxford: Oxford University Press, 1999.

Derrida, Jacques. *Specters of Marx: The State of the Debt, the Work of Mourning, and the New International*, trans. Peggy Kamuf. London: Routledge, 1994.

Marx, Karl. *Capital 1*, trans. Ben Fowkes. Harmondsworth: Penguin, 1990.

Morton, Timothy. *The Poetics of Spice: Romantic Consumerism and the Exotic*. Cambridge: Cambridge University Press, 2000.

O' Connell, Aaron D., M. Hofheinz, M. Ansmann, Radoslaw C. Bialczak, M. Lenander, Erik Lucero, M. Neeley, D. Sank, H. Wang, M. Weides, J. Wenner, John M. Martinis, and A. N. Cleland. "Quantum Ground State and Single Phonon Control of a Mechanical Ground Resonator." *Nature* 464 (2010): 697–703.

Thacker, Eugene. *After Life*. Chicago: University of Chicago Press, 2010.

CHAPTER THIRTEEN

Devastation

Matthew Fuller and Olga Goriunova

In this chapter we want to try to address the force, in the context of a general ecology, of devastation. What we refer to as devastation is not solely a kind of becoming of nothing in which the nothingness is produced by this or that becoming of some thing, neither are devastations simply diminutions of the stock of entities in the world or the finite number or range of things. Some aspects of devastation are captured in describing it as attenuation or diminution of the virtual, but such figurations are too extensive to address the recalibration of the virtual that devastation presents, and what we propose to do here is to map such shifts through general ecologies.

Devastation operates and couples with, protrudes from, and dissolves certain other kinds of becomings that are biochemical, military and economic, socio-political, technical and mediatic, among other things. General ecology is inclusive of the three Guattarian ecologies of the mental, social, environmental—ecologies beyond "nature"—but today it also takes on the overtones of and relates itself to the debates around such events as extinctions, their threatening immediacy and increasing intensity.[1] General ecology faces the need to recognize and explicate anxious humans, the strategies of modern warfare, calculations of probabilities, a rainbow of waste molecules in water, carcinogens, plastic- or high fructose corn syrup-packed bellies, oil spills, the proliferation of dross disguised as information, among many other layers and registers. Devastations cut across these to produce something that exceeds their categorical limits.

It seems that in the discussions of extinction, taking place for instance in the accounts of deforestation or other examples of the destruction of natural habitats, the Aristotelian model of genus and the forking paths of classification (and with them, primary and secondary substances and lasting identities) adhered to in the Linnean classification still have significant traction on the public sense of the diminution of the variety of species, in turn endangering the ecological and social horizons of possibility. But something more is occurring. In conditions of devastation it is not a set of

things becoming extinct under a category or idea that is thus itself transformed, affecting the others in a cascading logical fashion that uncannily follows a tree-like formation, but it is the concept as an existing multiplicity, a differential, that fails to actualize, a potentiality that is wounded in a way that makes it implode, that makes it actualize a devastating becoming.

Deleuze draws upon the example of a lens in Bergson, where the virtuality of all colors in white light are actualized to offer a range of shades; one could ask what happens to color if the blue of the sky is no longer actualizable because the atmosphere has changed or disappeared.[2] What changes in the concrete universal of light that passes through the lens when there is no blue of the sky?

Blueless

The philosophies of desire and of process wrote themselves out of the condition of subordination reinforced by the Hegelian tradition in terms of ideology, history, false consciousness and the like, by emphasizing becoming and difference rather than being and identity. Rather than a universe of "final perfection with static existence"[3] as Whitehead abbreviates that of Descartes, one could say that they replaced the ontology of a mechanical universe, in which the machine can fully come to a stop, with that of an ecology—of non-linearity.

In the preface to *Difference and Repetition*, Gilles Deleuze talks about the problem of rendering the argument for affirmation in relation to discussions of the negative, predicated upon more traditional philosophical tools such as doubt, criticism, opposition and so on.[4] The figure of the Beautiful Soul, in this account, sees only the gorgeously ever-differentiating oneness of it all, and is able to deduce neither a mode of living nor a reading of politics. Drawing on this fissure, for the purposes of measuring philosophy on the scales of a form of politics, this is a line of enquiry developed by Benjamin Noys in *The Persistence of the Negative*.[5] Our tack is different here, in that we want to develop a discussion of how what is often seen as negative, inimical, may operate by means of dynamics that are often rendered—when it comes to the figurative capacities of text-based thought—as belonging more properly to the anthropically beneficent fluctuations of nature in vitalist thought. Thus we are faced with an oxymoron: a lively, devastating vitalism, the becoming of obliteration, dark vitalism.

The conditions of the genesis of the actual are grounded in the virtual, which is a differential infinitely saturated with change, infinitesimal or infinitely large, multiple. The virtual is real but not yet actualized. The virtual is also fully immanent[6] and is affected by the actual, too; otherwise the virtual would operate as an eternal transcendental idea, unattainable and unthinkable. In what follows we seek to create an ethico-aesthetic

vocabulary for devastation as performing the process of actualization, the manifestations of the virtual–actual continuum which in turn involute the virtual.

Devastation is a kind of ontological flexure on the process of actualization and change. Devastations may not necessarily diminish complexity, and their effect is larger than the calculation of possibility, on the planetary or cosmic scales. There is no point arguing whether devastation only affects the domain of Eukarya or also Prokaryotic microorganisms; it does not necessarily only affect cellular forms of life while leaving chemical and physical structures intact. We also do not want to get stuck in the well-trodden paths of discussion centered on the reflexive subject, affective body, trauma, or death.

A metaphysical devastation, a devastation of the virtual, arises from a concatenation of shearings at multiple scales. Actual devastation doesn't create the virtual by way of resemblance, but necessarily feeds into it. Devastation in general ecology does not imply that there is an end to becoming or a negation of affirmation, but that there is a change to virtual becoming. Devastation seizes, eliminates or radically changes the conditions of other becomings. The tendencies of devastation are not, however, necessarily anti-organismic or entropic and as such faithful to the order of thermodynamics. Devastation can generate novelty and complexity outside diversity. Complex devastational forms include the dynamic behaviors of new auto-immune diseases, harmful molecule compounds, cancerous growths, radiation, accumulations of carbon dioxide, which do not eliminate complexity and wholeness in favor of randomness or a flat lack of differentiation, but radically redistribute the shares of potentiality, shape planes of activity and tangle with, impersonate and swallow other processes of change. The active growth of devastation is not the individually unthinkable scope of the death of the individual or the overwhelming absences of pure nothingness, it is something to the side of such things, being devastatingly vital, active, and productive.

The Chernobyl disaster thirty years on is a relevant example: the socio-political effects engendered by radiation seem to have ensured a lack of anthropogenic factors within the exclusion zone, contributing to its relatively higher biodiversity, with rare animals being spotted there. There is a window of instability in such radioactively charged biodiversity that allows certain elements to prosper for a while amid other unfoldings: the biochemical effects of radiation interfere with the microbial and fungal ability to process biological decay, thus leading to the conservation of the dead.[7] As a result, thousands of trees lie undecayed in the same spot where they fell. This interference with the dead is of a different quality to that of work attributed to the afterlife: it is an arrest of death.

Jean-Hugues Barthélémy has written on Simondon's formulation of "deadening," which "is contemporaneous with each vital operation as operation of individuation."[8] He suggests that the Simondonian view of

death as a deposit can be altered to reflect an understanding of death as "the very heart of life," a position he finds confirmed by contemporary biology, where "cellular suicide plays an essential role in our body in the course of construction." At the scale of cells, the death of certain of their number in a developing embryo is a precondition for growth as a process of the separation of bones, digits, orifices. In a related sense, Ray Brassier notes the way in which cellular specialization occurs in evolution when a primitive organism "sacrifices" a part of itself to protect the rest from the external environment and to functionalize itself, thus making death an origin of life, the death that can not be repeated in death itself.[9] Such a form of death, as part of an endosymbiotic becoming,[10] a link in a chain of becoming, or an excluded and unthinkable attraction at the core of being, is radically altered in devastation. Devastationary death leads to something other than further life and the recouping of material resources into linked systems, the becoming of other states or the pull of originary death. Devastationarily arrested deaths are multiplex, cutting across scales of interpretive frameworks or capacities of knowing.

At another scale, devastation as ecological event can be characterized as involving complex and manifold interactions across and within multiple kinds of entities and systems. The earth's history is marked by a number of massive, planetary-scale events. We know that there are ages on the earth when many things die, such as ice ages. The evolution of photosynthesis created the atmosphere, whose interaction with the rays of the sun created the ozone layer, and so life could evolve. Things (like free oxygen molecules) have qualities that can be destructive for other entities, and electro-magnetic radiation is perfectly "natural" as part of matter. Devastation does not simply amount to the existence of destructive qualities themselves or destruction per se. Devastation relates to changes in the conditions of becoming and can be of a form of very active production, reconfiguring the relations between stability and change, expansion and contraction, wreaking havoc in chains linking habitats to cosmologies, such as those that move from the destruction of forests to the extinction of the languages of those that live in them, resulting in a loss of ability to think in certain ways.

Above we differentiated devastation from a pair of other conditions. Death in devastation is not the traditionally understood part of the cycle of life and death, and patterns of growth and decay, nor is it the polar attractor of the death drive. Certainly, both of these conditions may take part in devastations. But devastations take things out of cyclical or deter-mined states into proliferating conditions of involution. In the case of Chernobyl, the afterlife and growth of radiation as the result of the disaster drastically deplete fungal and bacterial operations, resulting in among other things the non-return of nutrients to the soil. Such change delinks life from its source in non-life or other forms of life and alters the processes of becoming. This is not simply a deferral of the usual process, whereby trees are "stored" for later decay, but an effect of radiation's arrest of death in

life that is itself a kind of growth, a propulsive unfolding of things, for which we have no available ethico-aesthetic figures. One possibility for these trees is that they maintain this dry, unrotted state, constituting an expanse of excellent kindling, until the advent of a forest fire whose smoke and ashes would spread the radioactive material they store far beyond the current exclusion zone. This would be a growth, an affirmative becoming for radiation as a kind of devastation.

Melancholia of obliteration

In the discourse of natural history TV extravaganzas, as Donna Haraway puts it, "knowledge saves"[11] via conservation, scientific understanding, and popularization. Mediation of survival is one means of ameliorating conditions of devastation. In the case of Lars von Trier's film *Melancholia* however, there is nothing to be done.[12] A rogue planet is on a fatal and implacable collision course with earth. One is obliterated, we are obliterated, they are obliterated, everyone and everything is obliterated, along with the planet. There is no possibility for reflection afterwards and no prospective capacity to understand or sense obliteration. Perhaps the unknowable void, like air, water and other things is also a precious commons?

Is *Melancholia* just a scary occurrence of the impossibility of thinking the earth beyond human extinction or does it recount a differentiation in and from devastation: the differentiated becoming of the perishing of human species, animals, forests, flows, continents, the earth as a totality of its destruction, or as a subset of those of planets as a whole? *Melancholia* obliterates earth as a living planet, but it doesn't cancel out its physical matter, which is scattered in space and possibly left to drift as atomic rubble. Are we tempted as humans to simply bemoan the obliteration of the virtual that we equate with earthly human potentiality or is it indeed an imaginary act of thinking the perishing of the virtual of all matter, echoing in some way that of the ultimate fate of the universe and the ontology of dark energy?

Obliteration thus sets out the other margin from that of natural cycles within the bounds of which devastations become manifest. Obliteration brings us to the question of the void, finitude, the vastness of nothingness, and questions of cosmology, states and conditions that we do not pursue here but use as a point of approximate measurement. Such conditions are, as writers such as Schopenhauer and Thacker explicate, rather tricky to make observations about.[13] At the same time, and as such, they act as a rather convincing limit to what we can describe as devastation.

Spills

One of the most obvious and egregious of devastating abundances is that of oil spills, from grounded and broken tankers, faulty and unguarded valves on oil rigs, and the collateral damage inseparable from the development of new techniques such as fracking. By such means, the earth, all surface, gets in touch with its inner self. How is it possible to enter into knowledge of such events?

The becoming of the Deepwater Horizon event, the momentous leak from a BP rig in the Gulf of Mexico in 2010, for instance, is interrogated by a range of mechanisms, including risk discourse as epitomized in insurance contracts and legal liability; the articulation of claims of environmental stewardship, and the diminution of what the stakes of such might be; the technical language of oil-spill management, and the attendant withering of the terms of the precautionary principle; the media responses of the various companies involved, distinguishable by the variety of their more or less inept and mendacious quality. All of these produce their own kind of grasp on and amplification of the event, even when they try to smother it. Indeed, perhaps the urgency of a reckoning of devastation is partially driven by how such conditions are supposedly resolved by such discourse, such a resolution holding it at bay, boxing it off, rather than attempting any more sustained understanding which might risk fundamental implications for oil as a commodity.[14]

Oil is tragic because at the same time as providing enormous power it poisons those associated with it, however remotely. Indeed, part of the complexity of oil is its profound corruption of the discourses, persons, and institutions around it as they work with the impact of this immense energetic and toxic force. Such work includes the stabilization of certain forces (capacity for getting energy) and the harnessing of others for certain kinds of gain or utilization, and at the same time entails the marginalization of the recognition of certain of its consequences (climate change).

The tragic nature of oil is apparent in the frequent reports of the results of deliberate or accidental ruptures of oil pipelines in Nigeria and elsewhere, this compounding the baleful consequences of large-scale gas flaring and the generally haphazard and negligent treatment of its ecological effects.[15] Spills are regular, obliterating the use of land for farming and as spaces of ecological succor. The abundance of such oil indulges a disregard even for its wastage, not to mention the differential withering and bloating effects on local life on the part of the colonial powers of the oil companies.

When spills occur in the slums and shantytowns, people collect some of the oil in whatever containers are to hand. Frequently these spills result in conflagrations, killing and burning all those that had gathered to collect the oil in their meagre containers. Each such event is a catastrophe, but their ongoing form, and the negligence with which they are handled renders their

qualities those of devastation, in that their proliferation goes unchannelled. As devastation, such spills populate entire ecospheres. They change the capacity of parts of the surface of the earth to sustain life by smothering it in a substance from beneath its surface, one composed, of course, by decayed organisms.

One of the significant contingent factors about the way in which devastations mesh with human societies is that their unfolding is frequently gamed, manipulated or gambled on for political advantage. Devastations are political, and are drawn upon by meshings of rhetorical, calculative, juridical, economic, and socio-political forces and interests. This is something readily observable in the brinksmanship passing for advanced statecraft in the negotiations over climate change. Perhaps because obliteration is unimaginable, unrepresentable, that which edges towards it is not yet it. Devastation becomes the negotiable continuum. The void is unimaginable, therefore it acts as some solid, finite limit as a basis for non-negotiation, as a state that we have not yet reached. Tap-dancing on the rim of an abyss that cannot be seen looks all the more convincing if the dancers themselves cannot see the edge. What should be a convincing limit, is seen as a foundation upon which what is imagined to be political and economic advantage can be made. A moral, if not conceptual or speculative limit, thus provides the basis for speculation on its transgression, on the understanding that gambles will be made on the idea that it cannot be transgressed.

Devastation as personification

Discussing brain injuries and drastic neurological conditions, Catherine Malabou posits a "destructive plasticity" to describe physiological events in the brain that fundamentally change a person, such as advanced dementia in Alzheimer's disease, severe strokes, split identities and other phenomena. Malabou asks a double question founded in negativity, for which she aims to recoup the possibility, both in reason and in the capacity to recognize as fact. "Is there a mode of possibility attached exclusively to negation? A possibility of a type that is irreducible to what appears to be the untransgressable law of possibility in general, namely, affirmation."[16] For her, the trick whereby one cannot avoid the regime of affirmation, since even to recognize the negative is to affirm it, is to avoid the difficulty of making a recognition of the negative.[17] The structure that makes possible this trickery of affirmation, of this double negative that always pulls an affirmative out of its empty hat, is partially the effect of language in which a "no" always has a presence. In a certain sense this is a related problem to the unrepresentability or the unknowability of the void, of nothing. Destructive plasticity instead marks a break, a fundamental event around

which there is no possibility for a flickering of meaning between a positive and a negative, but instead a snuffing out of what had been. For Malabou, "destructive plasticity deploys its work starting from the exhaustion of possibilities, when all virtuality has left long ago."[18] In this work, Malabou provides a significant means for the recognition of the devastations within the scale of a person, itself a thing unfolding on many scales: within the brain; at that of memories; behavior; motoric function and so on. There is no inherent limit to the virtuality of a person other than its constituent coupling with actuality. What Malabou maps so well, although using a different conceptual vocabulary to us, are the modalities of damage that may constitute such actuality at the scale of the brain.

Devastation in common

At another scale, as Elinor Ostrom notes, devastations occur to commons[19] and are not limited to any particular scale, size or location. Devastation, in fact, may sometimes be the only common we are left with. One example is the waste commons of the North Pacific Gyre. Plastic, plastic-particular waste and microplastic waste (used in substances such as deodorants) have been found even in the rather more remote and more disconnected Southern Ocean.[20] As the waste enters into the bodies of fish or albatross, there is the generation of a set of second- and third-order poisonings, and first-order throttling and blockages, as the plastic objects take up space in stomachs, making them unable to fully digest food.[21] With the entry of this relatively new kind of entity, ecologies become unstable, yet difficult to map due to the redistribution of life and non-life, related—with no obvious counterfactual—to the question of the proof of an absence, of the new forms of death and life.

In relation to a commons of devastation, such as that of Bhopal, where those structurally least able to bear the burden of pollution have been gifted with the opportunity to freely have it absorbed by their flesh, water and children, new political subjects may arise. There is a certain resonance here with the way in which uncanny or alien forms may flourish in the Zone, as described by Boris and Arkady Strugatsky in *Roadside Picnic*. The devastated Zone has another mode of becoming and its potency as a mutational field is what is most stunning in *Stalker*. Such a response to devastation is part of what art often offers, a material imagination of adaptation, mutation, or horror—an aesthetic parallel to evolutionary models of symbiosis, commensality, and parasitism that allows for such conditions to be sensed.

But the problem with human culture in relation to the manifestations of devastation is that it is so often stuck in the positive, the little twinkle of redemption at the end of every 35mm apocalypse. There are very few

aesthetic figures (film director Kira Muratova is an excellent counter-example) that can contemplate the dark without drawing a resolutely positive lesson, but taking the time to stare without jerking back. Perhaps this is a lasting legacy of Judeo-Christianity, transformed into the Anglo-Saxon gift of compulsive optimism; and perhaps in turn the belief in the intensive and vital capacity of change has something of fantasy or of wishful thinking to it; one that is less that of a conceptual and aesthetic imagination enacting and invoking new worlds, and more that of a soothing tale of things sorting themselves out in a jolly cosmos where irresolvability, futility, and meagre meaning do not figure.

Poor human

Writing about devastation, it is impossible to waltz around the human. Like a grand piano in a bedsit, the human gets in the way in so many special ways: with abstract thought and the question of the obliterating destruction of the transcendental, the question of the empirical, as the cause of climate change, as the late subject of history and in all the luxurations of woe in what has been linked to some of the powerful figurations of the subject. Ecology as a whole can be seen as an increasingly tensile condition in what has come to be called the Anthropocene, the geological era defined by the impact of humans, often dated from either the start of agriculture or from the industrial revolution. There is a depletion of biodiversity, and a homogenization of ecospheres, that is, in the latter case, due to the generalization of certain kinds of organisms around much of the planet.[22] The distinct quality of devastations, however, is the generation of erasures as well as the formulation of novel admixtures, interactions and objects.

If we're to take Kerry Whiteside's analysis that there has been a divide in Anglophone ecological thought between the anthropocentric wing that regards nature as a value-laden notion whose meaning is renegotiated in relation to human needs, and those arguing for a nonhuman view of nature as "wilderness," then we can contend that the concept of the Anthropocene displaces these tensions. What the idea of the Anthropocene does is recenter such debates, providing for a few tensional foci: the threat to the human (framed in ontological terms), the danger posed by the human (susceptible to social, political, and ecological analyses), and the condition of ecology, where nature is historically evolving earth in its wider cosmic position in the Milky Way. By including the human within the term itself, the Anthropocene assigns more (negative) value to the anthropos.

After all the efforts at de-anthropologizing theory, and all the various phases it has gone through, this is a bizarre situation: the human is not the center of creation, but yet is its transmogrifying if not annihilating force. By becoming less central, removing itself from the position of dominion,

the specter of finite and full objectivity, the rule of reason, where such positions are in turn occupied by mathematical models, algorithms, data patterns, international agreements, the human also becomes a small schizophrenic element, sleepless, exhausted and—most importantly— responsible. Humanity becomes an objective force changing the planet: the Anthropocene is the age in which the human is both the most powerful and central, and simultaneously the least so.

The concept of the Anthropocene has enjoyed somewhat garrulous popularity and has been criticized for, for instance, generalizing humans into a single block of a species and failing to account for differences in "biophysical resources, cultural perceptions and global power struc- tures."[23] Perhaps a detour to Dostoevsky and his idiot Myshkin could provide another way of looking at this exercise of assigning responsibility: in Myshkin's sensorium, he is ready to take responsibility for all acts and events in the world onto himself. This is an ethico-aesthetic gesture, an ontological structure of feeling that is in tune with the condition of devas- tation: being implicated, being inside. Writing about the Anthropocene, Dipesh Chakrabarty suggests that "species thinking"—posited as occurring at the moment when a human needs to understand herself as a species—is untenable, both because it entails a return to essentialism, and is also a condition that it is impossible to experience.[24] Writing about the concept of species more broadly, Manuel DeLanda also notes the necessity to think species and individuals in a non-homogenous way across scales—a statement founded on a Deleuzian critique of Aristotelian generalization in favor of the virtual-actual distinction, with the virtual common to all animals.[25] A non-Linnean and non-Aristotelian thinking of species and ecology as well as a generalized ecology in some way relate back to the conundrum outlined by Chakrabarty, involving natural history in relation to a history of modernity and capitalism and calling for thinking in both chronologies, traversing between "capital and species history."[26] Since species history is fundamentally a site of contestation and invention, in addition to the marking out of chronologies, such a call means working out a whole range of new conceptual vocabulary.

How can difference be contaminated by too much difference? How might a philosophy of difference account for plastic in albatrosses' bellies? The cross-cutting of systems of stratification that yield plastics and yield albatrosses—the behavior of pelicans and the territorial life of plastics, given that just a few of these intersections create devastating conditions with an intensive character or networking of scales—does not bring transition to another state such as a deterritorialization, but an inflection of actualization that, while destroying the actual, also metastasizes the virtual.

Devastation is not always a catastrophic event. It can be slow and pleasant (sugar dumps in bodies) or unnoticeable; it can be cumulative, mutative, familiar. The non-linear causality of devastation holds but does not create complex things of wonder, as various machines of evolution,

or thermodynamic systems far from equilibrium are said to do. It creates something for which we have no image. Science has no teleology and the philosophy of difference proposes complex models of causality and yet the processual unfoldings of evolving life are supposed to be right, true, and wonderful. So what about when they are not?

Witnesses and warfare

Such a condition suggests something that deserves to be recognized. As it moves across scales, devastation requires a sliding subject, some abstract form of thought following scales, registers, atoms, organisms, habitats, languages, chemical compositions, pain, hunger, changes of structure. Malabou asks, what might be a phenomenology of damage? And in this is nested a clutch of questions. Within the scales of destructive plasticity and the richly varied susceptibility to damage of the brain, who or what, and with what instrumentation and sensitivities, is there to make an account of such an event? Since there is not always an other who can make an account of the ways a devastating change becomes manifest, or even a self marking the ways in which it becomes other to itself, what modes of witnessing are adequate to devastation? Is devastation always happening to an entity to which such an undergoing can be delegated and deferred?

In materialist ontologies the suffering, diminution, pollution, cancerous growth, changing ph levels, melting ice have scales and modes of existence larger than humans can conceive, experience, and project. Just as there is to life, there is an incomprehensibility to devastation. A problem for ecological science today is trying to comprehend—from experience, from imagination, from a fastidious testing of samples (of core ice, of tree rings, of atmospheric gases, of climatic records); trying to understand the roots, conditions, and counterfactuals of this incomprehensiveness. The problem of who or what is thinking and watching the devastation and for whom and at which scale it occurs, means also trying to establish the means by which such accounts can be elicited, at the same time as recognizing that a full unfolding of the condition is unknowable.[27] The simultaneously empirical and abstract status of devastation is a problem! It is one that calls for an abstract empiricism, one capable of making a reflection on the constitution of such a problem on multiple levels and scales. Perhaps, it is one that might resonate with the versions of the multiverse in quantum mechanics, string theory and modern cosmology,[28] in which the myriad of existing universes all require their own observers or poets, only a few of which happen to be constituted by a species that habitually speaks in terms of an "us." But this is not simply a problem for thought, and its iteration on a solely philo-sophical or scientific-technical level. As devastation may not be so evidently extreme, nor about immediate finitude, and can be differentiated from

obliteration at the far end of its continuum, it is devastation that becomes employed as a political tool, performs as rhetorical playground, as data to be calculated, is objectified into things to be traded, such as toxic waste, and is regarded as something from which some value can still be extracted.

Deleuze proposes, instead of the viewpoint of the Beautiful Soul attended to above, a Nietzschean affirmation of aggression and selection played out in differential terms, which may involve a sophisticated ability to work with what Bernard Stiegler calls the *Metis* of politics, an art of war that is neither walled off from metaphysics nor naturalized by it.[29] Perhaps articulating something of this condition, there is a certain confluence of operations between warfare, or the exercise of violent power (with or without the monopolies of the state), and the dimensions of the unthinkable manifest in abstract empiricism. Both are condemned to undertake operations within certain kinds of fog.[30] As such, the recognition of devastations is rendered partial by their inexplicable sense, in the same way that one must distinguish between the climate and the weather as operative at different though interlinked scales. The ethico-aesthetic and medial dimensions of the condition of devastation are significant and yet difficult to recognize as they are folded within various rationalities and shielded by epistemologies. One kind of devastation is certainly an occurrence without an ostensible aesthetics, since there is nothing left to sense it. Such sensing unites the question of the thinking subject or sensitive entity with those of the empirical, sensible, and the aesthetic as well as with those wars where devastation is deployed as a force.

Legendarily, the destruction of Carthage is one such occasion, like a curse extending to the seventh son of the seventh son, one that outlasts our capacity to imagine or to remember it since by the time such a curse is half-done its root is forgotten. The story of Carthage was that it was destroyed by the Roman army of the Third Punic War and then broken down, brick by brick, with even the ruins ruined, not as Alfred Jarry would have it by making beautiful new buildings, but by an irrevocable and omnipotent dismantling, and with the land being ploughed over with salt, rendering it forever unfarmable. Yet the devastation of Carthage as a site for human life, at least in terms of the poisoning of the land with salt, turns out not to have occurred. The historian Appian's description of the annihilation of the city, in revenge for the victories of Hannibal, makes clear the Romans' aim of total obliteration. No one left to recall the life of the city or what it was like to be its victim, yet there are some grounds, it appears, for its history, since at least it was written. This operation on memory is part of the condition of devastation. The problem with thinking about devastation is multiple. Such an enquiry occasions the problem of the witness: not only in terms of the question of what, if anything, remains to constitute a sense of an account, but also in terms of understanding the becoming of nothing or a radical change—how can such phenomena be recognized, if at all, and how is knowledge about them produced?

The concept of the witness endows sensing with primary importance. It is not about thinking (philosophy) or measuring (science), or gathering and giving evidence. Witnessing unites sense with memory, where evidence rests in bearing witness—a process that can be performed by a subject as well as by an object, e.g., a stone, a log. In turn, both science and poetry unite in attempting to elicit modes of witnessing, or better, chains of witnessing, from an event, to its registration in a change in certain molecules, substances, or capacities, to an instrument that is sensitized to them, to a mode of description and comparison that is adequate to them. Yet, as has been described in numerous ways, to witness is also an act.

Devastations move both between the ecological and political scales and across standard notions of both object and system. They are something that happens that renders the tabulations of positive and negative and the perspectival limits they imply, perhaps operative at certain scales, trans-ductable into such formats at certain times and from certain perspectives or scales, but moot at others. Here, the problems of mediation, intellection, perception, shift, combine, and re-sort.

Ecology is intimate to humans in every conceivable manner, and indeed composes them both over evolutionary time and in the lifespan of an individual, but is also the condition in which they find themselves stuck. There is a certain degree of intolerability to the finitude of a planet, particularly one in which climate damage has become a kind of political and military gaming field, one operated upon largely by an infuriating indifference that is voluminous in its churning of its own impressive incapacity to act. One of the conditions then of the current sense of devastation is a generalized claustrophobia produced across the immensity of the earth as it hangs amid this fog of a climate.

Part of this claustrophobia is a sense of strife turned, against its nature, into a force of conjoinment. As a People's Liberation Army strategy document from the last decade entitled "Unrestricted Warfare" noted, furthering Clausewitz, ecology has become a means of waging war—one unlimited in its scope.[31] Perhaps it is this systemic factor that is becoming significant in the present era—the ineptitude of established political or economic forms being their designated means of addressing and imagining a clever exploitation of the situation. The means by which this war is to be fought are in the processes of figuring themselves out and are to be found in the domains of energy and fuels; water and pollutants; the morphological manipulation of terrains via ice-melt such as that of the northern coast of Europe and flooding, such as that of all low-lying countries; and several other means. Following on from the consideration of their strategic usage, and the problems associated with them, leading to the adoption of the full range of both negligence and opportunism at the level of states' reactions to ecological crises, devastations also impose particular kinds of conditions for knowledge about them in terms of the kinds of cunning required for their exploitation.

What are the means to speak of the becoming of different kinds of devastations, of blossomings that obliterate? Some, indeed most, things cannot be known by organized forms of knowledge because there are not only so many of them, but also due to the problem of scaling second-order, observational knowledge—coming up with the techniques of inference, hypothesis, experiment, and modeling, among others. This condition in turn causes problems of proof, leaving precious moments of doubt available for exploitation by those with an interest in maintaining it. In order to close down the operative parameters science produces instruments and methods and practices that fillet reality for its juicy bits, taking part at times in this systemic occlusion, and at other times articulating fundamental conditions of multi-scalar inter-relations. Devastations operate in the condition that Rachel Carson notes in *Silent Spring*: "Seldom if ever does nature operate in closed and separate compartments."[32] A characteristic mode of devastation for instance is that found in the exponential increase in concentrations of poisonous chemicals as they move through a food chain. Samples of poisoned predator and prey species can be subject to biopsies, but, echoing the relation between species and individual, not the entirety of the population concerned.

As with the case of Carthage, devastations are, among other things, an operative component in systems of war. The capacity for them, the carelessness with which they are handled or flaunted, the opacity with which they are left as the world moves on, characterize their strategic value. Such a form of becoming of munitions is, for instance, active with the residual and freshly seeded crops of landmines, chemical and biological weapons, cluster bombs, nuclear weapons and their equivalents in industrial accidents: a constituent part of modern warfare in both its implemented and threatened states, as part of its operation as calculus, trauma, and frenzy. Each of these forms of weapon gains part of its power from the violation of ethics that they imply, and also for the unknowability of the violation of the future that their use unleashes. The calculation of the cost–benefit ratio of landmines for instance sees them deployed widely and rapidly as a means of asserting control over a territory, making it impassable. The condition of wild-seeding of such weapons sees them left in the ground for decades, a momentary tactical or strategic advantage lasting in swathes of unfarmable, impassable land. The deployment of nuclear weapons triggers the exercise of devastations as the actual settles into a state of strategically engineered "irresolvability."

The *political plastic,* as Eyal Weizman calls it, is generated out of the interaction of forces, potentials, and the affordances of entities such as laws turned into calculuses of the permissible and the bendable; the reach of weapons systems; landscape measures; and also out of potentials of retaliation, of destruction and modelizations and the analyses of such.[33] Indeed, the international history of the Cold War could be written through the interlocking systems for devastation and the mechanisms for making them implicit but calculable, known but ineffable, operative yet unused.[34] What is

interesting about such plasticity is that, like that discussed by Malabou, but operative at different scales, it has its limits, yet these are only discovered or used as momentary tropes within a larger set of fixings and changes in a sort of parametric emergence of a situation out of things without measure. The question of devastation in relation to sense, witness, and warfare can be seen as a question of measurement and is treated with a remedy of calculability. Calculation of the unknown extinction is one artifact of this condition and should perhaps be recognized as crystallizing the dire conditions of devastation in relation to the problematics of knowledge. These kinds of try-outs of little devastations, calculated and modeled diminutions, a training and development system anticipating the larger-scale devastations to come actually presuppose a condition of general calculability which in turn is a response to, or forms a conceptual pair with, the condition of irresolvability.

What is notable however about the question of devastation is that the techniques of observation that attempt to capture its characteristics proliferate according to context, but, as methods, need to be repeatable in order to gain greater traction on the problem. But since devastations often operate by the becoming of loss as well as by the growth of something unknown, they are paradoxical, since what we are able to recognize of them is both a form of presence, and an absence, producing a version of the logical problem of the evidence of absence. How do you prove the dissipation of the virtual? You may need a vivid imagination, or perhaps you may simply need to be glacially cold, painstaking. Perhaps indeed the latter, since devastation is, in a certain sense, the knife-edge upon which present social forms find their seat.

Dumps in bodies

Certain ideas about nature have a tendential form of operation in that what is sectored off as nature becomes non-conceptual, passive, overwhelming. There is a certain overlap between emphasizing the awesomeness and unknowability of the sublime and the idea that nature can absorb all that is thrown into it.[35] The mighty and eternally flowing river Yangtze makes a perfect chemical dump. The North Sea can be overfished, it is imagined, in perpetuity. The steppe stretches so far that it can absorb anything. Overcome with the power of nature, coupled with the operations of other ineffable mechanisms that condition knowledge, such as markets, the unknown is used as a dumping ground. If we are to think of the media of ecology then, the earth is a means of mediation, a pretext, a hyper-absorbent nappy for an incontinent humanity.

As well as dumps in seas and in landscapes, there are other kinds of volume being exuded, but into the flesh of human bodies: surplus production

that must be forever devoured, regurgitated, chewed, and gorged. As is well known, there is an epidemic of obesity in the world in which human bodies become the sites for the dumping of certain kinds of surplus. Obesity itself becomes an ecological crisis since it involves an increase in the volume of gross human biomass.[36] (Based on 2005 figures from the WHO, increasing population fatness is projected as having the same implications for world food energy demands as an extra half a billion people living on the earth— you need more food to sustain higher weight.)

Causes are multiple and of varying kind and interpretation. Aside from the variable genetic predispositions of individuals this situation of growth is characterized by: changes in food and access to quasi-foods; increased mediation of food into a signature of surplus that is yet unmatched by homo sapiens' ability to devour and offload it; lack of food and abundance of access to foods with high calorific value and lack of other kinds of nutrition; the persistence of a kind of body evolved in the context of hunter-gatherer forms of life into conditions more suited to species able to benefit from high quantities of sugar.[37] Generally, more physiologically simple species, such as slimes, bacteria, and algae are more directly able to translate such abundance into reproductive activity.

This in turn can be figured as a form of devastation. What we find with obesity however is that more structurally complex organisms can be said to internalize and mediate certain devastations at the same time as they are the grounds of them. This condition of the internalization and mediation of economically and politically expedient surplus is what characterizes the obesity epidemic as a peculiarly contemporary devastation.

Obesity has many factors but they are conjoined in the particularities of the way humans articulate more general biological characteristics. Food is mediated within the body by hormones, particularly the homeostatic factors, such as ghrelin, which helps signal hunger, and leptin, which signals the state of satiety. These hormones may interact with dopamine, released by the ingestion of food found to be delicious, yet decreasing in the amount yielded the more is consumed. Since the obese have less dopamine receptors, its activity becomes less capable of producing the required effect.

Within the body, multiple other systems are involved, such as the activity of fat cells, which are not simple warehouses for energy, but are also productive—generating fatty acids and hormones, among other things.[38] In turn, conditions such as diabetes, cancer, stroke, liver failure. and heart disease also have their particular capacities of formation.

As Guattari notes, systems of endocrine regulation may hold "a deter- mining place at the heart of assemblages"[39] giving a particular stubbornness or lubricious ease of implementation to certain social configurations. Such capacities of the body can be hooked into by particular substances and the assemblages around them, for instance generating what appears to be a virulent *conatus* between an agricultural policy, political tactics, human appetites, and the condition of obesity.

Richard Nixon's need for the support of farmers (in the run-up to the 1971 election) generated, via the promise of federal funds to grow the crop, the intensification of the farming practices of the American Midwest around corn. The achieved surfeit of corn required its uses: most obviously, in feeding to a glut of cattle and in manufacturing high fructose corn syrup (HFCS) for the American, and thus global, diet.[40] Once a product and a market was created, it persisted, as did the federal subsidies. HFCS is found in soft drinks, processed meat products, bread, sauces, cereals, and many other food and foodlike substances. In those in which extensive processing has decreased flavor or substances used as food in which flavor is not naturally occurring, it is useful as an additive. Eating or drinking HFCS represses leptin, and thus the eater's capacity to recognize that it is full or sated. Such a process need not occur with the full knowledge of what is occurring in any of the participant humans, nor in the agencies, markets, instruments, glands, intestines, brains, plants, policies, political intrigues, taste organs involved. Such a conjunction is sorted, amplified, ablated, contused, digested, and stored by the interactions of the predilections, intent and desires of the particular systems brought together in the ensemble.

Human bodies are places for regular substance panics (such as those associated with acrylamides, saturated fats, Bisphenol, plasticizers, etc.) in which ecologies of complex chains of media from the instruments and recording devices of labs, the persuasion mechanisms and institutions to which they are attached to those of televisions and the mechanisms falling under the scrutiny of communications couple with those ecologies tangled and forged inside organs and food and logistics systems. Characteristic of these is the reaction to the discovery that human milk becomes toxic when it concentrates chemicals such as PCBs stored in the mother's adipose tissue throughout her life (obesity perhaps being a necessary requirement of contemporary life in that we need sufficient space to store all the toxic chemicals we are exposed to; our other commons). The agency of such chemicals, residues of mindlessness towards matter, turns the body inside out, rendering moot the question of the scale to which it is most fundamental.

Here, the question of movements of dissipation and concentration of chemicals in a dispersed set of states and sites within an ecology becomes crucial (whether such materials are ideally to be recycled or warded off) and ties in with the question of energy—how much energy is needed to gather all that must be recycled, or to recoup all the matter that has spilled into a condition in which it is poison.[41] Beyond a certain point, which is not always so far, there is a devastating becoming which makes certain kinds of known lives untenable.

Notes

1 Félix Guattari, *The Three Ecologies*, trans. Gary Genosko (London: Athlone, 2000). Guattari touches on questions related to devastation when he discusses pollution, algal blooms, and Donald Trump.

2 Gilles Deleuze, "La Conception de la différence chez Bergson," *Etudes Bergsoniennes* 4 (1956). Translated as Gilles Deleuze, "Bergson's Conception of Difference," in *Desert Islands and other texts, 1953–1974*, ed. David Lapoujade, trans. Michael Taormina (Los Angeles: Semiotext(e), 2004).

3 Alfred North Whitehead, *Modes of Thought* (New York: The Free Press, 1968), 83.

4 Gilles Deleuze, *Difference and Repetition*, trans. Paul Patton (London: Athlone, 1994), xx.

5 Benjamin Noys, *The Persistence of the Negative* (Edinburgh: University of Edinburgh Press, 2010).

6 Gilles Deleuze, *Pure Immanence: Essays on A Life* (New York: Zone Books, 2012).

7 Rachel Nuwer, "Forests Around Chernobyl Aren't Decaying Properly," *Smithsonian*, March 14, 2014. Available online: http://www.smithsonianmag.com/science-nature/forests-around-chernobyl-arent-decaying-properly-180950075/?no-ist (accessed November 20, 2015).

8 Jean-Hugues Barthelemy, "'Du Mort Qui Saisit Le Vif': Simondonian Ontology Today", *Parrhesia* 7 (2009).

9 Ray Brassier, *Nihil Unbound. Enlightment and Extinction* (London: Palgrave, 2007), 237–8.

10 See Luciana Parisi, *Abstract Sex: Philosophy, Bio-Technology and the Mutations of Desire* (London: Continuum, 2004).

11 Donna Haraway, *When Species Meet* (Minnesota: University of Minnesota Press, 2007), 256.

12 *Melancholia* [Film], dir. Lars von Trier (Denmark: Zentropa, 2011).

13 Eugene Thacker, *In the Dust of this Planet, The Horror of Philosophy*, vol. 1 (Winchester: Zero Books, 2013).

14 Artists too attempted to turn people's gaze back on to the physical event— notably, Übermorgen, who declared the spill the largest oil painting in history, reframing aerial pictures of the event in such terms.

15 See "Oilwatch—Home", *Oilwatch*, last modified November 21, 2015, http://www.oilwatch.org/.

16 Catherine Malabou, *The Ontology of the Accident: An Essay on Destructive Plasticity*, trans. Carolyn Shread (Cambridge: Polity Press, 2013), 73. Tracking the structural linkage of possibility to affirmation, Malabou notes that Kant's freedom to say no becomes, for Hegel, a rounding principle of the doubling of negation, thus, an affirmation, where "categorical refusal is not possible." Negative possibility, that is formative,

for Malabou, is of another order: it "refuses the promise," "makes existence impossible," "prohibits ... the other possibility."

17 Brassier with his project of nihilism reads Nietzsche differently, putting the operation of affirmation into doubt. He proposes a discussion of the transcendental scope of extinction (through solar death and extinction of abstraction).

18 Malabou, *The Ontology of the Accident*, 89.

19 Elinor Ostrom, *Governing the Commons: The Evolution of Institutions for Collective Action* (Cambridge: Cambridge University Press, 1990).

20 "Study Reveals Widespread Plastic Distribution in Antarctic Waters," Tara, a schooner for the planet—Expeditions—Science—Environment—Education—Art—Events, last modified August 14, 2011, http://oceans.taraexpeditions.org/en/m/science/news/study-reveals-widespread-plastic-distribution-in-antarctic-waters/

21 Here there is a significant differentiation from the gestation process of ambergris that forms a mass around certain solids such as the remains of undigested squid beaks in the bellies of sperm whales. See Christopher Kemp, *Floating Gold: A Natural (and Unnatural) History of Ambergris* (Chicago: University of Chicago Press, 2012).

22 Paul Crutzen and Eugene Stoermer, "The 'Anthropocene,'" *Global Change Newsletter* 41 (2000).

23 Andreas Malm and Alf Hornborg, "The Geology of Mankind? A Critique of the Anthropocene Narrative," *The Anthropocene Review*, published online January 7, 2014, doi: 10.1177/2053019613516291.

24 Dipesh Chakrabarty, "The Climate of History: Four Theses," *Critical Inquiry* 35 (2) (2009). This is something that Chakrabarty sees as being epitomized in Michael Geyer and Charles Bright, "World History in a Global Age," *American Historical Review* 100 (1995).

25 Gilles Deleuze, *Difference and Repetition* (London: Continuum, 2008), 267–8; Manuel DeLanda, "Ecology and Realist Ontology," in *Deleuze/Guattari and Ecology*, ed. Bernd Herzogenrath (London: Palgrave Macmillan, 2009). See for a related discussion, Steven Shaviro, *Without Criteria: Kant, Whitehead, Deleuze, and Aesthetics* (Cambridge, MA: MIT Press, 2009), 89, fn. 11.

26 Chakrabarty, "The Climate of History," 220.

27 Paul N. Edwards, *A Vast Machine: Computer Models, Climate Data and the Politics of Global Warming* (Cambridge, MA: MIT Press, 2010).

28 See Mary-Jane Rubenstein, *Worlds Without End. The Many Lives of the Multiverse* (New York: Columbia University Press, 2014).

29 Gilles Deleuze, *Nietzsche and Philosophy* (London: Continuum, 2005) and Bernard Stiegler, *Technics and Time 1: The Fault of Epimetheus* (Stanford: Stanford University Press, 1998).

30 Carl von Clausewitz, *On War*, trans. Michael Howard and Peter Paret, abr. Beatrice Heuser (Oxford: Oxford University Press, 2007), 46: "War is the realm of uncertainty; three quarters of the factors on which action in war is

based are wrapped in a fog of greater or lesser uncertainty. A sensitive and discriminating judgement is called for; a skilled intelligence to scent out the truth."

31 Qiao Liang and Wang Xiangsui, *Unrestricted Warfare* (Beijing: PLA Literature and Arts Publishing House, 1999). Available online: http://www. cryptome.org/cuw.htm (accessed November 21, 2015).

32 Rachel Carson, *Silent Spring* (1962; London: Penguin, 2000), 52.

33 Eyal Weizman, *The Least of All Possible Evils: Humanitarian Violence from Arendt to Gaza* (London: Verso, 2011).

34 Liang and Xiangsui, *Unrestricted Warfare*.

35 See Timothy Morton, *Ecology Without Nature: Rethinking Environmental Aesthetics* (Cambridge, MA: Harvard University Press, 2009).

36 Sarah Catherine Walpole et al., "The Weight of Nations: An Estimation of Adult Human Biomass," *BMC Public Health* 12 (2012): 439. Available online: http://www.biomedcentral.com/1471-2458/12/439 (accessed November 21, 2015).

37 See, inter alia, the work of Rudolph Leibel, Columbia University.

38 E. E. Kershaw and J. S. Flier, "Adipose Tissue as an Endocrine Organ," *Journal of Clinical Endocrinology and Metabolism,* 89 (6) (2004).

39 Félix Guattari, *Schizoanalytic Cartographies*, trans. Andrew Goffey (London: Bloomsbury, 2013). See also Alexander A. Bachmanov et al., "Nutrient Preference and Diet-induced Adiposity in C57BL/6ByJ and 129P3/J Mice," *Physiology and Behavior* 72 (2001).

40 Jacques Perreti, "Why Our Food is Making us Fat," *Guardian*, June 11, 2012.

41 Paul Burkett describes the problem in relation to the question of thermodynamics, where it is true that "if we have enough energy, we could even separate the cold molecules of a glass of water and assemble them into ice cubes"; but "in practice … such operations are impossible … because they would require a practically infinite time" (62). This problem applies in particular to those "elements which, because of their nature and the mode in which they participate in the natural and man-conducted processes, are highly dissipative" and / or "found in very small supply in the environment" (63). In short, "the sombre message of the second law (that dissipation of matter and energy are unavoidable consequences of their use) mutes the seemingly optimistic message of the first law (that matter and energy are not literally consumed in their use)" (64). Paul Burkett, *Marx and Nature: A Red and Green Approach* (London: Palgrave Macmillan, 1999).

Bibliography

Bachmanov, Alexander A., D. R. Reed, M. G. Tordoff, R. A. Price and G. K. Beauchamp "Nutrient Preference and Diet-induced Adiposity in C57BL/6ByJ and 129P3/J Mice." *Physiology and Behavior* 72 (2001): 603–13.

Barthelemy, Jean-Hugues. "'Du Mort Qui Saisit Le Vif': Simondonian Ontology Today." *Parrhesia: A Journal of Critical Philosophy* 7 (2009): 28–35.

Brassier, Ray. *Nihil Unbound: Enlightment and Extinction*. London: Palgrave, 2007.

Burkett, Paul. *Marx and Nature: A Red and Green Approach*. London: Palgrave Macmillan, 1999.

Carson, Rachel. *Silent Spring*. 1962. London: Penguin, 2000.

Chakrabarty, Dipesh. "The Climate of History: Four Theses." *Critical Inquiry* 35 (2) (2009): 197–222.

Clausewitz, Carl von. *On War*, trans. Michael Howard and Peter Paret, abr. Beatrice Heuser. Oxford: Oxford University Press, 2007.

Crutzen, Paul and Eugene Stoermer. "The 'Anthropocene.'" *Global Change Newsletter* 41 (2000): 17–18.

DeLanda, Manuel. "Ecology and Realist Ontology." In *Deleuze/Guattari and Ecology*, ed. Bernd Herzogenrath, 23–41. London: Palgrave Macmillan, 2009.

Deleuze, Gilles. "Bergson's Conception of Difference." In *Desert Islands and other texts, 1953–1974*, ed. David Lapoujade, trans. Michael Taormina, 32–51. Los Angeles: Semiotext(e), 2004.

Deleuze, Gilles. "La Conception de la différence chez Bergson." *Etudes Bergsoniennes* 4 (1956): 77–112.

Deleuze, Gilles. *Difference and Repetition*. London: Continuum, 2008.

Deleuze, Gilles. *Difference and Repetition*, trans. Paul Patton. London: Athlone, 1994.

Deleuze, Gilles. *Nietzsche and Philosophy*. London: Continuum, 2005.

Deleuze, Gilles. *Pure Immanenc: Essays on A Life*. New York: Zone Books, 2012.

Edwards, Paul N. *A Vast Machine: Computer Models, Climate Data and the Politics of Global Warming*. Cambridge, MA: MIT Press, 2010.

Geyer, Michael and Charles Bright. "World History in a Global Age." *American Historical Review* 100 (1995): 1058–9.

Guattari, Félix. *Schizoanalytic Cartographies*, trans. Andrew Goffey. London: Bloomsbury, 2013.

Guattari, Félix. *The Three Ecologies*, trans. Gary Genosko. London: Athlone, 2000.

Haraway, Donna. *When Species Meet*. Minnesota: University of Minnesota Press, 2007.

Kemp, Christopher. *Floating Gold: A Natural (and Unnatural) History of Ambergris*. Chicago: University of Chicago Press, 2012.

Kershaw, E. E. and J. S. Flier. "Adipose Tissue as an Endocrine Organ." *Journal of Clinical Endocrinology and Metabolism* 89 (6) (2004): 2548–56.

Liang, Qiao and Wang Xiangsui. *Unrestricted Warfare*. Beijing: PLA Literature and Arts Publishing House, 1999. Available online: http://www.cryptome.org/cuw.htm (accessed November 21, 2015).

Malabou, Catherine. *The Ontology of the Accident: An Essay on Destructive Plasticity*, trans. Carolyn Shread. Cambridge: Polity Press, 2013.

Malm, Andreas and Alf Hornborg. "The geology of mankind? A critique of the Anthropocene narrative." *The Anthropocene Review,* published online January 7, 2014, doi: 10.1177/2053019613516291.

Melancholia [Film]. Dir. Lars von Trier. Denmark: Zentropa, 2011.

Morton, Timothy. *Ecology Without Nature: Rethinking Environmental Aesthetics*. Cambridge, MA: Harvard University Press, 2009.

Noys, Benjamin. *The Persistence of the Negative*: Edinburgh: University of Edinburgh Press, 2010.

Nuwer, Rachel. "Forests Around Chernobyl Aren't Decaying Properly." *Smithsonian*, March 14, 2014. Available online: http://www.smithsonianmag.com/science-nature/forests-around-chernobyl-arent-decaying-properly-180950075/?no-ist (accessed November 20, 2015).

Ostrom, Elinor. *Governing the Commons: The Evolution of Institutions for Collective Action*. Cambridge: Cambridge University Press, 1990.

Parisi, Luciana. *Abstract Sex: Philosophy, Bio-Technology and the Mutations of Desire*. London: Continuum, 2004.

Perreti, Jacques. 'Why Our Food is Making us Fat'. *Guardian*, June 11, 2012.

Rubenstein, Mary-Jane. *Worlds Without End: The Many Lives of the Multiverse*. New York: Columbia University Press, 2014.

Shaviro, Steven. *Without Criteria: Kant, Whitehead, Deleuze, and Aesthetics*. Cambridge, MA: MIT Press, 2009.

Stiegler, Bernard. *Technics and Time 1: The Fault of Epimetheus*. Stanford: Stanford University Press, 1998.

Thacker, Eugene. *In the Dust of this Planet: The Horror of Philosophy*, vol. 1. Winchester: Zero Books, 2013.

Walpole, Sarah Catherine, David Prieto-Merino, Phil Edwards, John Cleland, Gretchen Stevens, and Ian Roberts. "The Weight of Nations: An Estimation of Adult Human Biomass." *BMC Public Health* 12 (2012): 439. Available online: http://www.biomedcentral.com/1471-2458/12/439 (accessed November 21, 2015).

Weizman, Eyal. *The Least of All Possible Evils: Humanitarian Violence from Arendt to Gaza*. London: Verso, 2011.

Whitehead, Alfred North. *Modes of Thought*. New York: The Free Press, 1968.

CHAPTER FOURTEEN

Virtual ecology and the question of value

Brian Massumi

*All compasses—economic, social, political, moral, traditional—
have gone off the tracks, one after the other. It has become
imperative to reforge axes of value, the fundamental finalities of
human relations and productive activity. The ecology of the virtual
is thus just as urgent as the ecologies of the visible world.*

—FÉLIX GUATTARI[1]

Value resembles a dance, not a statue.

—RAYMOND RUYER[2]

The ecological urgency of a dance of value. It's hard to imagine such a
thing in the framework of our received notions of value. As designating
"fundamental finalities," values are most often presented as carved in stone.
The most widespread phrases in which the word currently occurs in the
West today are cases in point: "family values" and "democratic values."
Both, in different ways, equate values with inalterable norms vouchsafed
by a transcendent power, God in the first case, the State in the second.
Both posit these norms as universal and absolute. On the other hand, as
orienting "productive activity" value takes on two predominant figures,
both integral to capitalism: use-value and exchange-value. Use-value subor-
dinates value to function, making utility the arbiter of value. Thus mapped
to an external criterion, value is deprived of coordinates of its own, and
is emptied of any intrinsic power to determine the norm. Exchange-value
empties value in a different way: by quantifying it. Value is subordinated to

a general equivalent: money as universal standard of measure enabling all things, however singular, to be compared. Mapped onto a general equivalent, value glosses over the singularity of what it measures. Both use-value and exchange-value are more moving than a statue. This is due to the fact that they are hinged to another order—capitalism—with its own operative logic and line of variation. For example, what counts as "useful" changes as capitalism motors on. And the use-value *of* exchange-value is to oil the gears of perpetual circulation, concurrent with a constant fluctuation of prices. Move they may. But do they dance?

It is evident that when Guattari speaks of the imperative to reforge the axes of value, he has none of these dominant connotations of the word in mind. To understand what his revalued "ecology of the virtual" might be, the very concept of value will have to be reforged, beyond the normal compass. For Guattari, this means outside the framework of capitalism, but without returning to the appeal to a transcendent realm of absolutes. Value would then no longer equate with the norm or any manner of universal, and would not hinge on an external order to whose logic it is subordinated. It would re-ally itself with the singular: with what is such as it is, positively all of itself. It would re-ally with the singular, while somehow still providing a compass.

"That which is such as it is, positively all of itself." The phrasing echoes C. S. Peirce's definition of his category of Firstness, also known as Quality.[3] What would a theory of value look like that held to the singular and dwelt in quality, rather than laying down the norm or ascending transcendent?

Abiding time

Colors dance across surfaces. At sunset, they dance in the air. The red dancing on the horizon is wholly and only *this* red, such as it is, just *thus*: pure positive character, resplendent in its own singularity. Raymond Ruyer, who along with Alfred North Whitehead is among the twentieth-century thinkers who place the theory of value most prominently at the center of their thinking, began his major treatise on value with an analysis of color, extrapolating from there to the axiological level proper.[4] Whitehead, for his part, articulates his theory of value through his signature concept of qualities as "eternal objects." For him as well, the explanatory touchstone is color. What follows will work between these two thinkers, also from a start in color, moving in the Guattarian direction of a virtual ecology of values as orientational qualities of existence.

Ruyer enumerates four points on which the theory of color and the theory of value overlap. Things get complicated from the very first.

The first point is that qualities "are subjected to no temporal 'permanence.'"[5] In making this point, Ruyer alludes to a passage in Whitehead

where he writes that "a color is eternal. It haunts time, like a spirit. It comes and it goes."[6] Colors do not exist so much as they "subsist" outside of time, Ruyer observes. "For an indeterminate period red can go unperceived by any one."[7] But then it will return. Where was it in the meantime? In *potentiality*, Whitehead will answer.[8] When red is not being perceived, it isn't simply absent, and it isn't in some other world. Neither has it merely withdrawn, as object-oriented ontology would have it. "It neither survives, nor does it live."[9] It subsists, not surviving. Unliving, it "abides."[10] Its not being perceived is its abiding power to come again to paint the world in vivid hues. "It appears when it is wanted," to revivify the world.[11] A quality of experience is a positive power of *appearing* that bides time outside experience, poised for its own return, over any length of time and across any distance in space. The fact that it only appears when it is wanted in no way detracts from its status as a positive power. "Where it comes, it is the same color."[12] No wanting as attached to a particular experience has this abiding power. Occasions of experience do not abide, they become, and what becomes no sooner "perishes."[13]

This explanation itself raises a number of problems. A first question concerns the apparent contradiction between the revivifying dance of color as it appears in a sunset and Whitehead's statement that where red comes, it is the same color. Doesn't a quality of experience "dance" precisely because it is continually changing, painting the dusk with the nuances of its own spellbinding transformation? And doesn't every instance of red carry some defining peculiarity, owing to some circumstantial detail, an accident of illumination, for example, expressing itself in an errant shimmer, that makes it different from all other rednesses? Isn't every *this* red singular: only thus, such as it is? Wouldn't sameness across appearance be not only unliving, but downright deadening?

In order to reconcile this question it is necessary to rethink what we mean by the "same." A potential, which is what a color is outside any particular instance of it, is poised to be *any* instance of it. It is ever on the verge of coming again, in any number of instances. It is this poising for "anyness" that abides. The potential for red is ever-poised to give itself over to variation, as many times and wherever it is wanted, in an ongoing series of appearances that is inexhaustible. The "same" potential, in its abiding outside the time of any particular appearance of it, must be conceived as already tending toward different variations on its own theme. The potential always and already includes in itself the infinite variety of its own appearings. In any given occasion of experience, a set of these variations will successively appear, in time. For the circumstances in which it appears are constantly shifting. The conditions under which red appears in the sunset sky cannot stand still. This compulsive restlessness applies to all circumstances in which color appears (in which any quality appears), in different forms and to varying degrees. Sunset red runs through a series of variations on itself, within the limits of the sky's wanting it. The "any" of

the potential is realized in the *some* of this limited series of rednesses. In other words, the potential mutually includes infinite variety on an indefinite spectrum. The sky's wanting red realizes a certain limited arc selectively cut from the whole cloth of the color. That "same" full spectrum is given to the circumstances for selective expression. The same of a potential is singularly multiple, in the anyness of its abiding as in the someness of its appearing.

Given to decision

The relation between the singular-multiplicity of the abiding potential and singular-multiplicity of its actual appearing is the relation between "any" and "some."[14] In other words, it is a relation of selective determination. The circumstances want what they want (red), and it is they that decide which red(s). The potential *gives* "what" might come: the character or qualitative variety that will exhibit itself. The circumstances *decide* "which" of the "what" does come: they take hold of a limited set of variations on the potential's abiding power to appear. The relation of "any" to "some"—of potential to realization (in Whitehead and Ruyer's vocabulary) or of the virtual to the actual (in Deleuze's vocabulary)—is that of givenness to decision. This can also be stated as the relation between an abiding of variety, whatly indifferent to which it will be ("impassive," Deleuze says[15]), and an appetitive taking-hold of a wanted variation ("prehension" in Whitehead's vocabulary). Or again: between a select narrowness of realized experience, and the breadth of potential experience.

The lesson is that every singularity, as in potential and as actualized, is constitutively multiple.[16] This has far-reaching philosophical implications. The readymade category that seems most suited to potential is one that was shunted aside in the inaugural gesture of this chapter: that of the "universal." The problem with the concept of the universal is that in its most widespread usages it employs an unvarying notion of the same, mapping to the "general" side of the "general-particular polarity. Both sides of that polarity connote singleness (being one), if on different levels and in different ways. They both understand "this" to mean "not those": single as opposed to multiplicitous. In Ruyer, Whitehead, and Deleuze / Guattari's accounts, there is no determination that does not involve a multiplicity. "Any" to "some" is not reducible to the opposition between "this one" versus "those." Qualitative thisness necessarily involves a spectrum. Qualities keep company, potentially and decisively. It is always a question of *mutual inclusion*. The issue is its width: what arc of the spectrum is wanted? The "universal-particular" couplet only makes sense within a logic privileging a notion of substance, and considering the relations between substantial entities to be governed by the principle of the excluded middle. In other words, it privileges a *privative* logic (mutual exclusivity). The

qualitative, as opposed to substantialist, logic of potential and its realization is fundamentally *convivial* (appetitively so). It is all about degrees of mutual inclusion. The unsuitability of the universal-particular distinction has important political implications for the theory of value when it comes to the properly axiological level: a shift occurs in the logic of the qualitative from *difference* as a privative relation between mutually exclusive samenesses (general identities or particular cases) to a spectrum of *differentiation* involving a conviviality of appetition.[17]

Excess of character

Ruyer's second point about color and value concerns a notion that has quietly slipped into this discussion along the way: the circumstances. According to Ruyer, the circumstances of an actualization, the conditions calling for a potential's appearing, are not sufficient to explain the quality that appears.[18] You can describe what conditions are necessary for the appearance of red until you're blue in the face, and you will still not be able to convey to a color-blind person what red is, such as it is, in contradistinction to orange, yellow, and green. The bodily conditions of a color-blind person's vision do not "want" any red. They "some" the color spectrum otherwise. Red's power of appearing abides them. Colors are akin to pornography: you only know one when you see it. Qualities of experience are *subjective*, but not in the sense of belonging only to a subject or occurring in a mind. They are subjective in the sense that they have a *character*. They *are* their character. There is nothing to explain about "what" they are other than that character, such as it is. Their appearance tells all. There is nothing "behind" the qualitative character exhibited in their appearance that would explain what they are any better than the appearing of the character explains itself. In fact, explanations of what lies behind the appearance are more apt to lose the quality than present it better. A complete account of the physical and physiological conditions behind the appearance of red includes many things—red excluded. This is for the simple reason, as Whitehead observes, stating the obvious, that the wavelengths of light around which the physical side of the explanation centers have no color in and of themselves.[19] The same could be said of the physiological side of the equation: electrical nerve impulses are no more colorful than photon streams. This last point is crucial, because it extends the argument to all qualities of experience. Every quality of experience self-explanatorily *exceeds its empirical conditions*. This means that a scientific explanation, although true as far as it goes, does not fully account for the occasion. An empirical explanation is a reductive abstraction that focuses on only certain of the elements involved (those capable of being quantified with the regularity of a law). Empirical explanation selects for

how the occasion is quantitatively. The "how" of empirical explanation is a selective focus on a lawfully select "some" of the factors involved, arrived at precisely by subtracting the defining character of the occasion from it: the scientific explanation of the red of the sunset begins by bracketing redness, the qualitativeness of red. It takes red's qualitative nature for self-explanatory—which it is. But what it forgets is Whitehead's fundamental point that the occasion as explained by that defining character is *more concrete* than the scientific fact extracted (abstracted) from it.[20] Who would even think of explaining red scientifically if they had never seen it? The empirical explanation "hows" itself into an acquired color-blindness. When it sees red, it just sees red, such as it is—and proceeds to explain *away* that experiential fact with an abstractive explanation of how it came to be. The implications of this for neuropsychology, and its humanities cousins like neuroaesthetics, are grave. Also grave are the consequences for historical analysis, to the extent that it fashions itself an empirical enterprise, for example employing a linear cause–effect framework for "how" things came about modeled directly or indirectly on scientific notions of causality. History has to acknowledge that subjective and the qualitative are always wanting, and that the concrete facts of history exhibit a qualitative form of self-explanation. Any explanation bracketing this qualitative reality is deadeningly incomplete, because to explain away the qualitative factors of experience is to explain away potential.

The fact that a quality of experience appears under certain requisite conditions in no way detracts from its being such as it, positively all of its subjective itself. The myriad circumstantial factors of an occasion come together in such as way as to call to, and call forth, a defining qualitative character. But they do not *make* the quality. When red appears here, it will always already have appeared elsewhere, at another moment of time, and will no doubt appear elsewhen in another place. In its abiding power of appearing, red is ubiquitously unmade. It is always-already (in potential). It does not *emerge* from its conditions. It *appears* for them, when called. It fills their want with its self-explaining. In fact, its self-explaining is in a sense more concretely explanatory of the circumstances than they are of it: the red of the sunset makes apparent what this occasion is all about. The character red *characterizes* the complete occasion.

Now for the first time (always having been)

Whitehead insists on the idea that eternal objects, qualities, do not emerge.[21] To say that they emerge would be to say that something has been created ex nihilo. Color would then have come from an absence of color. In the fullness of the complete fact, color has not come out of nowhere. It has come out of its own abiding. It has come out of potential. It is odd

to say so, but theories of qualitative emergence (such as most theories of consciousness as arising from material interactions) in fact write potential out of the equation. So doing, they self-destruct. Nothing comes of nothing. And without abiding potential, that's just what there is.

But surely, there was a time before rods and cones. Didn't color emerge with the evolution of the retina? Weren't certain periods in the history of art characterized by the abrupt appearance of a new quality of color, such as the ultramarine so beautifully characterizing medieval painting?[22] Where was ultramarine before the secret of purifying it from lapis lazuli was discovered? To say that it was abiding is getting a little old at this point. More to the point, the appearance of a quality *carries its own time signature*. It instantiates its own time of potential. If potential is outside time, its abiding cannot be thought of as waiting around in the wings for the cue to enter the stage. To say that a quality carries its own time means that when it appears for the first time, as Guattari suggests, it appears abruptly *"in the mode of always having been."*[23] The "eternity" of the eternal object is not a waiting off-stage in the wings of time. It is for this reason that Whitehead dubs it an *"eternality"*[24]—a quality of eternity—that comes with character. The eternality of a color "subsists" here and now. *Now, for the first time, as always having been*: this is the temporal mode of appearance of a qualitative character. This singular time signature arrives on the wings of the appearance (rather than the appearance waiting on the wings of time).

This means that a quality is nothing outside its actual expressions, even though it cannot be contained in any one occasion in which it occurs, or even in their sum total. Whitehead's way of saying this is that everything real exhibits itself somewhere, sometime (and really subsists, for elsewhere and elsewhen). This is in fact his definition of "real."[25] This ties the definition of the real to an unabsorbable *excess* of what appears. For the theory of value this is key. In the experience of a value, a *moreness* of the world appears, as always having been, heralding as yet undetermined elsewheres and elsewhens. A more of potential appears, selectively enveloped in a defining qualitative character. The defining character is experienced as the *affective tonality* of the occasion: the "color" of the occasion as a whole.[26] Every qualitative experience is an experience of the world's moreness, a lively sense of potential that is immanent to the situation's singularity even as it exceeds it. This immanent self-exceeding of the situation is experienced as a sense of vivacity over and above the determinate character of the affective tonality enveloping it: as a *vitality affect* carrying and carried by the affective tonality.[27]

The immanent beyond

The importance of this for the theory of value is that it does away with transcendence in any normal sense of the word. Every experience is *immanently self-transcending*—to the exact extent to which it is lived qualitatively. Transcendence is done away with—but not the lure of a moreness to life that makes the idea of transcendence compelling. Paradoxically, what ultimately completes the concrete fact of an occasion's occurrence is the promissory note of incompleteness it envelops, in excess over its determinate character. That excess packs the occasion with potential for other occasions to avail themselves of. It stuffs it with immanent multiplicity. It is promissory in the sense that it betokens here and now vivacities of qualities to come. Every appearance of a quality is vivifying of the situation in which it appears, in direct proportion to the promise it carries for the vivification of others. Every quality is such as it is, excessively. It is positively all itself in the manner in which it vividly carries, immanent to itself, its own beyond.[28] More or less vividly: the vivacity a situation carries in virtue of its defining character will be proportionate to the intensity of its vitality affect. In passing, it is worth noting that this requires a non-quantitative theory of intensive magnitude as a necessary concomitant to a theory of value.[29]

The formula for the time of the qualitative, "now for the first time, as always having been," enables a necessary articulation: between the making of circumstances and the unmade of the qualities of experience that characterize them. The becoming of an occasion of experience covers a span. It proceeds through phases, and comes to a climax. It has a duration. The occasion's triggering into duration requires a coming-together of circumstances. The coming to a conclusion of the arc of this becoming requires something more: an activation. It requires a syncretic, synthetic working-together of diverse contributory factors. This must in fact be a self-activation, for the principle of syncretic synthesis must arise from within the occasion's stirring toward its own conclusion. The conclusion, Whitehead says, is felt before it is arrived at. It is felt as a "lure."[30] The lure is precisely the qualitative character that will crown the occasion's becoming, coming to definitively characterize it. The feeling of the lure energizes the occasion, pulling it forward through its own self-synthesis. It provides it a direction: a compass. It vectorizes the occasion toward its own achievement. The qualitative lure stands in the occasion's becoming for its own outside. It is and remains effectively *virtual*. For the achievement of the becoming's completing characterization is the precise moment of its perishing. It has exhausted itself in its own decisive achievement. Its activity recedes, as its becoming cedes to what the now-altered circumstances may want next. The quality stands in the occasion for a self-achieving, one with its exceeding. The quality's role is that of the lure of the virtual beyond, immanent to the occasion's coming to pass.

The lure of subjectivity

In describing this cooperation of the actual circumstances and the virtual lure of complete characterization, a decidedly subjective vocabulary has settled in. What is being described is the occasion's appetition (for itself): its "wanting" quality of experience. The occasion, Whitehead says, begins "objectively": from a basis in a coming-together of disparate circumstances that have been bequeathed to the occasion by the passing of others before it. But these given circumstances are not enough. Nothing would click without the energizing of a synthetic working-together-toward-a-conclusion. It is the quality, operating as a virtual lure, or as an eternal "object," that "gives" the potential for this arcing of the occasion in the direction of its completion. The donation of potential activates the occasion's appetitive self-activity toward an end. The lure of the potential subjectifies the occasion. The occasion snaps into its own vivacity. It *decides*, from the infinity of potentials, which virtual terminus it will take as its compass. It *cuts* into the spectrum of potential, and orients itself by the selective beacon of that virtual light.[31] The sunset cuts for red. Its self-synthesizing "decision" to be finally characterized by red bears witness to a degree of subjectivity—operative even on a level with the movements of matter (which henceforth can no longer be qualified as "dumb" and lifeless).[32]

Braided causality

This matters for the theory of value because it requires a very different account of causality. The usual conception posits a linear progression from cause to effect on the same level of functioning (that of mechanistic action-reaction). Here, on the contrary, there are two lines of causality operating on different levels, criss-crossing in the middle of becoming. One is actual (including but not limited to mechanism), the other virtual (really, luringly, effectively so). One pushes the occasion from behind with the force of inherited circumstance demanding conformity to given objective conditions; the other calls from ahead, pulling the occasion toward the future it will have been when it has done its all. The theory of color models causation for the theory of value as a *braided causality*.[33] Objective and subjective factors, actuality in motion and impassive virtuality, braid into the directional unfolding of the occasion toward a conclusion. The braiding is nothing like a mechanical part-to-part connection. It is a co-operation, across the differential between the objective and the subjective, and the actual and the virtual, that brings the occasion to life, by catalyzing a *transfer* of character. The objectivity of the circumstances becomes subjectively self-deciding, under the attractive force of the quality of experience. The occasion's self-deciding takes upon itself the characterization donated

by the "eternal object" operating as virtual lure.[34] The causality in play is more than mechanical: it is *transductive* (transferential in this processual sense, not at all in the psychological sense).[35]

In the braided causality conditioning the transduction, it is ultimately impossible to assign an unambiguous status of activity or passivity to the factors involved. The circumstances come to the occasion passively, as a heap of leftovers from past becomings. But they activate, acquiring an appetite for qualitative completion.[36] The virtual terminus that awakens that wanting and orients its unfolding "acts" virtually, with the impassivity of a lure. Whitehead is careful to retain this productive indecision between activity and passivity. The given circumstances, he says, are "patient" for the quality with which they actively seek to complete themselves.[37] The qualitative lure "energizes" the occasion's self-forming duration, as an exercise of its power to bide time and abide as potential. The word "conditioning" is a handy way of nominating the braided causality of the transductive process, avoiding the usual linearizing connotations of the word "causality."

Given and constructed

The transduction happens in a braided zone of indiscernibility between activity and passivity. This "indecision" between activity and passivity is a positive resource for the theory of value. It makes it possible to say both that the occasion makes itself, and that it is made. For example, the circumstances of medieval life provided the objective conditions for the appearance of ultramarine. These circumstances were seized upon, and synthesizing procedures invented for its manufacture. But it was not this blue per se that was fabricated. What was fabricated were the transductive conditions ripe for ultramarine to express its power of appearing. In other words, what were fabricated were the conditions for ultramarine to donate itself as a quality, such as it, all and positively as it is. What medieval industry invented was the singular coming-together of circumstances and working-together of factors requisite for just this blue to give of its potential. Medieval industry invented its historical *patience* for ultramarine. Thus ultramarine can be considered to have been *both given and invented*: constructed as an "eternal" factor of nature. Qualities of experience are *made* to exercise their sovereign *power* to appear in the mode of always having been. What "emerges," according to Whitehead, are the comings-together and workings-together patient for that self-appearance. The arrived-at qualities do not emerge. They just "appear," of their own power.[38] They make their appearance when the wanting is ripe for them. An occasion of experience is at once a recipient (of the objective conditions), a patient (of potential), and an agent (the subject of its own

synthesis).[39] None of this is in any way contradictory. Recipient, patient, and agent are roles: *modes of activity*, in an extended sense unsubordinated to the active / passive dichotomy ("activity" in this sense is different from "action"). Modes of activity need not observe the law of the excluded middle. They may relay, overlap, interplay, and reciprocally inflect. They co-occur.

Activist philosophy

Ruyer's theory of value insists that the cornerstone concept for axiology is *activity*.[40] Axiology is activist philosophy. This frees the theory of value from the statuesque imperative of prescription overshadowing occasions of experience from the pedestal of a lofty "ought": an end, an aim, carved in stone. In the theory of value as understood here, *there is no ought*. There is appetition, energized, aiming at the virtual terminus of its own self-completion. The aim might be off. The arrow of becoming might miss its mark. Circumstances intervening en route may deflect the becoming toward another defining quality.[41] More radically, the occasion may "decide" on the fly to self-deflect toward a different terminus. It may cut off on a different track. It may *invent its own lure*. It may *improvise* on its wanting, developing an emerging appetite for a different conclusion. It may self-recondition. In this theory of value, there is no ought—only potential and invention. Potential and invention, objectively conditioned and subjectively reconditioned. The difference between a quality like a color and a value proper, according to Ruyer, is precisely this: value comes into itself axiologically when activity turns "self-transforming."[42] This way of conceiving of value allies axiology to the invention of the *new*. It forcibly uproots it from its anchoring in the imperatives of tradition.

Force and value

Forcibly: the term is not gratuitous. "*Between force and value*," Ruyer writes, "*there is an identity of nature*."[43] He is using force in a sense beyond its mechanistic meaning, in a way consonant with the braided causality just described. "A phenomenon of force," he continues, "is both a fact and *more-than-fact*, a given and *more-than-given*, for force directs itself, beyond its present existence, toward a state it itself will produce."[44] Force is not a matter of the adequation of cause to effect, as mechanism would have it. More fundamentally, it is a question of what Erin Manning terms the *more-than*.[45] Force pertains to the braided causality of patience, crossed with terminal allure, cutting across an occasion's energizing, given over to the aim at self-completion, in a direction of selection.

Ecology of values

The inescapability of the concept of force for the theory of value points to the impossibility of insulating an axiological domain from the political. What the concept of force itself "wants" is a correlative concept of power. Value does not inhabit some pure moral domain. It is active in the world, alive with appetition and self-transformation. The political question necessarily intervenes on the ethical level of how the appetitions running toward self-fulfilment cohabit their shared circumstances—how they jostle and readjust to each other, or battle and elbow each other out; how they mutually intensify each other's run, or curtail one another's force of self-deciding. It is here that the *ecology* of values poses itself as a problem. That ecology is an ecology *of the virtual* in light of the energizing and orienting contribution of potential by qualities of experience in their conditioning role as character-building virtual aim attractors. The question raised earlier of the distinction between difference and differentiation finds its full force here. The politics implied by this theorization of value will give axiological priority to the more-than-given, the more-than-fact, beyond recognized constituencies and the fact of their belonging to given identity categories. It gives priority instead to their belonging to an ecology that forcefully, formatively hinges on the virtual.

Norm and value

Ruyer's third point about how the theory of color proper prepares the foundation for the theory of value is germane to this ecological question. It states that a quality of experience like a color is "at once *subjective and transsubjective, relative and transrelative.*"[46] Ruyer himself glosses this phrase in a more traditional way than will be the case here ("subjective" in the sense of being in a subject, transrelative in the sense of obeying a "strict normativity"[47]). The erasure of the ought from axiology does not erase normativity. But it does change the role of the norm, in a way signaled by Simondon.

For Simondon, the norm is not a model of behavior demanding obedience. It is neither a law of behavior, nor the regulative ideal of an identity. It is a rule of operation maintaining activity within certain parameters. When the becoming of one occasion of experience (or in Simondon's vocabulary, "individuation") perishes and another comes in its wake, the following occasion can seize the bequeathed conditions in a way that wants to follow in the footsteps of its antecedent. This occurs when there are germinal forms left by the antecedent occasion among the detritus of its passing, which then resprout as the new occasion self-energizes, and are selected by it to be determining of its course. Whitehead calls these

germinal forms "common elements of form."[48] The successor occasion subsequently unfolds in a way that makes its becoming analogous to that of its predecessor. Stated in a way that takes into consideration the undecidability between action and passivity, this analogized resprouting can be called "conformal becoming" or "transmitted self-rule." It constitutes what Whitehead calls a "serial order"[49] or "historic route."[50] Under these conditions, the occasions along the route remain within average modes of operation, reproducing certain shared values more than they invent new ones for themselves. In other words, they are homeostatic. What they collectively want is to calibrate their becoming for equilibrium, and to pass the equilibrium-seeking down the line. The operational parameters favoring this are *norms*. By this definition, norms function *immanently* to every occasion, sprouting anew in each subsequent becoming. They "rule" from within occasions' self-deciding. They are achievements, of sorts. Limitative achievements, it is true, but achievements nonetheless. As immanent to occasions' becoming, they retain a certain newness. The occasions are serially enlivened by repeated appearance of their shared defining character. They each "enjoy," as Whitehead would say, its serial return.

A value, in contradistinction to a norm, is in Simondon's words "the capacity for amplifying transfer contained in the system of norms."[51] In other words, the norm itself becomes a given circumstance for an intervening transduction that amplifies the becoming. By "amplification" Simondon means seizing upon factors also present in the given circumstances over and beyond the conformal germs regulating the norm. These factors are made to count as formative factors for the becoming. Their magnifying rise into importance shifts the appetitive focus. They bring into focus alternate orientations, shepherded to completion in different qualities of experience than those "normally" decided for. This "magnifies" the occasion in another sense. It packs its becoming fuller with virtual lures. It intensifies its wanting with alternate routes to alternate ends. This is the nonquantitative sense of intensive magnitude the theory of value requires. Greater qualitative intensity is packed into an occasion's becoming in the form of *contrasts* between alternatives held together, in their difference, in the occasion's unfolding.

Struggle and invention

This means that there is an ecology of value implicated in each occasion's self-decision: a virtual cohabitation that disturbs the equilibrium, necessitating struggle or invention. Or *both* struggle—the jostling and mutual readjustment of wanted qualities of experience or perhaps, that failing, a battling it out—*and* invention. Here, invention is the appearance of a new finality, an eternal object appearing for the first time: an alluring virtual

terminus never before felt, for all time. The occasion's completion will carry the birthmark of the ecological struggle of its reaching its end. In the end, it will appear as a complex quality of experience *patterned* by the contributing contrasts.[52] Value proper concerns the amplifying appearance of patterned intensity, predicated on inherited norms but inventively exceeding their conformal rule, with an "abnormal" avidity of appetition, energized in a way that leads far from equilibrium.[53]

Transsubjective

The process of valuation, Ruyer was quoted as saying, is both subjective and transsubjective, relative and transrelative. In the terms of the present account, actual occasions of existence are subjective in the sense explained earlier: self-deciding in their transductive patience for quality of experience, and achieving their own singular character. Subjectively, they are self-completing. They come to a peak, where their defining quality (contrastive complex of qualities) appears, no sooner to perish. It is only they that partake of their peaking and perishing. They are alone in their own self-enjoyment. This is the *atomistic* aspect of the process of valuation that Whitehead notes.[54] The atomistic completion of the occasion envelops all of its contributory factors, all of its self-deciding, in the singular (multiple) appearing of the crowning quality of experience, such as it has come to be, positively all itself. The singularity of the completing quality that finally characterizes the occasion abstractly wraps everything that prepared its appearance into its crystalline being-such-as-it-is, all and only that, now for all times. It is this atomic singularity, virtually shimmering with fissional and fusional potential that can only come to full expression in other, successor, occasions, that gives the occasion its *monadic* character. An occasion of experience is not merely atomistic. It is monadically so, *including its own others* in its being such as only it will have become. In this other-including monadic aspect, the occasion is what I have elsewhere called, riffing on William James, a "little absolute" (so immanently different from the grand absolute of the universal and transcendent).[55] There is a necessary aspect of transsubjectivity in-forming subjective becoming.

Transrelative

Whitehead's way of talking about a monadic occasion's virtual inclusion of its own others in its singularity, or what was called earlier its immanent self-transcendence, is that it includes its own "beyond" in its constitution. "It belongs to the essence of each occasion of experience that it is concerned with an otherness transcending itself."[56] What this means is that the "little

absolute" of every occasion is not absolute in a static or statuesque sense. It is virtually stirring with the potential for *other* occasions, *other* appetites, *other* patterns, *other* intensities, *other* ecological struggles and adjustments. In other words, its monadic aspect contains an *other* aspect. The occasion is crystalline in its singularity—but its facets are turned toward alterity. Guattari makes the equation: MONADISM = TRANSMONADISM.[57] The "little absolute" of the occasion is transrelative. It is impassively ashimmer with the potential nexts in the transductive series. It is to these next others that it bequeathes at its peak the intensive pattern it has invented. In its coming to completion, it has become now, for all times. Its intensity, its pattern, its invention, will be available as a given for ever more. It now always will have been a potential—even for past times where the wanting of its intensity spectrally stirred but did not peak in that alternative (now for the first time, in the mode of always having been, haunting time).[58] In this theory of value, the stolid "ought" of morality and normative ethics is trumped by the prospective *should* of the abiding promise. This is "should" as an auxiliary verb in the subjunctive mood (as in "should such a thing come to pass ..."). The difference is between beckoning enablement and prescription, promissory opening and correctness of closure. The "should" in this subjunctive sense designates the eternality of potential, for invention, beyond the norm. It marks the auxiliary abiding of the appetite for the amplified intensity of experience, luringly appearing now and again in new axiological achievements.

To sum up: The sense in which the occasion is "transsubjective" is that the potential that reappears along the transductive series may always be felt and taken up into the singularity of an other occasion. The potential will then re-peak, subjectively again, for that occasion. When the occasion singularly perishes, it will continue to haunt the transductive series like a spirit. An occasion, Whitehead says, is "immortal" in this sense.[59] Its potential moves through the little-absolute subjectivity of others' becomings. This toggles us back from the transmonadic aspect to the monadic. Paradoxically, in spite of their final status of little absolutes, it is with respect to their monadic aspect that occasions are "relative." Their initial becoming-into-themselves is relative to the inherited conditions from which they emerge—and from which they free themselves to the extent that they self-decide for their own singular character. It is in this initial bid for *freedom* that they are relative.[60] Upon their self-completion, as they peak, they are transmonadically fully determined once (now) and for all (for a virtual infinity of others). They move from the relativity of their beginnings through their little-absolutely subjective becoming to the transrelativity of their bequeathing.

Surplus value

Excess. The immanent beyond enveloped in the qualitative just this, thus, positively all of itself of self-achieving experience has now entered the core of the theory of value. The shift from a theory of "pure" quality like a color to an axiological value proper was said to revolve around the concept of activity. The concept of activity was said to concern activity of self-completion virtually including its own others, to which it bequeathes a newly invented pattern of qualities of experience. Virtually haloing that complex pattern is a wider complex of qualities on which the occasion turned its back, selecting them not to appear. These unselected alternatives form the virtual background against which the achieved pattern stands out—and without which it would lack the experiential emphasis that enables it to assert its being just what it is. The backgrounded complex of alternatives can be distinguished from the qualitative complex that emphatically appears against its virtual background by calling it, borrowing from Guattari, the occasion's *complexion*.[61] The occasion of experience bequeathes to its successors this extended complex composed of the actual pattern and its virtual complexion. It is this extended nexus that is bequeathed to the world as a *proposition* for a next occasion's bid for its own freedom.[62]

The key point here is that an occasion always proposes for the world a *surplus* of patterned potential. A next occasion makes good on the surplus, selecting its own alternatives. It recomposes the pattern. It re-colors the halo. It invents new patterns in its bid for freedom. *Process* turns on this serial realization of *surplus value*. The theory of value does not just extend to surplus value. It is essentially concerned with it. There is no theory of value, in its properly axiological sense, without a theory of surplus value. This means that the theory of value can reach no final resting point. It must follow the process of the becoming of values. That process revolves around the perpetual turnover of excess potential. Each self-completing achievement absorbs excess and reimparts surplus. When this process runs in the direction of the intensification of experience, in the qualitative sense discussed above, it achieves what Whitehead calls *progress*, which is synonymous for him with *adventure*: the intensifying aim "toward things not yet realized"[63] passing down an historic route. This is a non-teleological notion of progress as process in continual turnover that invents its own ends—and perpetually exceeds them.

Revaluation

The red of the sunset is a "pure" quality, little-absolutely enjoying its own achievement, wanting nothing but this, thus as it is. This is red in its

monadic aspect, assimilable to Peirce's Firstness. But the same red is no longer a "pure" quality but a properly axiological value when it is taken up, for example, by an artistic experience that decides the red should return other-thus, in another this: as a pigment pattern on a canvas. The painting takes up the proposition of red differently, reinvents its achievement, and reimparts it haloed with a different complexion of alternatives (in this case, likely to be expressed by the ultimately untenable distinction between "natural" quality and "cultural" value). The entering of red into a transductive series of *revaluation* corresponds to Peirce's Thirdness, or *relation*. This is the adventurous, transmonadic aspect. A crucial question now arises for the theory of value. The entire process is one of immediacy of experience becoming to self-enjoy the expression of its own intensity in the crowning achievement of the appearance of a completing quality of experience, complexly patterned and virtually complexioned. This means that relation is experienced as such, in all immediacy. In Peircean terms, there is a *Firstness of Thirdness*. This question of the direct experience of relation forbids the theory of value from straying into the ethereal realm of ideal universals (or into the abyss of withdrawn objects). It must remain faithful to effectively appearing singular multiplicities of experience. These are essentially subjective, but cannot be contained in *the* subject (the single, particular subject) owing to their transsubjective, transrelative participation in a transductive series, the whole, infinite spectrum of which is in some way felt in every completely determined, atomistic link in the braided chain. The theory of value must cleave to the experiential in this extended sense. In other words, it has a date with *radical empiricism* (defined by James as resting on the premise that relations are immediately real and really experienced).[64] The concepts of affective tonality and vitality affect introduced earlier provide useful takes on the immediate experiential reality of relation. But as Whitehead emphasizes, relation is already built into the concept of qualities of experience, for which he suggests the name "relational essences."[65]

This radically removes the theory of value from the spheres of traditional moral philosophy and normative ethics, which revolve around the fulcrum of "the" subject and its choices. From the axiological perspective suggested here, this traditional subject-centeredness amounts to so massive a reduction of the relational complexity of the process as to constitute a falsification. The concept of choice is a pale shadow of the selective becoming of the axiological process as understood here. The complexly decisive bid for freedom at the processually selective heart of becoming begs for an integral rethinking of what we mean by freedom.

Capitalist surplus value

Moral philosophy and normative ethics are not the only nemeses of the theory of the value as inseparable from a philosophy of becoming. The capitalist process has put its trademark on surplus value. Capitalism's singular take on surplus value is more defining of capitalism than either use-value or exchange-value (which are not unique to it, and figure in other systems). Surplus value is different from profit. Profit is a realization of surplus value in a measurable quantity: an actually appearing economic value. Capitalist surplus value is defined in contradistinction to profit as the capacity to generate a future profit. Surplus value is the excess of economic value, over and beyond any given share of profit, that runs through the process. Surplus value is produced in the turnover of profit, used as investment capital toward greater profit. It is the *quality* of economic value under quantitative increase. It may seem odd to say it, but capitalist surplus value, like all surplus value, is fundamentally qualitative. It is the qualitative *intensity* of the quantitative process of accumulating capitalist value. Profit is the monadic aspect of capitalism. Surplus value is its transmonadic aspect: its other-addressed invention of economic potential. Surplus value is the virtual halo of profit. It is the processual complexion of the capitalist system. As virtual, it is actually immeasurable.[66] Although capitalist surplus value is qualitative, as is all processual excess, the trans-ductive series it haunts is pinned to the atomistic realization of quantities of value. Seen from this angle, capitalism is a worldwide machinery for quanti-fying qualities of experience. No dimension of life escapes capitalism's appetite for converting qualitative surplus into an endless accumulation of quantified shares of value.

From the point of view of the theory of value developed here, capitalist surplus value is but a species of surplus value. It is not the model for surplus value, but an impoverished image of it. The theory of surplus value in the richest sense concerns the singular vivacity of a quality's appearing such as it is, just this, and the revivification this thus potentially bequeathes: it is a theory of *surplus value of life*. Capitalist surplus value is surplus value glutted to the point of qualitative starvation by its dependence on the continual reduction of quality to the accumulation of increasing quantity. Surplus value of life, for its part, refuses to starve its realizations with the wrong kind of excess. It subsists across the transductive series in order to insist on the immediately qualitative nature of each appearing valuation. Its process revolves around the directly qualitative intensification of experience: its increasing qualitative magnitude, as opposed to magnitudes of increasing quantity. Surplus value of life is in essential tension with capitalist surplus value. There is an implicit *anticapitalism* in the enriched theory of value. The playing out of this tension is the most crucial struggle involved in the self-decisions occasions of experience must make as they

bootstrap themselves into the bids for freedom that will potentially, provisionally, complete them.

The axiological anticapitalist struggle is the most crucial because the voraciously reductive process of accumulation associated with the turnover of capitalist surplus value has reached the point of endangering life itself. The actual ecologies Guattari refers to in the opening quotation have been brought to the point of collapse. There is an urgency to rethink the theory of value in a way that shifts the emphasis away from value production revolving on the quantification of value back to an essential concern for intensities of valuation that have (are) values in themselves: such as they are, postively all of themselves; such as they other potential onward for similarly intense, unabashedly qualitative, revaluations to come. A take on the virtual ecology is a necessary part of any response to the crisis of actual ecologies. For it alone is capable of haloing present realizations with anticapitalist potential.

Systematic anomaly

Fittingly, Ruyer's fourth and final point about how the theory of color overlaps with the theory of value concerns ecological complexity. He states it in terms of "system."[67] This is related to the point made earlier about the complexity of appearing and the complexion of the background of potential against which it appears. A color is a little absolute. Under one aspect, it presents its atomistic appearing such as it singularly is. But under its concomitant transrelative aspect, its appearing carries a systemicity. Red is red in virtual contrast to its complementary color, green. There is a system of colors. The contrast is everywhere active where red appears, even when it appears alone. Red's complementary values haunt it. If you stare at a monochrome red display and then turn your gaze away, the world turns green. If you focus on the shadow of a red object, it appears not grey but greenish. Where red appears, green subsists—poised to appear as the circumstances want. Green dances with red's circumstances. Red carries an ecological engagement with potential for greenness. Green is the most proximate other-value in the ecology of red. Red is always already virtual green.

This ecological systematicity of color is, oddly, considered invariant in traditional theories of experience. This is because its systematicity is indeed invariably passed down in the germinal forms in-forming the individuation of animal bodies (the genes). Or is it? It is not in fact entirely invariant—as any color-blind person will tell you. But as Ruyer off-handedly observes, people who are color-blind do not struggle with those who are not over redness[68] (they may struggle over inclusion and accommodation, but not over redness per se). When a value system is considered, however wrongly, to be

an invariant, the complementary contrasts missing from some realizations of the system are apt to be dismissed as a simple anomaly. In other words, this alternate realization is not treated as a value in itself. It is seen as a simple lack of the predominant value. It is only considered important if the variation interferes with the normative functions built into the human environment (for example, the effectiveness of signage). But surely, the lack of red is not just an anomalous absence. Surely, it has it own systematicity. It is not a simple lack, but the presence of an alternate system of color. Must not this alternate system carry intensities of experience that can be lived as values in themselves? Seen from this angle, color-blindness is a potential for adventure in its own right (as is autism, to take a culturally salient example for our time).

Domination and neurodiversity

In light of the earlier discussion of variety and variation, the theory of value owes it to itself to eschew invariants and counter their relegation of variations to the status of insignificant anomalies. It has to throw the staid conceptual baby of the invariant out with the normative bathwater. The social and political struggles of the last forty years have revolved around the affirmation of diversity. Variations of race, gender, ethnicity, and able-bodiedness have been at the political center of axiological struggle. Politically, the fundamental problem raised by the theory of value advanced here relates to the status of invariably dominated groups. When the dominating invariant is in operation, the singular variations associated with these groups tend to be construed as anomalies worthy at best of tolerance, or if they're lucky benevolent accommodation to the norms.[69] The invariant of invariants, the putative universal, the preeminent standard of existence, is, of course, the *human*. The examples of color-blindness and autism add the factor of *neurodiversity* to the political mix. In view of the preeminent role played by the imposed standard of the human, it can be argued that the issue of neurodiversity cuts across and exceeds such struggles as those around race, gender, ethnicity, and able-bodiedness, extending to all manner of variations in experiential complexion. As Erin Manning argues, this makes it a necessary strategic axis for a revaluated theory of value and its associated politics, arcing across the full experiential spectrum of potential.[70] There *should* be struggles over redness. There *should* be struggles over autistic perception in Manning's sense of the term.[71]

Ecological struggle

The point is that the theory of value, to live up to its potential adventurousness, must approach the ecological systemicity of every value,

however seemingly hardwired, as a question of virtual variety: ecologies of *systemic* contrast and complementarity. It should grasp these diversities of experience from the angle of their capacity to enter into the adventure: that of intensifying variation occurring as part of a *process* of revaluation.[72] It must see diversity as carrying whole new ecologies, promising the invention of qualities of experience worthy of struggle.

The theory of value as developed here does not stop at human neurodiversity. More far-reachingly, its ecological aim extends beyond the human brain to nonhuman modes of experience. This is not only meant in the sense of attending to nonhuman entities as part of the ecological complex and its complexions. It entails an integral revaluation of values, opening onto new vistas of surplus value of life and new, as yet indeterminate, fields of struggle. This process hinges on adventures of axiological invention. It does not content itself with the self-congratulatory pat on the back of the feeling of being oh-so tolerant and accommodating, or the smug satisfaction of getting it morally "right" by the prevailing standard. The process of invention avails itself of excess: the qualitative surplus value of life of the *more-than-human* haloing every predominantly human occasion of experience with an infinity of "other" potentials.[73]

It should be evident by now that the "actual ecologies" Guattari refers to in the opening quotation are not limited to the environmental. The overall ecology of values can be parsed into three reciprocally presupposing systems of complementarity, or virtual mutual inclusion: the environmental, the social, and the mental (the abstract).[74] The theory of value, as suggested by the singular vivacity of the quality of the experience of color, aims less at these systems per se than at their processual turnover into each other, and together into new postcapitalist patternings of experience, each a value in itself, such as it is, as well as carrying other-onward an immeasurably augmented intensity of virtual complexions, red ripe for experiential adventure beyond the human compass.

Notes

1 Félix Guattari, *Chaosmosis* (Bloomington: Indiana University Press, 1995), 91 (translation modified).

2 Raymond Ruyer, *La philosophie de la valeur* (Paris: Armand Collin, 1952), 204.

3 The formulae in the following paragraph also echo Peirce. See for example C. S. Peirce, *Pragmatism as a Principle and Method of Right Thinking* (Albany: State University of New York Press, 1997), 140. See also Brian Massumi, "Such as It Is: A Short Essay in Extreme Realism," *Body and Society* 22:1 (March 2016): 115–127.

4 Raymond Ruyer, *Le monde des valeurs* (Paris: Aubier, 1948), 9–38.

5 Ibid., 12.

6 Alfred North Whitehead, *Science and the Modern World* (New York: Free Press, 1967), 87.

7 Ruyer, *Le monde des valeurs*, 11. Deleuze also uses the term "subsistence," perhaps in dialogue with Ruyer, for the mode of reality of the virtual. See Gilles Deleuze, *Logic of Sense* (New York: Columbia University Press, 1990), 123 and Gilles Deleuze, *Difference and Repetition* (New York: Columbia University Press, 1994), 156.

8 "An eternal object can be described only in terms of its potential for ingression into the becoming of actual entities," Alfred North Whitehead, *Process and Reality* (New York: Free Press, 1978), 23. "If the term 'eternal objects' is disliked, the term 'potentials' would be suitable," ibid., 149. In general, the term "eternal objects" will be disliked in this chapter, but will be used sporadically.

9 Whitehead, *Science and the Modern World*, 87.

10 Whitehead, *Process and Reality*, 338.

11 Whitehead, *Science and the Modern World*, 87.

12 Ibid.

13 Whitehead, *Process and Reality*, 29.

14 Whitehead, *Process and Reality*, 114.

15 Deleuze emphasizes the indifference, or in his vocabulary "impassivity," of the eternal object, whose whatness he calls the incorporeal "attribute" that actually appears in the guise of a physical quality (*Logic of Sense*, 4–5). Here, the word "quality" is used to straddle the physical appearing and the incorporeal abiding, as two sides of the same coin. Deleuze also emphasizes that singularities are always already extending toward variations on themselves, as well as (as will be seen later in this chapter) toward other singularities (*Logic of Sense*, 53, 109–10).

16 This complicates what at first reading appears to be a cut-and-dried distinction in the thought of Whitehead between "simple" eternal objects like a color and "complex" eternal objects. In the present account, this distinction will be reinterpreted as a difference of aspect, rather a typology of different categories of eternal objects, using Peirce's concepts of Firstness and Thirdness (which reciprocally presuppose each other). Whitehead defines a "simple" eternal object as one that cannot be analyzed into components (*Science in the Modern World*, 166). This simplicity can only be relative to how the potential for color is prehended. As prehended from the perspective of its consequent nature, that is to say as it appears, a color will always be a contrastive factor of a complex field displaying the simplicity of its own immediate character (the field as a whole has the unified character of a Firstness). Even considered outside of any appearing, a color exhibits a virtual multiplicity, as involved in a system of color: a primary color, for example, cannot be conceived outside of its virtual accompaniment by its compementary, whose potential it carries (more on this later). As understood here, a simple eternal object is one that appears for an occasion, under certain conditions, as a function of the wanting, as

simply given. It is taken for simple—but this manner of taking must be part of its potential. Whitehead himself blurs the boundary between simple and complex eternal objects in passages where he refers to the "fusion" of the "individual essence" of an eternal object with other eternal objects (*Science in the Modern World*, 169), or says that "one" complex eternal object has a "unity" (*Process and Reality*, 24).

17 For Whitehead's critique of the universal-particular couplet, see *Process and Reality*, 48–57.

18 Ruyer, *Le monde des valeurs*, 12.

19 Alfred North Whitehead, *Modes of Thought* (New York: Free Press, 1968), 132–3.

20 Alfred North Whitehead, *Concept of Nature* (Cambridge: Cambridge University Press, 1964), 3, 171–3, and *Science in the Modern World*, 36, 66–7, 84, 87.

21 On the idea that potentials do not emerge and thus of themselves lack novelty, see Whitehead, *Science in the Modern World*, 103, and *Process and Reality*, 22. On appearance as opposed to emergence, see Alfred North Whitehead, *Adventures of Ideas* (New York: Free Press, 1967), 209–19.

22 Philip Ball, *Bright Earth: The Invention of Colour* (London: Penguin, 2001), 260–82.

23 Félix Guattari, *The Three Ecologies* (London: Athlone, 2000), 45; Félix Guattari, "From Transference to the Aesthetic Paradigm," in *A Shock to Thought: Expression after Deleuze and Guattari,* ed. Brian Massumi (London: Routledge, 2002), 244.

24 Whitehead, *Process and Reality*, 80, 176.

25 Ibid., 46, 59.

26 Ibid., 176–7, 180.

27 On the concept of "carrying" as a processual mutual envelopment of different qualities or modes of activity, see Erin Manning, *The Minor Gesture* (Durham, NC: Duke University Press, 2016), 131–64. On vitality affect, see Brian Massumi, *Semblance and Event* (Cambridge, MA: MIT Press, 2011), 43–4, 112, 115, and Brian Massumi, *What Animals Teach Us About Politics* (Durham, NC: Duke University Press, 2014b), 9, 25–30.

28 Whitehead, *Modes of Thought*, 69–70, 163–5.

29 See Bergson's critique of quantitative notions of intensity in *Time and Free Will* (Mineola, NY: Dover, 2001), Ch. 1.

30 Whitehead, *Process and Reality*, 25, 85, 87.

31 "The whole gamut of relevance is 'given,' and must be referred to the decision of actuality" (Whitehead, *Process and Reality*, 43). "The word [decision] is used in its root sense of a 'cutting off'" (ibid., 44).

32 Whitehead, *Modes of Thought*, 127–69.

33 This is a reference to Foucault's characterization of Deleuze's theory of causality in *Difference and Repetition* as "stitched causality"; Michel Foucault, "Theatrum Philosophicum," in *Language, Counter-Memory,*

Practice (Ithaca: Cornell University Press, 1977), 173. In *Logique du sens* (1990), Deleuze characterizes the causal contribution of the virtual side as a "quasi-causality."

34 I am departing here from Whitehead's vocabulary. For Whitehead, the "eternal object" is indeed an object. But this is using object in the technical philosophical sense of something given. The eternal object gives potential (abstractly given; "abstract" in the sense of dodging confinement to any one occasion); the circumstances give the initial conditions for the occasion's becoming bequeathed by past occasions (what Whitehead defines as the physically given). An eternal object is not an "object" in any normal sense of the word. Neither is it "eternal" in any normal sense of the word, as discussed in the treatment above of its paradoxical time signature, which prevents it from being in time. Whitehead uses "eternality" as a hedge against the usual connotation of "eternal" as endlessly enduring in time. My characterization of the misnomer that is the "eternal object" as "subjective" is a conscious inflection of Whitehead's concept of the eternal object by Peirce's concept of Firstness. Firstness in Peirce is subjective in an absolute sense, as requiring nothing else but itself for its reality, and being definable only in reference to itself (coming with the self-evidence of the "you know it when you see it"). Below, the occasion of experience as transferentially characterized by the "eternal object" is styled a "little absolute." The apparent opposition between the "objective" as applied to the given circumstances that initially condition an occasion, and the "objective" givenness of the eternal object as the potential subjectively characterizing the occasion's becoming, in fact falls away when it is considered that Whitehead specifies that what the formative factors making ingress as part of the initial circumstances donate is their *subjective form*: their pattern of activity. From this point of view, they figure as complex eternal objects making themselves felt as the initial or "primary" phase of the occasion's becoming, and from which that becoming departs rather than toward which it is lured. They are the potential already given in presupposition, rather than the potential given as a proposition for the occasion's attainment. The notion that the formative factors inherited in the circumstances donate subjective form ultimately dissolves any notion of objectivity in the normal sense as a factor in the process of becoming, earning Whitehead's philosophy its status as a radical "panexperientialism." The distinction between the object and the subject are distinctions between *roles* in the process of subjective becoming. The entities in Whitehead's metaphysics can be characterized as *subjectivities without a subject* whose determination requires no object, in the sense in which that term is understood either in everday life or traditionally in philosophy, against which their subjectivity would stand in opposition. For more on subjectivities without a subject, see Massumi, *What Animals Teach Us About Politics*, 40–1, 69–70, 96–7.

35 This is building on Simondon's sense of transduction; Gilbert Simondon, *L'information à la lumière des notions de forme et d'information* (ILNFI) (Grenoble: Million, 2005), 32–3.

36 This is a reference to Whitehead's concept of "reenaction," which complicates the associated concept of "conformation of feeling" or

"conformal inheritance." The latter concept states that an arising occasion of experience begins by inheriting the form of energy and vectored momentum bequeathed to it from the immediate past. However, each occasion is also said to "perish" as it reaches its completion. It would seem that the only way to reconcile these two propositions—perishing and reenaction, conformal inheritance and new arising—is to posit an imperceptible threshold or infnitely thin interval of activation at the hinge between the immediately preceding occasion leaving itself and its successor coming into itself. This threshold coincides with the impact of the lure proposing itself to feeling. On conformal inheritance and reenaction, see Whitehead, *Adventures of Ideas*, 163–6, 237–8.

37 Whitehead, *Process and Reality*, 192.

38 "The organism [another word for the occasion of experience] is a unit of emergent value, a real fusion of the characters of eternal objects, emerging for its own sake;" Whitehead, *Science in the Modern World*, 107. See note 21 above for the non-emergent nature of potential's appearing.

39 Whitehead, *Process and Reality,* 316.

40 Ruyer, *La philosophie de la valeur,* 61–9.

41 This is Whitehead's category of Conceptual Reversion: "There is secondary origination of conceptual feelings [the registering of the aimed-at quality of experience] with data which are partially identical with, and partially diverse from, the eternal objects forming the data in the primary phase"; Whitehead, *Process and Reality*, 249.

42 Ruyer, *Le monde des valeurs*, 11.

43 Ruyer, *Le monde des valeurs*, 48 (emphasis added).

44 Ibid., 142 (emphasis added).

45 Erin Manning, *Always More Than One* (Durham, NC: Duke University Press, 2013).

46 Ruyer, *Le monde des valeurs*, 12.

47 Ibid., 13

48 Whitehead, *Process and Reality*, 34; Whitehead, *Adventures of Ideas,* 203. The structure of DNA is the obvious example in the case biological individuation. But it is by no means the only kind of germinal form contributing to life. Simondon speaks of the "germs" of crystal formation as a model for his theory of indivuation (*ILNFI*, 75 note). It is important that it in the case of DNA it is its *structural quality* that is the "germ." What characterizes DNA in its formative activity is this complex eternal object. Whitehead specifies that his "common elements" are complex eternal objects. Common elements or germinal forms are smaller-scale transductions embedded in a larger transductive becoming. Transduction, according to Simondon, is by nature analogical (pertaining to the transfer of characters), at whatever scale.

49 Whitehead, *Adventures of Ideas,* 202, 205; Whitehead, *Process and Reality*, 34.

50 The corresponding term in Simondon is a "transductive series" (*ILNFI*,

211, 216–17. Whitehead refers to "historic routes (of inheritance)" throughout *Process and Reality*.

51 Simondon, *ILNFI*, 331.

52 The concept of patterned contrasts is central to Whitehead's theory of value, whose highest value is "beauty" understood as the "mutual adaptation of the several factors in an occasion of existence" in a way that intensifies the experience (*Adventures of Ideas*, 252). This mutual adaptation is the patterning of contrast. Beauty is a value in itself: "any system of things which in any wide sense is beautiful is to that extent justified in its existence" (265); "beauty is left as the one aim which by its very nature is self-justifying" (266). Although Whitehead equates beauty with "Harmony," what we normally call harmony is actually a sterile, lowest degree of it by Whitehead's reckoning. The most intense beauty, that which energizes transductive series of becomings, must have an element of "Discord" (256–66, esp. 266) and imperfection (276).

53 This is analyzed in Massumi, *What Animals Teach Us About Politics* as a "supernormal tendency" traversing animality.

54 Whitehead, *Process and Reality*, 286.

55 Massumi, *Semblance and Event*, 20–1, 179, 181–2. On the "minutest" occasion of experience including its "own others," see William James, *A Pluralistic Universe* (Lincoln, NB: University of Nebraska Press, 1996), 271–2.

56 Whitehead, *Adventures of Ideas*, 180. Or again: "The aboriginal data in terms of which the pattern weaves itself are the aspects of shapes, of sense-objects, and of other eternal objects whose self-identity is not dependent on the flux of things. Wherever such objects have ingression into the general flux, they interpret events, each to the other. They are here in the perceiver; but, as perceived by him, they convey for him something of the total flux which is beyond himself. The subject–object relation takes its origin in the double role of these eternal objects. They are modifications of the subject, but only in their character of conveying aspects of other subjects in the community of the universe. Thus no individual subject can have independent reality, since it is a prehension of limited aspects of subjects other than itself" (Whitehead, *Science in the Modern World*, 151).

57 Guattari, *Chaosmosis*, 113.

58 This is Whitehead's theory of negative prehension: "A negative prehension is the definite exclusion of that item from positive contribution to the subject's own real internal constitution. This doctrine involves the position that a negative prehension expresses a bond ... those eternal objects which are not felt are not therefore negligible" (*Process and Reality*, 41). All eternal objects contribute to each occasion of experience, anywhere along the timeline, however vaguely or faintly. This is allied to the notion that alternate routes are enveloped in each occasion of experience: "Each perspective for any one qualitative abstraction such as a number, or a colour, involves an infinitude of alternative potentialities" (Whitehead, *Modes of Thought*, 66–7).

59 Whitehead, *Adventures of Ideas*, 193.

60 On life process as a bid for freedom, see Whitehead, *Process and Reality*, 104.

61 Guattari, *Chaosmosis*, 112, 114. This is a somewhat different take on Guattari's concept of complexion than the one in Massumi, *What Animals Teach Us About Politics,* 78–9, 85–6.

62 On the infinite background of potential and the proposition, see Whitehead, *Process and Reality,* 112. See also Whitehead, *Adventures of Ideas*, 281. The equivalent concept in Ruyer's work is that of the "theme"; in Raymond Ruyer, *La genèse des formes vivantes* (Paris: PUF, 1958), 11–48 and passim.

63 Whitehead, *Adventures of Ideas*, 279.

64 For a treatment of this question of the direct perception of relation, with an attention to the question of value, see Brian Massumi, "Envisioning the Virtual," in *The Oxford Handbook of Virtuality*, ed. Mark Grimshaw (Oxford: Oxford University Press, 2014), 55–70. For the concept of radical empiricism, see William James, *Essays in Radical Empiricism* (Lincoln, NB: University of Nebraska Press, 1996).

65 The relational is essentially double. It involves other qualities in potentiality, as well as other actual realizations, and does so in a way that does not belie a quality's Firstness, or little-absoluteness: "An eternal object, considered as an abstract entity, cannot be divorced from its reference to other eternal objects, and from its reference to actuality generally; though it is disconnected from its actual modes of ingression into definite occasions. This principle is expressed by the statement that each eternal object is a 'relational essence'"(Whitehead, *Science in the Modern World*, 159–60). On relational essence, see also Whitehead, *Modes of Thought*, 68. Specifically on color: "We do not perceive disembodied colour or disembodied extensiveness: we perceive *the wall's* colour and extensiveness. The experienced fact is 'colour away on the wall for us.' Thus the colour and the spatial perspective are abstract elements, characterizing the concrete way in which the wall enters into our experience. They are therefore relational elements between the 'percipient at that moment,' and that other equally actual entity, or set of entities, which we call the 'wall at that moment.' But the mere colour and the mere spatial perspective are very abstract entities, because they are only arrived at by discarding the concrete relationship between the wall-at-that-moment and the percipient-at-that-moment. This concrete relationship is a physical fact which may be very unessential to the wall and very essential to the percipient"; Alfred North Whitehead, *Symbolism* (New York: Fordham University Press, 1985), 15–16. See also Whitehead, *Concept of Nature*, 149–50. Whitehead formulates the basic tenet of radical empiricism, without using that term: "the relations holding between natural entities are themselves natural entities, namely they are also factors of fact, there for sense-awareness" (*Concept of Nature*, 14).

66 Toni Negri, "Twenty Theses on Marx," in *Marxism Beyond Marxism*, ed. Saree Makdisi, Cesare Casarino, and Rebecca E. Karl (London: Routledge, 1996), 151–2.

67 Ruyer, *Le monde des valeurs*, 13.

68 Ibid., 11.

69 The application of the norm and the standard judgment of insignificance vis-à-vis "anomalous" variations plays out, of course, in much more complicated ways than this brief sketch is able to express. For example, the dismissal of the anomaly can flip over into an affirmation of the "exception." This is seen, for example, in the popular culture trope of the autistic savant and their IT prowess, or in the older stereotype of the "good" racial minority (the exceptional individual who has overcome their "social handicap" to succeed in life and become one of "us") or the "good cripple" (who doesn't make the able-bodied feel awkward when they don't know how to respond to their being in a wheelchair). Discussions within the neurodiversity movement often focus on this dynamic, pointing out that there are only "exceptions" because there is still the rule. These tropes are falsely inclusive strategies for saving the dominance of standard in the face of demands for a radical revaluation—feel-good strategies for neurotypical saving face.

70 Manning, *The Minor Gesture*.

71 Manning, *Always More Than One* and *The Minor Gesture*.

72 For an analysis of the difference between system and process, see Brian Massumi, "National Enterprise Emergency: Steps Toward an Ecology of Powers," in *Ontopower: War, Powers, and the State of Perception* (Durham, NC: Duke University Press, 2015), 41–3.

73 Brian Massumi, *What Animals Teach Us About Politics*; Manning, *Always More Than One*.

74 Guattari, *The Three Ecologies*.

Bibliography

Ball, Philip. *Bright Earth: The Invention of Colour*. London: Penguin, 2001.

Bergson, Henri. *Time and Free Will*. Mineola, NY: Dover, 2001.

Deleuze, Gilles. *Difference and Repetition*. New York: Columbia University Press, 1994.

Deleuze, Gilles. *Logic of Sense*. New York: Columbia University Press, 1990.

Foucault, Michel. "Theatrum Philosophicum." In *Language, Counter-Memory, Practice*. Ithaca: Cornell University Press, 1977.

Guattari, Félix. "From Transference to the Aesthetic Paradigm." In *A Shock to Thought: Expression after Deleuze and Guattari*, ed. Brian Massumi, 240–5. London: Routledge, 2002.

Guattari, Félix. *Chaosmosis*. Bloomington: Indiana University Press, 1995.

Guattari, Félix. *The Three Ecologies*. London: Athlone, 2000.

James, William. *A Pluralistic Universe*. Lincoln, NB: University of Nebraska Press, 1996.

James, William. *Essays in Radical Empiricism*. Lincoln, NB: University of Nebraska Press, 1996.

Manning, Erin. *Always More Than One*. Durham, NC: Duke University Press, 2013.

Manning, Erin. *The Minor Gesture*. Durham, NC: Duke University Press (2016).

Massumi, Brian. "Envisioning the Virtual." In *The Oxford Handbook of Virtuality*, ed. Mark Grimshaw, 55–70. Oxford: Oxford University Press, 2014.

Massumi, Brian. "Such as It Is: A Short Essay in Exteme Realism." *Body and Society* 22:1 (March 2016): 115–27.

Massumi, Brian. "National Enterprise Emergency: Steps Toward an Ecology of Powers." In *Ontopower: War, Powers, and the State of Perception*. Durham, NC: Duke University Press, 2015.

Massumi, Brian. *Semblance and Event*. Cambridge, MA: MIT Press, 2011.

Massumi, Brian. *What Animals Teach Us About Politics*. Durham, NC: Duke University Press, 2014.

Negri, Toni. "Twenty Theses on Marx." In *Marxism Beyond Marxism*, ed. Saree Makdisi, Cesare Casarino, and Rebecca E. Karl, 149–80. London: Routledge, 1996.

Peirce, C. S. *Pragmatism as a Principle and Method of Right Thinking*. Albany: State University of New York Press, 1997.

Ruyer, Raymond. *La genèse des formes vivantes*. Paris: PUF, 1958.

Ruyer, Raymond. *La philosophie de la valeur*. Paris: Armand Collin, 1952.

Ruyer, Raymond. *Le monde des valeurs*. Paris: Aubier, 1948.

Simondon, Gilbert. *L'information à la lumière des notions de forme et d'information*. Grenoble: Million, 2005.

Whitehead, Alfred North. *Concept of Nature*. Cambridge: Cambridge University Press, 1964.

Whitehead, Alfred North. *Adventures of Ideas*. New York: Free Press, 1967.

Whitehead, Alfred North. *Science and the Modern World*. New York: Free Press, 1967.

Whitehead, Alfred North. *Modes of Thought*. New York: Free Press, 1968.

Whitehead, Alfred North. *Process and Reality*. New York: Free Press, 1978.

Whitehead, Alfred North. *Symbolism*. New York: Fordham University Press, 1985.

INDEX